The History and Philosophy of
Art Education

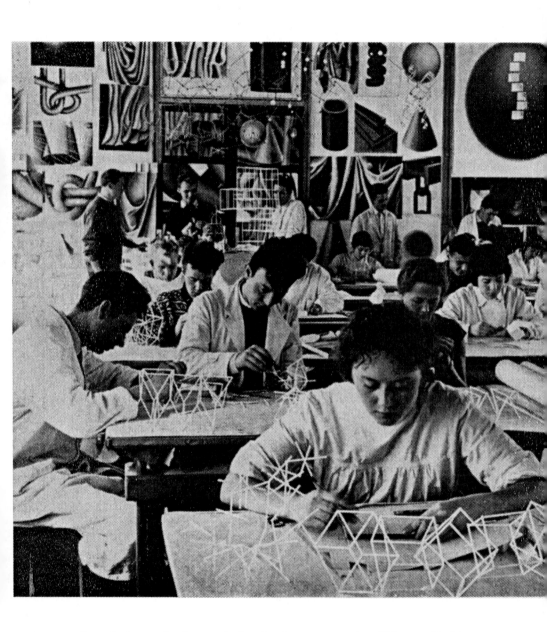

Frontispiece: A class of the basic course, Staatlichen Werkkunst-schule, Saarbrücken (Director: Oskar Holweck)

The History and Philosophy of Art Education

Stuart Macdonald

The Lutterworth Press
Cambridge

Published by
The Lutterworth Press
P.O. Box 60
Cambridge
CB1 2NT
England

e-mail: **publishing@lutterworth.com**
website: **http://www.lutterworth.com**

ISBN 0 718 89153 8 paperback

British Library Cataloguing in Publication Data:
A catalogue record is available from the British Library.

First published 1970
First published by the Lutterworth Press 2004

Preface to First Printing

A knowledge of the principles and methods of art education is essential for a true understanding of the art of different periods, and therefore for the art historian, but at the outset I would like to put the view that art education is a branch of the subject education rather than of the history of art. This is so evident as not to deserve mention, but some confusion has resulted from recent references to studies in art education as art history. The whole field of art education is clarified for research and teaching purposes if the subject is studied within the existing education disciplines of history, philosophy, psychology, and sociology of education. Student teachers in recent years have been receptacles for a disorderly conglomeration of facts on art education, of small import to them because there has been little stress upon what was done, is done, when, and why.

This investigation of the most important developments in Western art education was for me an exciting search into the unknown. The bulk of this history, from Chapter 3 to Chapter 17, was unexplored at the time of writing. Professor Quentin Bell has now published his excellent research, *The School of Design*, which covers the same period as three chapters of my work, and it should be interesting to compare our accounts, written at the same time from remote sources.

My chief acknowledgements must be to the educationists who have encouraged me by their interest in my work. Firstly, Professor W.A.L. Blyth of Liverpool University; then Professor R.A.C. Oliver, Mr Norman Morris, Mr William Gaskell, and Brother Augustine of Manchester; Professor J.P. Tuck of Newcastle, Professor A.C.F. Beales of King's College, London, and Mr Christopher Cornford and Mr Roger de Grey, A.R.A., of the Royal College of Art. It should be added that any student of the history of art education is indebted to Professor Nikolaus Pevsner, the pioneer in this field. My thanks are also due to Sir Robin Darwin, Rector of the Royal College of Art; Herr Oskar Holweck of the Saarbrücken Werekkunstschule; Mr John Holden, Principal at Manchester College of Art and Design; Mr Meredith Hawes, Principal at Birmingham; Mr David Bethel, Principal at Coventry; Mr Eric Taylor, Principal at Leeds; Mr Tom Hudson, Director of Studies at Cardiff; Mr C. H. Gibbs-Smith of the Victoria and Albert Museum; Mr W.J.L. Gaydon, Secretary of the National Society for Art Education; Mr G.E. Mercer, Secretary of the Royal Society of Arts; Mr Manston, Secretary of the Royal Drawing Society; Mr Cheshire, Librarian at the Birmingham College of Art; and Mr McKenzie Smith of the Aberdeen Art Gallery and Museum, all for various facilities made available for my research. Among others who have been of assistance, I would like to thank Mr Robert Mann, who shares my interest in the subject, Brother

Albert, F.S.C., Mr Arthur Hamer, Mr Peter Wilson, Mr Arnold Brownsett, and finally my wife Doreen who has been literally a literary widow of late.

The various institutions who have kindly supplied photographs for the plates are acknowledged thereon. The extract from a letter by Charles Dickens in Chapter 11 appears by kind permission of Mr C.C. Dickens, the Pierpont Morgan Library, and the Editors of the Pilgrim edition of *The Letters of Charles Dickens*.

<div align="right">S.M.</div>

Preface to 2004 Reprint

The author wishes to thank Professor Ron George, Dr. John Steers, and Mr. Bruce Holdsworth for their help and encouragement during the making of this reprint.

As thoughts of peace followed the Second World War, the minds of some enlightened educators returned to the problems of teaching art and design, being vaguely aware of the great knowledge of the subject which had been accumulated. Surely a knowledge of the various principles of drawing, as taught in the Italian academies, the French ateliers, and the Slade School should be acquired, as well as a grasp of colour, sound lettering, and costume design. It was with this in mind that the Intermediate Examination in Arts and Crafts was introduced into British Schools of Art in 1946.

But this examination, closely related to the practice and teaching of art and design, did not survive, and by 1983 even the options to take Art for the Post-graduate Certificate in Education were removed.

E.J. Milton Smith, Principal Lecturer at Leeds Polytechnic complained in the *Journal of Art & Design Education* in 1985 as follows:

> Successive Education Secretaries have not only appeared to ignore the valuable contribution that Art, Craft and Design makes to Education as a whole, but seems determined to undermine and then dismantle a highly successful system painstakingly built up throughout the twentieth century and generally acknowledged to be the best of its kind in the world. . . . A tremendous amount of history, tradition and expertise has been swept aside and the Teaching Profession at all levels will be the poorer.

However, now that universities have been recognized to form their own courses, leading to the award of their own degrees, we may be sure that options to study art and design education will be popular.

The international demand for *The History and Philosophy of Art Education* led to its publication in Britain by the University of London Press, and in USA by Elsevier, New York. A Japanese translation by Shuichi Nakayama of Kobe University was published by Tamagawa University in 1989.

<div align="right">SM
November, 2003</div>

Contents

Views compared with those of Dyce; The Imitative
Concept of Charles Heath Wilson

Utilitarian Concept of Henry Cole, the *'Government Officer'*;
The Principles of Pugin and Redgrave compared;
Redgrave's Ideal of Perfect Botany; Redgrave's Insistence
upon Formal and Symmetrical Geometry; Redgrave's
Contribution to Art Education; The Analytical Concept
of Ralph Wornum; Wornum and the French Schools;
The *Analysis of Ornament*; The *Grammar* of Owen Jones;
The Modernism of Christopher Dresser and Gottfried
Semper

Figures in the Text

Plates

1

Guilds, Academies, Societies, and Institutes

The concept of art education as distinct from craft training was realized in Italy in the sixteenth century due to the recognition of art as a product of the intellect rather than the skilful hand, a *scienza studiosa* investigating the principles of design of natural phenomena. The achievements of Leonardo, Michelangelo, and Raphael made it impossible to classify painting and sculpture as mere Mechanical Arts, unfit to rank with the Seven Liberal Arts. The very meaning of the word 'art' was changed.

From as far back as we can trace, art was considered as craft and skill. *Hemwt*, the word for art in ancient Egypt, was depicted as a mason's drill, and later, in the Classical era and the Middle Ages, the Latin *ars* signified the skill of working according to definite rules for a particular pursuit, trade, or profession; for example, *ex arte dicere* meant speaking according to the rules of oratory. Similarly, the mediaeval derivations, the French *l'art*, the Italian *l'arte*, the Spanish *el arte* and the English *art*, were synonymous with skill, profession or trade, hence the English and French *artisan*, and the Italian *artefice* used by Vasari. Likewise the German *kunst* signified trained skill or trade.

In ancient Egypt art was essential to the struggle for immortality and, being an important official pursuit, thousands of young artist-craftsmen had to be constantly in training, learning the traditional formulae for representation which were safeguarded by the priests. De Rachewiltz informs us that the inventory of the Temple library inscribed at Edfu includes the *Book of Prescriptions for mural painting and of the proportions to be given to the figures*.[1]

All art, architecture, engineering, and technology were looked upon primarily as craft, and the Egyptians held craft in very high esteem. The world itself was a piece of craftsmanship formed by the god Ptah of Memphis, the Great Artificer, 'the sculptor of sculptors, the potter of potters', the task of fashioning humans on the wheel being delegated to the god Khnum. The Egyptian master craftsmen, the architects, such

as Imhotep and Sennemut, usually held high rank in the priesthood, the chief priest of Ptah having especial control of art training as the 'Great Chief of Artificers' (*Uer-kherp-hemtu*), the living form of Ptah.[2] In a kingdom replete with colossal monuments the architects held a higher place in society than they have attained since; indeed Imhotep, vizier to Zoser and supposed architect of the step pyramid at Sakkara, was eventually deified as the son of Ptah, which, all in all, is even superior to being elected a Royal Academician.

Artist-craftsmen and apprentices were formed into a huge colony near each great temple or necropolis under construction, a permanent colony of workshops, with its own police and services under the control of the chief workman, who was responsible to the chief priests and ultimately to the Pharoah's vizier, who supplied the craftsmen with free food and clothing.

In addition to the temple papyri of instructions, there were sketch books passed down from master to master, full of approved outlines for their apprentices to square up, and transfer, enlarged, to walls, ready for the master's attention. Life could not have been very pleasant for those apprentices whose masters had been conscripted by the vizier to work by oil lamps hundreds of feet from daylight in the dust of sub-terranean tombs. Their greatest pleasure must have been to execute original sketches from nature, which, if approved, were added to the official drawing books.

The mediaeval concept of liberal arts for the education of freemen or gentry, as opposed to mechanical arts for the training of tradesmen or workmen, was rooted in Greek and Roman philosophy, most strongly expressed in Plato's tripartite schema for society in his *Republic*: the philosophers, the spirited auxiliaries or guardians, and the toilers for gain or existence. Not even the second category of his ideal society, the guardians, might take notice of the manual crafts, the practice of which he described as degrading. All arts must serve a moral purpose, music being used to express prayer to the gods, instruction of a neighbour, or the 'accents of brave men in warlike action' – not the laconic Spartans, we presume. The flute was unsuitable, its wide compass being super-fluous for the limited melodies appropriate for a life of courage and self-control. Practical art had similar perils, and Plato affirmed: 'We must supervise craftsmen of every kind . . . and forbid them to leave the stamp of baseness . . . on painting or sculpture.'

Artists in Greece worked for money, and in addition they took fees from their pupils. This, in Plato's view, debarred them from recognition as liberal educators. In Plato's *Protagoras*, Socrates asks Hippocrates:

'And suppose your idea was to go to Polyclitus of Argos or Phidias of Athens and pay them fees for your own benefit, and someone

asked you in what capacity you thought of paying this money to them, what would you answer?'

'I should say, in their capacity of sculptors.'

'To make you what?'

'A sculptor, obviously.'

Then, comparing letters, music, and gymnastics with art, Socrates declares:

'You didn't learn these for professional purposes to become a practitioner, but in the way of liberal education, as a layman and a gentleman should.'[3]

As well as these schools of sculpture, Plato mentioned that youths studied painting under Zeuxippus at Heraclea. We also know that Pamphilos, the master of Apelles, instructed a school of painting at Sikyon. Under these masters young artists acquired τέχνη, the Greek term for a professional skill, especially in art or craft. According to Pliny they first received some theoretical instruction in accurate drawing, geometry, and art appreciation. Fine rhythmic outline, spacing, symmetry, and proportion were considered the most important attributes. Drawing competitions, such as those organized at Teos and Magnesia, were probably judged mainly on finesse of outline, as in the famed competition between Apelles and Protogenes.

The Greek view that only philosophical and theoretical studies were worthy of the intelligentsia passed on to the Romans. The classifications of *artes ingenuae* (or *artes liberales*) and *artes sordidae* were current in classical Latin, and proved a foundation for Augustine, Capella, Boethius, and Cassiodorus, who formulated the schedule of the Seven Liberal Arts, finally classified by Isidore of Seville (A.D. 570–636) as the Trivium of Grammar, Rhetoric, and Dialectic, and the Quadrivium of Arithmetic, Geometry, Astronomy, and Music. It was to be expected that music was preferred to art, for the Greeks and Romans had already denied the quality of *ethos* to the representational arts, though attributing it to music. Painting and sculpture, if mentioned at all by mediaeval educationists, were classified with craft-trades such as tailoring and leatherwork, and rated beneath agriculture, hunting and medicine. This low rating was due to the belief that painting and carving were merely craft-skills, acquired by apprenticeship to the master of a shop, who, like baker or candle-stick maker, bought raw materials, and then sold for a profit articles produced by the 'mysteries' of his craft. In the age of chivalry, as in the age of heroes, such tradespeople were often regarded as knaves, which, if we can believe Cellini, they were.

The change in attitude came quite suddenly in the High Renaissance as the demand arose for intellectual artists capable of conceiving imagina-

tive historic, religious, and poetic compositions. Thus Giorgio Vasari, the son of a potter, who started his own career as a painter of stained glass, was able to declare: 'I have lived to see Art arise suddenly and liberate herself from knavery and bestiality.'

THE MEDIAEVAL GUILDS

Unless he was a monk, the mediaeval artist-craftsman was a member of a guild. Guilds or gilds were first mentioned by Saxon and Frankish scribes in the eighth and ninth centuries, and originated as associations for mutual aid and protection. From its foundation in Norman times the powerful guild merchant had craftsmen members, and up to the twelfth century there was little distinction made in Britain, or on the Continent, between merchants and armourers, carpenters, workers in stained glass, carvers, and so on.

Due to the rise of the craft industries in the thirteenth and fourteenth centuries, exemplified by decorative Gothic churches, armour, and costume, numerous separate guilds developed to control each craft. Each guild, company, or 'fellowship of crafts and mysteries' (termed a *fraglia* or *compagnia* in Italy, *métier* in France, and *zunft* in Germany) had its oath and charges of acceptance, entrance fee, annual subscription, common purse, insurance scheme, ordinances, and patron saint – St Luke in the case of painters. The greatest artistic guilds were the companies of masons and glaziers, and of these 'masonry has the moste notabilite', a masonic manuscript records.[4]

During the erection of great buildings, such as cathedrals, abbeys, or palaces, works departments or *ministeria* were formed with offices provided for the architects and master builders; the masons' and carvers' guilds would form lodges. Each guild employed had a strict hierarchy; for example, the masons were ruled by the principal master mason, then 'the master masons who have stick and gloves in their hands (and) say to the others "Cut here and cut there" ',[5] then the free or free-stone masons, then the hard-stone masons or hard hewers, then the masonry apprentices. Working under the guildsmen were a mass of workmen and boys, whom the masters were permitted to employ, 'provided that they showed them absolutely nothing of their trade'.[6] The nearest equivalent to the modern sculptor was the free-stone mason, who worked the intricate carvings in limestone, sandstone, and marble, often executing completely original and non-religious subjects.

As the masons and glaziers produced the most conspicuous crafts of the Gothic period, most aspiring artists entered their guilds. Painting was decorative in Northern Europe, confined mainly to gilding and using flat colours within outlines for enhancing sculpture and space-filling. There was probably, however, more painting than art historians

have given credit for, as the recent discovery of the fine coffin portrait of Archbishop Walter of York suggests.[7]

The guilds declined as the baronies, townships, and manors lost power and privilege in the fifteenth and sixteenth centuries. Strong monarchs with strong central governments would brook no local or party power over the national trade or economy. In England, for example, a statute of 1437 ruled against 'unlawful and unreasonable ordinances' formulated by guilds 'for their singular profit and to the common hurt and damage of the people'. Under the Tudors, guilds' ordinances were made subject to royal approval, their power over journeymen and apprentices was restricted, and their religious endowments confiscated. In Italy, the Pope, the powerful clergy and local nobility had grown impatient with guilds' restrictions upon the artists they employed, and reduced their power; for instance, in 1539 the sculptors of Rome were exempted from membership by the Pope, and in 1577 the fine artists of Florence were exempted by a local decree. The rise of new industries such as the hardware and textile trades contributed to the downfall of the guilds. Strictly-bound apprenticeships survived until the nineteenth century, but the guilds' leading role in producing artist-craftsmen had ended three hundred years before.

CRAFT APPRENTICESHIP

An integral part of the mediaeval scene was the idle or industrious apprentice, clothed and boarded by a master, aspiring to that master's daughter's hand or his model's body, toiling and sleeping in his master's shop, and roystering outside on holy days. Bound apprenticeship usually commenced at thirteen or fourteen years of age, and if the youth gave satisfactory service for five to seven years, and reached a fair standard of craftsmanship, he obtained a certificate from his guild and could then work as a journeyman. Sometimes a master paid his apprentices a small salary, sometimes if he were famous the youth's parents paid him. On occasion a youth of good family was allowed to study in a master's shop without being bound to him. Benvenuto Cellini, the famed goldsmith, related:

> 'When I reached the age of fifteen, against my father's will I placed myself in a goldsmith's shop with a man called Antonio di Sandro, who was known as Marcone the goldsmith ... My father would not let me be paid like the other apprentices, in order that, as I had adopted this craft from choice, I might be able to spend as much of my time designing as I liked.'[8]

The concern felt by Benvenuto's father was understandable as the early years of apprenticeship were normally spent upon mechanical

labours for the master and his journeymen. In a painter's shop the apprentice was required to grind, mix and strain colours, glues, gessoes, and plasters, to tint papers, and to prepare panels and wall surfaces. At first, little time could be spent on drawing, but some masters did not think this a drawback. Cennino Cennini in *Il Libro dell' Arte* (1437) advised apprentices: 'set yourself to practise drawing, drawing only a little each day, so that you may not come to lose your taste for it . . .'[9]

Cennini had been apprentice to Agnolo di Taddeo, son of Taddeo of Florence, Giotto's godson and favourite pupil. Cennini recommended the following drawing course for the apprentice. First, the simplest subjects should be copied, drawing very lightly with silver or lead point on a panel spread over with bone ash. During his second year the apprentice should take up precise ink line drawing using a goose quill, adding a wash with a blunt miniver brush. The Italian affirmed that such exact pen drawing would enable the artist to memorize objects. Next came brush drawing (drawing for painting) on paper stained with terre-verte or ochre, first putting on successive thin washes of ink for the shadows with a blunt brush, then applying washes of white lead mixed with gum arabic or yolk of egg for the lights, and finally sharpening up the outlines with a pointed brush. The emphasis was on a light and steady hand, and Cennini warned the apprentice of a cause that could make his hand 'flutter far more, than leaves do in the wind, and this is indulging too much in the company of women'.[10]

The remainder of the book consists of technical advice on colours; on painting on walls, cloth and glass; on gilding, casting, and mosaic; and on techniques for painting faces, drapery, diadems, dead men, and virgins. All the instructions were intended to produce finished craftman-ship, but Cennini did give a little intellectual guidance to the apprentice. He suggested, for instance, that a youth should select only the best work from a few masters for copying. 'Remember,' he added, 'that the most perfect guide that you can have, and the best course, is the triumphal gateway of drawing from nature.'[11] For perfect proportion of the male figure he suggested the face as a module, with a third of the face as a measure, giving these thirds as the forehead, the nose, and nose to chin. He gave the height of the perfect man as eight faces and two measures, equalling his width with the arms extended. 'I omit those of woman,' he added, 'because there is not one of them perfectly proportioned.'[12]

Apprenticeship finished, the journeyman could assist his master, or obtain commissions of his own, which he carried out in his master's shop. Either way the profit was shared, even a free workman, like Cellini, having to give up to a third of his profit to the master of the shop he was working in. After three or fours years as a journeyman, an

ambitious craftsman could submit a test piece of his work to be judged by the principal master and the councillors of his guild; if successful, he received permission to set himself up as master of his own shop, the ultimate ambition of all mediaeval artist-craftsmen.

ACADEMIES IN ITALY

'If you say that sciences which are not mechanical are of the mind, I say that painting is of the mind, for, as music and geometry treat of the proportions of continuous quantities, while arithmetic treats of the discontinuous, painting treats of all continuous quantities, as well as the proportions of shadow and light, and the variation of distance in perspective.'[13]

This justification by Leonardo of painting as a liberal art, probably written some forty years before the first academies of art were established, represents the new concept of art which became prevalent in Italy in the sixteenth century – art as a scientific subject, a liberal art worthy of academic enquiry.

The title 'academy' for a school or society was derived from 'Ακαδήμεια, the name of the Athens park in which Plato taught and acquired a plot for the foundation of his school of philosophy. In Renaissance Italy groups of savants of Greek and Latin literature, mathematics and science began to congregate regularly in the palazzi and churches for discussion and debate. The Platonic Academy founded in 1438 at the court of Cosimo dei Medici in Florence was an early example of this practice. Rome followed Florence's example, with an academy for Latin studies; neither academy was concerned with art. The earliest record we have of a connection between the title 'academy' and fine art is the inscription 'Academia Leonardi Vinci' which appears on six Renaissance engravings, including the complicated knot roundel in the British Museum. The inscription may not refer to an art academy, but to an intellectual circle which met in Milan. Ludwig Goldscheider suggests that the engravings were admission or prize tickets for scientific disputations.[14] It is well known that Leonardo organized many entertainments and debates. However, although neither Leonardo nor Michelangelo ran a formal academy, the new pattern of art education was emerging, for both artists had a select band of well-born and well-educated disciples; moreover the antique statuary of the Medici collection was now available to noble youths and gifted apprentices.

The school of painting and sculpture set up in the Medici garden (circa 1488) by Lorenzo dei Medici was the precursor of the art academy. This free school, where apprentices could come and go, clearly demonstrated that the guilds no longer had the sole right to train and control artists. Vasari relates: 'Lorenzo the Magnificent had at that time

appointed the sculptor Bertoldo (di Giovanni) to a post in his garden at the Piazza San Marco, less as a superintendent of his many and beautiful antiques, than as master and head of a school which he intended to set up for the education of outstanding painters and sculptors . . . For this purpose he asked Domenico Ghirlandajo to send him to the garden any apprentices of his whose talents point in that direction.'[15] So it came about that the young Michelangelo studied there under the aged disciple of Donatello, and ate at the Medici table.

An engraving executed by Agostino Veneziano in 1531 bears the inscription: ACADEMIA DI BACCIO BRANDIN IN ROMA IN LUOGO DETTO BELVEDERE MDXXI. Vasari tells us that this 'Baccio' was the Florentine sculptor better known in later life as Baccio Bandinelli (1493–1560). Bandinelli had started his famous copy of the antique 'Laocoon' in the Belvedere of the Vatican during the last year of the papacy of Leo X, and had quit the work after the Pope's death. On the accession of Clement VII in 1523, 'having been provided by the Pope with rooms and an allowance, he returned to the Laocoon'. In one of these rooms the sculptor and his pupils forgathered in the evenings.

Bandinelli, who surpassed his contemporaries 'in the nude with his outlines, shading, and finish', was undoubtedly a keen teacher. He employed Veneziano to do instructional engravings of 'a nude Cleopatra for him, and a larger sheet of anatomy', and 'to engrave a copy of a skeleton made by him [Bandinelli] out of dried bones'. Vasari's description of Bandinelli's behaviour has a familiar ring. He tells us that this teacher informed all and sundry that his artistic colleagues knew nothing of design, and on one occasion narrowly escaped death at the hands of one of them. Veneziano's engraving of Bandinelli's 'academy' in Rome, and a later engraving of the same artist's 'academy' in Florence, appear in Professor Pevsner's *Academies of Art* (1940).

There was a humble academy of fine arts founded at Perugia in 1546, but the first organized corporate art academy, the model for those later official academies which were created as societies of limited number, was the Accademia del Disegno promoted by Vasari, and established in Florence in 1563 under the protection of Cosimo dei Medici. Thirty-six members were elected, three of whom were Visitors appointed annually to instruct young artists. There were lectures on perspective, but no regular classes, and Vasari himself was dissatisfied with his foundation.[16] The Accademia di San Luca founded in Rome in 1593 under the protection of Pope Sixtus V was a better-organized and more intellectual affair. Federigo Zuccaro, its first president, a painter of vast frescoes crowded with colossal figures, organized a studio, daily afternoon debates on theory, and a general meeting once a fortnight. Corporate art academies were later established at Turin, Mantua, Venice, and

Naples, and many private academies sprang up, including the notable Accademia degli Incamminati founded at Bologna in 1589 by the Carracci family, and run by Lodovico with the aid of the eminent anatomist Anthony de La Tour; but it was the Rome academy, reformed by Pope Urban VIII in 1633, which became the most influential centre of art education in Europe until the nineteenth century, when artists began to prefer to study in Paris.

<div align="center">FRENCH ACADEMIES OF ART</div>

'Louis, – God's lieutenant-governor of the world, – before whom courtiers used to fall on their knees, and shade their eyes, as if the light of his countenance, like the sun, which shone supreme in heaven, the type of him, was too dazzling to bear.'[17] Thus Thackeray described *la merveille de son siècle*, the Sun King, and it is hardly surprising to find that the most authoritarian academy originated at his court. The art education required to produce the imperial grandeur Louis Quatorze desired could only be obtained in Rome. Nicolas Poussin, a student of the academy of Domenichino, had already established the French classical tradition with his statuesque figures arranged parallel to the picture plane, and had returned to Rome. Charles Le Brun, who had accompanied Poussin, was patronized by Fouquet and Cardinal Mazarin on his return to France, and when the monarch established the Académie Royale de Peinture et de Sculpture in 1648, Le Brun was selected to direct its activities.

After the fall of Fouquet in 1661, Colbert, the king's most powerful minister, took a deep interest in making the academy an efficient branch of the civil service, and Le Brun became the virtual dictator of French art when he was given charge of the Gobelins, the workshops for furnishing the royal palaces. French artists would hardly have dared to disagree on art matters with Le Brun now, since Colbert, who was bent on supplying the new French navy with galley slaves, and who favoured the pillory for indifferent craftsmen, had placed appointments, commissions, prizes, and art education in his hands. Colbert was determined, through Le Brun, to create a well-ordered style of French art, which would compare with the classical style of French literature that the Académie Française was formulating by approved forms of grammar, poetry, and rhetoric. An academic art training, which started with drawing each part of the body from models based on parts of Greek statuary, and ended with compositions of Classical epics, was an obvious parallel to grammar and literature. For this type of art education, contact with the source of copies of Classical art was essential, and in 1666 Colbert set up the Académie de France at Rome.

The academy in France with its protector, four vice-protectors, a

director, four rectors, twelve professors, and six councillors was modelled upon the Accademia di San Luca in Rome, but it was essentially a national institution, having none of the private character of the later Royal Academy in London. A royal grant was obtained in 1655, and studios were provided in the Collège Royal. Entrants had to be members of an approved workshop, and a monthly examination of their work by the professors determined whether they were to be allowed to continue their studies or to be promoted. Patronage provided prize competitions and medals, the ultimate success being the Prix de Rome, which entitled the recipient to study for three or four years at the Académie de France in Rome. The usual subject for a prize work was a heroic or religious epic, intended as an allegory of some actual achievement or devotion of the ruling monarch, for example, a conquest by Alexander, a labour of Hercules, the triumph of some virtue, or a Biblical epic.

The French academy in Rome was a small institution consisting of twelve students, of whom six were painters, four were sculptors, and two were architects, under the supervision of a director who had the assistance of professors of geometry, anatomy, and architecture. (The number of students rose to twenty during the nineteenth century.) The students passed their time copying works in the Vatican and other palaces, for one of the tasks of the director was to secure casts and copies of notable works and actual antiques for the academy and palaces of France. J. M. Vien, the master of David and the founder of the severe Classical school, appointed in 1775, was probably the most influential director, though J. A. D. Ingres, the pioneer of modern draughtsmanship, appointed in 1834, must run him close for the honour.

After the fall of the French monarchy in 1792, the direction of French art was taken over by Jacques Louis David, a member of the Convention who expressed his gratitude for the royal grant he had received for study in Rome by voting for the removal of his monarch's head. In 1795 David reconstituted the academy as the Académie des Beaux Arts, a title to which, off and on, the adjective Royale was added or subtracted, according to whether the French enthroned or dethroned a monarch. David's influence was paramount until the restoration of the Bourbons in 1814, and it was during this period of severe classical art that academic art education most exactly fitted the artists' finished subjects. Depictions of Classical epics suited both the republican idealists and the imperial Napoleon.

The decay of the Classical academic spirit was ensured by the Romantic movement, stimulated by the writings of Walter Scott and Victor Hugo, and the paintings of Gericault and Vernet. Classical art was reburied under an avalanche of deaths in battle, by poison, death-beds, murders, sacks, massacres, sacrifices, flights, incarcerations,

deluges, wrecks, retreats, storms, and other disasters dear to the romantic soul. As Thackeray put it, 'Andromache may weep: but her spouse is beyond the reach of physic. . . . Classicism is dead.'[18]

The spirit was dead, but a high standard of drawing was maintained at the École des Beaux Arts, the school of the Académie, due to the teachings of Ingres who was professor there in the fifties. In 1863 control of this school was removed from the Académie, and the number of candidates for entrance was so great that in the seventies, in addition to stiff entrance examinations in perspective, anatomy, design, and life drawing, which occupied nearly four weeks, history and other written subjects in French were introduced, aimed mainly at excluding the large number of British students, who were attracted by the superiority of the drawing there to that at the Royal Academy Schools. Their attitude to the merits of French art and British art was probably expressed by H. S. Tuke (later R.A.), a student in Paris in the eighties, when he wrote home: 'Went down to the Salon – Some splendid things, beats the R.A. into fits.'[19]

The academies of Europe were now taking the Beaux Arts as their model. Walter Shaw Sparrow gave a vivid description of the Académie des Beaux Arts in Brussels in his autobiography,[20] with its Room for the Torso Antique dominated by the Venus de Milo under a stream of gaslight, the Room for the Head Antique, and the Room for the Figure Antique. He remarked, 'A door from the Figure Antique led to that holy of holies, the Life Class, guarded by a stiff examination.' Following the advice of Van Severdonck, master of the Head Antique, the students hired plaster casts for use in their lodgings, drawing immense hands, feet, and eyes 'a yard long and more, constructing them angularly'. This angular drawing was the French method of 'drawing square' from point to point, as opposed to the British soft fudging within hard outlines. The advanced students drew heads, torsos, and whole figures in conté crayon, painted torsos in oil, and occasional full figure studies on canvases eight foot high. This was varied with oil painting from casts of the antique. Sparrow remarked, 'There were delightful tints in the dust.' The Brussels students were also encouraged, like those in France, to draw rapid sketches of people in the streets (*croquis*), and quick colour compositions (*pochades*). However, it is time to leave the industrious professional academies of Europe to consider a comparatively dilettante establishment.

THE ROYAL ACADEMY OF ARTS IN LONDON

The first British academy of art appears to have been the Academy of Painting established in 1711 by Sir Godfrey Kneller in Queen Street, London, a rather strange circumstance as the German held the opinion

that 'God Almighty only makes painters'. Sir James Thornhill succeeded to the governorship of this academy in 1716, but internal dissensions caused him to set up his own school at his house in the Piazza, Covent Garden. After Thornhill's death in 1734, one of his students, William Hogarth, who had upset the great man by eloping with his daughter, organized an academy in St Martin's Lane, a completely democratic institution which provided life models for the use of its members. Both the Dilettanti Society and the St Martin's Lane Academy prepared plans for a royal academy, but in 1755 they found mutual agreement impossible, largely because the professional artists refused to sanction the appointment of wealthy amateurs of the Society to the government of the proposed academy. The first approach to the throne was made in 1768, after William Chambers, Richard Wilson, Benjamin West and Paul Sandby had resigned from the Incorporated Society of Artists. Chambers put the scheme to George III. Joshua Reynolds after some hesitation agreed to join the venture, and on 10 December 1768 the Instrument of foundation was signed by the monarch, establishing the 'Royal Academy of Arts in London'.[21]

The Instrument laid down that: 'the said Society shall consist of forty Members only, who shall be called Academicians of the Royal Academy; they shall all of them be artists by profession at the time of their admission'. It stipulated, amongst other things, that the academy should be governed by a council consisting of an elected President and eight other persons, and that an annual exhibition of paintings should be held, but it is the provision for art education which concerns us here.

The Schools of Design of the Royal Academy were established by the Instrument, which instructed:

> 'IX. That the Schools of Design may be under the direction of the ablest Artists, there shall be elected annually from amongst the Academicians nine persons, who shall be called Visitors; they shall be Painters of History, able Sculptors, or other persons properly qualified; their business shall be, to attend the Schools by rotation, each a month, to set the figures, to examine the performances of the Students, to advise and instruct them, to endeavour to form their taste, and turn their attention towards that branch of the Arts for which they shall seem to have the aptest disposition.'

There were also to be elected Professors of anatomy, architecture, perspective and geometry, and painting, who were to read annually six public lectures in the Schools. A Keeper was to be elected, 'to attend regularly the Schools of Design during the sitting of the students, to preserve order among them, and to give them such advice and instruction as they shall require'.[22]

The Schools were opened in 1769 in Pall Mall, but in 1771 the King granted accommodation in the old palace at Somerset House. Later the Schools moved into the new palace, remaining there until 1836, when they were housed in the east wing of the National Gallery. In 1867 the Government granted the Academy possession of its present home, Burlington House, and shortly afterwards the Schools were established in the basement, a place of gloom, according to George Leslie, 'which not even the chatter of the pretty girls in their white pinafores can dispel'.

To gain entrance to the Schools, drawings had to be submitted to the Council, the required exercises varying only slightly throughout the eighteenth and nineteenth centuries. The requirements during the first half of the nineteenth century were typical: a chalk drawing from the antique, a drawing from an anatomical figure, and a drawing from a skeleton. If these works were acceptable, the candidate was registered as a probationer, but before he was admitted to the Antique School a further drawing had to be carried out on the premises to ensure that the submissions had been his own work. Instruction in the Antique School, of which there was little, was the Keeper's responsibility, while the Visitor had charge of the more advanced students in the School of Drawing from the Life; and in both these Schools intending painters and sculptors worked alongside, drawing, painting, and modelling from the antique or the live nude. During the nineteenth century the approved length of course varied from five to ten years, but a medal winner could become a Life Student. Two students are remembered for doing a stint of over twenty years, but William Etty, R.A., was the most notable attender. Leslie declared: 'Etty, whether he was Visitor or not, would come to the Life School, would seat himself beside the students and paint from the model . . . and during all the years of his membership he hardly ever missed an evening in the Life Class.'[23] Constable, during his month as Visitor in 1831, varied the monotony in the Life School by using a background of live foliage to create a Garden of Eden. The 'Life' was considered the most important school in the Academy, but advanced students could also study in the Painting School where the routine studies, up to the First World War, were portraits, costumed models, and copying from Old Masters. By the eighteen-fifties many students were following the example of those in French ateliers in making saleable works out of the costumed studies by painting in attractive backgrounds, but the Council put a stop to this enterprise in the sixties by ruling that costumed studies must be of head and shoulders only.

The instruction given at the Schools in the nineteenth century was, to be kind, poor. Even G. D. Leslie, R.A., son of an R.A. and one of the Academy's most loyal supporters, did not pretend otherwise. Of the

period when Fuseli was Keeper, Leslie wrote of 'wise neglect', and of the Visitors in the eighteen-fifties, 'From old men such as these we derived little or no benefit in our studies.'[24] William Powell Frith, writing of the eighteen-thirties, declared: 'The Academicians were visitors . . . one of the august Forty sitting with us the prescribed two hours, rarely drawing, oftener reading. In those days scarcely ever teaching.'[25] Attempts have been made to justify the Visitors and Professors, especially the latter, by claiming that they were too occupied with their professional commissions, but this is a circular argument, for many of them would not have constantly obtained lucrative commissions if they had not been elected R.A., an honour with obligations. Having collapsed completely in the first decade of the nineteenth century, the lecture system was resuscitated following political attacks upon the Academy, but even then the lectures were so poor that they had to be filled by compelling the young students in the Antique Class to attend. Notable exceptions were the well-illustrated professorial lectures given by Thomas Sandby (Architecture, 1768–98), William Hunter (Anatomy, 1768–83) and Richard Partridge (Anatomy, 1852–73). The last-named not only demonstrated with the model, the skeleton and diagrams, but also arranged dissections for the students to draw in King's College Hospital. Lack of enthusiasm for practical teaching caused the Academicians to delegate their duties; for example, in 1860 the professorship of perspective was abolished, and a teachership established open to non-members, also Associates were made eligible to become Visitors.

From this time onwards it was becoming obvious to students that the drawing methods taught at the Beaux Arts and the French ateliers were superior. Royal Academy students, who had spent five or more years in tedious imitation, were shocked to behold the fluent and constructive drawings of young men returning after spending only two or three years in Paris. During the eighties and nineties, under the presidencies of Leighton and Poynter, the organization of the Academy was greatly improved, but students were aware of these great men's foreign training, and of their belief in the superiority of French drawing methods. The drawing skill displayed by Alphonse Legros and Whistler finally confirmed the business, and those students who could afford it quit for Paris. Another cause of worry to some Academicians was the growing proportion of females in the Schools. In 1860 L. Herford's drawings were found worthy of probationary admission, but, when this candidate turned up at the Antique School, the Keeper was surprised to find no Laurence but a Laura. No prohibition was found in the rules, so the first female was admitted, and, in spite of the fact that females were not permitted to draw from the nude until 1893, their numbers gradually grew until the males were outnumbered; moreover, the male drift to

Paris caused many of the ladies to be the best students in the Schools. The ambitious curriculum of the Royal College and the fine drawing at the Slade contributed to the poor quality of entrants to the Schools, and during the first decade of the twentieth century many of the R.A. students were reported as incompetent by the Visitors. Some progressive Academicians wished to have a wide curriculum, including decorative art, but Leslie recorded, 'All that was taught by means of the Visitors remained the same as before – namely life-sized paintings from the head, and drawings and paintings from the nude figure.'[26]

Today (1969) the Royal Academy Schools at Burlington Gardens under the direction of the Keeper, Peter Greenham, R.A., and the Curator, Walter Woodington, provide two separate full-time three-year courses, both for advanced students with previous adult art training. Candidates for the senior course, leading to the R.A. Schools' Post-Graduate Certificate, should possess a Dip.A.D., or a university degree in Fine Art. Candidates for the course leading to the R.A. Schools' Certificate should have had at least three years' School of Art training, and have obtained a satisfactory General Certificate of Education at Ordinary level. The tradition of submitting works for admission as a probationer has been maintained, and in April/May painters have to submit life drawings and a minimum of six paintings, one of which must be a life painting. Sculptors must submit two works in the round and several life drawings. The first probationary term is spent in the Life-drawing School, and satisfactory students then proceed to the Sculpture or Painting Schools. The work there displays much creativity and originality, while the emphasis on life drawing maintains an invaluable link with past discipline. It should be remembered by critics of the R.A. Schools of the past and present that they have never had the large sums of public money made available to Colleges of Art and University departments, and, in view of this, their survival and progress is worthy of admiration.

ACADEMIES OF ART IN THE UNITED STATES OF AMERICA

The first phase of America's art education had followed swiftly upon developments in London. From the year 1764, four years before the foundation of the Royal Academy, young men had crossed the Atlantic to work in the studio of Benjamin West. These disciples of the Pennsylvanian protégé of George III included Charles Willson Peale, Rembrandt Peale, John Trumbull, William Dunlap, Washington Allston and Samuel Morse, a military and inventive group, inventive not only in art but also in the sciences, men who were to found the first academies in their home country.

Philadelphia's claim to have the senior art institution in the United

States rests upon the foundation of an academy in that city, initiated by Willson Peale's establishment of the Columbianum in 1794. This academy, which exhibited in Independence Hall in the following year, was deeply divided by social and political altercations and lay moribund until its reorganization as the Pennsylvania Academy of Fine Arts in 1807. Peale, a pupil of West from 1767 to 1770, soldier, and pioneer of museum display, palaeontology, prosthetic dentistry, and gaslighting, was a foundation member of the Academy and the chief author of its activities until his death in 1827.[27]

New York established its Academy of Fine Arts in 1802 and it was Colonel John Trumbull, late aide-de-camp of George Washington, who was the moving spirit in its early development. A pupil of West from 1780 to 1784, Trumbull succeeded as a painter of prominent men and historic events carried out in his master's style. His important works, such as his portrait of Washington and his 'Declaration of Independence', gave him the stature to be appointed president of the Academy in 1820, but his dictatorial methods caused Samuel Morse to set up the rival National Academy of Design in 1826, an academy more liberal in outlook and determined to extend art education to young students. This academy, which Morse based on its London counterpart, was governed by artists, unlike its rival which the Colonel ran with the assistance of prominent citizens, but public interest was low, and, unfortunately for the progress of public art education, from 1830 onwards Morse became more preoccupied with the dot-dash-space technique than with artistic communication. In 1834, William Dunlap wrote an interesting account of these early days of American art education, entitled *A History of the Rise and Progress of the Arts of Design in the United States*.[28]

The academies did not make much progress during the ensuing years of political turmoil, and they were regarded as museums rather than schools. Pennsylvania Academy had the misfortune to lose much of its collection by fire in 1845, but was described four years later as containing 'a very valuable collection of pictures and statuary'.[29] Progress was initiated during the years after the Civil War when an increasing number of young artists, drawn by the reputation of the French ateliers, journeyed to Paris. Among the best known were Thomas Eakins, who studied under Gérôme, and Morris Hunt and La Farge from the atelier of Couture.

The return of the atelier students raised the standards of American fine art, just as their counterparts had done in Britain. An aesthetic attitude and fine technique were introduced. Eakins made an impact as instructor at the Pennsylvania Academy, where he was appointed director of the school in 1879, by laying stress upon anatomy and drawing from the nude. His serious course of study was very much

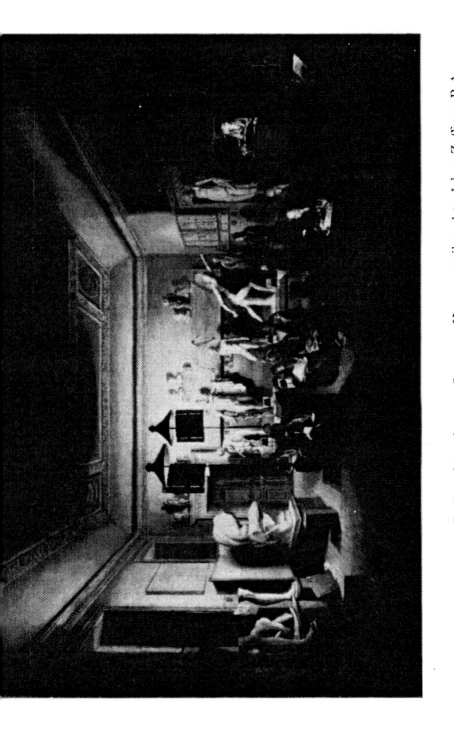

1. The Antique Room of the Royal Academy at Somerset House: attributed to Johan Zoffany, R.A.
Royal Academy, copyright

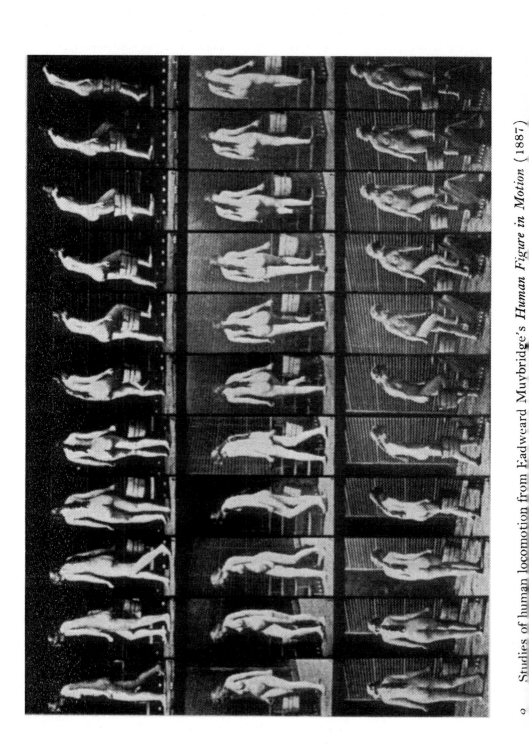

2 Studies of human locomotion from Eadweard Muybridge's *Human Figure in Motion* (1887)

appreciated by the students, but the parents of females were disturbed, especially by the mixed life classes in the atelier tradition.

The simple natural poses which Eakins insisted upon, rather than the fashionable sentimental and exotic postures, also gave offence. Moreover, Eakins was a pioneer of photography from the nude, and introduced Eadweard Muybridge, the English photographer, into the Academy to take his famous experimental series of photographs of 'human locomotion' from the nude.[30] Frederick Logan in his *Growth of Art in the American Schools* commented: 'The incident which precipitated his departure from the school of the Academy was his removal of the loincloth from a male model who was posing in a women's class so that the leg muscles could be properly studied in relation to the pelvis.'[31]

The academies were now set upon the same path as their European counterparts, albeit in a more humble way. They had their collections of casts and facilities for the study of anatomy and drawing from life, and were regarded as institutions for training professional artists and controlling official artistic projects. Because of this latter function there were, as was not the case with their European counterparts, many non-artists on their governing bodies. In them many single ladies pursued art as an accomplishment, but the academies were not looked upon as the means of disseminating art training to the general public or to children. However, the minds of educationists were already concerning themselves with this problem, as can be seen in Chapter 13.

PRIVATE SCHOOLS OF ART IN LONDON

The nineteenth century was the heyday of private art schools and institutes. They served three purposes in Britain: preparation for the Royal Academy, the production of drawing masters for the middle class, and the education of amateurs. Some of the best provided better conditions for painting than the R.A. Schools or the Slade.

William Powell Frith, R.A., recalled that Henry Sass, 'warned by an increasing family established his School of Art, at that time the only one in existence'. In 1835 Frith entered this school, where youngsters spent two years drawing from the antique in natural Italian chalk on grey paper by day, and copying outlines from Raphael, Michelangelo, the Carracci, and Poussin in the evening, until Sass judged them ready 'to try for the Academy'. Advanced pupils, often R.A. students, spent some time there, painting in monochrome from the antique, using only black and white oil paint on the palette, or painting subject pictures for R.A. prizes. Frith, Millais, C. W. Cope, W. E. Frost, J. P. Knight, and Rossetti were among the successful products of the system. This school in Charlotte Street, Bloomsbury, was taken over by F. S. Carey in 1840, and maintained a high reputation as Carey's School of Art.[32]

The next notable private drawing institution to be established in London was the school of C. E. Butler Williams at Maddox Street, Hanover Square, but this was an upper school for persons who had become interested in geometric and model drawing through Williams's instruction in Exeter Hall or Kay-Shuttleworth's training college at Battersea. Hopeful of becoming practioners or teachers of useful and industrial drawing, the pupils drew from geometric models on a stand after the method of M. Dupuis of Paris. Williams's *Manual for Teaching Model Drawing from Solid Forms*, published with the approval of the Committee of Council on Education in 1843, was the first instructional book on drawing issued on a large scale to teachers of the public day schools. The school changed its character after Williams's death, when Lowes Dickinson took over and provided drawing and modelling from the antique and a draped life model. A ladies' day class was also provided.[33]

Another well-known school was Leigh's at 79 Newman Street, set up in 1845 by James Mathews Leigh, a pupil of Etty, to train candidates for the Academy Schools. Among his notable students were H. S. Marks, R.A., J. F. Slinger, T. J. Heatherley, and John Sparkes, later headmaster at the Central School of Art, South Kensington. On Leigh's death (1860) the school was taken over by Heatherley and known, as now, as Heatherley's Art School. C. W. R. Nevinson recalled that in 1910, 'while the Slade was undoubtedly more professional than St John's Wood, I was not learning to paint; so I used to drop into Heatherley's, and paint *croquis* in the French manner, receiving no tuition but learning from the people around me.'[34]

St John's Wood School of Art was the last outpost of the tight and highly stippled drawing favoured by the Academy, about to be swept away by the clean constructive linear drawing of the Slade. From the eighties until the first decade of this century, pupils at 'the Wood' were particularly successful in obtaining entrance to the R.A. Schools. A. A. Calderon and B. E. Ward were the principals. Nevinson commended 'Mr. Ward, who I suppose had brought the Royal Academic honour within the grasp of more artists than any other tutor of his generation'. The student body, in which girls outnumbered boys by ten to one, drew from the antique using powdered chalk, the stump, and a hard pointed indiarubber, working in silence from 10 a.m. to 5 p.m. for five and a half days per week, 'a tremendous grind', wrote Nevinson, 'demanding a completion of tonal effects and tightness of technique unknown among students today, involving also a study of facial anatomy and of construction through anatomy'.[35] (The stumps which the students used were wads of soft paper, leather or cloth with which they could smooth out, or pick off, chalk and charcoal.)

The course commenced with drawing the outline of a bas-relief of

ornament and thence to shading, starting from a plaster cup and ball, then from casts of ornament, then successively from casts of hands, feet, head, torso, and full figure. This course from the antique completed, a student would prepare for the R.A. Schools. A double elephant size of Whatman paper was carefully stretched and the 'Ilissus', 'Theseus', or 'Venus' drawn thereon, a task occupying three months. Life-sized studies of parts of the body from the antique and anatomical drawings of the figure were also required.[36]

The last private school opened in London specifically for candidates for the R.A. Schools was the Byam Shaw and Vicat Cole School of Art in Campden Street, Kensington, established in 1910. It had just been made possible for students to pass quickly into the upper schools of the R.A. after submitting satisfactory coloured compositions, drawings and paintings from the head and the figure, and anatomical drawings, so Byam Shaw, an ex-student of 'the Wood' and the R.A. Schools, planned a thorough drawing and painting course with a stress upon life-painting, painting the draped model, and compositions. Shaw died only nine years after the School's foundation, too soon to witness many of its ex-pupils winning Academy medals in the early twenties, but his colleague, Cole, continued with Shaw's methods until he retired in 1926.[37]

It was in this period, the twenties, that faith in the antique was broken, for, although it survived in government Schools of Art until the late thirties, it survived only as one subject among many, of no great importance. The seeds of destruction of academies were sown by David, when he petrified the academic spirit of scientific enquiry by formulating a rigid Classic style. From the time that David insisted on students in the École des Beaux Arts painting from casts, to ensure cast-like figures in their compositions, the academic system tended to become a mere copying drill, ignoring new developments. In Vasari's time academicians loved to investigate anatomy and perspective because they were new sciences bearing on art, but nineteenth century academicians had a closed mind towards new scientific aspects such as Impressionist colour theory, new materials, and so on. As intellectual institutions the academies were dead. 'They are mortuaries,' declared Le Corbusier, 'in their cold-rooms there are only the dead. The door is kept well locked; nothing of the outside world can penetrate.'[38]

SOCIETIES AND INSTITUTES

During the latter half of the eighteenth century, and the first half of the nineteenth, many institutes, literary and philosophical societies, and Athenaea were established in the towns of Britain, and in some of these gentlemen gathered to copy from the prints, pictures, or antiques in the

institutions' collections, or to draw from the life model—nude, or in rustic costume. These repositories of culture with their collections, libraries, and lectures were close in intention to the Dilettanti Society, and had little interest in professional or useful art. This society had been formed in London in 1734 by a group of gentry who had travelled in France and Italy, and provided funds to send scholars and artists abroad to seek out ancient artefacts, collecting some and making casts and measured drawings of others.[39] The first important product of this scheme was the publication in 1762 of *The Antiquities of Athens* by James 'Athenian' Stuart, and in the following year the news of the excavations at Pompeii thrilled all lovers of the Graeco-Roman world. Fully illustrated books of antiquities then flowed from the press and found their way into local institutes. Cultural preoccupation with the antique was far removed from the real desire to improve general art education, but already a society had been started with the latter object.

THE SOCIETY OF ARTS

The Society for the Encouragement of Arts, Manufactures, and Commerce, now the Royal Society of Arts, has since its foundation in 1754 furthered public art education. The founder and first secretary, William Shipley (1715–1803), was himself a drawing master at Northampton, and the following is included in the minutes of the first meeting.

> 'It was likewise proposed, to consider of giving Rewards for the Encouragement of Boys and Girls in the Art of Drawing; And it being the Opinion of all present that ye Art of Drawing is absolutely Necessary in many Employments, Trades, and Manufactures, and that the Encouragement thereof may prove of great Utility to the public, it was resolved to bestow Premiums on a certain Number of Boys or Girls under the Age of Sixteen, who shall produce the best pieces of Drawing, and shew themselves most capable, when properly examined . . .'

To encourage industrial art there were prize competitions in 1758 for designs for weaving, calico-printing, cabinet-making, 'or any other Mechanic Trade that requires Taste', but response in these industrial sections was very poor, whereas there were many candidates for the drawing premiums, and notable artists, including Romney, Cosway, Lawrence, Cotman, Eastlake, Landseer, and Millais, received their first recognition by winning a prize.

The greatest contribution which the Society made to art education was the institution of public exhibitions. The first organized art exhibition in London was promoted by a member, Francis Hayman, and displayed in the Society's Great Room in the Strand in April 1760,

showing the works of Reynolds, Wilson, Morland, and Sandby to the public for the first time. Similarly the first public exhibition of industrial art was organized by members of the Society in March 1847 in their Great Room at the Adelphi premises. The great exhibitions which followed are referred to later.[40]

MECHANICS' INSTITUTES

Colleges of Art and Technology, indeed all institutions of adult education except the Universities, have their origin in the local Institutions and Mechanics' Institutes of the early nineteenth century. During this period local institutes, art societies, and literary and philosophical societies amalgamated, took on a more professional character, and built large premises containing galleries, theatres, and rooms for day and evening classes. According to the report of the Central Society of Education in 1837, it was the northern industrial cities which were most progressive in this respect, and the report affirmed that the old rural towns such as Lincoln, Hastings, St Leonards, Ripon, and others had no appreciation of knowledge and would not pay teachers for institutes.[41] The Liverpool Royal Institution's premises were opened in 1817, and those of the Manchester Royal Institution in 1829.

The local art academies attached themselves to these Institutions and exhibited there. Lectures and classes in literary and scientific subjects, and in drawing were provided for young professional men; for example, in 1835 the student body at Manchester included thirteen professional men, fifteen schoolmasters, fifty-two architects, artists, and engravers, and some clerks. Young mechanics or 'children of the labouring poor' were not welcome. Mechanics' Institutes sprang up to fill the gap.

As early as 1797 the Brotherly Society in Birmingham was conducting free classes in drawing, geography, and science for artisans, but this example was not generally followed. George Birkbeck, Professor of Natural Philosophy and Chemistry at the Andersonian Institution in Glasgow, was the first educationist to organize a course of lectures planned specifically for industrial workers. His predecessor John Anderson, an associate of James Watt, had allowed the mechanics, who assisted him to construct apparatus, to attend his lectures and had noted their interest. After Birkbeck had lectured to Glasgow mechanics with great success, he moved to London and was instrumental in founding the Mechanics' Institute there in 1823. Glasgow Mechanics' Institute was founded in the same year by seceders from the Andersonian Institute. Manchester Mechanics' Institute was founded in 1824, and other industrial cities quickly followed suit.

A Mechanics' Institute usually rented rooms for a library of books and prints, a lecture, theatre, and a museum of machines, minerals, models,

antiques, and stuffed animals. These rooms, often small and badly lit, were in the care of a janitor or housekeeper. Lectures were organized for at least two evenings per week on literary and scientific subjects, and fine arts, and elementary classes were formed for normal school subjects and architectural, mechanical, ornamental, figure, floral, and landscape drawing. Some modelling was also attempted, and the art syllabus sounded both impressive and encyclopaedic, but the lectures on fine art were historic and far above the artisans' heads, while the art classes were of a very low standard owing to the lack of teachers. Some idea of the amateur atmosphere of these institutes can be derived from the following descriptions of Manchester Mechanics' Institute in 1837, the first concerning George Crozier, a saddler, and his artist son, who helped to run the Institute, the second giving Benjamin Haydon's impression of a visit.

'To the Cooper-street institute the Croziers, father and son, gave a good deal of attention. A museum and natural history class had been established in an upper room, where the saddler-taxidermist carried on his craft in setting up birds and quadrupeds, and where he arranged the collection. Hither Sir Benjamin (Heywood) and the directors would come, diffusing hope and encouragement.'[42]

'Manchester in a dreadful condition . . . The young men drawing without instruction. A fine anatomical figure shut up in a box; the housekeeper obliged to hunt for the key.'[43]

However, Mechanics' Institutes multiplied and provided the sole chance the artisans had of learning to draw, until the establishment of the Schools of Design.

Sources

1. RACHEWILTZ, BORIS DE *An Introduction to Egyptian Art* Spring Books, London, 1966 (p. 99)
2. SHORTER, ALAN W. *Everyday Life in Ancient Egypt* Sampson Low, Marston & Co., London, 1932 (pp. 64–5); and WEIGALL, ARTHUR *The Glory of the Pharaohs* Thornton Butterworth, London, 1923
3. PLATO *Protagoras* and *Meno* Penguin Books, Harmondsworth, 1956 (pp. 41, 49)
4. *Cooke Manuscript* British Museum Additional MS 23198
5. BIARD, NICOLAS DE MS c. 1250, quoted from Gimpel in *Encyclopaedia of World Art* McGraw-Hill, New York, 1967
6. BOILEAU, ETIENNE *Livre des métiers* MS Paris, c. 1260 (Statutes, para. VII)
7. In York Minster, uncovered 1967–8

8. CELLINI, BENVENUTO *Autobiography* (Florence, *c.* 1562) Penguin Books, Harmondsworth, 1956 (p. 23)
9. CENNINI, CENNINO *The Craftsman's Handbook* (*Il Libro dell'Arte*) Translated Thompson, Daniel V. Dover Publications, New York, *c.* 1963 (reprint of Yale University Press edition, 1933) (p. 5)
10. Ibid. (p. 16)
11. CENNINI, CENNINO *The Book of the Art of Cennino Cennini* Translated Herringham, Christiana George Allen, London, 1899 (Chapter 28)
12. Ibid. (Chapter 70)
13. VINCI, LEONARDO DA *Treatise on Painting* (Codex Urbinas Latinus, 1270) Translated McMahon, A. Philip Princeton University Press, 1956 (Vol. I, p. 8) The original MS is probably a copy of Leonardo's statements made about 1550 on the order of Francesco Melzi, his executor.
14. GOLDSCHEIDER, LUDWIG *Leonardo da Vinci* Phaidon, London, third edition 1947 (p. 6, footnote 10)
15. VASARI, GIORGIO *Le Vite del Vasari, nell' edizione del MDL* Edited Ricci, Corrado Milan and Rome, 1927 (Vol. IV, p. 393), quoted by Pevsner, Nikolaus *Academies of Art* Cambridge University Press, 1940 (p. 38)
16. VASARI, GIORGIO *Lives of the Painters, Sculptors and Architects* (Everyman edition) J. M. Dent, London, 1927 (Vol. 3, pp. 76–7, 188–215; Vol. 4, p. 137); and VASARI, GIORGIO *Lives of the Most Eminent Painters, Sculptors and Architects* Translated de Vere, Gaston du C. P. L. Warner, publisher to the Medici Society, London, 1912–14 (Vol. 7, p. 64)
17. THACKERAY, W. M. *Paris Sketch Book* Smith, Elder, London, 1869 (p. 287)
18. Ibid. (p. 50)
19. TUKE, MARIA SAINSBURY *H. S. Tuke, R.A.* Martin Secker, London, 1933 (p. 60)
20. SPARROW, WALTER SHAW *Memories of Life and Art* John Lane The Bodley Head, London, 1925 (pp. 126–43)
21. HODGSON, J. E., and EATON, F. A. *The Royal Academy and its Members* John Murray, London, 1905 (p. 345)
22. Ibid.
23. LESLIE, GEORGE D. *The Inner Life of the R.A.* John Murray, London, 1914 (p. 25)
24. Ibid. (p. 29)
25. FRITH, W. P. A. *A Victorian Canvas* Geoffrey Bles, London, 1957
26. LESLIE, GEORGE D. *The Inner Life of the R.A.* John Murray, London, 1914 (pp. 42, 59, 66)
27. *National Cyclopaedia of American Biography*; *Dictionary of American Biography*; *Encyclopaedia Britannica*
28. DUNLAP, WILLIAM *A History of the Rise and Progress of the Arts of Design in the United States* Scott, New York, 1834
29. *A Handbook for the Stranger in Philadelphia*, by 'A Philadelphian' George S. Appleton, Philadelphia, 1849
30. LACY, P., and LA ROTONDA, A. *A History of the Nude in Photography* Bantam Books, New York, 1964 (pp. 34–5)

31. LOGAN, FREDERICK M. *Growth of Art in American Schools* Harper & Bros, New York, 1955 (p. 57)

32. *Art Union* (journal), 1848 (p. 19); and FRITH, W. P. *A Victorian Canvas* Geoffrey Bles, London, 1957

33. *Art Union*, 1848; and BUTLER WILLIAMS, C. E. *Manual for Teaching Model Drawing from Solid Forms, the Models founded on those of M. Dupuis* Parker, London, 1843

34. NEVINSON, C. R. W. *Paint and Prejudice* Methuen, London, 1937 (p. 24); MARKS, HENRY S. *Pen and Pencil Sketches* Chatto & Windus, London, 1894 (Vol. 1, pp. 16–34)

35. NEVINSON, C. R. W. *Paint and Prejudice* Methuen, London, 1937

36. COLE, REX VICAT *Art and Life of Byam Shaw* Seeley, Service & Co., London, 1932 (pp. 23–8)

37. Ibid.

38. LE CORBUSIER Address to Students of the Paris École, quoted by Pevsner, Nikolaus *Academies of Art* Cambridge University Press, 1940

39. *Old and New London* Cassell, Petter, and Galpin, London, *c.* 1880 (p. 155)

40. WOOD, SIR H. TRUMAN *History of the Royal Society of Arts* John Murray, London, 1913; and HUDSON, D., and LUCKHURST, K. *Royal Society of Arts* John Murray, London, 1954 (pp. 2, 8, 41)

41. Central Society of Education *Papers* Taylor & Walton, London, 1837 (Vol. I, pp. 220, 237–8)

42. LETHERBROW, THOMAS *Robert Crozier* (reprinted from *Manchester City News*) J. E. Cornish, Manchester, 1891 (p. 29)

43. STUART, CECIL *A Short History of the College. Programme of Regional College of Art Centenary Diploma Day* City of Manchester Education Committee, 1953 (p. 19), quoting diary of B. R. Haydon: entry for 26 May 1837

2

Academic Principles

Today many art teachers interpret the adjective 'academic' as eclectic, pedantic, or passé. This is understandable, for the original purpose of the academies of Classical and Renaissance times, a search through discussion for the fundamentals of philosophy, mathematics, science, and art, was replaced from the seventeenth to the nineteenth century, as far as art was concerned, by preoccupation with the Ancients.

There are two fairly direct ways to deduce the principles upon which academic art education was based. First, one can read the works of Vitruvius and Alberti, the chief heralds of the Renaissance art academy; second, one can study the lists of professorships in various art academies to learn what teaching was thought necessary. From these it can be deduced that students were directed towards certain principles of symmetry, proportion, anatomy, and perspective. They were also instructed in ancient history since, as Vasari pointed out, 'the invention of history' was essential for a painter. I do not deal with this, as it is hardly a principle, and Professor Quentin Bell has dealt with it very well in his *Schools of Design*.[1]

SYMMETRY AND PROPORTION

The earliest analytical approach to art stemmed from Babylonian and Egyptian investigations into number and geometry, essential to calculations for huge buildings and colossi. 'Exact calculation: the gateway leading to all things,' wrote Ahmes on papyrus (circa 1700–1550 B.C.). Measure preoccupied Egyptian scholars, and since their empirical geometry was mainly a geometry of area and volume, it is not surprising to find its application to their art, which had previously been sensual, instinctive, or imitative. The bases of academic concepts – geometry, measured proportion, and idealized form – pervade Egyptian art, giving it that formal, refined, and balanced appearance, which distinguishes it from the cruder art of Assyria. Scholars of Classical times were aware of these qualities in Egyptian work.

Diodorus Siculus, the Greek historian, travelling in Egypt circa 60– 57 B.C., was intrigued enough to calculate the proportions of the ancient sculpture, and concluded that the total height of the sculptures of

standing humans could be divided into 21¼ parts of equal measure.

The grids which the Egyptians used to square up their paintings and sculpture, and the various points marked upon them, have assisted theoreticians. Karl Lepsius (1810–84), the German Egyptologist, noted that the feet of the figures drawn in an unfinished tomb at Sakkara were measured between points marked in red ochre, and concluded that the foot was the module or basic unit of proportion. Others have given the length of the medius (middle finger) as the module. It is interesting to note that an Egyptian figure engraved in Lepsius' *Choix de Monuments funeraires* is divided into exactly 21¼ parts, confirming Diodorus; and that both the height of the foot and the length of the medius are one module.[2] The total height of the figure up to the top of the head-dress was the measure divided, and the proportion of the body often varies slightly because of this, sometimes being 19 modules to the head-band, and sometimes 19 to the top of the head.

The statuary of Egypt conforms to the 'Law of Frontality' rediscovered by K. Lange, who affirmed that 'whatever the pose assumed by the figure, it was subjected to the following rule: The median plane, which may be considered as passing through the top of the head, the nose, the spinal column, the breast bone, the navel, and the genital organs, dividing the body into two symmetrical parts, remains invariable and may not be bent or curved in either direction.'[3] This architectonic canon for statuary applies equally to temples if we take a centre line through the front elevation, or a line running from front to back through the plan; thus both the statuary and architecture demonstrate the Egyptian adherence to the principle of frontal symmetry for over two thousand years. Else Christie Kielland has made a very exhaustive study of the mathematical principles of Egyptian art in *Geometry in Egyptian Art* (1955), and one fact emerges very clearly indeed from the author's researches,[4] that the Egyptians were familiar with the Golden Section.

VITRUVIUS

Fine art in the Ancient World was architectonic, and the only comprehensive authority still extant upon the principles which governed Greek art is Marcus Vitruvius Pollio, a Roman architect of the time of Augustus Caesar. In his *Ten Books on Architecture* Vitruvius gave the 'fundamental principles', which he derived from Greek authors mentioned in his books, as Order, Arrangement, Eurythmy, Symmetry, Propriety and Economy. As Albert Howard noted in his introduction to Professor Morgan's translation, Vitruvius becomes rather involved and is ambiguous at times. His definitions of the first four principles overlap so much as to be practically synonymous, and the fifth, Propriety, is not really a principle but 'that perfection of style which comes when a work is

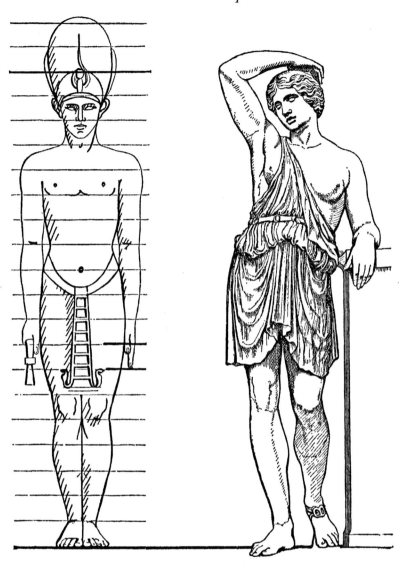

1 Egyptian Figure, and Amazon of Polykleitos

The Egyptian figure, taken from Lepsius's *Choix de Monuments funer-aires*, is divided from the top of the head into nineteen equal parts, the module being the longest finger. The Amazon (Berlin Museum), copied from a bronze by Polykleitos, demonstrates the simple dignity he achieved by balance and proportion.

authoritatively constructed on approved principles'. From the attention given to Symmetry throughout his work, Vitruvius obviously regarded this as the most important principle of the Greek artists. He gives the following definition:

'Symmetry is a proper agreement between the members of the work itself, and relation between the different parts and the whole general

scheme, in accordance with a certain part selected as standard'[5] [the module].

In Book III he gives the same definition for Proportion, and then goes on to say that Symmetry is the result of Proportion. It would appear that the simplest logical interpretation of his views is that Symmetry and Propriety, or balance and correct style, which he gives as results, are the product of the application of the principle of proportion.

The advance of Greek art was due to technical rationalization arising from an analytical outlook. 'Man is the measure of all things,' Protagoras had declared, 'of those that are, that they are, and of those that are not, that they are not', and man was considered, not only the chief arbiter and centre of the universe, but its model. The microcosm was the model and measure for the macrocosm. Even the gods were in man's image, so it is not surprising that, when the Greeks sought a system of proportion for both art and architecture, the human body was their basis, and the use of a module resulted. It has long been held that it was Polykleitos of Argos, the Greek sculptor of the fifth century B.C., who solved the problem of relating the natural harmonic proportions of the human figure to arithmetical proportions within a simple geometric framework.

THE CANON OF POLYKLEITOS

'The beautiful is not in the elements, but in the harmony of the parts of the body, of finger with finger, and all these with the metacarpus and the carpus [the bones of the hand], and of all these with the cubitus [fore-arm including hand], and of the cubitus with the arms, and of all with all, according as it is written in the Canon of Polykleitos.'

So wrote Galen, the famous Greek physician and anatomist of the second century. Mere fragments of the teachings of Polykleitos have survived, the only authentic sources for the Canon being passages from Vitruvius and Galen, and some extant Roman copies of his statues, especially those of his 'Doryphoros'. This idealized version of an athletic spear-bearer, of which there is a fair copy in the National Museum at Naples, is recognized as an outstanding example of the sculptor's concept of proportion; indeed, it has been dubbed 'the Canon'. Pliny stated that Polykleitos 'also made what the artists have called the Model statue and from which, as from a sort of standard, they study the lineaments'.[6] Aelian related that on one occasion the sculptor produced two statues from the same model, one made according to popular suggestion, the other governed by principles. Polykleitos then displayed both statues. The one based upon his Canon excited great admiration, the other mockery.

The details of human proportion which Vitruvius derived from Greek

authors have usually been accepted as constituents of the Canon. Vitruvius gave it piecemeal, the face and the open hand each as one-tenth, the head as one-eighth, head plus neck as one-sixth, head and breast to nipples as one-quarter, and so on; also that the centre point of the circle made by the tips of the extended limbs is the navel. The clearest demonstration of the Canon is to divide a square into sixteen equal squares, as Joseph (Giuseppe) Bonomi did in his *Proportions of the Human Figure* (1872). The cubitus then equals one-quarter of the width or height of the body, and is therefore the basic measure. This scheme shows the arm as a basic measure of the grid (rather than the head as is accepted today), and it conforms to the above statement by Galen, who knew the ancient Canon; thus there seems little doubt that Vitruvius was describing the same scheme.

The diagram from George Redford's *Ancient Sculpture* (1882) is

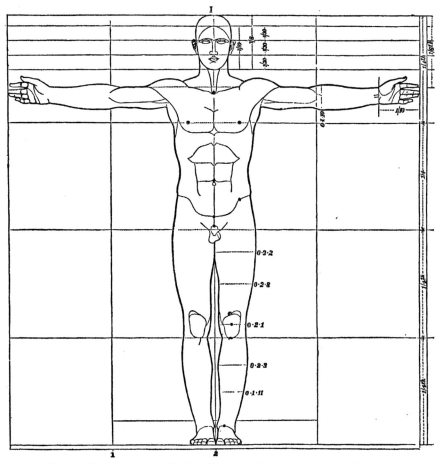

2 Bonomi's version of the Canon, derived from Vitruvius, as published in George Redford's *Ancient Sculpture* (1882)

Bonomi's version of the Canon, derived from Vitruvius. Vitruvius gave the head as one-eighth and the face as one-tenth of the height, and later theoreticians tended to divide the height by eight or ten. Some Greeks preferred ten divisions, agreeing with Plato that it was the 'perfect number', but others, especially mathematicians, preferred eight divisions, because they considered the 'perfect number' as six, and eight divisions could be arrived at by using six, adding one third of it to give eight. The Greek concept of proportion of the figure was of course applied to architecture, as Vitruvius affirms; the diameter of the column was the basic module, sometimes being one-eighth of its height, sometimes more, according to principles of symmetry established by Hermogenes. It should be realized that the principle of proportion based upon a module was only used as a guide by the Greeks to give a total symmetry, and there were many slight deviations, as in real human bodies; indeed, it is thought that there were two parts to the Canon of Polykleitos, the first part dealing with the principle of proportional relationship as described by Galen and Vitruvius, and the second part dealing with the subtleties of form, which improve symmetry, but cannot be grasped by simple measurement.

The discovery of the Vitruvius manuscripts at St Gall in the fifteenth century provided Renaissance artists and architects with a foundation for research into proportion, a main preoccupation of the first Italian academies. Bramante, Leonardo, Michelangelo and Palladio all owed much to Vitruvius. Giorgio Vasari wrote in 1568:

> 'Seeing that design, the parent of our three arts . . . having its origin in the intellect, draws out from many single things a general judgment, it is like a form or idea of all the objects in nature, most marvellous in what it compasses, for not only in the bodies of men and of animals, but also in plants, in buildings, in sculpture, and in painting, design is cognizant of the proportions of the whole to the parts, and of the parts to each other and to the whole.'[7]

The idea of using parts of the body as a module became a little absurd when the practice grew over-complicated and led to eclecticism in the eighteenth century. Measurements of ancient statuary and live models were made between numerous points, and students were asked to apply a host of calculations. Alberti must bear some responsibility for this because of the complicated system he advocated in *De Statua*. For a more interesting and purely mathematical concept of proportion, we must return to ancient Greece.

PYTHAGORAS

'All things consist of number . . . the elements of numbers are the elements of everything . . . God works everywhere by means of

geometry.' These fragments from the teaching of Pythagoras, the great mathematician of the sixth century B.C., demonstrate the Greek desire to order the universe at its most extreme. Three types of proportion were formulated by Pythagoras in accordance with the above principles: the *arithmetic,* the *geometric,* and the *harmonic.* To demonstrate these proportions it is usual to give three quantities, the first and third quantities being considered as *extremes,* to be compared with the central quantity or *mean.* The clearest definitions of the Pythagorean systems are given by Rudolf Wittkower in his *Architectural Principles in the Age of Humanism.* [8]

Arithmetic proportion exists when the first quantity is lesser than the second by the same amount as the third is greater than the second, e.g. 2 : 3 : 4. Geometric proportion exists when the first quantity is to the second as the second is to the third, e.g. 1 : 2 = 2 : 4. Harmonic proportion exists when the difference between each extreme quantity and the mean is the same fraction of each extreme, e.g. 3 : 4 : 6. In this case, the fraction is one-third, since 4 is greater than 3 by one-third of 3, and 6 is greater than 4 by one-third of six. Plato defines harmonic proportion in the *Timaeus.*

Pythagoras discovered that musical intervals are based upon ratios between lengths of string held at the same tension: 2:1 for the octave, 3 : 2 for the fifth, and 4 : 3 for the fourth. This astonishing discovery contributed to the Pythagorean belief that all things consist of number; moreover, it convinced Greek and, later, Renaissance scholars that artistic and musical harmony were analogous. Alberti wrote that 'the numbers by which the agreement of sounds delight our ears, are the very same which please our eyes . . .', and his fellow Italian, Giampolo Lomazzo, asserted that the human body was 'composed of musical harmony'. [9]

Besides basing his concept of the ideal life upon harmony, Plato adopted the twin Pythagorean belief that all things are structured by means of geometry. Pythagoras was credited by Proclus with the discovery of the five regular geometric solids, namely the cube, tetrahedron, octahedron, dodecahedron, and icosahedron; and it was these solids with equal faces, equal sides, and equal angles, which Plato gave in the *Timaeus* as the corpuscles or atoms of the elements.

The quantities in the Pythagorean types of proportion are commensurable using simple arithmetic, but the Greek also discovered incommensurable proportions in geometric figures that could not be expressed in the form of simple additions, fractions, or ratios, such as the relationship between the hypotenuse and the other two sides of an isosceles right-angled triangle. The most pregnant and intriguing proportion is a development of Pythagoras's geometric proportion, namely that created by the Golden Section.

THE GOLDEN SECTION φ

Naturally the Ancients, who sought the most significant or perfect number, also sought a perfect proportion, not based upon simple relationship such as 1 : 1, 1 : 2, 2 : 3, and so on, but upon the type of progressive dynamic proportion manifested by the human body and other natural forms, in which smaller parts are related to larger parts as the larger parts are to the whole. A clear definition of the desired proportion is: *That proportion which exists when the ratio between two quantities is such that the smaller is to the larger one as the larger is one to their sum.* Such a proportion which is not easily discernible 'in the first power', but which produces clearly related forms when elaborated, has been termed 'dynamic' by Jay Hambidge, who adopted the term 'Dynamic Symmetry' from Plato's *Theaetetus.*

Pythagoras was probably familiar with the proportion which the Greeks later called 'The Section'. It is significant that the pentagram was the symbol of recognition used by his followers, for if we construct a regular pentagram all the portions of line made by the intersections conform exactly to the ratio of the Section. It is said that Eudoxus, a pupil of Plato, who originated several theorems based upon the Section, established its aesthetic validity by asking his friends to mark a long stick at the point which pleased them most. In modern times A. Zeising, C. T. Fechner, and C. Lalo have also established by experiment that the

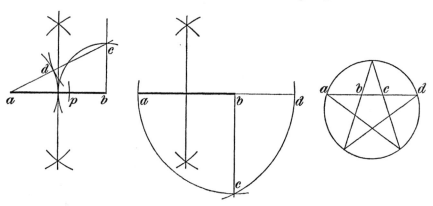

3 Finding the Golden Section

To find the Section in a given line *ab*. Raise perpendicular *bc* of a height ½*ab*. Join *ac*, and with compass point at *a*, using radius ½*ab*, cut *ac* at *d*. With compass point at *a*, using radius *cd*, cut *ab* at *p* (the Section). Then $\frac{pb}{ap} : \frac{ap}{ab}$.

To extend *ab* to give the Section at *b*. Drop perpendicular *bc* equal to *ab*, and with compass point at ½*ab* draw an arc through *c* cutting an extension of *ab* at *d*. Then $\frac{bd}{ab} : \frac{ab}{ad}$. In the pentagram $\frac{bc}{ab} : \frac{ab}{ac} : \frac{cd}{ac} : \frac{ac}{ad}$ etc.

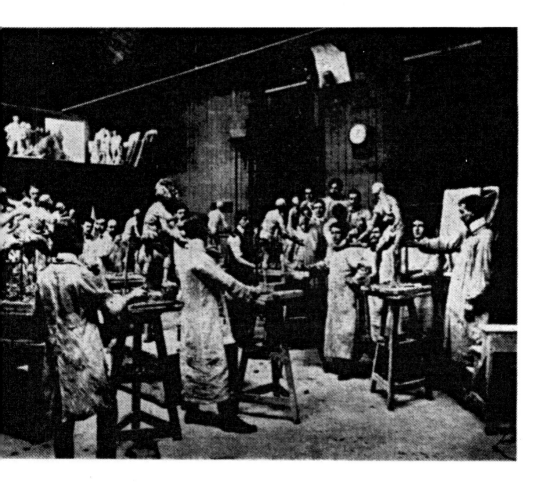

3. The Sculpture School of the Royal College of Art during the professorship of Edouard Lanteri
4. The culmination of the academic system of modelling, as demonstrated by Lanteri (seen in use in the top photograph)

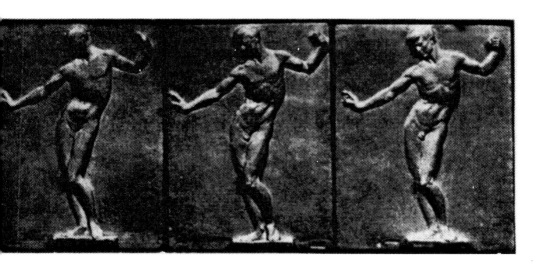

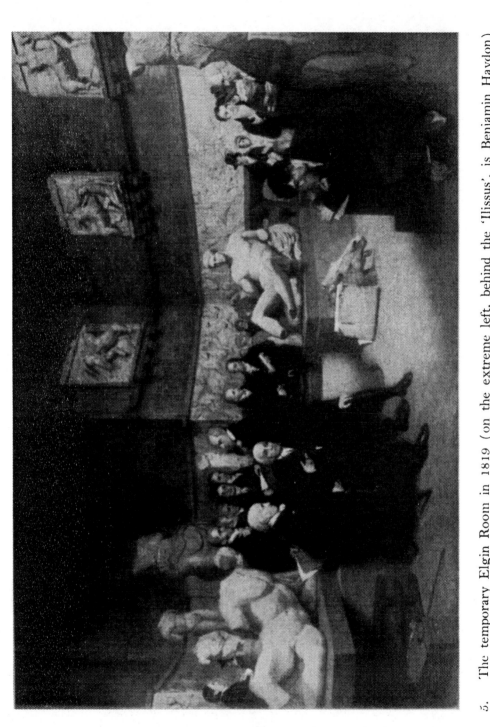

5. The temporary Elgin Room in 1819 (on the extreme left, behind the 'Ilissus', is Benjamin Haydon) Painted by A. Archer

By permission of the Trustees, British Museum

Section provides the most pleasing geometric forms and line divisions, the only rival being exact symmetry.

The Section is best obtained by geometric construction because of the difficulties of measurement, for if a line of given length is divided at the Section, the larger part is 0·618 of the whole, or if one wishes to extend a line AB to give the Section at B, one has to add 0.618 of the length of AB, giving a result which can be stated as 1.618, for which the symbol is ϕ (in honour, it is said, of Phidias who frequently used the Section). A clear grasp of the infinite geometric possibilities created by ϕ, of the recurrence of pentagonal symmetry in plant and marine life, and of the ϕ progression of numbers in nature in the Fibonaci Series 1, 2, 3, 5, 8, 13 . . . can be obtained from Ghyka's *Geometrical Composition and Design* (1952).[10]

Interest in the Section was resuscitated in the Renaissance, especially after the publication of *De Divina Proportione*, written in 1497 by Fra Luca Pacioli in collaboration with his friend Leonardo da Vinci. The geometric engravings in the Venice edition of 1509 are taken from Leonardo's drawings.[11] 'Without measurement, there can be no art,' wrote Fra Luca, and the academic approach to art was speeded. 'Let no man who is no mathematician read the elements of my work,' wrote Leonardo on the back of one of his drawings.[12] Artists busied themselves with calipers, compasses, rulers, and dividers seeking to establish evidence of what they now dubbed the 'Golden Section' in ancient statuary and architecture, and to put it into practice in their work. One of the clearest examples of its use is in Raphael's 'Crucifixion', in the form of a pentagram inscribed in one circle, coinciding with the horizontal in a pentagram in another. Many compositions were based upon a triangle, in which a perpendicular dropped from the apex cut the base at the Golden Section. It is interesting to notice that in an old engraving of an academy of painting, after Francesco Alberti, the paper on which the group of students in the foregound are working is inscribed clearly with ϕ.

ANATOMICAL STUDIES
'. . . I urge you to study the anatomy of the muscles, sinews,
and bones, without knowledge of which you will do little.'
Leonardo da Vinci[13]

Alexandria was the centre for medical studies in the Classical era, and it was here that Herophilos (fl. 300 B.C.) pioneered scientific dissection of the human corpse, and that Galen (fl. A.D. 150), the noted dissector of apes and lower animals, called to increase his knowledge. Aristotle referred to anatomical drawings of his time, but none of these Greek works have survived, and it was not until the fifteenth century that artistic anatomical drawings were current again.

'In painting the nude, begin with the bones,' wrote Alberti, 'then add the muscles and then cover the body in such a way as to leave the position of the muscles visible.' Antonio Pollaiuolo and Luca Signorelli took the advice to heart, so to speak, and Vasari related that Pollaiuolo 'dissected many bodies to examine their anatomy, being the first to show how muscles must be looked for if they are to take their proper place in the representation of the figure'. The engraving of his 'Battle of the Nudes' and the famed crossbowmen in 'St Sebastian' bear witness to his glory in the new knowledge. Signorelli's enthusiasm caused him to paint nudes on the frescoes at Orvieto which almost appear flayed, like the plaster *écorchés* of the academies.

Leonardo tackled dissection in a purely scientific manner, working in conjunction with Marcantonio della Torre, professor of anatomy at Padua, and concerning himself not only with the surface muscles, but also with the organs, veins, nerves, and bones. Vasari informs us that Leonardo made a book about anatomy for the professor, 'with red crayon drawings outlined with the pen, in which he foreshortened and portrayed with the utmost diligence. He did the skeleton, adding all the nerves and muscles, the first attached to the bone, the others keeping it firm and the third moving, and in the various parts he wrote notes in curious characters, using his left hand, and writing from right to left, so that it cannot be read without practice, and only at a mirror.' There are some fine examples of his anatomical studies of this period in the Windsor Castle collection. Leonardo did not intend that anatomical knowledge should be used to depict muscular bodies after the manner of the Greeks. He was too keen on nature to follow the antique model as Michelangelo and Poussin did. Anatomy was to be studied as an aid to arranging natural attitudes and graceful gestures true to nature; in his own words:

> 'The nude represented with muscles in full evidence is without motion, for motion is impossible unless some of the muscles relax ... He [the painter] should know their various movements and forces, and which sinew or muscle occasions each movement, and paint only those distinct and thick, and not the others, as do many who, in order to appear to be great draughtsmen, make their nudes wooden and without grace, so that they seem a sack full of nuts rather than the surface of a human being . . .'[14]

Leonardo obviously had little time for the rigid division of a torso into a bulging *cuirasse esthétique*. His younger contemporary Michelangelo had a greater passion for the Ancients and managed to combine the antique schema of the nude with the anatomical forms which he derived, according to Ascanio Condivi, from frequently dissecting

cadavers to the point when his stomach was so upset he could neither eat nor drink. Autopsies were eagerly attended by artists of the Cinquecento, but dissection became less necessary as the number of anatomical drawings and engravings increased. The publication in 1543 of *De humani corporis fabrica* by Andreas Vesalius, professor of surgery at Padua, was widely appreciated by artists, for the professor had employed Jan Stephan, an artist of great skill, to illustrate the dramatic postures of cadavers, and many were content to copy from them.

Looking at old engravings of art academies we are reminded of a butcher's shop by the models of parts of the body which lie around the room. Sometimes there is also a skeleton, sometimes a dissection in progress. The anatomical casts we can discern (as distinct from casts of ancient statuary) originated in the Quattrocento, when artists began to make models from parts of corpses in order to have an incorruptible model of each dissection. Eventually a whole figure of the male *écorché* was constructed, displaying the surface muscles of the body. When this first happened is not known, but it seems likely that Leonardo, with his love of making models of animals and machines, must have attempted such a model. Sir Kenneth Clark points out that the best known *écorché*, Cigoli's bronze in the Bargello, 'does recall, both in pose and physiological type, some of the Leonardo drawings in Anatomical MS. A. Windsor, 19003 V'.[15]

Colleges of Art still possess neglected *écorchés*, some after Cigoli, and others after originals by Edouard Lanteri, professor of sculpture at the Royal College of Art, who in the early years of this century, in conjunction with the publishing house of Chapman and Hall, produced numerous *écorchés* of figures and various limbs. Examinations of nineteenth century academies often included the memory drawing of both a skeleton and an *écorché* in a given pose, and this practice was continued into the nineteen-fifties for the Intermediate Examination for the National Diploma in Design. I suppose that its passing broke the last strong link with academic training. Drawing from the antique and drawing in strict perspective had been generally abandoned in Colleges of Art in the forties.

PERSPECTIVE

'Oh! What a sweet thing is perspective.'
Paolo Uccello

Perspective is the means of representing objects on a plane surface. It is important to realize that the various systems of perspective are not accurate optical science, but rather formulae or principles which were adopted by academics to approximate to visual impressions. Plane and solid geometry have at various periods been regarded as parts of

perspective, since both are methods of delineating forms on a surface plane; but most commonly perspective has been taken to mean the method of representing visual impressions.

The Greeks regarded perspective as mere artifice, Plato considering it a deceit, and this is understandable for, apart from the foreshortening of figures, perspective for the Greeks was limited to *scaenographia*, what today we call parallel or one-point perspective. Vitruvius's definition was: 'Perspective is the method of sketching a front with the sides withdrawing into the background, the lines all meeting in the centre of a circle.' He informs us that on the *scaena* of a Greek theatre were pieces of scenery with three faces, which could be revolved, usually to show three types of scene: tragic (palace architecture), comic (private houses with balconies), and satyric (country landscape). Thus perspective was discovered through attempts to divert the audience; in the words of Vitruvius:

> 'In the first place Agatharcus, in Athens, when Aeschylus was bringing out a tragedy, painted a scene, and left a commentary about it. This led Democritus and Anaxagorus to write on the same subject, showing how, given a centre in a definite place, the lines should naturally correspond with due regard to the point of sight and the divergence of the visual rays, so that by this deception a faithful representation of the appearance of buildings might be given in painted scenery, and so that, though all is drawn on a vertical flat façade, some parts may seem to be withdrawing into the background, and others to be standing out in front.'[16]

The frescoes of the cubiculum of P. Fannius Synistor (National Museum, Naples), painted circa 50 B.C., show clearly the three types of Greek theatre scenery mentioned by Vitruvius. The one-point perspective used is roughly accurate, but the oblique perspective is very poor. During the following Byzantine and Gothic periods the art which Boethius referred to as *perspectiva* was forgotten, and buildings were usually illustrated in crude oblique projection.

The classical method of using a single vanishing point was rediscovered in the first decade of the Quattrocento by the architect Filippo Brunelleschi, according to Antonio Manetti and Vasari. Brunelleschi drew a view of the Baptistry of Florence in parallel perspective upon a panel through which he pierced a small hole at the vanishing point. Curious citizens were then invited to peer through the hole at the reflection of the picture in a mirror, and were astonished to find that they seemed to be looking at the Baptistry itself. Alberti described Brunelleschi's one point method which is manifested in the works of Masaccio, Donatello, Uccello, and Piero della Francesca. Uccello's enjoyment of

perspective for its own sake can be judged from the arrangement of broken lances on the 'floor' of the 'Battle of San Romano', and the tiles in his 'Legend of the Profanation of the Host'.

Leonardo during his researches in optics noted the ratio between the diminution of an object and its distance from the eye. Optics also caused him to reject linear perspective for aerial perspective, so that he could experiment with his discoveries that colours greyed and that shapes faded as they receded. The academies did not follow suit, for the one point method was ideal for their frontal compositions, and so to the very end of classical painting, in the days of Leighton and Alma Tadema, one point perspective was considered most appropriate for an academic work.

This history does not deal with architectural education, and it was the student architects of the academies who were expected to become skilled at geometric and perspective drawing. Many painters have regarded it as a necessary evil, but from the sixteenth to the eighteenth century the subject was stimulated by the Italian and German Perspectivists who used perspective as a decorative style, to give an illusion, following the example of Egnazio Danti and J. B. da Vignola, the Bolognese Perspectivists. With the increased interest in aerial perspective and country landscape in the nineteenth century, linear perspective became less important, and the Impressionist painters, particularly Cézanne, made it seem rather irrelevant, but the subject held its ground in government schools of art as a useful subject for artisans and designers. In Britain the subject was at its peak from 1860 to 1901 when intending art teachers studied planes, shadows, and reflections, and solved complicated problems in the examinations of the Science and Art Department. The final separation of art and science education at the turn of the century caused the decline of perspective drawing. Today it lies moribund.

IDEAL BEAUTY
'Thou hast the eyes of Hera, the hands of Athena,
the breasts of the Paphian, the ankles of Thetis.'
Greek epigram

All academies of art were concerned with the quest for beauty, but there were two approaches to it, the first being the rational and technical approach to symmetry and proportion already discussed, the second an irrational idealist approach, stemming from a belief that an absolute beauty is to be found in various parts of artefacts and natural forms. Pliny the Elder related that when Zeuxis (fl. 420–390 B.C.) was 'about to execute a painting for the people of Agrigentum to be consecrated in the Temple of the Lacinian Juno [Hera] there, he had the young maidens of the place stripped for examination, and selected five of them, in order

to adopt in his picture the most commendable parts in form of each'.[17] In the same century the smooth delicacy and grace of the statues of Praxiteles seduced artists from rational symmetry towards a subjective and sensuous view of ideal beauty.

The search for a selection of beautiful human forms was resumed in the Renaissance, stimulated greatly by Alberti, who recommended it in his *Della pittura*. Proclus (A.D. 410–485), the Byzantine Neoplatonist, had commented that 'the works of nature are full of disproportion and fall very short of the true standard of beauty'. Raphael and his friend Castiglione followed this view that nature was defective, and believed that perfect parts could be extracted to combine into ideal beauty. Both Raphael and Durer made countless studies of faces and bodies in pursuit of the ideal, called by Reynolds, 'that central form . . . from which every deviation is deformity'.[18]

Strict academicians such as David and Ingres disapproved of this irrational search for absolute beauty. Art training should be technical and objective, and students should study the antique to see and draw nature in the Classical manner; in the words of Ingres:

> 'Do you think I send you to the Louvre in search of what is commonly called ideal beauty? Nonsense of that sort is responsible for the decadence of art in the worst periods of its history. I send you there to learn from the ancients to see nature, because they themselves are nature.'

The belief held by some academicians that conformity to Classical principles produced pure, high, and noble beauty, flavourless as pure water as Winckelmann advocated, as opposed to lowly emotional and sensual attraction, was particularly acceptable to nineteenth-century moralists, and accounts for the pathetic insipid nudes that confront us on the pages of Victorian art journals. A brief flash of the true Greek spirit was exhibited in their different ways by Rodin and Maillol, a last justification of the art academy before its eclipse.

ECLECTICISM AND REYNOLDS

The nadir to which some academies sank was due to faith in mere imitation and eclecticism. To sum up this disastrous viewpoint one can do no better than quote the beliefs of Sir Joshua Reynolds, which caused British students to copy historic art without any constructive teaching or method, in the vain hope that they would acquire the mysteries of 'the great style, genius, and taste'. To quote Reynolds, 'those who have talents will find methods for themselves'. Let us read his own words.

Upon originality:

> 'For it may be laid down as a maxim, that he who begins by

presuming on his own sense has ended his studies as soon as he has commenced them . . . he must still be afraid of trusting his own judgment, and of deviating into any track where he cannot find the footsteps of some former master . . . I could wish you would take the world's opinion rather than your own. You must have no dependence on your own genius.'

Upon exact copying:

'He who endeavours to copy nicely the figure before him not only acquires a habit of exactness and precision, but is continually advancing in his knowledge of the human figure . . . This scrupulous exactness is so contrary to the practice of the academies, that it is not without great deference I beg leave to recommend it to the consideration of the Visitors . . . so servile a copyist was this great man [Raphael], even at a time he was allowed to be at his highest pitch of excellence.'

Upon eclecticism:

'The more extensive therefore your acquaintance is with the works of those, who have excelled, the more extensive will be your powers of invention . . . With a variety of models thus before him, he will avoid that narrowness and poverty of conception which attends a bigoted admiration of a single master, and will cease to follow any favourite when he ceases to excel . . . he learns to discriminate perfections that are incompatible with each other . . . The habitual dignity, which long converse with the greatest minds has imparted to him, will display itself in all his attempts.'

Upon ideal beauty:

'The highest perfection of the human figure is not to be found in the Hercules, nor in the gladiator, nor in the Apollo; but in that form which is taken from them all, and which partakes equally of the activity of the gladiator, of the delicacy of the Apollo, and of the muscular strength of Hercules. For perfect beauty in any species must combine all the characters which are beautiful in that species . . . no one therefore must be predominant, that no one may be deficient.'[19]

It is impossible to visualize the eclectic mess a bemused student would have produced following such advice. Reynolds seemed loth to pass on particulars he had learnt; indeed, it was said that he did not permit pupils in his painting room, lest they learnt his methods.

As far as industrial design was concerned, Reynolds put forward the idea which was to dominate the Academy in the nineteenth century; in

his own words: 'if the higher arts of design [the fine arts] flourish, these inferior ends [taste in manufactures] will be answered of course'. Actually there was little hope of the design in the fine arts influencing taste in manufactures. Reynolds disapproved of decorative art, criticizing Veronese and Tintoretto for 'a style merely ornamental' and for brilliant colour, even ranking them below the Bolognese eclectics. The deep effect of this view on the Academy can be deduced later from the sayings of Sir Martin Arthur Shee, P.R.A.

OPPOSITION TO ACADEMIC PRINCIPLES

'There is no excellent beauty that hath not some
strangeness in the proportion. A man cannot tell
whether Apelles or Albrecht Durer were the more trifler;
whereof the one would make a personage by
geometrical proportions: the other by taking the best
part out of divers faces to make one excellent.'
Sir Francis Bacon

Such a discerning student of natural forms as Bacon could not have failed to digress from the classical concepts of ordered proportion and ideal beauty. When man has spoken of beauty, he has usually had women in mind, and, after the Renaissance, although the male nude was the principal subject of study in the academies, the nude in works of art became more and more exclusively the female nude. Moreover, by the mid–eighteenth century a further divergence was apparent: the type of female beauty increasingly admired was refined and petite, with an 'appearance of delicacy, and even of fragility', as Edmund Burke put it.

Burke acquired literary fame through his onslaught against academic principles in *A Philosophical Inquiry into the origin of our ideas of The Sublime and Beautiful* (1756), using very effective arguments, as can be deduced from the extracts quoted below (which appear under his original headings).

'II – Proportion not the Cause of Beauty in Vegetables
But surely beauty is no idea belonging to mensuration, nor has it anything to do with calculation and geometry . . . What proportion do we discover between the stalks and the leaves of flowers, or between the leaves and pistils; how does the slender stalk of the rose agree with the bulky head under which it bends?
III – Proportion not the Cause of Beauty in Animals
The swan, confessedly a beautiful bird, has a neck longer than the rest of his body . . . what shall we say to the peacock, who has comparatively a short neck, with a tail longer than the neck and the

rest of the body taken together? How many birds are there that vary infinitely from each of these standards, and from every other which you can fix . . .

IV – Proportion not the Cause of Beauty in the Human Species
The neck, say they, in beautiful bodies, should measure with the calf of the leg; it should likewise be twice the circumference of the wrist . . . These proportions are certainly to be found in handsome bodies. They are also certainly in ugly ones . . . both sexes are undoubtedly capable of beauty, and the female of the greatest; which advantage I believe will hardly be attributed to the superior exactness of proportion in the fair sex . . . it has been said long since [by Vitruvius] that the proportions of buildings have been taken from those of the human body. To make this analogy complete, they represent a man with his arms raised and extended at full length, and then describe a sort of square as it is formed by passing lines along the extremities of this strange figure . . . men are rarely seen in this strained posture, it is not natural to them; neither is it at all becoming.'[21]

Vitruvius had stated, 'The perfection of all works depends on their fitness to answer the end proposed and on principles resulting from a consideration of Nature itself', a theory which was adopted by some academics, and later achieved great popularity through the Bauhaus. Burke included the following attack on this principle:

'VI – Fitness not the Cause of Beauty
It is said that the idea of utility, or of a part's being well adapted to answer its end, is the cause of beauty or indeed beauty itself – on that principle, the wedge-like snout of a swine, with its tough cartilage at the end, the little sunk eyes, and the whole make of the head, so well adapted to its offices of digging and rooting, would be extremely beautiful . . . there are several of the domestic fowls which are seldom seen to fly and which are nothing the less beautiful . . . if beauty in our own species was annexed to use, men would be much more lovely than women . . . And I appeal to the first and most natural feelings of mankind, whether on beholding a beautiful eye, or a well fashioned mouth, or a well turned leg, any ideas of their being well fitted for seeing, eating, or running, ever present themselves?'

Burke substituted particulars for principles in suggesting that the qualities of beauty were smallness, smoothness, variety in the direction of the parts, gradual variation, of delicate frame, and of 'colours clear and bright, but not very strong or glaring'.

Three years before Burke's treatise, Hogarth had published his *Analysis of Beauty*, in which he had argued that the whole mystery of art is based upon a principle which Giampolo Lomazzo ascribed to Michelangelo,[22] in short, that a figure should be 'Pyramidall, Serpentlike, and multiplied by one, two, and three'. Hogarth's justifications for a line of beauty, illustrated by cherubs, chairs, casts, and corsets, attracted some ridicule; nevertheless Hogarth showed that lively composition and nature itself seldom conform to the regular symmetry and frontality supported by the European academies, where, he insisted, students were seduced from nature. Besides the serpentine or restless rococo line of elegance, he advocated 'Intricacy in form . . . that leads the eye a wanton kind of chase'.[23]

Generally, the more imaginative an artist was, the less he wished to conform to academic concepts, especially the idea that, by selective copying from the antique or nature, one could obtain a 'central form' of ideal beauty. Blake, who particularly detested Reynolds's teachings, declared: 'All Forms are Perfect in the Poet's Mind but these are not Abstracted or compounded from Nature, but are from the Imagination.'

The most savage opponent of the Royal Academy was Benjamin Haydon, an artist who urged that copying works of art led to mere mannerism, whereas artists should follow the Greeks, not by imitating their works, but by studying the living nude as they did. It was this crusader who drew up the first petitions for public art education in Britain.

Sources

1. BELL, QUENTIN *The Schools of Design* Routledge & Kegan Paul, London, 1963 (pp. 2–3)
2. REDFORD, GEORGE *A Manual of Ancient Sculpture* Sampson Low, Marston, Searle, and Rivington, London, 1882 (pp. 35–7)
3. LANGE, K., and HIRMER, M. *Egypt* Phaidon, London, 1955; and RACHEWILTZ, BORIS DE *An Introduction to Egyptian Art* Spring Books, London, 1966 (pp. 37–8)
4. KEILLAND, ELSE CHRISTIE *Geometry in Egyptian Art* Tiranti, London, 1955
5. VITRUVIUS, MARCUS *Ten Books on Architecture* Translated Morgan, Morris Hicky, and Howard, Andrew, edited Warren, H. L. (1914) Dover Publications, New York, and Constable, London, 1960 (Book 1, Chapter 2.4)
6. PLINY (GAIUS PLINIUS SECUNDUS) *The Natural History of Pliny* Translated Bostock, J., and Riley, H. T. Henry G. Bohm, London, 1857 (Book XXXIV, Chapter 19, p. 171)

7. VASARI, GIORGIO *Lives of the Painters, Sculptors and Architects* (Everyman edition) J. M. Dent, London, 1963 Introduction to 1568 edition
8. WITTKOWER, RUDOLPH *Architectural Principles in the Age of Humanism* Warburg Institute, University of London, 1949 (pp. 90–135)
9. LOMAZZO, GIAMPOLO *Idea del tempio della pittura* Milan, 1590
10. GHYKA, MATILA *Geometrical Composition and Design* Tiranti, London, 1952
11. GOLDSCHEIDER, LUDWIG *Leonardo da Vinci* Phaidon, London, 3rd edition 1947 (p. 5, footnote 3)
12. Windsor Library, Royal Collection, 19118, *c.* 1550
13. VINCI, LEONARDO DA *Treatise on Painting* (Codex Urbinas Latinus, 1270) Translated McMahon, A. Philip Princeton University Press, 1956 (Vol. I, p. 125)
14. Ibid. (p. 129)
15. CLARK, SIR KENNETH *The Nude* John Murray, London, 1956; Penguin Books, Harmondsworth, 1964 (Notes, p. 398)
16. VITRUVIUS, MARCUS *Ten Books on Architecture* Translated Morgan, Morris Hicky, edited Warren, H. L. Dover Publications, New York, and Constable, London, 1960 (Book I, Chapters 1 and 2, pp. 14, 150, 198; Book V, Chapter 6, p. 8; Book VII, Introduction, p. 11)
17. PLINY (GAIUS PLINIUS SECUNDUS) *The Natural History of Pliny* Translated Bostock, J., and Riley, H. T. Henry G. Bohm, London, 1857 (Book XXXV, Chapter 36, pp. 251-2)
18. REYNOLDS, SIR JOSHUA *Seven Discourses on Art* Cassell, London, 1888 (pp. 47, 52)
19. Ibid. (extracts)
20. BACON, FRANCIS *Essays:* 'On Beauty' (XLIII) 1597
21. BURKE, EDMUND *An Essay on the Sublime and Beautiful* (1756) Cassell, London, 1887 (pp. 100–29)
22. LOMAZZO, GIAMPOLO *Trattato della pittura, scultura, ed architettura* Rome, 1844 (I, pp. 34–5; II, pp. 97, 165)
23. HOGARTH, WILLIAM *The Analysis of Beauty* (1753) Edited Burke, Joseph Clarendon Press, Oxford, 1955 (pp. 5, 42)

3

The Petitioner
and the Politicians

'God help the Minister that meddles with Art!'
Lord William Melbourne

HAYDON AND THE WHIGS

National art education was authorized by the British Parliament in the
last year of the reign of William IV, during the ministry of Lord
Melbourne. It was established as an economic necessity, and certainly
would not have been considered at this time if it had not been so
regarded. The Committee of the Privy Council for Trade was alarmed
at the large expenditure on French designs by British manufacturers
and at the imports of superior French manufactures, particularly from
Lyons, where there was a thriving academy which instructed designers.
Even taking these facts into account, it is surprising that a grant for art
training was proposed only two years after the very first government
grant for any educational purpose; but for a decade the great politicians
had become conditioned to the idea of spending Government funds on
art by the vociferous demands of Benjamin Robert Haydon, the historical
painter (1786–1846).

Haydon's first petition to Parliament for Government aid for art
came in 1823, very appropriately, from his temporary abode in the
King's Bench debtors prison, in the vicinity where a fellow painter,
George Morland, had spent three years as an out-prisoner.[1] An
eloquent and persistent petitioner, Haydon was likely to appear on the
doorstep of any politician from the Duke of Wellington to a Birmingham
Unionist. In his early petitions, such as that of 1823, which was presented
to Parliament by Henry Brougham, the champion of the diffusion of
useful knowledge, Haydon requested grants for historical pictures for
public buildings. The British public, unlike the French, rarely saw any
work of art, and Haydon advocated civic paintings in civic buildings,
marine paintings in naval establishments, and so on, as opposed to the

60

contemporary practice of filling these public buildings with the portraits of officers and officials.

Haydon became acquainted with the prominent men of his day through his patron, Sir George Beaumont, and his first great opportunity for instructing them in the subject of state patronage came when he was commissioned by Lord Grey, the Whig premier, to paint a picture containing all the politicians who were seated at the Reform Banquet in the Guildhall. While they each sat in turn, Haydon impressed 'on his distinguished sitters those views upon the public encouragement of Art'.[2] They had to sit still and listen, and many, such as Lord Melbourne, enjoyed it.

Two years later, in 1834, when Melbourne was returned to power as Prime Minister, Haydon decided his lordship must have further instruction, called on Melbourne and was admitted into his dressing room. Melbourne, by conviction an eighteenth-century man of the world, was, according to David Cecil, always fascinated by people 'with an inability to doubt or hesitate about anything, which was the antidote to his own sad questioning vanity',[3] and he was intrigued to see the crusader again.

Melbourne appreciated many forms of art, but he did not believe that they necessarily had a beneficial effect on people. It amused him to appear more cynical and worldly than he really was; for instance, he once remarked: 'Raphael was employed to decorate the Vatican, not because he was a great painter, but because his uncle was architect to the Pope.' On this occasion, knowing full well Haydon's admiration for the ancient Greeks, he cheerfully informed the artist that the Government was against paintings in public buildings because they wished 'to emulate the simplicity of the ancients'.[4]

His lordship listened in mild amusement as Haydon assured him that 'the First Lord who has the courage to establish a system for the public encouragement of High Art will be remembered with gratitude by the English people'. Melbourne quipped: 'God help the Minister that meddles with art!'[5] Haydon's only consolation during this interview was the similarity between the neck which protruded from Melbourne's grey dressing gown and that of an antique sculpture, which fact he duly noted in his diary.

On his next visit to Melbourne, Haydon was astute enough to stress the point which he constantly urged from then on, and which eventually carried the day, namely, the superiority of French manufactures. 'Why is she superior in manufactures at Lyons? Because by State support she educates youth to design.'

Though Haydon was helped by Brougham to present his first petition, his most constant supporter was William Ewart (1796–1869), M.P. for

Liverpool, the champion of Free Libraries and of abolition of capital punishment. Haydon's argument that art would benefit manufactures also won him the support of the businesslike Sir Robert Peel and of the economist Joseph Hume. The Radical politicians at this time were looking askance at the Royal Academy, which according to its Instrument of foundation, had been established for the purpose of 'promoting the Arts of Design'. Now that it had become obvious that bad taste in design pervaded Britain, it was only to be expected that the Radicals should bitterly attack the negative attitude of this royal institution; and the Academicians rapidly, albeit unwillingly, became embroiled in the struggle for public art education.

THE ROYAL ACADEMY AND PUBLIC ART EDUCATION

'An Academy is a school, and I think a school is a good thing.'
Sir Martin Arthur Shee, P.R.A.[6]

It is rather startling to note that the Royal Academy was primarily intended to be an educational institution, as its name implies. When the artists who had quit the Incorporated Society of Artists originally presented their memorial to George III in November 1768, they begged him to establish 'a school or academy of design for the use of students in the arts'. Benjamin West and William Chambers assured the King that 'though they would not trespass on his time to enter into minute details of their plans at that moment, they begged leave to state the two principal objects they had in view, viz. the establishment of a well regulated school of design for the use of students, and an annual exhibition'.[7] By the time these 'minute details' had been worked out by these gentlemen, and the Instrument drawn up, the original excuse for a school of design had become a little submerged beneath the weight of material bearing upon the privileges, offices and emoluments of a restricted society, 'membership of which constitutes the Art peerage of Great Britain', as one admirer put it.[8]

Even so, in its early years the Academy had some claim to be 'promoting the Arts of Design' as this Instrument instructed. Eighteen engravers, ten architects, two coach decorators, and a medallion engraver were elected before 1800, but from this date onwards the Academy gradually became a High Art club for oil painters, sculptors and a handful of architects.

The author would like to make it quite clear at this point that he is not attacking the Royal Academy as an institution. Under Reynolds and, later, under Leighton, it advanced British art considerably, and, with the exception of the period from 1800 to 1860, has always maintained high standards of proficiency, essential to art; moreover, it now shares the distinction with the Society of Industrial Artists of being one of the few

British institutions where an artist can be certain that the jury is entirely composed of skilled professional artists. The Academy is liberal and enlightened and shows a wide cross-section of skilled art.

Nevertheless, it is surprising that some Academicians have during this century condemned the attacks made on their institution by politicians and artists during the presidencies of West, Lawrence and Shee. If the evidence is considered from the point of view of art education, it is irrefutable.

In the early years of the nineteenth century the Academicians' interest in art education did not even extend as far as their own Schools. The professorships were regarded as sinecures for senior members, and the other offices were often given to aged or impoverished Associates. There were many years in which the students in the Schools received no lectures from the professor of a particular subject, although the Instrument lays down that these salaried professors must annually give six lectures each. Lectures were so neglected by 1808 that the students received none of the required twenty-four lectures in that year. The Schools of Design, as they are called in the Instrument, had become merely studios in which young men copied antique and life in the hope of becoming Associates; in the words of an ex-student, giving evidence before the Select Committee of 1849, 'The study there was the figure, and for professional purposes exclusively.'[9]

The Academicians, far from 'promoting the Arts of Design', objected to the encouragement of any other artistic establishment in London, and members were forbidden to be 'members of any other society of artists established in London' under the first clause of their Instrument. When Charles R. Cockerell, R.A., wished to join the Institute of British Architects, he was instructed that he could not, neither could Turner join the Society of Water Colour Painters. The reason originally given for the foundation of the London Architectural Society (later the I.B.A., finally the R.I.B.A.) was that 'there is not one [institution] calculated for the encouragement of Architecture – the Royal Academy can hardly be deemed an exception'.[10] British water colourists and engravers, who at this time were, taken as a body, the finest and most original artists in Britain, were never elected full Academicians.

It can be seen that the professional portrait painters and sculptors of the Academy, who were soon to govern the policy of the Government Schools of Design, were hardly a suitable choice. Apart from the above, another reason for their unsuitability was their slavish adulation for inferior Italian art, for, while they paid lip service to the Divine Raphael, their inclinations were really towards the Mannerists and the Roman and Bolognese eclectics.

To realize the outlook which prevailed, one can study the evidence

of the P.R.A., Sir Martin Arthur Shee, given before the Select Commit-
tee of 1836. He stated that his predecessor as President, Benjamin West,
was the greatest historical painter since the Carracci, and that there
were (in 1836) artists in the Academy who were as great as Reynolds,
Hogarth, and Gainsborough had been – in fact, greater than Gains-
borough.[11] Shee obviously believed that West was great because he was
nearly as good as the Bolognese and Roman eclectics, since he also
compared West with Domenichino. As for the Academicians of 1836,
none, save Turner and Constable who had grown out of favour with
Shee and the Academy, could approach the original English talents of
Hogarth and Gainsborough. Shee's reason for rating Gainsborough
even below the Academicians of 1836 must have been his dislike of the
original touch of this native artist, who moreover had said some very
rude things about the gentry and the Academy.

Certainly both Wilson and Constable incurred displeasure for depart-
ing from the Italian style of landscape painting. The great Constable
had to exhibit in the Academy for seventeen years to be elected Associate
and for twenty-seven years to reach Academician, each election directly
following a great rise in his personal fortunes through legacies. Indeed,
the president, Sir Thomas Lawrence, told him that he considered him
very fortunate, as a painter of English landscape, to be elected at all.
The favoured Academy portraits of high society of this time were
painted rather crudely, with the maximum flattery, in the style of Lely
and Kneller, 'polished up by reference to that international grand style,
which had found its popular exemplar in the Roman, Pompeo Battoni'.[12]
These dashing portraits painted with *gusto grande* were later referred to
by the Pre-Raphaelites, a little unkindly, as being in the manner of 'Sir
Sloshua Reynolds'.

The Academy was so orientated towards Rome that even the
magnificent Gothic architecture of Britain was despised. English Gothic
had a sharp, clean, aesthetic appeal which irritated the cloyed and
'refined' minds of some Academicians. Charles R. Cockerell, Professor
of Architecture (1839–59), referred to 'the barbaric carvings and
disgusting monstrosities of Gothic Architecture'.[13] The dukes, earls and
lords of the Dilettanti Society were joined in membership by the most
prominent Royal Academicians, who followed the tastes of their
patrons; and three of these artists were very influential during the
formative period of public art education from 1835 to 1848, namely Sir
Martin Arthur Shee, P.R.A., Sir Richard Westmacott, R.A., and
Charles R. Cockerell, R.A. Catterson Smith, head of the Birmingham
School of Art at the beginning of this century, gave his view of Dilettanti
as men who 'ever try to press upon the artist some foreign or ancient
style', and wrote of the period under discussion: 'the whole of the centre

of society was following one fashion . . . which had its origin in the luxurious and disproportionately cultured classes in Italy . . . eating up before it all native Art instinct'.[14]

The Academicians, who regarded great native artists such as Blake, Girtin, Cotman, Cox and Cruickshank as belonging to lower branches of art, and who regarded a Roman training as desirable, could hardly have been expected to initiate, or consider seriously public art education in Britain.

In mitigation for their slavish following of the Dilettanti, and for their fears about public art education, one could plead the perilous financial position of the members of the Academy in the first half of the nineteenth century; for although the body had capital, many of its members were fighting against poverty, at least fifteen of this numerically very limited institution being recorded as completely destitute, and one poor Associate finding solace in the Thames. It was not until the fifties and sixties that a man's career was made by obtaining membership. George Dunlop Leslie, R.A., in his *Inner Life of the Royal Academy* described how his father Charles Robert Leslie, R.A. (1794–1859), Professor of Painting, only prospered during the last twelve years of his life, when the great Victorian art boom was commencing; 'it was, indeed, the only period of his life in which he was enabled to put by money at all'.[15]

In view of the paucity of instruction given by Academicians, even to their own students, and in view of their obsession with the imitation of the styles of eclectic Italians, I can hardly agree with Finberg's verdict in his life of Turner that 'the case against the Academy rested mainly on ignorance and misrepresentation'.[16] If this is true I must plead ignorance.

HAYDON AND THE RADICALS VERSUS THE ROYAL ACADEMY

Haydon's crusade for public art education was regarded by the more radical Whig politicians as a contribution to their campaign for useful knowledge. The most active of them, apart from the great Brougham, was Ewart, who was later responsible for the Parliamentary motion for public art education. Ewart and his associates, who advocated public museums, art galleries, and libraries upon the rates, believed that the Royal Academicians had no interest in carrying further the intention of their royal founder and promoting the 'Arts of Design' among the public. Joseph Hume, 'the guardian of the public purse', was particularly annoyed that the Academy had recently been allocated half the National Gallery in Trafalgar Square for their studios and Keeper's lodgings. The members were using a building built at public expense without having any public responsibilities, and Ewart thought that the Royal Academy collection should be opened free to the public, since the Academy should not be permitted to charge the public for entry into a public building.

There was indeed, at that time, a fear expressed by the dilettanti that, if collections were opened to the lower orders, the exhibits would be injured, and Haydon mischievously suggested that the Academicians were disturbed that the public might damage the shine on His Majesty's boots, which had been so assiduously applied by President Shee in the painting of the royal portrait.

Haydon had for many years been regarded by the Academy as a dangerous man of ideas. He had extolled the worth and quality of the Elgin Marbles, when many of the Dilettanti Society, following the lead of Payne Knight, were decrying them. Inspired by these Greek sculptures, he had then annoyed the Academy by suggesting to his aristocratic friends that art should be based upon a thorough knowledge of anatomical form, not upon the slavish copying of casts, nor upon copying Italian Mannerists, who had depicted dislocated necks and arms to achieve the Grand Manner.

When 'Dentatus', the first product of Haydon's new knowledge, was shown in the R.A. exhibition of 1809, it was first hung for two days in the main room at Somerset House. Then some of the hanging committee took it down and re-hung it in a small ante-room without a window.[17] This let Haydon down very badly with his patrons Lord Mulgrave, Lord Ashburnham and Sir George Beaumont, who had admired the picture during its production, so Haydon attempted to recover his reputation by entering the work for a competitive exhibition in the British Gallery. To the artist's delight it won the 'great prize' in preference to a work by one of the offending hanging committee.

Haydon was later naive enough to apply for associateship of the Academy and did not get a single vote. From then on the embittered artist waged an incessant war against the royal institution with the help of his Radical friends. He undoubtedly did himself great harm by what Leighton called 'his mordant gift of satire and his devouring thirst for ink', but he achieved much for art education, as will be seen later, and the Academicians, put on the defensive, were forced to ensure regular lectures and broaden their outlook. In fairness to the Academy as a whole, it must be said that many of them, especially the younger Associates, had more sympathy with Haydon's views on art than with those of Shee or the senior Academicians, but the system of government of the Academy, by which the Academicians had complete power over the Associates' election, their promotion, and acceptance of their work for exhibition, kept their lips sealed. Haydon repaid their discretion by referring to them as 'the most abject slaves in Europe'.[18]

Haydon's Radical adherents regarded the Academy as a club of privileged lackeys of the Tory Establishment; not primarily a school, as Shee claimed, but rather 'a select aristocracy of a limited number', as

Prince Albert later described it.[19] The great event of the Academy's year was the dinner at which senior military and naval officers, peers and bishops were entertained, with past and prospective portrait commissions in mind. The Iron Duke himself had already proved a gold mine, though little gold was extracted from his own pocket. During the Select Committee hearing of 1836 Ewart asked President Shee whether prominent artists were invited to this artists dinner, and when Shee replied that some foreign artists were invited, Ewart remarked sarcastically, 'You place them, of course, before persons who are distinguished in war?' Shee answered lamely that the Academy followed society.[20] Perhaps this reply summed it up from a Radical's viewpoint. Considering this conversation, one realizes how horrified Shee must have been by Haydon's idea of substituting compositions for the military, naval, clerical, and civil portraits in public buildings.

The Radicals, by conviction opposed to any institution which flattered the Establishment, were only too willing to listen to Haydon, so when Ewart's motion 'on the means of extending a knowledge of the Arts and Principles of Design' was put down in Parliament, an enquiry into the Academy was also proposed.

STATE INTERVENTION 1835

In 1835 the Government intervened in art education for the first time. A Select Committee on Arts and their Connection with Manufactures was appointed by Parliament on the motion of William Ewart, M.P. for Liverpool, 'to enquire into the best means of extending a knowledge of the Arts and Principles of Design among the people (especially the manufacturing population) of the country, and also to enquire into the constitution of the Royal Academy and the effects produced by it'.

In July 1835 the Committee began its first series of hearings on Arts and Manufactures under its chairman Mr Ewart. Those called to give evidence included two men concerned with public art education, Dr Waagen, Director of the Royal Gallery, Berlin, and James Skene, secretary to the Board of Trustees for the Encouragement of Manufactures in Scotland, which ran an academy in Edinburgh for artists and artisans. Also called were two architects, several Royal Academicians, several merchants concerned variously with textiles, metalwork, dress, jewellery, porcelain, and other decorative trades, and lastly some ornamental sculptors and decorators.

Practically all the witnesses agreed that French manufactures were far superior to British in design. Let us listen to the merchants talking about designs for manufactures: 'We import them exclusively from France.' . . . 'I have never found a good designer in England.' . . . 'In metallic manufactures the French are vastly superior to us in their

designs.' . . . 'The arts extend lower down society in France.' One prominent merchant, Mr Howell, admitted that he kept fifty-year-old French patterns for manufacturers to copy.[21]

The principal art witness called was the German, Dr Waagen, and this seems strange as it was the superiority of French design which worried the merchant witnesses. Indeed one of them, Mr Butt, said that the Germans 'are inferior to the French in design, as inferior as we are, or more so'. Even in the next session of the Committee the foreign witness was a German. The reason for this aberration was that Poulett Thomson and the officials of the Board of Trade were determined to establish the first Schools of Design as industrial schools based on the German *gewerbeschulen* rather than on the more successful French schools, which had a fine arts section, and which Haydon admired.

The merchants pointed out to the Committee that there was no point in paying an original designer in Britain; because there was no copyright as in France, any British design could be copied immediately. The safest course was to buy new French designs or copy old ones, hence the low standard of design in Britain.

The first session of the Committee closed on 4 September, but for Haydon there was no recess. Four days later he gave his first public lecture. It was in the London Mechanics' Institute, on the need for reform in English art. Haydon did not realize his talent for passionate oratory until the end of this first lecture, when Dr Birkbeck enthused: 'You have got 'em: it is a hit!'[22] (Haydon's palette still hangs in Birkbeck College, University of London.) Full of confidence, Haydon was now prepared to lecture in the provinces upon the need for Schools of Design.

In February 1836 the second session of the Committee commenced, and heard evidence at much greater length on European art education, on the Royal Academy, and on galleries and museums. Sir Martin Arthur Shee, P.R.A., and other Academicians were called and critically examined by Ewart. The session finished in August, and the final recommendations of the Committee were that a Normal School of Design should be established in London, that provincial schools should be assisted by grants, that museums and galleries should be formed, and that sculpture and painting should be used to embellish public buildings. These recommendations were obviously framed by Ewart, and the last one was a particular delight to Haydon. On his birthday in January of the following year he wrote in his diary:

'I find after thirty-three years' struggle . . . the Academy completely exposed . . . a School of Design begun; and I more than hope the House of Lords will be adorned with pictures.'[23]

Haydon in his childish enthusiasm had not given much thought as to whom the Government had given the executive power. Once the recommendations had been made it was the Board of Trade which got down to the business in the person of Poulett Thomson, the President. Thomson (afterwards Lord Sydenham), M.P. for Manchester, had proposed and obtained a grant of £1,500 from Parliament 'with great difficulty' to commence the School of Design, and this capable adminis- trator was keen to spend the money on a highly practical design school. Knowing little of art education, he considered that artists given the official title of R.A. would be most fit to plan the school in conjunction with the officials of the Board.

NO ART FOR THE ARTISAN

The first creative act of the Board of Trade, following the Select Com- mittee, was to form a governing body for the proposed school. Poulett Thomson invited twenty persons 'distinguished in art and manufactures' to be members of a council, and the first meeting was convened at the Board of Trade on 19 December 1836 with Thomson in the chair. The membership of the Council of the School of Design was divided into three categories, artists, manufacturers, and amateurs, and a permanent chair- man, Lord Colborne, was appointed. Public art education was to be controlled by this body until 1848. The Council was not only empowered to govern the central School of Design, but was also to administer the total Government grant for art education.

The artist members appointed by Poulett Thomson, a blue Whig very different in outlook from Haydon's Radical friends, were Academi- cians. Three of the most senior, Sir David Wilkie, Sir Augustus Wall Callcott, and Sir Francis Chantrey, were almost exclusively occupied with their professional commissions and did not have much interest in the new project (in fact, Chantrey actually denigrated its possibilities); but another member, Charles Cockerell, was an expert on architectural ornament, interested in forming a school for ornamentists.

Charles Robert Cockerell (1788–1863) had conducted several excavations of Greek temples and had sent many valuable fragments of Greek ornament back to the British Museum. He specialized in drawing reconstructions of Greek buildings and exact reproductions of the Classical Orders, and his views, as Professor of Architecture at the R.A. Schools, had great impact. Measured drawings of the Greek Orders became a prominent part of British architectural training and remained so in British schools of architecture until the nineteen-forties. Cockerell (whose buildings include the Taylor Institution, Oxford; the Fitzwilliam Museum, Cambridge; and the Banks of England at Manchester, Liverpool and Bristol) was worried about the lack of masons and

plasterers who could draw, understand drawings, or model. He envisaged the proposed school as a convenient source of supply, and during his ten years on the Council he tried to ensure that the pupils at the Schools of Design were occupied in copying Classical and Renaissance ornament.

William Etty, R.A., best-known artist on the Council, a distinguished painter of the nude, was the only artist member who favoured an art training for the artisan which included life drawing, but he was content when a School of Design in his native York, with a curriculum to his taste, was given a Council grant, and he did not interfere much with the London school.

Ewart naturally refused to serve on a council with the Academicians, who, he believed, did not wish to raise a new class of designers to the status of professional artists. The ambitious aims of Ewart and Haydon were disregarded and the new school seemed to be doomed to resemble the existing classes in ornamental drawing at Mechanics' Institutes. Ewart kept Haydon informed of developments, telling him that the artistic appointments to the Council of the School were exclusively Academicians, and that the principal of these, Chantrey, had ruined its prospects. Haydon recorded in his diary that a close acquaintance, the sculptor George Rennie, also told him: 'The Council has resolved that the *Figure* should not be the basis of education; 2nd that every Student who entered the school of design should be obliged to *sign a declaration* not to practise either as Historical! – Portrait Painter! – or Landscape Painter!'

By these negative stipulations Chantrey had ensured that there would be no rival institutions to the Academy Schools. Haydon was so incensed with this end to all his endeavours that he immediately wrote a letter of complaint to the Prime Minister. He also approached Poulett Thomson and asked him to his face if the Council had resolved the figure was not necessary. Thomson replied contemptuously, 'And is it, to fellows who design screens?' Obviously there was little hope of raising a class of artist-designers, as existed in France, if this was to be the evaluation of a designer.

The Academicians on the Council admired the composition and style of past works but they had little idea of the fundamentals of design. Chantrey boasted that in thirty years of art he had not learnt one principle. To the Academicians, design for industry was the lowest branch of ornament, even below the hand crafts. They were even worried that the future students might attempt ambitious designing, and the Council later laid down that the new School of Design was not 'a school for every kind of design, but for one kind only viz. ornamental'.[25]

The Council, with this object in view, appointed an architect, John Buonarotti Papworth, as Director of the School, to carry out a narrow policy of drawing and modelling ornament. Papworth believed that artisans should neither be shown High Art nor be allowed to study the live figure, lest 'young men might be tempted to leave the intended object to pursue that which is more accredited and honoured'.[26] The Academicians had found a director to their taste, and Papworth was asked if he would be so kind as to visit the new school on two days a week to consult his staff. There was now little chance of art for the artisans.

Sources

1. *Old and New London* Cassell, Petter, and Galpin, London, *c.* 1880 (p. 69)
2. HAYDON, B. R. *Autobiography* Edited Taylor, Tom (1853) Peter Davies, London, third edition with introduction by Aldous Huxley, 1926 (Vol II, p. 525)
3. CECIL, DAVID *Lord M.* Constable, London, 1954 (pp. 88–90)
4. Ibid. (p. 81)
5. HAYDON, B. R. *Autobiography* Peter Davies, London, 1926 (Vol. II, p. 572)
6. LESLIE, C. R., and TAYLOR, T. *Life and Times of Sir Joshua Reynolds* John Murray, London, 1865 (Vol. I, p. 299)
7. HODGSON, J. E., and EATON, F. A. *The Royal Academy and its Members* John Murray, London, 1905 (p. 11); and MOLLOY, F. *Sir Joshua and his Circle* Hutchinson, London, 1906 (p. 228)
8. CLEMENT, C., and HUTTON, L. *Artists of the Nineteenth Century* Trubner, London, 1879 (p. lix)
9. *Sessional Papers, 1849* Select Committee on the School of Design (p. 256)
10. GOTCH, J. A. *The Growth and Work of the R.I.B.A.* R.I.B.A., London, 1934 (p. 3)
11. *Sessional Papers, 1836* Select Committee on Arts and Principles of Design (p. 87)
12. EDWARDS, R., and RAMSEY, L. G. G. *The Regency Period 1810–1830* Connoisseur, London, 1958 (p. 56)
13. *Sessional Papers, 1836* Select Committee on Arts and Principles of Design (ibid.)
14. *Birmingham Institutions* Cornish Bros., Birmingham, 1911 (p. 275)
15. LESLIE, GEORGE D. *The Inner Life of the R. A.* John Murray, London, 1914 (pp. 272–3)
16. FINBERG, A. J. *The Life of J. M. W. Turner, R.A.* Oxford University Press, 1961
17. *Sessional Papers, 1836* Select Committee on Arts and Principles of Design (p. 90)
18. Ibid.

19. HODGSON, J. E., and EATON, F. A. *The Royal Academy and its Members* John Murray, London, 1905 (p. 341)
20. *Sessional Papers, 1836* Select Committee on Arts and Principles of Design (p. 157)
21. *Sessional Papers, 1835* Select Committee on Arts and Manufactures (pp. 22–40)
22. HAYDON, B. R. *Autobiography* Peter Davies, London, 1926 (Vol. II, p. 591)
23. Ibid. (Vol. II, p. 622)
24. Ibid. (Vol. II, p. 622); and HAYDON, B. R. *The Diary of Benjamin Robert Haydon* Edited Pope, Willard Bissell Harvard University Press, Cambridge, Mass., 1963 (Vol. IV, p. 396)
25. *Sessional Papers, 1849* Select Committee on the School of Design (Minute of 1843 Council meeting quoted)
26. *Sessional Papers, 1835* Select Committee on Arts and Manufactures (p. 93)

4

The Schools of Design

THE NORMAL SCHOOL OF DESIGN

When institutions for higher education were established in the early nineteenth century, it was not the practice to provide new buildings for them. The R.A. Schools, the Mechanics' Institutes and the Schools of Design were moved from one set of rooms to another in the course of years, and it was not until the last quarter of the century that such institutions were normally provided with their own buildings.

In 1837 the Board of Trade established the Normal School of Design in Somerset House, Aldwych, in the set of rooms 'on the right hand side of the main entrance from the Strand'.[1] These rooms had been vacated by the Royal Academy in the previous year, when the Academy was granted rooms in the National Gallery, Trafalgar Square. The staff of the new school was officially appointed on 3 May 1837, and consisted of the Director, J. B. Papworth, the headmaster, Mr Lambellette, the head of the Morning School, Henry Spratt, and the modelling and drawing master, James Leigh.[2] These gentlemen were the first teachers in Britain to be salaried out of public funds. John Buonarotti Papworth (1775–1847) had become famous in the Regency period as a Picturesque architect and interior designer, and had published books of designs for *cottages ornés*, conservatories and summer houses. He is remembered today for his work at Cheltenham, which included planning the Montpellier estate and Pump Room. James Mathews Leigh (1808–60), a pupil of William Etty, exhibited at the R.A. from 1825 to 1849, and, after his resignation from the School in 1843, ran his own successful art school at 79 Newman Street (later known as Heatherly's Art School).

The Normal School officially opened on 1 June with the daily Morning School from 10 a.m. until 4 p.m., but it made a very poor start. No enthusiasm came from the public, and the number of youths in the Morning School never rose above seventeen for the rest of the year. It should be mentioned that these pupils were aged from twelve upwards, and perhaps this is a good point in the narrative to define the main categories of male students who used the facilities at the Schools of Design throughout their existence.

In the Morning School there were first of all the apprentices in

73

architecture and in many crafts and manufactures, voluntarily released by employers, and usually in their early teens. Secondly there was a large proportion of boys who, in spite of the regulations, hoped to become artists and designers, some even aspiring to entry into the R.A. Schools. To circumvent the regulations the latter were classified as 'occupation undetermined'.[3]

When the more popular Evening School was started later, with a minimum age of fifteen years, the proportion of craft apprentices was greater, and the proportion of youths intending to be artists and designers much smaller. The occupation from which the largest number of pupils was drawn, in both the Morning and Evening Schools, in the early years of the Normal School, was that of interior decorator, officially classed as Arabesque (or Ornamental) Painter or Decorator.

One of the reasons for poor enrolment in the early days of the School was that the pupils had not only to provide their own drawing boards and 'other requisite materials', but also a morning fee of four shillings per week, part of which contributed to the salaries of the staff. Desperate to keep attendance up, the Council allowed youths to start in the School on any day during the school year, providing they had paid fees for that month.[4]

There was not, during Papworth's directorship, the strong emphasis on geometric Elementary Drawing which followed later, and the pupils were allowed to draw outlines of architectural ornament, such as scrolls and vases 'from the Flat' (from diagrams, books, and French lithographs) in the elementary section of the course. They then proceeded quickly to outline drawing and shading from plaster casts of ancient ornament such as acanthus leaves. These 'guides to successful imitation' were then drawn or modelled as repeated motifs for wallpaper patterns or plasterwork. By this copying the Council hoped that the pupils would commit to memory a multiplicity of historic motifs, so that they could combine them anew and spawn mongrel designs, the theory being that the more historical ornaments they knew 'the greater the number of combinations effected'.[5] To a modern student of psychology this constant bombardment of design symbols upon the cortex might seem a weird variation of Clark L. Hull's theory of increments to a habit strength. Unfortunately the conflicting nature of the symbols, and fatigue, no doubt extinguished the student's reaction potential.

The atmosphere in the School was that of a classroom. On entry the pupils went straight to their places with their drawing boards and paper, and then sat in rows behind the stands upon which their boards rested, while the master handed out diagrams of patterns or ornament on cards, or in books, so that they could copy 'from the Flat'. If a pupil was advanced enough to draw 'from the Round', a cast of ornament or an

actual ornament, say a vase, was placed on the stand in front of him. The pupils were not allowed to talk, nor to move about, nor to touch any casts, so even their concept of the Round was Flat.[6]

This pathetic situation did not escape the attention of Haydon, who took some delight in writing to Poulett Thomson on 28 February 1838: * 'My Dear Sir, I yesterday visited your Government School of Design. Oh! Mr Thomson, what an exhibition! Nine poor boys drawing paltry patterns – no figures, no beautiful forms! And this is the School of Design the Government of Great Britain has founded in its capital!'[7] There were few pupils indeed in the Morning School. Employers were not enthusiastic about day release, since they could see no difference between the work of this class and the current evening classes in Ornamental Drawing, which had existed for years in Mechanics' Institutes. Herbert and Richardson, who later joined the staff, agreed that under Papworth it was a mere drawing school.

In August 1837 the Evening School was introduced at Somerset House from 6.30 to 9 p.m., and the number of students on the roll doubled, but even this compared badly with the roll of drawing students at any Mechanics' Institute. The Academicians on the Council had set out to restrict the course at Somerset House to prevent the pupils acquiring any High Art, even resolving 'that drawing from the human figure should not be taught to students',[8] and the restrictions were succeeding too well. Poulett Thomson, with Ewart breathing down his neck, began to have doubts. The manufacturers were showing no interest in the school. The Government grant of £1,500 seemed to have been expended by the Council on setting up a school for a handful of interior decorators, and Thomson and Ewart, both Lancashire M.P.s, knew full well that the financial loss to Britain from buying French designs was ten times as great in the textile trades as in the remaining trades put together. To make matters worse, rumours of nepotism reached the public from Somerset House. One Papworth junior was appointed secretary to the Council, and one of the design prizes of the School was won by another young Papworth. This 'gave rise to considerable discontent in the School', especially as it was said that his entry was largely the work of one of the staff, dare we say Papa Papworth?[9]

The Board of Trade eagerly awaited the report of Mr Dyce of Edinburgh, whom the Council had sent to study the schools of design in France and Germany.

* The date given for this letter in Haydon's *Correspondence and Table Talk* (London, 1876) is 28 January 1837. This is not possible: the School of Design was not opened at this date. An entry in Haydon's diary covering 26, 27, and 28 February 1838 refers both to this visit to the School, and to the letter to Thomson.

THE TRUSTEES' ACADEMY

The first institution to be set up in Britain with the intention of teaching drawing to artisans was the Trustees' Academy in Edinburgh, established by the Board of Trustees for the Encouragement of Manufactures. The Academy opened its morning class in 1760 'from 10 till 12 in the forenoon, these being supposed the least likely to interfere with the time of workmen'. The first two masters, Delacour and Pavillon, were French fine artists who taught 'the merest rudiments of the art of drawing, such as were required by house-painters, pattern-makers, and others of that class'.[10] The students were limited to twenty and instructed free.

A succession of indifferent masters followed Pavillon, one of whom submitted another person's drawings to obtain the mastership, but in 1798 John Graham was appointed, an outstanding art teacher who banished the casts of ornament from the school, replaced them with classical casts of the figure, and rapidly turned the institution into a highly successful fine arts academy. Sir David Wilkie, Sir William Allan, and Sir J. W. Gordon were among his star pupils. Mr Skene, the secretary of the Trustees, remarked in 1835 that 'there is not an eminent name in the history of art in Scotland' who had not been educated there.[11] When David Wilkie was enrolled, his father consoled himself with the fact that his son had a mechanical turn of mind, and the drawing would help him in industry. He little dreamt that the fine art training there would enable his bairn eventually to become Sir David Wilkie, R.A. Some of the Trustees regarded such developments as a misuse of the Government fund they administered, because many Scotsmen were more keen to encourage 'useful art' for manufactures.

In no city was education more discussed at this time than in Edinburgh. The Scots were deeply interested in modern scientific and practical subjects as opposed to the exclusively classical education of the English grammar schools and universities, and from 1809 onwards numerous articles had appeared in that liberal mouthpiece, the *Edinburgh Review*, stressing the need for a wider, more practical approach, and attacking the contemporary preoccupation with the classics. A lively tradition of non-classical education had already been initiated in eighteenth-century Scotland, largely due to an enlightened Nonconformist middle class. John Anderson (1726–96) and George Birkbeck (1776–1841) had given impetus to scientific and technical education by teaching pure science and mechanics to Glasgow artisans, and the success of their pupils, together with the news of the teaching experiments of Fellenberg and Pestalozzi, inspired Scotsmen to further the cause of a more practical education by writing in the *Review*.

There were two distinct concepts of education in technical subjects at

this time: the progressive concept of these modern subjects as a branch of liberal education as important as the classics and the fine arts, and the illiberal concept of these subjects as merely useful for a functional vocational training for the less intelligent classes to fit them for their occupations. Anderson, Birkbeck, and many enlightened Scotsmen believed in the liberal concept and succeeded in raising many Scottish artisans to the status of professional engineers, but other Scotsmen, such as William Dyce, envisaged a strictly ordered Christian society in which every person should be trained only for that class of society in which he was predestined by God to serve. The latter were very eager to take the narrow view of methods practised at Hofwyl by Philipp von Fellenburg.

Fellenburg's institution provided a lower school for the children of labourers in which they received a very practical training consisting mostly of agriculture and nature study, an intermediate school for farmers' sons with some scientific and technical training, and an upper school for educating the upper class boys for their hereditary role in society. An article in the *Edinburgh Review* noted approvingly that the peasant children in the lower school 'never see a newspaper and scarcely a book . . . [and] are taught, viva voce, a few matters of fact, and rules of common application. The rest of their education consists in inculcating habits of industry, frugality, veracity, docility etc.'[12]

Those Scotsmen who interpreted Fellenburg's system as a training for future pursuits became disturbed as more and more of the students of the Trustees' Academy aspired to a fine art career, above their approved occupations; and in 1837 the Trustees appointed William Dyce, a young Edinburgh portrait painter with convictions about industrial art, to be master of the Academy. The Trustees also appointed Charles Heath Wilson, the son of the former master of the Academy, Andrew Wilson, to be master of a class for the study of ornament and design. Dyce and Wilson set out their ideas for improving the Academy in their *Letter to Lord Meadowbank and the Committee of the Honourable Board of Trustees for the Encouragement of Arts and Manufactures, on the best means of ameliorating the arts and manufactures of Scotland in point of taste*. This pamphlet was to prove of great importance. Its text convinced the Council of the Schools of Design in London that Dyce was the man they sought, a very practical Scot and a liberal educationist. Events were to prove him neither.

William Dyce (1806–64) had worked in Rome and had come under the influence of the hard, precise, German Nazarene painters, who worked and lived together like a mediaeval guild in the Franciscan monastery of Sant' Isidoro there, under the leadership of Johann Friedrich Overbeck. These Nazarenes objected to intellectual principles,

humanist influences, and emotional qualities in art, believing that, if these distractions were avoided in a picture, the residue would be purely religious. Overbeck, writing of art, or, as he called it, 'the tabernacle of art', in the terminology of religious dogma, stated that: 'Michael Angelo set up the antique as an object of idolatry, and Raphael was tempted to taste the forbidden fruit, and so the sin of apostasy in fine arts became manifest.' 'Certain it is that he looked on colour as something carnal,' wrote J. B. Atkinson, his biographer.[13]

Some authorities class Dyce as an early Pre-Raphaelite because of his dislike for the Renaissance and his meticulous style, yet Dyce was a narrow, High-Church Nazarene, very different from the poetic, romantic and turbulent Brotherhood, who startled the Royal Academy with new techniques and strange, brilliant colours. Even Hunt, the most meticulous painter of the Brotherhood, attacked the Nazarenes and disowned Dyce, saying that he 'produced the effect of a daguerreotype'. Dyce was certainly greatly affected by the Nazarenes and regarded art as severe and precise craftsmanship, in fact a science. He saw himself as a skilled practitioner who could inspire a workshop of hardworking artisans. Drawing from the nude or Renaissance casts (the forbidden fruit), intellectual principles, and all fine art he regarded as disturbing for them.

Dyce probably wrote the greater part of the letter to Mr Maconochie Wellwood ('Lord Meadowbank'); certainly he wrote the suggestion that the Trustees' Academy should become a workshop for producing patterns for manufacturers, and the advice that distinct reference should be made to the students' ultimate employment, to prevent an unprofitable course of study and 'to guard against an ambition, extremely foolish in very many cases, of ranking among the students of fine art, which complete access to the means of study often gives rise to'. The contribution of Wilson, who had spent his whole youth in Italy, probably included, as he later claimed, the passages about secondary artists in Italy rising to be heads of schools. Dyce would certainly not have encouraged any artisan to rise to the position of fine artist. He would have kept every one of them to the 'execution of designs entrusted to them', as the letter put it.[14]

The members of the Council of the Normal School in London were so impressed, when they had digested the views expressed in the letter, copies of which had been forwarded by the Trustees, that they proposed that Dyce should be sent to Europe to report on art education.

THE FRENCH AND GERMAN SCHOOLS

When Dyce arrived in France in September 1837 he found himself in a country with some eighty recognized schools of art under the super-

vision of the Ministry of Public Instruction and Fine Arts. Museums, galleries, palaces, and highly decorated churches of many periods were open for long hours with free admission, and the municipal buildings were furnished with works of art. The townsman's environment in Britain provided a wretched contrast; as Sir John Summerson has written, 'The Government buildings and academies of the peoples of the Continent were a reproach.'[15]

The school which had the highest reputation in Europe for producing designers was the Académie des Beaux Arts de Lyon. The academy had six departments, Painting, Sculpture, Architecture, Ornament, Engraving, and Botany, the last having a botanical garden provided for it by the municipality. In the department of ornament the students learnt *mise en carte* – the method of drawing out a pattern or preparing a model for industrial production.[16] Despite the fact that the students were nearly all the sons of factory workers selected by the mayor, they considered themselves as 'artists in the highest sense of the word'. The distinction between High and Low Art was not maintained as in Britain; in fact, the students did not decide whether to enter the fine arts departments or the ornament department until they had completed a basic course of drawing and painting. Life drawing was an important part of the course, and the life class was open every evening.[17] The other large French school which dealt with design was the École Gratuite de Paris, and it had a similar system.

Dyce found the schools in Germany more to his liking. In Prussia they were not under an educational body as in France, but were trade schools under the Privy Councillor of Finance. There were four of these schools (at Breslau, Königsberg, Danzig, and Cologne), called *gewerbeschulen*, and a central principal school at Berlin, the Gewerbe Institut, to which the best pupils were forwarded. Instruction was free; it included mathematics and physics, and was not so much education in art as in the actual 'manufactures with which art is concerned'. The students could increase their technical knowledge by reference to the museums of the Institut, the museum of industrial inventions, or the museum of models 'of the most remarkable monuments of antiquity and the middle ages'.[18]

The Bavarians ran the system most favoured by Dyce. All the primary schools had classes for outline drawing of geometrical shapes and simple elements of ornament, the same type of drawing which Dyce was later to introduce generally in Britain through his *Drawing Book*. At this stage 'embellishment' such as tone and colour were prohibited. Perspective was also taught. These primary design classes were optional and when the pupils who had studied in them left, they could choose one of the thirty secondary *gewerbeschulen* which existed in Bavaria for training artisan designers. In the *gewerbeschulen* the pupils learnt French, history,

geography, natural philosophy, and chemistry, and continued to draw in severe outline until they were sufficiently accurate 'to design architecture very correctly' and to model with precision. Those pupils who were considered sufficiently intelligent were then admitted to one of the three Bavarian Polytechnics, where they could pursue engineering, architecture, water theory, forestry, mining, and languages. At this level the design taught had little to do with art; it consisted of scientific information concerned with design as applied to the technical subjects listed above and to local industry, and practical instruction on industrial methods of production in the school *werkstatt* or 'apartment for the practical study of industry'. At Augsburg the emphasis was on the local industry of calico printing, at Nuremberg on metal casting, and at Munich, the capital, on stained glass, metalwork and wood-carving. This was all very technical; indeed, Baron von Klenze told the Select Committee of 1836 that it was a scientific education that designers received in Bavaria, and he admitted that the Polytechnics lacked co-operation between artist and artisan.[19]

Dyce, himself a graduate scientist, was delighted with the Bavarian system. It corresponded with his own conviction that design is science, and can be learnt scientifically, starting from simple geometrical outlines and ending with complicated technical facts about engineering, colour, fabrics, and so on. However, in spite of the technical system of the Bavarians, it was acknowledged throughout Europe that the standard of their design, apart from that of their traditional handicrafts, was far lower than the standard of the French, who stressed the art influence. Dyce knew this, and also realized that France was the greatest exporter of designs, but he ended his Report in a typically devious manner by stating that the nations which did most for art education did not always earn the greatest profits from exports. He returned to England determined to import the German system.

DYCE ATTEMPTS THE GEWERBESCHULE SYSTEM, 1838–43

Shortly after his return from France and Germany, Dyce presented an abstract of his Report to the Board of Trade, and the final draft was submitted in April 1838. The Board was deeply impressed, but before use could be made of Dyce, the services of the Papworths had to be dispensed with. Thus in June the directorship of the Normal School was abolished, and in July the secretaryship. Dyce was then appointed Superintendent and Professor of the School. The Report of his tour was published for Parliament in 1840.

When Dyce took up his appointment on 31 July 1838, one of his first tasks was to raise the number of pupils in the School, as there were only nineteen pupils in the Morning School and twenty-seven in the Evening

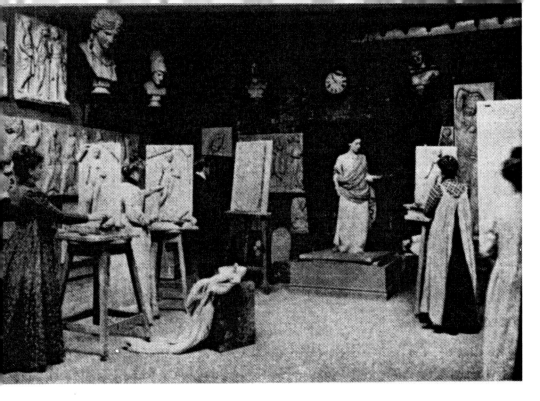

The objects of Benjamin Haydon achieved:

6. Relief modelling from the nude: Manchester (*c*. 1900)—model draped for photograph

7. Drawing and painting from the nude: Liverpool (*c*. 1925)

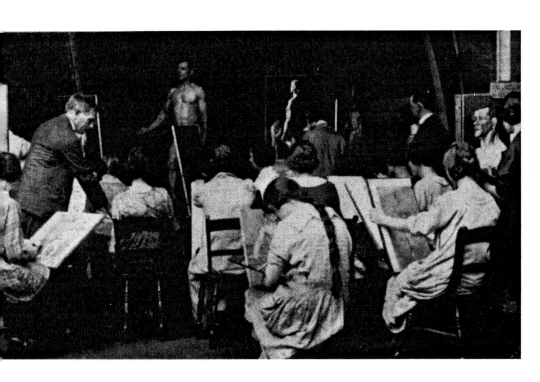

8. The North London School of Drawing and Modelling, Camden Town

School, a ludicrous position for a national school of design.[20] There were several reasons for the small attendance. Firstly, the classes at Somerset House did not even provide the range of instruction available at the London Mechanics' Institute. Secondly, the fees were very high for Victorian artisans, being sixteen shillings per month for morning pupils and four shillings per month for evening pupils. A third circumstance threatened to make the School obsolete.

Earlier in the year, while Papworth was Director, Haydon, Ewart, Hume and Thomas Wyse had set up a rival institution in the former house of Sir Isaac Newton in St Martin's Street, Leicester Square. This venture, the Society for Promoting Practical Design, provided lectures in anatomy, design, and colour, and classes for drawing from the antique and from 'a fine female model' introduced by Haydon.

The artisans flocked to this life class and the Council became very perplexed. In pursuit of the policy that the Normal School must not produce artists, an 'express minute of the Council prohibiting the study of the human figure' had been passed, but now, as a result of this and of the School's practice of merely copying ornament, the artisans sought some fine art influence for their work elsewhere. Unpleasant as it seemed, there was only one solution, and on 10 August 1838, at the first Council meeting attended by Dyce as Superintendent, it was resolved that 'the human figure for the purpose of ornament be taught in the school', and as a counter-attraction to St Martin's Street both a male and a female model were employed.[21]

The Superintendent Professor then attempted the difficult task of transforming Somerset House into a *gewerbeschule* with a *werkstatt*. In December a Monsieur Trenel was appointed to visit the School twice a week to give lessons in weaving and the application of patterns to ruled paper. Within a year, to Dyce's mortification, Trenel's class had to be discontinued, and the Jacquard loom, which the Council had purchased, ceased to operate. The young artisans had studiously avoided the *werkstatt*. Those who were already in the textile industries knew looms and patterns well enough, and those who were not had no interest in them. The largest class ever found in Dyce's *werkstatt* numbered six.

The total number of students in the School under Dyce in 1838 and 1839 never rose above the maximum attendance of seventy-nine achieved under Papworth, so the Council in 1839 reduced the morning fee to a quarter of the current one, and the evening fee to one-half, with the result that in 1840 the number of pupils gradually increased.

Dyce organized the School into seven classes in 'the order of study pursued in the German Schools, by which the drawing of the figure is made subsequent to a course of ornamental design'. This was contrary to the French system, which was to learn to draw and paint freely from

nature and the live model before proceeding to study ornament or one of the fine arts.

The seven stages or classes at Somerset House were so planned that there was little fine art influence. The pupils had to work for a probationary period of three months in Class VII, copying outlines, first drawing straight lines with a hard lead pencil, then bisecting and trisecting them with more straight lines. After rubbing out innumerable lines and achieving lines straight enough to satisfy the drawing master, pupils were allowed to copy geometric figures and curves on grids. In the next stage, Class VI, they learnt how to shade objects by copying diagrams of shaded cubes, cylinders, spheres and cones in chalk. Class V consisted of modelling from casts of ornament, fruit, flowers, and shells.

Drawing 'from the Round' was permitted in Class IV, and the pupils drew from casts of ornament and natural forms, as above. Colour was introduced in Class III, and the pupils copied from coloured drawings and from fruit and flowers in elementary colours. Youths who progressed as far as Class II were first allowed to copy elementary outlines of the human figure 'from the Flat', as in the fourth number of the Government *Drawing Book*, and then to draw from casts of the figure, that is, 'from the Round'.

The final stage, Class I, consisted of 'instruction in the history, principles and practice of Ornamental Design, and its application to the various processes of manufacture, including the study of oil, tempera, fresco, encaustic and wax painting and the practice of various branches of decorative art'. This last stage sounds rather grand, but very little instruction or lectures were given. The various grids for the repetition of fabric and wall paper patterns were copied from the second number of the *Drawing Book*, and then flowers, roots, corals, shells, mosses, birds, feathers, or shapes derived from historic ornament were copied on to these grids in chalk or body colour, and repeated as in block printing.

Drawing from the nude was not included in this general course, and Dyce, who had been forced to establish a class of the living model by external circumstances, insisted that life drawing was 'not to be entered upon unless the future prospect of the student needs it'.[22] These 'prospects' were limited to crafts in which the nude figure frequently occurred, such as arabesque painting, wall paper printing, and metal work. By the rules of the School each student had to state during his first three months probationary period to what ornamental manufacture or decorative art he intended to apply his studies. Thus Dyce attempted to ensure the limitation of life drawing; however, the pressure from the pupils was such that, from July 1841 when the Council appointed John Rogers Herbert, A.R.A., to be Master of Figure, numbers in the life class swelled and the School itself became much more popular.

THE FIRST TEACHER-TRAINING CLASSES IN ART

One useful by-product of Dyce's insistence that the artisan needed a special vocational art training was the establishment in Somerset House of the first class specifically intended for art teachers. This class was set up in 1841 when six exhibitions worth thirty pounds per annum were awarded to advanced pupils. The awards were renewable if their work proved satisfactory each year.

This Normal Class practised teaching on the younger students in the School, and was intended to produce teachers of ornamental drawing to replace in a few years the older type of academic drawing master, but unfortunately this new provision broke down very quickly, because the supply was ludicrously small to fill the demand from the provincial Schools of Design which began to spring up in the early forties. The exhibitioners were offered posts in their first year in the Class.

This first Normal Class included five notable students – George Wallis, later master at Spitalfields, then head at Manchester, then at Birmingham, and finally Keeper at the South Kensington Museum; George Lambert, first head at York; Richard Norbury, first director of the art classes at the Liverpool Institute; Henry Durrant, first head at Sheffield; and George Thompson, first head at Nottingham. Lambert and Norbury were the first to go, at the end of their first year, and Wallis, Thompson, and Durrant took up their appointments in January 1843, half-way through their second year, so a second class had to be formed.

This second Normal Class, formed in May 1843, consisted of Silas Rice, later assistant at Manchester, then head at the Potteries for fifteen years; William Denby, later master at Somerset House, then at Marlborough House, and finally at South Kensington; Kingsford Lane, later assistant at Somerset House; Adam E. Findon, later assistant at Manchester; and James Kyd, later assistant at Birmingham, then second master at Manchester, and finally head at Worcester.

Of the exhibitioners from both classes, Lambert died of typhus in his first year at York, Durrant was dismissed from Sheffield after one session, Thompson resigned at Nottingham after his second session and so did George Wallis at Manchester. Denby and Kingsford Lane stayed on at Somerset House, the latter being taken on the staff as he had been rendered lame in an accident. The remainder was the total permanent contribution of the Normal Class to the improvement of the designing skill of the provincial artisans.[23]

Because of this acute shortage of teachers the Council of the School deemed it expedient from then on to encourage any likely prospective teacher of ornamental drawing to attend the advanced classes in Somerset House for a brief period, often merely a few months, and then

to go forth to teach in the provincial Schools. The management of the Head School,* who were expending £10,000 a year from Government funds, did not seem to regard teacher training as an important priority at this time.

Dyce was in a difficult position. His endeavours to produce teachers of ornamental drawing to check the fine art influences in the provincial Schools seemed doomed to failure. As early as 1840 the first of these institutions, the Manchester School, had applied for an annual grant from the Council, and Dyce had discovered to his dismay that it was in reality a thriving school of fine art.

THE FIRST PROVINCIAL SCHOOL OF DESIGN

While Dyce had been touring the Continent assimilating German and French design training, Benjamin Haydon was touring Britain expounding the merits of an art education for artisans. He dined with wealthy manufacturers and lectured to mechanics, speeding by rail from city to city by means of what he called 'the supreme rapidity of steam'.

Haydon fired his audiences with enthusiasm for art and for the setting up of provincial schools with the figure as the basis of study, maintaining that the human figure is the supreme work of design and form. He stressed that, after following a freehand course which included life drawing, some artisans could choose to be designers, others to be painters or sculptors. He told the mechanics:

> 'The Government is determined to prevent you from acquiring knowledge. You might become artists but you will be denied the power to advance yourselves . . . the method employed by Mr Dyce, a follower of the dry, hard, Gothic German school, is based on the German gewerbeschule, whereas my proposals are based on the practice of the school at Lyons – and which do you think is best, German design or French?'

Haydon journeyed from one institute to another and drove home 'the naked truth', as he called it, using a live nude as a visual aid.[24] His tours included Edinburgh, Glasgow, Newcastle, Liverpool, Leeds, Bradford, Sheffield, Hull, Birmingham, Leicester, Bath and Oxford, but it was at Manchester that he met with his first great success in the provinces.

Although the Select Committee of 1835–36 had intended to encourage the establishment of provincial Schools of Design, it was six years before the first of them received official recognition, when, on 16 March 1842,

* The institution at Somerset House was referred to as 'the Head School' during the forties to distinguish it from the provincial schools.

John Bell, Master at Manchester, was placed on the official list of paid appointments at Somerset House. Haydon had delivered a series of lectures on painting in the Manchester Mechanics' Institute in 1837, and later dined with eight Manchester gentlemen, including the banker philanthropist James Heywood and some ladies, 'one with a fine head'. Haydon urged the necessity of a school and the banker asserted that 'it was astonishing how it would get on if men had shares bearing interest, not but what I prefer donations'.

On 19 February 1838 a first 'meeting of gentlemen favourable to the establishment of a School of Design' was held in the theatre of the Royal Manchester Institution (now the City Art Gallery). Heywood invited Haydon and a report was ready by a provisional committee for the School.[25] Haydon arrived back in London, 'having accomplished all I left town to do – the establishment of a School of Design in Manchester'.

The necessary donations and yearly subscriptions raised, the Manchester School was established in two cellars in the basement of the Institution on 3 October 1838. Recently the head porter of the Art Gallery was kind enough to allow me down into these cellars. I asked if he could open the door from Nicholas Street, which had been the entrance to the School, and walked down the steps and round the old rooms. One could imagine the tired young men descending into these cellars at 7 p.m., after the long Victorian working day, and then setting to work for two hours. One small cellar provided a painting studio for the Master; just opposite, across the corridor, is the larger room in which some thirty students worked each night. There are some half-windows at pavement level, but the studios must have depended on gas lighting.

Into these low cellars stepped the first Master, John Zephaniah Bell of the Bells of Blacket, portrait painter to Queen Maria of Portugal, pupil of Baron Gros of Paris, a High Artist in every sense of the word. Bell had been assistant painter to Haydon's friend, Sir David Wilkie, and his appointment was undoubtedly supported by Haydon.

Under Bell's guidance the Manchester School of Design rapidly developed into an art school with a bias towards life drawing, for Bell 'argued that by the study of the Human Figure the way was made easy for other paths'. By 1840 there were courses in ornamental drawing, flower drawing, figure drawing, modelling, pattern drawing for calico printing and fancy weaving. Lectures were given on painting, sculpture, anatomy, zoology, and botany, some of these occasionally given by Haydon, 'the Socrates of Art', as one pupil called him. A small museum of casts, models, paintings, designs, and mechanical inventions was collected, and a library was formed including books of engravings. The

students also made visits to the Zoological Gardens at Higher Broughton to draw the animals.[26]

The honorary secretary of the School was an enlightened manager of a decorating business, George Jackson, who had previously given a series of lectures at the Manchester Mechanics' Institute on the need for the School, and who was largely responsible for interesting the philanthropists who backed the school financially. Jackson had a great deal to do with organizing the curriculum, which for those days was a very broad one. He tried to break down the barriers between the training of a designer and a fine artist. 'If,' he stated, 'there was not the distinction between High Art and Ornamental Art, we should get a better standard.' Neither did he believe in extensive copying of the ornament of the Ancients. 'Nature was their teacher, why not ours?' he asked the Manchester mechanics.[27]

Both Bell and Jackson opposed Dyce's concept of a narrow vocational training for a particular branch of ornament, but Bell was too inclined to fine art for Jackson's liking: all the senior students seemed to be turning to a career in art, not design. Bell soon provided these students with a room of their own in which they executed chalk drawings of the living model using the 'stump'. The final achievement was to be allowed to paint from the Master's private model for two hours every morning in the summer. The three prizes the Master awarded were for life drawing, plant drawing, and drawing of architectural ornament.

Paradoxically the manufacturers on the council of the Manchester School, especially the art-loving philanthropists Edmund Potter and James Thomson, were not in favour of a vocational school. They were proud of their art school, agreed with Bell rather than Jackson, and thought that a fine art influence was what the artisans in calico printing needed. Jackson was in a difficult position, and he resigned. He said that he did not object to the figure, but could not agree with putting 'the figure first'.

DYCE INSPECTS THE MANCHESTER SCHOOL

The Council of the Manchester School had applied for a grant from the Board of Trade as early as 1840, but it was not until the spring of 1842 that the Board promised an annual grant of £150, provided that a like amount was raised in Manchester.

This method of financing the Provincial Schools of Design followed the contemporary practice of financing the building of elementary schools by local voluntary efforts. The first grant of public funds for education had been made in 1833, and it had been stipulated that, if an area required a new school, the Government would grant half the cost of the building provided the other half was raised locally. In the case of elementary

schools the voluntary contributions came from the religious bodies which ran them, but the funds for Mechanics' Institutes and Schools of Design had to come from the donations and annual subscriptions of local philanthropists, and from students' fees. In 1839 the Committee of Council for Education had decided that public funds should not be granted without 'the right of inspection'. The Board of Trade followed this precedent, and in January 1843, shortly after it was agreed that the Manchester School should receive an annual grant, Dyce was sent north to Manchester to inspect the School.

Bell had already felt the wind of change: his opponents on the Council of the Manchester School had just succeeded in closing his morning life class. Bell's private model had been found in a state of distress (as described in Chapter 8), and 'advantage was taken of the circumstance to abolish that class'. A class for drawing casts of ornament was substituted for the life class, and 'a small collection of ornaments in plaster was purchased' to bring the curriculum nearer to Dyce's at Somerset House.

The senior students would have none of it, and followed the example of the London students who had left Somerset House to attend Haydon's life classes. They set up a morning life class in a Mr Benson's attic studio in King Street and formed a society called 'The Roman Bricks', which lasted for twenty-two years. Haydon commended the Manchester students with enthusiasm, commenting, 'This is going on like early Christians.'

Bell received his next blow when Dyce had the laws for a Government-supported School of Design sent to him, which stated that 'no person making Art his profession should be eligible for admission as a student'.[28] Dyce then visited the School in person and argued with Bell, urging the introduction of geometric outlines, drawing books and pattern grids. He objected to Bell's system because it was producing 'good draughts-men in the artistical sense'. However, it was Dyce's turn for a shock when he interviewed the manufacturers. They argued that the freehand drawing and fine art influence, which Bell provided, improved the skill and taste of the artisans, whereas they were competent enough at pattern making and weaving; and 'a considerable number of subscribers to the school threatened to withdraw support if pattern designing was introduced'. Dyce complained later that the manufacturers were greatly opposed to him. He returned to London and, to give his directions official status, he drew up a letter of detailed instructions and handed it to the Secretary of the Board of Trade, Shaw Lefevre, to sign and send to Mr Winstanley, secretary of the Manchester School.

Bell now found it impossible to continue with his curriculum. The Government grant had been bestowed directly on the Council of the

Normal School, and the grants for provincial schools were dependent on the Council's approval.

At this juncture, by a strange paradox, Dyce resigned because he had been requested by some of the Council to spend more of his time directing the Normal School. Charles Heath Wilson, his former colleague in Scotland and a fanatical historicist, took over. To cap the confusion Dyce took up the less arduous task of Inspector of Provincial Schools of Design, with the result that the masters of the new provincial schools which were springing up became very inhibited about their ascribed roles, and began to develop the anxiety neuroses of Pavlov's dogs. Dyce, the advocate of a modern pattern workshop, inspected them, but Wilson, the devotee of ancient and Renaissance art, directed and appointed them.

The last straw, as far as Bell was concerned, was applied in October, when a decorator brought a large canvas into the advanced students' room to execute a wall pattern. The Master objected and the decorator complained to some influential citizens, and to Mr Jackson. He received some support, so Bell resigned on 7 November 1843.

Bell had succeeded from his own point of view. Before interference from London the numbers in the School had risen steadily, from 36 pupils in 1839 to 98 in 1841; all this was achieved without any Government aid such as Dyce had, and, unlike Dyce, Bell had managed to keep his mature students. In addition to pattern designers and craftsmen, who formed the bulk of the student body, there were seventeen artists, five architects and two teachers who were regular attenders. Several of his students of humble origins became well-known artists in later life, including the future president of the Manchester Academy, Robert Crozier, the son of a saddler. Bell quit Manchester with a light heart, having completed in his cellar studio two large cartoons which had just won him £200 in the national competition for the murals for the new Houses of Parliament. On the strength of his newly-won reputation he set up a private academy in London.[29]

THE POMPEIAN DIRECTORSHIP, 1843–47
'Indeed it looked a good deal more like a large Pompeian bath
than an English School of Design.'[10]
John Rogers Herbert

On 2 May 1843 Charles Heath Wilson, Superintendent of the Department of Ornamental Art at the Trustees' Academy at Edinburgh, was appointed Director and Headmaster at Somerset House, and was thus given greater power and a larger salary than either of his predecessors. He was also empowered to direct the provincial schools.

An extreme historicist, even by Victorian standards, Wilson's ambition was to turn the Schools of Design into museums where the students could execute exact copies of historic ornament. In order to achieve this, the Director had first to communicate the historic emphasis to the masters of the Schools, and then to form a large collection of casts and drawings of ancient ornament. He began therefore by preparing a syllabus of lectures on 'Historic Principles and Styles of Ornamental Art' for all Schools of Design, and dispatched tracers to Pompeii to reproduce ancient Roman wall decorations, full size and in full colour. Cast after cast was purchased out of the Government grant, until poor Deverell the secretary complained: 'They are heaped together round the gallery. . . . [There is] want of sufficient space to . . . place them upon the walls.' Deverell, an extremely conscientious clerk, who usually worked a twelve-hour day in Somerset House, found it quite impossible to catalogue them, as many were physically inaccessible.

The Director attempted to obliterate all vestiges of Dyce's influence. His task was not easy, for not only were the Director's own staff admirers of Dyce, but also many of the provincial masters were his former pupils and their drawing lessons were biassed towards the needs of various trades. Wilson thought this vulgar. His 'system was never to allow a young man to study for his business as he said the school was a High Art school'.[31] Carpentry students were not shown how to design in wood, but made to draw Renaissance figures in outline from engravings, while upholsterers were required to paint arabesques. Wilson denigrated any attempt to create original designs with reference to utility; an artist would merely return to savagery by being original. The British student could only hope to improve, in Wilson's opinion, by the exact imitation of Roman and Italian ornaments, and by arranging the motifs, thus learnt, into new combinations. Figure drawing for designing should be learnt primarily by copying the graceful outlines of Greek and Roman works, from engraved copies and from the cast.

Frederic Shields, the famous illustrator of Defoe's *Journal of the Plague Year*, described how he, a student at this time, drew Greek outlines from flat copies at Somerset House. He considered this 'of inestimable value to him at that time', but actually Shields, though a great natural draughtsman, was a poor judge of where his own greatness lay. During his time at Somerset House he acquired his first admiration for the academic finished drawing and High Art which eventually stifled his brilliant direct drawing and produced the inferior cast-like drawings of his frescoes in the Chapel of the Ascension, Bayswater.[32]

Wilson's belief in a very exacting standard of imitation caused him to insist that many advanced pupils were put back to Elementary Drawing. The evening master in geometrical and architectural drawing, C. J.

Richardson, complained that an architecture student had been kept for some months 'shadowing a ball' in the elementary section of the Figure Class and that he was not permitted to leave that class and study architectural details, so he left in despair. The great majority of the pupils were similarly confined to Elementary Drawing, precisely what had been taught 'in many schools in London for fifty years conducted by drawing masters'.[33]

The Director's attitude to Dyce's former staff and students led to a permanent state of unrest at Somerset House. Leigh, the modelling and drawing master, resigned in the first few months of his directorship, and Mr Spratt, the head of the Morning School, escaped to Sheffield School of Design where he was grateful to accept a mastership with a lower salary. John Rogers Herbert, A.R.A., the last remaining member of Dyce's staff, was a different proposition. The Master of Figure and a friend of the Pugin family, he held opposite views to Wilson and believed that attack was the best defence. On occasion he advised art students not to study in Rome, for, Herbert said, the young artist 'may get honey from the flowers, but is more likely to get poison than honey'. There could be no peace in Wilson's establishment while this Gothic viper talked about Italian ornament as if it was something the Borgias had dreamt up.[34]

WALLIS, PIONEER OF EDUCATION IN DESIGN

Being well on the way to turning Somerset House into a cast museum, Wilson turned his attention to the provinces to ensure that the curricula of all provincial Schools of Design were evenly divided between copying outlines of the Figure and copying Ornament. In pursuit of this aim, he began to transfer staff from one School to another without prior consultations with the councils or committees of the Schools. This was possible because from 1842 the provincial masters were salaried by the Council of the Head School in London.

During his second year of office the Director was astounded to discover that the new Master at Manchester had actually started a Design Class in a School of Design; moreover, he was attracting adults to the School by his exciting methods. The attendance doubled and grateful manufacturers were awarding prizes. Wilson gathered that these methods were nothing to do with copying engravings and casts of historic ornament and determined to quash the new development immediately.

George Wallis (1811–91), Master at Manchester, and later head at Birmingham, was a product of the first Normal Class for art masters. Master at Spitalfields School of Design at the time when Bell resigned at Manchester in disagreement with Dyce, Wallis wrote to the former

secretary George Jackson and informed him that he was in agreement with Dyce's programme, and on 5 December 1843 he was appointed Master at Manchester.

Wallis was the first head of a British School of Design to consider his task was one of education, for although Wallis had trained under Dyce his approach was more liberal, as can be gathered from the fact that he referred to himself as an artist educator. During his year at Spitalfields, Wallis had the advantage of teaching artisans from the local silk industry, and became convinced that Dyce's view that artisans should merely be learning to make the patterns necessary for their future pursuits was not enough.

At Manchester Wallis's first steps were to reduce the time spent on Elementary Drawing and to introduce a Design Class. He gave a Wednesday evening lecture on the principles of design and organized a demonstration theatre. It was here that he demonstrated a principle and then asked his students to produce an original design based on the same principle for the following Wednesday. These original designs had to be for specific purposes, such as chair backs, calico, or wall decorations, and were pinned up, discussed, defended, and criticized. Wallis said that each student became an instructor, not only of himself, but of the class. Thus seminars in design were begun in Manchester in 1844. In these seminars Wallis always praised originality and fitness for purpose. He admitted that it was useful to study historic design, but he maintained that 'nature is the only true source of originality'.

Little wonder that the Director and the Royal Academicians on the Council were upset about Wallis's stress on originality. Tracers were busy in Pompeii, and Sir Richard Westmacott, George Richmond, and Ambrose Poynter, recently appointed to the Council, had recommended that a Mr Ludwig Gruner should produce an expensive series of volumes full of copies of ancient and foreign ornament entitled *A Book of Ornamental Design for the Purposes of Decoration and Manufacture*, which volumes, in the opinion of Sir Henry Cole, contained copies of existing copies of Roman copies of copies of Greek originals, and badly drawn at that.

The Manchester School was going from strength to strength and Wallis received continual applications from the manufacturers for apprentices. Progressive methods were paramount. Students were encouraged to use various media, and, instead of drawing in hard outline in Dyce's manner, or rubbing and polishing to produce an academic style to Wilson's taste, they used ink, crayon, chalk, and brush, and modelled in clay. Wallis particularly objected to tedious rubbing with the 'stump'. 'The stump,' wrote Wallis, 'is injurious to the youthful student . . . the point of a crayon is better.'

Wallis never allowed an exact copy. If a student insisted on doing a copy, it had to be drawn larger, and he was taken off flat copies immediately he had learnt to manipulate his chosen medium. 'By this means,' wrote Wallis, 'he forms a mode of treatment of his own, and never falls into "manner", which is the bane of the Schools and Academies.'[35] This was directly contrary to Wilson's ruling that students should 'draw from engravings of the antique – we can desire no better models.'

To add injury to these insults Wallis organized a design course in a School of Design. His course included original design projects with criticisms, comparison of generic arts with origins in nature, drawing plants from life, constructive study of the human figure and comparative anatomy of animals, and demonstrations of the general principles of art.

Wallis had moved far from the practices in the Pompeian halls of Somerset House, so, a clash being inevitable, he crossed the Rubicon and submitted a complete outline of his course to the Council of the Manchester School. Meanwhile, the Director was mustering his forces in the capital, his first move being to consult the newly-appointed Inspector of Provincial Schools, Ambrose Poynter.

THE FIRST INSPECTORS OF ART

Having decided that the Government grant for a provincial School must be dependent upon conforming with the course at Somerset House, the Council were faced with the problem of implementing this decision. At first it was deemed sufficient to send Dyce, the Superintendent-Professor, on a few trips to the new schools springing up in Haydon's footsteps. Spitalfields received a grant in 1841, Manchester and York in 1842, and Nottingham, Sheffield, Coventry, Birmingham and Newcastle in 1843. The Committee of Council on Education had been faced in 1839 with a somewhat similar problem of determining 'in what manner the grants should be distributed', and had appointed the first H.M. Inspectors. The Board of Trade followed precedent, and appointed a Government art inspector.

The first inspector of art was appointed on 30 May 1843, when William Dyce was made Inspector of Provincial Schools of Design, straight after his resignation from his professorship at Somerset House. Dyce could do little in his new post owing to his disagreement with the policy of historicism at Somerset House; in any case, he was too busy painting religious subjects for submission to the Royal Academy, in consideration of which he was to be elected A.R.A. in the following year. In that year (1844) he was appointed Professor of Fine Arts of King's College, London University; in June 1845, just when the controversy between his pupil Wallis and Director Wilson was coming to a head, he resigned.

Dyce was succeeded by Ambrose Poynter, the Official Referee of
Metropolitan Buildings. Both Dyce and Poynter had better-paid occupa-
tions than their inspectorship and it was not taken very seriously. The
few Schools of Design that existed were rarely visited by them, and
there was no particular plan behind their visitations. It was remarked,
for example, that Poynter and a member of the Council arrived without
notice in a provincial school, and the local committee were unable to
answer their summons; so the visitors 'looked over the school for half
an hour or so, and then they left!'[36]

The appointment of Poynter, and later of Stafford Northcote (both
officers of the Board of Trade), to the inspectorship was the beginning of
a campaign by the Board to wrest control from the Royal Academicians
and fellow historicists. The reader may wonder how such a fanatical
historicist as Wilson had sufficient backing to browbeat local com-
mittees, but in actual fact his policy of copying Classical and Renaissance
ornament was so favoured by some of the Council, that even when the
results of this policy wrecked the provincial Schools, and the outcry from
them and from the press forced his resignation, the Council saw to it that
he was still guaranteed the largest income of any art teacher in Britain.
The most influential members of the Council in 1845, when Wilson
launched his attack on Wallis, were Canova's pupil Sir Richard West-
macott, R.A., who 'helped largely to further encumber our cathedrals
with pseudo-classical monuments' of Pitt, Fox, and Captain Cook; and
Charles R. Cockerell, the Classical architect and archaeologist. These
were later joined by George Richmond who 'stood at the very head of
genteel water colour painters'. None knew much about industry or
industrial design, nor had they any conception of what Wallis was
trying to do; indeed, as the *Journal of Design* commented, 'It would be a
cruelty indeed to place these artists in the midst of Alderman Copeland's
Pottery at Stoke, or Messrs Thomsons' Printing-works at Clitheroe, or
the Coalbrookdale Iron-works ... they would think china was not pottery,
and would hardly know whether metals were to be *carved* or *chased*!'

Ambrose Poynter, the new inspector, was more to Wilson's liking
than Dyce had been. Poynter, the father of a future president of the
Royal Academy, was first and foremost a civil servant, agreeing with
everybody and consistently sailing before the wind. His sympathies lay
with High Art, but he was always conscious that his employment was
with the Board of Trade. 'Mr Poynter's only *forté* has been always to be
on *every* side in *every* dispute,' commented the *Journal of Design*.[37]

THE RESIGNATION OF THE ARTIST EDUCATOR

The first action Wilson took against the Manchester School was to send
written instructions in August 1845 calculated to abolish the Design

Course and the wider approach to drawing which was developing in the School. He instructed Wallis to see that the students did a longer elementary drawing course based on rigorous copying of engraved outlines, and demanded at least two hours a week on copying Ornament and two on copying outlines of the Figure. To Wilson's surprise, some of the Council of the School backed Wallis and he ignored the Director's instructions. Even after the summer vacation there had been no change, so Wilson asked Poynter to go and discuss the matter with the Council at Manchester.

Poynter arrived in Manchester in early October, but, sensing the way the Manchester wind blew, he did not argue Wilson's views strongly; and when George Jackson, who was now secretary again, drew up a document in accord with Poynter's inspection report tolerating the Manchester policy, Poynter seemed in agreement with him, and merely made one amendment to the paper.

George Wallis was well satisfied with the result of the inspector's meeting with the Council, especially as Poynter had 'expressed his satisfaction' in a minute, but the Mancunians did not know the civil servant they were dealing with. They were naturally staggered when, shortly afterwards, a final demand arrived from Somerset House stating that if the School did not conform immediately its grant would be withdrawn. The Council at Manchester gave way. The support of Wallis had not been unanimous; in fact, two of the chief benefactors of the School, J. Thomson and E. Potter, backed Wilson's course, which they thought was closer to the fine art course they desired than Wallis's. Wallis resigned, and in later years Poynter was accused of betraying the Manchester School. All the senior students left and the numbers dropped disastrously. There was soon a deficit in the School's funds and some two years later Poynter, after Wilson's fall from grace, stated in a report that the Manchester School had been rendered useless.

During Wallis's progressive mastership there were prizes for designs for calico, wool-muslin, furniture, fabrics, murals, and stained glass, most of which were given by manufacturers, and the book prizes were on design and craft subjects. In the years immediately after his departure, a few young ladies were given novels for drawing and painting and some boys received the bound *Lectures of Royal Academicians*, flattering to those on the central Council, but rather pointless for aspiring calico designers.

A Mr Sitzenick was appointed at Manchester as a temporary expedient, while waiting to take up the mastership at Paisley. By February 1846 a man had been found with a suitable reverence for High Art and ancient ornament: Henry Johnstone, trained in Paris and Munich. Johnstone was appointed to the post of headmaster, the old title of

master now being dropped by the Council in London, and a few weeks later Wilson forwarded a student teacher from the Normal Class to join him as second master. This master, Silas Rice, had the honour of having painted some ornamental panels on a royal pavilion.

Wilson made a special journey to Manchester to be present at the introductory address given by the new headmaster, and it was arranged that this justification of Wilson's policy would be printed. Johnstone assured his audience that he would be guided by 'the highest authorities in Art', meaning perhaps the Academicians on the Council, and he indirectly condemned the spirit of originality which had arisen in the Manchester School by saying that if 'each man had been left to his own ingenuity', Art would have been in the same state as that of the savage nations. The best means of teaching was to place before students exact imitations of Art, and the sooner that Schools of Design became 'museums of Art', the better.[38]

Wilson then rose and informed the students of his schemes for the School. The tracers at Pompeii were to provide 'accurate elevations of entire edifices . . . so that we shall bring to your habitations the walls of Pompeii'. It is rather difficult to imagine anything more bizarre than these elevations hanging on the walls of the dim catacombs which still exist under Manchester Art Gallery. Wilson was armed with a set of coloured imitations of Italian church ornament, and an extra grant of £100 for the School, thus manifesting the great benefits of conforming with Somerset House.

Henry Johnstone spent exactly one year trying to attract pupils for Elementary Drawing and the imitation of ornament. He quit the art world on 2 March 1847, his last recorded words on the subject showing that 'his view of life having undergone a change, he had decided to relinquish the pursuit of Art as a profession'. Actually he took up the pursuit of money in a French business house.

The Council in London next appointed the son of a Royal Academician, a Mr D. Davies Cooper, who, according to the *Art Union* 'does not pretend to know anything about Art decorative or ornamental'. Like Johnstone, Cooper walked in the shadow of Wallis and was not supported. The School became bankrupt and Cooper, who was described as 'useless', was dismissed. Wilson had certainly stirred up a hornet's nest by forcing Wallis's resignation. Wallis himself was not deterred from art as a career. He first set up a school of his own in Manchester, but being offered the post of superintendent of the design department in a large Manchester factory, he seized the chance to put his ideas into practice. From 1851 to 1857 he was to distinguish himself as headmaster of the Birmingham School of Design, and ended his career at South Kensington.

THE FORTY-FIVE REBELLION

While Wilson was ensuring that the provincial Schools conformed with the course at Somerset House, his own establishment was being torn by dissension. The trouble originated from the mature students who studied the figure from casts and life in the evening under John Rogers Herbert.

Herbert, the Master of Figure, was a popular eccentric who attracted the older students. He displayed open contempt for Wilson as an artist and teacher and for Roman and Renaissance ornament, and his figure students began to do likewise. The Director was harassed by this hostile faction into making a show of authority. He removed casts (without informing Herbert) while students were working on them, and arranged them around the School as if it was a museum. This merely annoyed the students further, and their vexation turned to mockery when Wilson erected the huge casts of Lorenzo Ghiberti's Baptistry gates as actual gates 'in an absurd manner'.[39] The Director had a particular reverence for these gates. His father had set up a similar pair in the Trustees' sculpture gallery at the Edinburgh Institution a quarter of a century earlier. Parental inspiration undoubtedly motivated Wilson, for, just as he wished to bring the very walls of Pompeii to the Manchester pupils, and an Italian environment to his London charges, so Andrew Wilson, years before, had asked David Scott, R.S.A., to paint a copy of Michelangelo's 'Last Judgment' on the ceiling of the Trustees' Academy.

In the spring of 1845 the standard of revolt was raised by a gathering in the Cast Room. Wilson had ordered both the gas lighting and heating to be extinguished in Herbert's evening painting class, and on another occasion had set up a draped lay figure, which all but two of the students refused to draw. Action was taken against these students and the Director put up a notice drawing attention to their dereliction. Next, according to Sir George Clerk, Vice-President of the Board of Trade, 'an unseemly altercation took place in the class room, Mr Herbert appealing to the students against the character of Mr Wilson. It was then found necessary, in order to preserve discipline, to suspend the class.'[40]

Six weeks after the incident Haydon was in full possession of the facts and sent in this vivid account, which appeared in *The Times* on 14 May under the pseudonym 'Alpha'.

'The Figure-master, more enthusiastic than discreet, felt indignant at an order put up in his schools which appeared to him to reflect on the conduct of his scholars; angry words took place before the scholars; the Decorative-master called the Figure-master into his room, angry words again went on, the Figure-master elegantly called the Decorative-master "a snob", and the Decorative-master

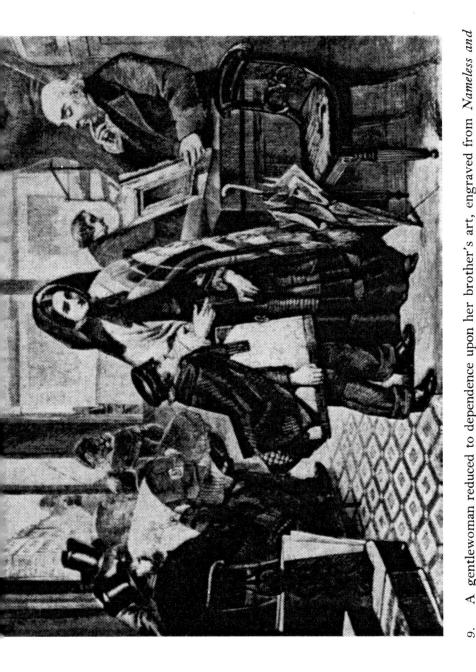

9. A gentlewoman reduced to dependence upon her brother's art, engraved from *Nameless and Friendless* by Emily Mary Osborn (1834–84)

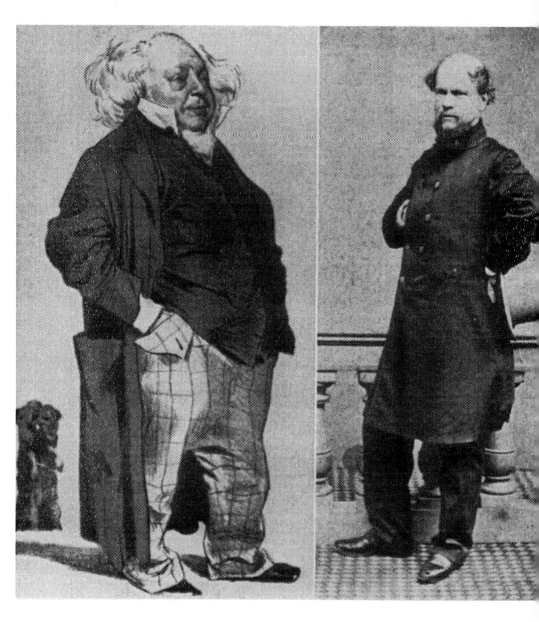

10. *Left:* Sir Henry Cole, K.C.B. (1808–82)
 By courtesy of 'Vanity Fair'

11. *Right:* George Wallis (1811–91)
 Victoria and Albert Museum, Crown copyright

still more elegantly called the Figure-master "a liar and a scoundrel".

Tantaene animis, etc. *

Luckily, neither master having the organ of combativeness very largely developed, separated, bowing, and swearing vengeance before the Council – a very pretty way of occupying precious time, spending public money, and advancing the refinement of the mechanic.'

Haydon's account of this interview in the office must have originated from Herbert. He was not acquainted with Wilson. The insults exchanged are interesting. Herbert was of the bright younger generation at the Royal Academy who regarded the dilettanti, the Rome-loving R.A.s on the Council, and their protégé Wilson as art 'snobs'. To the conservative Wilson, Herbert was near to 'a liar and a scoundrel', or at least dishonest. For example, Herbert had cultivated broken English with a French accent to amuse his colleagues and students, though he could speak no French. Charles Landseer remarked that he had 'tumbled down whilst at Boulogne and broken his English', and later added, when Herbert sailed for the Middle East, 'he will return speaking Gum Arabic'.[41] On top of this the man was a papist, a Roman Catholic friend of Pugin, the arch-enemy of the decadent ornament taught at Somerset House. In Herbert's opinion the taste for ornament in Britain was so bad that special bad designs were prepared in France 'to suit the taste of this country'. However, in spite of Herbert's contempt for all the ornament Wilson held dear, the Director's immediate motivation for calling the Figure-master a liar was probably because Herbert had suggested that he did not draw ornament on the blackboard or lecture to the students about it, as he was incapable of doing either.

After the closure of their class by Wilson, the students formed their own evening life class at 18 Maddox Street, where Mr Dickinson conducted day classes for ladies. The students drew up letters and forwarded them to the Board of Trade and various periodicals, complaining of the Director's incompetency, his conduct, and of being made to study Arabesque and Pompeian 'absurdities'. The Council then interviewed the rebels, but confirmed Wilson's suspension of thirty-five students. The ensuing clamour in the press, especially in *The Builder*, caused Ewart to raise the matter in Parliament on 27 July, but to the relief of the Board of Trade the matter was shelved the following day.

Herbert was expected to resign tactfully after the closure of his class,

* *Tantaene animis caelestibus irae?* – Are there such violent passions in heavenly minds? (Virgil, *Aeneid* I, 11).

but declined to do so. The members of the Council were averse to the dismissal of a member of the Royal Academy, so they just went ahead and appointed J. C. Horsley in his place. Actually it was rather strange that Herbert stayed so long under Wilson, for he was such a restless character that Landseer gave his home address as 'Crocker's furniture van'.[42] He did eventually return to the School as head of the Class of Ornament in 1848 after Wilson's downfall, and one of his first requests was that Richard Burchett, the most prominent rebel student of the '45, should join him as one of his staff. Another chief rebel, R. Herman, was appointed to the School in the following year.

John Callcott Horsley (1817–1903), who was appointed the new Master of Figure on 1 July 1845, could be relied upon to deter students keen to paint the living nude as a path to a fine art career. A painter of Dutch-style interiors, he later became known as 'Old Clothes Horsley', because of his campaign against nude pictures at the R.A., and he prudishly used the Latin *in puris naturalibus* for 'in the nude'. The students in his class were set to do hard metallic outline drawings from the cast or draped figure finished with deep shading.

The rebellion having been put down there was 'a sumptuous dinner at the Strand Hotel' for the Pompeian party. Some of the masters and selected students, 'the latter being from the upper classes only', entertained Wilson and some of the Council with suitable obeisances. The *Art Union*, which at this time backed Wilson, reported that there was a 'rivalry between masters' at this dinner to show the greatest respect for and confidence in the Director. Henry Townsend, the evening master for Ornamental Drawing said that 'it was impossible to speak too highly of the Council', and two students of the ornamental party were particularly effusive.[43] These two, Mackenzie and Woods, were rewarded with prizes for their work in the annual exhibition at Somerset House, Mackenzie for a vase 'intended to exhibit a combination of porcelain, ormolu, and costly gems', Woods for an intricate cabinet library showing Victoria's and Albert's heads supported by Neptune and Amphitrite in the true Pompeian manner, on top of which was a cabinet for curiosities, and in which were crimson silk ventilating panels 'for the prevention of mildew'. This last touch, showing the outlook of a curator, must have gone straight to Wilson's heart.

The Director's difficulties seemed to be over, but there were still suggestions in the press that none of his staff had any practical experience of carrying out the Roman and Renaissance art in vogue at Somerset House. To Wilson's relief a brilliant young artist, completely trained in Italy, had arrived in London, an artist capable of painting a fine amorino on a loggia pillar in a mere half-hour. This virtuoso was summoned post-haste to Somerset House.

ALFRED STEVENS

The artist called for interview was Alfred Stevens (1818–75), the great draughtsman, sculptor and industrial designer, who was then practically unknown. Wilson determined to use his gifts as widely as possible and Stevens wrote on 26 August 1845: 'I was sent for the other day to Somerset House and offered a place in the School of Design as Professor of Everything . . . The truth is they have been so lately lashed by the press as incompetent that they tremble for their places and are very happy to find one knowing a little of what they ought to understand themselves.'[44]

Stevens was appointed morning master for architectural drawing, perspective, modelling, and ornamental painting on 7 October, and on the same day C. J. Richardson, the noted Elizabethan-revival architect and furniture designer was appointed evening master. The bold, brilliant drawings and models of the new morning master inspired the students, but they were puzzled by his plentiful 'unfinished' works. Used to hatching and polishing within hard outlines they could not understand his swift searching studies in chalk, or his bold modelling. One student, viewing one of Steven's 'unfinished' clay models, knowingly bet another, 'Ten to one he will never finish it and will break it up.'[45] Stevens, although his designs were generally in the Renaissance style, did not believe in slavish copying, but rather in searching and constructive study of the design of natural forms in the tradition of Michelangelo and Leonardo. Art education should be based on sound intelligent drawing, not on copying outlines or rough sketching. He informed one student, 'Sir, we don't sketch here; we draw.'

Stevens was not happy at Somerset House. He undoubtedly realized that the staff, who were trembling for their places, as he put it, were utterly inferior to him as artists, even more so as designers, as were also the Royal Academicians connected with the School. He disagreed with the Council's concept of High and Low Art, and liked to quote Michelangelo: 'I know but one Art.' He was of artisan origin and was not consulted on policy in spite of being 'Professor of Everything'; in fact, the various Select Committees mentioned in this book seemed hardly aware of his existence. Stevens, Florence-trained, preferred Wilson's methods to the rigid mechanical methods of his Gothic opponents who followed Dyce, but he could not respect the Director as an artist. He resigned on 10 November 1847, and wrote: 'I have just given up my place at Somerset House – not before I was heartily sick of it.'[46]

The artist's connection with the Schools of Design did not entirely end with his departure from Somerset House. Later, when he was designing metal plate in Sheffield, he became a close friend of Young Mitchell, the master of Sheffield School of Design, and the students there

benefited from his instruction, two of them later working with him on his Wellington monument for St Paul's. Steven's fine portrait of the dying Mrs Mitchell and her child is in the Tate. Three of the artist's pupils distinguished themselves – Beavis, Sykes, and Baker, the first as a water colourist, the second as a designer at South Kensington, and the third as the founder of the School of Art at Dunfermline and teacher at Stirling.

The resignation of Stevens deprived Somerset House of the only teacher with the technical and practical ability for industrial art, in fact the only competent designer, with the exception of Papworth and Richardson, that the School ever possessed. Be that as it may, back at the time of Stevens's engagement Wilson and the Council felt reasonably happy. They had acquired an Italian-trained designer to fight the Anglo-German influence of Herbert and Dyce.

THE DISSOLUTION OF THE DIRECTORSHIP AND COUNCIL 1847

The Victorian public paid great respect to the authorities, and Wilson, backed by the Royal Academicians of the Council and the middle-class students remaining in the School, must have felt quite secure. The Director was at first strongly backed by the editor of the *Art Union*, Samuel Carter Hall, whose journal devoted pages to the work of R.A.s and to the most hideous examples of Victorian ornament. During the '45 rebellion this periodical stated that Mr Wilson 'is the son of a highly respectable gentleman, an excellent artist of Edinburgh' and that he had been 'brought up to Art from the cradle – residing for some years in Italy'. When Herbert was 'resigned', the magazine backed Wilson again, stating that the loss would be 'more irreparable if he went'. The students' complaints were reported as childish ignorance.[47]

However, in the autumn of 1846, when the first rumours of a Council investigation reached the ears of Hall, his staff began to enquire more thoughtfully, and the *Art Union* quickly changed sides. A reporter visited the annual exhibition in Somerset House and complained it contained nothing more than elementary drawings. He also wondered why there was no observation of living nature. Hall next discovered that the Annual Report for 1846 was being withheld and concluded that an adverse report was in abeyance. By the next annual exhibition the *Art Union* no longer put forward the view that Wilson's loss would be 'irreparable', but reported 'total incapacity', stating that even the prize exhibits, one of which was 'hideously ugly', were bad.

The official investigation of the School resulted from the Master's letters of complaint about the directorship. In the autumn of 1846 Townsend and Richardson wrote directly to the Council, and Richard Redgrave, A.R.A., a temporary member of staff, wrote an open letter to

the Prime Minister, Lord John Russell. The Council responded by nominating a Special Committee to investigate their complaints. The Committee, which sat at intervals from December 1846 to April 1847, revealed not only Wilson's incapacity as a teacher and the rebellious cabal on his staff, but also the incapacity of the Council itself to impose any order; in October the Board of Trade took over control by appointing a new governing body called the Committee of Management, all the members of which were officers of the Board except two artists, Westmacott and Richmond. The Council with its categories of artists, manufacturers, amateurs, and officials was now deprived of power and in April 1848 my lords of the Board of Trade were 'therefore pleased to dissolve that body'.[48]

The immediate object was to quieten the whole business down; the Government was heavily in debt and had expended some £100,000 on the Schools of Design. Melbourne's cry of 'God help the Minister that meddles with Art!' seemed to be justified. J. Shaw Lefevre, late secretary of the Board, was made secretary of the new Committee, and the *Journal of Design* reported: 'Then there is Mr J. S. Lefevre . . . Commissioner for managing Church revenues in two capacities, Commissioner for investigating the British Museum, Commissioner for settling the Scotch Annuity Tax, in short, Commissioner for every thing which needs to be coaxed into quietude . . .'[49] The first requisite for quietude was the removal of Wilson to conciliate the manufacturers and the staff of the Schools of Design, and this was done before the dissolution of the Council, shortly after two officers of the Board, Stafford Northcote and G. R. Porter, had been appointed to that body for the purpose.

The dismissal of the Director had to be gentle to prevent any further trouble, so on 3 November 1847 the Council requested 'that in future Mr Wilson should confine his attention to the branch schools'. He was instructed to report all his proceedings direct to the Board of Trade and to cease his duties at Somerset House. The historicist made one last attempt to realize his dreams and begged to take charge of the new Class of Ornament and be provided with a museum, but the Board of Trade was determined to be rid of him without offending the distinguished R.A.s, such as Cockerell and Westmacott, so in the words of Henry Cole, the Council 'screened an inefficient officer', and Wilson was appointed Director of Provincial Branch Schools. At a meeting on 8 January 1848 the Council mentioned to Wilson the need for practical lectures in the provincial Schools, and cruelly stressed 'invention and originality'. He was also requested to 'conciliate the manufacturers'. Poor Wilson had little chance of placating his chief enemies, the provincial staffs and their committees. Lectures at Sheffield and Birmingham were attempted, since to speak at the School he had bankrupted at Manchester was out of the

question. Sheffield, in Yorkshire fashion, bluntly refused to permit his lecture, and the Birmingham authorities recorded: 'No lecture here, as the committee prefer that the master should lecture and no one else.'[50]

The management at Glasgow did, however, permit Wilson to inspect the School of Design, and he presented such a bad report of the School, which was actually thriving far better than the English Schools of Design, that the head, Mr McManus, and his assistant Robertson were dismissed. The post was then offered to Wilson himself and he accepted. Having been robbed of his museum at Somerset House, Wilson now took joy in increasing the large collection of casts in the Glasgow School of Design, arranging them in chronological order with appropriate inscriptions. A large number of students were returned to Elementary Drawing under Mr Dessume, who was ordered to enforce a rigorous standard of imitation. The ex-pupils of McManus drew up a memorial for his return, but to no avail; Wilson kept his position in Glasgow for fifteen years, until he was 'retired' by Henry Cole and returned to Italy, where he died (in Florence, his spiritual home).

There was a comic sequel to Wilson's appointment at Glasgow. The Scots, upset by the abrupt nature of the correspondence from the Committee in London, which ordered the dismissal of McManus and Robertson, had discovered to their delight that the Board of Trade had promised to make up Wilson's salary to the £400 a year he had received as Director, so these canny gentlemen deducted £100 a year which they had contributed to the salary of his predecessor, thus discomfiting the naïve Sassenachs.

Ambrose Poynter, the inspector who had been instrumental in carrying Wilson's campaign to the provincial Schools, did not fall from grace; on the contrary, he was one of the few members of the Council who managed to obtain a place on the new Committee of Management. He had adroitly changed sides when Wilson fell into trouble, taking the side of the manufacturers and criticizing the provincial Schools for being 'mere drawing schools'. The provincial masters were so incensed by this criticism from one who had helped to impose a strict standard of Elementary Drawing that they drew up a memorial of protest and sent it to the Board of Trade. The signatories included the following headmasters: Cooper of Manchester, Hammersley of Nottingham, Young Mitchell of Sheffield, Nursey of Leeds, Patterson of York, Stewart of Norwich, and Gifford of Coventry.[51] At this point it is interesting to discuss their establishments.

THE PROVINCIAL OR BRANCH SCHOOLS

From 1844 to 1847 six more Schools of Design had been officially recognized for Government grants: at Glasgow, 1844; Norwich, 1845;

Stoke, Paisley, and Leeds, 1846; and Hanley in 1847. The total number of branch Schools was now fourteen, counting the already extant schools at Manchester, Spitalfields, York, Nottingham, Sheffield, Coventry, Birmingham, and Newcastle upon Tyne. None of these played such an important part as Manchester in the controversies with Somerset House, as we can deduce from the evidence of the Select Committee of 1849, but several of them showed interesting variations of development.

The second School founded in the provinces was the York School of Design, established through the interest of William Etty, R.A., who, though he spent his career painting nudes in and near his beloved Academy, was born and died in York. Under his influence, the School developed into a drawing and painting school for aspiring artists and well-born young ladies. The cathedral city was not one of the main industrial centres of Yorkshire indeed, Mr Poynter reported that there was 'no basis upon which the utility of the school can be developed'. The School was officially recognized on 26 July 1842, when George Lambert was appointed Master.[52]

On Lambert's death from typhus the following winter, J. Patterson was appointed, who was rather a crude draughtsman, but a competent flower painter. Many ladies came to copy flowers from French lithographs and from life, and the great Etty himself conducted the life class on occasion. The School proved popular, and in 1848 it was necessary to find new accommodation so the students were moved into the old classroom of St Peter's School in the Minster Yard. During this period the School produced several promising artists, including Henry Moore, R.A., the marine painter, and there were useful drawing classes for the schoolboys of York. The fact that the School was given a grant as a School of Design and that it was not strongly attacked in the forties for its fine art policy was no doubt due to Etty's position on the Council at Somerset House.

The Nottingham and Sheffield Schools were the next to be recognized, both on the same day. In October 1842 the citizens of Nottingham held a meeting to raise the funds necessary to obtain an equivalent grant from the central Council. Their efforts being successful, the School was recognized on 13 January 1843, when George Thompson was appointed master by the Council, and on 1 April the classes were accommodated in the People's Hall, Beck Lane (now Heathcoat Street). From 1845 onwards the School enjoyed a high reputation under James Astbury Hammersley, who was transferred to Nottingham from the staff at Somerset House. Hammersley had previously been chief designer for Wedgwoods, and understood the needs of artisan students and manufacturers. He believed that the artisans saw enough of manufacturing and designing processes during the day and needed some drawing and fine

art in their evening classes. Most of the manufacturers agreed, and it was reported that his pupils 'could command the market for designers among the lace manufacturers' and that sixteen of the best paid designers in the area attended the School. Hammersley took great interest in teaching the children in the national and parochial elementary schools, but the private drawing masters and the schoolmasters complained about the headmaster and his second master Frederick Fussell doing this work when they were being paid as School of Design staff.

The Nottingham Mechanics' Institute had a large rival drawing class and were working from the Government *Drawing Book* (as did the elementary classes at the School of Design), so when Hammersley was requested to lend the Institute the School's copy of Raffaelle Morghen's *Elements of the Figure* to trace for figure drawing purposes, he felt the duplication was becoming absurd. He could not get the backing of his committee against either this duplication or the schoolmasters' complaints, so he informed Poynter, the Government inspector, confidentially, that he was seeking another appointment. Stafford Northcote, the other inspector, then wrote privately to Hammersley and told him there was a possibility of an appointment at the Manchester School, which was then having a disastrous time under Davies Cooper. The Manchester committee eagerly dismissed Cooper and appointed Hammersley, and the intelligence of their impending loss 'was very ill received' by the chairman and parson of the Nottingham committee, when Poynter made it known to them. Hammersley's later career is described in Chapter 11.

The Sheffield School of Design, recognized on 13 January 1843, had an unfortunate start. The first master, Henry Durrant, only lasted one year. He was, like Thompson of Sheffield and Wallis of Manchester, a pupil and disciple of Dyce, so like them he was dismissed under Wilson's régime, and Henry Spratt, the former head of the morning school at Somerset House, took over. The third head appointed within a space of three years was Young Mitchell, a pupil of the great Ingres and a friend of Alfred Stevens. With his atelier background, Mitchell was devoted to drawing, and saw eye to eye with Haydon. He claimed it was necessary to work 'in the spirit of the Elgin Marbles' and requested the Council to send the School a skeleton and an anatomical figure. Like other teachers of fine art, such as Haydon and Zephaniah Bell, Mitchell was popular with the art-thirsty public.

During their inspectorship, Stafford Northcote and Poynter visited the School and found the whole business rather puzzling. The Board of Trade had intended that the School should improve the Sheffield steel utensil and silver plate industries by teaching artisans to model forms in clay suitable for casting and chasing, so the inspectors asked Mitchell why there was no modelling class. The headmaster replied that anyone

who could draw properly could model. Poynter commented ironically that this was 'an argument, which would reach to the inutility of any modelling class at all'.[53]

The Coventry School was recognized next, on 21 March 1843, when John Evans was appointed master by the central Council. Evans shared the same fate as other masters appointed during Dyce's superintendence, dismissal during Wilson's directorship. E. Gifford succeeded Evans in February 1846 and the pupils followed the Director's course of elementary drawing and copying from the cast. Some advanced students spent their time 'shading from the flat or from casts, and others are drawing the figure from the antique' or drawing from plants. After Wilson's downfall at Somerset House the School was one of the few institutions to welcome a lecture from the wandering Director of Provincial Schools, actually on ancient Greek art. Some pressure must have been exerted by the manufacturers, for Poynter reported: 'There are four students who design and draft their designs, and they have now set up a small room in which they intend to execute the ribband.' The Sixth Annual Report (1849–50) proudly announced, 'A ribbon has been made in the school!' The School must have soon abandoned this leaning towards Coventry's ribbon industry, judging from a remark made by Sir Joseph Paxton, the noted architect and M.P. for Coventry. Viewing the School's exhibition in St Mary's Hall in 1856, he exclaimed, 'On looking round the room I see many pretty drawings – very praiseworthy! beautifully done!! but where are the ribbons? I see no ribbons!' Coventry had the distinction of remaining the only School of Design free from debt.[54]

The Birmingham School of Design originated from classes formed by the Birmingham Society of Arts, founded in 1821, 'for the encouragement of Arts and Manufactures, to find accommodation for students, to provide a museum of casts of the most approved sculptures and of all works illustrative of the different branches of art'. The professional artists in the Society followed the opinions of the Royal Academicians, several of whom were appointed honorary members, and one of its chief objects was 'to combine the beauty and grace of Italian design with the unrivalled skill of British workmanship'. This adulation of Italian work was encouraged by Sir Robert Lawley, who presented the Society with a collection of casts, and recommended that a master be selected of 'taste and genius from the R.A. of London and to send him to Italy to perfect himself'.[55]

Classes were formed to draw from the numerous casts, and in 1839 a home for the Society and its collection was built in New Street (demolished 1912), but in 1841 the Board of Trade ruled that these classes would only be recognized as a School of Design entitled to an annual

grant if the Society raised the equivalent funds and conformed to Dyce's course of instruction at Somerset House. The professional artists of the Society were not prepared to raise the money for classes that would exclude fine art, nor were their patrons, so in the following year these members resigned and departed to form the Birmingham Society of Artists (later R.B.S.A.) with Sir Martin Arthur Shee, P.R.A., as president. The Society of Arts and the newly formed School of Design, which was now dependent upon the patronage of manufacturers, stayed in New Street.

The first master, William Charles Thomas Dobson, officially appointed on 1 August 1843, was a past student of the R.A., as Lawley had recommended, but he was so keen to go 'to Italy to perfect himself' that he only stayed two years, then quit for Rome, where he perfected himself sufficiently to become eventually an R.A. After a year under a Mr Heaviside, the School was entrusted to Thomas Clark, the drawing master at King Edward's School. The most valued prize in the School at this time was awarded for the best outline of the cast of the 'Laocoon', a very tortuous task! However, the new headmaster preferred warm modern beauties to cold ancient ones. Unfortunately, in 1849 an Iago arrived on his staff. This kill-joy, the new third master W. Oliver Williams, closely observed Clark's antics with the Female Class during the session of 1850 to 1851, but did nothing about it. The second master, John Kirk, entered into the bacchanalian spirit of the establishment, being constantly drunk, on occasion for a fortnight at a time. A crisis arose when the head asked Williams to give a gentleman a picture he was copying. The green-eyed monster took possession of the third master, and on 12 June 1851 Williams submitted charges against the headmaster to the secretary of the School's Committee, as follows:

> '1st. That Mr Clark is in the habit of taking some of the Female Class into his private room, and on some occasions with the door fastened on the inside, and that he has been seen leading one of the Females with his arm around her waist from the large room towards his own Room, just after the departure of the class.'

The other charges were, in short: second, that Clark absented himself from the School, often for days; third, that he had allowed students into the School on Sundays; fourth, that he had admitted a number of ladies to the Female Class from the regular course without registering them in order to conceal this from the committee; fifth, that he had made Williams give away the picture; sixth, that he had given a prize for work not done in the School; seventh, that he had drawn up false attendance registers; eighth, that his monthly reports to the Government were a tissue of falsehoods.[56]

Williams ended with the statement that: 'Ladies have left the School in consequence of Mr. Clark's inattention.' Clark could hardly have been expected to gratify them all. The final consequences were that Williams was dismissed, and the Board of Trade posted Clark to be master at Nottingham, a city renowned for beautiful girls.

At this time the School did not much benefit the local metal industries. As at Sheffield, there was no modelling class. The largest single category of young craftsmen attending were japanners, and when some examples of decorative japanned metal were sent from Somerset House, the inspectors remarked that the young japanners at the School could already do better. Among the pupils of the School was Edward Burne-Jones.

Affairs took a turn for the better after September 1851, when George Wallis, late head at Manchester, took charge. The School was in such a riotous state after five years under Clark, that, after a few months trying to enforce discipline without the cooperation of the members of the committee, Wallis took the bold step of telling them to close the School, and took a rest in Brighton. On his return he reformed the School from scratch, working for five days per week up to 9.30 p.m., without much help from the second master who was still constantly intoxicated. A modelling class was formed and Wallis turned the emphasis towards industrial design. To his relief, in his second year as headmaster, the Academicians lost their last vestiges of control at Somerset House, and Henry Cole, who admired Wallis, took control of public art education.[57]

The Newcastle upon Tyne School of Design was established at the request of the secretaries of the Newcastle Fine Arts Society. The first master, appointed on 19 December 1843, was William Bell Scott (1811-1900), the Pre-Raphaelite poet and painter. Scott carried on the fine art tradition and, like Zephaniah Bell of Manchester, he objected violently to Dyce's rules banning fine art students and life drawing. Unlike Bell, did he not resign. 'I hung up the rules and broke them by my practice,' he declared. There was no major industry in the city which demanded designers, and Scott kept the School extant by interesting local fine art patrons by exhibitions. In 1848, for example, an exhibition from the collections of the Duke of Northumberland, Lord Ravensworth, John Gibson, and other gentlemen was organized in Blackett Street, Scott showing paintings by his brother David Scott, R.S.A., and himself. In a room of the Royal Hotel, Scott exhibited the works of his students. In 1849 Scott exhibited his brother's large canvas 'The Triumph of Love', together with the drawings and models of his students.[58]

The Committee of Management in London could hardly approve a subsidy for the pursuit of fine art by ladies and gentlemen, and the Board of Trade withheld the grant for 1849. This was renewed the

following year, partly as a result of a petition to Lord Granville, and partly because the committee of the School invited R. N. Wornum of the central School to give one of his rather unwanted lectures on historic ornament, thus demonstrating a slight leaning towards ornamental design.

When Henry Cole was given control of public art education in 1852, Bell Scott was a happier man. Cole approved of any number of ladies and gentlemen provided they paid fees.

The Glasgow School of Design was recognized on 4 June 1844. Under the first headmaster, Henry McManus, and his assistant master, Alexander D. Robertson, the School became very popular, and in the third year of its existence the number of admissions was 808, of whom 238 were males over twenty, a record number of mature students for that time. The chairman, Archibald Alison, Sheriff of Lanarkshire, proudly announced in 1848 that 'it was second to none, and that it was first, in point of numbers, to any similar institution in Great Britain, not even excluding the parent institution at Somerset House'. This popularity was due to the fact that it was in reality a school of fine art. The highlight of the work shown in 1848 was a bust of Niobe by a young student, and the *Art Union* reported that 'A great many are engaged in flower-painting, in colouring, in arabesque, and in chiar'-oscura painting', and added as an afterthought that some classes were 'contemplated for the practice of design'. This journal had remarked in the previous year that 'it does not appear that any prize was offered or bestowed for any design or approach to design'. The nearest approach to design was high-relief sculpture for drawing-room decoration. The work done at Glasgow is clearly illustrated by the descriptions of a visiting reporter in March 1848:

'It was extremely interesting to observe certain of the more advanced pupils, of both sexes, sedulously engaged in the large gallery in drawing and shading the human figure from the round, in oil as well as in water tints . . . the models being the numerous fine full-sized casts from the antique, which are ranged around the apartment. In another room we observed one or more beautiful copies (in oil) of arabesques, the originals of which are in the Vatican. But perhaps the most interesting department of the school is that in which modelling in stucco is taught. The number of pupils engaged in this branch is, we understand, already very considerable. . . . In this department was exhibited a very fine figure which was placed on the table for the inspection of the meeting, being a reduced model of one of the Townley marbles (the enlarged cast is amongst those in the gallery), a girl in a half-recumbent posture playing at a game, the production of a Miss Harvie. A number of similar works

are in progress, some of them statuettes, and others copies of sculpture in alto-relievo; and we understand it is intended to make the talents of the pupils available by disposing of such models to the public at large as drawing-room ornaments.'[59]

Wilson must have been extremely attracted by Glasgow's gallery of casts from the antique when he came up in the summer of 1848 to enlighten the ladies' day class concerning the mythology, habits and customs of the Greeks 'particularly describing the ceremonies and mysteries'. There seems to have been little justification for the dismissal of McManus and his assistant Robertson from the School in October 1848, and their replacement in December by Wilson and Murdoch. McManus, with only two assistants, was coping with great numbers, and the Glasgow School was producing more ambitious work than Somerset House, even in the matter of copying casts of ornament. If the idea was to teach more industrial design, Wilson was hardly a suitable choice. An injustice was done, and the students registered their indignation in writing.

Under Wilson the numbers were drastically reduced and Glasgow became more of a middle-class art school than ever. Poynter found during his inspection of 1849 that there were only 197 students registered and that 'the class of female students contains several ladies who cannot be fairly said to belong to the class of persons for whose education these schools are supported by the Government'. Wilson was asked to set up a separate class with full private fees for these high-born ladies. A sop to design training was offered in 1851 by the appointment of Joseph Ebsworth as master for mechanical engraving and engineering, but Glasgow, during its fifteen years under Wilson, continued to be mainly an art school for painting and modelling from casts.

The only School of Design established in 1845, the troublous year at Somerset House, was at Norwich, the first Master, William Stewart, being appointed on 5 August. Norwich could hardly be described as an industrial city; and as under William Stewart, and his successors George Stewart and John Heaviside, the total of day and evening students in the School of Design was small (eighty-eight in 1847, for example), it was only allowed one master. Naturally, with Norfolk's tradition of landscape painting the pupils sought art rather than design, and it was not until the fifties, when the school became a School of Art under Claude Nursey, pupil of Sir David Wilkie, that success was ensured.

In August 1846 Schools of Design were recognized at Stoke, Leeds, and Paisley. The Potteries' School, of which there was a branch at Hanley, was rather fortunate in one respect. The copying of ancient ornament, encouraged by Somerset House, was more applicable to Victorian pottery decoration than it was to the textile and metal products

of other industrial centres. John Murdoch, an ex-pupil of Wilson at the Trustees' Academy and his assistant at Somerset House, was the first master appointed at Stoke, and John Robinson was the first master at Hanley, appointed the following year. Murdoch set his pupils off drawing copies of ancient ornament from the flat and the round, and a part-time teacher, Mr Jeannet, taught them to model from casts of models of antique ornament by Albertolli. Mr Battam, designer for Copelands, complained that the students stopped at mere copies and that 'exercises of original conception . . . were not allowed by the rules regulating the school'. An apprentice from Copelands had, during his time in the school been 'employed in drawing only from the group of Cupid and Psyche'. Robinson at Hanley agreed that copying from ornament and from figure outlines was not enough, and advocated drawing from the nude. [60]

When Wilson was appointed headmaster at Glasgow in 1848 he took with him his most faithful disciple, Murdoch, and the Potteries' Schools were combined under Silas Rice who remained headmaster for the next fifteen years.

The Leeds School of Design was started under the auspices of the Leeds Mechanics' Institute and Literary Society. Claude L. Nursey, later head at Belfast, then at Norwich, was the first master at Leeds, being appointed on 19 August 1846. Nursey, as one would expect from a pupil of Haydon's friend David Wilkie, ran the School as much like a school of fine art as possible, seemingly on the policy advocated by Haydon, for the inspection report of 1849 declared that the advanced pupils were drawing the figure with great success, Nursey being 'careful to explain it anatomically'. There was no School of Design at Bradford, but a drawing class met three times a week, and Nursey travelled to instruct it every Saturday. [61]

Paisley developed on similar art school lines under Mr Sintzenich. The emphasis there on copying outlines of eyes, noses, and ears of ancient origin from the flat and round did not seem to the Paisley shawl manufacturers to be relevant to the textile trade, and one of them referred to it critically as 'making faces and so forth'.

The Schools of Design in Ireland were officially established on 1 May 1849 when headmasters were appointed for Belfast, Dublin, and Cork; Nursey, McManus, and Willis respectively. In addition to these, five more Schools were recognized before the eclipse of the system: Macclesfield, 1850; Stourbridge and Worcester, 1851; St Martin's (London) and Waterford, 1852.

Even from this brief account of the Branch Schools it is obvious that few of the masters or pupils were interested in Dyce's concept of a school for ornamental design only, and that the schools were ripe to become Schools of Art.

THE DEATH OF HAYDON

On 22 June 1846, Dyce, Wilson and the Council lost their most un-compromising opponent. Benjamin Haydon made a Roman end of himself. By 1844 his debts had driven him to painting successive pictures of Napoleon musing for five or six guineas apiece. His last great attempt to become solvent was a public exhibition of two of his large canvases, one of Aristides, the other of Nero, in the Egyptian Hall, Piccadilly, during March 1846. In the event, thousands of people flocked in to gaze at a dwarf, 'General Tom Thumb', in an adjoining room, but only a handful paid to view Haydon's superior anthropotomy and he lost over a hundred pounds in expenses. Haydon did not commit suicide in a pique, because his vanity was hurt by this incident, as has been suggested by several authors. He had suffered many rejections in his lifetime and he noted in his diary that General Thumb had beaten, but not conquered him.

Refusing to accept defeat, the artist started a series of four large canvases, but his debts were now over £3,000. At this juncture a friend offered him a loan, but afterwards entertained Haydon to dinner and told him the funds were no longer available. The artist then decided to kill himself. Having been seven times arrested and four times imprisoned for debt, he realized that it was certain that he would be re-arrested before completion of his canvases. He knew his sight and his mind were deteriorating and mentioned his 'delusions'. His family, he thought, would be better off without him.

After writing to the Duke of Beaufort and Sir Robert Peel for some money due to him, and receiving £50 from Peel, he put the sum on one side for his family and returned some books, which he had not paid for, to a shop. On the morning of 22 June he bought a pistol and, after kissing his wife, locked himself in his painting room where he wrote his will, carefully enumerating all his debts and assets. Haydon then shot himself through the head, but the ball did not pierce his brain effectively owing to the hardness of his skull, so with characteristic determination he gave his throat a gash 'extending to nearly seven inches in length', and died. He left his diary open at the last entry:

'Finis of B. R. Haydon
"Stretch me no longer on this rough world" – *Lear**
End –
XXVI Volumes'[63]

* '. . . O let him pass. He hates him
 That would upon the rack of this rough world
 Stretch him out longer.' *King Lear*, V, iii, 314
Professor Willard B. Pope of the University of Vermont gives Haydon's words as 'tough world', and he may be right. However, looking at the photostat of the actual entry, it can be seen that the stroke of the first letter of the first of these two words is not crossed. The other 't's on the page are, so it could be argued that Haydon's wild stroke was intended to be an 'r'. The last word, which Professor Pope gives as 'volume', seems to me to read 'volumes'.

Compositions of heroic figures are possibly the most difficult subjects to make artistic, and are suitable only for a select few. Haydon's choice of such finished subjects stifled his art. He had a natural broad touch and sketching style, which shows in his ink drawings such as the 'Virgin watching the Sleeping Christ' in the Whitworth Gallery, Manchester, or in his 'Meeting of the Unions' in the Birmingham Art Gallery, which shows Impressionistic touches. His 'Mock Election', bought by George III, is successful, and if he had continued to paint contemporary genre subjects as did Hogarth, whom he admired, or his own friend Wilkie, he would probably have produced many notable works. Watts, an expert on the figure, said of Haydon that 'his expressions of anatomy and general perception of form are the best by far that can be found in the English school', but he also noticed that the roughness of Haydon's handling and his dabs of colour were unsuitable for his heroic subject matter.[64]

Haydon's tragedy was that his fanatical enthusiasm often overcame the natural discrimination he undoubtedly had. Walter Scott remarked that he was 'too enthusiastic', a true comment, but strange coming from an equally enthusiastic and improvident man. Keats wrote in a verse upon Haydon of his 'high mindedness, a jealousy for good'. Lord Grey had warned Haydon that he would suffer much for his causes, but Haydon had replied, 'That is true, my lord, but you were fifty years before you carried your public objects [the Reform Bill].'[65] Tom Taylor wrote of Haydon's struggle: 'A less elastic temperament and a less vigorous constitution would have broken in one year of such a fight.' The aging artist ended his own life not because he would not fight any more, but because he knew that he could not.[66]

Sources

1. LESLIE, GEORGE D. *The Inner Life of the R. A.* John Murray, London, 1914 (p. 12)
2. *Sessional Papers*, 1849 Select Committee on the School of Design (p. 426)
3. *Fourth Report* of the Council of the School of Design, 1845 – Occupations of Male Students
4. *Third Report* of the Council of the School of Design, 1844 – Rules
5. Introductory address of the new headmaster (H. Johnstone, nominee of the Council) Cave & Sever, Manchester, 1846
6. *Third Report* of the Council of the School of Design, 1844
7. HAYDON, B. R. *Correspondence and Table Talk* Edited Haydon, F. W. Chatto & Windus, London, 1876 (Vol. II, p. 234)
8. BROWN, FRANK P. *South Kensington and its Art Training* Longmans, Green, London, 1912 (p. 4)

9. *Art Union*, 1847 (p. 395)
10. BRYDALL, ROBERT *Art in Scotland* W. Blackwood & Sons, Edinburgh and London, 1889 (p. 145)
11. *Sessional Papers, 1835* Select Committee on Art and Manufactures (p. 79)
12. *Edinburgh Review*, October 1819 (Vol. XXXII, No. 64, p. 492)
13. ATKINSON, J. B. *Overbeck* Sampson Low, London, 1882 (pp. 33, 69, 99)
14. DYCE, W., and WILSON, C. H. *Letter to Lord Meadowbank and the Committee of the Honourable Board of Trustees for the Encouragement of Arts and Manufactures, on the best means of ameliorating the arts and manufactures of Scotland in point of taste* Thomas Constable, Edinburgh, 1837; *Dyce Papers*, Aberdeen Art Gallery and Museum
15. SUMMERSON, SIR JOHN *Georgian London* Penguin Books, Harmondsworth, 1962 (p. 140)
16. *Sessional Papers, 1836* Select Committee on Arts and Principles of Design (p. 2)
17. *Art Union*, 1840 (p. 143)
18. DYCE, WILLIAM *Report . . . made . . . consequent to his journey on an enquiry into the state of Schools of Design in Prussia, Bavaria, and France* House of Commons, 3 March 1840; and *Sessional Papers, 1836* Select Committee on Arts and Principles of Design (p. 2)
19. Ibid. (p. 194)
20. *Report* of the Council of the School of Design to the President of the Board of Trade, 1841
21. *Sessional Papers, 1849* Select Committee on the School of Design (p. 60) and BROWN, FRANK P. *South Kensington and its Art Training* Longmans, Green, London, 1912 (p. 4)
22. *Third Report* of the Council of the School of Design, 1844 – Prospectus and Rules of Attendance; and LEFEVRE, J. SHAW *Letter* to the Council of the Manchester School
23. SPARKES, J. C. L. 'Schools of Art' *International Health Exhibition Literature* London, 1884 (Vol. VII, p. 771); and *Sessional Papers, 1849* Select Committee on the School of Design (p. 426)
24. PASTON, J. *B. R. Haydon and his Friends* Nisbet, London, 1905 (p. 97); and HAYDON, B. R. *Correspondence and Table Talk* Chatto & Windus, London, 1876 (Vol. I, p. 201)
25. Ibid. (Vol. II, p. 235)
26. CROZIER, R. *Recollections, 1879* MS (Manchester Reference Library 709.42 M2); and LETHERBROW, T. *Robert Crozier* (reprinted from *Manchester City News*) J. E. Cornish, Manchester, 1891
27. JACKSON, GEORGE *Essay* read at Manchester Mechanics' Institute, 1837 Manchester School of Design papers (Manchester Reference Library 709.42 M2)
28. CROZIER, R. *Recollections, 1879* MS (Manchester Reference Library 709.42 M2)
29. Ibid.; and LOVE, B. *Handbook of Manchester* Love & Burton, Manchester, 1842

30. *Sessional Papers, 1849* Select Committee on the School of Design (p. 149)
31. Ibid. (pp. 271, 123–7)
32. MILLS, E. *Life and Letters of Frederick Shields* Longmans, Green, London, 1912 (p. 9)
33. *Sessional Papers, 1849* Select Committee on the School of Design (p. 123–7)
34. MARKS, HENRY S. *Pen and Pencil Sketches* Chatto & Windus, London, 1894 (Vol. I, p. 158)
35. WALLIS, GEORGE *Letter* to the Council of the Manchester School of Design Manchester, School of Design papers (Manchester Reference Library 70942)
36. *Journal of Design and Manufactures*, March–August, 1849 (Vol. I, p. 165)
37. Ibid. (pp. 26), and ibid., September 1849–February 1850 (Vol. II, p. 142)
38. Introductory address of the new headmaster Cave & Sever, Manchester, 1846
39. *Art Union*, 1845 (p. 163)
40. *Hansard* (House of Commons), 27–8 July 1845
41. SMITH, STEPHEN *Art and Anecdote* Hutchinson, London, 1921
42. REDGRAVE, F. M. *Richard Redgrave – a memoir* Cassell, London, 1891 (p. 66)
43. *Art Union*, 1845 (p. 268)
44. STANNUS, H. *Alfred Stevens and his Work* Autotype Co., London, 1891 (p. 6)
45. TOWNDROW, K. R. *Alfred Stevens* Constable, London, 1939 (p. 69)
46. STANNUS, H. *Alfred Stevens and his Work* Autotype Co., London, 1891 (p. 7)
47. *Art Union*, 1845 (pp. 163, 239)
48. *Sessional Papers, 1849* Select Committee on the School of Design (p. xvi)
49. *Journal of Design and Manufactures*, March–August 1849 (Vol. I, p. 26)
50. *Sessional Papers, 1849* Select Committee on the School of Design (pp. 379, 160, 381, 377)
51. Ibid. (p. 369; and *Journal of Design and Manufactures*, September 1849–February 1850 (Vol. II, p. 144)
52. *Sessional Papers, 1849* Select Committee on the School of Design (p. 364)
53. Ibid. (p. 362)
54. From annual reports and cuttings in strong box, Coventry College of Art
55. British Association *Handbook for Advancement of Science*, 1913 (p. 322); and *Birmingham Institutions* Cornish Bros., Birmingham, 1911 (p. 281)
56. Birmingham Society of Arts and Government School of Design *Minutes Book* for 1851–5 (pp. 3–4)
57. Ibid. (pp. 41, 50, 117)
58. *Art Union*, 1848 (p. 196), 1849 (p. 352); and SCOTT, WILLIAM BELL *Autobiographical Notes on the Life of William Bell Scott* W. Minto, London, 1892 (p. 178)
59. *Art Union*, 1848 (pp. 160, 228, 277, 354, 369)
60. *Sessional Papers, 1849* Select Committee on the School of Design (p. 260)

61. Ibid. (p. 368); and *Art Union,* 1848 (p. 277)

62. *The Times,* 25 June 1846

63. HAYDON, B. R. *The Diary of Benjamin Robert Haydon* Edited Pope, Willard Bissell Harvard University Press, Cambridge, Mass., 1963 (Vol. V, p. 553)

64. PHYTHIAN, J. *George Frederick Watts* Grant Richards, London, 1907 (pp. 6–7)

65. HAYDON, B. R. *Autobiography and Memoirs* P. Davies, London, 1926 (Vol. II, pp. 765, 815); and HAYDON, B. R. *Correspondence and Table Talk* Chatto & Windus, London, 1876 (Vol. II, pp. 349, 450)

66. HAYDON, B. R. *The Life of Benjamin Robert Haydon – his autobiography and journals* Edited Taylor, Tom Longmans, Brown, Green, London, 1853 (Vol. II, p. 595)

5

The Philosophies of Haydon, Dyce, and Wilson

*'The most difficult accomplishment in the arts is the power
of drawing correctly the human figure. As the greater
involves the less, when the power of drawing the human
figure is acquired, the power of drawing everything else
becomes easy and requires little effort.'*
Benjamin Robert Haydon[1]

THE ANTHROPOTOMICAL CONCEPT OF BENJAMIN HAYDON

In 1807, when Haydon first set eyes upon the sculptures from the
pediment of the Parthenon, standing in Lord Elgin's penthouse in Park
Lane, he was instantly struck by the knowledge of anthropotomy
evident in the work, and particularly by the use of anatomical forms on
the female figures, such as the radius and ulna on the forearm. 'I was
astonished,' he wrote, 'for I had never seen them hinted at in any female
wrist in the antique.' Haydon had already dissected the human body, and
it was this experience which enabled him to grasp, more than any other,
the pure excellence of the Elgin Marbles. He commented: 'I had seen
enough to keep me to nature for the rest of my life.'[2]

Haydon's concept of art education was simply this. The basis of all
art education is the study of the forms of the human figure. He argued as
follows:

'. . . if any school of design, though exclusively devoted to manu-
facture be founded, without provision in its code of instruction for
the knowledge of the human figure, the very elements of taste and
beauty in manufacture will be omitted in the basis; and it naturally
follows that if the elements (known and acknowledged as such) be
omitted in the foundations, the superstructure will be imperfectly
supported and must fall to the ground.'

Haydon agreed generally with the training given at the Royal

Academy which, he wrote, 'as a school is excellent', and submitted that in a School of Design a student should first draw from the antique figure to give evidence of his proficiency to the council of the school, who would then consider if he was capable of tackling the live figure. As to equipment:

> '. . . the first reasonable steps would be the purchase of fine casts of the Ilyssus, Theseus, Gladiator, Torso, Venus, Apollo, Laocoon; 2ndly a collection of feet, hands, heads, and a plaster anatomical figure; 3rdly the Best Books on Art, Anatomy and Design and then that the students should proceed before designing ornaments, as has been detailed above . . . and that no student should be admitted but by a drawing, where at least a decent knowledge of the figure should be apparent.'

He added that, if his scheme was not carried out, the students would not be instructed as they were in France, and would not obtain the information they had a right to expect. He argued that it was harmful to separate ornamental art from High Art.

> '. . . the same principle regulated the milk jug and the limb, and it is not by separating the inferior from the superior, you attain excellence in both; but, it is by combining the two; as the Greeks did, the Italians, and the French at present do.'

Haydon attempted to give some common principle in Greek treatment of ornament and the figure and in the Roman treatment of the same, and deduced that 'every line or curve in Greek art was based on the Ellipsis – while the circle was the basis of Roman Art'. He illustrated these principles with some sketches of Greek and Roman capitals, sculpted knees, and jugs, in his letter of 17 January 1837 to Poulett Thomson.

The scheme for art education proposed by Haydon had one great advantage over that practised by Dyce, and later by Redgrave. His proposal of 'the Figure first' would at least have ensured, if the test on the figure had been put into practice, that students were capable of drawing before being allowed to continue with their studies. Students would not have been permitted to drag out a weary existence of slowly copying geometry and ornament and deluding themselves that they could draw or design.

Haydon's scheme for art education was shelved during his lifetime, but in the eighteen-sixties and seventies the French system, which was practically identical, and which he had constantly praised, was introduced through the medium of the new Slade School of University College, London, and through the appointment of Edward Poynter as Director for Art of the Science and Art Department. Poynter brought the methods

of the French to Exhibition Road, and, in the words of William Gaunt, 'Under him students began to draw from life, and this was his great reform.'[3]

The students and provincial masters of Haydon's day were inspired by his assertions that they were both potential artists and designers. Robert Crozier, the President of the Manchester Academy of Fine Arts, recorded in his old age how Haydon, that 'Socrates of Art', encouraged him when a student. The students were averse to the Government *Drawing Book*'s injunction that the 'ornamentist has no right to enter' the ground occupied by the fine arts, and lent willing ears to his argument against this rigid classification of artists. 'Why separate the education of artist and mechanic? What right has any man to fix a limit to the exercise of human ingenuity?'[4]

Haydon fought that art education should be spread, firstly, by Government patronage for paintings for public buildings; secondly, by open museums for the people; thirdly, by Schools of Art for all classes of people. It would be foolish to pretend that all these means were realized because of Haydon, but they were realized, and Haydon was their chief protagonist and suffered ridicule for his opinions.

THE PRAGMATISM OF WILLIAM DYCE

'Any branch of study . . . should be regulated by the practical necessity for such instruction . . . I should give them merely such exercises as were necessary for their future pursuits.'
William Dyce[5]

Today, at a time when Colleges of Art and Design are bent on bringing together art and industry, we might be tempted to believe that Dyce was an enlightened pioneer of the Bauhaus concept of art education. It is also possible that Dyce's leanings towards the Nazarene concept of a mediaeval *werkstatt* may cause us to think that he was an early Pre-Raphaelite advocate of Morris's concept of art for all, 'a glorious Art, made by the people and for the people, as a happiness to the maker and user'. In actual fact, whereas the artisans of later years were passionately interested in both the Pre-Raphaelite and Bauhaus concepts, because they elevated the designer to his rightful place as a creative artist, the artisans of Dyce's day were not interested in his pattern-making and weaving classes when he was Superintendent of the Normal School. Moreover, during the time that he was Head of the Class of Ornament he had to request that pupils be conscripted into it from the popular Classes of Form and Colour.

The young artisans at the School of Design were compelled by Dyce, shortly after entry, to state their future employment, which, to Dyce's

way of thinking, meant their present employment. He considered that it was dangerous to open their minds to fine art, and in his letter to Lord Meadowbank he stressed the necessity to guard against the ambitions of the pupils to rank 'among the students of fine art, which complete access to the means of study gives rise to'. Dyce's system did not enable the mechanic to rise at all; it merely gave him the opportunity for 'self-improvement' in the Victorian sense of the word – or rather it would have done if Dyce's classes had been successful.

Dyce could hardly have chosen a worse period to try to persuade artisans that they merely needed a useful training for preparing patterns for their own trade. The mediaeval apprenticeship system had received its *coup de grâce* in 1814 when it was decreed by Act of Parliament that a man might exercise any craft or trade he pleased, and the artisans of the forties were assimilating the ideas of progressive educationalists such as Lord Brougham and Robert Owen, the latter of whom was teaching that by education the children of 'any one class in the world may be readily formed into men of any other class'.[6]

Dyce's narrow concept of training artisans was influenced by his religious beliefs. His association with the German Nazarenes and his membership of the High Church movement caused him to long for the re-establishment of a class of mediaeval craftsmen working religiously for the glory of God, and like the Nazarenes he believed that fine art was a distraction from this religious task, if influenced by Renaissance humanism or the study of the nude.

Dyce was preoccupied with methods, not with art. He argued that one could not expect the students' works to be examples of taste: 'they would be merely exercises done . . . The object is to teach the art of preparing designs for manufactures'.[7] This was Dyce's worst error. The original purpose of establishing the School of Design was to improve the standard of taste in the country and to raise up a new class of designers. This was precisely what the French and German schools were doing: the French by encouraging practical contact with the fine arts and the Germans by a wide course of liberal education. Dyce seems to have misinterpreted the German system, which was based on the ideal of realizing the potentialities of every member of the nation so that each would serve the state in his appropriate role, as Hegel and Fichte advised. The German system permitted students to advance themselves, to choose their subjects, and, as can be seen from the account of Dyce's tour (pages 79–80), there was a wide range of subjects in the Berlin Institut. The Prussian concept of an educational institution was defined by Matthew Arnold in the Taunton Commission Report as 'the instrument which the people use to procure the fulfilment of their own desires'.[8]

From a Platonic viewpoint, Dyce's system was the teaching of the mechanical facts of pattern making and professing 'to put knowledge into a soul which does not possess it', instead of attempting the conversion of the soul 'to ensure that instead of looking in the wrong direction, it is turned the way it ought to be' to contemplate the Good, Beauty, or Art, or whatever we wish to call our artistic and educational aspiration. Dyce did not go as far as the Revd. R. St John Tyrwhitt, a fellow Churchman, who said: 'The pupil as such must put by all his feelings about beauty . . . it is skill alone which wins grace', but in Dyce's classes the Victorian artisans, after their long day at the loom or squaring up patterns, must have felt that here was 'Endless labour all along, Endless labour to be wrong' (in the words of Dr Johnson).

It was Dyce's lack of appreciation of the need for a liberal education which hampered his schemes. George Wallis, one of his pupils, succeeded in attracting not only the young but also the older artisans. He used many of Dyce's methods but he turned his pupils' minds towards creative design and emphasized its intellectual aspects. The artisans were being educated, and appreciated it. Just as Wallis used many of Dyce's methods, and succeeded because his basic beliefs were liberal and educational, so Haydon used completely different methods and succeeded for the same reason. Haydon's classes were so enthusiastic that he complained of being smothered by the mechanics who surrounded his person.

Professor Quentin Bell in his *Schools of Design* states that 'Dyce was an inspiring teacher', and quotes a Royal Academy student to justify this statement. There is little doubt that Dyce was most enthusiastic in his attendances at the Royal Academy Schools but this has no bearing upon his teaching, or rather lack of teaching in his Class of Ornament at the School of Design. Even his fellow headmasters stated that there was little chance of the Class succeeding unless somebody would spend time upon it. Those who have defended Dyce, on the grounds that a creative artist should be allowed time for his own work, do not seem to realize the small proportion of the week during which he was required to attend – two mornings and one evening.

Although Dyce's view of design training was pragmatic, the above evidence seems to support the respective views of his friend Redgrave and his foe Haydon, that Dyce was impractical and an experimentalist. Redgrave regretted that Dyce 'was continually contending with a committee which he had not the art to lead nor the power to convince; thus his wise suggestions were either disregarded or only partially adopted, and finally it was left to others to carry into execution what he had proposed'.[9]

The 'others' who carried into execution some of the methods

proposed by Dyce were Cole and Redgrave himself. One result was the most dull, tedious and mechanical drawing produced in any period, and another was a proliferation of strange 'flattened' geometrical designs peculiar to British Schools of Art. It would be unfair to Dyce, however, not to admit that his basic concept of design as science ultimately had some very beneficial results.

DESIGN AS SCIENCE?

'Ornamental design is, in fact, a kind of practical science . . .'
William Dyce[10]

The academic theory that good design could be achieved by following scientific and geometrical principles was furthered by increasing interest in mathematics related to industrial design in the early nineteenth century. A contributory factor was the previous knowledge in academies of the mathematical bases of Greek architecture and sculpture. These sources of the scientific theory of design can be discerned in the evidence given before the Select Committee on Arts and Principles of Design in 1836.

Two Radicals on the Committee, William Ewart and Dr John Bowring, asked purposeful questions to elucidate from witnesses the application of scientific principles to art. Thomas Leverton Donaldson, secretary of the Institute of British Architects, was giving evidence and stated:

> 'Geometry of course is the foundation of scientific knowledge which is necessary for all workmen, as giving them a greater knowledge of form and delineation.'

Ewart then led with: 'In fact the basis of form in art is geometry?'
Donaldson concurred: 'Yes, and in nature too . . .'
Dr Bowring, the colleague of the Utilitarians Bentham and Mill, then led with a further question to demonstrate the link between utility and beauty.

> 'There is probably no example of a perfect machine which is not at the same time beautiful?'
> 'I know none,' replied Donaldson.

Ramsay Richard Reinagle (1775–1862), R.A., an ardent believer in scientific principles derived from Greek art, when giving evidence before the Committee made some dogmatic statements, remarkably akin to the principles and propositions expounded by Redgrave and Owen Jones in later years, as the following extracts will demonstrate:

> 'All elegant forms are derived from curvilinear ones . . . radiation is the first arrangement of lines which presents anything like the

appearance of an agreeable form . . . I have discovered the ruling law of the Greeks to be in thirds, that two and one always constitute varieties of the most agreeable character, as do three and five, two and five, etc.'[11]

The scientific approach to art instruction was first clearly demonstrated in the drawing books of the early nineteenth century. There were two main types of drawing book at this time, firstly books of diagrams for copying which reduced drawing to its primary elements, starting with a perpendicular line, then continuing with horizontal lines, inclined lines, curved lines, then forms connected with these essential lines (the square, the triangle and the cube), and ending with copies of ancient ornament, or of objects and landscapes. The second, 'non-scientific', type of book was simply a series of engravings of ornament, landscapes, or flowers to be copied.

The *Compendium of the Theory and Practice of Drawing and Painting, illustrated by the Technical Terms in Art: with practical observations on the essential lines and the forms connected with them*, published in 1818, was an early example of the scientific approach. Its first chapter opens with the portentous words:

'According to Abbe Longuerre the elements of every science must be learnt whilst we are very young; – the first principles of every language, the A, B, C of every kind of knowledge.'

Dyce, a student of science in his youth, was the author of the most widely-used drawing books of the century. The original version of his best-known book, published in 1843, was intended as a textbook for elementary instruction in ornament for the Schools of Design and consisted of exercises progressing from geometrical figures to examples of ornament. Chapman and Hall published four versions of this work: *The Drawing Book of the Government School of Design, Elementary Outlines of Ornament, Selections from Dyce's Drawing Book*, and a text to the *Drawing Book*, bound separately. Outlines from the book, mounted on card, were also available. *Elementary Outlines of Ornament*, commonly known as '*Dyce's Outlines*', was the most widely used of these publications.

Because the book was approved by the Council of the School of Design and later by the Department of Science and Art, its contents were regarded as the authoritative system of drawing. The book provided the perfect mechanical method for the unimaginative teacher with no knowledge of art, and sold very well; but artisans, children, and many art masters detested this way of drawing.

The artisans particularly, after a day in the workshop or factory squaring-up and drawing out patterns, were most resentful and usually

quitted the Schools after a few lessons. The headmaster at Belfast School of Art wrote in 1853 that 'abstract examples, like Mr Dyce's, are uninteresting and unintelligible to the pupil. He usually fails in copying them, tires, gets disheartened and disgusted and leaves the school after a short time.' The heads at Coventry and Limerick, F. R. Fussell and D. Raimbach respectively, wrote in the same vein, the latter commenting that 'the scholars of the evening drawing school regard Dyce's later drawings with disgust'. Thomas Vowler, Bishop of St Asaph, considered the geometrical outlines of ornament were particularly unsuitable for children and he advocated outlines 'selected for the purpose of pleasing children'.[12]

However '*Dyce's Outlines*' and numerous other drawing books based upon the geometrical system plagued children and young artisans throughout the century and beyond. One unfortunate Victorian girl, after drawing a series of vertical, horizontal and oblique straight lines and proceeding through upright oblongs, graduated to a grave with grass around it. 'How I worked and slaved with pencil and rubber,' she recalled later, 'to get on to that gravestone.'[13]

A paragraph from a drawing book by John Bell, a sculptor and a master at the Head School of Design, demonstrates the depths of scientific analysis reached in drawing at this period:

'A simple line in drawing is a thin mark drawn from one point to another. Lines may be divided into two classes –
1. Straight lines which are marks that go the shortest road between two points as A B.
2. Or Curved which are marks which do not go the shortest road between two points as C D.'

If design is in fact practical science, what exactly can be analysed? In Dyce's opinion, historic ornament should form the basis for study. One should not imitate the details of historic ornament, one should imitate its basic geometrical structure. In Dyce's own words:

'The remains of ancient ornamental art are now to be examined, less in detail, than as the constituents of the whole systems or styles of decoration . . . During the whole of the studies of my class constant reference must be made to the actual practice of ornamental art in past ages.'

Although Dyce admitted that the study of nature was important, he stressed that it should only be applied to design on lines established long ago. In his last year as headmaster of the Class of Ornament he was rather disturbed by the stress which Redgrave, master in the Class of Colour and lecturer on Botany, laid upon analysing nature rather than existing ornament and declared:

'Heartily concurring in the opinion so ably urged by my friend, Mr Redgrave, in his lecture of last Friday, that original design can only be produced by the same means from which it resulted in past ages, viz. by a reference to nature, the source of all beauty in design, I would only require that such reference should be aided by the experience afforded us in the labours of our predecessors . . .

'We do now not take it [ornamental art] up for the first time, its principles have been more or less truly developed from the earliest ages.'[14]

Dyce preferred analysis of ornament because ornament demonstrated more rigid geometrical structures than nature. He justified this by claiming 'that in the employment of geometrical forms we are but following the great example of Nature herself'. The Class of Ornament carried out the 'dissection of existing ornament and reclothing the skeletal lines with new forms from original sources'. The danger of this system is obvious. If we do as the Greeks did, go to nature and analyse it, we may discover new and exciting forms and structures; but if we use the skeletal lines of historic ornament as a starting point and then apply to them a natural object (say a flower), we are copying a fixed convention or mannerism of former ornament, not following a principle as Dyce claimed.

Dyce's conviction that geometry was the basis of design led him to rule that only geometrical patterns should be used on carpets as they would then appear suitably flat and solid. This was a rule rather than a principle, the principle being that a carpet should look flat. A correspondent of the *Journal of Design* in 1849 grasped this fact and refuted Dyce's geometrical rule by asserting that a meadow looked flat, and was not geometrical, and that it was preferable to have the 'springy texture of grass and moss than hard mosaic or parquet'. The writer added: 'I fear that the too great propensity which masters and lecturers have to generalise may tend to substitute mannerisms for invention.'[15]

Principles of design had become a popular topic for artistic controversy and it is now appropriate to discuss the architect, admired by Dyce and Redgrave, and especially by Herbert, who provoked much new thinking on this matter.

PUGIN'S VIEWS COMPARED WITH THOSE OF DYCE

The great new influence on design thinking from the eighteen-forties to the sixties was the work of Augustus Welby Northmore Pugin (1812–52). His genius as a designer is best studied from his pen and ink sketches and his writings, since many of the buildings he designed were not completed according to his specifications nor in the materials he

advocated. Killarney Cathedral and Alton Castle, Staffordshire, are fine exceptions.

Pugin's use of Gothic sprang from a passionate conviction that the British should develop their own native architecture in their own local materials. He did not detest Classical and High Renaissance art for religious and moral reasons as Dyce, Herbert, Redgrave, and Ruskin did. With his natural eye for design he admired it, but thought it unsuitable for Britain and British students. He made these points very clear in a letter to Herbert, published in *The Builder* in August 1845, in which he attacked the policy of the School of Design under Wilson's directorship. He wrote:

'The real source of art is *nature*, and the best artists of every nation and period have taken it as their standard, and represented it under the peculiar aspect of their locality and period . . . Now the School of Design in its present form . . . is in fact a hindrance to the revival of true taste and feeling, for the minds of the students are perverted by copying the same stale models that have been used for years without producing a single artist capable of designing anything original or appropriate. I see nothing but Pompeian arabesques, Greek friezes and capitals – works certainly good in their kind – but more than useless when employed to form a school of English artists; they lead to a miserable system of adaptation of obsolete symbols and designs, appropriate only to times and people from whom they originated . . .'

The difference between the ideas of Pugin and those of Dyce, Redgrave, Wornum, Cole, Owen Jones and other system makers is obvious from the above, and from other passages in the letter which read:

'It is absurd to talk of Gothic leaves or Gothic figures; the types of foliage introduced in the decoration of the first mediaeval buildings are all to be found in nature; and any garden and field can supply beautiful models for the sculptor. I am now preparing a work on vegetable and floral ornament, in which, by disposing leaves and flowers in geometrical forms, the most exquisite forms are produced. . . . *The finest productions of Christian art are the closest approximations to nature, and when they failed in proportion and anatomy, it was not a defect of principle, but of execution.*'

Pugin did indeed lay down principles of design, but these were broad and liberal. They are described (pages 233–5) when Redgrave's concept of art education is discussed.

It is very difficult to give a fair comparison of the views of an artist

with those of Dyce, because Dyce was so devious in his writings. For example, he constantly denigrated the importance of life-drawing for the designer, yet claimed credit for its introduction into the Head School. He also claimed that students' work should be merely exercises done, not examples of taste; yet on another occasion stated that: 'Our business here is . . . with good taste in design.'[16] He claimed that nature was the source of design, yet who would think so from his drawing book? Actually he made the geometry of existing ornament the basis of design training. The results of Cole and Redgrave adopting his system were described by George Moore as follows:

> 'Engraved outlines of elaborate ornamentation were given them, and these they drew with lead pencil, measuring the spaces carefully with compasses. In about six months or a year the student had learned to use his compass correctly, and to produce a fine hard black-lead outline; the harder and finer the outline, the more the drawing looked like a problem in a book of Euclid, the better the examiner was pleased.'[17]

The final contradiction with Dyce was that, unlike Pugin, Stevens, Redgrave, Townsend, Richardson, Herbert, Owen Jones and other teachers, he hardly ever attempted to design anything. He was almost exclusively a fine artist.

THE IMITATIVE CONCEPT OF CHARLES HEATH WILSON

Wilson was not an eccentric pedant. His policy of imitating Classical and Renaissance art was the prevalent concept of art education held by the dilettanti, the upper class, and the senior Royal Academicians of his day. Owing to a long period of Puritanism after the Reformation, the British had not developed their own Renaissance arts as the French had done, and with the revival of art in the Georgian period the only possible means of acquiring art which the upper class could perceive was to imitate the Italian art of the past. That brilliant eclectic Sir Joshua Reynolds expressed the view that 'there is nothing new under the sun, or if there is, it is not so good as that which is old'. His maxim was: 'Genius is the child of Imitation.' Wilson would have agreed completely.

Charles Heath Wilson had resided with his father Andrew Wilson (1780–1848) in Italy; his heart was always there, and he retired there to spend his last years. Architects of his time were working away from the Georgian style towards the Classical Revival, imitating Greek and Roman buildings and often decorating their interiors with Pompeian or Louis Quinze plaster ornament. Wilson's policy of Elementary Drawing followed by imitation of Roman ornament was, therefore, useful to the

London interior decorators who frequented his School, but almost useless to those students in the textile industries in the Provincial Schools.

That Wilson's concept of public art education was also that of the senior Royal Academicians was evident when his policy was impugned and Cockerell and Etty quit the Council of the School. A month after Wilson's resignation Cockerell wrote to the *Art Union* giving a 'declaration of respect and value of the past services and for the qualifications of Mr Wilson as Director of the Government School of Design'. Cockerell added that he did not wish to give reasons for his own resignation, 'but I consider myself bound on all occasions to declare the esteem in which I hold the character and conduct of Mr Wilson'.[18]

Wilson was the type of art teacher whom Rousseau feared most, as can be judged from these words from *Emile*:

> 'So I shall take good care not to provide him with a drawing master, who would only set him to copy copies . . . and lose his sense of proportion and taste for the beauties of nature.'[19]

Wilson's directorship did, however, further the growth of art education in one respect, in the formation of art museums. In his day there were hardly any collections open to the public, and the artisans could only glean ideas from the engravings and lithographs stored in Mechanics' Institutes and Schools of Design. During his directorship he induced each School to gather the nucleus of an art museum which was to be assiduously used by its students for a century to come. The casts and ceramics collected by Wilson at Somerset House were neglected, pushed into corners, and relegated to cellars under the triumvirate which followed, but plenty of them survived, some eventually forming part of the South Kensington Museum.

Sources

1. HAYDON, B. R. *Letter* to Charles P. Thomson Esquire, dated 17 January 1837 Victoria and Albert Museum Reference MSS Haydon 86 J. 16
2. HAYDON, B. R. *Correspondence and Table Talk* Chatto & Windus, London, 1876 (Vol. I, p. 35)
3. GAUNT, W. *Victorian Olympus* Jonathan Cape, London, 1953 (p. 168)
4. *Art Union*, 1843 (p. 143)
5. *Sessional Papers, 1849* Select Committee on the School of Design (pp. 63, 73)
6. OWEN, ROBERT *Essays on the Formation of Human Character* (1812) 'Essay Fourth' B. D. Cousins, London, 1840 (p. 66)
7. *Sessional Papers, 1849* Select Committee on the School of Design (p. 73)

8. Schools Enquiry Commission, 1868 (Vol. I, p. 72)

9. REDGRAVE, RICHARD, and REDGRAVE, SAMUEL *A Century of Painters* Smith, Elder, London, 1866 (p. 560)

10. *Journal of Design and Manufactures*, March–August 1849 (Vol. I, p. 65)

11. *Sessional Papers, 1836* Select Committee on Arts and Principles of Design (p. 32)

12. *First Report* of the Department of Science and Art, 1854 (pp. 65–9)

13. SCOTT, C. *Social Education* Ginn & Co., London, 1908 (p. 260)

14. *Journal of Design and Manufactures*, March–August 1849 (Vol. I, p. 94)

15. Ibid. (p. 168)

16. Ibid. (p. 94)

17. MOORE, GEORGE *Modern Painting* Walter Scott Publishing Co., London and Felling-on-Tyne, new (enlarged) edition 1906 (p. 65)

18. *Art Union*, 1847 (p. 396)

19. ROUSSEAU, JEAN JACQUES *Emile* (Everyman edition) J. M. Dent, London, 1961 (p. 108)

6

Cole Acquires a Kingdom

COLE TAKES AN INTEREST

On 5 August 1847 John Shaw Lefevre, Secretary of the Board of Trade, was introduced on a Chelsea steamer to Henry Cole, Deputy Keeper of the Public Records. It was a momentous event in the history of British art education. The two civil servants got on famously, and for the first time a man with a knowledge both of art and of uses of government became involved. At this date Cole believed that the Schools of Design should be made completely self-supporting, by means of fees and from the production of patented designs, and that they should be governed by one permanent civil servant, not by a committee. Lefevre, by virtue of his office, had sat on the Council, and later the Committee, of the Head School of Design, witnessing the endless wrangles between the artist members, the manufacturers, the amateurs, the officials, and the staff of the School (which, incidentally, was just about to be put in the absurd position of having three headmasters), so the opinions of his new acquaintance must have seemed to have beautiful simplicity. Lefevre was so impressed that he invited Cole to call upon him at the Board of Trade to be introduced to Henry Labouchere and Earl Granville, the President and Vice-President respectively.[1]

Cole was far from a disinterested party. He intended to be the one permanent civil servant governing the Schools of Design. His first venture into the field of art education had been the publication of illustrated handbooks on Westminster Abbey, Hampton Court, and other mediaeval buildings, which had interested him as he perused the Public Records; but the turning-point in his career occurred in 1846, when he was awarded a silver medal by the Society of Arts for a tea service which he had designed, and which was subsequently sold in hundreds of thousands by Mintons. Prince Albert, President of the Society, commended the service on 5 August 1846, when it was presented at Buckingham Palace for his inspection. It had become apparent that the amateur artist and architect Prince Albert of Saxe-Goburg-Gotha was, like many German princes, interested in improving the design of manufactures – 'to wed mechanical skill with High Art', as H.R.H. put it. Within three years of his arrival in Britain, the Consort had assumed

the presidency of the Society of Arts, and was now taking a very active interest. There was a great possibility that art for manufactures might, under Albert's influence, eventually form an important department of the Government. Cole surely must have grasped this. He later described Albert's inspection of his tea service as 'a link in the chain of circumstances leading to that great Exhibition, which sowed the seed for the beginning of the South Kensington Museum itself'.[2]

Cole, a great opportunist, had advanced himself as a civil servant by attacking existing inefficiencies with great energy, using the maximum publicity to ensure Government action. In 1836, when employed as a sub-commissioner of the Records Commission, he had succeeded in persuading his friend Charles Buller, M.P., to move for a Select Committee, which resulted in the dismissal of the idle secretary of the Commission and the creation of the Public Records Office. Cole's subsequent organization of the Records led to offers of various secretaryships, including one from Rowland Hill on behalf of the Mercantile Committee on Postage which he accepted in February 1838. Birkbeck Hill declared that Cole 'was the author of almost innumerable devices, by which in his indefatigable ingenuity he contrived to draw public attention to the proposed measure'. The impact of Cole's publicity was highly efficacious and an unwilling Government was forced to introduce the uniform Penny Post. Rowland Hill noted in his diary on 8 January 1842: 'Cole leaves me today. The progress of the Penny Postage – has been greatly promoted by his zeal and activity.'[3] Cobden was so impressed that he offered Cole the secretaryship of the Anti-Corn Law League, but Cole declined for, although his sympathies were with Whigs, Radicals and Liberals, his instinct as a civil servant was to avoid any definite political alliance.

After Cole had won the silver medal for his tea service he was able to bring himself constantly to the Prince's notice, for he now joined the Society of Arts and began to organize a series of exhibitions of British art manufactures, shown in 1847, 1848, and 1849 to increasingly large numbers of the public. At the same time Cole founded an association of prominent artists and manufacturers called 'Felix Summerly's Art Manufactures'. This remarkable organization, which paid Cole twelve and a half per cent on all sales, but could lose nothing, was a demonstration of his genius for arranging a system which thrust all responsibility for getting payments upon the results achieved by his associates although he retained complete control. It was, in a way, a precedent for his system of payments on results in art education.

When Cole was introduced by Lefevre to the Vice-President of the Board of Trade he met the peer who was to be his most constant sponsor throughout his future career, Lord Granville. It was George Leveson-

Gower, second Earl Granville (1815–91), who was to offer Cole his
first post in art education, and who later, in his capacity as Lord
President of the Council, was responsible to Parliament for Cole's
activities in education. Granville, an excellent man of business, said that
he admired Cole for his efficiency and strong will.[4]

Shortly after Granville had met Cole at the Board of Trade, a minute
of the Board recorded: 'Read a letter from Henry Cole – Ordered that
Mr Cole be requested to communicate further with my Lords on the
steps to be taken for the employment of the Schools of Design in the
production of designs for Government departments.' Cole not only
complied with this request by producing two reports on this subject, but
also produced a third, dated 29 December 1848, highly critical of the
system of management of the Head School, referring to instances of
improvident expenditure and stating that 'by no means short of a
complete change of system can the School fulfil its object, and its duty
to the public'.[5]

TRIUMVIRATE IN DEPTH

'There is no king in Israel: every man doeth that
which seemeth right in his own eyes.'

Judges 17, 6

The assaults which Cole now mounted against the Head School of Design
were greatly assisted by a new system of management introduced after
the transfer of Wilson to the directorship of the provincial Schools, a
system which could be called a triumvirate in depth. The new governing
body established on 17 November 1847 was the Committee of Manage-
ment, the top tier of which was the officers of the Board of Trade,
John Shaw Lefevre, Stafford Henry Northcote, and George Richardson
Porter. Responsible to this trio were the Sub-Committee of Instruction
consisting of Sir Richard Westmacott, R.A., George Richmond, and
Ambrose Poynter, who were expected to advise and report to the
Committee upon the running of the Head School, which was now split
into three classes each with a headmaster.

Two of Wilson's former staff, Townsend and Horsley, were appointed
headmasters of the Class of Form and the Class of Colour respectively,
and Dyce rejoined the School as headmaster of the Class of Ornament.
In December the rest of the staff were appointed: Richard Redgrave,
A.R.A., as lecturer on Botany and Flower Painting in the Class of
Colour; Richard Burchett, the former rebel, as master in the Class of
Form; and William Denby as master to assist in the Classes of Form
and Colour. There was an elementary section for each class, until
October 1848 when a separate Elementary Class was set up under W. H.
Deverell.[6]

There was not much cooperation between the headmasters, nor was there any regular system of progress or transfer from one class to another, with the result that the pupil artisans avoided Dyce's Class of Ornament, preferring to study form and colour. Dyce attended the two mornings and one evening a week required of a headmaster, and since the vast majority of the pupils attended in the evenings it is not surprising that Dyce's Class was unpopular, but he seemed to think there was a conspiracy against him, and asked that pupils be conscripted into his class. Townsend and Horsley tried to oblige by selecting eighteen students from their classes 'to form a nucleus of a Class of Ornament' but most of these students left. They could copy patterns and ornaments from books in their workshops.

Dyce got no support from the Sub-Committee of Instruction. Westmacott the classical sculptor, Richmond the portrait painter, and Poynter the architect had no sympathy with his ideas. Poynter said proudly of the School: 'No designs are made by the establishment. I do not conceive that to be the object at all.' Stafford Northcote, the most influential Board of Trade member of the Committee, thought likewise. 'We have not done anything,' he said, 'in the way of setting up what are called workshops – our school does not profess to teach that which is much better learnt in the workshop or manufactory.'[7]

On 15 July 1848 Westmacott, Richmond and Poynter conducted an inspection of work in Somerset House, and their report was placed before the Committee of Management in August. This report gives some idea of the tedious labour in the elementary section of Townsend's Class of Form. It recorded, for example, that of thirteen shaded balls, each of which occupied a student for one or two months, one only was judged to be a 'satisfactory representation of a spherical body'. The standard of drawing in Dyce's Class of Ornament was heavily criticized. Only six of his pupils exhibited, and the only commendable work had been done at home by one who was already a designer. Horsley's pupils were also censured, so he and Dyce resigned in protest in September and quit the field of public art education for good. John Rogers Herbert, R.A., succeeded Dyce, and Richard Redgrave, A.R.A., succeeded Horsley.[8]

Dyce resigned partly because of alleged 'impediments from the other masters', partly because he objected to 'an authority of inferior artists' between himself and the Board of Trade, but mostly because he was unwilling to spend more time at the School, as the Committee suggested. He had some ground for complaint about the artistic inferiority of the Sub-Committee to the headmasters on whom they passed judgment, as far as two out of its three members were concerned, namely Richmond and Poynter. Dyce and Horsley were elected R.A. before Richmond was, and Poynter, an architect, was never even an Associate.

Henry Cole could not have hoped for a more inefficient system of management to criticize, and its demolition promised to be a far easier task than the destruction of the Records Commission or of the old postage system.

During his promotion of the Penny Post in 1838 and of a uniform railway gauge in 1846, Cole had written pamphlets, articles and advertisements, and he now decided to embark on a much more ambitious project to achieve his objects in art education, a journal of his own.

The widely-read *Art Union* was at first favourable to Cole. Samuel Carter Hall, its editor, thought that Cole's use of members of the Royal Academy, such as Mulready, Maclise, Redgrave, Horsley, and Herbert, to design his Art Manufactures was an excellent scheme. Art manufactures such as pottery, glassware, cutlery and candlesticks were considered Low Art, and Cole's efforts to wed manufactures with High Art promised to extend the journal's reading public among manufacturers, merchants, shop-keepers, and designers. Thus in 1847 the *Art Union* devoted six articles and an illustrated page to Felix Summerly's Art Manufactures and proclaimed that Cole 'in experience, taste, and judgment is second to none'. The editor even had some of the manufactures exhibited at his journal's office, but in the following year Cole began working on the production of a journal of his own, and all mention of his manufactures was omitted from the *Art Union*'s pages with the exception of a blistering two-page attack upon Cole's efforts, signed 'A Manufacturer'.[9]

The first number of Cole's *Journal of Design and Manufactures* was published in March 1849, and the editor of the *Art Journal*, as the *Art Union* had been renamed, began to grasp the purpose of the new journal. Cole was accused of trying to take over the Schools of Design, and ridiculed by the *Art Journal* as follows:

> 'Another rumour is still more preposterous, that a party who has been for two or three years successfully labouring to prove his own incompetency as to all matters appertaining to design, is to obtain a permanent place in this direction.'[10]

Cole's attacks on the Head School commenced in the first issue with an attack on its teaching policy, describing a dessert plate as 'from the design of a pupil taught at the School of Design, where it is evident he could not have learned even the A B C of his profession – the rim is purely Louis Quatorze – the ornament of an Alhambra character, and the centre of the Italian school – forcible evidence of imperfect education in the designer'. He next attacked the inspectorate, asserting that if

Ambrose Poynter were reappointed, it would be brought before Parliament so that 'every local school committee shall know how he treated the Manchester School in 1845'.

As far as the new system of management was concerned, Cole's journal commented that 'the School is likely to be permitted to flounder in a course of absolute self-management, until the natural results of such anarchy follow', and the right solution was that 'the executive should be paid, and as limited as possible in number'.[11]

THE FEMALE SCHOOL OF DESIGN

Cole's next target was one liable to arouse the sympathetic gallantry of the respectable middle class, namely the conditions in the Female School which the *Journal of Design* described as follows:

'... the glare of light in the front rooms is fortunately modified by the condition of the windows which are cleaned once in six weeks – the windows of the back rooms might advantageously be washed down by the parish engine, as they look down upon a rather close neighbourhood, and have a fancy soap manufactory, with a steam engine just beneath them.' Cole queried how a girl could be inventive 'while her brain is feverish and her chest sinking for want of a due supply of oxygen'.[12]

A female class had originally been started at Somerset House in March 1842. William Dyce had smiled upon this venture, for although it may have been true, as one parent suggested, that Dyce 'was more intent on cultivating the great talent he has since displayed as an artist, than in attending to the humble pupils' in the Head School, he certainly approved of the middle-class girls in his establishment, and the female superintendent said that he visited them daily. His successor Wilson was not so keen on their presence in Somerset House as they were occupying room which could have been used for a museum. His secretary, W. R. Deverell, was particularly anxious to be rid of them and planned their abrupt departure. In October 1848 the class was removed, without prior consultation with the superintendent, Mrs McIan, to a house in the Strand to form a separate Female School. This house was packed with young ladies of thirteen years upwards, installed in four small living rooms and two attics, all lit from the south, the entrance being through a soap manufacturer's shop.[13]

The chief concern of Fanny McIan and the fond Victorian parents was the respectability of the site, or rather the opposite. All the young ladies were 'from the better and educated class ... daughters of physicians, solicitors, artists ... in a very respectable phase of life', and Mrs McIan complained that the school was very near the south end of Drury Lane and her girls might be mistaken for actresses. She said that 'when the school was at Somerset House there was a respectability about

it'. An irate father complained in the *Art Union* that the school was 'in a bevy of gin palaces, old clothes shops, pawnbrokers, etc. and with numerous ramifying alleys leading to purlieus of contagion and infamy'.[14]

However, despite its environment and despite the fact that the Committee and headmasters neglected to visit it, the Female School surprised the Board of Trade by producing work superior to that of the males at Somerset House. Wilson had already found it necessary to introduce a second list of prizes to prevent the girls acquiring them all, and when exhibitions were held at Somerset House, their work was always praised. Even when the *Art Union* condemned the exhibition wholesale in 1847, a rider added 'we must however except the Female School'. Moreover, although it was alleged during the Select Committee of 1849 that the male classes at Somerset House hardly produced a designer during its existence and the *Art Union* doubted 'if more than a dozen have made their way to factories or obtained employment', the Female School not only enabled some ladies to support themselves as designers but actually sold pupils' designs for silverware, pottery, chintz, lace, bookbindings, title pages and wood engravings to manufacturers. Of course, the superiority of the females' work was not confined to the Head School, it was fairly universal. The great Gladstone commented upon this phenomenon at the prize-giving for Spitalfields School in 1848.[15]

The chief reason for the superior standard of the girls' work was due to their intelligence and education, but a contributory factor was, as some wags suggested, that they had been neglected, and thus spared the attentions of the artists on the Council and of the directors, headmasters and inspectors; so, uncluttered with eclectic advice, and free from the casts which Mrs McIan rejected, pleading insufficient room, the practical-minded and artistic females forged ahead. A class for wood engraving was set up, and much drawing and painting from plants was done. Mrs McIan had visited the École Royale de Dessin in 1844 and had noted how much the Parisians worked from nature and plaster models of nature. It is significant that the floral and fruit panels painted by her pupils were often praised.

Unlike the male school, Mrs McIan's establishment had a long waiting list. Only seventy pupils could be crammed in the building and the superintendent thought that her charges should have more spacious accommodation. She particularly resented the removal of the class from Somerset House because she suspected that Deverell and Poynter had engineered the move to provide room for the new junior Elementary Class under W. H. Deverell, the son of the secretary. Fanny McIan was not one to keep quiet about grievances, and Henry Cole was delighted to draw attention to her complaints as further examples of mismanagement.

FINANCING THE SCHOOLS OF DESIGN

Another easy target for criticism was the system of financing the Schools of Design. From the outset the Board of Trade had given administration of the whole annual grant of £10,000 for public art education to the Council of the Head School, and the Council gave its own school the lion's share, with no conditions attached, while the provincial Schools were only allowed a sum equal to the local donations and subscriptions, up to a maximum of £600 a year. Unfortunately the Schools usually set their annual expenditure according to the previous year's budget, and if the sum of the promised subscriptions fell by £200, a like amount was not forthcoming from the Council, so the local School fell into debt to the tune of £400. John Sparkes, later head at Lambeth School of Art, remarked that 'very few localities kept the engagement'. The influential manufacturers on local committees pestered the Board of Trade, who then felt compelled to ask the Council to make up the debts to ensure the survival of the branch Schools. Cole remarked that 'in many places – the more the Government aided, the less the locality did for itself'.[16] The salaries of the masters were paid out of the Parliamentary grant and were fixed annual salaries, varying from £150 to £300, based initially on the importance of their posts. These were in the nature of personal contracts and were proved a little absurd when masters, such as Hammersley of Manchester or Wilson of London, moved to less important posts and took their guaranteed salaries with them. The final contribution of the Council to the provincial Schools was free gifts of examples (casts, lithographs, engravings, models and drawing cards) and books.

The system of finance proved a failure. Most of the Schools of Design had fallen into debt and only seventeen had been established in the first ten years; in the words of the *Art Union*: '– ten years' labour has scarcely produced a mouse, an expenditure of little short of £100,000 has originated hardly an atom of benefit to the Manufacturers of Great Britain.'

The regulations of 1843 circulated by Lefevre on Dyce's behalf had an adverse effect on the finance of the branch Schools. Lefevre wrote: 'It is termed a School of Design, not of Drawing. Nor is it a School of every kind of design, but for one kind only, viz. Ornamental; to which accordingly all the exercises of the pupils . . . must have a reference.' This instruction discouraged local philanthropists, such as the great calico printers James Thomson and Edmund Potter of the Manchester committee, from making generous contributions. Potter queried how middle-class persons could be expected to subscribe to institutions for artisans in which their own artistic offspring were not welcome. This made the schools a mere charity. Potter said that 'when we sought to

increase the subscriptions, we were met with the objection that the school was intended to be of no benefit to anybody except calico printers – and that, in fact, it was not an Art school'.[17]

Cole realized the financial disadvantages of this situation and he later commented disapprovingly that the Board of Trade had 'absolutely excluded middle-class students from Schools of Design, or were always attempting to do so'. With no fees from the middle class and no examinations to test progress, the Government seemed to be faced with dispensing many more thousands as charity for the dubious improvement of the artisan class. Henry Labouchere, the President of the Board of Trade, was determined at all costs to prevent this.[18]

THE SELECT COMMITTEE ON THE SCHOOL OF DESIGN, 1849

The assault which Cole mounted on the Head School had several prongs, as might have been expected from the son of a Dragoon Guards' officer. While the *Journal of Design and Manufactures* harassed on the flank, Cole made use of the same frontal attack as was used to demolish the Records Commission and old postage system, namely, the Select Committee. Charles Milner Gibson, M.P. for Manchester, proved his ally and obtained a Select Committee on the Schools of Design on 10 March 1849.

All the witnesses served Cole's purposes, for, though many expressed opinions contrary to his, all the conflicting views, especially those of the management, inspectorate, and staff, suggested utter confusion to the public. Some witnesses proudly insisted that the Schools were schools of art which did not profess to produce designs, others claimed they should be schools for training designers, but were in fact mere elementary drawing schools, no better than previous classes in Mechanics' Institutes. The majority of the manufacturers confirmed the public's fears that they did not employ ex-students of the Schools as designers. A perspicacious 'Birmingham Manufacturer' was convinced that Cole had selected these witnesses, and in a letter to the *Art Journal* enquired: 'Can you inform me by whom the selection of witnesses for examination before the committee was made?'

Cole himself gave evidence and stressed, among other things, the absurdity of the fact that the Schools concentrated on drawing form and ornament, whereas the real economic need was for teaching designers for prints on calico and for woollen cloths. He made the point that cotton was the greatest manufacturing industry and that its annual production was eight times as large as its nearest rival, wool. Cole was careful not to antagonize the three headmasters at Somerset House. It was the management he had to abolish to attain power, and he stressed in evidence that, although these headmasters (who had all designed for his

Summerly's Art Manufactures) had 'distinguished themselves in Ornamental Art', the artists on their Committee of Instruction knew nothing about it. The headmasters, particularly Redgrave and Herbert, pleased Cole by their evidence which also questioned the competence of the artistic management. Their evidence infuriated the 'Birmingham Manufacturer', who complained that these responsible 'professional criminals' had assumed the character of judges and even this was tolerated.[19]

Cole placed before the Select Committee the three reports drawn up by him for the Board of Trade, in the last of which he had suggested hopefully that it was essential to make the responsibility for running art education definite and individual. Cole did much work briefing the chairman, Milner Gibson, and when the sittings were concluded he drew up the Draft Report on Gibson's behalf. He had performed the same service for Charles Buller in order to bring down the Public Records Commission; indeed, Buller referred to him as 'the attorney for the prosecution'. The Draft Report on the School of Design was not quite so successful. It was so strong against the management of the School that the Select Committee could not approve it. A more favourable report was agreed upon and the rejected report was appended. Cole saw to it that his draft became widely known through his *Journal of Design,* where it was praised as a masterly digest of the evidence, but the rival publication, the *Art Journal,* provided space for Ralph Nicolson Wornum, the lecturer in the history of Ornamental Art to the Schools of Design, to reply. Wornum had been incensed by a paragraph in Cole's draft which referred to the abstruse nature of his lectures and concluded that 'your committee have great doubts of the propriety of their continuance'. Wornum welcomed the rejection, asserting that:

> '. . . it would have been strange if such a masterly digest of evidence as that unique pattern book, the *Journal of Design,* terms it, had met with any other result. The chief fault of this draft report is doubtless that it is too masterly – the sifter deserves great praise for his dexterity. . . . The upshot of all this sifting appears to be that the Schools of Design will never be of any use to the community until a "well paid" deputy-president be appointed to control the whole working machinery of the Schools.'[20]

The publication of the evidence of the Select Committee proved the start of the death knell for the Schools of Design. The system survived only because Cole was too preoccupied with his work on the Executive Committee of the Great Exhibition; in his own words: 'The preparation for the Great Exhibition of 1851 arrested the further prosecution of the idea of giving to the School of Design a practical direction'. However,

the dissolution of the management was carried on inexorably by Labouchere and Granville. Immediately after the Select Committee the Board dissolved the Committee of Management and so got rid of the last Royal Academician on the governing body, Sir Richard Westmacott.

The new committee of 1849 was very much a part-time body, consisting of the chief officers of the Board of Trade, Labouchere, Granville, Northcote, Porter, and J. Booth. Redgrave, headmaster of the Class of Colour, and Poynter, the inspector, often attended. Labouchere, Granville and Redgrave were all friendly admirers of Cole and the only important opponent of his schemes on the committee was Stafford Henry Northcote (1818–87), later Earl Iddesleigh, a rising politician destined to be Chancellor of the Exchequer. A classical scholar and an amateur of the arts, Northcote's Tory background made him more favourable to the idea of an art school than a *gewerbeschule*, and he was both amused and amazed at Cole's pragmatic concept of a school of design producing patterns for Government purchase. Northcote was the only member of the committee who might have organized an efficient management to check Cole, and the latter breathed a sigh of relief when Northcote resigned from the Board of Trade in 1850. Cole commented gratefully in the *Journal of Design* that anarchy would follow.

The headmasters of the School, Redgrave, Herbert, and Townsend, could hardly have been expected to resist Cole strongly. All had designed for Summerly's Art Manufactures, and, through Cole's influence, the Queen had purchased some of their products. Ralph Wornum, who had chosen to attack Cole's Draft Report in the *Art Journal*, lest the history of ancient ornament be swept out of the Schools, soon felt the full weight of Cole's counter-attack. For example, in 1850 it was rumoured that the Head School was moving to Marlborough House because the floor of the Great Room at Somerset House had been declared unsafe. Some wags suggested that the weight of the 1,550 plaster casts in the building was the cause of the peril, but Cole's journal took the view that it was Ralph Nicolson Wornum's ponderous vocabulary; indeed, 'the weight of his sesquipedalia' might collapse the floor 'and jeopardise the lives of his crowded audience'. In the same year the *Journal of Design*, while quoting Redgrave's lectures at length with approval, published three severe criticisms of Wornum's together with a letter from one of his audience in the Potteries, asserting that his lectures were 'much above the heads of the people' who wished to be taught designing for pottery.[21]

Before Cole became too preoccupied with the Great Exhibition of 1851, one last blow was aimed at the Schools of Design which made their position more untenable. The Council of the Society of Arts, called by some 'King Cole's Court', decided in 1850 to promote art schools for artisans, and on 1 May the North London School of Drawing and

Modelling was set up in St Mary's Terrace, Camden Town, with the help of a donation of £25 from Prince Albert, the Society's president. The illustration of this school (Plate 8) from the *Illustrated London News* of 17 January 1852 is particularly interesting. It clearly shows, from left to right, the male class for ornamental drawing from the Round and the male class for linear geometry from the Flat in the Drawing School, and some of the segregated ladies, who have finished their work in the Modelling School, listening to the drawing master. The central ornament to the right of the clock was the best known ornament of the period, the Trajan Scroll. As it is nine o'clock the class is nearly ended, and a young artisan is being directed by the attendant, who aptly stands by the rules board, to place his portfolio neatly upon the others.

COLE HAS HIS WAY

The success of the Great Exhibition, with its credit balance of £213,305, caused the Queen to award Cole a C.B. on behalf of a grateful Prince Albert, who wrote to him after the Exhibition closed:

'You have been one of the few who originated the design, became its exponent to the public, and fought its battles in adversity, and belong now to those who share its triumphs, and it must be pleasing to you to reflect how much you have contributed to them by your untiring exertions, as it is to me to acknowledge my sense of them. Believe me always yours truly

Albert'[22]

Henry Labouchere (1798–1869), later Lord Taunton, had been (as President of the Board of Trade) *ex officio* the Government's chief representative on the Commission for the Exhibition of which Granville was Chairman, and they had both witnessed Cole's efforts to ensure its financial success. Both these members of Lord Russell's administration believed in competitive free trade and self support, and the success of the Exhibition without any Government subsidy gave them great satisfaction. It must have been no surprise to Cole when, on 31 October 1851, Granville offered him the secretaryship of the Head School. Cole was in such a position of strength that he could afford to defer until he was offered a proper department of the Board of Trade.

Cole's diary of 14 January 1852 records: 'walked with Mr Labouchere to see the House of Commons, and to the Board of Trade – Asked me to undertake the management of the Schools of Design.' The following day Cole wrote a letter to Labouchere from his home at The Terrace, Kensington, suggesting that 'a Department of the Board of Trade should be created, analogous to the Naval and Railway Departments,

having a special secretary, through whom all the business should pass for the decision of the President or Vice-President. . . . Such a name as the "Department of Practical Art" would I think, be well understood and appropriate'.[23] On 26 January Cole was invited to meet Labouchere at the Board of Trade and his principle of a new department was agreed. Cole was instructed to submit detailed proposals.

His battle for a department virtually over, Cole arranged for the cessation of the *Journal of Design* in 1852. It had now served his purpose. Its termination was a pity, for, like most of Cole's works, the *Journal* had elements of originality. Unlike the *Art Journal*, it was an attempt to produce a magazine wholly for designers and manufacturers, and included actual pieces of printed textiles from leading firms. It is of handbook size, convenient for the designer's desk and pocket. Cole probably regretted its passing, but he could hardly have edited a popular periodical on design as head of a Government department.

Sources

1. COLE, SIR HENRY *Fifty Years of Public Work* G. Bell, London, 1884 (in two volumes; some of the chapters are by Cole, others were written up from his notes by his son, Alan S. Cole, and his daughter Henrietta, who edited the work after his death) (Vol. I, p. 109)
2. Ibid. (Vol. I, pp. 106–7)
3. HILL, SIR ROWLAND, and HILL, G. BIRKBECK *Life of Sir Rowland Hill* Thos. De La Rue, London, 1880 (Vol. I, pp. 295, 447)
4. FITZMAURICE, LORD EDMUND *The Life of the Second Earl Granville* Longmans, Green, London, 1905 (p. 395)
5. COLE, SIR HENRY *Fifty Years of Public Work* G. Bell, London, 1884 (Vol. I, p. 110); and *Sessional Papers, 1849* Select Committee on the School of Design (p. 350)
6. *Art Union*, 1847 (p. 415), 1848 (p. 31)
7. *Sessional Papers, 1849* Select Committee on the School of Design (pp. 30, 45)
8. Ibid. (pp. 403–4)
9. *Art Union*, 1847 (p. 230), 1848 (p. 279)
10. *Art Union*, 1849 (p. 231)
11. *Journal of Design and Manufactures*, March–August 1849 (Vol. I, p. 21), September 1849–February 1850 (Vol. II, p. 111), September 1850–February 1851 (Vol. IV, p. 28)
12. *Journal of Design and Manufactures*, September 1851–February 1852 (Vol. VI, p. 30); and *First Report* of the Department of Practical Art, 1853 (p. 35)

13. *Sessional Papers, 1849* Select Committee on the School of Design (pp. 119–21)
14. *Art Union,* 1848 (p. *366*)
15. *Art Union,* 1847 (p. *309*), 1848 (pp. *31, 366*); *Sessional Papers, 1849* Select Committee on the School of Design (pp. 119–21)
16. SPARKES, J. C. L. 'Schools of Art' *International Health Exhibition Literature* London, 1884 (Vol. VII, p. 794); and *Sessional Papers, 1864* Select Committee on the Schools of Art (p. v)
17. *Letter* from J. Shaw Lefevre, Secretary of the Board of Trade, to the Secretary of Manchester School of Design, 8 March 1843; and *Sessional Papers, 1864* Select Committee on the Schools of Art (p. 123)
18. *Sessional Papers, 1864* Select Committee on the Schools of Art (pp. 27, 34–6)
19. *Art Journal,* 1849 (p. 287)
20. Ibid. (p. 349)
21. *Journal of Design and Manufactures,* March–August 1850 (Vol. III, pp. 63, 96, 121, 154)
22. COLE, SIR HENRY *Fifty Years of Public Work* G. Bell, London, 1884 (Vol. I, p. 203): Letter from Windsor Castle, 15 October 1851
23. Ibid. (Vol. I, pp. 295–6)

7

Sociological —
Art Education For Whom?

'. . . assuredly it will take time to remove a very
general impression of its utter incapacity for all
practical and really useful purposes.'
Art Union (comment on the Head School of Design[1])

Before we can fully understand the provision which Cole organized for
public art education, it is essential to know the various classes of
persons who felt the need of it in the mid-nineteenth century.

In the eighteen-forties the greatest threat to continued Parliamentary
investment in art education had been the vexed problem of provision.
The official policy of the Board of Trade that the Schools of Design were
provided to improve the skill of artisans in manufactures ignored several
classes of the public who felt the need of art education, and who were not
only attending the Schools, but were also supporting them by their fees.
To learn what classes of society were making use of the Schools of
Design, it is useful to study lists of classes provided throughout the day.
The time-table below is typical and lists the classes given in most of the
Schools.

Morning Male (or Public or Artisans') Class	7 a.m.–9 a.m.
Special Gentleman's (or Amateur) Morning Class	9 a.m.–12 noon
Special Ladies' (or Ladies' Private) Class	1 p.m.–3 p.m.
Governesses' Class	6.30 p.m.–9 p.m.
Public Evening Classes: Male (or Artisans')	6.30 p.m.–9 p.m.
Female	6.30 p.m.–9 p.m.

Male pupils were classed as gentlemen or artisans, though in both
categories some were mere boys. The female pupils were classed as
ladies or governesses (often 'reduced gentlewomen') or females. Even
the lowest category of females were considered to be socially above the
male or artisans' class, since these girls were usually considered lower
middle class, being daughters of poor clerks, shopkeepers, teachers, and

so on. These females were protected from the attentions of the artisans by being compelled to quit the building in the evening before the male class was released.

Not only did many pupils of the Schools of Design come outside the plans of the Board of Trade for artisans, but the headmasters themselves had never been trained to instruct artisans in design. Young Mitchell at Sheffield, J. Z. Bell at Manchester, W. C. T. Dobson at Birmingham, J. Patterson at York, J. A. Hammersley at Nottingham, and W. Bell Scott at Newcastle were drawn from an existing class of teachers known as 'the drawing masters'.

THE DRAWING MASTERS

The drawing masters were ex-students of the private academies in Britain, France and Italy. Their first aspirations had been directed towards becoming a High Artist honoured by the Royal Academy, but when they had encountered difficulties, those who did not desert the art profession became poorly-paid drawing masters. Of the masters mentioned above, only one, W. C. T. Dobson, attained the rank of Royal Academician and that many years after he had quit the field of public art education.

The poverty of the unsuccessful artists who took up the precarious existence of drawing masters and mistresses was such that they became figures of ridicule. The drawing teacher was 'the Pill Garlick of his profession, his boots cracked, and hat as seedy as ever', commented a contemporary drawing master.[2] The direct picture of the plight of the drawing master was painted by Thackeray in his article 'The Artists' in *Heads of the People*.

'Poor Rubbery, the school drawing master! Highgate, Homerton, Putney, Hackney, Hornsey, Turnham Green are his resorts; he has a select seminary to attend at every one of these places; and if from all these nurseries of youth, he obtains a sufficient number of half-crowns to pay his week's bills, what a happy man is he!' Soho was the artists' quarter, and poor John Rubbery set out from there on some weekdays to walk the twenty-five-mile round of his places of employment. The artist shown with Rubbery on Figure 4 is a more successful colleague, Sepio, who is giving private tuition in water colours to a young lady.

The drawing master was not paid a salary even if employed in a grammar school. He invariably received a fee per pupil instructed. He did not teach them basic principles of drawing, applied to real objects; indeed, had he done so, his services would not have been retained. It was understood that his task was to help his middle-class charges to make presentable copies of landscapes, ruined abbeys, and castles, from engravings and lithographs; 'something for a wet half holiday' as one

SEPIO.

RUBBERY.

For him light labour yields her wholesome store;
Just gives what life requires, but gives no more.

Not worth a halfpenny; Sold for a guinea.

4 From 'The Artists' by W. M. Thackeray in *Heads of the People*

master remarked. Unlike his fellow teachers, the drawing master had no diploma, degree, or official certificate of proficiency. This was a great drawback and after certificates for art teachers were introduced by the Board of Trade in the fifties, the number of privately-trained drawing masters rapidly decreased.

However in the forties and early fifties it was the drawing masters who were recognized as teachers for the educated, whereas teachers in the Schools of Design were looked upon as mere instructors of artisans, with the exception of a few headmasters. Some middle-class families were so certain that the Schools were 'not right' socially that they would not employ drawing masters who taught or attended classes there. The committees of the provincial Schools of Design preferred to put a privately-trained drawing master in charge, especially one skilled in water colours, whilst former students of ornamental drawing in the Schools occupied inferior teaching posts. An ironic criticism of this policy appeared in the *Journal of Design* in 1850 from 'A Landscape Painter who has not been very successful in his profession'. He asked how one qualified for a master's post, since one did not need a training in ornament, and he went on to suggest that Kendal or Keswick would be a more appropriate locality than Manchester for that city's landscape school (the School of Design).

Henry Cole, who had this letter published, did not regard either the drawing masters or the former students of Schools of Design as com-

petent teachers of drawing for designers or of technical drawing, and he decided that the most pressing need was a national school for training certificated art masters to teach the various classes of people who needed art instruction.

LADIES AND FEMALES

Although Victorian worthies were fully agreed that public money should be spent on art education for the male artisan 'of the humbler classes', rather than upon the middle-class male, yet, by a strange paradox, when they considered the art education of the female it was the middle-class young lady who occupied their thoughts, not the female of the operative classes.

The *Art Journal* pointed out that 'it is with respect to the respectable classes our question has the chief pertinancy . . . Suppose a British bank collapses or Death makes a call upon the head of the family – what is to become of her then?', and the *Journal of Design* noted that there was 'a preponderance of half a million of the female sex' and that these 'respectable young women should be assisted to make for themselves an honourable occupation'.[3]

When the North London School of Drawing and Modelling opened its doors to females in 1850 it was to provide 'the means of obtaining an independent income'. Even as far afield as Philadelphia, Pennsylvania, the reason given for provision was similar. Mrs Peter, a leading citizen, wrote that owing to young men going West, there was an increasing number of young women dependent upon their own resources, and that 'the School of Design opens at once the prospect of a useful and not ignoble career'.[4]

However, when working class girls were considered, the Victorians were very uncertain of the merits of any education other than training in morals and habits for these future operatives, housewives, or domestic servants. Eliza Meteyard gave the typical Victorian viewpoint in her articles on female education in the *Popular Educator*, when she stated that her articles did 'not refer so much to reading and writing, or grammar or accounts as to such things as habits, manners, personal cleanliness, neatness, etc'.[5]

An article in the *Art Journal* in 1861 gave the view that art education was pointless for working-class girls, since their career was labour. Earl Granville did not share this view. The noble lord had attempted to reassure the public by relating how he had met 'a most munificent promoter' of education in the Manchester Exhibition of 1856, who had assured him that art education 'was bad for a very large class of those brought up in our schools – namely those girls who were destined to be domestic servants'. The gentleman feared they would become distracted

and get ideas above their station. Granville assured him that art education would teach them precision and neatness.[6]

The demand for art education for the better-class females was so great, especially in London, that, as we have seen earlier, the young ladies selected for the Female School of Design were 'from the better and educated class'.

The tuition of ladies had been, and still was in 1850, the mainstay of the drawing masters. The chief purpose of this private art tuition, although many claims were made for it, was to occupy maidens' minds with a harmless pursuit. Many tedious methods were devised to pass the hours, and Thackeray commented upon them: 'Mezzotinto is a take in, Poonah painting a rank villainous deception. So is Grecian Art without brush or pencils; these are only small mechanical contrivances, over which young ladies are made to lose time.' However, as long as safe subjects were chosen, such as Kenilworth Castle or Tintern Abbey, Alice was as well occupied as in collecting shells, skeletonising leaves, or pressing grasses.[7]

Painting in water colours was considered a particularly safe occupation for a young lady; their misty glow could transform English meadows into Elysian fields. Gordon Roe commenting on this view of the edifying qualities of water colours quoted a comic epitaph: 'She painted in water colours. Of such is the Kingdom of Heaven.'[8] Even the English meadows were unsafe for ladies in the company of bachelor tutors, and mammas preferred governesses or approved married drawing masters. Their apprehensions on this score must have been increased by the seduction of Mrs Effie Ruskin by her handsome drawing instructor, Millais. Samuel Austin, the Liverpool water colour artist, was dismissed from the Liverpool School for Young Ladies by the headmistress, who told him: 'You are altogether too good looking and on the days you are here the girls can think of nothing else.'[9]

The task of the drawing master or mistress in the private seminaries was to ensure that each of the fee-paying young ladies produced a presentable copy of an engraving to be viewed by their mammas on the annual open day. Ruskin mentioned how the drawing master 'with courteous unkindness permits the young women of England to remain under the impression that they can learn to draw with less pains than they can learn to dance'.[10] Thackeray suggested unkindly that the drawing teacher 'in the course of the year, has done every single stroke . . . but when the young ladies are mammas, . . . can they design so much as a horse, or a dog or moo-cow for little Jack who bawls out for them? – not they'.[11]

The Schools of Design, and later the Schools of Art, fulfilled two main needs for females. Firstly, the ladies could learn from the headmaster

how to paint landscapes and flowers, and secondly, the Schools promised a career as a governess or freelance designer to the less fortunate 'reduced gentlewomen' or 'daughters of decayed tradesmen'. In most of the Schools there were separate Ladies' Classes, often larger than the Female Classes, but at the Head Female School there was no segregation since all the pupils qualified as ladies, and about seventy more gentlewomen were usually on the waiting list. Class distinction was a serious problem; for example, at Chester School of Art in 1863 the headmaster had to decide whether the daughter of a local minister of religion was superior enough for his Select Ladies' Class or too respectable for his Female Class.

Public provision of art education for wealthy young ladies caused many outcries in Victorian times, especially from the private drawing masters who were being gradually deprived of a livelihood. Public education was regarded as a charity for the poor and provision for ladies in Government schools was regarded as a misappropriation of charitable funds. In 1849 the Select Committee on the Schools of Design had noted with concern that at the York School there were 'seven ladies on the books of the school, who certainly ought not to be there – four relations of wealthy clergy and three of a wealthy doctor's family'. This attitude did not only apply to art education, of course, but to any class in an institution supported by Government grants; for instance, a government inspector visiting a Sheffield cooking class was flabbergasted when a female pupil exclaimed: 'I am awfully gone on that, I must show our cook.'[12]

The headmasters would have been foolish to discourage such young ladies. Their presence encouraged fond mothers to pay fees so that their own daughters could mix with such respectable epople. It was said that at York 'the school was greatly strengthened by the accession of these ladies'.[13] The ladies not only paid full fees but busied themselves organizing bazaars which produced for some Schools more than half their annual income. For instance, at Warrington in 1854 the Christmas Bazaar and Tree brought in £138 out of a total income of £265. Some large occasions such as a ball for the Spitalfields School of Design or the Bloomsbury Female School could bring in a thousand pounds or more.

Henry Cole, by conviction a pragmatist and a Utilitarian, had no intention of excluding the ladies.

GENTLEMEN AND ARTISANS

Although provision for young ladies in reduced circumstances was generally approved, the presence of middle-class gentlemen in Government schools was not.

Art was the last profession to be considered fit for a gentleman. The

earliest advocates of art education for the gentry argued the pleasurable and cultural aspects of art for the courtier, and its utility for the man who governed, never suggesting art as a profession, lest, as Sir Thomas Elyot feared, 'someone will scorne me, sayenge that I hadde well hyed me to make of a nobleman a mason or peynter'.

Elyot, whose *Boke named the Governour* (1531) was the first English book to urge art education, saw art as a necessary part of child develop-ment – as natural expression, for he wrote: 'If the childe be of nature inclined, as many have been, to paint with a penne or to fourme images in stone or tree, he shulde not be therefrom withdrawen or nature be rebuked . . . he shulde be, in the moste pure wise, enstructed in painting or kervinge.' He also referred to a child who, 'gatherying to him all the parts of imagination, endevoureth himself to expresse lively . . .'.[14]

A gentleman, Elyot ventured to suggest, might practise art for the useful purposes of field sketching, map-making, geometry, astronomy, and cosmography. Art, useful for military and naval gentlemen, had already been stressed by Baldassare Castiglione in *Il Libro del Cortegiano* (1528), which was translated into English by Sir Thomas Hoby in 1561. The Italian had mentioned art, from which 'there ensue many commodities, and especially in warre, to draw out the Countries, Platformes, Rivers, Bridges, Castles, Holdes, Fortresses . . . which though a man were able to keepe in his mind (and that is a hard matter to doe) yet can he not shew them to others'.

Castiglione also urged that a courtier without art education could not fully appreciate the beauty of landscape, 'a noble and great painting, drawne with the hand of nature and of God', nor the beauty of women, for even those 'that doe enjoy and view the beauty of woman so tho-roughly that they think themselves in Paradise, and yet have not the feate of painting . . . should conceive a farre greater contentation, for then shoulde they more perfectly understand the beauty that in their brest ingendreth such hearts ease'; moreover, a painter could 'expresse the grace of the sight that is in the black eyes, or in azure with the shining of those amorous beames'.[15]

Until the nineteenth century, Latin, Greek, reading, and writing, sometimes with a little arithmetic, constituted the formal education of a gentleman, and it was not claimed that art should be a serious subject of study but rather a spare time pursuit. Comenius (1592–1670) suggested that children of four or five should be supplied with chalk to make dots, lines, hooks, or round Os, 'either as exercise or amusement', and advised parents: 'It may be useful to put chalk into their hands, with which they may delineate on a slate or on paper, angles, squares, circles, little stars, horses, trees, etc., and it matters not whether these be drawn correctly or otherwise, provided they afford delight to the mind.'[16] Richard

Mulcaster, Henry Peacham, John Brinsley, and John Dury, school-masters and tutors of the sixteenth and seventeenth centuries, linked drawing with writing, and stressed its use for other subjects. Peacham anticipated the drawing book methods of the nineteenth century. 'For your first beginning and entrance in draught', he wrote, 'make your hand as ready as you can in those general figures of the Circle, ovall, square, triangle, cylinder . . . for these are the foundations of all other proportions'.[17] John Locke (1632–1704), in agreement with Castiglione, recommended drawing for a gentleman so that he could put down what he saw for later use by himself and others.[18] However, in spite of all the recommendations, drawing for young gentlemen was mainly confined to the military and naval academies until the second half of the eighteenth century, when attitudes changed owing to the rejection of puritanism and the revival of native fine art accompanied by the social ascent of the Royal Academicians. Thenceforth drawing masters for ladies and gentlemen were in demand, but no educated person considered being a designer.

When the members of the Select Committees of 1836 and 1849 were considering the Schools of Design, a number of them realized that there was a need to raise up a new class of designers to compete with the well-educated designers of France, who were kept constantly employed by British manufacturers. Referring to England, a textile merchant asserted that he was 'not acquainted with any drawer of patterns, who is an educated artist', and a Glasgow cotton printer reported that the designers in Paris were 'of a much higher class of men – they are more respectable'.[19] R. N. Wornum, the lecturer at the Head School of Design, remarked that, while the British artisans were 'excellent putters-on and squarers-up, in other countries designers have been a distinct class for years'.[20] Thackeray wrote about how French art students 'comport themselves towards the sober citizen . . . from the height of their poverty, they look down upon him with the greatest imaginable scorn – a scorn, I think, by which the citizen seems dazzled, for his respect for the arts is intense. The case is very different in England where a grocer's daughter would think she made a mesalliance by marrying a painter.'[21]

There were two main viewpoints in the mid-nineteenth century. The first, supported by the Royal Academicians on the Council of the Head School, by the clergy, indeed by most of the public, was that public art education was a charity provided for the improvement of artisans. The second, progressive but unfashionable, viewpoint was that the best way of producing a new class of designers was to encourage all social classes to enrol at the Schools.

Bishops chaired several School of Design committees, and clergymen

wrote books on drawing. Canon Richson's books 'for the humbler classes – based on principles strictly philosophical', the Bishop of St Asaph's *Outlines*, and the Revd R. St John Tyrwhitt's *Handbook of Pictorial Art* were popular books approved by the Government.

The moral benefits of art education can be gathered from Tyrwhitt's book. This handbook by a pupil of Ruskin was frequently awarded as a Government drawing prize to instil wisdom into the artisans. It is fascinating to listen to this owl Tyrwhitt awhile. 'All success must be won by hard and systematic exertion, which will save him from lower desires . . . Nobody expects that the whole of the working classes will at once take to drawing and entirely renounce strong liquor – but many may be secured from temptation to excess . . . Teaching children good drawing is practically teaching them to be good children.'[22]

The progressive view of a comprehensive School of Art for all classes had received a severe setback by the Government regulations of 1843 which stressed that 'no person making Art his profession should be eligible for admission as a student' in a School of Design, and by the insistence of William Dyce that students should state their future employment in order to guard against the artisans' ambitions to become fine artists. The heads of the provincial Schools, some of whom were trying to raise the status of their institutions, were vexed by these regulations. Young Mitchell, the head at Sheffield, wrote that what was needed was 'a class of highly educated men' as in France.

Pupils of the artisan class did not, as the headmasters pointed out, stay in the Schools, nor were they regular attenders during their short stay. The situation in the Ryde School was typical. 'The number of persons of the artisan class at present on the books is 35, but the average attendance of such persons was but 16 or 17 at a time.' It is easy to get the wrong impression of the student body of a nineteenth-century art school from the various employments of the pupils given in the register. The young artisans enrolled were largely transient and the permanent pupils were the governesses, young architects, teachers, amateurs and skilled craftsmen. Edmund Potter, chairman of the Manchester School, said that artisans valued the school 'very little. I judge by their attendance.' The headmasters, replying to a circular of 1863, reported that artisans never stayed long enough to win prizes or medals, and that the better-educated pupils were the reliable ones. The head at York went so far as to set up a completely free class for young artisans to persuade them to stay on later as fee payers.[23]

From a sociological viewpoint it is interesting to note the Science and Art Department's definition of an artisan: a working man in receipt of daily or weekly wages. E. A. Davidson, headmaster of Chester School of Art, had his own definition. 'If the father is not rated for Income Tax,'

he ruled, 'or if the son earns his own living by weekly wages, I call him an artisan.' Sparkes, head at Lambeth, ridiculed the Government's definition. He said that some of his engineer pupils, classed as artisans, earned between two and four pounds per week, whereas clerks, not classed as artisans, received an annual salary which worked out at fifteen shillings per week. However, since Government medals, prizes and grants were intended for artisans only, heads chose to regard everyone who could possibly be so-called as an artisan, such as master craftsmen, prosperous engineers, decorators, jewellers, architects, sons of wealthy tradesmen, and so on. Art students had to enter their 'station' on their examination papers, and one examinee, hopeful of payment, is recorded as entering 'occupation – scholar'.

The true 'children of the labouring poor' rarely availed themselves of the provision intended for them, for, as Edmund Potter said of the young Manchester calico printers, 'it is not likely that tired and dirty at six o'clock they will walk one or two miles to an Art School, before they go home, they will not and do not do it'.[24] The artisans were not at fault; the Elementary Drawing that they were required to do was as stultifying as the putting-on and squaring-up they did in the factory pattern-shops during the day. What they sought was some experience of finer art. Their objections to the mechanical type of drawing introduced by Dyce have already been fully discussed.

The headmasters' quest for permanent and reliable male fee-payers in order to acquire respect and recognition for their schools was very difficult. Ruskin commented: 'It is surely therefore to be regretted that the art education our Government schools is addressed so definitely to the guidance of the artisan, and is therefore so little acknowledged hitherto by the general public.'[25] Although the Schools advertised morning classes 'for the higher grade of society' or 'for persons of superior condition' at the rate of a guinea a quarter, such males were not usually forthcoming. The exclusion of life drawing and landscape as a result of the regulations of 1843, had caused a withdrawal of middle-class pupils from the Schools, which were no longer regarded as proper schools of art. Elementary Drawing and drawing casts or ornament had no appeal for the middle class. An ex-student of Manchester School of Design recalled young gentlemen from the Athenaeum coming 'on a Wednesday evening, but they were soon satisfied, as drawing from casts was not so easy'.[26]

Cole gave the contemporary middle-class viewpoint when he declared that 'art is regarded as a luxury in education, permissible to girls, but unnecessary for boys'. The view of a Victorian mother was given by Hubert von Herkomer, R.A., who described how she asked if her son could enrol in his art school, because a nice light occupation would

just suit her boy, who was in fact 'not quite right in his head'.[27]

It will be seen later how the sure hand of Henry Cole steered the Schools of Art on a course which satisfied the public, yet encouraged headmasters to enrol the middle class.

CHILDREN IN THE PUBLIC DAY SCHOOLS

'A common child is as difficult to understand as a colt
or puppy, and almost as different from the young artist or
designer as any colt or puppy can be.'
H. Grant[28]

It is surprising to consider that, in a period when parochial teachers were desperately trying to teach the three Rs and religious instruction to poor children, most of whom attended for less than two years, it was thought important to introduce drawing lessons. Actually, the church societies considered drawing to be a suitable practical exercise for improving children. In 1836 the secretary of the Central Society of Education had written: 'Drawing has hitherto been looked upon as a polite accomplishment, in which it is graceful to be proficient . . . It however affords great aid in defining, expressing and retaining certain ideas . . . and must assist in the formation of habits of attention from the circumstances of its requiring so much care and accuracy.'

There were no art masters in the societies' public day schools, but some progressive managers encouraged the teachers to give drawing instruction to large numbers of children. In the Model School of the British and Foreign School Society in London a Mr Crossley instructed five to six hundred children in a large room; 'pencils and paper are not used, but the desks are painted black, and a black line of a foot in depth is painted round the school-room; on these the boys draw with chalk geometrical figures, birds, animals, machinery and maps; we were struck by the spirit of some and the precision of others. The map of the world is so impressed upon the memory of the children, that they draw it from recollection faithfully and with readiness.' A boy was selected at hazard out of the highest class and he drew a complete map of Europe immediately on request.[29]

The teachers often did not demonstrate themselves. The school could purchase sets of diagrams of simple objects mounted on pasteboard, each large enough to be observed by fifty children at a time. At Chester one valiant teacher taught upwards of one thousand pupils from the blackboard, with the multitude split into classes under monitors. In the forties and fifties many of these elementary teachers were following the system of the Government *Drawing Book*, drawn up by William Dyce, proceeding from copying straight lines to geometrical figures and thence

to the outlines of simple ornament. The teacher at Chester showed more initiative than this system of mere copying. He marked in the lines of construction of cubes, pyramids, and so on, and catechized the children about their structure, often leaving parts of the drawings unfinished on the board to make the children puzzle out the rest.

Some teachers drew on the blackboard while the pupils drew after them line by line upon their slates. Other teachers started off by handing out copies on pasteboard, but this individual or group copying had disadvantages. A quick or careless boy could finish his slate drawing in a few minutes; the master might not get round to his work for at least fifteen minutes, and 'this quarter of an hour,' wrote Henry Grant, a teacher and author of a drawing book, 'is spent by the healthy boy chiefly in wasting his materials and kicking, shoving, or otherwise impeding his slower or more painstaking neighbours'.[30] Most of the pupils worked on slates with slate pencils, or with chalk on painted desks or wainscots. Pencils and paper were considered expensive media, though some teachers did recommend them to promote neatness as 'a discipline for the faculties, which has been the main object with regard to the children who have used it'.[31]

It is surprising how many art school teachers agreed with copying straight lines and geometrical shapes as the most appropriate art for children. As in other periods they seem to have been creatures of contemporary fashion rather than educationists. Some of their recommendations (such as those of J. Kyd, head at Worcester School of Art) were so geometrical as not to be freehand drawing at all. D. Raimbach at Limerick, G. Newton at Durham, and G. Stewart at Macclesfield suggested that it would be enough if the teacher checked the monitor's copies. Stewart asserted that copying Roman capitals from the flat would be suitable art for these poor children.

The most adventurous courses were being suggested and started by educationists, not by art teachers. Some of the infant schools were many years ahead of the art schools, for whereas the art masters encouraged purely mechanical copying from the flat and from the cast throughout the century, infant schools, as early as 1838, were giving lessons on well-known objects, which the children were allowed to handle, and teaching children to mix colours.[32]

In the fifties the Bishop of Sodor and Man conducted an experiment in the parochial schools of his diocese to find out what would arouse the interest of the children and concluded that the copying of geometrical lines and simple ornament as advocated by Dyce was wrong, and that drawing familiar objects was the answer. Another educationist of the period, the author of a *First Steps in Arithmetic*, in 1849 outlined in the *Journal of Design* a course had been conducted with success in a village

school in Kent. The course included drawing objects which need no perspective, memory drawing, border patterns, sketching with black conté and white chalk on brown paper, figure drawing, inventing patterns, and original composition. Unfortunately the identity of this progressive educationist is not revealed in the *Journal*.

The need for provision for Elementary Drawing in the day schools had been constantly urged by the staff of the Head School of Design, who resented the presence of elementary students in their establishment. Their employers, the Board of Trade, were also concerned about the low standard of drawing which was affecting the design of British products; but the Board had no control over the public day schools. The only solution seemed to be for the Board to provide its own Elementary Drawing schools, but there was a serious drawback to this scheme. The advanced classes at many Schools of Design were so unsuccessful and badly attended that a withdrawal of elementary classes would have left some of the Schools with no *raison d'être*.

The organization of a national system of drawing in the public day schools was to be Cole's great task.

Sources

1. *Art Union*, 1848 (p. 31)
2. *Art Journal*, 1858 (p. 307)
3. Ibid. 1861 (p. 107); and *Journal of Design and Manufactures*, September 1851–February 1852 (Vol. VI, p. 31)
4. *Art Journal*, 1850 (p. 362)
5. *Popular Educator* Cassell, Petter, and Galpin, London, n.d., c. 1880 (Vol. I, p. 65)
6. *Art Journal*, 1857 (p. 353)
7. THACKERAY, W. M. *Heads of the People*: 'The Artists' G. Routledge, London, 1878 (p. 166)
8. ROE, F. G. *The Victorian Child* Phoenix, London, 1959 (p. 118)
9. MARILLIER, H. C. *The Liverpool School of Painters* John Murray, London, 1904 (p. 56)
10. RUSKIN, JOHN 'Education in Art' (1858), supplement to *A Joy for Ever* (1857) George Allen, London, third edition 1893 (p. 220)
11. THACKERAY, W. M. *Heads of the People*: 'The Artists' G. Routledge, London, 1878 (p. 165)
12. BINGHAM, J. H. *Sheffield School Board, 1870–1903* Northend Ltd, Sheffield, 1904
13. *Sessional Papers, 1849* Select Committee on the School of Design (p. 364)
14. ELYOT, SIR THOMAS *The Boke named the Governour* (1531) J. M. Dent, London, 1907

15. HOBY, SIR THOMAS *The Book of the Courtier* (1561) (translated from Castiglione, B. *Il Libro del Cortegiano* Aldus, Venice, 1528) J. M. Dent, London, 1928

16. COMENIUS, JOHN AMOS *The School of Infancy* (1633) University of North Carolina Press, Chapel Hill, N.C., 1956

17. PEACHAM, HENRY *Compleat Gentleman* (1622) Clarendon Press, Oxford, 1906

18. LOCKE, JOHN *Some Thoughts concerning Education* (1693) Cambridge University Press, 1934

19. *Sessional Papers, 1849* Select Committee on the School of Design (p. 90); and *Sessional Papers, 1836* Select Committee on Arts and Manufactures (p. 28)

20. *Art Journal*, 1852 (p. 16)

21. THACKERAY, W. M. *Paris Sketch Book* Smith, Elder, London, 1869 (pp. 38–9)

22. TYRWHITT, R. ST JOHN *Handbook of Pictorial Art* Clarendon Press, Oxford, 1868 (pp. 2, 6, 14, 371)

23. *Sessional Papers, 1864* Select Committee on Schools of Art (p. 129); and *Art Journal*, 1855 (p. 351)

24. *Sessional Papers, 1864* Select Committee on Schools of Art (pp. 108, 129)

25. RUSKIN, JOHN 'Education in Art' (1858), supplement to *A Joy for Ever* (1857) George Allen, London, third edition 1893

26. CROZIER, R. *Recollections, 1879* MS (Manchester Reference Library 709.42 M2)

27. HERKOMER, SIR HERBERT VON *My School and my Gospel* Constable, London, 1908 (p. 67)

28. *First Report* of the Department of Science and Art, 1854 (p. 59)

29. Central Society of Education *Papers* Taylor & Walton, London, 1837 (Vol. I, pp. 7, 172)

30. *First Report* of the Department of Science and Art, 1854

31. *Journal of Design and Manufactures*, March–August 1849 (Vol. I, pp. 122–4)

32. Central Society of Education *Papers* Taylor & Walton, London, 1839 (Vol. IV, p. 45)

8

Schools of the Department of Science and Art

'When we want steam, we must get Cole.'
Prince Albert[1]

THE ESTABLISHMENT OF THE DEPARTMENT OF PRACTICAL ART

The period from 1852–73, during which Henry Cole directed public art education, saw the most rapid increase of art institutions in British history and included the establishment of the first training school for art masters, the first Government art examinations and teaching certificates, the first state art education in the public day schools and the training colleges, the first art masters' association, and the first great museum of applied art, later to become the Victoria and Albert Museum. A national system of art education was set up of such thoroughness and rigidity that it truly merited the name 'cast iron'.

One of the last offices of Henry Labouchere as President of the Board of Trade, before the fall of Lord Russell's administration, was to ensure that Cole had his way. On 16 February 1852 the Board of Trade, with Labouchere in the chair, authorized the creation of the Department of Practical Art of the Board of Trade, and a few days later the Schools of Design were informed by a circular letter to their committees from G. Richardson Porter, Secretary of the Board, that 'their Lordships . . . have made the following arrangements, with a view to their more efficient management. . . . A department of the Board of Trade has been created, called "The Department of Practical Art". This department consists of two officers, called Superintendents of Schools of Practical Art, and a secretary. . . . My Lords have been pleased to appoint Mr Henry Cole to the first mentioned of these offices, namely, that of superintendent of the business of general management; and Mr Richard Redgrave to that of art superintendent.'[2]

The *Art Journal* complained in despair that 'the mischief has been entirely the work of Mr Labouchere, the late President of the Board of

Trade'.[3] However, Henry Cole had come into his kingdom, which he was to rule and enlarge for twenty years.

When Cole assumed office and took over supervision of the twenty-three Schools of Design in Great Britain, the Central School was still in Somerset House. There was no provision in this school for the widely varying careers of the students, nor was there any proper system of progression. Future craftsmen, teachers, clerks, and designers could be found in any class, for once a student had passed out of the Elementary Class, he usually managed to enrol in the class of his choice and stayed there.

The first task which Cole set himself, as General Superintendent, was to separate the various functions of the Central or Head School and the priority was to obtain the necessary separate accommodation for each.

His first acquisition was part of Marlborough House, which he obtained from the Queen on the excuse of needing room to display some objects purchased from the Great Exhibition. Cole moved his Department into this building so quickly, once he had heard that permission had reached the Office of Works from the Palace, that the Board of Trade had not even received confirmation of the move, and, in his own words, 'I was upbraided with having taken possession with the full intention of using the place'.[4] Cole had, in fact, not only the full intention of using the first floor as a museum, but also intended to use the second floor for special technical classes, and did so later in the year. He could not take possession of the ground floor without pushing the Vernon Collection out into the Mall, but he did insinuate a ladies' class into the kitchens.

Cole next secured rooms in the Literary and Scientific Institute in Great Smith Street, Westminster. The Elementary Drawing Class was removed from Somerset House and opened at the Institute on 2 June 1852 as the Elementary Drawing School.

The Head School at Somerset House, renamed the Metropolitan School of Ornament for Males, was put under one headmaster, Richard Burchett, and a training class for art masters for the Schools of Art was established there. The Female School of Design, then at Gower Street, was renamed the Metropolitan School of Ornament for Females, and its class of wood engraving was moved to the second floor of Marlborough House to join the Special Technical Classes which Cole was establishing there.

The Provincial or Branch Schools were renamed Schools of Practical Art, and it was Cole's intention that they should concern themselves with Elementary Drawing and supplying the Metropolitan Schools with good students.

The pattern of provision which Cole established in 1852, and which is

now discussed in detail, continued until the last decade of the century.

PROVISION FOR TEACHER TRAINING IN ART

'The great work that is before the London School is to form a normal school of people competent to teach,' Henry Cole had stated before the Select Committee of 1849.[5] Whereas the managers of the Schools of Design had constantly affirmed that their chief purpose was to train ornamental designers and improve the artisans for the Board of Trade's purposes, Cole had assumed a definitely educational viewpoint. The prospectus for the new courses at Marlborough House made the point that anybody could attend 'without reference to preparation for any special branch of industry',[6] and the first annual report of the Department of Practical Art stated that the object of the Class for Training Masters was 'to secure a uniform system of sound elementary tuition throughout the country'.

In the following year a circular sent to H.M. Inspectors by the Council on Education noted that 'the Department of Practical Art has determined to encourage the multiplication of common drawing schools, and to confine the schools of design to a few districts in which application of art may be studied with advantage by persons already instructed in the rudiments of delineation'.[7]

The Council on Education may have believed that Cole intended to provide for schools to train designers, but the local Schools of Art did not. In actuality Cole had planned two main areas of provision: firstly, for a central training school and art museum, and secondly, for schools of elementary art in the provinces which would teach parochial children and feed the expensive central institution with candidates for training as art masters. During 1852 and 1853 Cole and Redgrave gave a series of lectures in Schools of Art on the importance of Elementary Drawing, and on 28 February 1853 they were up at Manchester lecturing 'on elementary instruction in Art'. The Committee of the Manchester School seemed very much aware of Cole's intentions and its members protested: 'We are not prepared to be reduced to the rank of an infants' school or nursery for the metropolitan establishment at Marlborough House.'

The provision which Cole organized for training teachers of art fell into three categories: training existing schoolmasters and school-mistresses, training pupil teachers and students in training colleges, and training masters for the Schools of Art.

TRAINING SCHOOLMASTERS AND SCHOOLMISTRESSES IN ELEMENTARY DRAWING

'Elementary Drawing in National Education was the new principle brought into activity in 1852,' claimed Henry Cole.[8] Ever anxious to

demonstrate the practical side of his art department, Cole quickly took steps to bring it into direct contact with the public day schools. A post of Teachers' Training Master was created and J. C. Robinson, who had distinguished himself as a teacher of the advanced classes at Somerset House, was appointed.

The duties of the Teachers' Training Master were firstly, to visit the National and Public Elementary Day Schools to instruct teachers in Elementary Drawing; secondly, to supervise instruction given in the London schools by masters-in-training of the Department; and thirdly, to prepare teaching manuals and drawing examples for copying. The Training Class for Schoolmasters, Schoolmistresses, and Pupil-Teachers met on two evenings a week and on Saturday afternoons, and the London teachers were so keen to attend that Robinson had seventy teachers and pupil-teachers in the class by the fourth meeting. They had to pay a fee of ten shillings per session, which was a considerable sum in 1852.

The course consisted of eight stages of the National Course of Instruction, which had just been drawn up by Richard Redgrave, the Art Superintendent, and Richard Burchett, the headmaster (see Appendix C). These eight stages, numbers 1, 2, 3, 4, 5, 6, 7, and 13, constituted the Primary Course for Schools which the teachers were expected to repeat for the children after graduation. The first part of the training course was called Elementary Drawing from Flat Examples, and the teachers commenced it by copying out an exercise, which the Department had just produced as an entry test for admission to any Elementary Drawing Class, say in a School of Art. This consisted of drawing three large capital letters, about 8 inches high, from examples mounted on a card, starting off with a simple straight A, then doing the simple circle of the O, and finishing with the double curve of S. Outlined and shaded diagrams of simple objects, ornament, and the symmetrical forms of leaves were then copied. The teachers were next given a short course on Linear Geometry with instruments.

Having now completed the first section of the course from the Flat, the teachers, 'thus armed with hand power, some training of the eye',[9] were then allowed to start the Elementary Course from Solid Examples. Robinson set simple solids and casts of ornament before them, and demonstrated how to give instructions on them from the blackboard. The teachers were next taught Linear Perspective using instruments, and the course ended with some of the most promising painting a flower in colour from a print supplied by the Department.

The complete course was intended to give their future pupils 'a power of close and refined imitation from the flat, knowledge of the elements of practical geometry, and the power of drawing objects themselves.

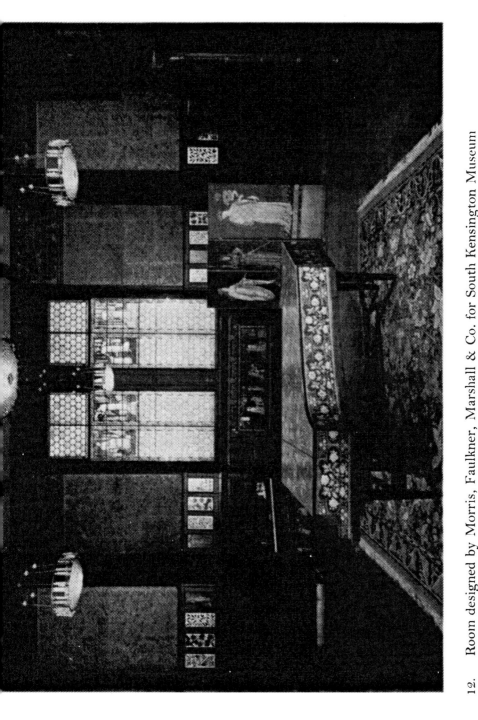

12. Room designed by Morris, Faulkner, Marshall & Co. for South Kensington Museum
Victoria and Albert Museum, Crown copyright

13. Cast No. 471 of the Department of Science and Art: scroll from the Forum of Trajan
14. Victorian artisan's nightmare? The cast and carvings of the Royal Architectural Museum, photographs of which were circulated to the Schools of Art

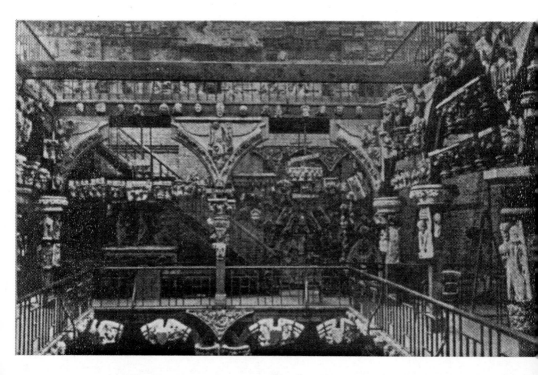

Redgrave maintained that geometrical drawing had to be practised before one could progress to drawing solids, such as casts of ornament, 'geometry being the basis of all ornament', as he put it. Redgrave believed that all drawing in schools should be 'strictly imitative'.[10] This course, which was conducted in Marlborough House, served as a model for the early drawing classes for teachers and pupil teachers at the local Schools of Art, and was propagated by the *Manual for Teaching Elementary Drawing* prepared by Robinson under the supervision of Redgrave, also by the production of a first course of elementary outline examples consisting of two sets of capital letters on cards and twelve plates of outlines large enough to be pinned or copied on to the blackboard and to be viewed by the whole class.

This first course for teachers and pupil-teachers was quickly succeeded (from 1853 onwards) by the extended course for pupil-teachers and students in Training Colleges, which could also be taken by serving teachers in the local Schools of Art.

TRAINING PUPIL-TEACHERS AND STUDENTS IN TRAINING COLLEGES

While Cole was rapidly expanding the activities of the Board of Trade in the field of art education, the Committee of Council on Education was endeavouring to introduce into the public elementary schools sound practical subjects which would improve the character of the future working man and make him more efficient.

The Committee took the first positive step towards the establishment of drawing on a national scale in 1853 when it made drawing compulsory in the Training Colleges by 'requiring evidence of a certain proficiency in drawing' from all students for whose examination the College received a grant. This regulation was affirmed by a minute of the Committee of 20 August 1853 which stated that 'an exercise in drawing will in future form part of each examination of the students. Their Lordships will seek the assistance of the Department of Science and Art in setting and testing this exercise.'[11]

Cole eagerly offered his services and the Committee asked the Science and Art Department to prepare a series of exercises for the Colleges' Christmas examinations of 1853. Cole and Redgrave not only provided examination papers, but also drew up a seven-year course, starting with exercises for first year pupil-teachers and ending with the final exams in the Training Colleges. This course consisted of freehand drawing, geometrical drawing, perspective, drawing from solid models, drawing from natural forms, and drawing objects from memory.

By the regulations of the Committee of Council on Education of January 1854 all apprentice or pupil-teachers were required to take one

examination in drawing each year. H.M. Inspectors of the Council visited the public day schools annually to supervise the examinations in reading, writing, and arithmetic, and it was decided that the drawing examinations could take place during these visits. The inspectors were required only 'to place the exercises in drawing before the pupil-teachers, collect such exercises, and transmit them to the Council with the papers on other subjects'.[12] The papers were then forwarded by the Council to the Science and Art Department for examination, and the Council later awarded a prize of water colours, or drawing instruments, or a book, worth £1, to each pupil-teacher who passed his or her exam.

Pupil-teachers could either study in their own school under a visiting or resident teacher certificated by the Science and Art Department, or attend the local School of Art at half-fees amounting to 3d per week. The Council pointed out that the pupil-teacher could now attend for forty weeks for a sum of 10s and win a prize worth £1 if he succeeded! The cost of materials was conveniently overlooked.

After the successful pupil-teachers had gained entry to the two-year Training College course they were required to take the Second Grade certificate papers in drawing in their annual Christmas examinations, and if, by the end of the course, a student had succeeded in obtaining a certificate for each of the four drawing papers of this grade, he had now obtained the Full Second Grade Certificate and was awarded the Certificate of Competency to teach Elementary Drawing, known in the eighties as the Elementary School Teacher's Certificate.

Every schoolteacher who obtained this certificate received an additional £1 in his annual allowance from the Council on Education. In addition to this, £1 was granted to the same certificated teacher from the Science and Art Department for every pupil-teacher under his instruction who passed the annual examination of the Department for pupil-teachers, up to a maximum of £3. He could also obtain payments of 2s or 3s for each successful paper passed by his pupils in the First Grade exams. Colleges appointed resident drawing masters certificated by the Department, and, although not many students obtained the Full Certificate (29 in 1857 and 62 in 1859, for instance), many were examined (1270 up to Christmas 1854), and obtained results satisfactory enough to encourage them to complete their Full Certificates in local Schools of Art after they had left College. For example, in 1867, 191 Full Second Grade Certificates were awarded to members of School of Art classes, many of whom were teachers.

ART MASTERS IN TRAINING AND THEIR CERTIFICATES

'Armed with certificates, diplomas and degrees we shall
mount on paper steps, fulfilling satisfactorily our tasks of
squashing out every spark of native insight
and self-sufficient genius.'
Howard Spring

The Class for Training Masters for Schools of Art was set up in
Somerset House in 1852 under the direct supervision of the headmaster,
Richard Burchett, and in August of the following year these art masters-
in-training were moved to Marlborough House together with the
general students to share the building with the Training Class for
Schoolmasters and the Special Technical Classes. All these together
comprised the Central Training School of Art, renamed the National
Art Training Schools in 1863 after the removal to South Kensington,
and eventually becoming the Royal College of Art in 1896. The move
from Somerset House (at the request of the Treasury, to make room for
the General Registrar of Births, Deaths, and Marriages) severed the
last link with the era of the Schools of Design.

Cole's intention was that the Class for Training Masters should
prepare specialist teachers of drawing for the local Schools of Art, and in
1852 he invited the local Schools to request students of eighteen years of
age to submit work to the Art Superintendent; if Redgrave approved
their efforts, they would be examined by Burchett. A successful applicant
was admitted to the Class in October and granted a maintenance
allowance of £1 for every week he attended. During his course the
master-in-training had to teach Elementary Drawing in the London
public day schools, in the general or model classes, and in the Training
Class for Schoolmasters.

When a successful student left he was granted a Certificate of
Competency for a Mastership. The first certificates, issued in 1853,
were testimonials that mentioned the stages of drawing instruction
which the holder was entitled to teach (say Elementary, Model, and
Freehand), but from January 1855 a series of six certificates of the
Third Grade were introduced, each one of which was obtained by
taking examinations in a group of related stages of the National Course
of Instruction. These were as follows:

1st: Drawing Group
2nd: Painting from Ornament and Nature (with Elementary Design)
3rd: Painting the Human Figure (with Anatomical Studies)
4th: Modelling Ornament (with Historic Ornament and Elemen-
tary Design)
5th: Modelling and Drawing the Human Figure (with Anatomical
Studies)

6th: Technical Group (Advanced Architectural and Mechanical Drawing)

The text of one of these certificates is given below. It is interesting because the certificates retained the same form throughout Cole's period of office, with the exception of the sentence on the annual value, the deletion of which caused the revolt of the art masters, described in Chapter 11.

> DEPARTMENT OF SCIENCE AND ART
> *Certificate for Art Instruction*
> Certificate of competency to give instruction in those stages of art which are classed as the Second Group.
> *Second Group – Painting Group with examination in Styles of Art*
> Stage 11. Painting ornament from copies *a*) in monochrome *b*) colour
> Stage 12. Painting ornament from the cast *a*) in monochrome *b*) colour
> Stage 14. Painting from nature *a*) flowers *b*) landscapes
> Stage 15. Painting compositions as studies of colour
> Stage 22. Elementary Design
> > *a*) Natural objects treated ornamentally
> > *b*) Ornamental arrangement to fill a given space in monochrome
> > *c*) In colour
> > *d*) Studies of historic ornament (drawn)
> *Annual value attached to this Certificate for the Second Group –* £10
> > Examined 11th day of July 1855 and passed
> > Lord Stanley of Alderley
> > President of the Board of Trade

By this date a candidate for the Training Class had first to obtain his Full Second Grade Certificate at a local School of Art and then spend a year or so there, until he was eighteen, teaching the Elementary Class and the children in the public day schools. During this time he had to submit eight examples of his work to Redgrave and, if these were satisfactory, he was asked to sit a general knowledge paper which included history and some mathematics, the first to ensure that he was capable of following the course on history of ornament, and the second because Cole required him to 'understand arithmetic, as far as the elementary rules of vulgar and decimal fractions and duodecimals and be acquainted with the proportions of the first book of Euclid's elements'– the fractions were necessary in order to ensure that he was capable of grasping proportions of areas of colours (see the 'propositions' of Owen Jones, Chapter 12, pages 247–8), of colours for mixing, and of ornament. Geometry was considered essential for all drawing, especially technical and architectural.

It was possible to leave the Training Class at the end of the first year

after obtaining the Third Grade Certificate of the First Group and teach in a local School of Art, and many did, but students could stay on and take one certificate after another. It was possible to obtain six full certificates (seven in the seventies), and by 1864 five art masters had been persevering enough to have each passed over fifty sections of the twenty-three stages of the National Course of Instruction, thus each obtaining five full certificates. Some of the masters-in-training came and went over a period of seven years, returning from masterships to the Training Class when they felt inadequate to perform their functions in the Schools of Art, and continuing in the class until they were re-appointed by the Department.

John Sparkes and Alexander Macdonald gave a clear picture of their arduous experiences as masters-in-training in their evidence before the Select Committee of 1864.

Sparkes entered the Training Class in October 1855 and followed the normal procedure of obtaining the certificate for the Drawing Group and then that of the Painting Group. He was next directed by Redgrave into the Special Technical Classes for mechanical drawing under William Binns, and he later complained: 'For two years I was not allowed to touch a brush, I was employed wholly in mechanical and architectural drawing – work which was particularly disagreeable to me.'[13] During this time he passed two certificates of the sixth or Technical Group.

No sooner had the masters-in-training entered the Training Class than they were put out on parochial teaching about which, said Sparkes, they complained very grievously. Macdonald, for instance, was put in charge of the drawing lessons at three parochial schools in his first year, and another student was actually taking eight schools for an hour's lesson per week. The schools had to pay £5 a year to the Department for the services of an art teacher, so the latter was earning £40 a year for Cole's establishment – considerably more than his grant. Students who stayed on after obtaining the first two certificates were required to teach the fee-paying students in the General and the Special Technical Classes for up to eight hours per week. The termination of the students' courses in the Training Class was entirely up to Cole, who used to appoint them to suitable vacancies at the local Schools of Art as they came up.

In order to encourage self-support and to remove any suggestion that local Schools could expect direct grants from the Department, a Science and Art Minute of the Board of Trade of 23 March 1853 laid down that the whole management and costs of the Schools of Art were the responsibility of their committees. This included responsibility for appointing staff, but in actual fact, although Cole maintained that this was so, he retained control over staffing, because a School of Art could not acquire approved staff for the Department's course of instruction

except from him, especially from 1856 onwards when an art master could not obtain the Department's payments on results unless he was certificated by them. In practice, Cole made it quite clear to local committees that if one of his certificated nominees was not appointed, he could withhold payments from any School, as can be seen later from the case of George Anderson at Coventry (see pages 213–14).

The *Art Journal* of 1864 recorded the case of a nominee of the Department who brought an Elementary Class 'to the verge of ruin'. The head was then sent another who could not 'draw as well as many girls in the schools', and after he resigned, a third was sent who was so dull and stupid as to interest nobody. However, the head said that he was taught the peril of protesting against the Department's nominees, as he was nearly removed himself.[14]

Alexander Macdonald in his evidence before the Select Committee of 1864 described how he had attempted to negotiate by letter with the managers of Dundee School of Art, and how Cole had rebuked him for daring to write to gentlemen of such standing. Cole ordered him to take the post on the managers' terms immediately, or to leave the Central Training School. Redgrave and Burchett advised him to comply. Macdonald used this episode to show that appointments were not made between the managers and the candidates, but by the Department. Art masters-in-training could be asked by Cole to take any post at any time after their first year, and would have been foolhardy to refuse to do so.[15]

The training of art masters remained virtually the same throughout Cole's period of office with the exception that, from 1862, the first art master's certificate could be taken at a local School of Art.

DRAWING FOR THE PUBLIC DAY SCHOOLS

The elementary schools, referred to in this book as public day schools, comprised the national and parochial schools, usually referred to in Government documents of that time as 'schools for the poor'. From 1852, boys and girls in public day schools in the London area were taught drawing from a Government syllabus, and by 1854 the subject was being taken throughout the country as a result of the recommendation of the Committee of Council on Education that Training College students and pupil-teachers should study and teach drawing, and be tested by examinations set by the Science and Art Department of the Board of Trade.[16]

From the outset, prizes and payments granted to these teachers seem to have proved so attractive that the Government became worried about both expenditure and the neglect of other subjects, and on 24 February 1857 the Committee laid down that if 'undue preference were given to Drawing over other necessary branches of instruction, or that Drawing

was not made conducive to good writing – these payments would be liable to be withdrawn'.[17]

The Primary or First Grade course for schools was strictly utilitarian and started with linear geometry and perspective, then continued with outlines of simple objects from the flat copy. After this the children were allowed to copy solid geometrical shapes, and then returned to the flat copy to draw outlines of the human figure and animals. The final achievement was drawing flowers in outline and painting them, both from flat copies.

Six casts of classical ornament usually gathered dust, pegged to the classroom walls, while the busts of Diana and the young Augustus stared with sightless eyes from the top of a press upon the plebians below. These casts, recommended by the Department for schools, were intended rather to instil an appreciation of art and ornament, than for any practical purpose. The First Grade course did not include such ambitious drawing from the round and even the figure and flower stages were rarely attained – firstly, because the pupils were kept practising the exercises required for the First Grade examinations, on the results of which the teachers received payments; and secondly, because they were instructed by the inspectors that drawing must not veer towards fine art.

The First Grade examinations consisted of four papers of a purely mechanical nature:

a) Freehand: Outline in pencil from a flat example of ornament.
b) Model: Outline of a geometrical solid, such as a cube.
c) Memory: Outline from memory of a common object.
d) Linear Geometry: Some easy problems in practical geometry.

Even the freehand paper was mainly mechanical, as it was a formal elevation, not a true view of the ornament, as can be seen from the example of ornament shown for First and Second Grade examinations at the top of Figure 6 (page 190).

The exercises were taught by certificated schoolmasters and pupil-teachers. The payments on results which the art masters received for children taught in connection with their Schools of Art were not contingent upon them actually teaching. They simply visited the schools and supervised the type of instruction given. The Birmingham School of Art Committee remarked: 'This connection is of the very slightest nature and consists in the occasional visit of an Art Master to each of the schools in question.'[18] Walter Smith, head at Leeds and the most successful propagator of Cole's system to parochial schools, did his task so well that by 1864 over 5,000 pupils were being taught in connection with his school, and it could claim payments for the employment of five local scholars (art pupil-teachers).

The insistence of the Education Department on mechanical imitation, to coordinate hand and eye and give habits of accuracy, was expressed clearly in a circular of 27 February 1858 to H.M. Inspectors of Education, which instructed:

> 'You should endeavour to disabuse persons of the notion that the kind of drawing which has been hitherto known as an accomplishment in schools for the rich, is that which would be taught under the present Minutes in schools for the poor. The kind of drawing which it is proposed to teach, is, in the strictest sense, an education of the eye, and of the hand, such as may indeed be the first step in the career of a great artist, but must at any rate enable the common workman to do his work more neatly and better.'[19]

The philosophy behind the practice of imitation was that it would make the mind operate accurately; and since, the Utilitarians insisted, drawing was as easy as writing, all intelligent children could learn to draw very accurately. The Victorians seemed to have had a wonderful aptitude for ignoring the evidence of their own eyes. Some art masters had other ideas. Robert Scanlan, head of the Cork School of Art, protested to Cole that he had known many children 'who with the utmost care and attention of the master, never could accomplish the simplest object laid before them'.[20] The head at Limerick, David Wilkie Raimbach, later head at Birmingham, James Astbury Hammersley, head at Manchester, Charles Heath Wilson at Glasgow, and Young Mitchell at Sheffield were prominent objectors to the stress on geometrical drawing, and to the idea that art could have a mechanical foundation.

A statement by the Reverend J. S. Howson, Principal of the Liverpool Institute, in which the School of Art was situated, pleased Cole so much that he inserted it in the *Science and Art Directory* of 1856. The reverend gentleman asserted, among other things, 'It is almost as easy to learn to draw a chair or a chest of drawers as to learn to set down your own Christian name and surname in real good handwriting.'[21] Mr Hannah, a member of the committee of the Carlisle School, shared this opinion, and said at the School's opening (in order to swell the entry) that drawing and writing were the same thing, since the alphabet 'was nothing else than making twenty-six imitations'.[22] Some justification for this theory could be maintained as long as the children were confined to slow mechanical drawing of outline from copies and of geometrical solids, and this was the practice until the early years of the twentieth century. R. Catterson Smith complained in 1901, when he was appointed head of the Birmingham School of Art, about current methods, 'flat copies being then almost wholly in use',[23] and Professor Nikolaus Pevsner states that during his own schooldays in Germany 'cubes and

spheres in outline were still my models'.[24] This was up to 1914.

The mechanical and imitative drawing imposed on the schools by Cole and Redgrave did not receive its *coup de grâce* until the nineteen-thirties, when Marion Richardson's exhibition of children's work in London finally convinced art teachers of the superiority of creative work, and brought a flood of colour into the dull classrooms, an especial boon to city schools. One of her pupils gave the perfect answer to advocates of exact imitation, when confronted with a group of objects to copy for the School Certificate course:

'Why should I copy that? It's there already.'[25]

SPECIAL TECHNICAL CLASSES AND THE SOUTH KENSINGTON WORKSHOPS

The most progressive move which Cole made in art education was his attempt to establish practical design classes on a permanent basis. The Special Technical Classes, established in 1852, were at first considered by Cole to be the most important function of the Department apart from the work in relation to the public day schools, and they occupied all the classrooms on the second floor of Marlborough House.

These classes were largely dependent upon Gottfried Semper, the German architect and designer, whom Cole appointed Professor of Metalwork, Pottery, and Furniture, and who helped to supervise the class for moulding and casting in plaster taken by Townsend and Brucciani. Special Classes for Enamelling and Painting on Porcelain were taken by John Simpson, for Woven Textile Fabrics taken by Octavius Hudson, for Chromo-lithography taken by Vincent Brookes and Miss Channon, and for Engraving on Wood (females only) taken by John Thompson, the notable engraver, and Annie Waterhouse.

The Special Evening Class in Architectural Detail and Construction was taken by C. J. Richardson, M.I.B.A. (the well-known Elizabethan revivalist), where the pupils were instructed in what we would today call building geometry and measured drawing, but in those days known as 'Practical Geometry applied to Masonry, Plastering, etc. and Architectural Details'. Lectures on historic ornament were given by Ralph Wornum, Librarian, Keeper of the Ornamental Casts, and Professor of Ornamental Art, and by Owen Jones, the famous designer and author of books of ornament.

All the students on the General Course (the private fee-payers) were allowed to study in the Technical Classes, provided that they had passed through the first six stages of elementary drawing of the Course of Instruction and had spent a period in the Special Class for Artistic Anatomy where Henry Townsend demonstrated from the living model and, occasionally, from dissections.

Cole, a confirmed Utilitarian, had suggested in 1849 that the Schools of Design 'might be made to produce designs for those articles which are used in several Government Departments, the Navy, the Army, the Office of Works, etc'.,[26] and he now put the female engraving class to work upon producing copies of diagrams and ornamental casts for circulation to the schools, while chromo-lithography students prepared copies of coloured ornament under the direction of J. C. Robinson.

Cole's first great chance to prove his theory of the usefulness of his Department came very quickly in the first year of its establishment. The Duke of Wellington had died on 14 September 1852, and after several designs for the funeral car, prepared by the Royal undertakers, had been rejected, the Lord Chamberlain turned to Cole, and the Department of Practical Art was requested to provide a design, which, as one would have expected, was promptly passed by Prince Albert.

Just three weeks were allowed for the production of the car, an enormous carriage seventeen feet high, twenty-seven feet long and eleven feet wide to be covered with all the necessary insignia, which task, Cole said, 'would reasonably occupy a whole year'.[27] Redgrave and Semper designed the car, Cole organized its industrial production, and fifty female students worked day and night under the direction of Octavius Hudson to produce the embroidered heraldry. The ponderous and ornate final product, which now rests in the crypt of St Paul's, was pronounced by a Victorian wit to be an unfortunate instance of 'most haste, worst speed'. Cole, true to his utilitarian beliefs, would have preferred something simpler, and said that 'it was, perhaps, less a reality viewed on true aesthetic principles than a simple bier borne by soldiers'.[28]

Unfortunately, this was the last important public result of the classes apart from the manufacture of copies for the schools. The classes were rather expensive to run, and the Department was intended to be as self-supporting as possible; also the museum was becoming the main attraction for the public and Cole had to effect economies so that every possible penny of the Parliamentary grant could be spent upon building up the collections. Another contributory factor to the lack of development of these classes for the Board of Trade's purposes was that Cole had realized the enormous possibilities of future finance through further connection with the Committee of Council on Education, and was rapidly steering all classes away from trade purposes towards teacher-training.

In 1855 Professor Semper left for Zürich, and there was nobody to replace him. Redgrave and Wornum did not believe that a student needed practical experience in different materials to understand how to design for them; he had merely to learn the principles, grammar and analysis of the sciences of ornament and of colour.

Professor Wornum had no idea of how a designer can acquire a feeling for a particular material. He regarded material as something a design could be 'put on'. He asserted: 'It was not how to apply a design but what to design . . . While the accomplished knowledge of Ornamental Art may be a matter of five years, the mere mechanical process of application is, in comparison, a mere matter of five hours.'[29] The Art Superintendent, Richard Redgrave, expressed similar views, albeit more glibly, saying: 'We do not want to teach men the art of weaving, but the Art of designing for weavers.'[30] How little they both knew of the possibilities of design evolving from practice with a material!

From 1855 the Special Classes became chiefly advanced classes for masters-in-training and for general students working for Third Grade Certificates in the Design Stages of the Course of Instruction. Edmund Potter, President of the Manchester School of Art, complained that even the trade classes at Marlborough House were now planned for the use of the masters-in-training and that 'The School was virtually converted into a normal training institute for teachers'.[31] After the move from the Board of Trade to the Committee of Council of Education in 1856, the Technical Classes were known as Advanced Classes and no further technical classes were set up at South Kensington when the School opened there in 1857. *The Engineer* reported that Cole had decided 'to abandon educating pupils in special technicalities'.[32]

Cole's next venture into the applied arts was the setting up in 1858 of the South Kensington workshops or ateliers. The staff and students of the Department were put to design and decorate the new buildings to be erected there. Captain Francis Fowke of the Royal Engineers was put in charge of the workshops, and Graham Sykes, a modelling master from Sheffield School of Art and a pupil of Alfred Stevens, was appointed in July 1859 to give Fowke artistic assistance. Fowke used first to have a consultation with Cole about the accommodation required and then draw up plans in order to make several models of the project. Working drawings were then executed on the basis of the approved model and Sykes, with some advanced students, made models of the architectural details under Fowke's supervision. The present quadrangle of the Victoria and Albert Museum was one of the first projects of the workshops.

A class of mosaicists was set up in 1862 and many mosaics were executed for the walls of the museum. The frieze around the Albert Hall was the work of this class. The elaborate decorations of the Ceramic Gallery were also carried out by students under the supervision of the designer F. W. Moody.[33] Cole not only used student labour, but he also had the bright idea of effecting an economy by using convicts to do some of the simple work such as inserting the black and white marble

chips in the floors of the cloisters, corridors and roadway of the museum, which he afterwards referred to as 'opus criminale'.[34] Members of the Royal Academy were also engaged for work in the museum, namely Frederic Leighton, George Leslie, Henry Pickersgill, Val Princep and Henry Marks; also Edward Poynter, who designed the tiles for the grill room. A notable and artistic work was the decoration and furnishing of a dining-room in the museum by Morris, Marshall, Faulkner and Company, with wall panels and windows by Burne-Jones (see Plate 12).

The works were commissioned on behalf of my lords of the Committee of Council on Education, but, as the *Art Journal* reported, it was a matter of 'my lords, alias Mr Henry Cole'. The advantage to Cole of maintaining the South Kensington workshops was that he could use the Parliamentary grants for erecting the museum exactly as he wished, without even the necessity of modifying his plans to satisfy architects. It seemed that there was a promising future for art students and gifted artists, working on Government projects – indeed, the spirit of the Italian Renaissance appeared to have descended upon South Kensington – but unfortunately, when Cole resigned in 1873 the Treasury removed control of the erection of the museum from the Science and Art Department and transferred it to the Office of Works. Four years later the employment of students in the museum ceased, and the workshops closed.

THE GENERAL STUDENTS

Cole's whole system was designed to extend education in drawing to schools throughout Britain, and as a result the vast majority of students in the Schools of Art were very little involved in his plans. They had no intention of teaching in a Government School of Art, nor in a public day school. Government teachers were not regarded as gentlemen; in fact, they were hardly 'respectable', as can be judged from the decision of the Newcastle Commissioners of 1861 that schoolmasters could never be promoted to inspectorships because their 'previous training and social position' made them unfit 'to communicate and associate upon terms of equality with the managers of schools and the clergy'.[35]

The students in the Central Training School were divided into these categories: art masters-in-training, free students and national scholars training to be designers, and the general fee-paying students. The last category comprised at least nine-tenths of the student population during Cole's period of office. Every student in the School took his certificates by following the General Course in the four General Classes of Drawing, Painting, Modelling, and Composition in Design, and some progressed to the Special Technical Classes. The fee-paying general students could attend any classes, take any certificates, use the Museum, and stay in the School as long as they wished.

The general students were not approved of by the public, unless they were ladies in reduced circumstances, but they were a very important part of the revenue of the Department, and Cole encouraged their attendance.

There were many females in the Central Training School's classes, but the 'ladies' were segregated at the Female School of Art, Gower Street. Cole moved the old Female School of Design to Gower Street in 1852, and consoled himself for the expenditure on superior accommodation by doubling the fees and halving the number of staff per student. Several students, including Rosa Bonheur, later exhibited at the Royal Academy, and Laura Herford, the first female to be admitted as a student to the Royal Academy Schools, was trained there. The Gower Street School was a very select seminary, patronized by the Queen, and later by the Princess of Wales. One Fancy Bazaar could raise thousands of pounds and, as a result of royal patronage and the financial exertions of the ladies, new premises were opened in Queens Square, Bloomsbury, in 1861.

The ladies and other general students who paid full fees in local Schools of Art, if put together, outnumbered the prospective teachers and artisans for whom the schools were meant to exist. This was the case, for instance, even in an industrial city such as Manchester in 1863. Out of 368 students, only 46 could possibly be classified as artisans, and 73 as teachers and pupil-teachers, leaving 249 students of whom 22 were schoolboys; 58 of these 249 were actually classified as amateurs and 48 as 'students'.[36] In country Schools of Art such as those at Truro and Penzance the art masters were almost entirely dependent upon the boys and young ladies, as were also the masters in old county cities such as York and Norwich.

It was unusual for an educated young man to study in a Government School of Art though many unsuccessful attempts were made to encourage them. In Liverpool, for example, in 1862 'an offer was made to arrange morning classes for gentlemen (fee, one guinea per quarter for 2 hours per week), but there seems to have been little or no demand for them and after 1866 the offer was withdrawn'.[37] As might have been expected, it was a different matter with the Morning Ladies Class, which became so numerous that the ninety ladies had to be divided into two classes. The Liverpool mothers were obviously very keen to place their daughters under the expert tuition of the headmaster, John Finnie, whose landscapes were regularly exhibited in the Royal Academy. The Manchester School of Art also had a thriving landscape class under J. A. Hammersley, while the Sheffield School under Young Mitchell and the Newcastle School under William Bell Scott were particularly successful at cultivating fine art. The Liverpool School grew so fashion-

able that a special Private Day Class for Ladies was 'opened by the Headmaster, in which they are taught such branches (landscape, etc.) as they desire to acquire without the tedium of the more disciplinary method laid down in the *Art Directory*'.[38]

The students who paid full fees often carried out the exercises of the Government's course of instruction and submitted them for medals, but hardly any of them aspired to be designers, or ornamentists as they were then called. It was very difficult to obtain positions and they were badly paid. Many of the students hoped to become fine artists in this age of Leighton, Watts, Millais and Landseer, when more paintings were being sold than in any other half-century. The Class of the Living Model was popular with such aspiring artists.

THE NUDE: CLASSES OF THE LIVING MODEL

Redgrave and Burchett, like Dyce, did not believe that drawing from the nude model was an important factor in the training of a designer as the French did, and the Department's course of instruction ruled out the possibility of any stress upon it. Cole, however, was no prude and was not averse to the study of the nude; in fact, on one occasion he had taken Queen Victoria in to view some nude studies by William Mulready, R.A. (against the advice of Edward Cardwell, President of the Board of Trade), during a royal visit to the National Competition Exhibition at Gore House. Cole approved of any class, provided that it brought in more fee-payers to support the Schools, but he threw all responsibility on to local committees because of clerical opposition. Rule 148, which he drew up for the *Science and Art Directory*, laid down: 'When there are sufficient numbers of students who can draw and paint the figure from casts, and the nude figure becomes desirable, the arrangements for that purpose should have the written approval of the committee.'[39]

This regulation, which made it necessary to give official approval to life classes, caused many of them to close, since there had been almost a conspiracy to pretend that the living nude did not exist. Life-drawing classes were not published on the official lists of classes printed each year for the benefit of the public, and only the headmaster was allowed to take such a private class and pose the model. How unpleasant it had been at Manchester when a model had been found moaning in the corridor outside the headmaster's room 'by a gentleman and a lady'. Life classes were suspended for over a decade, after it was noised abroad that there was a living nude female on the premises.[40]

Charles Bowyer Adderley, M.P., who, as Vice-President of the Committee of Council on Education, was Cole's chief in 1858, had a particular objection to life drawing, and not only tried to suppress it during his period of office but two years later, when in Opposition,

brought to the attention of the House of Commons the fact that large numbers of young men in the Hibernian Academy, which was connected with the Science and Art Department, 'had been permitted to be present when women were sitting as models, not for the purpose of Art study, but to gratify a prurient feeling of curiosity'. This information followed a motion put down by Lord Haddo who, with the support of thirty-two members of Parliament, proposed that Government grants should be withdrawn from any Schools of Art where 'the living female model is engaged'.[41]

Victorian educationists, who were mostly clergymen, were happy about the character training given by years of 'students' drill' with an HH pencil under a 'well drilled South Kensington teacher' but they were unsure of other aspects of art training. A student might develop 'art emotion' and become morally disturbed. Even Ruskin's cry of 'Truth to Nature' was thought dangerous if applied to the nude. Ruskin, himself an advocate of 'true and good' art, was embarrassed by the problem of the nude model and preferred to ignore it, hoping that his admonitions about pagan and infidel classic art, and his references to the 'dark carnality of Michelangelo', would discourage drawing from the nude.

One of the strangest aberrations of Victorian morality was the shielding of female classes from the female nude. Up till 1893 in the Academy Schools female students were not permitted to draw from the nude, but at this late date they were allowed to draw and paint a partially draped male nude. A few years later this practice 'became universal for female students'.[42]

One can only conclude that the Victorians had deep feelings of guilt about exhibiting the female nude, even to females. They could not in their puritan minds agree with Blake that 'The nakedness of woman is the work of God', and were so obsessed with the thought of the female body that it would never have occurred to them that a male body could be sexually attractive to a female, so it was permissible for young ladies to draw one. A male model was, of course, pretty amply draped, for even the baby cupids on Victorian Valentines usually wore skirts.

The female nude did not start to become respectable until that 'deuce of a swell' Frederic Leighton arrived on the Victorian scene. His high academic draughtsmanship and his statuesque classical nudes convinced many moralists that here indeed was noble High Art. G. F. Watts contributed to their conversion with his neutered nymphs. By the eighties the merits of an advanced student's work could be measured by his ability to convert the nude with his cast-conditioned eye into the semblance of an Ariadne or Apollo, and many a Greek nose sprouted on an English face. Drawing the nude was at last vindicated. High Art had now turned the unmentionable bare body into 'that noblest of visible

things', something as lofty as the Parthenon pediment. Morality was now satisfied, and there was little danger of a student developing that 'fleshly imagination' that Ruskin abhorred.

However, in Cole's day the influence of Leighton had not sufficiently permeated society, and general disapproval kept the number of life classes down; by 1863 only one in eight Schools of Art held them. Significantly, these included the Schools which obtained the best results in the National Competition of the Department: Lambeth, Sheffield, and Warrington.

ARTISANS' CLASSES

During the whole of Cole's period of office (1852–73) the stress was on education in drawing, not in design, and, as we shall see, all pretence to be teaching designing for trade to artisans was dropped after 1864 when artisans' classes were referred to as night classes for drawing. The artisans' evening classes tended to be filled with the lower middle class (such as clerks, builders, engineers, and young architects) and the term 'night classes' was more appropriate.

The failure to train youths of the artisan class was due to the refusal both of the Government and of the local manufacturers to provide scholarships for them to study in day classes. Art, especially Victorian Art, always was a time-consuming occupation and the tired artisan realized that he had no chance of covering the necessary ground in the evenings. It was common in Britain at this period to preach about the system of public art education being specially planned for the artisan, whereas the French were inclined too much towards fine art, but, in actual fact, there was much humbug in this. As has been shown, France provided free art education for the sons of factory workers, Britain did not. The British artisan even had to pay fees (though these were reduced).

The greatest paradox of the British system in Cole's time was that a member of the artisan class never darkened the daylight in the doorway of the Central Training School in London. To obtain one of the twelve to fifteen national scholarships awarded annually by the School to intending designers, the candidates had to have studied long enough in a School of Art to have obtained four Second Grade papers and to be sufficiently accomplished to obtain the highest award available – a national medal in the special design stages of the National Course of Instruction.[43] It is little wonder that these were won by youths of the lower middle class who usually turned to studying for the Third Grade teaching certificates once they were admitted.

Cole, unlike many of his contemporaries, did not stress the fact that the Schools of Art were provided for the improvement of the artisans,

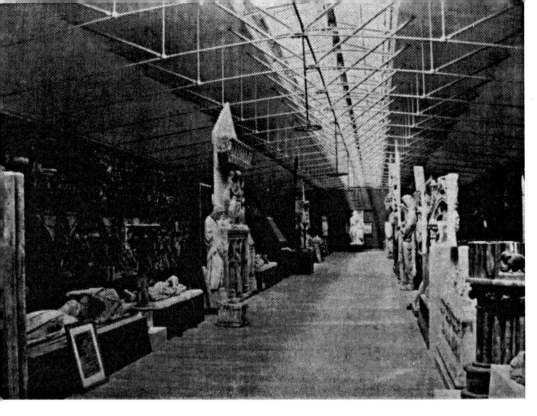

15. Museum of architectural carvings and casts in the 'Boilers' (*c.* 1860)
Victoria and Albert Museum, Crown copyright

16. The 'Brompton Boilers' before demolition (1890)
Victoria and Albert Museum, Crown copyright

17. '. . . gorgeous courts arise at South Kensington': the Quadrangle

Victoria and Albert Museum, Crown copyright

and on one occasion he had the temerity to say that schools were for all classes of students 'from duchesses' daughters downwards'. To give fixed grants to local Schools of Art for the maintenance of students of the artisan class would have been very much against Cole's principles, for, he said, 'the instant you begin to distribute public money – any amount you give never affords any satisfaction'.[44]

Cole held evolutionary views and believed that, provided plenty of Schools of Art and school drawing classes existed to diffuse knowledge of drawing, the meritorious would use these facilities to succeed. His basic philosophy was that the fittest would survive and that events always evolved towards an appropriate end at the right time – in his own words, 'Forces are always operating unseen, unknown, inscrutable. All events in the world, however trifling, naturally result from causes in action, and happen at their appropriate times.'[45] It was hardly to be expected that a man with such a philosophy would provide grants to help the lower members of human society.

Each section of the provision for art students which Cole organized has now been studied and to clarify our picture of the various classes in the local Schools of Art it is useful to look at the time-table which was approved by him for these schools in 1855.

TIME-TABLE

Mondays and Thursdays: Classes
Gentlemen's Morning Elementary, 11 a.m. to 1 p.m.
Ladies' Elementary, 2 to 4 p.m.
Boys' Evening Elementary (under 15), 7 to 8 p.m.
Artisans' Evening Elementary, 8 to 9 p.m.

Tuesdays and Fridays: Classes
Gentlemen's Advanced (or Special Class), 11 a.m. to 1 p.m.
Ladies' Advanced (or Special Class), 2 to 4 p.m.
Artisans' Evening Advanced Class, 7 to 9 p.m.

Wednesdays and Saturdays
Class for schoolmasters and pupil teachers, 6 to 8 p.m.

THE MUSEUM

*'Unless museums and galleries are made subservient to
purposes of education, they dwindle into very sleepy affairs.'*
Henry Cole

As we have seen, there had been an early attempt to provide an art museum in the Head School of Design during the directorship of Charles Heath Wilson, but after his dismissal in 1847 the casts he had collected were pushed on one side or out of sight. In 1852 Cole found them 'in all parts of the schoolrooms and buried in the cellars of Somerset House,

where a large collection was found in a neglected and ruinous condition, practically inaccessible to use and uncatalogued'.[46]

When Cole was appointed by the Board of Trade, the only specific reference to his duties as regards museums was his duty 'to report to my Lords on the preservation and arrangement of the collection of works of art in the possession of the schools'. Deverell, the Secretary, was put in charge of the library and of supplying works of art to the branch schools, but shortly after taking office Cole suggested that a collection should be made of ornamental manufactures from the Great Exhibition. Prince Albert was delighted and used his influence so that 'an authorization was obtained from the Lords of the Treasury by the Board of Trade, for the expenditure of £5000'.[47] Cole, Redgrave, and Owen Jones were given the task of selecting the exhibits. They chose textiles, ceramics, and metalwork from the British, Foreign and East India Company's stands, and in addition Cole was allowed by the Queen to search for artefacts in some of the rooms at Buckingham Palace, from which he carried away Sèvres porcelain 'worth £1000 from housemaids' closets in bedrooms'.[48]

The Queen next gave him permission to have all these acquisitions exhibited on the upper floors of Marlborough House, Pall Mall, a royal palace which was temporarily disused owing to the youth of the royal children. Her Majesty and the Prince Consort were interested enough to view the exhibition privately on the morning of Monday, 17 May 1852, and the Queen, noticing a deficiency of lace in the textile collection, had some sent from the Royal Wardrobe on her return to the Palace. This special mark of royal interest rather took the public by surprise and the *Illustrated London News* reported that, with such sympathies for the cause of industry and art, 'we need have no fear for the future, which can only be one of progress and ameliorated position for our working classes'.

This collection exhibited in Marlborough House was named the Museum of Ornamental Manufactures and was opened for the first time to the public on Wednesday, 19 May 1852. It was the nucleus around which eventually grew the great Victoria and Albert Museum. No sooner had the Museum of Ornamental Manufactures opened than Cole showed his intention of making it educational by arranging for Owen Jones to give a course of public lectures in the theatre on the ground floor, and, after the Museum was opened daily, a catalogue was provided giving details of the processes employed in the production of each object with some critical observations on its design.

THE CHAMBER OF HORRORS

After arriving at the top of the stairs on the first floor of Marlborough House, visitors on their way into the Museum had to pass through an

ante-room in which 'Examples of False Principles in Decoration' were 'exposed "in terrorem" – with the sentence of condemnation affixed to each'.[49] These horrors in the ante-room were contrasted with the objects that Cole, Redgrave, and Owen Jones had selected from the Great Exhibition, which represented the 'Correct Principles in Decoration'. Owen Jones declared in the catalogue of the latter:

> 'There are here no carpets worked with flowers on which the feet would fear to tread, no furniture the hand would fear to grasp, no superfluous and useless ornament which a caprice has added, and which an accident might remove. . . . We have no artificial shadows, no highly wrought imitations of natural flowers, with their light and shade, struggling to stand out from the surfaces on which they are worked, but conventional representations founded upon them.'[50]

This attempt to educate the Victorian public was dubbed 'The Chamber of Horrors' and on 4 December 1852 an amusing article, entitled 'A House Full of Horrors', appeared in *Household Words*, a weekly periodical conducted by Dickens. It described how a Mr Crumpet had returned from seeing these exhibits 'haunted by the most horrid shapes.

> 'I could have cried, sir. I was ashamed of the pattern of my own trousers, for I saw a piece of them hung there as a horror. I dared not pull out my pocket handkerchief while anyone was by, lest I should be seen dabbing the perspiration from my forehead with a wreath of coral. I saw it all; when I went home I found that I had been living among horrors up to that hour. The paper in my parlour contains four birds of paradise, besides bridges and pagodas.'

This episode ridiculed the Department's condemnation of designs which used representations of real animals and plants. Poor Crumpet's moment of truth came as he was draining a cup of tea. 'Butter – fly – inside my cup! Horr – horr – horr – horr – ri – ble.'[51]

Cole was so enthusiastic about his 'Chamber of Horrors' that he suggested to Mr Laing, the chairman of the Crystal Palace Company, that he ought to open one at Sydenham. Laing misunderstood him, thinking that Cole was referring to Madame Tussaud's tableaux, and he made a point of asking Owen Jones if Cole's mind had become affected during his recent visit to Paris.

THE LOAN COLLECTIONS AND THE TRAVELLING MUSEUM
Cole was not only Secretary of the Science and Art Department from 1857 to 1873, but also Director of the South Kensington Museum. His

work in this field merits a separate history and it is only possible to mention in this book some of its aspects which affected public art education. One of his most progressive measures was the institution of the Loan Collections and the Travelling or Circulating Museum. The first loans of objects from the Museum were made from Marlborough House in 1852, when the Board of Trade sanctioned arrangements 'by which local Schools of Art may not only borrow articles from the Museum, in each year during the period between 15 July and 15 September, for exhibiting in their own localities, but may also have the opportunity of purchasing any duplicates, or superfluous qualities at half the original cost to the Department.'[52]

In August 1854 the Travelling Museum was established and special vans were made with removable tops, so that packaged exhibitions could be placed straight on to railway waggons and conveyed to the provinces. Museum staff travelled with the exhibition and unpacked and arranged the exhibits after arrival at their destination. These travelling exhibitions were shown at both private and public institutions, provided that they would meet the cost; and pictures and other works of art were shown in church and mechanics' institutes, local museums and schools of art. The Loan Collections were particularly popular and encouraged localities to establish large museums of their own. By the year of Cole's retirement the Museum had 'circulated objects to 195 localities holding exhibitions, to which more than 4 millions of local visitors have contributed above £93,000'.[53]

Another popular museum service that Cole introduced was the provision of photographs and electrotypes of objects in the Museum. In 1858 a sales department was established for these over the refreshment room in the South Kensington Museum, and George Wallis (1811–91), the former head of Manchester School of Design and of Birmingham School of Art, was placed in charge. His efforts proved so successful that in 1863 he was promoted to Keeper of the Art Division's Collections, a post he held until his death.

That Cole, in the first year's existence of the South Kensington Museum, had a clear conception of its educational purpose is shown clearly by the following words spoken in November 1857. The last paragraph is particularly relevant.

'The working man comes to the Museum from his one or two dimly lighted, cheerless dwelling rooms, in his fustian jacket, with his shirt collars a little trimmed up, accompanied by his threes, and fours, and fives of little fustian jackets, a wife, in her best bonnet, and a baby, of course under her shawl. The look of surprise and pleasure of the whole party when they first observe the brilliant

lighting inside the Museum show what a new acceptable and wholesome excitement this evening entertainment affords to all of them. [Cole was particularly proud of the brilliant lighting.] Perhaps the evening opening of the Public Museums may furnish a powerful antidote to the gin palace.

'But it is not only as a metropolitan institution that this Museum is to be looked at. Its destiny is rather to become the central storehouse or treasury of Science and Art for the use of the whole kingdom. As soon as arrangements are made, it is proposed that any object that can be properly circulated to localities should be sent upon demand being made by the local authorities. The principle is already fully at work, and its extension to meet the public want depends altogether upon the means which the public may induce Parliament to furnish. It may be hoped by this principle of circulation to stimulate localities to establish museums and libraries for themselves.'[54]

PUBLIC EXHIBITIONS

During his years with the Science and Art Department, Cole helped to organize various great exhibitions of arts and manufactures on the lines of the Great Exhibition of 1851. These included the British Section of the Exposition Universelle of 1855 at Paris, after which Napoleon III awarded Cole the Legion of Honour, the Great Exhibition of 1862, and the British Section of the Paris Exposition of 1867. After these, Cole proposed that annual exhibitions should be held at South Kensington, and the first of this series was opened by the Prince of Wales in 1871, followed by others in 1872, 1873, and 1874.

None of these exhibitions was a financial success, partly because Prince Albert was no longer alive to inspire the public with his interest, and partly because of a progressive practice of separating the exhibitions into various classes of objects. Albert had suggested this to Cole, saying 'put all the pianofortes together', and Cole put it into practice.[55] This was a great advance from an educational viewpoint for those seriously interested in the exhibits, but it did not attract the Victorians to any great extent. They preferred all manner of mixed curiosities such as colossal statues, insects in amber, huge machines (working), enormous trophies, scented fountains, and indiarubber furniture.

The provision of the Museum (first at Marlborough House, then at South Kensington) with its Loan Collections, together with the great public exhibitions, inspired the building of the local museums of British towns which took place during the sixties, seventies and eighties; moreover, it is due to Cole's insistence that a museum is an educational institution that the South Kensington Museum, now the Victoria and

Albert Museum, is still today administered under the direction of the Department of Education and Science, unlike any other large museum.

In 1852 the Board of Trade had promulgated that 'the local intelligence of the inhabitants shall create Schools of Industrial Science and Art', but, although under Cole's supervision 120 Schools of Art were set up in the next twenty years, bricks and mortar were not very forthcoming. It was unlikely that they would have been, considering that free libraries, art galleries, and museums had not been established in the majority of British cities. The Public Libraries Acts, of 1855 for England and Ireland, and of 1867 for Scotland, sanctioned the appropriation of land by a borough or district Board for the erection of buildings 'suitable for public libraries, or museums, or both, or for schools for science and art'. This was badly worded and suggested that a district could have a public library and museum *or* a school for science and art. The meaning was not really made clear until the Act of 1884, which stated that since 'doubts are entertained as to the meaning of those provisions . . . it is hereby declared and enacted that –

> 'Buildings may under the said sections be erected for public libraries, public museums, schools for science, art galleries, and schools for art, or for any one or more of those objects.'[56]

Such buildings could be paid for by obtaining a mortgage and paying off the debt with private subscriptions, or with a portion of the allowed penny local rate (the maximum), but during Cole's period of office, not only did the majority of Schools of Art receive nothing from the rates, but they often had to pay a substantial rent to use the rooms of a library and museum supported by such rates. In the eighteen-fifties and sixties most of the Schools of Art rented rooms, and if a school was built, it was due to voluntary local efforts. Paradoxically it was not in the largest industrial cities that they were erected, but in the county towns and in old cities – for example, Wolverhampton (1854); Norwich (1857); Bristol (1858); Lambeth, Coventry, and Nottingham (1863); Lincoln and Exeter (1865).

Buildings were usually erected in those areas where the ladies and gentlemen regarded them as schools of fine art, the funds being raised by bazaars, conversaziones, and soirées where patrons ran stalls and students and staff exhibited their paintings. Claude Nursey, the head at Norwich, made such an impression on the local gentry with his activities as secretary of the Norfolk and Norwich Fine Art Association that the Corporation built a school in 1857. Baronets and Members of Parliament attended his fine art bazaars, and the new building was not only paid for

within two years, but was in credit. At Bristol, a local lady left a legacy sufficient to build the new School of Art and Fine Arts Academy. At Exeter, local donations made possible the erection of the spacious Albert Memorial Museum and School of Art.

While the students of these schools worked in comparative luxury, the students at Manchester laboured in the cellars of the Royal Institution (now the Art Gallery), the Liverpool students worked in the Institute School, and the Birmingham students were cramped into the rooms of the Society of Arts' building. The industrial philanthropists would not pay up, although many of them were, like Edmund Potter of the Manchester Committee, the great calico printer, incomparably wealthier than the country art lovers.

The Schools of Art in the industrial cities were involved in the instruction of large numbers of poor children and artisans and thus with the Government's course of instruction for them. The manufacturers therefore felt that this entitled their Schools to a substantial part of the annual Parliamentary grant for Science and Art. Those engaged in the textile industries were particularly unwilling to contribute towards building a School because the Department's method of teaching design by geometrical drawing and copying casts was notably unsuitable for the textile industries.

Edmund Potter maintained that the School at Manchester should have been 'based on the same views of public utility as the School of Lyons, teaching the principles of the art of design as applicable to all industrial art, and laying a solid foundation of instruction for those who may decide upon the pursuit of higher art hereafter'. He went on to state that a 'School of Art for High Art . . . would have been better supported, and I believe we could have obtained large subscriptions from the locality, perhaps equal to £1000 per year'.[57] Potter's views, which were similar to those of Haydon, with whom he had been acquainted, were proved correct; for after Cole's resignation, when the Schools of Art swung towards fine art under the direction of Edward Poynter, local philanthropists gave large sums of money for building Schools of Art and their museum galleries.

The maximum contribution which the Science and Art Department would grant towards an approved building for a School of Art during Cole's period of office was £500 at the rate of 2s 6d per square foot, provided that certificated masters were teaching the Government's course in the school which applied and that the plans for the new building had been passed by Cole and Redgrave. The Department's requirements are interesting today because they formed the basic plan around which the present Colleges of Art were elaborated. The plan shown on page 184 of the old building of the Manchester School of Art,

which is still in use today, is a typical product of these requirements. On page 185 is an abstract of the Science and Art Department's Form No. 359, Building Grants for Schools of Art, first issued in September 1859.

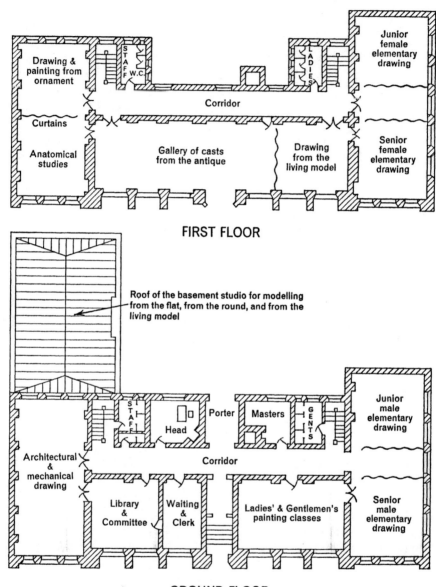

FIRST FLOOR

GROUND FLOOR

5 Plan of Manchester School of Art

Designed in 1878, opened in 1881, the school shows the influence of Cole's requirements for a Government School of Art.

REQUIREMENTS

1. Elementary Drawing Room East to West 20 x 30 by 16 ft. high. Top lighted.

2. Exhibition Room for casts, books, etc. 30 x 40 by 16 ft. high. Top lighted.

3. Painting Room 20 x 15 by 16 ft. high. Side lighted, contd. over roof and North lighted.

4. Modelling Room 20 x 15 ft.

5. Masters' Room 12 x 15 ft. North lighted.

6. Female Cloak Room 12 x 8 ft.

7. Toilets

8. Kitchen and a bedroom for attendant 12 x 10 ft. each

The classrooms should communicate with one another, as well as by corridor, and the staircase must give access to all rooms. Windows must be large and free from mullions and small panes. Only three classrooms were regarded as essential; the most important was the Elementary Drawing Room which was often divided into two halves by a curtain, separating the Male Class from the Female Class. A large blackboard dominated the room and the class who sat on forms at long desks on which card diagrams could be propped for copying. In the male section of the room there usually stood several large flat tables for geometrical and mechanical drawing. A large press stood against the wall from which the master took the examples for copying at the beginning of each lesson. The pupils were not allowed to talk or move about once this had been done.

In the Modelling Room there were long stands or tables with planks erected over them, upon which the casts recommended by the Department could be hung for copying (see Plate 24). The casts were usually removed from the walls and hung from the planks at the beginning of each period. Apart from these casts in relief there were usually some busts and other statues stood upon pedestals around the room.

The Painting Room was used only by the advanced students and the ladies' classes, and was always well equipped, but the Museum or Exhibition Room was intended by Cole to be the largest, because it served as an encouragement to local patrons and visitors to contribute to the building-up of a larger collection.

One of the greatest problems at night was ventilation, owing to packed classes and the large number of gas-burners needed for lighting; indeed, the classrooms must have been very unhealthy in an age when tuberculosis was rife.

Sources

1. COLE, SIR HENRY *Diary*, 30 November 1863 Cole Bequest, Victoria and Albert Museum, London (where Cole's diaries, 58 years in 43 volumes, are deposited)
2. *Illustrated London News*, 28 February 1852 Text of letter (p. 171)
3. *Art Journal*, 1852 (p. 103)
4. COLE, SIR HENRY *Fifty Years of Public Work* G. Bell, London, 1884 (Vol. I, p. 284)
5. *Sessional Papers, 1849* Select Committee on the Schools of Design (p. 291)
6. *First Report* of the Department of Practical Art, 1853 (p. 195)
7. Minutes of the Committee of Council on Education, 1853–4 H.M.S.O. (p. 39)
8. *Sessional Papers, 1864* Select Committee on Schools of Art (p. 3)
9. *First Report* of the Department of Practical Art, 1853 (pp. 49–51)
10. Ibid.
11. Minutes of the Committee of Council on Education, 1853–4 (p. 36)
12. Ibid. (p. 39)
13. *Sessional Papers, 1864* Select Committee on Schools of Art (p. 74)
14. *Art Journal*, 1864 (p. 281)
15. *Sessional Papers, 1864* Select Committee on Schools of Art (pp. 161–2)
16. Minutes of the Committee of Council on Education, 1853–4 (p. 36); Supplementary Minute of 20 August 1853 and Regulations of 26 January 1854 (p. 37)
17. Minutes of Committee of Council on Education, 1856–7 (p. 25); Minute of 24 February 1857 (para. 8)
18. Minutes Book of Birmingham School of Art and Society of Arts: Annual Report for 1863–4 pasted in book
19. Minutes of the Committee of Council on Education, 1857–8 (p. 27); Circular letter of 27 February 1858
20. Replies to Circular 96 (14 November 1853), to art masters; *First Report* of the Department of Science and Art, 1854 (pp. 64–8)
21. *Directory* of the Department of Science and Art, 1856 (p. 80)
22. *Art Journal*, 1855 (p. 217)
23. *Birmingham Institutions* Cornish Bros., Birmingham, 1904
24. PEVSNER, NIKOLAUS *Academies of Art* Cambridge University Press, 1940 (p. 229)
25. RICHARDSON, MARION *Art and the Child* University of London Press, 1948 (p. 61)
26. *Art Journal*, 1849 (p. 350)
27. *Illustrated London News*, 30 October 1852 (p. 354) and 27 November 1852 (p. 463)
28. Ibid.
29. *Art Journal*, 1849 (p. 350)
30. *Sessional Papers, 1849* Select Committee on Schools of Design (p. 345)

31. POTTER, EDMUND *Journal of Social Progress* Birmingham, 1856 (p. 7) Birmingham Reference Library C9 – 14787
32. *The Engineer*, 1857 (Vol. IV, p. 423)
33. *History of the Victoria and Albert Museum* H.M.S.O., 1958 (p. 17)
34. COLE, SIR HENRY *Fifty Years of Public Work* G. Bell, London, 1884 (Vol. I, p. xiii)
35. SKEATS, HERBERT S. *Popular Education in England: Abstract of the Report of the Royal Commission on Education* Bradbury & Evans, London, 1861 (p. 20)
36. *Sessional Papers, 1864* Select Committee on Schools of Art (p. 272)
37. TIFFEN, J. *History of Liverpool Institute* Tinling, Liverpool, 1935 (p. 114)
38. Liverpool College of Art *Honours and Prize Lists, 1869–87* Liverpool Picton Local History Library, Reference H. 373 – 22 INS.
39. *Directory* of the Department of Science and Art, 1856 (p. 28)
40. CROZIER, R. *Recollections, 1879* MS (Manchester Reference Library 709.42 M2)
41. *Art Journal*, 1860 (p. 191)
42. LESLIE, GEORGE D. *The Inner Life of the R.A.* John Murray, London, 1914 (p. 60)
43. Science and Art Department of the Committee of Council on Education Form 441, 24 February 1863
44. *Sessional Papers, 1864* Select Committee on Schools of Art (p. 233)
45. COLE, SIR HENRY *Fifty Years of Public Work* G. Bell, London, 1884 (Vol. I, p. 2)
46. *First Report* of the Department of Practical Art, 1853 (p. 35)
47. *Illustrated London News*, 13 March 1852 (p. 211); and *History of the Victoria and Albert Museum* H.M.S.O., 1958 (p. 5)
48. COLE, SIR HENRY *Fifty Years of Public Work* G. Bell, London, 1884 (Vol. I, pp. 284–5)
49. *Illustrated London News*, 11 September 1852 (p. 195)
50. *Catalogue of Articles in the Museum of Manufactures chiefly purchased from the Great Exhibition of 1851* Department of Practical Art, London, 1852
51. *Household Words*, 4 December 1852 (Vol. VI, pp. 265–70)
52. COLE, SIR HENRY *Fifty Years of Public Work* G. Bell, London, 1884 (Vol. I, pp. 286–8)
53. Ibid. (Vol. II, p. 347)
54. COLE, SIR HENRY Introductory Addresses on the functions of the Science and Art Department, 16 November 1857, at South Kensington. Given in *Fifty Years of Public Work* G. Bell, London, 1884 (Vol. II, p. 293)
55. COLE, SIR HENRY *Fifty Years of Public Work* G. Bell, London, 1884 (Vol. I, p. 264)
56. Public Libraries Acts: 1855, Section 18 (England) and Section 9 (Ireland); 1867, Section 10 (Scotland)
57. *Sessional Papers, 1864* Select Committee on Schools of Art (pp. 123, 127)

9

A National System for Public Art Education

*'A master must use those examples of study, and teach
according to the principles that are sanctioned by the
Department, which retains the entire control over the system
of instruction to be followed.'*
Department of Practical Art, Form 132

THE NATIONAL COURSE OF INSTRUCTION

It was inevitable that, after fourteen years of contrasting opinions and changing policies in the Schools of Design, the Board of Trade would seek a uniform system for public art education, and Cole introduced one in his first year of office. This national system consisted of the National Course of Instruction, the National Competition, and the National Graded Examinations in Art.

Exact uniformity was ensured by the National Course of Instruction and no examination could be passed, no prize won, no grants made, nor certificate obtained, except in specified stages of this course.

The Course consisted of four Divisions of Instruction, each of which had several stages, the sum of which comprised the twenty-three Stages of Instruction. The Stages, given in full in Appendix C, were mechanical steps to the acquisition of 'hand-power'. Twenty-one were successive exercises in copying from the Flat, or Round, or Nature, intended, as Redgrave asserted, to be 'strictly imitative' until Stages 22 and 23 were reached – a most unlikely eventuality. Only a minority of the students ever reached Stage 10; indeed, sometimes about half of all the students, even in a larger School of Art, such as the one at Manchester, were only at Stage 2.

Redgrave must bear the greatest responsibility for the actual exercises of this course of copying which prevented the local Schools of Art from showing any enterprise. Cole planned the organization and enforcement of the system, but it was Redgrave's responsibility, first as

Art Superintendent and later as Inspector General, to decide on the art work done in the Schools of Art; indeed, in 1894 Redgrave's wife wrote to the secretary of Coventry School of Art claiming that 'he was mainly responsible for the system of art teaching adopted in this country'.[1]

The introduction of the Course in 1852 posed an immediate problem for Henry Cole. Thousands of prints and casts had to be produced to ensure complete uniformity in the Course, in the National Competition and in the Department's examinations.

If one opens the first Report of the Department of Practical Art at page 68, a diagram confronts the eye which gives a very clear idea of the task of the Victorian art student, namely copying. The diagram shows the piece of art school furniture recommended by the Department. It is not an easel, a trestle, a donkey, or a table, it is a long desk with an upright portion on which is a slotted wooden rail to support a large piece of card. A short fillet is fixed on the desk top to support the base of the drawing board that would be placed next to the card; on this card a print of an approved work of art was mounted.

By January 1853, when this diagram first appeared in print, Cole had already set his staff to work producing examples to be copied for the various Stages of the Course of Instruction for the National Competition. The headmaster, Richard Burchett, concentrated on producing plates on geometry and perspective, his deputy, Robert Herman, produced a set of outlines of the human figure, while J. C. Robinson, the Teachers' Training Master, drew out a set of Elementary Outlines. By the following year the production and storage of examples became an important branch of the museum at Marlborough House, and Robinson was made curator of the art section of the Museum. One of the functions of this section of the Museum was to supply copies of the collection of Casts of Ornamental Art kept by Ralph Nicolson Wornum. Robinson occupied himself with the making of copies of ornament in outline, filled in with washes of colour for the Eleventh Stage of the Course of Instruction.

This work gave Cole an opportunity to use the Technical Classes and to make one of those useful innovations he loved so dearly. The copies were sent upstairs to the Female Special Class for Lithography where the girls, with the help of Redgrave, copied them out on to stone and produced the necessary chromolithographs. A master at the Spitalfields School of Art, John C. Brown, was given the task of preparing freehand outlines of objects to be copied for the most popular exercise in the Schools of Art, namely Stage 2a: *Freehand Outline from the Flat*. (Details of the copies or casts supplied for each stage are given in Appendix C.)

As well as the examples in outline, and in outline and colour, there

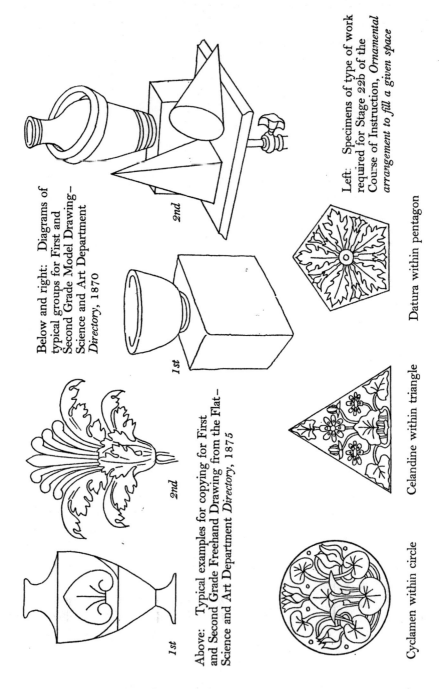

Below and right: Diagrams of typical groups for First and Second Grade Model Drawing–Science and Art Department *Directory*, 1870

2nd

1st

Above: Typical examples for copying for First and Second Grade Freehand Drawing from the Flat–Science and Art Department *Directory*, 1875

2nd

1st

Left: Specimens of type of work required for Stage 22b of the Course of Instruction, *Ornamental arrangement to fill a given space*

Datura within pentagon

Celandine within triangle

Cyclamen within circle

6 Examples of the work required for art examinations of the Science and Art Department

was a third variety of flat copies: examples of shaded objects such as ornament, flowers, and the human figure. There were also flat examples for Stage 9: *Anatomical Studies,* depicting the outline of a sculpture, such as the 'Discobolus' of Myron with the bones and muscles filled in (Department No. 459). Lastly there were some flat examples from which to practise mechanical and architectural drawing.

The flat examples were usually washable and mounted on millboard, often front and back, measuring about ten inches by eight inches. Flowers, the favourite examples of the ladies' classes, such as 'The Wallflower' and 'The Passion Flower', taken from Dicksee's *Foliage, Fruit and Flowers,* were printed nearly two feet high.

The second category of examples provided by the Science and Art Department were the solid examples for drawing 'from the Round'. These consisted of card models of geometric solids and simple buildings, plaster casts of architectural ornament, and pottery vases. The third category of examples was for drawing 'from Nature' and included stuffed birds and large sea-shells.

Payments to the management of Schools of Art won by examination successes were not made in cash by the Department, but in examples and books to the value of the amount due; only the masters received cash for their own payments. The examples could also be purchased from the Department 'at a greatly reduced price – at half the prime cost', as Cole frequently asserted.

The examples were not particularly well drawn to start with, and after further transmogrifications by the students, the results must have lacked any aesthetic appeal. John Sparkes, headmaster of the Lambeth School of Art, produced a drawing card before the Select Committee of 1864, one which his students had to copy to learn Stage 6: *Human or Animal Figure from the Flat,* and said: 'This sheet of eyes is as wonderful in its way as anything I ever saw for bad drawing.' The astute Robert Lowe replied to this criticism later by inferring that Sparkes had no right to attack them since he had never exhibited figure studies of his own, but Sparkes remained adamant and asserted that even if they were done by Robert Herman, the deputy head of the Central School, and revised by J. R. Herbert, R.A., they were still incorrect. Sparkes also drew attention to the fact that the only examples of an architectural elevation supplied by the Department was one of a barracks. An Irish member of the Committee, Mr Maguire, no doubt impelled by his dislike of the English military presence in his own country, exclaimed: 'Could anything be more hideous than that?'[2]

The range of copies used by the majority of the students was certainly very limited, and, as most of the students in the local Schools of Art were preoccupied with the first freehand stage, Stage 2, they were usually

copying in outline the Trajan or Tarsia scrolls; in fact, if medals were awarded mostly for the Tarsia scroll one year, they ignored the Trajan the next.[3] However, we must leave the poor students stippling, stumping and washing in their scrolls, and study the competition which Cole provided to judge these productions.

<center>THE NATIONAL COMPETITION, 1852–1915</center>

The National Competition for Schools of Art was the most enduring part of Henry Cole's system; in fact, it survived the Department of Science and Art. For sixty-three years the public judged the comparative merits of the Schools of Art by the prizes awarded to them in this competition which were enumerated at length in the art journals of the day.

There had been annual exhibitions of the students' work in the Head School of Design in the forties, but although critical reporters from the *Art Union* found their way into the Great Room at Somerset House, these shows were not advertised to the general public. However, in 1851 there was a public exhibition in Marlborough House of works from all the Schools of Design, organized to coincide with the Great Exhibition, and this was very successful. Cole decided that such exhibitions could be used to stimulate the keen competition between the Schools of Art, which he thought necessary for efficiency. All the highest prizes, payments, and even scholarships could be based on such a contest.

The first exhibition of the Schools of the Department of Practical Art was opened at Marlborough House on Wednesday, 19 May 1852, having been launched in style by the Queen and Prince Albert, who had a private view of the works two days previously. The exhibits, which consisted of drawings and designs from twenty-three Schools of Art, were limited to those that had been awarded prizes by the Department. Cole also took the opportunity of displaying the £5,000-worth of exhibits which had been purchased from the Great Exhibition. The Manchester School obtained more prizes than any other provincial school, one medal going to Frederic Shields, this gifted artist being an evening student at Manchester at the time. Another prize-winner was John Finnie of the Newcastle School, later head at Liverpool for forty years.

Cole announced that the next exhibition would be a National Competition, and the Department ruled that 'the system hereafter will become one of mutual competition' and that there would be two annual exhibitions at Gore House of prize-winning works in the Competition: an exhibition of advanced work in June and of elementary work in November.

The surest way to obtain a free-studentship or to obtain a maintenance allowance at the Central Art Training School was to gain a medal for an

advanced work in the Competition, and when National Scholarships were introduced in 1863, candidates had to have won such a medal. In Cole's time the works submitted for the Competition were judged by Redgrave and three of his fellow Royal Academicians – Sir Charles Eastlake, Daniel Maclise, and John Callcott Horsley. All three artists practised a very meticulous type of painting and approved of the Course of Instruction and of the tedious labour expended on each drawing submitted for a medal. They did not wish local Schools of Art to be considered real art schools, like their Academy Schools, but rather schools for teaching elementary drawing and copying ornament.

Sir Charles Eastlake, President of the Royal Academy, giving evidence before the Select Committee of 1864 declared: 'I confess I do not see that the masters have any right to complain of the actual system, it is the lot of all teachers, especially elementary teachers, that they must go over the same ground, and it is the very fact of the system of instruction being so stereotyped that makes it safe. . . . I think the system is very good.'[4] The prize-winning drawings from the Competition were circulated to the Schools of Art by the Department, thus ensuring that the drawings became increasingly stereotyped. Drawing for a medal became a very precise procedure indeed.

DRAWING FOR A MEDAL

'Mr Oliff at South Kensington was three months at the
Egg Plant – and two and a half months at the Pilasters.'
John Sparkes[5]

When R. H. A. Willis, the successful applicant for the headship of the Manchester School of Art, presented himself for interview in 1883 he was equipped like a field marshal, for in his possession were two national gold medals, three silver, two bronze, four Queen's prizes of books, four out of the seven full Art Master's Certificates (consisting of twenty-one Third Grade Certificates) and portions of the remaining three.

According to George Moore, the desire to organize art in such a way 'proceeded in England from a love of respectability. To the ordinary mind there is something especially reassuring in medals, crowns, exams, professors and titles.'[6] There is some truth in this, but the popularity of the medals and certificated stages of instruction was also due to the Victorian concept that success could only be attained by remorseless exertion. The gold medal, inscribed with depictions of the virtues, was the Victorian's concrete expression of the summit of excellence achieved only after years of climbing upwards from Stage 1a of the Course of Instruction. Tyrwhitt in his approved *Handbook of Pictorial Art*

asserted that 'genius for drawing is genius for taking an unusual amount of trouble to learn it' and that 'there is no doubt that the best drawing master for real beginners is the well-drilled South Kensington teacher'.[7]

Even those familiar with this Victorian viewpoint will be astonished to learn of the actual time consumed in the execution of a drawing for a medal. John Sparkes, head at Lambeth, asserted that to do one 'would require from twelve months to two years, and I have even heard of an instance of a medal drawing having been three years in progress – a single drawing'. These times are for night-class students working three or four evenings per week from six to nine o'clock. One Aberdeen student was so stimulated by the thought of acquiring the prized medal that he worked four evenings a week for a year rendering the Trajan Scroll in sepia from the cast (Department No. 471). Luke Fildes (later Sir Luke Fildes, R.A.), a pupil-teacher and national scholar from Warrington School of Art, took six months of day classes at South Kensington over a chalk drawing of apples.[8] Sir Hubert von Herkomer, R.A., an ex-student of the Central Training School, commented: 'from the academic point of view, man's life is infinite; it matters not how much he may be wasting it in his youth – all discipline of mind!'[9]

The masters of the Schools of Art worked particularly hard to ensure that 'medal drawings' were ready for the annual examination by the inspectors from South Kensington, because medals were the highest honours apart from the National Scholarships and brought forth both a financial reward from the Department and praise from his school's committee in its annual report. A member of the committee of the Potteries' School of Art related to the Select Committee of 1864 how 'the master of our school found it exceedingly difficult to obtain the completion of several drawings in time for examinations, so much so, that he told me that in one case he was obliged to give a pupil his dinner at his house for a fortnight, and he gave several others their tea, and had it made into an evening for them'.[10] Bearing in mind the suggestions of some of the Select Committee of 1864 that payment for medal drawings might encourage dishonesty, one can not escape the wicked thought that perhaps while these pupils were satisfying nature, the master was busy imitating it!

George Moore, a student in the Training Schools in Cole's time, gave a vivid description of a youth carrying out one of these drawings at South Kensington.

> 'I shall never forget the scenes I witnessed there. Having made choice of a cast, the student proceeded to measure the number of heads; he then measured the cast in every direction, and ascertained by means of a plumb-line exactly where the lines fell. It was more like land-surveying than drawing, and to accomplish this portion

of his task took generally a fortnight, working six hours a week. He then placed a sheet of tissue paper upon his drawing, leaving only one small part uncovered, and having reduced his chalk pencil to the finest possible point he proceeded to lay in a set of extremely fine lines. These were crossed by a second set of lines, and the two sets of lines elaborately stippled, every black spot being carefully picked out with bread. With a patience truly sublime in its folly, he continued the process all the way down the figure, accomplishing, if he were truly industrious, about an inch square in the course of an evening. . . . After three month's work a student began to be noticed; at the end of four he became an important personage. I remember one who had contrived to spend six months on his drawing. He was a sort of demigod, and we used to watch him, anxious and alarmed lest he might not have the genius to devote another month to it, and our enthusiasm knew no bounds when we learned that, a week before the drawings had to be sent in, he had taken his drawing home and spent three whole days stippling it and picking out the black spots with bread.

'The poor drawing had neither character nor consistency; it looked like nothing under the sun, except a drawing done at Kensington – a flat, foolish thing, but very soft and smooth.'[11]

Richard Redgrave who, as Inspector General for Art, was responsible for encouraging this type of drawing, stippled with chalk and smudged with bread crumbs, was called upon to defend the fact that some of the students were taking over a year on a drawing when he was giving evidence before the Select Committee on the Schools of Art, and he replied: 'I should think, if they do, they are improving themselves . . . if a student sees the shades of difference, then he becomes a man of taste.'[12] Unfortunately the majority of the students in the Schools of Art could not observe fine 'shades of difference'. They worked by gaslight and the shade was very intense, strong black shadows being thrown by any protuberances on the cast.

'The witchery and mystery of shadow' held a morbid attraction for Victorians, who preferred romantic gloominess, or what one of them described as 'the preciousness of parsimonious light', to clean, light, direct drawing. Mysticism was prevalent with regard to casts, and many believed that if these copies of antiquity were perused for hours the secrets of High Art might be revealed. Robert Crozier, a student of the time, noted that his drawing master, W. Bradley, founded his instructions on the head of Mars, and Crozier's biographer recorded how 'the secrets of refinement, beauty, nobility, etc. were revealed to him'.[13] Another student recalled how 'we would trudge every evening to the

plaster casts, then still at South Kensington, and in the atmosphere of gas and fog walk and squeeze round the Hermes of Olympia – waiting with patient faith for the mystery of art to be solved'. Her companion, Miss C. Anstruther Thomson, later wrote a series of essays on the secrets of art revealed by various ancient busts such as the 'Aberdeen Head' of young Heracles and the 'Bologna Head' of Athene Lemnia.[14]

The Victorians believed in absolutes, therefore there must be absolute beauty; and, since this beauty had been attained in the past, the surest way for the student to attain it was by copying ancient art. This view persisted throughout the century and, although covered up with high flown verbiage, the real message of the erudite art examiners of the period was very basic: mere students should never presume to supplant the beauties of the ancient world. Originality was usually condemned as 'delusive innovation and false assumption' or suchlike. George Aitchison, A.R.A., examiner of the Principles of Ornament at the Science and Art Department, gave the typical view when he wrote: 'All ornamental arts, that are not realistic imitations must be founded on precedent art . . . some ornament, after it has once been perfected, seems incapable of further improvement. The egg and tongue may be cited as an instance.'[15] Steeped in Classical Art as the examiner was, he would have been horrified at the suggestion that the best thing would have been not to bother with drawing eggs and tongues at all.

MEDALS AND MEDALLIONS

Government medals were awarded to the pupils of Schools of Art for the first time in May 1852 for the works exhibited in Marlborough House, and from then until 1856 thousands of drawings were sent there to compete for national medals and the Queen's prize of books.

Each student could submit several works, but not more than one work in any Stage of the Course of Instruction, and only three medals could be awarded to a School of Art for any one Stage. Cole hoped in this way to encourage the Schools to enter for as many Stages as possible; and because he particularly wanted to extend designing for manufactures, a proviso was made that a student could submit as many works for Stage 23: *Applied Design* as he wished. The Schools received ten shillings-worth of approved books or examples for their libraries for every medal awarded, the headmaster usually visiting Marlborough House to select them. Books and examples up to a value of £10 could be won by obtaining a medal in *Applied Design*.

By 1856 Cole decided to check the flood of paper from the provinces and a new system was established by which Local Medals were introduced. These were awarded by the Department's inspectors during their annual visits to local Schools of Art to supervise the Second Grade

examinations. Each School of Art could obtain a maximum of thirty medals and the inspector only selected the better drawings for dispatch to London for the National Competition.

The medals for the Competition were replaced by new National Medallions. The annual reports of the local Schools were proud to list any National Medallion, Honourable Mention, Local Medal, or selection for the National Competition, for which a maximum of a hundred Medallions were awarded.

It is interesting to read a contemporary description of the Medallion which was so cherished by local committees. *The Engineer* reported:

> 'This medallion has been executed in repoussé by M. Vechte, and has in its centre a portrait of her Majesty. The allegory embodied in the medallion is thus explained by M. Vechte: "The principal figure at the top of the medal is Genius, attended on his left by Justice, Truth and Science, essential to an Academy of Artists, and on his right by a student meditating. In the background crouches Jealousy or Ignorance; whilst Fame is proclaiming the merit of the successful student and Time and youthful Genius hold the shield to receive the student's name."

> 'The medallion was to have been executed in silver but bronze has been substituted, on the alleged ground that the artistic merit of the design was injured by taking the impression in silver. The exchange is not a pleasing one to the recipients, and has given rise to a considerable amount of grumbling — a medallion which cannot be taken out of its case without showing its hollow "Brummagem"-looking back, and rattling like a kettle lid, is scarcely to be dignified with the word National.'[16]

After the Catholic young ladies at the Cork School had inspected with interest the various virtues and vices depicted on the medallion of a recipient, they complained that their nudity was offensive to modesty. Certainly this was no way to mitigate the Irish troubles and 'to aid in the civilization and amelioration of the Country' which James Healy, the head at Clonmel, defined as the object of art education in his establishment.[17]

The National Medallion caused further dismay in Manchester. The calico printers thought that the Department, whose professed object was to stop them having to pay out huge sums to French designers, should not have chosen a Parisian to design it. Vexation with Vechte veered to laughter after a 'brilliant assembly of the élite of Manchester' had assembled in the Town Hall in October 1857 to witness the first distribution of the medallions, only to discover that they were not yet in production. Earl Granville, on the platform, went through the motions.

After a system of full payment on results was established in 1863, drawing for medals assumed greater importance, because an art master could earn over £30 a year for local medals and additional money for any medallions gained by his students.

In 1866, motivated no doubt by the criticisms of the worthlessness of his Department's medals, Cole introduced a new national award of ten gold medals, twenty silver, and fifty bronze, to take the place of the hundred medallions. The local medals were abolished. The award of these medals continued throughout the century without change except for an increase in the number of silver and bronze medals, and the National Competition survived until 1915 when it was discontinued by the Board of Education in order to give the Local Education Committees more freedom to plan the courses in their Schools of Art to meet local requirements.

THE ART EXAMINATIONS OF THE DEPARTMENT

From 1852 to 1854 the examinations for local Schools of Art were restricted to assessments for medals and prizes carried out in London in connection with the National Competition, and the only examination papers set by the Department were the internal ones at Marlborough House for Certificates of Competency for Art Instruction, described earlier. The next steps were the introduction of drawing examinations into the Training Colleges at Christmas 1853 on the instructions of the Committee of Council on Education, and of annual drawing examinations for pupil teachers in January 1854.

By February 1855 the children in the public day schools had been taught some of the Primary Course of the Department by the newly-trained teachers, and prizes were awarded for successful exercises. The Department laid down that 'six prizes annually will be awarded in each school taught drawing by a master of a School of Art . . . Each prize will consist of a pair of compasses, pen and pencil . . . They will be awarded by the masters of Local Schools of Art at the Midsummer vacation.'[18] After he had awarded the prizes, the art master collected the winning works and posted them to Marlborough House, where some of them were assigned further prizes in the autumn examination for the elementary section of the National Competition.

A complete system of graded examinations in art was arrived at after the Science and Art Department was put under the jurisdiction of the Committee of Council on Education in 1856. The three grades of examination, organized by Cole, were:

Third Grade, or Art Masters Certificate Level, taken at the Central Art Training School, the holder of which was entitled to teach in a local School of Art.

Second Grade, or Art Students Certificate Level, taken at the local Schools of Art or at the final examination in a Training College, the holder of which was entitled to teach pupils for the First Grade examinations.

First Grade, or Elementary School Level.

The four Second Grade papers were taken in the evenings during the annual visit to the School of Art of one of the Science and Art Department's inspectors. When an inspector arrived for the visit, all the work which had been executed since his previous visit was displayed on the walls, so that he could award up to thirty local medals for the best works on show. The Second Grade papers were afterwards worked in his presence when he had read out the questions. The inspector left the school with these papers and with the best medal-winning exhibits. The latter were then entered for the National Competition.

The award of local medals was abolished in 1866 because of the expense of the visits, and during the rest of Cole's period of office all works were forwarded to London where payments were awarded for the number of satisfactory exercises worked. Cole's system of three grades of examination lasted until 1896, when the National Art Training Schools were reconstituted as the Royal College of Art.

Sources

1. REDGRAVE, ROSE M. Letter written from 27 Hyde Park Gate, London, to the Secretary of Coventry School of Art, dated 3 April 1894 Coventry College of Art strongbox
2. *Sessional Papers, 1864* Select Committee on the Schools of Art (p. 80)
3. Ibid. (p. 67); and *Briti.h Architect*, 8 May 1874
4. *Sessional Papers, 1864* Select Committee on the Schools of Art (p. 181)
5. Ibid. (p. 72)
6. MOORE, GEORGE *Modern Painting* Walter Scott Publishing Co., London and Felling-on-Tyne, new (enlarged) edition 1906 (p. 67)
7. TYRWHITT, R. ST JOHN *Handbook of Pictorial Art* Clarendon Press, Oxford, 1868 (pp. 2, 19, 281)
8. *Sessional Papers, 1864* Select Committee on the Schools of Art (pp. 66, 72)
9. HERKOMER, SIR HERBERT VON *My School and my Gospel* Constable, London, 1908 (p. 38)
10. *Sessional Papers, 1864* Select Committee on the Schools of Art (p. xxiii)
11. MOORE, GEORGE *Modern Painting* Walter Scott Publishing Co., London and Felling-on-Tyne, new (enlarged) edition 1906 (pp. 65–6)
12. *Sessional Papers, 1864* Select Committee on the Schools of Art (p. 23)
13. LETHERBROW, T. *Robert Crozier* (reprinted from *Manchester City News*) J. E. Cornish, Manchester, 1891

14. THOMSON, C. ANSTRUTHER *Arts and Man* John Lane The Bodley Head, London, 1924 (pp. 22, 33)
15. WARD, J. *Principles of Ornament* Chapman & Hall, London, 1896 (pp. 4–9)
16. *The Engineer*, 18 June 1858 (Vol. V, p. 464)
17. *Art Journal*, 1854 (p. 273)
18. Art Directions of the Science and Art Department, 1855 – Appendix P; and Minute 170 of the Board of Trade, February 1855

The Move
to South Kensington

A NEW SITE FOR THE CENTRAL SCHOOL AND MUSEUM

The Great Exhibition of 1851 had been so well attended that the Royal Commissioners were left with a profit of £213,305 and this surplus was expended upon the purchase of two large Kensington properties, the Gore House estate, on which now stands the Albert Hall, and the adjoining Baron de Villars' estate, on which now stands the Victoria and Albert Museum.

The original idea of purchasing the Gore House estate was Prince Albert's. Cole recorded in his diary on 13 August 1851 that the Prince had summoned the Executive Committee of the recent Great Exhibition to Osborne, 'to tell us of his plan for disposing of this surplus and to invite our opinions. The Prince proposed to centralize the leading learned and artistic societies upon a site opposite the Exhibition Palace in Hyde Park.' However, there were so many private and political opinions to be considered that by November, according to Cole, 'The Prince had quite given up collecting together the societies.'[1] The Consort was now considering the possibilities of using the Gore House site for a new National Gallery and the de Villars' estate for a Museum of Manufactures and a School of Design.

Cole first made use of the properties in June 1853, when he used old Gore House for exhibiting the advanced works of the Schools of Art which had been sent up for the National Competition. The staff of the *Art Journal* seemed very wary of Cole extending his kingdom and referred to Gore House as the country seat of his department, Marlborough House being its town residence.[2]

Prince Albert's first proposal for the museum on the de Villars' or Brompton site was for a building 'on the lines of the Palais Royal – shops with a colonnade and flats for residences above',[3] but this scheme was considered too elaborate for a temporary measure, and much simpler buildings were decided upon – the notorious 'Brompton Boilers'.

Cole's diary of 14 June 1855 records: 'To Buckingham Palace. Met Lord Stanley [of Alderley], Sir William Cubitt, and Bowring, who came

about erecting an iron house at Kensington.' This iron house, the first establishment of the Science and Art Department to be built at Kensington, was duly erected to house the art collections from Marlborough House, an educational collection of books, maps, diagrams, and models, a collection of models and inventions, and a collection of animal produce. This building, made of iron with long skylights, built under the supervision of Cubitt, the builder of the royal palace at Osborne, caused a great outcry (see Plates 15 and 16, also page 204).

The 'Boilers' were, in a way, rather progressive in design, heralding a simple engineering approach to architecture, and their plain interiors set off the exhibits better than the usual highly ornamented walls of those days, but it was their exteriors which horrified the Victorians. The museum was compared with tunnels, factories, railway sheds and barracks, and the public enjoyed Cole's discomfiture hugely.

Cole, unusually for him, took a defensive posture and made some rather lame excuses. He wrote to General Grey in August of the following year:

> 'There is that unlucky iron shed, which will prove a most unfortunate thorn, I suspect. . . . All its ugliness is laid upon my department, which knew nothing about it till Redgrave and I returned from Paris and found the columns fixed. The public laugh at its outside ugliness and us. And we, in addition, must be mute on that point, and also on its radical defects for its object. The light is so bad below the wide galleries that nothing can be exhibited well there. Above the gallery the angle of light is quite wrong for pictures. The iron produces excess heat in summer and cold in winter.'[4]

Cole's excuse was not exactly truthful when he stated that his department 'knew nothing about it' until Redgrave and he returned from France. Admittedly he had been in Paris with Redgrave and Captain Francis Fowke, R.E., supervising the British section of the Exposition Universelle until November 1855, during the time the 'Boilers' were commenced, but he had known about the plan for the iron building from June onwards, after the discussion with Cubitt at Buckingham Palace. It seems incredible that a man of Cole's thoroughness should not have known a great deal about the proposed building for his own department.

Cole's chief regret was not that the building had artistic demerits, but that the bad engineering had produced a museum which was badly lit, leaky, and of very uneven temperature. He could bear criticism from contemporary architects who loved ancient styles, but for his department to be ridiculed for producing an inefficient building was much more hurtful to Cole, and he took steps that in future sound engineering principles would be observed. Unfortunately, his experience of the

excessive heat in the Crystal Palace of 1851 and of the temperatures in the 'Boilers' put him off structures of iron and glass for the rest of his career.

The next buildings to be erected on the site were some long wooden sheds, and these, together with three old houses they adjoined, provided accommodation for the Central Training School which had notice to quit Marlborough House by Christmas 1856. It was deemed necessary by the Queen that this royal palace should now be prepared to accommodate the Prince of Wales, who was approaching sixteen years of age, so these sheds were hurriedly erected at South Kensington to serve as classrooms.

Cole decided to employ Captain Fowke to supervise further building at South Kensington and in 1857 his permanent transfer to the Department was obtained. Cole wrote later: 'It was Captain Fowke's duty to bring the iron shed, the dry-rotted houses, and a series of wooden schools into working unity. . . . In the midst of this work he was called upon to build a picture gallery to house Mr Sheepshanks gift of pictures, and he did so in concert with Richard Redgrave, R.A., who had discovered the right formula for a top-lighted gallery.'[5] Fowke's appointment began the Science and Art Department's long association with the officers of the Royal Engineers which eventually led in 1884 to one of them, Colonel Donnelly, taking charge at South Kensington. Cole, the son of an army officer, had a great regard for the army and preferred engineers to architects, believing that the Royal Engineers were progressive men of the age, whereas architects were obsessed with historic styles.

Cole's interest in the employment of Royal Engineers on public works had grown during his work on the Executive Committee for the Great Exhibition under the efficient chairmanship of Colonel William Reid, R.E. Henry Labouchere, who had recommended Reid for the chairmanship, influenced Cole on this matter, as he later admitted. 'Lord Taunton,' wrote Cole, 'was accustomed to say that whenever the Government was in a difficulty in finding an officer of high capacity for civil administration, the right man was sure to be obtained among the officers of the Royal Engineers.'[6] Cole's particular admiration for Francis Fowke (1823–65) stemmed from the inventiveness of that officer, whose brain children included a collapsible camera, an improved umbrella, a portable fire-engine, and a lighting machine for gas burners.

Fowke was responsible for planning all the buildings of the Science and Art Department at South Kensington up to the time of his early death in 1865. He concerned himself with structure rather than ornament, and the large plain buildings which he designed for the Vernon and Turner Collections, at a cost of a mere 4d per cubic foot, were far too unornamental for the public, who compared them with goods depots. The

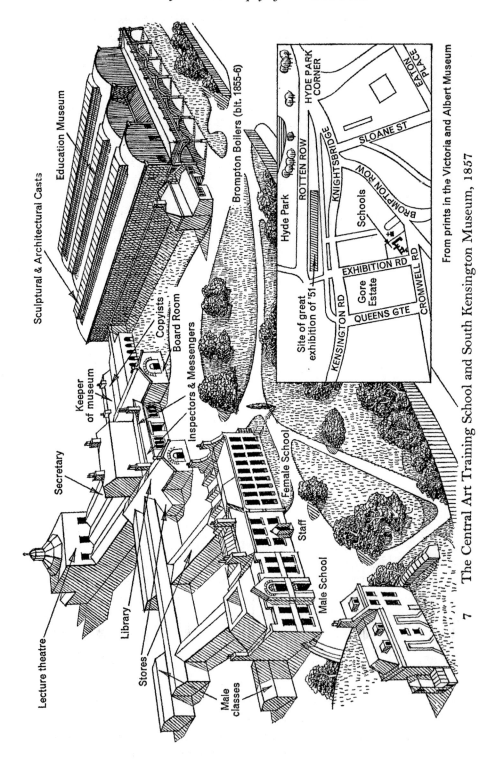

Sculptural & Architectural Casts

Education Museum

Brompton Boilers (blt. 1855-6)

Copyists

Board Room

Keeper of museum

Inspectors & Messengers

Secretary

Lecture theatre

Library

Stores

Male classes

Female School

Staff

Male School

Hyde Park

HYDE PARK CORNER

EATON PLACE

SLOANE ST

ROTTEN ROW

KNIGHTSBRIDGE

BROMPTON ROW

Schools

Site of great exhibition of '51

EXHIBITION RD

Gore Estate

KENSINGTON RD

QUEENS GTE

CROMWELL RD

From prints in the Victoria and Albert Museum

7 The Central Art Training School and South Kensington Museum, 1857

most obvious examples of his interest in structure were the huge domes of the Albert Hall and of the Exhibition building of 1862, and the decorative iron structure of the halls of that exhibition.

Cole found the answer to criticisms of plainness at South Kensington during a European tour he made with Samuel and Richard Redgrave in 1859. Struck by the suitability of the open arcades and wide courts of Italian fifteenth-century palaces for displaying exhibits, and by the terracotta ornament on these palaces, which was much more economic than carved stone, he summoned Fowke out to view the palazzi and noted in his diary: 'I hope we shall adopt this system at Kensington.'[7] He had the satisfaction of reporting later that 'the highly decorative buildings at South Kensington, in terra-cotta and red brick, have cost under 1s the cubic foot exclusive of mosaics, decorative paintings, and the like. This is below the cost of an ordinary London house of the first class. Terra-cotta and brickwork are but slightly affected by the smoke and atmosphere compared with Portland Stone.'[8]

Much more stringent economies were practised on the accommodation for the art masters in training, who remained in their wooden classrooms and dilapidated houses for six years; but even the meagre amount of Government money expended upon them was bountiful compared with the funds which reached the local Schools of Art, as can be seen in the next chapter.

FROM THE BOARD OF TRADE TO THE EDUCATION DEPARTMENT

From its establishment the Department of Practical Art, under the guidance of its General Superintendent, Henry Cole, had moved rapidly away from vocational training for the Board of Trade's purposes towards general education. Training national teachers in elementary drawing had been the first step, followed quickly by amalgamation with science education. The Surplus Report of the Commissioners for the Great Exhibition had stressed the need for provision for science and art education, and so had the Queen's speech in 1853; and on 16 March of that year the Board of Trade sent a letter to the Treasury with their annual estimates outlining suggestions for a 'United Department of Science and Art'. The Board proposed that Dr Lyon Playfair should be secretary of the united department and that 'local intelligence and energy should create Schools of Industrial Science and Art'.[9]

The Department of Science and Art was inaugurated in October 1853 with Lyon Playfair as Secretary, Cole as Inspector General, and Redgrave as Art Superintendent. Two inspectors were appointed to assist Cole, H. Bowler and Robert G. Wylde. This situation continued for four years and must have been very irksome for Cole, who disliked

sharing his responsibilities with anyone; but perhaps he was consoled by the fact that the Department was now of much greater importance. The *Art Journal* went so far as to suggest that Cole 'contrived to associate' the departments so as to become 'master and owner of every department of the Department'.[10]

From Christmas 1853, when Cole had arranged with the Committee of Council on Education to set drawing examinations for students in Training Colleges and for pupil teachers, the Art Division of the Science and Art Department had become deeply involved in general education; and, largely as a result of these measures, which included payments and expenses for examinations, on 26 February 1856 by Order in Council the Department of Science and Art at Marlborough House was put under the jurisdiction of the Committee of Council on Education, together with the newly formed Education Department at Whitehall. This did not mean that the Science and Art Department was supervised or managed by the Education Department; both departments were equally responsible to the Vice-President of the Committee of Council and were managed separately. The involvement of the Science and Art Department with general education was quickly demonstrated by a minute of 30 March 1856 which directed that 'exams and prizes should be offered to all persons, whether taught through the agency of the Department or not; and affirms the principle of making payments to school and master on the exam results of the schools for the poor'.

Lyon Playfair resigned as Secretary of the Science and Art Department at the end of the session of 1856–7, and in October 1857 Cole was appointed Secretary and General Superintendent, and Redgrave became Referee and Inspector General for Art.

Sources

1. COLE, SIR HENRY *Diary*, 2 November 1851 Cole Bequest, Victoria and Albert Museum, London
2. *Art Journal*, 1856 (p. 50)
3. COLE, SIR HENRY *Fifty Years of Public Work* G. Bell, London, 1884 (Vol. I, p. 322)
4. Ibid. (Vol. I, p. 323)
5. Ibid. (Vol. II, p. 351)
6. Ibid. (Vol. II, p. 323)
7. Ibid. (Vol. I, p. 332)
8. *Fifteenth Report* of the Department of Science and Art, 1867–8 (p. 200)
9. *First Report* of the Department of Science and Art, 1854 (pp. x, 1, 9, 11)
10. *Art Journal*, 1864 (p. 279)

11

Payment on Results
in Art Education

'*It became necessary to change the system unless Art was
only to be taught as a charity.*'
Henry Cole[1]

THE ORIGIN OF PAYMENT ON RESULTS

Holman in his *English National Education* pointed out that the principle
of Payment on Results in education was already latent as early as 1857
when the lords of the Education Department suggested 'an arrangement
whereby the teacher was given some interest in obtaining the capitation
grant, e.g. a percentage upon it, in addition to the salary otherwise
assured to him'.[2] S. J. Curtis wrote in his *History of Education in Great
Britain* that Robert Lowe's introduction of the system was probably
inspired by a paragraph of the Newcastle Commission report of 1861,
which proposed a searching examination 'to make the prospects and
position of the teacher dependent to a considerable extent on the results
of this examination'.

Both Holman and Curtis were mistaken in their view of the origin of
Payment on Results. The principle of Payment on Results was not just
latent in 1857, it was very active in the Science and Art Department; for
instance, on 30 March 1856 the Board of Trade affirmed the new
principle 'of making payments to school and master on the exam results
of the schools for the poor'.[3] When Robert Lowe became Vice-President
of the Committee of Council on Education in 1859, he knew Cole, and
the system of payments he was operating, very well. Form No. 441,
24 February 1863, of the Science and Art Department of the Committee
of Council on Education states that 'a system of payments on results
tested by public examination . . . has been partially carried out with
great success for several years'.

A year later Cole expanded on this point in evidence before the
Select Committee on the Schools of Art:

'I wish the Committee to understand that the payment upon results is only following out a principle that has been in operation for seven years, a little more extensively . . . the success of the system of payment on results for drawing, especially with reference to the poor schools, has operated as an example to induce the primary branch of the Education Department to adopt the same principles, for reading, writing, and arithmetic.'[4]

Although Cole had done much to introduce the system of Payment on Results, this was not his ultimate aim. His ambition was to make all the institutions of his Department self-supporting. He was rather of the Whig-Radical way of thought. Self-support within a fiercely competitive system, or self-support in competition with such a system, were equally valid. In his youth Cole had frequently met John Stuart Mill, to whom he was introduced by the poet Thomas Love Peacock (in whose house Cole lived). Cole was undoubtedly influenced by Mill's Utilitarian philosophy that an education 'controlled by the State should only exist, if it exist at all, as one among many competing experiments, carried on for the purpose of example and stimulus, to keep others up to a certain standard of excellence'.[5]

Cole regarded a state system of art education as a stimulus to private effort. He always made a special point of mentioning any art schools which were financially independent of the Department and managing their own affairs. However, if institutions wished to obtain Government money, they had to demonstrate examinable results to receive payment. In his view these were imperfect institutions, for a perfect institution, whether school, museum, or exhibition, should not only be self-supporting, but show a profit.

'If one could contemplate a system,' he said, 'by which the people being instructed would pay the total cost of their instruction, that possibly would be the perfection of a system . . . it may be some years yet before they pay quite enough.'[6] This was possibly perfection, but when an institution actually showed a profit, Cole brought it to the public's notice as the highest degree of excellence.

PARTIAL PAYMENT ON RESULTS, 1854–63

The system of Payment on Results evolved indirectly, on one hand from the desires of successive principal officers of the Board of Trade – Lord Granville, Lord Stanley of Alderley, Henry Labouchere, J. W. Henley, and Edward Cardwell – and of Henry Cole to make the local Schools of Art self-supporting; and on the other hand from Cole's wish to compel them to spread the teaching of elementary drawing in the public day schools.

As early as September 1848 Cole had written to Sir Denis le Marchant, Secretary of the Board of Trade, suggesting that the Schools of Design should support themselves by designing for Government departments; and later, when the Board of Trade put forward the idea of self-support for the Schools, the Lords of the Treasury were delighted. A Treasury minute appended to the educational estimates for 1850–51 reads: 'My Lords observe with satisfaction that the Committee of Privy Council for Trade contemplated that these institutions become self-supporting.'[7]

No sooner had Cole taken over the general management of the Schools than his Department set about abolishing the direct grant system by which Schools were subsidised by the Council of the Head School. He declared later that 'Mr Labouchere, now Lord Taunton, had to some extent pointed to stopping it before he went out of office',[8] and when the first estimates for the Department were submitted by J. W. Henley, the new President of the Board of Trade, in 1852, a letter was appended from Cole and Redgrave, stating their intention, as 'a leading principle – to make the Department as far as practicable self-supporting in all its branches'.[9]

The first step, taken in March, was to abolish the principle of fixed annual salaries, paid to provincial art masters since 1842; in Cole's words, 'That system was nipped in the bud immediately by Mr Henley.' The new system of payment for masters was said by Cole to be 'payment partly by fixed salary, partly by fees', but in actual fact these payments were not fixed at all. The masters were only guaranteed that their annual salaries would be made up to £70 if their payment from fees fell short of this figure.

In June the Department issued an ominous statement which anticipated the philosophy of Payment on Results. The benefits of the new system of payment from fees with minimum guaranteed salaries, it was pointed out, was that it made art masters 'partners in the success of their labours . . . If their classes are thronged with students and their fees are large . . . the emoluments should be in proportion to the success of their labours'.[10]

It was the custom of most of the provincial Schools of Art to pay half of the pupils' fees to the masters, and occasionally the whole of them, but there were some exceptions where they received a fixed salary and no fees. The latter would have no obligation to increase their classes and spread the teaching of drawing, so on 28 January 1853 the Board of Trade laid down that a portion of the fees be paid to the staff of the Schools. This portion was to be paid into the Masters Fund of the School and shared out among the staff by agreement between them and the managers. The first Report of the Science and Art Department reminded the managers: 'It is now a fundamental rule to make fees paid

by students a part, and as much as possible the principal part of the master's income, in order that his remuneration may be in proportion to his exertions and success.'[11] The Department received considerable public support for its new policy. *The Engineer* gave its approval of 'the self-supporting principle which underlies all the actions of the Department, and we confess that there is nothing which has more entirely won us over to the Department's policy, than its resolute adherence, in spite of all temptations and opposition to this fundamental principle. We have a great suspicion of everything which needs bolstering up with Government subsidies.'[12]

Even the small guaranteed payments to make up some masters' salaries to £70 went against Cole's principle of self support and in 1854 a scheme was prepared to replace these subsidies with payments for qualifications. The Art Superintendent, Richard Redgrave, and the Headmaster of the Central Training School, Richard Burchett, had been introducing new examinations for the art masters-in-training by which they could obtain various Certificates of Competency for Art Instruction. Edward Cardwell, the President of the Board of Trade, suggested to Cole that these could form the basis of a new policy; and on 4 March 1854 a minute of the Board abolished the annual salary subsidies and established a system of graduated payments for art masters dependent upon the number of certificates they had obtained. The Directory of the Science and Art Department of that year affirmed that 'an annual salary of from £10 to £50, according to the character of his certificates is the only permanent payment the teacher will receive from the Department'. In practice a master received £10 annually for each certificate held.

Cole and his chief, Lord Stanley, still faced with the problem of inducing the art masters to extend their teaching to pupils of the public elementary schools, introduced the minute of 30 March 1856 affirming the new principle 'of making payments to school and master on the exam results of the schools for the poor'. The ideal of self-support had led to Payment on Results. The new regulations of the Department, resulting from this minute, awarded the teacher 6d for each child taught drawing in the elementary schools, and 3s for each child who won a prize in the annual First Grade examinations of the Department. In order to compel the art school master to extend his teaching in the parochial schools, Cole ruled that an art master would not only fail to get the above payments for the children's instruction, but also the fixed payments on his Certificates of Competency unless one per cent of the population of the School of Art's area of instruction was taught drawing. The art masters were given until August 1858 to raise the numbers of their parochial pupils to one per cent. It was further affirmed by a minute of the Committee of Council of 18 July 1858 that an arrangement

for instruction in drawing of at least one per cent of the population of any district was essential for obtaining an art master.

It might seem to the reader that enthusiastic art teachers could under the Department's regulations obtain a substantial reward for their labours by working a large number of pupils up to a prize-winning standard, but Cole had other ideas. His primary object was to extend and improve instruction in drawing, not to reward teachers. The fourth Report of the Department explained that 'the total amount to be expended in prizes of this kind can always be regulated as the demand for them increases, the standard of excellence can readily be raised – papers can, from time to time, be increased in difficulty'.[13] This was the basic plan of the system for which Cole claimed credit. He asserted in evidence before the Select Committee of 1864 that 'the advantage of the new system is, that you can keep the expenditure more under control. You have only to raise the standard from time to time, and thereby you can keep the total sum under control.'[14]

The maximum number of local medals given to pupils of each School of Art, for which an art master received payments, was fixed at thirty, and the maximum proportion of parochial pupils who could receive prizes was also regulated; but the latter was altered from time to time. For instance, in 1856 a maximum proportion of one prize for every seven pupils in a class was allowed, but for the·following year Cole reduced the proportion of possible prize winners to one in ten. This in fact meant that the number of 'good' marks in First Grade papers, for which a prize was obtained, was reduced in any public day class and that the art master would have to teach in more schools to obtain the same amount of 3s payments as before. No matter how high a standard was achieved in the classes he instructed, the payments possible were strictly limited. On the other hand, when the art masters taught more and more children to obtain greater payments from the Department, all Cole had to do was to raise the standard by again reducing the proportion of children eligible for a 'good' mark.

The Engineer, which had previously been enthusiastic about Cole's policy of self-support, must have been one of the first publications to note the change of policy to Payment on Results and its implications. This periodical commented in 1857:

'The whole matter is placed beyond the control of the art master. His most energetic exertions may, at any time, be rendered abortive. . . . The national effect of all this is quite obvious and equally disastrous. It is destructive of confidence between the Department and its masters.'[15]

Worse was to come for the art masters, as can be seen in the following

pages, for they were now under the Committee of Council on Education, and in 1859 Earl Granville and Robert Lowe, both admirers of Cole and advocates of Payments on Results, were returned to power and became the President and Vice-President respectively.

From all the above evidence Cole's claim that Payment on Results was pioneered in his Department seems to be justified. It was not the same system as that introduced for general subjects by the Revised Code; it was in fact more vicious and complete. The ordinary schoolmaster had a salary, and the education grants included money for the numbers in attendance. The art masters, under the system described below, were to receive no Government payments whatsoever, except for payments on the results of graded examinations and medals made to the Masters' Fund at each School of Art. Their main chance of earning a living lay in attracting students who could afford to pay full fees.

COMPLETE PAYMENT ON RESULTS

By 1863 the only fixed payments made by the Science and Art Department on behalf of the Art Division were the grants for the number of Certificates of Competency held by the art masters, and on 24 February the Committee of Council on Education, with Earl Granville in the chair and Robert Lowe present, put down the following resolution:

'That after 1 October 1863, payments will cease to be made in respect of certificates taken by Masters of Schools of Art, but that a system of payments on results tested by public examination, which has been partially carried out with great success for several years, shall wholly regulate the payments to Schools of Art, and that such payments shall be made only on behalf of artisans, children of the labouring poor, scholarships, persons in training as Art teachers or employed as designers for manufactures.'

Cole supplied arguments and factual evidence for these measures, showing that from the beginning of his period of office the Government expenditure per student had grown less and less, and promised that one day perhaps his ideal state of self support might be reached. The minutes preceding the above resolution read:

'My Lords find that, the number of students learning drawing has increased from 3,296 in 1851 to 88,196 in 1862, whilst Parliamentary aid has been reduced from £3 2s 6d per head to 8s 8d, the latter charge inclusive of the cost of the collection at South Kensington . . . the fees paid rose from £3,447 in 1852 to £18,083 in 1862 and the schools have become to a great extent self-supporting.' This was indeed powerful justification for the New Minutes which followed during the year.

The New Minutes of 1863 abolished payments for art masters'

certificates and for art pupil-teacherships and reduced the payments made for each child who passed the First Grade examinations. The term 'art pupil teacher' was abolished and the words 'local scholar' substituted, and such a scholar was only to receive £25 as salary if 1000 parochial children were being taught in connection with his School of Art. The reasons supplied by Cole for the New Minutes are given in the Report of the Select Committee of 1864, as follows:

1. To prevent the masters claiming to be officers of the State.
2. To stimulate the activity of the masters.
3. To bring expenditure under control from time to time by raising the standard.
4. To reduce the Parliamentary aid per pupil by increasing the number of children taught in the parochial schools.
5. To restrict Parliamentary aid to the artisan class.[16]

The only beneficial measure, as far as payments were concerned, was the introduction by the minute of 3 March 1863 of fifteen National Scholarships to be awarded for merit in the National Competition. This measure was intended to encourage gifted artisans and aspiring designers from local Schools of Art to concentrate on designing which was, after all, the original purpose of establishing public art education. The scholarships were only awarded to holders of the full Second Grade Certificate who had won a medal in the National Competition for works in the *Design* or *Special Technical* (*Applied Design*) Stages (22 and 23) of the Course of Instruction.

These medal winners had then to submit, in the following September, a design or set of designs for objects of manufacture, and the successful candidates were accepted into the Training Schools in October, where they were allowed a maintenance grant of £1 per week for ten working months for at least two years and were entitled to study in the art museum at South Kensington from 10 a.m. to 4 p.m. The National Scholarships became the most sought-after art award and remained so for the rest of the century. Frank P. Brown, an ex-student at South Kensington, remarked that 'these national scholars, educated as designers and ornamentists found little difficulty in obtaining remunerative employment'.[17]

To make payments on results comprehensive, Cole had to rid local Schools of Art of two categories of master: firstly, the uncertificated older masters who had been appointed on a full salary by the Board of Trade in the days of the Schools of Design; and secondly, various uncertificated assistants who were paid from local fees. Cole had relied upon the numbers of such assistants diminishing from 1856, when Government payments on results of the Art Division's exams were made

payable only to certificated teachers. His hopes were not entirely fulfilled, because several local committees continued to allow uncertificated assistants a portion of the School's fees; also some uncertificated teachers made use of the system to obtain pupil-teachership allowances year after year. A case in point was that of William Hough of the Coventry School. By 1862 he had been an assistant for nine years and might have continued if his pedagogic success had not brought him to Cole's notice.

In August 1862 Henry Rafter, headmaster at Coventry, had sent in a letter of resignation to his committee, giving as his main reason the falling-off of fees, but it is clear from a later letter that his real reason was because he was treated as an inferior, for he stated he was willing to talk with any gentleman of his committee 'with whom I can confer on a standing of equality'. The committee then nominated Hough as head, with effect from October, but in December a sharp rebuke arrived by letter from the Department. The committee were informed that this uncertificated teacher could not take charge, even for six months, and that Hough must be examined by the Department in February. A master-in-training, George Wedgwood Anderson, was dispatched from London to take charge while Hough prepared himself, but the luckless headmaster failed his examinations and thus, in spite of a remonstrance from the students, he was dismissed. Anderson was given the appointment, and held it for thirty years. Regrets for the passing of Mr Hough appeared in the School's annual report.[18]

Another unfortunate was W. Boyton Kirk, the modelling master at Birmingham. A piece of his work had been retained by the Department as an example of modelling, but since he was uncertificated, he was instructed to submit to Redgrave the drawings required before taking a Third Grade Certificate. These were rejected, and in his letter of resignation Kirk expressed regrets 'that such honourable and skilful men as Messrs Cole and Redgrave should be glad to possess in their immaculate Museum a specimen of my Art, and yet consider the Artist incompetent and unworthy of the humble post he has held'.[19]

The former masters of the Schools of Design presented a more difficult problem for Cole. When he had assumed office in 1852 there were over thirty of these being paid from £150 to £400 per annum as salaried officers of the Board of Trade. As the years passed their numbers diminished, and Cole judged that it would be more economic to wait, rather than retire them upon a pension. He respected their right to an official salary, as can be deduced from the following episode.

James Astbury Hammersley had been appointed headmaster of Manchester School of Design on 1 May 1849 by the Board of Trade with an annual salary of £300. Besides greatly increasing the attendance

at Manchester, Hammersley was thriving in private practice, and according to the *Journal of Design*, exhibiting 'most exquisite sketches in water colours of the Lakes scenery'. He had been fortunate enough to have conducted Prince Albert round an exhibition of paintings at Peel Park, Salford, on the occasion of the Consort's visit to Manchester's Art Treasures Exhibition in 1857, and H.R.H. had commissioned him to paint 'the castled crag of Drachenfels', near Bonn where the Prince had studied. Edmund Potter, chairman of the Manchester Committee, reported later, with disapproval, that in 1860 Hammersley was earning £300 from the Department, plus £131 from fees, and over £300 from private practice.[20]

It seemed to Potter that Hammersley was getting above himself, especially when the head asked for secretarial assistance, and friction grew apace. Hammersley quickly obtained the headship at Bristol School of Art, which had just moved into new premises, and in his letter of resignation showed his poor estimate of the treasurer and secretary of the Manchester committee, complaining that all had been badly done 'and with much loss to the school. Fees frequently not paid at all, fines not imposed, and a very large sum of money annually lost to the school.'[21]

The committee who had 'rather forced upon him the resignation, after some years of a little irritation', congratulated themselves at first because they assumed that the £300 grant for the head's salary would continue to be remitted to the next incumbent, but, Potter declared later: 'Upon his going, however, the £300 a year went with him, and there was a considerable irritation and strong feeling upon the part of the Directors with regard to that sum of money going with Mr Hammersley.' Their tempers were not improved by the fact that grateful students had recently presented the head with a gold watch for ten years of devoted teaching. However, Cole had no intention of paying the salary to Manchester, because if he had, the School would have regarded it as a fixed payment.[22]

By 1863 there were only seventeen salaried masters remaining, and during the next two years Cole made a clean sweep of them. The heads at Bristol, Birmingham, Dublin, Macclesfield, Newcastle, Paisley, Sheffield, and Stoke received superannuation because of 'abolition of office', and some of the older masters such as C. Heath Wilson of Glasgow, R. S. Lauder of Edinburgh, Young Mitchell of Sheffield, and J. Kyd of Worcester were 'retired' because of 'ill health'. School managers were informed that the salaried masters could remain if they wished to pay them, but, being uncertificated, they could not obtain Payments on Results. Cole was a good judge of the Victorian business-man: the masters were not reappointed.

Payment on Results was now fully comprehensive, but the managers and masters had been provoked too far to expect them to submit without a great effort to obtain redress.

THE REVOLT OF THE MASTERS

The art masters, because of their low social position, had relied upon the wealthy members of their committees to right their wrongs, but on the publication of Science and Art Minute 441 of the Council on Education (24 February 1863), depriving them of their certificate payments, the last guaranteed portion of their salaries, the masters took matters into their own hands.

As soon as he had studied the circular of the Minute, John Sparkes, head at Lambeth and one of the most successful government art teachers of the century, contacted art masters in and around the metropolis and the masters-in-training at South Kensington. His correspondence resulted in a meeting at which was founded the Association of Art Masters. Sparkes, who was elected secretary, then wrote to provincial masters offering them membership and sending them some carefully structured questionnaires, which provided him with much information opposed to the Department's policies. The art master at Truro ended his reply to Sparkes with the words: 'I have therefore only to meet starvation in the best way I can.'[23]

The managers were not so much irritated by the treatment of their art masters as by the fact that their local institutions were receiving a meagre amount of money, as if of no importance. For example, on 9 April 1863 a correspondent pointed out in the *Manchester Guardian* that in the previous year the Department had paid out an average of £154 to each local School of Art, and expended £56,542 8s 7d on the South Kensington institution. In this year the western side of the present Quadrangle of the Victoria and Albert Museum was being completed to provide residences for Cole, Fowke his chief engineer, and two other officials. Cole actually made great use of the residence, setting forth daily on his morning tour of inspection with Jim, his Yorkshire terrier. His evening tours are occasionally recorded in his diary: 'Thro' Museum at night . . . Museum in evening . . . Took Evelyn Redgrave to see lighting.'[24] However, to the provincials these red brick residences, planned by Captain Fowke in the style of an Italian palazzo and decorated in terra-cotta by Godfrey Sykes, seemed sheer extravagance.

The *Art Journal* commented that 'the officials at South Kensington have built a small palace for themselves and a barn for the Female School of Art'.[25] A scheme which Cole had just initiated for the decoration of the Museum by Academicians and leading decorative artists, and which eventually involved costly expenditure such as £1,000 for a

lunette by Frederic Leighton, convinced local committees that as long as Cole retained control, the Department would have no money to spare for provincial institutions.[26]

Walter Smith, the headmaster at Leeds, complained that 'gorgeous courts arise at South Kensington, Venetian glass and majolica plates are purchased at fancy prices, whilst Provincial Schools of Art in important centres of manufactures, are crippled and curtailed . . . to be made mere elementary drawing classes, in order that South Kensington may have a public curiosity shop . . . its walls are resplendent with gilding; whilst unhappily, many a poor country School of Art cannot get decent room for its pupils to work in'. The annual report of the Manchester School (1862–3) complained: 'It seems unjust that local institutions should be left to starve, while so much money is lavishly spent on the central establishment at Kensington.' The Revd R. Gregory, chairman of the Lambeth School, lamented: 'Under the new Minute we must either give the master a salary or he must starve till we know what the results are.'[27]

The art masters and their committees were now united in opposition, with the exception of the Birmingham and Chester Schools. At Birmingham the Radical faction agreed with Utilitarian ideas on education and the managers were on good terms with Cole and Redgrave from their first meeting with them in 1852; in fact, Redgrave was engaged annually to award Birmingham's local design prizes. The School's annual report (1862–3) declared: 'While your Committee are strongly of the opinion that these [changes] are both uncalled for and unnecessary, as well as likely to act most injuriously on the School, they have taken no part in the agitation which has been made against their introduction, being both willing to give any scheme proposed by the Government a fair trial, and convinced that if it is found impracticable it will be withdrawn.' E. A. Davidson, headmaster at Chester, seemed content with the purses, presents, and fees bestowed upon him by the Chester 'Special Ladies Class', and was quite willing to make agreeable comments on the Department.[28]

The action, when it was taken on 26 February 1864, took the form of a deputation to Earl Granville, the President of the Committee of Council on Education, consisting of eight members of Parliament, headed by Colonel Wilson Patten, and some art masters and managers. A signed memorial was presented to Granville, complaining of: '*Firstly* the injustice of doing away with the masters' certificate allowances, *Secondly* the impolicy of doing away with art pupil-teachers, and *Thirdly*, the unfairness of spending so overwhelming a proportion of the annual grant on South Kensington.' Granville replied that the masters had neither legal nor moral claim to payments on their certificates, and that the amount expended under the New Minutes would be quite as great as

under the old in the opinion of the political and permanent officers of his department, by whom he undoubtedly meant Robert Lowe and Henry Cole.[29]

Lowe had already defended Cole against charges of lavishing money on the residences for officials on the grounds that their presence was necessary in case of fire, but I am sure that this argument was supplied by Cole, who, twenty-eight years earlier, had rescued the records from the Augmentation Office on the night the Houses of Parliament were burnt to the ground. One exchange between Lowe and Cole, who became very friendly during their association in office, is worthy of record. Lowe asked Cole to prepare a memorandum on keeping architects to their estimates, and, Cole related, 'I said, a design could not be made all at once. Man was not made at one effort.' 'You mean,' said Mr Lowe, 'that the monkey was an imperfect experiment.'[30]

However, returning to the matter in hand, Granville told the deputation that he would not make any changes unless a Parliamentary committee recommended it. A month later Cole found himself placed in the situation in which he had frequently placed others, on Sir Stafford Northcote of H.M. Opposition moving for a Select Committee.

ROBERT LOWE VERSUS JOHN SPARKES

Rather than refer to the mass of evidence given by the managers and masters to the Select Committee on the Schools of Art of 1864, it is simpler to study the encounter between Robert Lowe, the leading political advocate of Payment on Results, and his most effective opponent, John Sparkes, head at Lambeth.

The first day's evidence given by Sparkes contained some very telling proofs of prevarication by the Science and Art Department respecting the loss of certificate payments, which the art masters regarded 'as an absolute breach of faith'. Sparkes quoted a letter from Richard Redgrave, written to Leonard Baker, master at Stirling, about certificates, which affirmed that, provided the master was teaching, 'payments upon them are as certain as any other Government salaries'. Sparkes also pointed out a passage in the *Science and Art Directory* which stated that the certificate gratuity 'is the only permanent payment the teacher will receive from the Department'. He also submitted a Certificate for Art Instruction to the Committee bearing the words, 'Annual value attached to this Certificate for the 2nd Group – £10.'

Sparkes also presented to the Committee a well-structured questionnaire showing the replies of the art masters to questions he had circulated, and a signed memorial from the art masters-in-training which implied that the South Kensington Museum and Library were for public effect rather than for improvement of students. The memorial reads:

'We the students in training at the Central School, South Kensington, declare that the Art Collections and Library of the South Kensington Museum are far from affording us that assistance in our studies which is declared to be their primary object. The regulations of the Department require our constant attendance in the school during school hours, whilst in the intervals between the hours of study the Library and Museum are closed, during a great proportion of the year, on those days which are called students' days: persons unconnected with the Department have therefore, greater facilities for using the Library and Collections . . . than have we, the students, for whose training and Art education it is stated they were principally intended.'[31]

Sparkes aimed a direct blow at Cole by producing the names of forty well-known designers to contradict Cole's assertion, made before the Select Committee of 1849, that no designers had been trained at the old Schools of Design. It is very unlikely that Lowe and Cole expected such a series of efficient and well-supported attacks upon their system from an art master, and Lowe made sure he was present at the next hearing, where the following dialogues took place:

1183 [*Robert Lowe*] What have you done for the Government that they should enter into binding obligations with you?

[*John Sparkes*] I have consented to change my profession, to become a teacher of Art to artisans and to qualify myself to take certain certificates with the view of teaching what I had learnt in the school, upon a certain plan which the Government thought was a good plan for artisans to be taught upon.

1189 Your claim is that your salaries are to be raised to an artificial height by the action of the Government, that is what the masters ask, is it not?

Yes. With regard to the word 'artificial' I may observe that it can never be raised to any extent. I could never be demoralized by my large income received upon that score as it was limited to £50 a year.

1192 You may cut yourself loose from the Government, and set up as a private teacher, may you not?

Yes.

In reply to Sparkes's criticisms of the poor examples and copies supplied by the Department, Lowe remarked, 'I cannot trace in your mind the slightest notion that it is the duty of the school to supply them to itself.'

Alexander Macdonald, a master-in-training who gave evidence of the hardships of a student's life at South Kensington, also felt the edge of

Lowe's tongue. Macdonald claimed that since he had studied and taught in the Central Training School for five years, the Department was obliged to find him a desirable appointment or to continue to maintain him as a student-teacher. Lowe asked him to prove this obligation from art directions of the Department of Science and Art, and summed up: 'The long and short of it, as I understand it, is this, you have been taught a profession, more than £300 of public money has been expended upon you, and in consideration of those facts, you claim to be maintained by the public for the rest of your life in the training class, if you choose to stay there?'[32]

The most masterly criticism Sparkes made during evidence was of Cole's policy of meagre Payments on Results achieved only by artisans and poor children. 'The Government,' said Sparkes, 'insists upon a school having classes that do not pay, and drives the managers to the paying classes.'[33] Sparkes could not hope to win his battle for the art masters against the politicians; however, his personal efforts in making the Lambeth School into one of the most successful in Britain eventually won him the headship of the National Art Training Schools after the resignations of Cole and Redgrave. Alexander Macdonald was also fortunate, inasmuch as he obtained the mastership of Oxford School of Art on its opening in the Randolph Gallery in 1865, and in 1872 the mastership of the Ruskin Drawing School.

PAYMENT ON RESULTS ENDURES

The benefits achieved by the Committee for the art schools and their masters were exceedingly small. The *Art Journal*, still in deadly opposition to Cole, was carried away by some critical queries published in the Report concerning Cole's theories of self-support, and it referred to the findings as 'the thin edge of the wedge', and added that the Committee's 'main object was to put on his trial Mr Henry Cole', and that 'without saying so much in so many words . . . it has condemned the whole of the policy pursued by Henry Cole'. Admittedly the Report stated that 'Your Committee are of the opinion that the system of payments on results introduced by the recent Minutes, is not well adapted to the Schools of Art', but it added, at Lowe's suggestion, that the Government could legitimately 'substitute a system of payment on results for a system of payment on certificates'.

The main objects of those who had fought for the Select Committee had been, firstly, the continuance of certificate payments; secondly, a large proportion of the annual Government grant for local Schools of Art; and thirdly, the removal of Cole from office. None of these objects was obtained. The only concession made to the masters in the Resolutions was 'that a capitation payment should be made for every artisan student,

who has received forty lessons within the year' to bring them into line with the science teachers of the Department.[34]

Perhaps if Richard Redgrave had commented during his evidence upon the perilous nature of an income dependent upon results in art and had pointed out the difficulties of running an art school with a staff of one or two teachers, the findings of the Committee might have been more favourable to the masters; but this strange art teacher, whose own post at Kensington was a salaried part-time appointment, and who had sprung to fame with his pictures of 'The Poor Teacher' and 'The Governess', must have reserved his sympathies for genteel teachers and reduced gentlewomen, not for lowly males who taught artisans. He declared in evidence that the old system of fixed payments encouraged a large staff where one teacher would have been sufficient, and asserted: 'it is far more satisfactory to pay on results than on certificates'.[35]

The Resolutions of the Committee terminated grants for building, renting, and repairing local Schools of Art, and for examples, models, casts, and apparatus; on the other hand it was resolved 'that a central training school for teachers be maintained as at present'.

It can be seen from all this that the *Art Journal* was completely mistaken about 'the thin edge of the wedge'. Payment on Results for art masters was to continue in one form or another until the turn of the century. Cole's removal was extremely unlikely; not only was he backed by Granville and Lowe and a multitude of Radicals, but he was, as far as the Queen was concerned, the authority on art connected with manufactures, as her late husband had assured her. The *Art Journal* hinted darkly that Cole derived his power 'from the patronage he enjoys'.

The longest and, as it turned out, the most important Resolution of the Committee was the fifth, which attempted to prevent the increasing tendency to enrol the 'paying classes'. It laid down that State aid would only be granted to schools that opened night classes for artisans at least three times a week under certificated teachers in suitable premises. The wording 'night classes' was thenceforth officially adopted instead of the old 'artisans classes', and typified a new way of thinking about courses in education which has endured until today – evening or vocational courses on one hand, full-time day educational courses on the other.

The pretence that the purpose of the Schools of Art was to teach designing to artisans was completely exposed by the definition of the purpose of such a class in the *Art Directory* of 1865. 'A Night Class is a class for instruction in Elementary Drawing held after 6 p.m.' To sum up, a School of Art had only to have three elementary classes to qualify for Government payments and for the employment of an Art pupil-teacher. Also, provided it had such classes, it could obtain payments of

10s for each satisfactory work sent to South Kensington by any student, so the masters paid increasing attention to the middle-class boys and girls in the day classes who were most likely to produce successful works – the 'paying classes'. In the session 1866–7, Sparkes's School of Art at Lambeth won three out of the ten national gold medals awarded by the Department, four silver medals awarded by the Royal Academy, and a bronze medal in the Paris Exposition. The *Art Journal* commented that 'this school has achieved astounding results, but they have been won by ignoring the Government plan of instruction altogether'.[36] This was not entirely true; what Sparkes and other masters were doing was concentrating on the fine art stages of the Course of Instruction, which the middle class pupils were keen on, and which promised a golden future now that the Victorian fine art boom was commencing.

THE RESIGNATION OF HENRY COLE

Cole resigned in April 1873 after twenty-one years in the service of art education, and it is interesting to read his own view of his claim to fame, which he gave to the students of Nottingham School of Art three months before his resignation.

> 'Since the year 1852, I have witnessed the conversion of twenty limp Schools of Design into one hundred and twenty flourishing Schools of Art in all parts of the United Kingdom, and other schools like them, in the Colonies and the United States. Five hundred night classes for drawing have been established for artisans. One hundred and eighty thousand boys and girls are now learning elementary drawing. Twelve hundred and fifty Schools and Classes for Science instruction have spontaneously sprung up. The South Kensington Museum has been securely founded as a National Centre for consulting the best works of Science and Art, as a Storehouse for circulating objects of Science and Art throughout the Kingdom. Whilst this Museum itself has been visited by more than twelve millions of visitors, it has circulated objects to one hundred and ninety-five localities holding exhibitions, to which more than four millions of local visitors have contributed about ninety-three thousand pounds.'[37]

Cole should be judged by contrast with his contemporaries, many of whom considered Art to be a precious achievement which had no place in the public day schools. Art as a useful subject was ridiculed by many Victorians, who only had time for High Art of the Classical tradition. The art manufactures of various nations which Cole amassed at Kensington were regarded as oddities. Lord Palmerston reflected the upper-class attitude when he viewed the majolica in the Museum and exclaimed:

'What is the use of such rubbish to our manufacturers?'[38] Sir Rupert Kettle, writing two years after Cole's death, declared:

> 'No part of the South Kensington institution has been subject to such merciless and persistent . . . I will not say censure . . . but jeers and scoffs. But it has grown beyond the reach of satire. The English people have become proud of it. They see at South Kensington the most magnificent collection of Decorative Art that ever was brought together.'[39]

Cole's mind was so attuned to the mood of his times that he frequently amazed his political chiefs. If Cole wanted a thing done, it usually was done. Earl Granville wrote to Earl Charles Canning, Governor General of India, in February 1861, 'we have ordered a building designed by Captain Fowke and Cole', and in a letter in April he admitted to Canning that 9,999 persons out of 10,000 did not see the point of the projected exhibition. 'Nobody,' he wrote, 'wished for it excepting Cole, and it is a great proof of the power of a strong will.' In order to derive maximum publicity for the international exhibition of 1871, Cole arranged for the unfortunate Prince of Wales and his entourage to walk the longest possible route around the roadways outside the exhibition. W. E. Forster, vice-president of the Council on Education (1869–73), declared that Cole 'was the only despot that could have made a procession walk half a mile'.

To act as he did Cole needed a thick skin, an asset for which H. A. Bruce, vice-president of the Council on Education (1863–5), commended him. Controversy stimulated and amused Cole: thus when he had read in *Hard Times* the utterances of Gradgrind and the government officer (see Chapter 12), he wrote to Dickens in a humorous vein instructing him to report to Redgrave for enlightenment on the 'correct principles' of decoration.

Dickens replied by letter on 17 June 1854 regretting that he was unable to call on Redgrave as he had retreated to Boulogne in the company of Gradgrind and others. He added that, although he agreed in the main with Gradgrind, he went too far. Dickens expressed the hope that 'we shall meet at last at some half-way house where there are flowers on the carpet and a little standing room for Queen Mab's Chariot among the Steam Engines'.[41]

The letter shows that Dickens, who, according to Ruskin, was 'a leader of the steam-whistle party *par excellence*', was in general agreement with Cole's policies, but thought them too harsh, especially on children.[42]

However, the influence of Cole and Redgrave was to be most permanent in child education. Long after the art schools had swung

towards fine art, child art education was biassed towards geometrical outline. The so-called 'free-arm drawing' of the early years of this century, and the drawing of geometric 'type solids', which flourished until the second world war, were rooted in the National Course of Instruction. (See Plates 32 and 36.)

Sources

1. *Sessional Papers, 1864* Select Committee on the Schools of Art (p. v)
2. HOLMAN, H. *English National Education* Blackie, London, 1898 (pp. 136–7)
3. Science and Art Department of the Committee of Council on Education Form 441, 24 February 1863
4. *Sessional Papers, 1864* Select Committee on the Schools of Art (p. 19)
5. MILL, J. S. *Utilitarianism, Liberty, and Representative Government* (Everyman edition) J. M. Dent, London, 1910 (p. 161)
6. *Sessional Papers, 1864* Select Committee on the Schools of Art (p. vii)
7. Civil Service Estimates IV *Hansard* (House of Commons), July 1850; and *Journal of Design and Manufactures*, March–August 1850 (Vol. III, pp. 186–7)
8. *Sessional Papers, 1864* Select Committee on the Schools of Art (p. 231)
9. Ibid. (p. iv); and Minute of the Board of Trade, 31 March 1852
10. *First Report* of the Department of Practical Art, 1853 (pp. 41, 329)
11. *First Report* of the Department of Science and Art, 1854 (p. 93)
12. *The Engineer*, 1856 (Vol. II, p. 232)
13. *Fourth Report* of the Department of Science and Art, 1857 (pp. 30, 53)
14. *Sessional Papers, 1864* Select Committee on the Schools of Art (p. xi)
15. *The Engineer*, 1857 (Vol. IV, p. 442)
16. *Sessional Papers, 1964* Select Committee on the Schools of Art (pp. xxiv–xxv)
17. BROWN, FRANK P. *South Kensington and its Art Training* Longmans, Green, London, 1912 (p. 18)
18. RAFTER, HENRY Letters to the Coventry School of Art Committee dated 18 August and 3 September 1862, and letters from the Secretary of the Department of Science and Art dated 27 December 1862 and 7 January and 31 March 1863 Coventry College of Art strongbox
19. Minutes of Birmingham Society of Arts and School of Art, 1855 (Copy of letter from W. Boyton Kirk dated 17 August 1855)
20. *Journal of Design and Manufactures*, September 1849–February 1850 (Vol. II, p. 210); *Art Journal*, 1859 (p. 236); and *Sessional Papers, 1864* Select Committee on the Schools of Art (p. 125)
21. *Sessional Papers, 1864* Select Committee on the Schools of Art (p. 124)
22. Ibid. (pp. 154, 289)
23. Ibid. (p. 79)

24. COLE SIR HENRY *Diary*, 12 January, 11 February, 13 November 1865 Cole Bequest, Victoria and Albert Museum, London
25. *Art Journal*, 1863 (p. 146)
26. Ibid., 1864 (pp. 76, 222, 282); and COLE, SIR HENRY Letter to Frederic Leighton dated 14 July 1868, published in Barrington, Mrs Russell *Life, Letters and Work of Frederic Leighton* George Allen, London, 1906
27. *Art Journal*, 1864 (pp. 218–19); and *Sessional Papers, 1864* Select Committee on the Schools of Art (p. 49)
28. Minute of Birmingham Society of Arts and School of Art, 4 March 1852; and Annual Report of the year ending December 1863
29. *Art Journal*, 1864 (p. 100)
30. *Fifteenth Report* of the Department of Science and Art, 1867–8 Appendix D (p. 200); and COLE, SIR HENRY *Fifty Years of Public Work* G. Bell, London, 1884 (Vol. I, p. 8)
31. *Sessional Papers, 1864* Select Committee on the Schools of Art (pp. 261–6, 74–5)
32. Ibid. (pp. 55, 256, 270, 76–7, 162)
33. Ibid. (p. 85)
34. *Art Journal*, 1864 (pp. 279–81); *Sessional Papers, 1864* Select Committee on the Schools of Art (pp. xi and xvii)
35. Ibid. (pp. xxv, 233)
36. *Art Journal*, 1867 (p. 29)
37. COLE, SIR HENRY *Fifty Years of Public Work*, G. Bell London, 1884 (Vol. II, p. 388)
38. Ibid. (Vol. I, p. 292)
39. *Art Journal*, 1884 (p. 15)
40. FITZMAURICE, LORD EDMUND *The Life of the Second Earl Granville* Longmans, Green, London, 1905 (pp. 391, 395); and COLE, SIR HENRY *Fifty Years of Public Work* G. Bell, London, 1884 (Vol. I, pp. 218, 268)
41. MS, Pierpont Morgan Library, New York (extract published by kind permission of Mr C. C. Dickens, the Pierpont Morgan Library, and the editors of the Pilgrim Edition of *The Letters of Charles Dickens*)
42. RUSKIN, JOHN *Letter* to Charles Eliot Norton, Venice, 19 June 1870 In *The Works of John Ruskin* (Library edition) Edited Cook, E. T., and Wedderburn, Alexander George Allen, London, and Longmans, Green, New York, 1907 (Vol. XXXVII, p. 7)

12

The Philosophy of the
South Kensington Circle

THE FOUNDERS OF THE SOUTH KENSINGTON SYSTEM

From 1857 onwards the rather cumbrous title of the Department of Science and Art was eschewed by the public, who preferred to refer to 'South Kensington'; for instance, the popular description of the Department's Course of Instruction was 'the South Kensington system', and of its officials 'the South Kensington circle, or clique', but, although much appeared in print about South Kensington, few correspondents seem to have been really aware of the aims of the system, or even of its origin. The Secretary, the Inspector General, and the Headmaster of the Art Training Schools were looked upon as officials, not as artists, and Cole did not allow himself to be drawn into proclaiming theories of art or aesthetics. This seems to have lead to some confusion as to the authorship of the system, although by the eighties it had become a way of life in the Schools of Art. In 1888 the *Manchester Guardian* queried: 'Can anyone tell us where the South Kensington system came from – who, so to speak, invented it? Was it Owen Jones? Was it Henry Cole? Who was it?'[1]

Cole of course was responsible for the national system. Redgrave and Burchett were the originators of the actual exercises of the Course of Instruction, and Wornum chose many of the casts used. The Course was modified by Cole in 1853 to provide instruction for four classes of person: schoolchildren, general students, designers, and engineers. We may have no doubt that Cole obtained the appointment of Redgrave and Burchett because their ideas coincided with his. During his entire career Cole never endured working under or over any person he disagreed with.

One point Cole had constantly stressed during his attacks on the Public Records Commission and on the Council of the Head School of Design was the need for individual responsibility. At the beginning of his autobiography he referred to Jeremy Bentham's belief in 'single seated responsibility' and, like Bentham, Cole believed in a strong system imposed by the educator. He wrote: 'I think to act upon the principle of "every one to his taste" would be as mischievous as "every one to his morals".'

Possibly the strongest definition Cole gave of personal responsibility

to the public was in his 'Address on the Functions of the Science and Art Department' at South Kensington in 1857, when he affirmed:

> 'All administration . . . must insure, first, responsibility as direct, clear, and defined and individual as possible, and second, full publicity; without these all corporate action becomes corrupt and torpid . . . It may be asserted that there is not a single detail in the action of the Department . . . which does not invite the fullest publicity.'

The more intellectual colleagues whom Cole employed for short periods in the Department, Semper, Jones and Wornum, provide us with a key to the philosophy behind the South Kensington system. They all disliked the French methods of art education and preferred the German, and tended to be Utilitarians rather than Romantics. Whereas in general education the Utilitarians and philosophical radicals, such as Mill, Roebuck, and Buller, were championing useful knowledge and attacking the traditional classical learning, in art education they championed useful ornamental and mechanical drawing, as opposed to an aesthetic atelier training in the French and Italian academic traditions.

In 1867 the Committee of the Birmingham School of Art described the Course of Instruction as 'a system of instruction . . . which was devised originally by some of the most thoughtful of our Academicians and which is closely connected with the names of Dyce, Herbert, Westmacott, and Redgrave, and which, though differing in many respects from the system pursued in France, has yet close affinity with that of the leading Teutonic nations'.[2]

It is confusing to the modern reader to find that geometry and technical drawing were considered part of art education by the South Kensington circle. Cole and Redgrave not only drew no distinction between these subjects and art, but affirmed that geometry was the basis of drawing and design; the headmaster of their Art Training Schools, Burchett, was an exponent of this belief and author of works on geometry and perspective. Cole and Redgrave were convinced that their view of art training was progressive and educational as opposed to the cultural approach of the dilettanti and of many academicians. The admission that a young artist was a sensitive person who could make rapid progress without a great amount of regulated labour was anathema to Utilitarians who had a strong objection to anyone getting away with less work. J. S. Mill looked forward to a time 'when the rule that they who do not work shall not eat, will be applied',[3] and Cole's whole outlook was governed by the exhortation he chose for the title page of his autobiography: 'Whatsoever thy hand findeth to do, do it with thy might' (*Ecclesiastes*, 9, verse 10).

The South Kensington system, taken in the broad sense, was not simply the Course of Instruction, but as it included all the various provisions which Cole introduced, he was sometimes given credit for the whole structure; for instance, Frank P. Brown, headmaster of Richmond School of Art in 1912, and an ex-student at South Kensington, described Cole as 'Pioneer of systems of general Art education in the United Kingdom'.[4]

THE UTILITARIAN CONCEPT OF HENRY COLE, THE 'GOVERNMENT OFFICER'

'Accuracy in addition and straight lines are a national want and through the Department, the public seek to obtain State help in the production of them.'
Henry Cole, address at South Kensington, 16 November 1857

It would be difficult to imagine a more suitable middle-class Victorian for promoting Utilitarian principles than Henry Cole. As a young man in his twenties he used to hurry, once a week, from the office of Francis Palgrave the barrister, where he worked, to the India Office to take a midday stroll with the poet Thomas Love Peacock, or with John Stuart Mill. His long conversations with Mill, who at that time was feeling the full impact of Jeremy Bentham's principles, had a great effect on him, and Utilitarianism was further implanted in Cole by his visits to the reading group in George Grote's house, and to the London Debating Society. Cole's great respect for Mill's views continued throughout his life, and during his career at the Science and Art Department he liked to consult the philosopher on the ethics of legislation.

Bentham's principles of utility and facility were manifest in Cole's educational activities, but as far as utility was concerned, he felt, like Mill, the weakness in Bentham's principle of judging one's actions and objects by what would cause the 'greatest happiness of the greatest number'. He was more pragmatic than Bentham or Mill and prided himself on being very modern and practical; on one occasion he quoted his friend Charles Buller, M.P., as saying 'that the Benthamites had very good hearts, but wanted intellect!'[5]

Cole believed that if basic art education was spread to great numbers of children under a system of competition the best and fittest art would evolve and emerge. The taste displayed in the Great Exhibition was not a matter of great concern to Cole, but the number of works displayed and the number of visitors caused him to assert that 'The history of the world, I venture to say, records no event comparable in its promotion of human industry with that of the Great Exhibition'.[6] The number of visitors to the South Kensington Museum was carefully recorded and published for the benefit of periodicals such as *The Engineer*, the *Art*

Journal, and the *Illustrated London News*, and, as far as public art education was concerned, Cole's pride and joy was the annual total of children working exercises in elementary drawing in the ordinary public day schools.

Professor Collins in his book *Dickens and Education* is mistaken when he states: 'Marlborough House had no connection with ordinary schools and it was entirely unlikely that one of its staff would be thus addressing Coketown school-children.'[7] He is repeating a mistake made by Professor K. Fielding in the article 'Charles Dickens and the Department of Practical Art' in the *Modern Language Review* (XLVIII, 1953).

The subject discussed by both authors is the character of the Government officer in *Hard Times*. Professor Fielding made the interesting discovery that written at the top of Chapter Two on the manuscript plan for the book were the names Gradgrind, Cole, Sissy, and Bitzer, and that the words 'Marlborough House Doctrine' were also inscribed. All the names appear in the chapter except that of Cole, so it is reasonable to assume, as Professor Fielding suggests, that the unnamed government inspector is a caricature of Cole, or rather of what he stood for. The episode in the Coketown classroom is worth describing here as it is one of the few notable comments on the theories of the Department.

The Government officer, 'A mighty man at cutting and drying', having just obtained from Bitzer, a model pupil, the approved definition of a horse, went on methodically to ask the pupils whether they would paper a room with representations of horses and if they would use a carpet having reproductions of flowers upon it; and not having had satisfactory spontaneous answers in the negative, he held forth to the Coketown children on taste:

> ' ". . . You are not to have, in any object of use or ornament, what would be a contradiction in fact. You don't find that foreign birds and butterflies come and perch upon your crockery, you can not be permitted to paint foreign birds and butterflies upon your crockery. You never meet with quadrupeds going up and down walls, you must not have quadrupeds represented upon walls. You must use," said that gentleman, "for all purposes, combinations and modifications (in primary colours) of mathematical figures which are susceptible of proof and demonstration. This is the new discovery. This is fact. This is taste." '[8]

This brilliant piece of satire by Dickens shows his clear grasp of the rigid doctrines expounded by Owen Jones and Redgrave in Cole's Department at Marlborough House. Professor Fielding wrote that 'it would be entirely wrong to accept Dickens' travesty as deserved . . . the new officials were not unreasonable in laying down as general principles

that conventional designs should usually be used for materials to cover flat surfaces', but some would disagree with Professor Fielding and say that Marlborough House laid down not only principles but rigid rules and that the officials, especially Cole, were extremely despotic.

To return to the passage from Dickens, the point about flowers on carpets was a favourite one of William Dyce and of Owen Jones. Dyce had asserted that only geometrical patterns should be used on carpets in order that they should appear flat, and Jones, who had become enamoured of geometrical Arabic designs, believed the same. This insistence upon geometrical patterns was a narrow rule, not a principle. The principle is that a carpet should look flat. A correspondent of the *Journal of Design* in 1849 was astute enough to grasp that this ruling about geometrical shapes was narrow, since, he said, a meadow looked flat and was not geometrical, and that it was more preferable to have the 'springy texture of grass and moss than hard mosaic or parquet'.

Owen Jones stated, with aversion, during a lecture at the Society of Arts in 1853, 'We walk on flowers and tropical plants, crushing them beneath our feet.' Some other statements which illustrated the principles of the group are very similar indeed to those of the government officer given above; for example, on the matter of quadrupeds on walls, Redgrave's protégé Richard Burchett, who became the headmaster at Marlborough House, said, referring to wallpaper, 'I think that an elephant would not be a proper animal to put upon that paper, particulary a large one – he would be quite out of place on the wall. A trellis covered with pineapples is all right.'[9] An elephant, particularly a large one, is too big to fit against a wall in fact, therefore you must not have an elephant represented upon a wall. Pineapples on a trellis stand upright in fact, therefore you can be permitted to represent them on a wall. This is fact. 'What is called Taste, is another name for Fact,' Dickens's Government officer asserted. 'Fact, fact, fact!' said the gentleman.

The last part of the Government inspector's speech about 'combinations and modifications (in primary colours) of mathematical figures' is aimed at Redgrave and Jones, especially the latter, whose propositions on ornament were becoming well known through his lectures, some of which were remarkably akin to the inspector's remarks, such as: 'The whole and each particular member should be a multiple of some simple unit', and 'The primary colours should be used on the upper portions of objects, the secondary and tertiary on the lower.'[10]

The following statement by Professor Fielding is probably the origin of Professor Collins's mistake, and it would have angered Cole more than any other words about Marlborough House if he had been alive to read it. Professor Fielding wrote:

'Although responsibility for Cole's department was later transferred

from the Board of Trade to the Committee of Council on Education and he had already supervised the apprentice Schools of Design, there was no connection between Practical Art and ordinary schools for children. Both the ideas and action of the novel are flawed . . . it either shows a complete misunderstanding of the issues involved or was calculated misrepresentation.'

It appears that it was Professor Fielding who misunderstood, not Dickens. Cole never supervised the 'Schools of Design' and there were several practical connections between his Department and the ordinary schools, long before it was transferred to the jurisdiction of the Committee of Council. It is appropriate first to use Cole's own words to answer Professor Fielding:

'Elementary Drawing in National Education was the new principle brought into activity in 1852.'[11]

One of the first measures taken by Cole in 1852, as described in Chapter 8, was the establishment of classes for teachers and pupil-teachers of the ordinary public day schools. A first course of elementary copies for schools was published at Marlborough House in the first year of the Department's existence, and by the time Dickens was publishing *Hard Times* in 1854, not only was an official primary course operating in many schools, but the officials at Marlborough House were providing examinations for the day schools and general Training Colleges, while the art masters-in-training, who had moved into Marlborough House in 1853 were teaching weekly in parochial schools.[12] Government inspectors were also conducting local examinations and forwarding the papers to Marlborough House, and it is not unreasonable to suppose that one of these gentlemen, or an official from Marlborough House such as Redgrave, Burchett, Robinson, or Captain Owen, R.E., the inspector of the Training Colleges, might have been tempted to address pupils upon the lines of Redgrave's *Principles of Decorative Art*, which were akin to Jones's propositions and were published in a cheap manual by the Department.

The Utilitarian doctrine of principles, grammar, and analysis, as expounded first at Marlborough House, then at South Kensington, was intended to reduce art to a systematized body of knowledge governed by strict rules. Bentham's principle of facility, which requires that a system should proceed from the simple to the complex, was imposed on art education by Cole and Redgrave to an extent that has never been equalled; a glance at the systematic progression of the twenty-three stages of the Course of Instruction in Appendix C will bear this out. When Professor Philip Collins wrote that 'Dickens misunderstood the ideas that he was satirizing. Cole and his colleagues were not utilitarian

kill-joys, they were protesting against the horrible vulgarities of mid-Victorian decoration,'[13] he must have been unaware of the true nature of the Course of Instruction promulgated from Marlborough House, which, together with the tedious medal drawings, killed all joy in art work save the finishing of it. Hubert von Herkomer, R.A., who studied in the Art Training Schools when Cole and Redgrave were in office described 'the miserable agony' of such work.[14]

Cole personally was rather a jolly character, albeit thick-skinned, the happy father of a family and the producer of the *Home Treasury* of children's stories. However, like many Utilitarians, where public education was concerned he was against sentimentalism, romanticism, historicism, intuitivism, and sensualism. The handbooks which he had produced for historic buildings when in the Records Office were intended as guides to the history and architecture of the buildings, but Cole did not believe that historicism should govern contemporary works, hence his dislike of the architects of his own period and his preference for Royal Engineers.

The opposition engendered by his attempts to introduce utilitarian engineering architecture is typified by the following statements. The Revd Charles Boutell, speaking at Sheffield in 1862, reported that:

> 'At a recent meeting of the Society of Arts, Mr Cole said, in the most explicit manner, that the body of architects were a set of ignoramuses, that there was but one great architect, and he a captain of military engineers, and that the building which he has designed to contain the Exhibition is one of the finest, if not the finest building that ever was produced in the world; on the contrary, that building is an outrage to architecture and a disgrace to England. There is not a railway shed that ever was built that is not as fine a work. It is simply like a carpenter's shop magnified to a large extent, with no design or ornament, or good point about it whatever.'

The *Art Journal* added:

> 'We are tired of appealing to the architects, whether as individual artists, or collectively as constituting a great Art-profession, to come forward and to denounce both shed-making and the shed-maker.'[15]

Cole considered architects to be ignoramuses because of their pre-occupation with historic styles, whereas he was concerned with structure, space, economy, day and night lighting, temperature, damp-proofing, and resistance of materials to chemicals in the air. Cole's concern about these points can be judged from his insistence on height and mullion-free

lighting for art rooms, his pride in the bright gas lighting inside the South Kensington Museum, the system of lighting in the Sheepshanks Gallery, his praise for Captain Fowke's structural ironwork, and his recommendation of impervious ceramic ornament for buildings.

Cole envisaged art, or any other subject for that matter, as an integral part of a utilitarian education. His attitude to science was typical of the same viewpoint and is exemplified by a letter of 1858 to Mr Lingen of the Primary Branch of the Education Department. 'I cannot help thinking,' wrote Cole, 'that "Science in general" belongs to "Education in general" and would grow best with it.' Similarly with art.[16] His Utilitarian concept of universal art education was well illustrated by his words at the opening of the Elementary Drawing School at Westminster in 1852: 'It should be felt a disgrace to every one who effects to be well educated if he cannot draw straight lines.'

A neat straight line was the first step to accuracy, in Cole's opinion, for 'Drawing is the power of expressing things accurately'. Cole suggested to the art masters that this accuracy could be developed from four years of age, using slate and pencil, since, he asserted, the elements of drawing were simpler than the letters of the alphabet. After a childhood period of linear geometry and drawing outlines of simple solids, adolescence would be spent on more complicated imitation until, in their mature years, the few surviving advanced students, who had progressed as far as Stage 22 of the Course of Instruction, were allowed to proceed with designing. It might surprise the reader that a Utilitarian permitted the copying of historic ornament as part of the Course of Instruction, especially since Cole had mocked the Schools of Design for this practice; but he really had no alternative. Contemporary design was largely based upon historic motifs and the artisans had to learn them. However, he did his utmost to encourage students to submit work in the creative Design Stages (22 and 23) of the Course, by allowing a student to submit an unlimited number of entries in these stages for prizes in the National Competition.

The Design Stages, the Special Technical Classes and the South Kensington Workshops were all intended by Cole to serve 'the useful purposes of life' and to prepare students for 'future practice in manufactures and workshops', but the chief object of this convinced Utilitarian was to bring art education to the greatest number of people through the South Kensington Museum and the public day schools.

THE PRINCIPLES OF PUGIN AND REDGRAVE COMPARED

The most notable advocate of principles of design in the Victorian period was Augustus Welby Northmore Pugin, and his writings greatly influenced the South Kensington circle. *The True Principles of Pointed*

or Christian Architecture, published in 1841, crystallized the views of the opponents of late Renaissance architecture and lavish rococo decoration. Pugin began with the words:

> 'The two great rules for design are these. First that there should be no features about a building which are not necessary for convenience, construction or propriety; second that all ornament should consist of enrichment of the essential construction of the building.'

In his *Glossary of Ecclesiastical Ornament* Pugin further clarified his viewpoint, stating:

> 'That Art has its fixed principles any departure from which leads to inconsistency and unmeaning effect, is a truth never to be lost sight of. . . . Ornament in the true and proper meaning of the word signifies the embellishment of that which is in itself useful in an appropriate manner. Yet by a perversion of the term, it is frequently applied to mere enrichment, which deserves no other name than that of individual fancy and caprice. . . . The symbolical association of each ornament must be understood and considered, otherwise things beautiful in themselves will be rendered absurd by their application.'

Three principles of ornament, which Redgrave stressed, can be detected in these passages from Pugin's writings: utility, fitness, and unity of style. Various official publications on design by Redgrave appeared during his period of office, the chief of which were *Report on Design* (1851), *On the necessity of Principles in teaching Design* (1853), *Report on Design as applied to Manufactures* (1855), *Report on Applications of Drawing and Modelling to the Common Arts* (1867), *Report on the Present State of Design* (1871). In addition there are his lectures published in the *Art Journal* and the *Journal of Design* quoted in the present work. It is much more convenient for the student, however, to read the *Manual of Design*, compiled from Redgrave's writings and addresses by his son Gilbert R. Redgrave, and published in 1876 as an official handbook for the Committee of Council on Education, one year after his father's resignation. Gilbert stated: 'I have confined myself almost wholly to his own words. Indeed, nearly all the matter might be placed in inverted commas.'

Following chapters on the source of style and its elements arising out of construction, Redgrave described 'Utility, which must be considered before decoration', and proposed 'that as construction necessarily implies a purpose, utility must precede ornament'. He attacked Victorian ornamentation of 'cabinets so covered with carved ornaments, that they will not open, so embossed with useless reliefs that it is dangerous to come near them, so heavy that they hide without exhibiting the in-

valuable rarities they are intended to contain; rich and costly buffets, that have neither sideboard for the dining utensils, nor shelves for displaying the plate, chairs that give no repose to those who sit in them, and caskets that, from being too fragile to be touched, are a misery to their possessors'.[17]

Redgrave's next proposition was on the principle of 'Fitness of the ornament to the material to which it is applied', and proposed that 'design must be bad which applies to the same constructive forms and ornamental treatments indiscriminately to different materials'. He stressed that 'Each material has its own peculiar constructive qualities' and 'each mode of execution has its characteristic qualities'. It is interesting to note that, unlike William Morris, and like the rest of the South Kensington circle, Redgrave did not condemn machines. He approved of them, but admitted that 'it is a matter of extreme difficulty and one requiring long experience in manufacture, to tell how a design will work'.[18]

Redgrave was at his weakest, when he argued on his principle of 'Unity of style and decorative subordination'. He could hardly be expected to understand this principle properly, as an official of a department which used historic ornament as examples, and he could not really conceive an artist developing an original style straight from nature. He fell back on the idea that unity of style was produced by sentiment such as the religious one in the Gothic period, and admitted that 'In our own times any wide-spread sentiment is unfortunately wanting'.[19] He had stated in 1847 that he was against the designer who 'collects a stock of examples in the Greek, Roman, Mediaeval, and other styles and selects here a Greek honeysuckle, and there an acanthus leaf . . . a ram's head from the horns of one altar, a festoon of flowers from another', yet he, Owen Jones and Wornum provided students with a mass of examples of historic ornament.

It was a paradox that Redgrave, who loved botany, should have thought that the structure of historic ornament was important, but Dyce's concept of the science of ornament seems to have impressed him deeply. In spite of all this, however, Redgrave's interest in plant forms did, as we shall see, lead to a style, which, although mocked, did at least permit a minimum of originality.

REDGRAVE'S IDEAL OF PERFECT BOTANY

'There is no need of books, or prints, or museums, treasuring up casts and specimens; only go abroad into the fields and hedgerows.'
Richard Redgrave[20]

It is astonishing to discover that the above are the words of Redgrave, the artist who was responsible for the type of artwork done in the

Schools of Art from 1852 to 1875, a period during which the most exact and mechanical imitations of copies and casts of flowers, foliage, and ornament were carried out. Even casts of bunches of blackberries were supplied. It was not until the end of the Drawing Course and of the Modelling Course that a pupil was permitted to draw or model plants from nature (see Appendix C).

Redgrave, as can be judged from the next few pages, often expressed the most contradictory views in dogmatic terms and, such was his blind faith in his own judgment, that he could never bring himself to admit the dull kind of work his Course of Instruction had produced.

Redgrave had first become interested in botanical drawing in his youth during his occasional trips into the country on business for his father's counting house, but in the years that followed he made his name by exhibiting in the Royal Academy his 'social teachings' – subject pictures such as 'The Poor Teacher', 'Going to Service', 'The Fortune Hunter' and 'The Reduced Gentleman's Daughter'. No sooner had his 'social teachings' established his reputation with the sentimental Victorian public and caused him to be elected Royal Academician than he returned to landscape painting, in which, a contemporary asserted, 'the herbage weeds and wild flowers were most marvellously painted'.[21]

Redgrave was a member of the Catholic Apostolic Church and, like its founder Henry Irving, had some vision of a changed world once the Apocalyptic prophesies were fulfilled. He argued that the world of nature was imperfect through bad climate and he longed to have it exactly conforming to orderly principles. Redgrave wrote:

'We may in imagination look forwards to the glorious daylight of Eden . . . to realize the perfect development of vegetable life . . . then the alterations of heat and cold, summer and winter, storm and tempest, shall not act upon it to mar its perfection . . . the sweeping branches shall form an umbrageous tent of shade, and a tree shall be a perfect pyramid of verdure and an encircling crown of flowers.'[22]

Redgrave noted with approval Ruskin's comment on trees painted by early Renaissance artists: 'All signs of decay, disturbance and imperfection are banished, the tree grows straight, equally branched on each side.'

Redgrave submitted that, although Ruskin had attributed this to ignorance, the principle of banishing imperfections was a just one. Redgrave desired a perfect climate which would produce plants conforming exactly to geometric principles, preferring the carefully tended plants at Kew to those produced by the irregularities of the English climate, which he referred to as the 'pigmy foliage of our land' compared to the foliage of 'Indian climes where it is seen in its grandest and

noblest forms'. 'Of such marvels of vegetation we islanders are hardly sensible,' he added. Redgrave's search for mathematical order in nature is shown by the following statement about 'symmetry with variety':

> 'In confirmation of this principle of beauty, we shall find the corolla of many plants divided into an odd number of petals, as three and five, whereby the symmetry of a polygonal figure is superadded to the variety contained in the triangle and the pentagon, figures which have no angles opposite, no sides parallel the one with the other.'[23]

A modern student, after a first glance at Redgrave's exhortations to art students to observe plant structure, might conclude that at last pupils could break away from the imitation of historic ornament and develop original designs based upon the natural arrangement and rhythmic growth of plants; but Redgrave confused the beneficial concept of being visually aware of the geometry of design in nature with a harmful concept of using measured geometry as the basis of ornament. Nature was put in a straight jacket. The few pupils who had progressed beyond Stage 2 had spent so much time on geometry, and on outlining and shading rigid models, that any tendency to produce free rhythmic lines had been eradicated.

The art masters were instructed that all Stages were to be 'strictly imitative' until Stage 22: *Elementary Design,* in which there were four alternatives:

a) Natural objects ornamentally treated.
b) Ornamental arrangement to fill a given space in monochrome.
c) As (*b*) above, in colour.
d) Studies of historic ornament drawn or modelled.

Well, the reader might think, at least (*a*), (*b*), and (*c*) require some originality, but, alas, little invention was permitted under the Science and Art Department directions. For (*a*) Redgrave saw that the students were supplied with mounted prints of Ornamental Analysis of Nature, showing flowers and details of them in flat elevation and plan, ornamentally treated.

In *A Century of Painters* by Richard Redgrave and his brother Samuel, Richard, writing about himself in Caesarian style, affirmed:

> 'To exercise the invention the following method was devised by the art superintendent – a method wholly new in the use thus made of it. It consisted first in the ornamental analysis of plants and flowers, displaying each part separately according to its normal law of growth, not as viewed perspectively, but diagrammatically flat to the eye; so treated it was found that almost all plants contain

many distinct ornamental elements, and that the motives to be derived from the vegetable kingdom were inexhaustible. Moreover this flat display of the plant was specially suitable to the requirement of the manufacturer, to reproduction by painting, weaving, stamping, etc., to which naturalistic renderings do not readily lend themselves; while this treatment of the plant is also in conformity with that followed by the Oriental nations and by the best artists of the middle ages.'[24]

For sections (*b*) and (*c*) of Stage 22, Redgrave gave three years' notice of the required plant and type of geometrical figure to be filled. For example, the *Directory* of the Science and Art Department for 1856–7 gave them as:

'Flowers and leaves of wild strawberry within a pentagon for 1857.
Flowers and leaves of yellow crowfoot within a hexagon for 1858.
Flowers and leaves of cranesbill within an octagon for 1858.
The circle on which all these polygons are based to have a radius of 7 inches.'

The three years' notice enabled the masters to supervise the slow outlining of the set flowers and leaves on a geometrical basis and the washing in of the required colouring. The Inspector General must have felt proud satisfaction as he viewed on the walls of the Training Schools the lines of painted polygons, submitted for the National Competition, in which nature had been reduced to flat geometrical order. Redgrave justified these exercises as follows:

'It was intended to teach the pupils the laws of distribution, and the rules best adapted to cover given spaces with ornamental forms and colours. A boundary form being given, such as a circle, a lozenge, a hexagon, triangle etc., the students were first required to place simple spots of black or white with agreeable interspaces over the surface. Afterwards some simple floral or leaf form is given, then a flower, or a flower combined with suitable foliage; or the students are allowed to use any ornamental forms available from a given plant, to vary the colour, the colour of the ground etc. From year to year the forms and fillings are changed throughout the schools. The plan has had a valuable effect in stimulating invention and leading on to designs for fabrics, wall papers, carpets etc.

'In the annual display in London of hundreds of studies of the same form filled in with the same plant, sent up from all the schools of the department, many of them of very great merit, it is hard to find any two that approach to sameness.'[25]

Actually the same flat elevations of parts of the flowers were often

used, but students used different geometrical constructions according to the advice of their art teachers. Kate Greenaway (1846–1901), noted for her children's book illustrations, submitted in 1864 a hexagon filled with the usual flowers and leaves, which, although very intricate, linear, and flat, is quite a fine design. The arrangement of a conventional plant shape within a given geometrical shape, later known as 'space fillings' or 'panel fillings', continued as an important part of design courses in Schools of Art for fifty years after Redgrave's retirement.

When the students of Redgrave's day arrived at Stage 23, *Applied Design,* they could submit similar work to the above as designs for hexagonal tiles, or they could paint a rather large version as the unit to be repeated for a carpet or wallpaper design. George Moore commented:

> 'The isolated pattern looks pretty enough on the two feet of white paper on which it is drawn; but when the pattern is manifolded, it is usually found that the designer has not taken into account the effect of the repetition . . . and at Minton's factory all the designs drawn by Kensington students have to be redrawn by those who understand the practical working out of the processes of reproduction . . . So complete is the failure of the Kensington student, that to plead a Kensington education is considered to be an almost fatal objection against any one applying for work in any of our industrial centres.'[26]

REDGRAVE'S INSISTENCE UPON FORMAL AND SYMMETRICAL GEOMETRY

It was Redgrave's insistence upon the use of formal and symmetrical geometry that produced the stencilled, Moorish, and Gothic appearances of the wallpaper and fabric designs produced for Stage 23 of the Course of Instruction. The eye is oppressed by flattened floral forms and tapes, which appear to be cut out of sheet metal, arranged upon a rigid geometrical grid. Even if a design looked suitably flat, Redgrave condemned it if the forms from nature were freely repeated. 'In such a case, then,' he wrote, 'the geometrical law of recurrences is arrived at adventitiously, the necessity inducing it being ungoverned by the controlling will of the designer, who therefore has neglected all the beauty resulting from a proper choice of regulating form.'[27] Nature had to be controlled, flattened, boiled-down, planned geometrically, and made symmetrical. This is beauty produced by regulation. This is flatness for utility. This is Fact!

Walter Crane referred to the 'flatness of treatment' at this time which, he said, became the whole of the law producing 'the flat-ironed primulas and the genus of enfeebled flora and fauna generally, which so often, alas, do duty as decoration. As if decorative art . . . required everything to be

thoroughly well boiled down before it could be properly assimilated.'[28] Edward Poynter, who succeeded Redgrave in the Department, claimed that 'this determined insistence upon the necessity of a purely flat kind of decoration has produced as a result a kind of work, quite as unfortunate, if not more so, than the vulgar rococo ornament which it has superseded'.[29]

Not only did Redgrave insist upon formal geometry and flatness, but also upon symmetry. For example, he praised the Japanese for 'their refined feeling for balance' but criticized them for unsymmetrical construction – 'the absence of symmetry is felt to be an error in principle'.[30] The most orderly nation on earth was not quite orderly enough for the Inspector General.

REDGRAVE'S CONTRIBUTION TO ART EDUCATION

The rock that Redgrave's efforts foundered upon was the dreadful method of slow drawing done on the Course of Instruction described earlier in this history. He would not admit that the swifter point to point freehand drawing and sketching of the French was superior to the tedious hatching within sharp outlines which the British art students were compelled to do. He said of the French method:

'This tends to great freedom and ease of execution, if at some loss of correctness and truth; too often, also, the study from flowers and foliage is confined to copying the designer's rendering of Nature rather than any recurrence to Nature herself. By this the freedom and ease of the decorator is arrived at, though at the loss of novelty and of imitative truth. Our English course of teaching seeks freedom through knowledge attained by careful and precise imitation, the French system rather seeks facility and fluency without such foundation. . . . Yet there is no doubt that the more precise instruction required by us would act as a corrective . . . in French decorative art, without depriving it of the rare manipulative skill in which we are deficient.'

Redgrave was wrong; the South Kensington method of drawing deprived young students of manipulative skill.

Redgrave, no doubt on the defensive against the mockery heaped upon the South Kensington system of imitating the flat copy and the cast, made some astonishing statements; for example: 'It is in this spirit of a loving study of nature, coupled with a due appreciation of art, that the courses in our public art schools are now arranged . . . through the whole course the student has, as soon as possible, the thing itself placed before him for study rather than a drawing from it given him to copy.'[31] These statements are complete rubbish as can be judged from a brief glance at

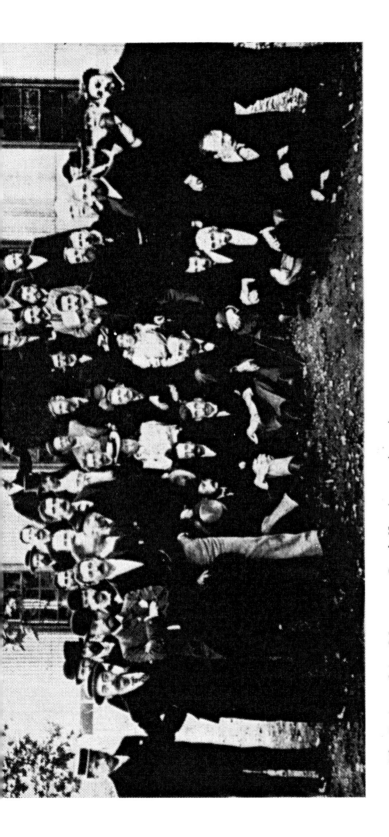

18. The Society of Art Masters at South Kensington (1888)
In the centre of these proud possessors of Third Grade certificates, many of whom served under Cole, are E. Taylor (chairman), A. Fisher, C. Hodder, J. Smith, T. Simmonds, G. Trobridge, and J. Brenan, headmasters at Birmingham, Brighton, Edinburgh, Bristol, Derby, Belfast, and Cork respectively
National Society for Art Education, copyright

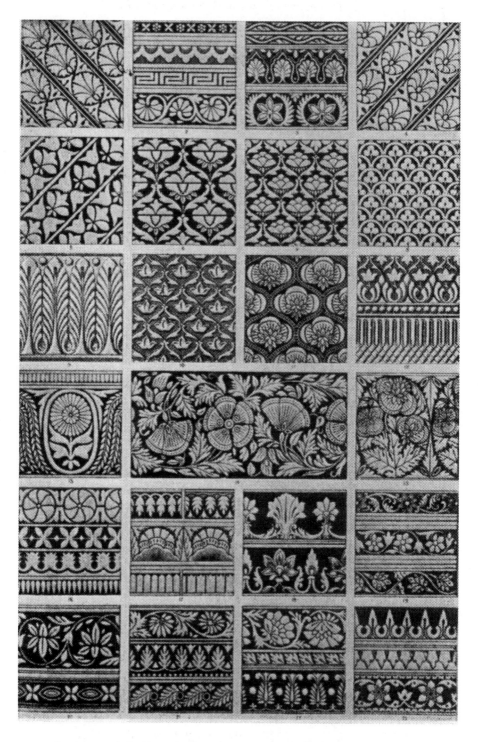

19. A page of Indian designs from Owen Jones's *Grammar of Ornament* (London, 1856). These designs show the historic structures which fascinated Wornum, such as the fret, scroll, palmette, and diaper

the twenty-three stages of the Course of Instruction. One of the main contributions Redgrave made to art education was the enforcement of the national practice of working from the Flat which lasted throughout the century; hence the complaint of R. Catterson Smith as late as 1901 that flat copies were then 'almost wholly in use'.[32]

Redgrave believed in students copying ancient ornament and it surprised him, as it did Wornum, that often the German and French students preferred to copy and design contemporary ornament rather than drawing from the antique. He said of Germany:

> 'It would seem here, as in France, that the choice was somewhat capricious [a deadly sin, in Redgrave's book] and that at times the ornament of the day replaced for the purpose of study those finer examples which should be derived from the antique or from the best periods of the Renaissance.'[33]

Although Redgrave made a negative or even harmful contribution to education in drawing, some important benefits to designing emerged from his regime. Many of the principles that he expounded and circulated were sound, provoking discussion and further writings on the subject. Secondly, the analysis of plant forms, which he advocated, greatly influenced his younger contemporaries and some notable books on the matter were later published for the benefit of art students, such as Lewis Day's *Nature and Ornament* (1908). Even the formalized plant designs within polygons were an advance upon the previous practice of mere imitations and combinations of existing designs. Poynter was unjust when he claimed that these designs, approved of by Redgrave and Owen Jones, were as bad as early Victorian rococo. William Morris owed a little to his studies of the type of conventional designs approved by Redgrave, especially from the pages of Jones's *Grammar of Ornament*. It could also be claimed that the linear vignettes of the Art Nouveau style owe much to the linear floral designs of the polygons produced under Redgrave's direction.

However, for Ralph Wornum, Cole's next colleague, the only depiction of nature of great interest had been achieved in stone some two thousand years ago.

THE ANALYTICAL CONCEPT OF RALPH WORNUM
'We have not now to create Ornamental Art, but to learn it;
it was established in all essentials long ago.'[34]
Ralph Nicolson Wornum

The first half of the nineteenth century produced a flood of illustrated literature on the newly-established pursuit of archaeology. *Le Description de l'Egypte* published by order of Napoleon in 1809 was followed by

N. Bettoni's *Le Tombe ed i Monumenti illustri d'Italia* (1822), J. Rosellini's *I Monumenti dell' Egitto e della Nubia* (1832), F. Gau's *Antiquities de la Nubie* and J. Fergusson's *Illustrations of the Rock Cut Temples of India* (both 1834), F. Albertolli's *Fregi trovati negli scavi de Foro Trajano* (1838), O. Jones and J. Goury's *Plans and Details of the Alhambra* (1842), and A. H. Layard's *Monuments of Nineveh* (1849).

These folios were published mainly for wealthy dilettanti, but publishers quickly found there was a need for books of selected specimens of historic ornament for the architects and ornamentists to imitate. A. W. Pugin's *Specimens of Gothic Architecture* published in 1821 was followed by numerous handbooks of specimens of historic artefacts. The Germans led the field in production of books of classified collections of ornament, and the Head School of Design sponsored the production of Ludwig Gruner's *Specimens of Ornamental Art* from 1845 to 1850. A third type of publication developed from a desire to use the basic elements of these styles in a more creative way. These books dealt with the analysis, grammar, and principles of historic ornament, and one of the best known was Ralph Wornum's *Analysis of Ornament*.

Ralph Nicolson Wornum (1812–77) had made a deep study of the works mentioned above, and indeed of many others. He had started his career as an artist in 1832 by entering Sass's Academy, after leaving Oxford University and abandoning the prospect of taking up the legal profession. His father, the inventor of an upright piano action, was a man of means, and this enabled the young artist to spend the years from 1834 to 1839 in Europe, where he familiarized himself with the German, Italian, and French art galleries. On his return to London he had set himself up as a portrait painter without much success, and took up writing on art history, his first notable work being the article 'Pictura' in Smith's *Dictionary of Greek and Roman Antiquities* (1841). Four years later he started writing for the *Art Journal*, and compiled an unofficial catalogue of the National Gallery (1847), authorized by Sir Robert Peel.

Wornum had the outlook of a catalogue compiler, and every aspect of art had to be broken down, so that it fitted into an orderly list of divisions and subdivisions. It can be judged later in this account how much this affected his ideas of educating the designer. His well-ordered catalogue of the National Gallery, which set an example followed by many European galleries, established his reputation, and on 4 July 1848 the Board of Trade, harassed by criticisms concerning the lack of lectures on ornament for artisans, appointed him visiting lecturer on Ornamental Art at 10 guineas per lecture at the Head School of Design and 5 guineas at the Provincial Schools.

During the session of 1848–9 he toured Britain giving eight lectures on Ancient Ornament, dazzling the poor artisans with descriptions of

such glories as the 'Golden House' of Nero and the 'Colossus' of Zenodorus; and in the following year he delivered addresses on Mediaeval and Renaissance Ornament. In these talks Wornum analysed the historic styles and attempted to classify every kind of ornament into an appropriate division or subdivision. For example, Greek painting was classified in four divisions, Skiagram, Polychrom, Monogram, and Monochrom; if there were no such technical names for subdivisions, Wornum used others. Typical of his approach is the following passage from his *Analysis of Ornament*:

> 'There are two classes of the painted Greek pottery, the black and the yellow . . . Of the black or former class there are two varieties, the one painted only with animals, the other with figures. . . . Of the yellow vases there are three varieties or sub-classes – the severe, the beautiful and the rich.'[35]

The academic nature of his complicated classifications provoked the managers of the provincial Schools of Design to both mirth and anger, and when he lectured to the Manchester School in 1848 its council boycotted his talk, Mr Fraser, the president, pronouncing that, because Wornum was not going to lecture on calico printing, his lecturing was useless. The *Journal of Design* echoed the protests about the unsuitability of these lectures, but once the Schools of Design were overthrown Cole found use for Wornum. The art historian's aptitude for orderly classification appealed to the civil servant, so when the Department of Practical Art was established Wornum was appointed Librarian and Keeper of the Ornamental Casts; and, because at this time Cole was establishing the Museum at Marlborough House, Wornum was sent to France to report 'on the arrangement and character of French art collections, and systems of instruction in the Schools of Design in France'.

WORNUM AND THE FRENCH SCHOOLS

Wornum now had the opportunity to study the reasons for the undoubted French superiority in drawing and designing, and to suggest the introduction of French freehand drawing methods which were introduced at the Slade School and at South Kensington many years later; but unfortunately, to accept these methods he would have had to abandon his concept of the need to analyse historic ornament. In France he looked in vain for any evidence that a deep knowledge of historic ornament was the reason for the French superiority; but, after touring the Écoles de Dessin, Écoles des Arts et Métiers, Académies des Beaux Arts, and several museums in Paris, Rouen, Lyons, and Sevres, he had to admit: 'Ornament, as a distinct art, is not taught in France.'[36]

The French students drew, painted, and modelled mainly from nature to improve their sense of design, so Wornum wrote disparagingly that the Écoles de Dessin were 'mere drawing and modelling schools', and that at Rouen it was 'simply flower painting'. The École Royale des Beaux Arts at Lyons, which had the highest reputation for producing designers, also had an important flower painting class; and historic ornament, from which Wornum believed so much could be learnt, was only used for drawing practice in the elementary stages before the students progressed to real flowers. The live model was considered the main source of inspiration and training, or as Wornum put it, 'the human figure is the engrossing object of study'. He noted with disapproval that many reproductions of the same casts were stored away in the schools' *magasins des plâtres*, from which they were only taken out to draw for periodical competitions, and casts of ornament were only used 'to develop the faculty of drawing or colouring, but not for their own sakes'. The French, being realists rather than historicists, regarded casts as objects from which students might practise drawing in order to acquire some sense of proportion, and some technique.

Wornum found that, although France was full of museums, the collections of ornamental casts were neither classified nor accessible for use by the art students. He noted that there was a fine collection of classical casts at the Musée des Études in Paris which was displayed for effect or *coup d'oeil*, rather than for classification. To complete the picture, there were no lectures for students on ornament, such as Wornum had given.

Wornum could hardly be expected to admit that all the research which he was carrying out into the classification and analysis of historic ornament was of little benefit to the designer, and accordingly he grudged the French their superiority, and finally concluded that it was 'clearly much more owing to the shortcomings of other nations' than to their system of art education.

THE 'ANALYSIS OF ORNAMENT'

After his return to Marlborough House, Wornum busied himself with classifying and cataloguing the library and cast collection; but, after only two years as librarian, Sir Charles Eastlake, P.R.A., recommended him as Keeper of the National Gallery. Wornum eagerly took up this post in December 1854, and remained there until his death in 1877. However, his contribution to the Department had not quite finished and in 1856 his past research in its library bore fruit in the form of his *Analysis of Ornament*. This book probably had as much influence on the teaching of aspiring designers in the Schools of Art as Jones's *Grammar of Ornament* did.

Wornum's concept of training the designer can be summed up simply as follows. The student should be shown the conventional structures of historic ornaments. He would then be capable of arranging objects from nature on these structures and so produce new designs. To use Wornum's own words:

'It is only by a knowledge of the characteristics of styles – the standard types of all ages, that even system will effect that variety and individuality of expression, which alone will secure a permanent gratification of success. . . . The great art of the designer is in the selection and arrangement of his materials, not in their execution. There is a distinct study of ornament wholly independent of the merely preliminary exercises of drawing, colouring and modelling.'[37]

It is easy to grasp the gulf between Wornum's ideas and those of the masters of the French schools of design. Wornum was concerned with learning 'ornament, for its own sake'; the artistic execution of the design was very much a secondary skill. The French held the opposite view – fine drawing, colouring and modelling were everything; classification, analysis and learning were immaterial.

Wornum's attempt to classify all ornament 'theoretically and scientifically', as he put it, would probably seem absurd to modern designers, aware of the countless millions of variations of line, form, colour, rhythm, and texture, in both natural and man-made designs, but to the orderly minds of those Victorian teachers who sought 'fact, fact, fact', Wornum's divisions and sub-divisions were very satisfying.

The *Analysis of Ornament*, which Wornum described as 'a review of the ornamental devices of thirty-five centuries', was a refuge for the dogmatic mind, containing pedantic passages such as this one.

'The whole grammar of ornament consists in constant repetition and series. A perfect contrast of form may be defined as the two sides of a solid or section of the solid, generated by the revolution of an outline around a given axis; as, for instance, a sphere is the solid generated by the revolution of a semicircle around its diameter.

'Repetition and series are nearly identical. Series comprises repetition, and defines its order.'[38]

The chief message of the book for the student was that he should learn the conventional arrangements of historic ornaments such as the zigzag, the fret or labyrinth, the scroll, the guilloche, the echina and astragal (egg and dart), the anthemion or palmette, and the diaper. He was permitted to 'change the details – as long as the arrangement is not

disturbed'. There was, for example 'scarcely a weed in England that might not have been substituted for the honeysuckle' on the Greek anthemion arrangement. His justification for copying Greek ornaments of 'upwards of two thousand years ago' was 'because it would be, perhaps, impossible to select others of a less decided individuality'.

Wornum's vindication of ornament as a space-filler to give repose to the mind is typical of the industrious Victorians, who felt disturbed if any surface was allowed to remain plain. He affirmed:

> 'Ornament is one of the mind's necessities, which it gratifies by means of the eye . . . the eye requires variety of surface to gratify that faculty of mind called taste – how is this variety to be effected? By dividing surface into compartments – known as panels, borders, cornice, frieze, basement, or dado; capital, shaft, base, pedestal; neck, body, foot, and so on . . . the mere division of an object into such parts is done for the sake of variety of effect, in obedience to one of the necessities of the mind.'[39]

The *Analysis of Ornament* ran to nine editions as an approved Science and Art Department textbook and prize-book. There was no other book on the theory of ornament to compete with it until the nineties; the *Analysis* cost eight shillings and the other famous book on ornament, Jones's *Grammar of Ornament*, was not a textbook, but an expensive library edition costing over £5. Written papers on the Principles of Ornament introduced by the Science and Art Department in the eighties led to the publication of several new widely read textbooks such as *Elementary Principles of Ornament* (1890) and *Principles of Ornament* (1896), both by James Wood, head of the Macclesfield School of Art; and *Theory and Practice of Design, Decorative Design* (both 1894), and *Lessons on Decorative Design* (1896), all by Frank Jackson, second master of Birmingham School of Art.

Whereas Redgrave and Jones were the chief originators of the principles and laws of design in these books, Wornum was the chief originator of the idea of the 'elements' of design in them. The elements consist of frets, zigzags, scrolls, palmettes, and so on. In particular, *Lessons on Decorative Design*, in which a whole chapter is devoted to analysing Greek and Roman acanthus ornaments, would have delighted Wornum.

In the last decade of the century the study of ornament developed into two separate studies as ideas on design progressed, the Principles of Ornament, and Historic Ornament. Laws and Principles of Ornament became less dependent upon illustrations of historic ornament and more upon geometrical figures such as circles, squares, and spirals. Skill with the set-square, T-square, dividers and compasses became more im-

portant than ability to draw historic ornaments. The history of ornament became a separate academic study for its own sake, as exemplified by the famous art school textbook of the period from 1899–1930, *Historic Ornament* by Richard Glazier, head of Manchester Municipal School of Art.

However, Wornum's influence can be detected in many of the textbooks of the thirties on pattern design, which still encouraged students to base their designs on frets, zigzags, guilloches, scrolls, and diapers. Historical motifs were finally eradicated from the Schools of Art by the appearance on the market in the late thirties of colourful abstract fabric patterns based upon contemporary painting movements in Europe.

THE 'GRAMMAR' OF OWEN JONES

Whereas the *Analysis of Ornament* was the most influential textbook on ornament sponsored by the Science and Art Department, undoubtedly the most important reference book was the *Grammar of Ornament* by Owen Jones.

The *Grammar*, although a very expensive tome, was deemed an essential requisite for a School of Art in the latter half of the nineteenth century, and though long forgotten by art students it is still to be found in a remote corner of their college libraries. Its cost being prohibitive for many Schools of Art, Cole arranged in the early fifties for the book to be given to them on account of their examination results, and a cheap booklet of the 'propositions' from the work was made available. The complete *Grammar*, in imperial folio, contains 120 plates (in full colour) of notable types of historic ornament, selected because of their structural connection with one another. A list of thirty-six propositions is given, some on form, some on colour, and a few on general principles.

When the *Grammar* was published Owen Jones was already famous for his previous researches on Moorish, Italian, and Chinese ornament, and for his decorations for the Great Exhibition of 1851. His propositions which he had expounded in lectures at the Society of Arts, and later at Marlborough House on Cole's invitation, are an amalgam of the principles of Pugin, Dyce, and Matthew Digby Wyatt. The propositions have some good points, such as the fitness for purpose of ornament given in the third, but unfortunately many of them are not general principles but rigid rules. The following are some of these more dogmatic 'scientific' propositions:

'All ornament should be based upon a geometrical construction.'
'The whole and each particular member should be a multiple of some simple unit.'
'All junctions of curved lines with curved lines, or of curved lines with straight should be tangential to each other.'

> '. . . the proportions of a double square, or 4 to 8, will be less beautiful than the subtle ratio of 5 to 8; 3 to 6 than 3 to 7; 3 to 9 than 3 to 8; 3 to 4 than 3 to 5.'

Reading the above, it is understandable why Cole and Redgrave insisted on entrants to the Training Class having some knowledge of fractions as well as of geometry. To continue, below are two propositions on colour, the second of which might in practice involve the use of duodecimals which the students were also required to know.

> 'The primary colours should be used on the upper portions of objects, the second and tertiary on the lower.'
> 'Each tertiary being a binary compound of two secondaries is neutralized by the remaining secondary as 24 of olive by 8 of of orange, 21 of russet by 11 of green, 19 of citrine by 13 of purple.'[40]

One can almost hear Dickens's 'third gentleman' chanting in the background: 'This is the new discovery. This is fact. This is taste.'

Cole, Redgrave, Wornum and Jones were rightly against the excesses of the naturalistic school of ornament of their time, on the grounds that this school was disguising everyday objects as plants and animals, and in Wornum's words 'often substitutes the ornament itself for the thing to be ornamented'. They detested such elaborate naturalism, because it went against their geometrical principles, and it might have been expected that their new approach to design would produce a geometrical simplicity; but alas for the poor artisans, such was not the case. All open spaces had to be subdivided into compartments. Designing became a matter of drawing out intricate geometrical structures. Ornate foliage and anatomy was replaced by ornate geometry. To quote the *Grammar*:

> 'The general forms being first cared for, these should be subdivided and ornamented by general lines. The interstices may then be filled in with ornament which may again be subdivided and enriched for closer inspection.'

This ornamentation would give 'that repose which the mind feels when the eye, the intellect and the affections are satisfied from the absence of any want'. The ostentatious Victorians, who feared that an absence of ornament in any space might suggest a want of funds, gratefully responded to suggestions from decorators eager to profit from creating imitation panels, friezes, and styles to subdivide into smaller units, mathematically proportioned to satisfy their owners' eyes. These units or compartments were then filled with stencilled shapes taken from the *Grammar*.

The *Grammar* mainly affected interior decorations such as wallpaper, wall and door paintings, and curtain fabrics. The flat stencilled appear-

ance of the patterns was too harsh for feminine apparel. However the unfortunate textile students in the Schools of Art endured the full impact of the geometrical constructions insisted upon by South Kensington; and they were, as late as the nineteen-forties, the last art students to escape from the strict discipline of T square, set-square, protractor and compasses.

THE MODERNISM OF CHRISTOPHER DRESSER AND GOTTFRIED SEMPER

Christopher Dresser (1834–1904) was the most progressive and exciting designer of the South Kensington circle. He co-operated with Owen Jones in the production of the *Grammar of Ornament* and executed the 'Plans and Elevations of Flowers' therein. Three years later he joined the staff at South Kensington, and in the same year, 1859, his *Unity in Variety* and *Rudiments of Botany* were published.

Dresser's training as a botanist at the University of Jena caused him not only to be interested in the common principles of plant structure but also in the power and forces of growth. His reductions of plant forms to simple flat symbols, ideal for designers' stencils and stamps, were of great assistance to Redgrave, and according to Schmutzler, 'the patterns, ideal figures, and essential forms of his illustrations are true precursors of the symbolic and sign-like ornaments of Art Nouveau'.[41]

Dresser's two-dimensional designs, although akin to Jones's, had a rather eccentric character. It is remarkable to see one of them with the Futurist title 'Force and Energy'. The three-dimensional objects which he designed after, and under the influence of, his official visit to Japan in 1876 are astonishing for their period. His teapots, pitchers, cruets, and kettles are truly remarkable for their clean sharp lines, absence of ornament, and modernity. They could almost have been produced fifty years later at the Bauhaus.

Dresser produced many books that had a progressive influence on designers, but as far as the art students were concerned, it was his use of flat symbolic plant forms that were influential. He had the distinction of being the only member of the South Kensington Circle who practised the simplicity they all preached. He was much more clear-headed than Redgrave, and understood the practical application of his theories. His *Principles of Decorative Design* is full of useful advice for the designing of furniture, work in clay, stained glass, upholstery, and iron-work. He stressed 'fitness or adaptation to purpose' and proposed that 'the material of which an object is formed should be used in a manner consistent with its own nature and in that particular way in which it can be most easily worked'.[42] It was regrettable that, for economic reasons, Dresser was not enabled to develop workshop classes as Professor Semper had done.

Gottfried Semper (1803–79) was a modern in theory rather than in practice, for his style of work was Neo-classic. Originally this great architect had come over from Germany as a refugee, and had organized the Danish, Swedish, Egyptian, and Canadian sections of the Great Exhibition of 1851. He already had a considerable reputation for his buildings in Dresden, which included the new opera house (1841) and art gallery (1848). He had also supervised the decoration of the Japanese Palace, and the knowledge he had acquired in Dresden of the various crafts made him invaluable to Cole.

Semper's advanced idea of a community of artists and craftsmen anticipated the Bauhaus system. Professor Pevsner in his *Academies of Art, Past and Present* refers to Semper's beliefs as follows: 'Tuition in Fine Arts and Decorative Art should not be separated at all.' All training should take place in workshops conducted in a spirit of community and with 'a brotherly relationship between master and apprentice'. Pevsner continues: 'He actually introduced workshop teaching for architecture, metal technique and cabinet making into his own studio and also – on the example of the Nazarenes – allowed his pupils to take part in carrying out commissions received by him.'

Semper's influence was to be felt in Germany, not, unfortunately for our students, in Britain. There is not room in this book to discuss the only other important figure connected with the South Kensington Circle, Matthew Digby Wyatt (1820–77), who agreed that machinery and engineering architecture were desirable but was a historicist in practice. His work and ideas are best studied in Professor Pevsner's *Matthew Digby Wyatt*.[43] Pevsner also gives some information on the whole group in *High Victorian Design*,[44] as does Sigfried Giedion in *Mechanization takes Command*.[45]

Sources

1. GREENWOOD, T. *Museums and Art Galleries* Simpkin, Marshall, London, 1888 (p. 259)
2. Annual Report of the Birmingham Society of Arts and School of Art for the year ending 31 December 1867 (in Minutes Book for 1867, p. 4)
3. MILL, JOHN STUART *Autobiography* (World's Classics) Edited Laski, Harold J. Oxford University Press, 1924 (p. 196)
4. BROWN, FRANK P. *South Kensington and its Art Training* Longmans, Green, London, 1912 (caption to frontispiece)
5. COLE, SIR HENRY *Fifty Years of Public Work* G. Bell, London, 1884 (Vol. I, p. 16)
6. Ibid. (Vol. I, p. 116)

7. COLLINS, PHILIP *Dickens on Education* Macmillan, London, 1964 (p. 156)
8. DICKENS, CHARLES *Hard Times* (Chapter 2, 'Murdering the Innocents')
9. *Sessional Papers, 1849* Select Committee on the School of Design (p. 313)
10. JONES, OWEN *The Grammar of Ornament* Day & Son, London, 1856
11. *Sessional Papers, 1864* Select Committee on the Schools of Art (p. 3)
12. *First Report* of the Department of Practical Art, 1853 (pp. 5, 6, 50, 346); and *First Report* of the Department of Science and Art, 1854 (pp. xxi, xlviii, 30); and Minutes of the Committee of Council on Education, 1853–4
13. COLLINS, PHILIP *Dickens on Education* Macmillan, London, 1964 (p. 156)
14. GREENWOOD, T. *Museums and Art Galleries* Simpkin, Marshall, London, 1888 (p. 257)
15. *Art Journal*, 1862 (pp. 106–7)
16. COLE, SIR HENRY *Fifty Years of Public Work* G. Bell, London, 1884 (Vol. I, p. 309)
17. REDGRAVE, RICHARD *Manual of Design* Chapman & Hall, London, 1876 (pp. 36–7)
18. Ibid. (p. 43)
19. Ibid. (p. 48)
20. REDGRAVE, RICHARD 'Lectures on the study of botany by the designer' *Journal of Design and Manufactures*, March–August 1850 (Vol. III, p. 99)
21. *Art Journal*, 1859 (p. 207)
22. REDGRAVE, RICHARD 'Lectures on the study of botany by the designer' *Journal of Design and Manufactures*, March–August 1850 (Vol. III, p. 99)
23. *Art Union*, 1848 (p. 14)
24. REDGRAVE, RICHARD, and REDGRAVE, SAMUEL *A Century of Painters* Smith, Elder, London, 1866 (pp. 564–5)
25. Ibid. (p. 566)
26. MOORE, GEORGE *Modern Painting* Walter Scott Publishing Co., London and Felling-on-Tyne, new (enlarged) edition 1906 (p. 64)
27. REDGRAVE, RICHARD *Manual of Design* Chapman & Hall, London, 1876 (p. 138)
28. CRANE, W. *The Claims of Decorative Art* Lawrence & Bullen, London, 1892 (p. 4)
29. *Art Journal*, 1884
30. REDGRAVE, RICHARD *Manual of Design* Chapman & Hall, London, 1876 (pp. 21–2)
31. Ibid. (pp. 160, 162)
32. *Birmingham Institutions* Cornish Bros., Birmingham, 1911 (p. 297)
33. REDGRAVE, RICHARD *Manual of Design* Chapman & Hall, London, 1876 (p. 163)
34. WORNUM, RALPH N. *Analysis of Ornament The Characteristics of Styles – An introduction to the study of the history of ornamental art* (1856) Chapman & Hall, London, seventh edition 1882 (p. 22)
35. Ibid. (p. 54)
36. WORNUM, RALPH N. *Report on the arrangements and character of the French*

art collections and systems of instruction in the Schools of Design in France H.M.S.O., 1853, quoted in *Art Journal*, 1853 (p. 49)

37. Ibid. (pp. 4, 188)
38. Ibid. (p. 14)
39. Ibid. (pp. 20–1)
40. JONES, OWEN *The Grammar of Ornament* Day & Son, London, 1856 (p. 5)
41. SCHMUTZLER, ROBERT *Art Nouveau* Thames & Hudson, London, 1964 (p. 100); and *The Studio*, 1898 (Vol. XV, pp. 104–14)
42. DRESSER, CHRISTOPHER *Principles of Decorative Design* Cassell, Petter, and Galpin, London, 1876 (p. 22)
43. PEVSNER, NIKOLAUS *Matthew Digby Wyatt* Cambridge University Press, 1950
44. PEVSNER, NIKOLAUS *High Victorian Design* Architectural Press, London, 1951
45. GIEDION, SIGFRIED *Mechanization takes Command* Oxford University Press, New York, 1948

13

America imports
Cole's System

'All should be taught a fair hand, and swift, as that is
useful to all. And with it may be learned something of
drawing by imitation of prints and some of the
first principles of perspective.'
Benjamin Franklin

ORIGINS OF ART EDUCATION IN THE UNITED STATES

It may be remembered that in his speech at Nottingham Cole claimed
credit for the fact that schools like his own 'flourishing Schools of Art'
had been established in the United States.[1] He was referring to those
formed by Walter Smith of the Science and Art Department, headmaster
of the Leeds School of Art. Smith's work in America dates from 1870,
and great work it was, but it would be wrong to assume that he arrived
in a country which was destitute of art education for children.

Art education was first introduced on a large scale into the schools of
the United States during a wave of interest in German, Swiss, and
British practical methods of education, stimulated by Horace Mann,
William Bentley Fowle, Henry Barnard, and Amos Bronson Alcott. As
early as the eighteen-twenties, Fowle introduced drawing into some
Massachusetts schools, and in 1830 he published *An Introduction to
Linear Drawing*,[2] advising that art be taught upon geometric principles.[3]
Barnard, influenced, like Dyce, by Fellenberg's practical methods,
stimulated interest through his Connecticut Journal. Alcott, during the
years 1834 to 1839, employed in his famous Temple School a drawing
master, Francis Graeter, an artist who was particularly keen on children
being taught to draw from nature, a rather unique point of view in those
days when the 'useful' drawing, earlier advocated by Benjamin Franklin,
was favoured.[4] However, although the men mentioned above did sterling
work, it was that great statesman and educationist, Horace Mann, who
provided the chief impetus, and prepared the ground for Walter Smith.

Horace Mann (1796–1859), creator and first secretary of the Massachusetts State Board of Education, was in an ideal position to diffuse knowledge of educational matters. The Board could neither found nor administer schools (in the words of Professor Messerli of Washington, 'Horace Mann could neither hire nor fire a single common school teacher in the State'), but the Board could and did introduce a system of county institutes and normal schools for training teachers.[5] Regular reports were published, Mann's lectures were disseminated, and his views were circulated in the *Common School Journal,* which he edited from its first issue until 1848 when Fowle took over.

In May 1843, just six years after Dyce's tour, Mann made the same progress through Europe, and, like Dyce, he returned full of enthusiasm for the German system of education. Mann was particularly impressed by the oral work, reading methods, and board drawing of the Prussian schoolmasters.

The system of art instruction practised in Berlin schools was evolved by Peter Schmidt, who conducted the elementary drawing courses in that city; and Mann, after his return to Massachusetts, introduced it to American teachers through the medium of his periodical. It was a particularly vicious course, even more so than that given in Dyce's *Drawing Books,* and was described in the *Journal* as 'a series of twenty-four lessons upon nineteen rectilinear blocks, together with directions for drawing a niche, a cylinder, and a ball, in every possible perspective view'.[6]

Unfortunately many of Schmidt's rectangles were neither geometrical projections nor in true perspective; for example, many had the base horizontal and their sides showing in perspective, and on occasion a line for an edge was wrongly omitted. This mongrel perspective plus geometrical projection was typical of the period. Thousands of children laboured to render accurately the inaccurate, for, as in Britain, the chief means of instruction were the diagrams to be copied from such a periodical either by the teacher on to the blackboard, or directly by the children from drawing books such as the manuals produced at that time by William Minifie and William Bartholomew.

WALTER SMITH IS INVITED TO MASSACHUSETTS

From 1848, when Mann had introduced drawing into its grammar schools, the problem which faced the Massachusetts Board was the complete lack of art masters, especially masters to teach the useful subject technical drawing to improve industrial designing in the state. In the eighteen-fifties and sixties the citizens of the United States had become aware of the improved art education for the artisan or art workman in Europe, largely as a result of reading about and visiting the

great exhibitions and expositions in London and Paris, to which Cole had contributed so much effort; and they had been particularly impressed by the fact that, after studying the improved art-workmanship of the British exhibits in the Great Exhibition of 1862, the French had sent over a commission to study Cole's system of art education with a view to 'adopting many of the features of the South Kensington Museum and Training School for Art Masters'.[7] The United States Commissioner of Education noted with interest the visits of British artisans to the Paris Exposition of 1867, sponsored by the Society of Arts, and he quoted one of the English jurors there as saying that in France 'a due provision for art education, for instance, is not a favour on the part of the administration, but one of the conditions of its continuance'.[8]

The senior citizens of Massachusetts were already coming round to this view. Their grammar schools had taken up drawing in 1848 on the advice of Mann, and in 1864 the subject was made compulsory in grammar grades in Boston. Complete state intervention commenced in 1869, when the State Board authorized free instruction in drawing in all towns over 5000 inhabitants, and drawing was required in all common schools in 1871.[9] Motives were not entirely altruistic; some citizens urged exactly the same argument as the British used for establishing public art education in 1837, namely the huge import bill for patterned textiles. Minifie pointed out that Americans imported 36 million dollars worth of textiles from Britain and 11 million dollars worth from France.[10] It is not surprising that this enlightened state took the lead in the United States; it had already been the first to establish a university college, a high school, a normal school, and a board of education, and at this time the Massachusetts Institute of Technology was growing rapidly.

The next problem for the State was to find a qualified person to supervise the required art instruction, and in 1870, after considerable correspondence with the authorities at South Kensington and with managers of the British Schools of Art, the Boston School Committee appointed Walter Smith to be Director of Drawing for the Boston schools and State Director of Art Education.[11]

Smith had trained under Redgrave and Burchett at South Kensington until 1859, when he was appointed by Cole to the Leeds School of Art, then conducted by Charles Ryan. He quickly became joint-headmaster with Ryan, then headmaster, and during his stay at the School he worked with tremendous drive setting up art classes in many Yorkshire towns, such as Bradford, Huddersfield, and Keighley. In addition to the success of his itinerant art teaching, the examination results of his pupils at Leeds were among the best in Britain. Smith himself was awarded a money prize on account of this by the Science and Art Department, and a trip to Paris to report on the art work of French students.

The Leeds School of Art, run in connection with the Mechanics' Institute, was miserably accommodated in a house in East Parade near the Town Hall. A few of the old houses still show their windows above the shop fronts, but number 22 has gone, demolished in 1911. It was the enthusiasm displayed and the successes achieved by the artisans, who attended Smith's evening 'Mechanical and Architectural Class' in that house, that convinced him of the validity of the methods he later established in America.

Smith's resignation in 1869 was motivated by his belief in art as popular education, as opposed to art as a cultural accomplishment. In 1868 the School had been moved into the newly built Institution – ostentatious premises, now the Civic Theatre, which still dominate the hill on Cookridge Street. A cast museum was formed, new studio furniture supplied and Smith was offered additional staff, but the school committee asked him to quit itinerant teaching and devote himself entirely to the Institution. Smith resigned rather than comply.[12]

The offer of an appointment in Massachusetts must have seemed a godsend. Smith realized, firstly that he could never organize local art education to his taste, because of all the legislation emanating from South Kensington, and secondly that he would never be promoted to a position in the Central Department. He had already had the temerity to request that the Department give up nomination for jobs, and adopt a system of 'advancing men to high official positions, from among the workers'; moreover, apart from his attack on Cole for lavishing money on the museum, mentioned earlier, he had published independently his report on the French Schools of Design, which Redgrave had previously suppressed, partly no doubt because of Smith's description of the type of drawing advocated by the Inspector General for Art as 'the slow torture of stippling with the chalk point'.[13]

After the Massachusetts Board had confirmed Smith's appointment he was furnished with £500 to spend on copies of art, and in 1871 he brought with him to Boston, not only examples of the drawing cards and casts used in the British schools, but also a set of work of British art students, 'exhibiting every stage' of the Course of Instruction.[14]

Smith was soon hard at work lecturing, demonstrating, and organizing night classes. His lectures were afterwards condensed as *Industrial Drawing in the Public Schools* (1875), and the drawing course he conducted appeared as the *Teachers' Manual of Free Hand Drawing and Designing* (1873). The *Manual* consists of hundreds of engraved plates of exercises all in hard, clear, and thin outline, proceeding from squares and polygons to ornament and analysis of plants in the 'flat-ironed' plan and elevation views which Crane abhorred. The diagrams would certainly have given youngsters a better idea of designing than those of

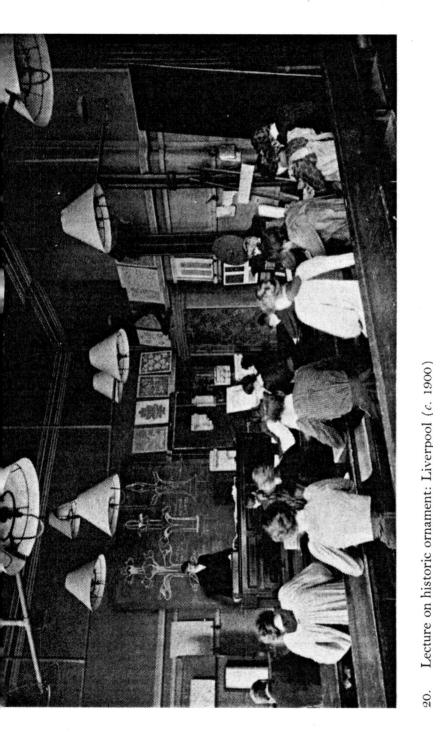

20. Lecture on historic ornament: Liverpool (*c.* 1900)

21. Typical works of the early Victorian naturalistic school which, Wornum said, 'substitutes the ornament itself for the thing to be ornamented'

Dyce, or of Schmidt. The botanical examples owe much to Richard Redgrave and Christopher Dresser of South Kensington.

THE FIRST INDUSTRIAL ART SCHOOL IN THE UNITED STATES

Smith pointed out at this time that 'the chief obstacle in the way of teaching drawing at present lies in the difficulty of procuring competent teachers', and, he added, 'I don't know one.'[15] This problem was resolved in 1873 by the establishment of the Massachusetts State Normal Art School in Boston to serve the same purpose as the masters' training classes at South Kensington. Smith was appointed principal and Professor of Art Education. Richard Boone in his *Education in the United States* (1889) stated that the establishment of this Normal School 'marked the beginning of an intelligent interest in drawing in the United States'.[16]

It could perhaps be claimed that the Normal School was the first public school of art in the United States. There were already schools attached to the academies of New York and Philadelphia, also the School of Fine Arts had been endowed at Yale by Augustus Street, and opened to students in 1869, but these were rather fine art studios than programmed schools. It is interesting to note, however, that the Philadelphia School of Design for Women, now the Moore Institute, referred to earlier (Chapter 7), was set up as early as 1844 through the efforts of Mrs Sarah Worthington King Peter, who also promoted an association for the advancement of tailoresses, and founded art museums and convents. She had commended it to the committee of the Franklin Institute as a source of future employment for females, who 'owing to the increasing drain by emigration to the West' were left dependent upon their own resources.[17]

The Normal School had a much greater industrial and technical bias than the British Schools of Art, and its programme would hardly have attracted the large proportion of amateurs and dilettanti who were still provided for under Cole's system. The *Annual Catalogue* of the School, quoted by Frederick Logan, stated as its basic aim: 'This school is intended as a training school for the purpose of qualifying teachers and masters of industrial drawing.'[18] Smith gave a detailed account of the programme of the School and of his philosophy of art education in his booklet *Popular Industrial Art Education* (1882), written for the benefit of the trustees of the Pennsylvanian Museum and Industrial School of Art.

Every student had to start in Class A, Elementary Drawing. The programme, consisting of twenty-four subjects, was far more ambitious and rapid than the Elementary Drawing course in Britain; it was also based more upon realities and was less abstract. Admittedly the

students did some geometrical problems, but the orthographic projections were of machines, building construction details and furniture, not of cones, cubes and cylinders. In this respect Smith was following the French system of mechanical drawing which he had assimilated in Paris in 1863, and commended in his report of 1864 as 'incomparably superior' to British methods.[19] Drawings from casts of the human figure, of animals, and of ornament and designs from plants completed the first year course.

For examination the first year student had to give a demonstration lesson on the blackboard and submit the above exercises. If successful, the student then obtained the first grade diploma, and, as in Cole's system, was allowed to leave and teach first grade drawing in a primary or intermediate school. If an ambitious student wished to continue he could then choose to spend a year in Class B (Form, Colour, and Industrial Design), or in Class C (Constructive Arts), or in Class D (Sculpture and Design in the Round).[20]

As the school progressed in public estimation, students stayed on longer, and they could obtain a second grade diploma for grammar school teaching after two years, a third grade for high and normal schools after three years, and a fourth grade for art and technical schools after four years. There were several important differences between Smith's programme and the South Kensington system. For example, Smith insisted upon a reasonable speed of drawing. He included some industrial design in every class programme. Also he discouraged the copying of casts of the Classical and Renaissance periods, which, he thought, did not echo the spirit of his age.

Henry T. Bailey, writing on art teaching in the United States, commented: 'For twelve years Smith taught, lectured, published text-books and circulated exhibitions everywhere. To him more than to any other person credit is due for laying the foundation for American art education.'[21]

Walter Smith's exhibit at the State Centennial, 1876, included work from the Normal School and from twenty-four towns in Massachusetts, and shortly after that towns in all parts of the United States began to foster art instruction; in 1879 the National Association of School Superintendents resolved that 'Industrial drawing should form one of the fundamental branches of study in all grades'. Twenty-two cities had followed Boston's lead shortly after 1870, and by 1884 most cities in the U.S. had made graded drawing exercises compulsory in their public schools. Five years later, in 1889, there were thirty-seven schools of design in the States for 'the promotion of the industrial arts'. Bailey commented: 'Behind all this development stands first in influence, as the alma mater par excellence, the Massachusetts Normal Art School

organized by Walter Smith and developed by Otto Fuchs and George H. Bartlett.'[22] Even from this short account it can be deduced how Smith followed the system of art education organized by Henry Cole; for example, the central school in the metropolis for training art masters, a central exhibition of works from the schools, circulating exhibits, night classes for artisans, graded stages of instruction, and publication of approved textbooks.

SMITH'S UTILITARIAN CONCEPT OF ART EDUCATION

It should not be thought that, because Smith attacked Cole for spending money on the South Kensington Museum, and for neglecting the useful schools of art in manufacturing centres, that he did not admire Cole's system and his Utilitarian outlook.

In November 1863, when Smith was one of the party of British art masters sent by Cole to report on the French students' work in the Palais de l'Industrie, his final conclusions were in favour of the English system: 'A comparison,' he wrote, 'of the English and French systems of Art-education is overwhelming in favour of the former. I should consider it nothing less than calamitous if any serious modification of our English system were made with a view of assimilating it to the French.' The book critic of the *Art Journal* was puzzled by his report, because the British were aware of the superiority of the drawing and design in the prosperous French schools and design studios, admired by British manufacturers, to the inferior work of the bankrupt local Schools of Art in Britain, whose usefulness 'the manufacturers, as a body, ignore'.[23]

Smith's viewpoint later echoed from the pages of the *Report* of the Massachusetts Board of Education of 1871: 'It is now admitted by all who have examined the subject that every one who can learn to write can learn to draw, and that drawing is simpler in its elements and more easily acquired than writing.' These words could have been Cole's! Smith repeated much the same philosophy in the introduction to his *Teachers' Manual*, stating 'that any person capable of learning any branch of study can learn to draw, so as to be able to represent general forms with as much ease and certainty as he can speak or write. To do this he must first learn the alphabet of the study, and know by name and at sight any feature of form from the dot to the most subtle compound curve, and from the simplest geometric form to the last problem in perspective'.[24]

Frederick Logan quoted a passage from Smith's *Industrial Drawing* to show that the Professor's young daughter did not see eye to eye with him on the ease and certainty of representation, for, wrote Smith, 'she is wildly indignant with me at any faults I point out, and simply turns round and thrashes me if I point out a faulty line'.[25]

Of course, the girl was justified. Most of Smith's methods, although

reasonable in an industrial art school, were unsuitable for the children his graduates had to teach, although it must be said in his favour that he did encourage memory drawing, drawing from oral description, and freehand in first grade work for young children. This was a great advance on the copying of abstract forms from drawing books that was the sole art preoccupation of many British children.

Smith was, above all, a teacher, a believer in intelligent instruction from the blackboard. Like some modern art teachers, he did not so much believe in the production of finished artistic works, but rather in enlarging the students' experience. He said of art teachers: 'it is infinitely more important that they should know their subjects well, and present them truthfully, than that their object should be to make nice-looking drawings'. He claimed in 1882: 'We have already abolished the practice of picture making from elementary day schools, and substituted for it instruction in drawing.' Like all his contemporaries Smith could not appreciate the 'incorrect' efforts of children and he considered that any attempt to produce pictures or artistic drawings was 'most offensive and impertinent in the lower grades'.[26] Like Dyce and Redgrave he made the error of thinking that if children copied outlines from a manual, or from the board, and learnt the theories of mechanical drawing, they would draw well; but the basis of learning any type of drawing is, initially, a foundation of free manipulation and individual observation.

Smith's concept of industrial drawing for children dominated American art education until the end of the century, but by 1880 the influence of his manual was on the wane. A passion for drawing from real objects, rather than copying exercises, arose owing to the influence of Froebel and the 'objective' teaching practised at the Oswego Normal School, New York. The drawing from geometrical solids or 'type forms', such as cones, spheres, and cubes, was widely introduced at this date, and was quickly followed, as in Britain, by drawing from all manner of solid models to teach 'habits of observation'. Object drawing was a step forward inasmuch as the children were improving their perception of form, space, and structure from visible things. It was not to be until the turn of the century that, owing to the efforts of Arthur Wesley Dow, the creative and aesthetic aspects of American child art were widely considered.

The greatest contribution Smith made to American art education was the diffusion of knowledge of what he called 'the scientific basis of true drawing, upon which all intelligent art must rest'.[27] Today we take perception of perspective and projections for granted, and it is difficult to imagine Britain and American art and industry pervaded by incorrect freehand and mechanical drawing, as they were before Cole and Smith held sway. Smith's other great contribution was the prototype of the

American art school and teachers' college, many of which are still far more closely related to industry and commerce than their British and French counterparts. The great majority of art teacher training establishments in Britain, for example, are not even concerned with appreciation or teaching of industrial design in the nation's schools. Where in Britain would members of staff teach in both a department of art education and of applied art (art concerned with industry) as at Wisconsin University? Where in Britain would art teachers be trained alongside students doing business and engineering studies as in American Teachers' Colleges? Why did many American art institutions assimilate the ideas of the Bauhaus over a decade before the British did? One could argue that the industrial path upon which Walter Smith set American art education supplies the answer.

Sources

1. COLE, SIR HENRY *Fifty Years of Public Work* G. Bell, London, 1884 (Vol. II, p. 347); and speech at Nottingham, 15 January 1873
2. FOWLE, W. BENTLEY *An Introduction to Linear Drawing* Hilliard, Little, and Williams, Boston, 1830
3. EISNER, ELLIOT W. (Professor of Education, University of Chicago) 'American Education and the Future of Art Education' *Sixty-fourth Yearbook of the National Society for the Study of Education* University of Chicago Press, 1965 (p. 300)
4. PEABODY, ELIZABETH *Record of a School* Roberts, Boston, Mass., 1835 (p. 270, footnote)
5. MESSERLI, JONATHAN (Assistant Professor of Education, University of Washington) 'Horace Mann and Teacher Education' *The Year Book of Education 1963* Evans Bros., 1963 (p. 70)
6. SCHMIDT, PETER 'Schmidt's Guide to Drawing' *Common School Journal*, 1843 (Vol. V, pp. 241–3)
7. *Report* of the United States Bureau of Education, Washington, 1873 (p. c)
8. *Report* of the Commissioner of Education, Washington, 1870 (p. 444)
9. BAILEY, H. TURNER 'Art Teaching: The United States' *Encyclopaedia Britannica*, edition of 1949 (Vol. II, p. 488)
10. EISNER, ELLIOT W. 'American Education and the Future of Art Education' *Sixty-fourth Yearbook of the National Society for the Study of Education* University of Chicago Press, 1965 (p. 300)
11. BOONE, RICHARD G. *Education in the United States* Appleton, New York, 1889 (p. 229)
12. *Annual Reports* of the Leeds Mechanics' Institution and Literary Society, 1859–70

13. SMITH, WALTER *Report on the Works of Pupils of the French Schools of Design* Simpkin & Co., London; Baines & Sons, Leeds, 1864 (pp. 1, 44)

14. *Report* of the Massachusetts Board of Education, 1871 (p. 162)

15. *Report* of the United States Bureau of Education, Washington, 1873 (p. cl)

16. BOONE, RICHARD G. *Education in the United States* Appleton, New York, 1889 (p. 229)

17. *Art Journal*, 1850 (p. 362)

18. LOGAN, FREDERICK M. *Growth of Art in American Schools* Harper & Bros., New York, 1954 (p. 70), quoting Massachusetts Normal Art School Third Annual Catalogue, 1875–6

19. SMITH, WALTER *Report on the Works of Pupils of the French Schools of Design* Simpkin & Co., London; Baines & Sons, Leeds, 1864 (pp. 39–42)

20. SMITH, WALTER *Popular Industrial Art Education* Rand, Avery & Co., Boston, Mass., 1882 (pp. 48–55)

21. BAILEY, H. TURNER 'Art Teaching: The United States' *Encyclopaedia Britannica*, edition of 1949 (Vol. II, p. 488)

22. Ibid.

23. SMITH, WALTER *Report on the Works of Pupils of the French Schools of Design* Simpkin & Co., London; Baines & Sons, Leeds, 1864 (pp. 39–42), also quoted in *Art Journal*, 1864 (pp. 219, 252)

24. SMITH, WALTER *Teachers' Manual of Free Hand Drawing and Designing and Guide to Self-Instruction* Rand, Avery & Co., Boston, Mass., 1873 (Introduction)

25. LOGAN, FREDERICK M. *Growth of Art in American Schools* Harper & Bros., New York, 1954 (p. 70), quoting from Smith, Walter *Industrial Drawing in the Public Schools* Prang, Boston, Mass., 1876 (p. 6)

26. SMITH, WALTER *Popular Industrial Art Education* Rand, Avery & Co., Boston, Mass., 1882 (pp. 45–8)

27. Ibid. (p. 35)

14

The Swing to
Fine Art

Redgrave resigned as Inspector General for Art in September 1875, and was succeeded by Edward John Poynter, A.R.A. The accession of Poynter, whose title was Director of the Art Division of the Department of Science and Art, was bound to expedite the movement towards fine art, already taking place in the Schools of Art, a movement which had recently caused Redgrave to accuse the masters of identifying their interest 'less with the sound instruction encouraged by the Department, than with the capricious wishes of the middle class, who at present rather resist such sound instruction'.[1] Edinburgh School of Art, under Charles Hodder, was, like Lambeth, leading in the national medal and money stakes by concentrating on the fine art stages of Redgrave's course. The *Art Journal* of 1873 remarked that Edinburgh's high position was 'mainly due to the study of the antique statue, based upon anatomical analysis and acquaintance with the details of the extremities'.[2] In spite of thirty years of official encouragement of the 'scientific' approach of Dyce and Redgrave, Haydon had triumphed.

The newly appointed Director of Art, together with Frederic Leighton and Lawrence Alma Tadema, belonged to a group of esteemed High Artists who sought noble and ideal beauty through Classical art and the nude model, using the methods of the Continental ateliers. Poynter had informed the Slade students that 'constant study from the live model is the only means of arriving at a comprehension of the beauty in nature and of avoiding its ugliness and deformity'.[3] His preference for the direct drawing of the French had caused him to attack the drawings submitted for examination at South Kensington:

'Are any of them executed under six weeks of painful stippling with chalk and bread? How much knowledge of the figure is it supposed the student has acquired during the process? Some of these prize drawings have come under my notice of which the elaborately stippled background alone must have occupied more than a fortnight in the execution.'[4]

William Gaunt has commented: 'Abandoned under his regime was the grubby curriculum of the old government Schools of Design – that vague "design" which some thought to be due to an imperfect translation of the French "Écoles de Dessin", those vague intentions of applying art to industry which consisted in copying ornamental motifs taken from many sources; the drawings from casts, stippled with chalk and smudged with bread crumbs, which served as diplomas, won certificates, and took many months to do.'[5]

It should not be presumed from Gaunt's over-enthusiastic view of Poynter's influence that lively swift freehand drawing was introduced. Cross-hatching and stippling enclosed by a hard outline was banished, but now, under Poynter, careful copies of classical casts and of the nude were carried out in powdered black or brown chalk worked with leather or paper stumps, and heightened with white chalk if on coloured paper. The *Art Journal*, commenting on Poynter's influence at the Slade and South Kensington, remarked: 'In both places he has always supported the French system of education; that is shading with the stumps in preference to point work [hatching and hard continuous outline with the point], working from the undraped model and limiting the time of a figure drawing to six days, instead of wasting weeks on it as the custom was.'[6]

The *Art Journal*, which invariably favoured the Classical works of the Academicians, was giving too fair a picture. Admittedly the Kensington students in Poynter's time accomplished a nude in chalk in six full days, but before they were admitted to the advanced class of the living model they had to produce exact chalk drawings from casts of the antique nude, which occupied months, and eventually as the system developed, years; the first year being elementary antique, and the second, advanced antique. In elementary antique, casts of eyes, noses, ears, knees, and so on were drawn one after another. John Willock, lately head of the Department of Design at Manchester, remarked that as late as 1903 six weeks, or even longer, was required for each drawing, often only of a cast of part of the body.[7]

An ex-student, describing South Kensington in Poynter's time, wrote that there were 'two hundred general students, these were mostly studying to be artists and were drawing and shading from the antique, and from life, and painting still life . . . they were mere youths sent by their parents without any idea of what branch of decorative art they were going to follow. Consequently they worked aimlessly, without the masters taking much notice of them.'[8]

George Wallis, Keeper of the Art Collections at Kensington during Poynter's directorship, complained of continuous change of policy, 'which in the end, resulted in a looseness as to the true purpose of study in these national institutions until at last their original purpose as

nurseries for Art workmen, and for the growth and encouragement of designers for Art manufactures, got lost sight of; and it is feared, at the present time, that decorative Art has fewer attractions for nine-tenths of the students of our schools than it has ever had. Pictorial Art is everything – ornamental Art comparatively nothing.'[9] The appointment of Poynter seems to have been one more of the periodic devilish moves to reverse existing trends, and to continue the eternal see-saw of confusion in official art education. From the commencement of public art education the appointments of heads of the central institution had created the maximum swings of policy; firstly Dyce (Germanic and Utilitarian), then Wilson (Italian and academic), next Cole and Redgrave (Germanic and Utilitarian), and now Poynter (French and academic).

George du Maurier, who studied with Poynter at Gleyre's atelier, depicted him in *Trilby* as the industrious apprentice Lorimer, and referred to his obsession with artists of the past – 'never a modern, moderns didn't exist'. Poynter's design teaching was limited to insistence upon correct representation of the Greek Orders in the backgrounds of figure compositions, upon classical drapery studies, and upon classical motifs for ornament. The robed classical figures we still observe on the insignia of insurance companies are due partly to his influence. For forty years after Poynter's appointment galleries of casts of the Classical nude became the central feature in the major art schools.

RUSKIN'S LACK OF INFLUENCE

Ruskin has often been referred to as the master of the Victorian art world, and attempts have been made to show his influence upon art education by quoting small extracts from his voluminous writings; but in practice his views had little influence upon the official courses in Schools of Art and public day schools. This lack of influence was due to two facts. Firstly, like Morris, he lacked interest in Government art schools. Secondly, many of his ambiguous statements could be taken to justify the existing system, and were often quoted against advocates of lively freehand drawing and bold painting from nature.

When addressing the National Association for the Promotion of Social Science in 1859 he admitted, 'I have not acquaintance enough with the practical working of that system to venture any expression of opinion respecting its general expediency', but after expressing this ignorance, he went on to attack the most modern aspect of the Course, namely the Design Stages, asserting that 'it is my conviction that, so far as references are involved in it to the designing of patterns capable of being produced by machinery, such references must materially diminish its utility as a general system of instruction'. He then followed with a

statement about a student of art which the art masters could take to justify all the mathematical tendencies of the Course of Instruction and the tedious slavery of spending years copying the complex outline of the Trajan Scroll:

> 'To give him habits of mathematical accuracy in transference of the outline of complex form, is therefore among the first, and even the most important, means of educating his taste.'[10]

In a lecture at the Manchester School of Art in 1857, speaking of a young man's work, he said, 'If his work is bold, it is insolent; repress his insolence' – very harmful advice to give Victorian art masters who were already imposing a repressive course. At Mansfield night art class in 1873, a date by which students had obediently endured the restrictive Course of Instruction for twenty years, Ruskin stressed that prizes were awarded for 'superior diligence and more obedient attention', not for 'indications of superior genius'.[11]

How the precepts were used to justify contemporary practices can be judged from Tyrwhitt's *Handbook of Pictorial Art*, an approved textbook and prize-book of the Science and Art Department from 1869 to 1900. Tyrwhitt, who acknowledged he owed everything to Ruskin's personal advice, complained, 'One of the greatest difficulties of a conscientious master in a modern school is the continued struggle with ladies and gentlemen who think that accuracy is "niggling",' and he added, 'in no case ought mathematically correct study of form ever be long discontinued, for any reason whatever'.[12] Ruskin was in the habit of presenting to art schools, for the guidance of students, finely stippled pictures of fruit by William Hunt, an artist who had assured Ruskin, 'I like to see a thing fudged out.'[13] The College of Art at Manchester possesses such a work, and another hangs in an office in the Leeds College. Two particularly hideous examples of this niggling method appear in Tyrwhitt's book through the kindness of the Oxford professor. Even Redgrave, who agreed with a student spending months hatching a large drawing for the National Competition, was taken aback by the tedious methods pursued by Ruskin's disciples. Redgrave recorded: 'Kingsley showed me some sketches, I suppose on Ruskin's principle of looking through a hole in a card, for they were as small and minute as such work would be; moreover they represented a month's labour on a piece of paper about the size of a visiting card.'[14]

This was in 1858, and it was not until after Ruskin's appointment to the Slade professorship of fine art at Oxford that the great man became fully aware of the type of art being practised throughout British schools. He could hardly avoid noticing: there was a Government School of Art already established, under his nose, in the Randolph Gallery. 'After

carefully considering,' he wrote in 1871, 'the operation of the Kensington system of Art-teaching throughout the country, and watching for two years its effects on various classes of students at Oxford, I became finally convinced that it fell short of its objects in more than one vital particular; and I have, therefore, obtained permission to found a separate Mastership of Drawing in connection with the Art Professorship at Oxford; and elementary schools will be opened in the University galleries, next October, in which the methods of teaching will be calculated to meet requirements which have not been contemplated in the Kensington system.'

In 1872 the University assigned the western wing of the galleries in Beaumont Street to the Ruskin Drawing School, and the attempt to counteract the Kensington system commenced, generously endowed by Ruskin with £5000, a sum with which Cole would have established a dozen Government schools. What resulted? A plentiful supply of young ladies, desirous of painting delicate water colour landscapes under the supervision of the master, Alexander Macdonald, and keen to profit from copying the many specimens of the art provided by the professor.

On average, throughout the rest of the century, only two or three undergraduates were in attendance. The elementary schools never got off the ground; the Government School of Art soldiered on in the Gallery basement, while Ruskin dreamt up fresh schemes in the clouds of Coniston Waterhead. Cole's system throve, and in 1877 Ruskin wrote in chagrin, 'the Professorship of Sir Henry Cole at Kensington has corrupted the system of art teaching all over England into a state of abortion and falsehood from which it will take twenty years to recover'.[16] Cole could have been highly amused to be referred to as 'professor'.

Much has been made of the fact that, in the preface of his *Elements of Drawing*, Ruskin advocated that parents should allow their children to daub, and later to paint subjects of their choice. Ebenezer Cooke, a pupil of Ruskin's drawing class at the Working Men's College, and Thomas Ablett (see Chapter 18) were inspired by this passage. However, as far as formal art education was concerned, Ruskin urged the most careful and constant imitation. Of design he had little idea: for him it was either good or bad ornament. Artists should be produced by art schools, he asserted, 'irrespective of any consideration of economy of facility of production . . . Try first to manufacture a Raphael; then let Raphael direct your manufacture.'[17] He ignored the fact that a Raphael would never have been produced without the Renaissance background of artists designing in two and three dimensions in difficult materials. How the stippled still life work, and the Turneresque renderings of landscape and architecture, which Ruskin advocated could ever produce an industrial designer it is impossible to imagine.

Undoubtedly Ruskin's writings strengthened the desire of many an art student to become a Turner or a Raphael, though without any intention of directing manufacture, but his influence on official policy and on the work done in Government schools was negligible. The use of classical casts, French drawing methods, and the nude model in the Schools of Art under the influence of Poynter, and the continued practice of the Elementary Drawing system of Cole and Redgrave in the public day schools were anathema to Ruskin.

Sources

1. SPARKES, J. C. L. 'Schools of Art' *International Health Exhibition Literature* London, 1884 (Vol. VII, p. 813)
2. *Art Journal*, 1868 (p. 194), and 1873 (p. 48)
3. BELL, MALCOLM *Drawings of Sir E. J. Poynter* George Newnes, London; Charles Scribner, New York, 1912 (p. 16)
4. SPARKES, J. C. L. *Schools of Art* International Health Exhibition Literature, 1884 (Vol. VII, pp. 815–16)
5. GAUNT, W. *Victorian Olympus* Jonathan Cape, London, 1953 (p. 168)
6. *Art Journal*, 1881 (p. 28)
7. WILLOCK, J. S. Obituary of E. Bradbury *News Bulletin* of Manchester School of Art, 1961 (p. 20)
8. *Art Journal*, 1884 (p. 366)
9. *Art Journal*, 1879 (p. 5)
10. RUSKIN, JOHN *A Joy for Ever* George Allen, London, third edition 1893 (p. 221)
11. Ibid. (p. 229); and RUSKIN, J. 'The Political Economy of Art' First lecture given at Manchester, 10 July 1857 Smith, Elder, London, 1857 (p. 36)
12. TYRWHITT, R. ST JOHN *A Handbook of Pictorial Art* (1868) Clarendon Press, Oxford, second edition 1875 (pp. 3, 157)
13. COOK, EDWARD T. *Studies in Ruskin* George Allen, London, 1891 (p. 94)
14. REDGRAVE, F. M. *Richard Redgrave – a memoir* Cassell, London, 1891 (p. 94)
15. RUSKIN, JOHN *Fors Clavigera* George Allen, London, 1871
16. Ibid. (Vol. I, IX), 1877 (Vol. VII, LXXXIX)
17. RUSKIN, JOHN *The Elements of Drawing* (1857) George Allen, London, 1892 (pp. x, xiv)

15

The Slade and its Concept of Drawing

THE SLADE SCHOOL OF FINE ART, UNIVERSITY COLLEGE, LONDON
In 1868 Felix Slade, lawyer, landowner, and distinguished collector of books, prints, and glass, died, leaving his art treasures to the nation and £35,000 of his fortune for the purpose of founding chairs of fine art at Oxford and Cambridge Universities and at University College, London. An extra £10,000 was bequeathed to the College to endow six scholarships in fine art; Ruskin was appointed professor at Oxford, Digby Wyatt at Cambridge, and Edward Poynter at London. University College contributed to the foundation and its school of art was opened in 1871 in the first section of the north wing of the Quadrangle to be built.

It was this London school which was to distinguish itself as 'the Slade' by setting a new and refreshing standard of figure drawing for the British art schools, under the successive direction of Poynter, Legros, Brown, and Tonks.

From its opening, the Slade School in Gower Street had great social advantages over the contemporary art schools. It was free from the regulations and restrictions of Cole's state system, it was on a sounder financial footing than any private school, and it had the additional status of being part of a university college. The surest confirmation of its respectability was made in 1871, when Edward Poynter, A.R.A., a lauded High Artist, was appointed to the first professorship. It was only to be expected that persons of the middle and upper classes, especially the ladies, would prefer to attend the Slade rather than the South Kensington schools, where the course was tedious and some of the pupils of rather humble origin.

No specific entrance requirements were insisted upon at the Slade apart from approval of a candidate's drawings by the professor, followed by a short interview with him, and in the heyday of the Slade all manner and age of candidates entered the School – aesthetic dandies, foreign immigrants, retired officers, débutantes, blue stockings, intellectuals, Bohemians, and, above all, plenty of beautiful and decorative Slade girls, in the seventies sporting brightly embroidered pinafores, in the aesthetic eighties and early nineties 'very variegated in faint-coloured costumes,

limply at variance with their high spirits – in greenery, yallery, Grosvenor Gallery tints and hues', according to one student. Some of the males rivalled the girls in the splendour of their apparel. Shaw Sparrow described how the young T. C. Gotch wore a costume 'designed, cut out and made by himself – knee-breeches and an original tunic in Burnett serge, peacock blue in colour, choicely piped, and lined with cashmere of an art green'.[1] C. R. W. Nevinson commenting on a 'Slader', wrote: 'Mr Fothergill was an exquisite in dark blue velvet suiting, pale-yellow silk shirt and stock, with a silver pin as large as an egg, and patent court shoes with silver buckles.'[2]

The ambition of most Sladers was to become a professional artist and eventually a Royal Academician. However, because the Slade, unlike other exclusive art schools such as St John's Wood School, was free from visiting teachers of Academic rank, the students tended initially to be very independent in spirit. A large proportion continued their studies in Paris and then gravitated towards the New English Art Club.

The New English started in 1886 at the studio of G. P. Jacomb-Hood (an old Slader), a large barn-like building in Manresa Road where the first Chelsea Arts Ball was held. W. R. Sickert and W. J. Laidley were chiefly responsible for putting the Club on its feet, together with George Clausen, La Thangue, Stanhope Forbes, Frederick Brown, Wilson Steer, and Havard Thomas (the last three becoming Slade staff members later). These artists had returned from French ateliers, inspired by Realism and Impressionism, and determined to show the Royal Academy what painting was all about. The Slade's connection with the Club was strengthened after 1892 when Fred Brown became Professor and encouraged his students, including William Orpen, Augustus John and Walter Russell, to join. The Club weakened gradually as English Impressionism became respectable and the members became Associates of the Royal Academy. Even the most Bohemian of Sladers, Sickert and Augustus John, went the way of the world.

ALPHONSE LEGROS

During his stay in Paris in the eighteen-fifties J. M. Whistler sought the company of Courbet and his circle. Fantin Latour introduced him, and the American became particularly friendly with an admirer of Courbet and Millet, Vivant Alphonse Legros (1837–1911). Latour and Legros were very poor, and Whistler on his return to London persuaded them to cross the Channel and installed them in the home of his brother-in-law and patron, Seymour Haden, who not only boarded exiled French artists on roast beef and champagne, but also bought their pictures.

Fantin Latour, horrified by the London rain and fog, returned to settle in Paris, but Legros did not fancy this prospect. He was sought by

his dead father's creditors, and by 1871 the Courbet circle was in disgrace following the unsuccessful Paris insurrection with its attendant slaughter. Courbet, a prominent member of the Commune, was held responsible for the destruction of the Vendôme Column and fled to Switzerland. Legros decided to remain in England for life.

In 1867 a well-placed punch to the eye of Legros ended his friendship with Whistler, a handful of the American's admired curls ensuring no rapprochement.[3] However, the introductions which the Frenchman had now obtained to Rossetti, Watts, Haden, Val Princep, Leighton, and especially to Edward Poynter proved invaluable. On Whistler's advice he had set up as a teacher of drawing and etching, and his first official appointment was the post of teacher of etching at the National Art Training Schools then governed by Henry Cole, himself an exponent of that craft who had exhibited an etching in the Royal Academy of 1865.

Edward Poynter was far too busy painting large canvases, such as 'Atalanta's Race' and 'A Visit to Aesculapius', to pay more than an occasional visit to the Slade, and the work there was conducted by his second-in-command F. G. Slinger, a very conscientious but rather uninspired ex-student of Gleyre's atelier. Legros was just the man Poynter was seeking to introduce French drawing methods and he arranged for the Frenchman to have virtual charge of the Slade. When Poynter became Director of the Art Division of the Department of Science and Art in 1875, he resigned the Slade professorship in favour of Legros.

Legros succeeded to the chair in 1876 and immediately made a great impact on the Slade. He was the skilled French draughtsman *par excellence*, and his uncanny accuracy and speed astonished the Victorians. During his professorship he used to give regular demonstrations of painting a head at great speed. Using a canvas washed in with greyish umber, he rapidly painted in the outlines and masses in raw umber until a complete head was rendered in monochrome. He then applied colour, thinly on the shade but in thick impasto on the lights, completing the portrait in eighty to one hundred minutes. This method of working, although used for centuries by European portrait painters, astonished British art students accustomed to months of labour on each drawing.

These demonstrations were carried out in the Slade and in various Schools of Art throughout Britain. The old catalogue o fManchester City Art Gallery (*c.* 1896) records his pictures rather like miracles with witnesses.

'No. 11. Study of a Head. *A. Legros*
Painted before a large number of Art Students of the University College, London, 1883, as a practical lesson in Art. Time occupied

in painting, one hour and forty minutes. Presented to the Corporation by the Artist, 1884.'

'No. 14. Ditto – one hour and forty-five minutes.'

'No. 16. Ditto

Painted before a large number of students of the Manchester School of Art in the rooms of the Royal Manchester Institution, 19th Sept. 1879 – one hour and forty minutes.'

D. S. MacColl recalled how, after Legros had given the performance at Aberdeen in one hour twenty minutes flat, 'the local art master trained in the school of stipple and stump, rubbing out and niggling in again, forthwith gave up his post to become a pupil at the Slade'.[4]

The speed of the Frenchman's draughtsmanship gave the students new hope, but it was his precise point-to-point line drawing and etching which proved the most valuable influence.

LECOQ DE BOISBAUDRAN AND MEMORY TRAINING

Alphonse Legros attributed his speed and accuracy to the training he had received in Paris from Lecoq de Boisbaudran. There seems to be some justification for his view since Fantin Latour, Rodin, and Dalou, all of similar deft and accurate touch, were also Lecoq's pupils.

In the fifties Lecoq could often be observed touring the Louvre in the afternoon, students in his wake, pointing out the notable points of various masterpieces and allocating them to students for copying. His pupils were not just required to copy still-life paintings and portraits in the Museum, but to draw or paint them from memory on their return to Lacoq's atelier. Legros earned his master's admiration for his memory, especially, on one occasion, when he produced a fine drawing from memory of Holbein's 'Erasmus' (Louvre Museum). Boisbaudran also took his students out in the woods bordering the Seine. Models were promenaded, then rested while the students sketched the scene from memory.

Horace Gregory mentions in his biography of Whistler how the American learnt of Lecoq's method from Legros and how he used to train his visual memory by gazing at a scene, then turning his back and drawing it. Whistler obviously believed there was some truth in Lecoq's memory training and the learning of appearances 'by heart'. Legros passed on Lecoq's views to his Slade students in these words:

> 'I wish to impress upon you more and more strongly the necessity of studying your models with such a thoroughness as to get them by heart. To that end persistent drawing must be kept up.'[5]

Catterson Smith, the head of the Birmingham School of Arts and Crafts in the early years of this century, introduced into the School a

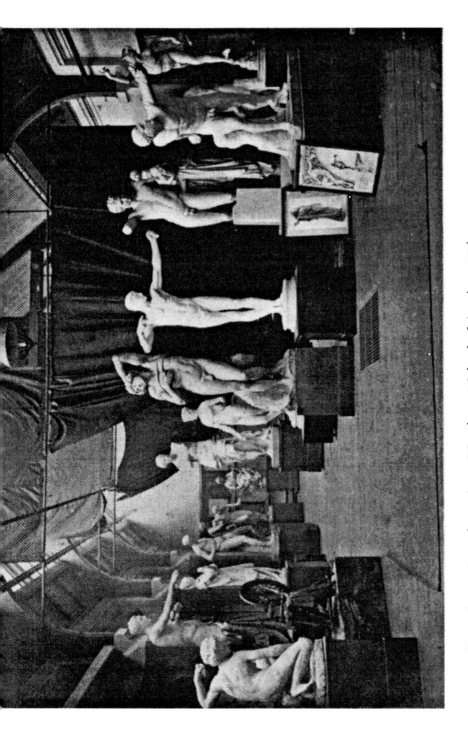

22. Gallery of casts from the antique: Manchester School of Art (*c.* 1900)

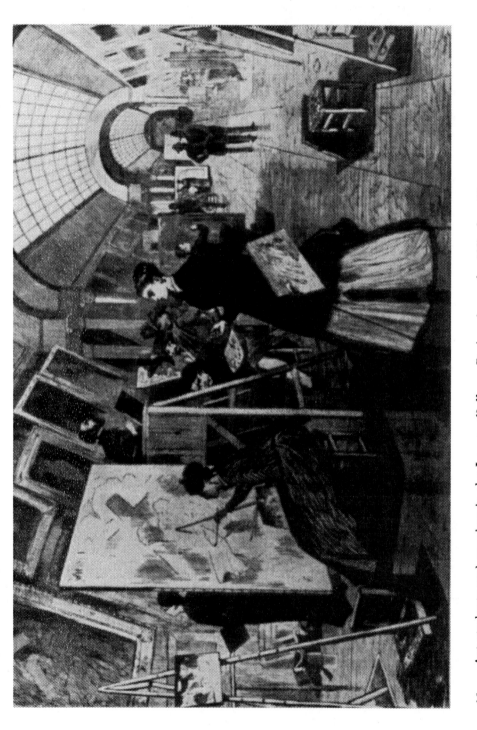

23. Art students and copyists in the Louvre Gallery, Paris—drawn by Winslow Homer

From the engraving in 'Harper's Weekly', 11th January 1868

further development of Lecoq's method. Lantern slides of various subjects were shown for a few moments to Smith's pupils and then withdrawn. The pupils had then to close their eyes and outline the subject. Marion Richardson commented:

> 'This "shut-eye" drawing was perhaps Mr Catterson Smith's greatest contribution to art education. It was a wonderful means of clarifying and impressing the image and of keeping it before us while we set to work with open eyes.'[6]

Up to the second world war memory drawing of groups of objects, withdrawn after a few minutes of study, was widespread in British schools and taken in examinations such as the School Certificate, the theory being that one learnt to be conscious of the construction of objects and the space between them by this memory method. Today the practice has been generally abandoned.

LEGROS' CONTRIBUTION TO THE SLADE

Legros, like Boisbaudran, was a firm believer in copying from the old masters. One of his innovations at the Slade was a collection of full-sized photographs of drawings of Leonardo, Michelangelo, and Raphael, framed upon the School's walls. Another innovation was the equipping of the top floor at Gower Street as an etching studio, where every Saturday Mr Goulding, a master printer, attended to instruct the students. T. C. Gotch, G. P. Jacomb-Hood, and William Strang became distinguished etchers with the encouragement of the professor, who was himself brilliant in this medium. Hood recalled how, years later, Strang took him into a room full of his sleeping children and observed drily, 'I have to feed them all on copper-plates.'[7]

Painting was encouraged by competitions for executing compositions of subjects set by Legros, often of a Biblical nature. The winning compositions were photographed and circulated to encourage the students, and money prizes were awarded. The professor also recommended students for travelling scholarships, the purpose of which was to study and copy the technique of the masterpieces in European art galleries. Complete copies of pictures were not required, but only notes and sketches of compositions together with copies of parts of the picture. Legros contributed part of his own salary to the annual travelling scholarship.

Disciplined drawing was, however, the chief occupation of the Slade students. Charles Ricketts wrote of Legros: 'Discipline, balance, design, a hatred for all exaggeration – such were the sober virtues he valued and strove for.'[8]

Legros kept up the tradition, introduced by Poynter, of a curtailed

period in the Antique, where the newcomer was set to work drawing a large plaster cast of an eye, then an ear, then a nose and so on, taken from Greek, Roman, or Renaissance statuary (never from Gothic nor any other non-Classical period). When Legros considered a student had acquired sufficient skill and accuracy he or she was allowed to proceed down to the Life Room to draw and paint from the nude.

Legros insisted upon fine clean line drawing 'with the point' of natural pale-grey Italian chalk on white paper. Shading was put on all in the same diagonal direction, from right to left, line close to line, in what became known as the 'east-wind' fashion. The drawings were always commenced by putting in points to indicate the placing of the important junctions of the forms of the body. The philosophy behind his system of drawing is outlined later.

Unlike one of his successors, Henry Tonks, Legros did not seek contact with most of his pupils. He did not even address them in English; Slinger acted as interpreter, and the general run of students had to be satisfied with a *'pas mal'* from the professor. It was his enthusiasm and powers of draughtsmanship that inspired the students, whose one wish was to please him. He paid special attention to the gifted students and the results of his methods became apparent in the late seventies when the first stream of distinguished artists graduated from the School, including William Strang, Charles Furse, H. S. Tuke (all later honoured by the Royal Academy), Harrington Mann, Charles Holroyd (later Sir Charles, Curator of the Tate and National Galleries), Oswald de Glehn, T. C. Gotch, James Linton (later Sir James), Evelyn Pickering (later Mrs William de Morgan), William Rothenstein, D. S. MacColl, W. R. Sickert, J. B. Clark (later Curator of the R.A. Schools), and Charles Green. This was the first wave of talent which emerged from the Slade. The second was to come in the nineties, just after Legros's retirement.

Legros is chiefly remembered today for his fine etchings, such as 'The Death of the Vagabond' and the illustrations for Poe's *Tales of Mystery and Imagination*. Many of his pastoral subjects strongly resemble the work of Millet, the idol of his youth. He died in 1911, shortly after catching a chill at the Memorial Exhibition of Alfred Stevens, whose chalk drawings he greatly admired.

FREDERICK BROWN, HENRY TONKS, AND WILSON STEER
'I am the Lord thy God, thou shalt have no other Tonks but me.'
Anon.

During the eighties the Westminster School of Art, then in Tufton Street in a room adjoining the Architectural Museum, acquired a high reputation for drawing and painting from the nude. The headmaster, who had studied for several years in Paris, was a gifted member of the

New English Art Club and an intimate friend of Wilson Steer and Walter Sickert. It was this headmaster, Frederick Brown, who was chosen to succeed Legros at the Slade on the professor's retirement in 1892, despite the fact that two Royal Academicians applied for the post.

Frederick Brown brought with him to the Slade his friend Wilson Steer as teacher of painting, and C. Koe Child from the Westminster School as secretary. They were followed shortly by Henry Tonks, whom Brown appointed Assistant Professor. Tonks, who was at that time Demonstrator in Anatomy and Curator of the Museum at the London Hospital, was a brilliant young surgeon who had lately been Senior Medical Officer at the Royal Free Hospital and protégé of Sir Frederick Treves, the surgeon. He was attracted to the evening life classes run by Frederick Brown at Westminster by his desire to learn something of the French concept of drawing, and became a fellow student of Walter (later Sir Walter) Russell, Charles Furse, Frank Pegram, C. Koe Child, and David Muirhead. Brown's masterly exposition of the construction of the nude made a deep impression on Tonks, and introductions to Whistler, Sargent, and Wilson Steer drew him further into an artistic milieu. On Brown offering him the post at the Slade, he accepted with delight and withdrew from the medical profession.

Under Brown and his fanatical assistant professor the Slade achieved an even more exacting standard of line draughtsmanship, and a stream of distinguished artists received their training there, including Augustus and Gwen John, Ambrose and Mary McEvoy, William Orpen, Wyndham Lewis, Walter Russell and Ethel Walker in the nineties, and later Harold Gilman, J. D. Innes, Spencer Frederick Gore, G. L. Kennedy, Gerald Chowne, Eleanor Monsell, Albert Rutherston, W. I. Strang, Randolph Schwabe, Matthew Smith, Derwent Lees, Duncan Grant, and Vanessa Bell, and, immediately before the first word war, Stanley and Gilbert Spencer, Mark Gertler, Robert Gregory, C. W. R. Nevinson, Paul Nash, Ben Nicolson, Colin Gill, and William Roberts. Brown retired in 1917 and Tonks succeeded him as Professor in 1919 on his return from active service as a medical officer and war artist. During the immediate post-war period some of the more notable inhabitants of the Life Room were A. Gwynne Jones, Roger Furse, Oliver Messel, Rex Whistler, David Liddell, and Adrian Daintrey.

Fred Brown was a reticent person, extremely dedicated, and opposed to any superficial path to success, such as the copying of contemporary style or fashion in art. A fellow artist described him as 'the grim and intransigent type of revolutionist'.[9] It was due to his influence that many artists connected with the Slade gravitated to the radical New English Art Club. His success as a teacher was due both to the attitude he inspired by his consistent honesty about drawing, and to the staff he selected.

275

Henry Tonks (1862–1937) was the forceful and formidable purveyor of Brown's principles. The Life Room was always hushed when Tonks was circulating on one of his periodic criticisms. His cadaverous figure, his strong face with its Roman nose and Hitler forelock, his eloquence, and his sarcasm, as he sat side-saddle on a 'donkey' fixing the student with his hooded eyes, mesmerized even the most adventurous young artists into silent submission. Adrian Daintrey recalled: 'He pronounced and did not seem to want or expect an answer. He seldom got one from me, or I believe any student.'[10] Nevinson remembered, 'He asked me to define drawing, a thing I was fortunately able to do to his satisfaction, as I neither mentioned tone nor colour in my stammering definition but kept on using the word outline. But he nevertheless managed to shatter my self-confidence, and I was wringing wet by the time he left me to go to Stanley Spencer.'[11]

Gilbert Spencer recalled in his biography of his brother that Nevinson approached Stanley on his arrival in the Life Room and told him that some marks on the floor 'were all that was left of a number of students, who had melted'. Gilbert wrote of Tonks: 'His entry into a room was authoritative and commanding, and without side. He talked of dedication, the privilege of being an artist; that to do a bad drawing was like living with a lie; and he proceeded to implant these ideals into his students by a ruthless and withering criticism.'[12]

Modern educators would condemn Tonks outright in this day when we stress the fostering of the pupils' individual viewpoints, yet Tonks was considered to be the most successful art teacher of his time, over a period of forty years. In spite of his severity Tonks encouraged originality in his students' paintings. Drawing had to be taught in a scientific manner, but when a student showed creative powers in painting Tonks was one of the first to acknowledge it, as in the case of Stanley Spencer and Rex Whistler, both of whom he praised in their student days. He demanded respect, but in some ways he gave it; for instance he did not refer to 'students' during his criticisms, but to 'artists'.

The severity and angularity of Tonks in the gloomy Life Room was offset by the presence of the great bulk of the teacher of painting, Philip Wilson Steer, a product of the Gloucester School of Art and Julian's atelier in Paris.[13] Steer, a colourist and impressionist, was admired deeply by Tonks who prevailed upon their mutual friendship to keep this wealthy painter at the Slade during his entire professorship. The painter used to say little to the students except 'Go on with that' if he approved. He said nothing if he disapproved. Often, if a student had clean round brushes, Steer would work upon his canvas with delicate strokes of light bright colour and then ask the student to continue. His opinion was reverenced by Tonks, especially for judging scholarship and

prize winners, and the professor loved to go to social evenings with Steer in tow like a great St Bernard.

The students in the Life Room received the constant attention of assistants Russell (later Sir Walter Russell) and Lees, and later of Charlton, White, Wilkie, and Wheatley, who passed from board to board, drawing incisive corrections of the details of the pose to the side of the students' drawings. The nude model posed on the throne under a top north light was the sole object of study, and a plain grey or khaki cloth was hung behind to ensure that no environment was considered.

Tonks drew the students' attention to the drawings of Michelangelo, Rubens, Rembrandt, and especially to Ingres whom he considered to be the supreme example of a draughtsman of contours, by reproductions of their work affixed to the walls, together with drawings by two of Tonks's star pupils, John and Orpen.

Obviously there are objections to the single-minded emphasis which Legros, Brown and Tonks put on contour to the exclusion of other factors, and these objections are described below when the Slade concept of drawing is discussed. However, because of the high quality of life drawing produced at the school, the Slade system became universal in British Schools of Art from the nineteen-twenties to the nineteen-fifties and ex-students were much sought after to take charge of life-classes.

THE SLADE CONCEPT OF DRAWING

The basic principle of drawing held at the Slade under Legros, Brown, and then Tonks was that drawing is the representation and expression of form by the study of contours, and that only. A. S. Hartrick, a student at the Slade under Legros, stated:

> 'His method of teaching drawing based on that of the old Italian masters, to draw with the point and by the character of the contour, rather than by the mass in tone, is the best, if not the only one for the proper training of a student. Drawing is the study of the representation of form, and the expression of form is the end of drawing.'[14]

Legros discouraged any treatment which obscured or confused the form. W. Shaw Sparrow recalled:

> 'He objected to reflected light in workmanship because it prevented students from seeing broadly, and he was down on drawings that became dark. The best students in the room made grey drawings.'[15]

The kind of drawing prevalent in the Government Schools of Art, a hard outline filled with dark hatching or stippling, was not permitted, and the concept of contour replaced that of outline. D. S. MacColl commented:

'Under M. Legros the lesson of determined line and brushwork was driven home – definiteness in stroke as opposed to lazy fudging.'[16]

The concept of drawing upheld by Legros, Brown, Tonks, and the staff at the Slade was clearly defined by J. Fothergill in his article in *The Slade* (1907) as follows:

'... the representation of form still remains the one and only power of drawing ... Drawing, then, has nothing to recommend it except that which it expresses, which is form. And if it does not excel in this, it falls flat ...

'A drawing is plastic in graphic form. For this reason what is called a "sculptor's drawing" has no peculiar meaning for us at the Slade, since it is just this "sculptor's drawing" that we try to make, and no other. There is no other ...

'Contour, then has no beauty or value in itself any more than has shading, they are both beautiful and have value only in so far as they are determined by, and pregnant with, ideas of touch, i.e. in so far as they express the corporeity of form ...

'The construction gives it (the drawing) corporeity or three, dimensional quality, its action, attitude, relative proportions, directions, planes in space etc ...

'A drawing of a human figure must express one conception, viz. the conception of its character or construction, which must be as simple in conception and expression as a drawing of a square box.'

The Slade concept of drawing is not the unique and correct concept claimed by its exponents. Drawing contour lines to suggest sculptural form is only one aspect of drawing. Expressions of movement, design and pattern by rhythmical lines, or by decorative lines and masses, are some alternatives which may be just as valid. Even the Slade concept of contours is only one idea for rendering form. Infinite numbers of contour lines run in every direction round any one area of the body. It is simple to conceive the idea of a contour round the top of a section of one slice of a relief map, but to render contours of a three-dimensional form in line, as the Slade students did, is only one formula and a difficult one for the graphic depiction of the plastic. Any rendering of form is only the expression of an idea of touch, as George Berkeley claimed. Fothergill referred to this haptic sense of form when he stated:

'The draughtsman can give only his ideas of form. These ideas if they are to represent form as we know and appreciate it, must be ideas of touch.'[17]

It was the custom in Schools of Art in Tonks's day to study anatomy by filling in the outline of a man with bones and muscles learnt from

skeletons, diagrams, and casts. This study of anatomy in detail was intended to instil a knowledge of form, but the actual forms of the nude, especially the female, are little related to the complications of the muscles shown on anatomical diagrams.

Tonks, although an expert on anatomy, did not encourage students to regard the nude as an anatomical study, but rather as a construction of solid forms tilted into various positions governed by the directions of the main bones. 'Directions, directions,' Tonks would reiterate, pointing out the basic egg-shapes of the masses of the thorax, pelvis, and thighs inclined on their axes, the bones.[18] He insisted on construction, but not on precise accuracy as did Legros, nor on the tight drawing of the Victorians. The word 'outline' was repugnant to him, and he insisted that a drawing should be 'kept open' in order to leave something to God, nature, or inspiration.

The great contribution of the Slade concept of drawing formed by Tonks and his predecessors was 'intelligent' drawing. Drawing was given a positive intellectual direction towards a search for knowledge of form, and the slavish outlining, shading, plumbing and measuring of the South Kensington system was completely superseded.

THE SLADE TODAY

The Slade, while still emphasizing the paramount importance of fine drawing, has now become a far more ambitious and comprehensive school of art than in former years.

The School was not of course solely preoccupied with life-drawing during the earlier periods of its history, although indeed it was the principal subject of study. It has been mentioned how Legros had encouraged the students to paint and etch, and in 1893 Professor Brown organized provision for sculpture. Modelling and carving studios were built later and in 1916 the title of Professor of Sculpture was awarded to Havard Thomas, who had distinguished himself as a defender of Epstein's Strand sculptures against the public outcry which greeted them when they were erected in 1908. He was succeeded by his son G. Thomas in 1920, and then by A. H. Gerrard, who was awarded the title of Professor in 1948.

The History of Art made a shaky start in 1890, but was not regularly established until 1904 when D. S. MacColl was appointed to a lectureship. The famous art critic Roger Fry succeeded MacColl in 1909, and acquired many admirers and opponents. Tancred Borenius, the scholarly Finn from Sotheby's, followed in 1914, the title of Professor being conferred upon him in 1922. In 1927, following the Durning-Lawrence benefaction, his title was changed to the Durning-Lawrence Professor of the History of Art and he held the position until his death in 1947,

when he was succeeded by Hubert Wellington. Rudolf Wittkower, the noted author of *Architectural Principles in the Age of Humanism*, was the next professor, holding the chair from 1949 to 1956, when he was succeeded by Ernst Gombrich. L. D. Ettlinger, the present (1969) professor, followed Gombrich, being appointed in 1959.

Tonks was succeeded in 1930 by Randolph Schwabe who directed the School through the difficult war years when it was combined with the Ruskin School of Drawing at Oxford, at that time under Albert Ruthers-ton. The Slade is today under the direction of the Slade Professor, Sir William Coldstream.

The University awards two levels of diploma and a certificate of proficiency to Slade students. The University of London Diploma in Fine Art can be obtained after a four-year course in Drawing and Painting with one subsidiary subject, or in Drawing and Sculpture with one subsidiary; the subsidiary subjects being Painting, Sculpture, Graphic Art (Autographic Printmaking), Stage Design, or Architecture. Entrants who have previous full-time art school study may be exempted from up to two years of the Diploma course. The Diploma is now classed as graduate for salary purposes, but many students who wish to become teachers go on to take the Art Teachers' Certificate at the Institute of Education of the University.

The University of London Postgraduate Diploma in Fine Art is a two-year course open to graduates and persons who the University considers qualify as graduates by education and experience. Each student specializes in one or more of the following: Painting, Sculpture, Graphic Art, Stage Design, and must also take a course in the History of Art, or Aesthetics, or the Study of the Film.

The Certificate of Proficiency may be awarded to any student who has made satisfactory progress over a period of not less than three terms, and who has not obtained a diploma at the end of his stay.

In the Unit for the Study of the Film, directed by Professor Thorold Dickinson, facilities are provided for wide research into historical and contemporary film material, and there are opportunities for practical work. Film screenings, lectures and seminars are arranged as extra-curricula activities for the students of the Slade and other departments of University College. Sir William Coldstream's deep interest in the development of a film unit within the School is derived from his early enthusiasm for this medium and from his experiences in the years before the second world war when he worked on documentary films with John Grierson.

The Department of History of Art of University College was established in 1965 while the subject was under the direction of the present Professor, L. D. Ettlinger, Ph.D., F.S.A., the noted art

historian. Slade students on the Diploma courses attend lectures in the Department and are required to pass examinations on the history of art. In addition to the services of the professor and his staff, arrangements are made for students to attend lectures at the Courtauld Institute.

Sculpture Studies are directed by Reg Butler, the internationally-famous modern sculptor, who succeeded A. H. Gerrard in 1966. Originally a qualified architect, Butler taught at the Architectural Association before the second world war; in the forties, while an editor of the Architectural Press, he worked on technology and sculpture, his first one-man sculpture show taking place at the Hanover Gallery in 1949. In the following year he became the first Gregory Fellow in sculpture at Leeds University.

He achieved wide recognition in 1952 at the Venice Biennale, and in 1953 he was awarded first prize in the Institute of Contemporary Art's competition for works based on the theme 'The Unknown Political Prisoner'. Having had experience of working as an engineer and blacksmith, Butler grasped the structural and emotional possibilities of wrought and welded iron, his training as an architect being manifest in taut, mysterious, tower-like structures and the planning of his minute maquettes. He has now turned to investigating the potentialities of the human form in action.

Butler's views on art education, given in a series of five lectures at the Slade in 1961, have now been published in his book *Creative Development*.[19] Butler is severe but honest, advocating fewer art students, a ruthless attitude to weaker students, and two years of 'supported freedom' for the stronger students after completion of their planned courses. He advises the exposure of students to a wide range of experiences. All teachers concerned with adult art education should read this book.

The Slade staff today (1969) consists of many distinguished art educators and artists, including William Townsend; B. A. R. Carter; Patrick George; I. E. Tregarthen Jenkin; J. A. M. Aldridge, R.A.; Lisbeth-Anne Bawden; Jeffery Camp; R. B. Claughton; Bernard Cohen; John Collins; Robyn Denny; Brian Elliott; Maurice Feild; Nicholas Georgiadis; Anthony Gross; J. S. Jones; Michael Kellaway; Philip King; Lynton Lamb; Robert Medley; B. dos Santos; Peter Snow; Philip Sutton; Euan Uglow; Keith Vaughan, C.B.E.; Robert Stanbury; and A. W. Lucas.

SIR WILLIAM COLDSTREAM

Sir William Coldstream,* C.B.E., D.Litt., the present Slade Professor

* Fellow of University College, Vice-Chairman of the Arts Council of Great Britain, Chairman of the National Advisory Council on Art Education, Trustee of the National and Tate Galleries.

of Fine Art, is the most influential figure in British art education today –
one might say almost a latter-day Sir Henry Cole, albeit a gentler
knight. David Sylvester, the art critic, has commented:

> 'Almost anyone in the British art world who is neither highly
> established nor a maverick must, I imagine, experience moments of
> disorientation when he doubts his own existence other than as part
> of a dream in the mind of Coldstream.'[20]

Coldstream (born 1908) founded the school of painting at 316 Euston
Road in 1937 together with Victor Pasmore and Claude Rogers. The
Euston Road group, which included Lawrence Gowing, Graham Bell,
and Colin McInnes, became identified with painting from natural
environment as opposed to the surrealist and more abstract artists who
were becoming popular. The work of the group had a great influence on
the paintings of environmental subjects which were executed in the
Schools of Art in the forties and fifties for the National Diploma in
Design. Coldstream, a distinguished painter, has remained constant in
this naturalistic tradition (unlike Pasmore) and excels in highly
sensitive and calculated paintings from the nude.

The Slade has always preserved a serious, scholarly and dedicated
aura as opposed to the worldly, bustling, Bohemian, commercial, or
gallery-conscious atmosphere of other schools of art. It is appropriate
that the School, one of the few British institutions mainly devoted to the
practice of fine art, should preserve this serious tradition derived from
its previous professors and its association with University College. It is
good to find an art institution which concentrates on Drawing as a main
subject and takes the disciplines of Anatomy and History of Art
seriously. It would be a tragedy if the Slade lost its highly individual and
independent outlook.

Sources

1. SPARROW, WALTER SHAW *Memories of Life and Art* John Lane The Bodley Head, London, 1925 (p. 101)
2. NEVINSON, C. R. W. *Paint and Prejudice* Methuen, London, 1937 (p. 23)
3. PEARSON, HESKETH *The Man Whistler* Methuen, London, 1952 (p. 25)
4. MACCOLL, D. S. 'Augustus John' In *The Slade* Edited Fothergill, John Richard Clay & Sons, London, 1907 (p. 8)
5. WRIGHT, HAROLD J. L. *Etchings of Alphonse Legros* Print Collectors Club, London, 1934
6. RICHARDSON, MARION *Art and the Child* University of London Press, London, 1948 (p. 12)

7. JACOMB-HOOD, G. P. *With Brush and Pencil* John Murray, London, 1925 (p. 16)

8. RICKETTS, CHARLES, and DODGSON, CAMPBELL *Paintings, etc., by Alphonse Legros* Grosvenor Galleries, London, 1922 ('Appreciation' section)

9. JACOMB-HOOD, G. P. *With Brush and Pencil* John Murray, London, 1925 (p. 77)

10. DAINTREY, ADRIAN *I Must Say* Chatto & Windus, London, 1963 (p. 63)

11. NEVINSON, C. R. W. *Paint and Prejudice* Methuen, London, 1937 (p. 24)

12. SPENCER, GILBERT *Stanley Spencer* Gollancz, London, 1961 (p. 104)

13. MACCOLL, D. S. *Philip Wilson Steer* Faber & Faber, London, 1945 (p. 19)

14. HARTRICK, A. S. *A Painter's Pilgrimage* Cambridge University Press, 1939 (p. 8)

15. SPARROW, WALTER SHAW *Memories of Life and Art* John Lane The Bodley Head, London, 1925 (p. 94)

16. MACCOLL, D. S. 'Augustus John' In *The Slade* Edited Fothergill, John Richard Clay & Sons, London, 1907 (p. 8)

17. FOTHERGILL, JOHN 'The Principles of Teaching Drawing at the Slade School' In *The Slade* Edited Fothergill, John Richard Clay & Sons, London, 1907 (p. 39)

18. HONE, JOSEPH *Life of Henry Tonks* Heinemann, London, 1939

19. BUTLER, REG *Creative Development* Routledge & Kegan Paul, London, 1962

20. SYLVESTER, DAVID 'Dark Sunlight' *Sunday Times* Magazine 10 June 1962 (p. 8)

16

The French Ateliers

The latter half of the nineteenth century, the period of the great art boom, was the heyday of the French ateliers. Young artists from Europe and the United States flocked to Paris to pursue art in the established routine – atelier in the morning, Louvre in the afternoon.

Arriving in Paris, a prospective student usually installed himself in a cheap room in the Quartier Latin, and then set out for a recommended atelier, bearing his drawings. If the master approved of them, he was allowed to start working from the nude in the following week; but, if they were judged poor, he was either completely rejected, or directed to spend a period drawing casts of ears, noses, arms, legs, and so on. Before entrance was completed the name of the *nouveau* was posted up in the atelier, so that an entrant could be banned if the students disapproved. One purpose of this was to prevent a majority of English and Americans in the student body which virtually governed the atelier.

The student had to be there promptly at seven on Monday mornings to secure a good place for the week or fortnight to be spent on drawing and painting the nude. Models were numerous and, if a student arrived early on certain Mondays, he could help to choose the model for the next pose. Sir Alfred Munnings, P.R.A., recalled:

> 'Each mounted the throne, one after the other, amid cries of approval or dissent. I felt sorry for the poor women who were too unattractive to please. Some were white, others brown, yellow or even pale green.'[1]

The relaxed atmosphere of the atelier was demonstrated by the natural behaviour of the female model. Whereas in British life rooms she appeared through a door or from behind a screen, discreetly naked under a gown which she divested on the throne immediately before the pose, in the French atelier the fully-clothed girl often walked directly to the throne, throwing off her garments on to a chair.

A teacher was not ever-present as in Britain, and the pose was usually set at 8 a.m. by a *massier* (monitor). During the pose, talk was carried

on incessantly in French, the use of English often being subject to a fine, and Englishmen, used to the deathly silence at St John's Wood or the Slade, were disconcerted. An old Slader studying at Laurens' atelier wrote home:

> 'The noise, the heat, the smoke, and the students in general depress me beyond measure, and I am played out pretty soon every day, but one learns.'[2]

After the *massier* had ordered the model to rest, the British *nouveau* had an opportunity to take in his surroundings. The atelier had none of the schoolroom atmosphere of the life room he was used to. It was a workshop, democratic and lively.

The area around the throne was packed with easels and low-backed chairs, with up to forty students around one model, while on the outskirts of the throng youngsters drew from the casts which usually occupied the area around the door. Chalk caricatures covered the lower portion of the wall, and the colourful scrapings from hundreds of palettes plastered the area above shoulder height – 'a polychromous decoration not unpleasing' as Du Maurier put it. Above this band of colour hung rows of canvases by former students which had won prizes in studio competitions. Higher up still, on one wall, ran a gallery for stacking canvases, reached by a portable ladder. The new student's eye may have rested on this ladder with some trepidation, if he had heard of its secondary purpose; for, if a student displeased his comrades, he was liable to be rushed to it, with a cry of '*A l'échelle*', to hang there as if crucified for a period befitting his offence.

The student's attention was recalled to his work by a chant of '*C'est l'heure, Mademoiselle. C'est l'heure!*' from the young men around him. The chant continued until the model returned to the throne, and work was resumed.

At midday the newcomer, for his *bienvenue*, was expected to provide drinks all round at a café, or to have rum punch and cakes brought in to the studio. The unfortunate was then asked to sing or give some other performance on the throne. His last task before leaving for lunch was to clean all the students' brushes. He had to perform this task daily until the next *nouveau* enrolled.

Afternoons were usually spent copying a work in the Louvre, often for a commission, but some students of unusual stamina carried on with life drawing and painting in an atelier which offered an afternoon *cours libre*, such as Colarossi's in the Rue de la Grande Chaumiere. Impecunious students could proceed to shops in the Rue Bonaparte or the Rue des Saints, where they were supplied with canvases upon which were printed outlines of well-known paintings, usually religious. The student painted

in the colours and received a few francs on returning the completed canvas. The last resort of the most impoverished students was to paint endless Stations of the Cross.

The *cours* for drawing and painting the nude or draped model, which took up all the mornings, was not the sole occupation encouraged by the ateliers. There was also a *concours* or competition, usually lasting a month. A subject, often Biblical, was set by the master or one of the visiting professors, and the students painted a composition in oils in their spare time. Some ateliers were opened on Sundays for competitors. Occasionally there was a *concours* based on the regular routine of the ateliers, the subject set being a painting of a male or female torso. The professor judged the prize-winner. The *concours* system was introduced into the Slade by Poynter and Legros to encourage the painting of compositions.

The atelier routine was a far more comprehensive and advanced fine art training than a student could hope for in England or America, hence its great popularity.

THE ORIGIN OF THE FRENCH ATELIER SYSTEM

The reputation of the Paris ateliers as centres of art education originated in the seventeen-nineties from the atelier of David, where Ingres, Gros, Girodet, Gerard, and Navez imbibed their master's austere Classicism, while drawing and painting the nude to a formula derived from Greek statuary. Previously young painters had studied in their master's atelier, but it was to acquire the science and method of his craft, not to learn, together with a mass of other pupils, a narrow gospel of art.

David's aesthetic, which he owed partly to his master J. M. Vien, the pioneer artist of Classical reaction, was based on a new idea that art should not just be founded upon academic principles, but also directly upon ancient statuary and architecture. It was an archaeological concept derived from the writings of Winckelmann, an attempt to resurrect a golden age. This new aesthetic dictated by David, President of the revolutionary Convention, and later painter to the Emperor Napoleon, had to be studied by any artist who sought success in the Republic or Empire. Classical art had been a creation of reason, and as such could be learnt.

The ateliers of David's pupils, Gros and Ingres, carried on his tradition, Gros remaining absolutely faithful to his master's Classicism, but Ingres digressing towards High Renaissance art. While many of David's pupils deplored all developments in art since the fifth century B.C., Ingres preferred to date the decline of Classical standards from the death of Raphael. He argued:

'Yes, I may be accused of fanaticism about Raphaelism and the

artists of his age, but I shall never be modest save before Nature and their masterpieces. Every step of progress in my career I owe solely to my constant and profound study of those law givers of art. Their successors have taught me nothing but what is vicious, and what I have had to forget.'[3]

Ingres opened his famous atelier in 1825 in the Rue de Marais, next to his own studio, and impressed upon his pupils the principles of Raphael's ordered compositions. There were soon over a hundred pupils, the most notable of whom were Flaudrin, Chassériau, and Lehmann. It is strange to think of Young Mitchell, the future head of Sheffield School of Design, at this atelier, and J. Z. Bell, the future head at Manchester, at Gros's atelier, in such exalted company, and descending later to the cellars and cells of the pathetic Schools of Design.

An eclectic, akin to Reynolds, Ingres was disturbed lest his followers be influenced by the contemporary trends towards Romanticism and Realism.

'What,' he queried, 'do those would be artists mean who preach the discovery of something new? Everything has been done, everything has been found out.'[4]

Ingres seemed unaware that, although his Raphaelesque compositions contained nothing new, he himself had developed a new sensuous and decorative line, admired by Degas, Puvis de Chavannes, and Gauguin, which Paul Valery called 'the arabesque of form', and which carried the seed of destruction of the Neo-classical art done in the ateliers and in the École des Beaux Arts, where he was professor.

Paul Delaroche and Thomas Couture, both pupils of Baron Gros, each became master of a famous atelier, and during the second half of the century, through their efforts and those of Ingres and Cabanel at the Beaux Arts, the centre of European art education swung from Rome to Paris. It was above all the example of Ingres's fine drawing which raised the quality of art training in Paris (as it did later in London through his influence on the Slade professors), a contributory factor being the advance of photographic printing in the sixties which made prints of the drawings of Michelangelo, Raphael, and Rubens available to the atelier students.

GLEYRE'S ATELIER

The largest atelier in Paris in the fifties and sixties was that of Charles Marc Gabriel Gleyre, who had succeeded Paul Delaroche (died 1856) as its master, and who eventually handed it over to Jean Gérôme. It was Gleyre's atelier that acquired international fame in the nineties as 'Carrel's atelier' in George du Maurier's *Trilby*.

J. M. Whistler, E. Poynter, Thomas Armstrong (Director of the Art Division and South Kensington Museum, 1881–97), T. R. Lamont, V. Cameron Princep, Joseph Rowley, Aleco Ionides, and Du Maurier himself were all students at Gleyre's. In the original version of *Trilby* in *Harper's Magazine* Whistler appeared as Joe Sibley (the 'idle apprentice'), Poynter as Lorrimer (the industrious apprentice), T. R. Lamont as the Laird, Joseph Rowley as Taffy, and Aleco Ionides as the Greek; but Whistler was so incensed that, in the book, the name and character of the idle apprentice were changed to Anthony the Swiss, a more pleasant individual. However, parts of the original description of Whistler are still discernible, such as:

> 'Always in debt like Svengali . . . humorous, witty, and a most exquisite and original artist, and also somewhat eccentric in his attire (though scrupulously clean), so that people would stare at him as he walked along – a thing that always gave him dire offence!'[5]

Gleyre's most distinguished pupils in the early sixties were the Impressionists Monet, Renoir, and Sisley. Their leader Manet had studied at the atelier of Thomas Couture, pupil of Baron Gros and Delaroche. The post-Impressionist Van Gogh and his contemporaries Toulouse-Lautrec, Anquetin, and Emile Bernard studied at the atelier of Fernand Cormon, pupil of Cabanel. The Impressionists and post-Impressionists disliked the academic discipline but admired the draughtsmanship of Ingres, the idol of the ateliers and of the École des Beaux Arts.

Gleyre's insistence upon fine line drawing with the point in the tradition of Raphael and Ingres, as opposed to the broad chalk masses favoured by many fashionable French painters, was his great contribution. It was said of him that he 'never drew a line without having first assured himself how Raphael would have proceeded'.[6] He had an original theory that the most effective way of achieving tones in colours was by the addition of black which would also harmonize them. There is little doubt that Whistler, although he preferred to mix with Courbet's circle, absorbed Gleyre's theories and so developed his partiality for fine line and black and white values.

THE ATELIERS OF DURAN AND LAURENS

Silence only reigned in the ateliers when the master or the visiting professor made his weekly round of the easels, spending a few minutes with each pupil. The very attire and manner of the great men demanded a respectful hush. The grandest master of an atelier was Monsieur E. A. Carolus Duran, a short strong man with scented beard, curling mous-

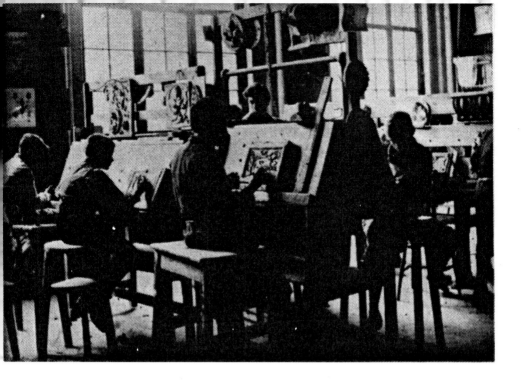

24. Elementary modelling in relief: Birmingham School of Art (*c.* 1900)
25. Designing birds in 'brush forms' from stuffed birds (at rear of Design Class), and portrait illustration (at front of class): Birmingham (*c.* 1910)

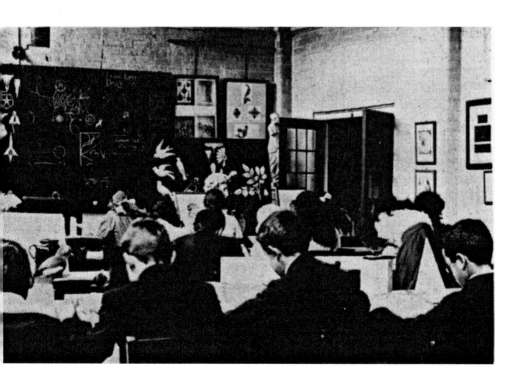

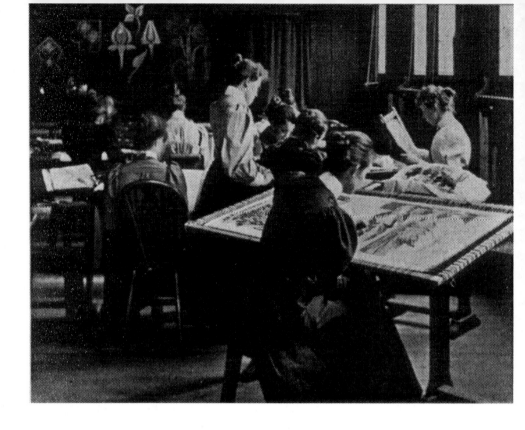

26. Needlework class: Birmingham (*c.* 1900)
27. Illumination on vellum: Manchester School of Art (*c.* 1919)

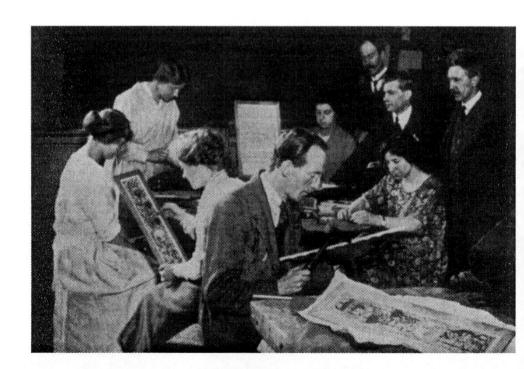

taches, wide collar, white and velvet suit with lace cuffs – something straight from Dumas. Expert duellist, horseman, and guitarist, Duran painted portraits of grandes dames, exhibited in the annual Salon. His large sculpture and painting studios, L'Atelier des Élèves de Monsieur Carolus Duran, off the Boulevard Montparnasse, opened in 1872, soon proved to be the most fashionable in Paris, and included ladies' classes, particularly popular with American and English girls.

On Duran's entrance every eye turned in his direction. Charles Merrill Mount described the 'entire class following him from easel to easel, eager to catch every word, to see every correction made by his hand',[7] a hand held imperiously aloft when he desired a clean brush. Duran did not insist upon disciplined drawing of the construction of the model. He was very much the professional painter and his popularity lay in the way he tried to help students to develop their own way of painting to a professional standard. Duran's own interest lay in the paintings of the Spanish and French Realists, especially Velazquez, Goya, Courbet, and Manet. The brush was his instrument, and his pupil John Singer Sargent, the great virtuoso of the brush, owed much to him, as indeed did Edward Stott, A.R.A., another painter from his atelier.

The most popular atelier with old Sladers in the seventies and eighties was that of Jean Paul Laurens, a painter of dramatic historic events such as 'La Mort de Marceau'. H. S. Tuke, T. C. Gotch, Oswald de Glehn, Jacomb-Hood, and many other pupils of Legros studied there, despite his objections. Sir Alfred Munnings, P.R.A., also studied there. Tuke wrote:

> 'The strongest men from all countries flock here. For example those who took the highest honours at the R.A., at Kensington, and at Antwerp all come to pousser their studies further. One most noticeable thing is the length of time the big men study, 8 or 9 years usually.'[8]

Laurens was chiefly popular because of the care and time he expended on teaching his pupils to paint. *'Toujours les valeurs,'* he used to insist, meaning that one should always look for the value of one area of paint against another.

THE ACADÉMIE JULIAN

The largest atelier in Paris at this time was the Académie Julian with some four hundred students. Monsieur Julian was a poor artist, but a clever businessman, and persuaded four eminent jurors of the Salon to be the visiting professors. Adolphe W. Bouguereau and Robert Fleury corrected and criticized the work in one main studio, Jules Lefebvre and Gustave Boulanger in the other. These jurors proved a great attraction,

each student hoping that, if these great men awarded him a prize in the monthly *concours*, he had a great chance of exhibiting in the annual Salon. George Moore and Wilson Steer were two of Julian's notable pupils.

Julian's could be regarded as the last great stronghold of the academic tradition outside the Beaux Arts. By the seventies, 'the grammar of art – perspective, anatomy, and "la jambe qui porte" '9 was beginning to look rather irrelevant when contrasted with the wide, bright horizon of the Impressionists. The day of the odalisque, the posed bather, and 'La Source' was over. The figure could no longer be considered in isolation in the atelier; the Impressionists had taken it outside into its natural environment. However, the ateliers prospered greatly until the end of the century, for tradition dies hard, but by the nineteen-twenties the great ateliers were no more.

Sources

1. MUNNINGS, SIR ALFRED *An Artist's Life* Museum Press, London, 1955 (p. 67)
2. SAINSBURY, M. TUKE *H. S. Tuke, R.A.* Martin Secker, London, 1933 (p. 54)
3. UZANNE, OCTAVE *Ingres* Newnes, London, 1906 (p. xiv)
4. Ibid. (p. xix)
5. DU MAURIER, GEORGE *Trilby* (1894) (Classics series) Collins, London & Glasgow, 1953 (p. 109)
6. PEARSON, HESKETH *The Man Whistler* Methuen, London, 1952 (p. 10)
7. MOUNT, CHARLES MERRILL *John Singer Sargent* Cresset Press, London, 1957 (p. 27)
8. SAINSBURY, M. TUKE *H. S. Tuke, R.A.* Martin Secker, London, 1933 (p. 56)
9. MOORE, GEORGE *Confessions of a Young Man* (1888) Brown, Watson, London, 1961 (p. 54)

17

From Applied Art
to Design

Design is the arrangement of forms and colours of an artefact or natural form. The word is from the Latin verb *designare*, meaning to mark out, trace out, contrive, or arrange. The noun *designatio*, in its meaning of arrangement of order, is the nearest equivalent in Latin to the modern word. Vitruvius, when giving his fundamental principles, grouped together order and arrangement, as follows:

> 'Order gives due measure to the members of a work considered separately, and symmetrical agreement to the proportions of the whole . . . Arrangement includes the putting of things in their proper places and the elegance of effect which is due to adjustments appropriate to the character of the work.'[1]

The mediaeval Italian noun *disegno* usually meant the marking out or first stage of an artefact, but during the fifteenth and sixteenth centuries the word came to embrace the inventive process for every type of art work, thus Leonardo called it 'the parent of our three arts'. Vasari referred to 'the arts of design', and it will be remembered that the academy in Florence was called the Accademia del Disegno. The arts of design were considered to be painting, sculpture, and architecture, hence the title Schools of Design of the Royal Academy. Calling these arts 'the arts of design' led to some loss of the original meaning of design, especially from the eighteenth century onwards when people spoke of the higher arts of design on one hand, and the lower art of ornament on the other, a division that was deepened in the nineteenth century by the enormous quantity of wretched ornament, mass-produced to satiate the industrial rich. After fifty years' burial under this welter of ornament, design was resurrected in the eighteen-nineties when art and craft were reunited by a new reverence for fine craftsmanship.

The Arts and Crafts Movement derived its first inspiration from Pugin, for with the Gothic Revival came a demand for mediaeval crafts, but a brief glance at the engravings of Gothic furniture in the *Art Journals* of the eighteen forties and fifties makes clear the bad design of the articles which first met this demand. Although William Morris

(1834–96) was a romantic child of the Revival, he was also a very practical offspring. The urge to create furniture was roused in him in the late fifties, when he found it difficult to purchase well-designed solid furniture for his London studio and his intended home at Bexleyheath. With this in mind he set up the firm of Morris, Marshall, and Faulkner in 1862, from which time, until his final venture the Kelmscott Press, well-designed carpets, tapestries, wallpapers, furniture, stained glass, and books became available to the Victorian public.

As can be seen later, Morris concerned himself very little with formal art education, but his influence upon artists and architects, such as Crane and Lethaby, caused societies to spring up with definite educational aims.

THE ART WORKERS' GUILD

In 1894 Heywood Sumner, master of the Art Workers Guild, was able to declare at its annual general meeting that 'the authorities are beginning to recognize that if you want a good man for a public post connected with the Arts, the A.W.G. is the place to come to for the purpose'.[2] The Guild had certainly penetrated public art education, for in that year Walter Crane was Director of the Manchester School of Art, F. M. Simpson, R. Anning Bell and C. J. Allen were Professor of Architecture, Instructor in Painting and Design, and Instructor in Sculpture respectively at Liverpool, and W. R. Lethaby and George R. Frampton were Joint Inspectors and Advisers to the L.C.C. Education Board. A little later Crane became the first Principal of the Royal College of Art, Lethaby, the first Principal of the Central School, and another member, R. Catterson Smith, the headmaster at Birmingham.

The Art Workers' Guild, the powerhouse of the Art and Craft Movement in education, was originally promoted by the committee of St George's Art Society, a society founded in 1883 by the pupils of R. Norman Shaw for discussing art and architecture. Shaw, the leading architect of the day, declared that the architects of his generation must make the future for themselves and knock at the door of art until they were admitted.[3] The young architects circulated invitations to progressive architects, artists, and designers, and at their second meeting in the Charing Cross Hotel on 11 March 1884 the Art Workers' Guild was founded.

Monthly meetings were organized for: '1st, practical expositions of different Art methods, and handiwork such as etching, mezzotint, wood-engraving, metal-work, glass-painting, carving, etc.; 2nd, more social gatherings for conversation and discussion, with a paper occasionally read by a member, or some eminent authority, on any Art topic; 3rd, small exhibitions of old and modern objects of beautiful workmanship, as well as of pictures and drawings.'[4]

There were many offshoots from the Guild, such as the Liverpool, Birmingham, and Edinburgh Art Workers' Guilds, the Women's Guild of Arts, the Junior Art Workers' Guild, and so on, but by far the most important branch concerned exhibitions.

THE ARTS AND CRAFTS EXHIBITION SOCIETY

In 1886 one of the original members of the Guild, W. A. S. Benson, a decorative metal worker and cabinet maker, and an intimate of William Morris, formed a committee drawn almost entirely from the Art Workers' Guild to establish the Arts and Crafts Exhibition Society, which held its first exhibition in the autumn of 1888 at the New Gallery, London. Walter Crane was elected the first chairman and president of the Society, and the following text is taken from the first circular, drafted by that artist.

> 'The Arts and Crafts Exhibition Society has been formed with these convictions, and with the aim (1) of taking measures for organizing an exhibition of the decorative arts, which shall show (2) as far as possible the inventive and executive powers of the designers and makers of the various works that may be exhibited, such as textiles, tapestry, and needle-work, carvings, metal-work, including goldsmith's work, bookbinding, painted glass, painted furniture, etc. etc., to illustrate the relation of the arts in application to different materials and uses, without however, excluding paintings or sculptures less directly of a decorative kind when space is available for showing them in proper relation. (3) It is not proposed to undertake the sale of works, but to refer intending purchasers directly to the exhibitors.'[5]

The Society's exhibitions which followed set a new standard of taste for the Victorians, and encouraged many young artisans to enrol in craft classes when they were provided in London in the late nineties.

INTRODUCTION OF CRAFTS AT THE ROYAL COLLEGE OF ART

From the closure of the museum workshops by Poynter in 1877, until 1886, there was no practical craftwork at the National Art Training Schools. General Donnelly, the secretary of the Science and Art Department, was particularly opposed to its introduction, and a correspondent of the *Art Journal*, A. Harris, went so far as to say that 'the regulations of the Department virtually exclude the student's employment upon material'.[6] The Report of the Royal Commission on Technical Instruction of 1884 stated that industrial design 'has not received sufficient attention in our schools and classes. In fact, there has been a great departure in this respect from the intention with which the

Schools of Design were originally founded, viz. the practical application of a knowledge of ornamental Art to the improvement of manufactures.' This report strengthened the hand of Thomas Armstrong, the Director of the Art Division, and he invited Walter Crane to lecture in the National Art Training Schools. Crane related:

> 'At this period [1886] . . . I undertook a series of lectures or demonstrations in various crafts allied to decorative design in which I had had personal experience, such as gesso and plaster relief-work, sgraffito, tempera, painting, stencilling, designing for embroidery, repoussé metal work . . . I believe they were the first lectures of the kind at South Kensington – forerunners of the time when craft classes became part of the ordinary college course in design . . . To Mr Armstrong's initiation, also, was due the first classes in enamelling, at the school, as he secured the services of M. Dalpeyrat to give a series of demonstrations in the art to selected students, one of whom was Mr Alexander Fisher, who revived enamelling so successfully.'[7]

These were historic developments, the beginnings of the Arts and Crafts Movement in public art institutions. The enamels were fired in the metallurgical laboratory of the Science Division. Seventeen years later the *Art Workers' Quarterly* commented: 'Nearly all the enamellers in this country at the present day were pupils in Mr Fisher's enamel classes, either at Finsbury College or Regent Street Central School of Arts and Crafts, or received private instruction from him.'[8]

As far as the Schools at Kensington were concerned the lectures by Crane and Fisher in the eighties were exceptions to the routine, for the Schools were run solely for providing drawing, painting, and modelling teachers; indeed, in Armstrong's first year as director (1881–82), the Department had reduced the number of art students from 621 to 426 by allowing only intending teachers to enrol. The only concession to design was the appointment of H. H. Stannus to lecture on ornament.

A change commenced in 1898 when Crane was given charge of art at South Kensington. Two years previously the Queen had graciously consented to a change of title for the National Art Training Schools, and the Kensington institution became the Royal College of Art, granting its own diploma. The Directorship of Art, held by Thomas Armstrong, was abolished in 1897, and Crane was appointed to direct the new College by the Committee of Council on Education in 1898. Crane had already commenced his crusade for design education, decorative art, and craft-work in the Schools of Art. In 1892 Charles Rowley, the Manchester patron of the Pre-Raphaelites, had offered him the post of Director of Design at the Manchester Municipal School of Art, and Crane took up

8 Some of Walter Crane's diagrams from *Line and Form* (1900),
 showing the breakaway from ornament towards free design.

the appointment in the autumn of the following year. An architect, Richard Glazier, was headmaster at that time, a man who was to gain recognition through his well-designed *Manual of Historic Ornament* (1899), a famous textbook in the Schools of Art.

Crane issued a paper of suggestions for a course which included 'brush-drawing and the study of silhouette, memory drawing, plant study and surface pattern, study of the figure in action, and its ornamental adaptation to architectural design and space-filling'. An elaborated version of this course later formed his book *Line and Form* (1900). He also gave a course of illustrated lectures on the influences which affect design, and this appeared as *The Bases of Design* in 1898. These two books with his previous work *The Claims of Decorative Art* (1892) made Crane the most influential art teacher in Britain, especially in the Schools of Art in manufacturing areas. Crane spent one week in every month directing the course at Manchester, but, because of the rigid exercises required for the Art Division's examinations, he found it difficult 'to dovetail new methods with the existing curriculum'. However, his lectures made a deep impression upon students and staff. Henry Cadness, who ran the Design Room at the time, wrote *Decorative Brush-Work and Elementary Design*, partly based upon Crane's ideas, in 1902, and Miss E. Bradbury, then a student, told me she would treasure her notes of his inspired lectures until her death. Crane resigned at Manchester in July 1897, and Professor Mackinder of University College, Reading, asked him to become Director of the new art department. Morley Fletcher, formerly a teacher at the Central School, was headmaster of the Reading School of Art, and Crane's task was to plan its integration with the new college. This did not occupy much of his time.

In July 1898 Crane was invited to become Principal of the Royal College and he took up his duties in October. He reported that the College was in a chaotic state. 'It had been chiefly run as a sort of mill in which to prepare art teachers . . . The curriculum seemed to my unacademic mind terribly mechanical and lifeless . . . The staff of masters seemed anxious to meet my wishes, but they had been hardened by long service in a system with which I was out of sympathy.'[9] He had some praise for Edouard Lanteri of the Modelling School who 'had saved the credit of South Kensington for years past'. Crane introduced lectures and demonstrations in design and handicrafts, on enamelling by Alexander Fisher, on bookbinding by Cobden-Sanderson, on pottery by William Burton, and on book illustration and processes of reproduction by Joseph Pennell. A class in stained glass was established under J. S. Sparrow. However, Crane became impatient with the slow progress he could make under his chief, Major General Sir John Donnelly, and

resigned at the end of his first year of office, being succeeded by Augustus Spencer, the former head at Leicester.

That the Design School was formed at the Royal College in 1901 was due to Crane, for the scheme of reorganization was mainly his. By the Board of Education Act of 1899, the Science and Art Department had lost its autonomy by a merger with the new Board of Education. In the following year the Board formed the Council of Advice on Art to direct the nation's art education policies, the members appointed being Sir William Richmond for painting, Onslow Ford for sculpture, T. Graham Jackson for architecture, and Walter Crane for design. As a result of the deliberations of these four gentlemen, all members of the Art Workers' Guild, the Royal College was completely reorganized in 1901 into four schools: Architecture under Professor Beresford Pite, Painting under Professor Gerald Moira, Sculpture under Professor E. Lanteri, and Design under Professor W. R. Lethaby, again all members of the Art Workers' Guild. Craft classes were set up, including stained glass under Christopher Whall, pottery under Mr Lunn, metalwork under H. Wilson, etching, engraving and lithography under Frank Short, illuminating and calligraphy under Edward Johnston, embroidery and tapestry under Mrs Christie, and wood-carving and gesso under George Jack, nearly all members of the Art Workers' Guild.

WILLIAM RICHARD LETHABY (1857–1931) AND THE CENTRAL SCHOOL

The new professor at the Royal College had already established a great reputation as an arts and crafts teacher. The right hand man of Norman Shaw for twelve years, he was responsible for much of the work on New Scotland Yard. Lethaby, one of the five original founder members of the Art Workers' Guild, personified the first purpose of the guild, the association of architects with artists and craftsmen.

In 1896, when the London County Council established the Central School of Arts and Crafts in Upper Regent Street, Lethaby was appointed its first principal. In cramped rooms the architect gathered about himself a group of expert craftsmen-teachers, and thus founded a school which quickly became the largest centre for craft education in Britain. Pevsner tells us that in 1901, the year that Lethaby resigned, Hermann Muthesuis, the founder of the Werkbunds, called the Central 'probably the best organized contemporary art school'.[10] Fred V. Burridge, former head at Liverpool, took over from Lethaby, and in 1908 the School moved to its present site in Southampton Row. The facilities for craftwork were far superior to those at the Royal College. The first floor contained large workshops devoted to the work of the silversmith, goldsmith, and jeweller; and under the supervision of Douglas Cockerell the binder,

J. H. Mason the compositor, and Noel Rooke the illustrator, the book production was of a very high standard. Dress, needlework, and embroidery were popular classes, and one of the largest was for cabinet-work and furniture, which took up the third floor. The stained glass students were nearest to heaven, on the top floor.

The School still (1969) thrives in the Row under the direction of Michael Pattrick, but, rather sadly, its title is changed to the Central School of Art and Design. The School provides a Pre-Diploma course and the Dip.A.D. is taken in Fine Art under Morris Kestelman, in Graphic Design under Brian Yates, in Three Dimensional Design under A. Halliwell, G. Harding Green and Brian Wood, and in Textiles under Audrey Levy.

CRAFT EDUCATION FOR THE ARTISAN AT LAST

The Arts and Crafts Movement was aided by the Technical Instruction Act of 1889 which gave each local council power to form a Technical Instruction Committee, and to levy a penny rate for 'a more perfect system of Science and Art Teaching more especially for the artisan classes'. Here was the first real chance for local councils to provide classes for artisans relevant to local industries. Shortly afterwards annual 'Whiskey Money' was granted. This money resulted from a Government decision in 1890 to reduce the number of public houses. A tax was imposed on wines and spirits to compensate any dispossessed publicans, but opposition to this redress caused Arthur Acland to suggest that the annual funds raised from the new tax should be granted instead to local councils for technical instruction, thus, as R. L. Archer pointed out, 'technical education increased whenever drinking increased'.[11]

An inevitable outcome of this aid was that local subscribers were no longer willing to support the Schools of Art, with the beneficial result that the municipalities began to take entire responsibility, and from 1890 to 1901 many schools were renamed 'The ——— Municipal School of Art'. The final change to today's system came in 1903 when the Schools of Art were put in the charge of the local Education Committees under the provisions of the Education Act of 1902, which merged the duties of School Boards and Technical Instruction Committees.

The Birmingham city fathers were the keenest advocates of craft education; indeed, William Morris was president of their School of Art. In 1890 the Birmingham Council established a training school for jewellers and silversmiths – a revolutionary step, preceding Lethaby's efforts by six years. But Birmingham was exceptional; it was the London County Council Schools which gave the great impetus to the movement in the nineties and in the first decade of this century. Following the example set by Lethaby at the Central School, classes for a

multiplicity of handicrafts, from pottery to piano making, were established in the Schools of Art at Camberwell, Camden, Clapham, Hammersmith, Lambeth, Putney, South London, and Westminster, in the Battersea Polytechnic, and in the Shoreditch and Sir John Cass Technical Institutes.

A great stimulus was given to interest in artistic crafts in the nineties by Glasgow School of Art under the direction of Francis Newbery, the headmaster. Charles Rennie Mackintosh, Herbert McNair, and the Macdonald sisters, brilliant products of the School, excelled in Art Nouveau. Mackintosh was typical of the progressive architects of his day; like Lethaby, he was an architect/painter/decorator, his masterpiece being the Glasgow School itself (1898–1909).[12] Within this building Newbery assembled a gifted staff of designers – Anning Bell and Caley Robinson were respectively professors of decorative art and mural decoration; D. Y. Cameron was visiting master in etching; and Anne Macbeth, James Gray, and Wylie Davidson were in charge of needle-craft, pottery, and metalwork.

Charles Holme's revolutionary magazine *Studio* played a prominent part in exalting craftwork, including that of the Glasgow School, by constantly publishing photographs and articles on examples and exhibitions of the work of progressive designers. Many foreign periodicals followed its example, and thus the market for fine craftwork was increased. However, in British provincial art schools craftwork was not exalted, in spite of much lip-service; whereas design studios eventually appeared upstairs, crafts and trades were usually in the basement.

ART, CRAFT, AND TRADE SCHOOLS

The local School of Art, released from the control of the Science and Art Department, municipalized, and now directed by the Technical Instruction Committee of the local council, changed its character completely between 1900 and 1914. From being a drawing school it 'assumed the dual character of a school of art and a trade school', in the words of C. Stephenson, principal of Bradford School of Art at the time. Many of the managers of the Schools were directors of the chief industries in their localities and welcomed the fact that 'every School of Art is now free to develop its usefulness on the lines best suited to its local industry and other requirements', as R. B. Dawson, headmaster at Kidderminster, put it.[13]

The sociological structure of the student body at Schools of Art is clearly given in the annual syllabuses of the Leicester School during this period:

'The school gives tuition to three classes of students – Craftsmen: to make workmen better workmen. General Students: for the

cultivation of observation, appreciation, and knowledge of art. Teachers: to qualify those who are, or intend to become, teachers to give instruction in art.'

Training local worker-craftsmen was put first; indeed, in many schools it was regarded as the main object. B. J. Fletcher, principal at Leicester at the time, and a member of the Art Workers' Guild, stated:

'To help the trades mentioned, and to localize and develop skilled craftsmanship in any direction, is the main purpose of the school. It is with the worker-craftsmen and employers that the school is mainly concerned.'[14]

The provision for trade classes became very complex. From 1905 the Board of Education paid grants to Technical Instruction Committees for day technical classes to fill the gap between leaving Elementary Schools at thirteen and apprenticeship at sixteen years. Some of these classes in crafts were provided in Schools of Art, some in Technical Schools. The pupils, 'free admissions', attended five days a week free of charge, and during their second and third years received a maintenance grant of five and six shillings a week respectively. Gifted pupils sometimes stayed for six years in all, assisted by local scholarships. 'Such boys find little difficulty in obtaining employment in the City workshops,' wrote R. Catterson Smith, the Birmingham Director of Art Education, in 1912. From 1913 these day technical classes became Junior Technical Schools and Junior Art School Departments with a Board of Education capitation grant of £5 per head. These schools were in turn replaced by Technical High Schools, and in the rare case of Manchester, by a High School of Art.

Craftsmen over sixteen on day release, or at evening classes, attended Trade Classes in Schools of Art, or Technical Schools, or in separate Trade Schools. At Manchester the art institution was called the Municipal School of Art and School of Trade Craft Training right up to 1940. From 1915, at which date it became possible to graduate as a fully qualified art teacher only at a major School of Art, many of the small Schools were almost entirely preoccupied with trade and craft classes for house painting, sign writing, carpentry, bookbinding, wood-carving, plastering, and so on. Before his retirement in 1939, one of the last pronouncements of R. A. Dawson, the craft-hungry head at Manchester who controlled six branch schools, was the enigmatic promise that 'Solid Plastering would extend', but the demand for fine craftsmanship was diminishing, and the days of plaster board, prefabrication, adhesive lettering, and the paperback were nigh.

Though many principals urged that their primary purpose was the training of worker-craftsmen, the main structure was planned for the

general students, working for internal diplomas and the Board of Education's examinations. Following the example of the Royal College in 1901, local Schools had been divided into departments: Design, Modelling, and Painting, with an Architecture Department in some of the largest. The full-time staff was small from this date until the first world war, even in the major Schools – for example, in Manchester, under the Headmaster there were the Design Master, with one full-time assistant and six part-time craftsmen; the Modelling Master; the Painting Master with two female assistants, one for the antique, one for still life; and the Elementary Master for the lower school with a male assistant for geometrical drawing and a female for freehand. The head took the architecture lectures with the part-time assistance of an architect. Thus the total staff was ten full-time and seven part-time teachers. At Bradford during the same period there were four general art teachers and sixteen craftsmen-instructors.

'DESIGN' SCHOOLS AND APPLIED ART

After the head, the most important teacher was the Design Master, who supervised many of the general classes and all the craft classes. Although general students studying branches of design could choose to work in a craft class, Design consisted mainly of drawing and painting designs on paper, following the various categories of the Board of Education's examinations such as design in outline, natural forms from casts, and so on. Theory lectures were given in principles and history of styles by the design staff, and lectures on techniques of various industrial and craft processes by craftsmen and designers. Visits to factories and museums were included in Design courses, but the main aim was to produce the compleat designer on paper; for example, the views of A. H. Baxter, head of the School of Arts and Crafts of Battersea Polytechnic, reported in 1916, are typical.

'The aim of Mr Baxter is to produce a complete designer by the converging roads of draughtsmanship, the study of colour and the historic styles of ornament, and a complete understanding of the technical difficulties involved in the production of workable designs.'

The syllabus of the Design School at Manchester School of Art in 1924 was as follows:

I. INTERMEDIATE OR LOWER SCHOOL COURSES (DAY AND EVENING)
Essential subjects: *part 1*

1. Object and memory drawing – various media
2. Industrial design – principles, processes, materials, heraldry,

lettering with historic examples

3. Drawing from casts or natural forms – animals, birds, drapery etc.

Part 2 of the essential subjects course – the same, plus

4. History and styles

Optional subjects for parts 1 and 2

5. Practice of selected handicrafts, or specialized branches of design, or other additional practice of subjects of parts 1 or 2.

6. Anatomy – first course

7. Flower painting

II. ADVANCED OR UPPER SCHOOL CLASSES

Preliminary knowledge – principles, lettering, heraldry, costume, etc.

Drawing or modelling from historic ornament or from casts

Drawing from the antique or from life

Modelling natural forms

 a) figure details – head, hand, foot etc.

 b) animals, plants, birds

Architectural drawing

Although craft classes were the responsibility of the design masters, they were not integrated into design courses and were considered practical subjects of the craft sections, even the popular embroidery, costume, and decorative needlework classes. Design was art that could be applied to craftwork – 'applied art' – whilst craft was craft.

On 13 July 1931 the Board of Trade, dismayed by the recent slump in demand for British products, appointed a Committee under the chairmanship of Lord Gorell on the Production and Exhibition of Articles of Good Design and Everyday Use. The Gorell Report, presented on 16 March 1932, stated: 'It is common knowledge, we believe, that cooperation between Industry and Art Schools is not always so close as it should be', but the only suggestion of the Committee for art schools was that the existing system be strengthened by the services of first-rate practising artists and craftsmen, in part-time capacity. Following a recommendation of the Committee, the Board of Trade formed the Council of Art and Industry in January 1934 under the chairmanship of Frank Pick, but this Council, appointed 'to deal with questions affecting the relations between art and industry', thought of art and industry as separate. 'No effort should be spared by the art schools to impart improved taste and a wider understanding of art to the part-time pupils, who come to them from factory design rooms. . . . It is for the factory and not for the art school to impart to these part-time pupils the necessary experience of the methods and processes of manufacture. . . . When non-industrial

pupils are being trained whole-time at an art school to enter industry . . . the school must impart some understanding of industrial requirements and some technical knowledge,' declared a report of the Council.

CREATIVE DESIGNS IN CRAFTS

In 1887 a student of Macclesfield School of Art had delighted the examiners of the National Competition by submitting a woven fabric with his design. Only a few years earlier the headmaster at Halifax School of Art had pointed out to the examiners that the carpet designs which were winning awards were impracticable, and they had agreed that in future they would demand a portion 'put upon point or squared paper'; in addition, the headmaster at Nottingham had complained that 'a design for a hand-made flounce, to which a silver medal was awarded, was called by the examiners in their report "a machine-made lace curtain" '.

In spite of this official ignorance and neglect, craftwork had been designed and produced in various schools since the outset of public art education, and during the early part of this century, mainly due to the Arts and Crafts Movement, much was submitted for the National Competition; but since it was not compulsory for national examinations, many full-time students of Design did not devote their time to working in craft materials. A great change took place from 1935, when facilities were provided by the Board of Education for students to submit specimens of craftwork based on their examination designs. The response was such that the Board was encouraged to make the sending in of such 'testimonies of study' compulsory in the following year.

Following the Gorell Report's recommendations for closer coopera-tion between art schools and local industry, and for exhibition centres at schools, the Board of Education in 1933 issued Circulars 1431–2 which proposed a hierarchy of art classes, art schools, and art colleges, 'an ordered system of art instruction leading up to a regional Art College', the responsibility for organization being left to local authorities. The Schools at Leicester, Birmingham, Bradford, and Leeds were recognized as Regional Colleges of Art by the Board before the outbreak of the second world war arrested developments.

Immediately after the war more Regional Colleges were recognized and the examinations were changed to introduce more creative design in craft. The Board's Examination in Drawing, usually taken after two years' study, was replaced by the Ministry's Intermediate Examination in Arts and Crafts for which a student had to submit an actual work in a chosen craft, a small cast model of a human figure, a life drawing, a costumed life drawing, an anatomical drawing of a figure in action, a pictorial memory composition, and a general knowledge paper which

covered lettering, the history of architecture, the history of costume, and other subjects, which the student was required to illustrate from memory – a most searching examination requiring much knowledge and many basic skills. In the same year, 1946, the Ministry's National Diploma in Design replaced the Board's final examinations in Painting, or Modelling, or Industrial Design, or Pictorial Design. A student could now specialize in a particular industrial craft such as Fabric Printing, or Dress Design, or Pottery, for example; thus a design student pursued some form of practical craftwork throughout his whole four-year course.

ART TEACHER TRAINING

During the first world war Cole and Redgrave's system was finally eradicated. The National Competition went in 1915, and in 1913 the Board of Education's Drawing Examinations in Life, Antique, Memory and Knowledge, Architecture, Anatomy, and Perspective replaced the many categories of drawings which could be submitted piecemeal to the Board for Art Class Teacher's and Art Master's Certificates. The Board's Drawing Examinations were now taken after two years in the Intermediate or Lower Courses of a School of Art and, after a further two years in one of the Advanced or Upper School Courses, students were examined by the Board in Painting, or Pictorial Design, or Modelling, or Industrial Design, according to their chosen school. The possibility of such high qualifications in Design for Elementary School leavers of the artisan class had already been quashed in 1912 by Circular 786 of the Board, which ruled that only those who had enjoyed 'a good general education up to the age of sixteen or later' could take the advanced examinations. Full-time courses at Schools of Art, whether intentionally or not, were now designed to produce teachers, not practising designers.

The famous Rules 109 were introduced by the Board in 1913: they established the first national pedagogic course for art teachers, entitled the Principles of Teaching and School Management, and led to the Board of Education's Teaching Certificate for Teachers in Schools of Art. By the Rules, candidates were required to possess a School Certificate or its equivalent, to have passed advanced examinations in art, and to take a one-year course upon the methods of teaching art in various types of school and the relation of art to the community and industry. Leading Schools of Art were recognized as centres for the course, the London Day Training College serving the purpose in the capital. This certificate was renamed the Art Teacher's Diploma (A.T.D.) in 1933, and responsibility for the award was delegated to universities and colleges of art in 1952. From this date some Colleges of

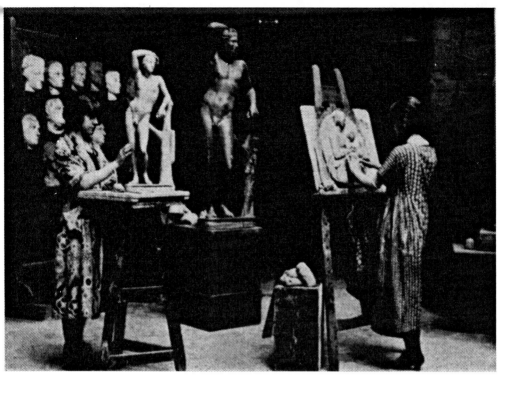

28. Modelling in the Twenties: from the antique
29. Cast models from the antique and from life

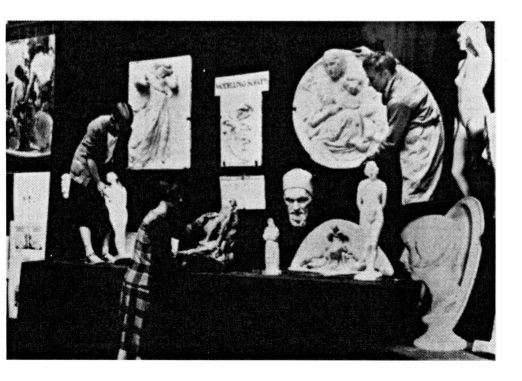

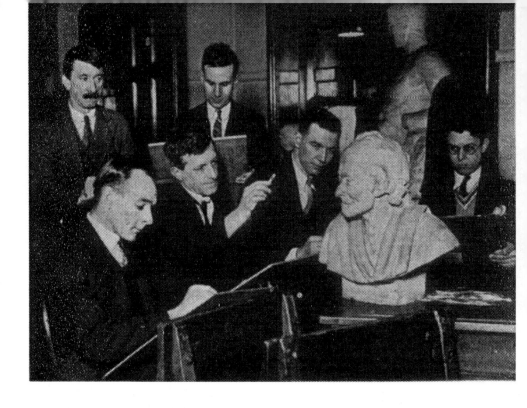

30. Misdirected part-timers measuring up Voltaire: Manchester
 (*c.* 1930)
31. Sketching animals: an important part of design courses in the
 thirties and early forties

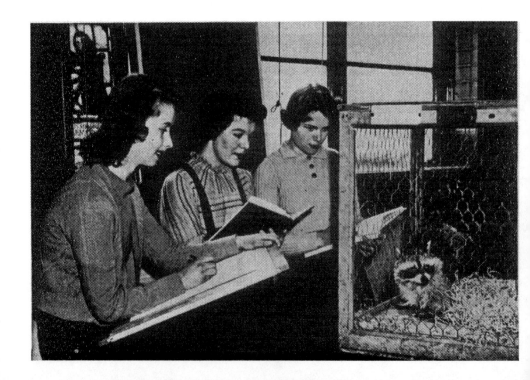

Art continued to award their own A.T.D., but the diploma was subject to passing the written examinations for the Art Teacher's Certificate (A.T.C.) of the local university's school of education.

Since the commencement of Diploma in Art and Design courses in 1962, colleges have gradually abandoned the A.T.D. type of course with its heavy bias towards crafts, and have encouraged more concentration on educational studies for university certificates in education.

ARTS AND CRAFTS IN THE SCHOOLS

The Arts and Crafts Movement did not penetrate general education for children for about forty years after its outset, that is if we consider crafts from the artistic standpoint, as inseparable from art. Craft, derived from the Old English *cræft*, meaning power and skill, can be interpreted in many ways, and in the schools the subject has been known, according to the outlook of the day, as Manual Training, Handwork, Handicrafts, and Arts and Crafts.

The earliest purpose of craft instruction was for useful industrial application. If we exclude needlework, taught to girls from Anglo-Saxon times, it could be said that craft teaching commenced in British schools in the eighteenth century. The schools concerned were charitable institutions, 'schools of industry' for pauper children, where carpentry, cobbling, and tailoring were taught to boys, spinning, needlework, and cooking to girls, their products being sold to maintain and feed them. John Locke in his essay 'Working Schools' had recommended such schools in every parish, and William Pitt advocated compulsory attendance for paupers, but the schools did not become general; in fact, by 1803 only one out of nine children on parish relief was receiving any education. Nor did craft training spread quickly to the better types of school, despite Locke's advice that even a young gentleman should *'learn a Trade, a Manual Trade*; nay, two, or three, but one more particularly'.[15] The handicrafts at Rowland Hill's school at Tottenham, Edward Thring's workshops at Uppingham, and the recreational craft classes at Bedford Grammar were isolated examples. Although a few Training Colleges, such as that at Chester, had organized craft classes for their students as early as the eighteen-fifties, it was not until the late eighties that craft was accepted in the public day schools.

MANUAL TRAINING CENTRES

In 1885 a woodwork class was set up in the playground sheds of Beethoven Street School, Paddington, by the school keeper, J. Chenoweth. Such instruction for elementary school children had been in existence for a short time in Manchester and Birmingham, but the Paddington venture was the first to bear fruit. Neither the Education

Department nor the Science and Art Department allowed a grant for such a class, so a Joint Committee of the City and Guilds of London Institute, of the Livery Companies, and of the London School Board was formed to establish workshop centres in Manual Training to serve children in the London elementaries. Provision for training teachers had already been organized by the City and Guilds, who set up the first Normal Manual Class in 1886. Final Government approval, in the form of finance, came in 1890, following the Report of the Cross Commission (1888) which affirmed that 'it is the subject of very general regret that boys from seven years old should lose all the benefit of this training [manual work] and be limited to the end of their school life to a mere literary education'. A grant of six shillings per scholar was paid by the Science and Art Department, and soon thousands of children were occupied at local centres making racks for tooth brushes, letters, keys, newspapers, pens, and books, and sawing common dovetails under the supervision of trained craftsmen. A teaching qualification was available from 1892 when the City and Guilds introduced Manual Training Teacher's Certificates.

Manual Training Centres usually served only selected older children from the public elementaries, concentrating upon simple industrial woodwork (rarely metalwork), the sole object being to encourage precision of hand and eye in the future artisan. However, a more educational approach had been conceived in Scandinavia.

FROEBEL, SLOYD, AND EDUCATIONAL HANDWORK

Children under seven had carried out handwork in British schools in the form of 'occupations' from 1854, when teachers had been able to study constructions of Froebelian 'gifts' or occupation materials made by the pupils of Bertha Ronge, shown in the Society of Arts' education exhibition. Unfortunately Froebel's concept of kindergarten education through activities was not fully understood at the time and 'occupations' were often used as a school handwork subject by British infant teachers, rather than as a complete system of education. Children carried out block-building, stick-laying, paper weaving and folding, paper cutting, pasteboard modelling, pea work, and net drawing on squared slates as a mechanical craft routine, as Dickens had feared they might at the outset.

The word *sloyd* was derived from an Icelandic term for creative handwork and was adopted for educational purposes by Uno Cygnaeus, who introduced the subject into Finnish schools.[16] Cygnaeus, a follower of Pestalozzi and Froebel, believed that handwork must be truly educational, that it should not stop with Froebelian occupations, but should carry on throughout education, instilling a life-long love of

practical work. Sloyd commenced with the simplest, most natural way of carrying out craftwork (for example, from carving with a knife in woodwork), and was intended to develop aesthetic feeling for form and material; in this way it differed from Manual Training. The boys and girls were expected to produce objects which interested them for their own use. Another fundamental difference was that the sloyd teacher was a teacher first, not a craftsman turned instructor.

The high reputation of sloyd was established by Otto Saloman with the woodwork produced under his supervision at his uncle's school at Naas, Sweden. At this school, founded in 1872 for local boys and girls, Saloman organized practical courses for teachers during which they made simple objects in wood for their own use. During the eighties and nineties thousands of teachers, including a considerable British contingent, enjoyed Saloman's courses, and carried their products triumphantly home. A British Sloyd Association was founded, but in spite of initial enthusiasm, especially among female teachers, the sloyd system of woodwork did not replace, nor even modify, mechanical Manual Training for boys. Various reasons were given for its rejection, such as the superiority of a chisel to a knife, the need for always making a measured drawing before working in wood, the use of glass paper in sloyd, above all the accuracy of the British system which restricted the boys to forms based on rectangles. 'Wood-sloyd' included curved forms as equally important. Another argument against sloyd was the time taken to complete the course, but this was not really valid for much sloyd can be done in the child's own time. Scandinavian boys are still encouraged to use the axe and knife in the sloyd tradition, and many have developed a natural feeling for various woods which is reflected in the simple and subtle forms of their fine furniture.

Though sloyd was rejected in Britain for Manual Training in woodwork and metalwork, it was taken up enthusiastically by progressive teachers of educational handwork, particularly females, and in 1897 the Sloyd Association was merged with the Educational Handwork Association. Such progressive teachers, especially Froebelians, were dissatisfied with the practice of sending selected children for a weekly lesson to Manual Training Centres to work under the supervision of a craftsman. J. A. Green, Professor of Education at Sheffield, typified their doubts when he complained of handwork 'conducted in centres the control of which is not in the hands of the ordinary teaching staff. In such a position it is apt to remain a mere training in certain manual dexterities, selected from the standpoint of industry.'[17] The growing number of adolescents in the Elementary and Central Schools demanded a more educational and less vocational approach. Up to 1911 most children were educated either at an Elementary or a Grammar School, but from that year Central

Schools were established to take the place of the higher Elementaries which took children up to fifteen years of age.

Central Schools were intended to provide a general education for boys and girls about to enter into trades, industries, and domestic duties, and the workrooms in them gave a great fillip to practical work. The Board of Education backed the educational approach and a continuation of the Educational Handwork already practised with juniors was introduced. Two contemporary experts, J. Martin and C. Manley (the latter a pupil of Saloman), described it in their book *Educational Handwork* (1912) as 'a method of training the activities of the child, in order to simplify the approach to such subjects as Arithmetic, Mensuration, Geometry, and Drawing'.[18] There were now three categories of craftwork for seniors: Educational Handwork for the production of apparatus and models for school subjects, usually done in the classrooms; handicrafts such as bookbinding, pottery, basketry, and needlework, sometimes done in the school workroom, sometimes in the classrooms; and lastly wood and metal work done in the workroom, at a centre, or at a junior department of an art or technical school. The scope of practical work widened so much that it soon included practical field work in geography, history, surveying, and so on, and with the Education Act of 1918 the Board of Education approved the title of Practical Instruction, making it an integral part of the school curriculum.

HADOW: SCHOOL ARTS AND CRAFTS COMBINE

The teacher who supervised the Practical Instruction Rooms in the new Central and Senior Schools usually possessed a certificate in Manual Training or Educational Handwork, neither of which demanded a knowledge of art, and although the educational models were often excellent, the handicraft side of the work usually consisted of ugly imitations of existing objects. By the twenties the authorities were becoming design-conscious, owing to the well-organized lectures and exhibitions of the Design and Industries Association, and seriously alarmed by the separation of drawing, design, and handicrafts in the schools. The Hadow Report on the education of the adolescent (1926), which was concerned with the establishment of Modern Schools with a leaving age of fifteen, stressed 'the training of boys and girls to delight in pursuits and rejoice in accomplishments – work in music and art; work in wood and metals'. Referring to Practical Instruction, the Report affirmed: 'In all such courses emphasis should be laid on the artistic aspect of the work, which should be closely linked up with the courses in drawing and applied art.' The Report also urged the importance of 'mastery of one or more of the simple arts and crafts . . . The art room should be regarded as a workshop, sometimes used for class instruction,

at other times for groups of pupils doing different kinds of work according to their tastes and abilities.' It was suggested that practical work for girls should move away from the narrow concept of useful needlework and should practise 'some of the various artistic crafts, such as leatherwork, bookbinding, basketry, the staining and painting of white wood, stencilling, and where conditions are suitable, pottery, enamelling, and weaving'. Two years after the Report, the City and Guilds added 'Arts – Crafts' to its examinations list. The Arts and Crafts Movement was at last to penetrate general education, some thirty years after its introduction into Schools of Art.

The most significant suggestion of the Hadow Report was that, besides the formal class instruction for the recognized art course of object drawing, memory drawing, geometrical and mechanical drawing, and design, art teachers were expected to supervise group work in artistic crafts. Previously most of them had restricted their pupils to the drawing subjects listed above and to 'Design', which consisted of space-filling, drawing out patterns, and occasionally modelling motifs in clay for repoussé work, carving, or moulding.

Practical craftwork was not taken up generally by art teachers after the Hadow Report. Those from Schools of Art had not been made to produce craftwork during their training and were loth to stoop to it now. A teacher of the thirties informed me: 'Art masters did things on paper – scrolls, cartouches, bookplates, repeats, stencilling, silhouettes, and the like. Design was on paper.' It was mainly in the girls' classes in Senior and Central Schools that artistic crafts were practised, especially in London from the thirties onwards, with the encouragement of R. R. Tomlinson; even then it was often the contribution of needlework and handwork teachers, and the centre of the movement was not an art school, but the London Day Training College. The art school graduates teaching in grammar schools avoided craftwork, their duty as they saw it being to get pupils through School Certificate drawing examinations.

The art/craft teacher was not very common until after the second world war. From 1948 all graduates of Schools of Art had produced practical craftwork during their training, and from the same date artistic crafts were encouraged in the grammar school by the introduction of practical crafts into the examinations for the Cambridge School Certificate. The London, the Southern, the Welsh, and the Associated Boards for the General Certificate of Education now run such examinations and thousands of children have benefited. The Certificate of Secondary Education, established in 1963, with teacher-control of the syllabus content, has also made possible a concentration upon creative crafts if the art teacher so desires.

THE IDEAS OF THE ART-SOCIALISTS

Socialism was the political creed of Morris and his closest associates, Burne-Jones, Crane, Emery Walker, and Cobden Sanderson, romantic Socialism based upon the ideal mediaeval state as conceived by Pugin and Ruskin. The machine had no place in this Utopia: ideally every object should be made by a new public of artist-workmen, 'by the people, for the people, as a joy for the maker and user'; for the great works of yore at South Kensington were works of 'common fellows', Morris assured the students of Birmingham School of Art. Rejecting the industrial society of his day and longing for revolution and reversal, he had no plans for introducing craftwork into existing educational institutions. His lack of interest in creative craftwork or design in general education is displayed in his evidence before the Royal Commission on Technical Instruction, given at the age of fifty.

> 1597 [*Chairman*] Are there any departures from the present curriculum of the provincial schools of art, that you would consider essential so far as preliminary training goes?
> [*Morris*] I think not. I do not know with any degree of nicety what the training is, but I think not.
> 1635 Are you acquainted with the weaving schools on the Continent, and which are now being established in this country?
> No, I do not know them. I have heard of them with a great deal of interest.
> 1641 Do you think that that [weaving] would be better taught him in the art school than in the factory?
> I am not sure whether it would not be difficult to teach it in the school.

Morris's support for the exacting South Kensington Course of Instruction, the products of which he had marked as examiner for the National Competition, can be deduced from these further extracts:

> 'I think a man who is going to be a designer wants to be taught to draw thoroughly. In all these manufacturing towns there are departmental schools of art and one may assume that a man goes through his course there, which, as far as I can understand, is a good course on the whole . . . drawing should be taught more or less from drawing the human figure, because it gives a standard of correctness.'

His other recommendations also followed established lines, such as the need for museums of historic examples, or drawings or prints of them, available to students. The only original idea Morris put forward in evidence was a retort to the *dreadful* suggestion that an actual

industrial machine, a Jacquard loom, might be supplied to an art school. Morris replied that a student 'ought to be able to weave himself', meaning on the old hand-and-foot loom.

It was the architect Charles Robert Ashbee who attempted to construct a society of art workmen on the lines advocated by Morris. In 1884 Toynbee Hall had been opened to commemorate the university extension lectures which Arnold Toynbee had given to the workmen of Whitechapel. Ashbee had lectured in the settlement, and in 1888 he established nearby the Guild and School of Handicrafts, a guild for craftsmen and the training of apprentices. The East End was hardly suitable for such a mediaeval society and in 1902 the Guild moved to Chipping Campden, where smallholdings were formed to support the community. Ashbee found employment for many of the best trainees of the Guild as teachers in the technical and art schools he despised, thus the Arts and Crafts Movement was stimulated in educational institutions and the Guild weakened.

SHOULD WE STOP TEACHING ART?

Ashbee argued that public money was wasted on art schools, and should rather be spent on setting up numerous craft workshops. 'The Craft cannot be learned in the school,' he wrote, 'the craft can only be learned in the life of the workman in the workshop . . . real learning of the craft comes in the life of the workman, when the first workshops tests begin.'

In 1911 the architect published a blistering attack on art schools, *Should We Stop Teaching Art?* In the same year the Departmental Committee on the Royal College of Art had reported, and Ashbee, quoting Appendix IV of the publication, stated: 'In a period of ten years 459 students have been trained at the Royal College of Art, out of those only 32 have made the practice of Art in any form their livelihood . . .' Ashbee added: 'the English art schools, of which the Royal College is the chief, have resulted, so far, in the creation of a certain type of official . . . perpetuation of a type of teacher, the Art School Master, who is divorced from the actual conditions of life and often teaches what he does not practise . . . The Society of Art School Masters ask, among other things for letters after their names and robes to wear on their backs.'[19]

Walter Crane, who, unlike Morris and Ashbee, was keenly interested in the Schools of Art, made this defence in a letter to *The Times*:

> 'The recent Departmental Committee on the Art Schools was mainly composed of men more or less hostile to the Government Art Schools and the Royal College of Art, but, though the latter especially was accused of deficiency in practical relationship to the trade of the country, representatives of industrial design are

conspicuous by their absence on the new Standing Committee with the natural result that the new syllabus is more academic than ever.'[20]

However, Crane himself was deficient in interest in the main function of industrial design, the provision of fine but cheap machine products for the people.

MORRIS, CRANE, AND APPLIED ART

It is a great mistake to believe, as many have done, that Morris, because he was a practical craftsman, fully understood the concept that design could evolve directly from experience and use of materials, in the sense that Gropius did. Morris believed that the only way for students to produce correctly the tradition-based designs he loved was through the old handcraft processes, and by study of historic designs in the museums he recommended. In his opinion, and in the opinion of his disciples, such as Crane and Lewis Day, there was a correct type of 'applied art' to suit each craft material, this study of 'history and styles' was an essential part of a Design course in an art school. Morris once defined design as 'mastery of style'. As Herbert Read wrote, the influence of Morris 'was mainly in the sphere of applied ornament and decoration, and did not touch the more fundamental problems of form'. His disciple Crane actually used the words 'applied art' in his writings, and, though he later substituted 'design', it was 'applied art' that he and Morris initiated in the Design Schools of Schools of Art, not true design. The separation in Crane's mind shows in an article in the *Art Workers Quarterly*. 'I have spoken chiefly of design,' he wrote, 'from the point of view of surface decoration – but from the point of view of construction good design may, of course, be quite independent of ornament.'[21]

'It was all Morris and Crane,' I was assured by J. S. Willock, for many years head of the Design School at Manchester; and as far as theory went it was all Walter Crane, since, as Pevsner stressed, Morris never believed in theories on paper.

Crane first achieved a reputation as an art educationist in 1892 with *The Claims of Decorative Art*, a book which discredited the 'scientific' principles of Redgrave and Owen Jones, the preoccupation with historic ornament advocated by Wornum, indeed the whole 'cast iron system of education' of the Science and Art Department. A few passages will suffice to give his viewpoint.

> 'Originality is crushed by the weight of authority, is confounded and abashed by the mass of examples . . . It is on the unquenchable spontaneity of this [native art] instinct that I should rely on to give birth to new forms of art, even were all types and conditions

of the art of the past destroyed. After a course of examination at South Kensington of vast multitudes of designs in any and every style under the sun, I could almost bear such a catastrophe with equanimity . . . I hold that the true root and basis of all art lies in the handicrafts, and that artistic impulse and invention weakens as it loses its close connection and intimate relationship with them . . . There is of course no absolute determination of rules for all cases. There is nothing absolute in art. *Art is not science.*'[22]

At this time Crane had, like Morris and Ashbee, little interest in art schools, 'because,' he wrote, 'I believe that the only training worth having in the arts must be in the workshop, as of old.' His interest in the teaching of design in art schools was to come shortly afterwards, when he could hardly maintain indifference in face of the delight art masters took in his books.

The Bases of Design, published in 1898, was an academic study of the various influences which had affected design such as architecture, utility, material, method, conditions, climate, race, symbols, and so on. It had a broad outlook, unlike the previous works on Ornament, but the whole foundation of the book was typical of the attitude which produced the art school subject, Design: it was something one could learn from historic studies. The art school masters eagerly took it up as a set book and a second edition was soon in demand. *Line and Form* followed in 1900, a progressive work, moving away from the South Kensington concept of principles derived from historic works towards the elements of art, such as outline, silhouette, movement, texture, rhythm, counterbalance, quantities, contrast, and so on. Blackboard diagrams based upon the illustrations in this book dominated the Design Rooms of Schools of Art for the next thirty years.[23]

The paradox which caused the Arts and Crafts Movement to check progress in design education in Britain within this same period was the snobbery of deeming handcrafts superior to machine products. Morris, Crane, and their associates, in claiming this superiority, were guilty of the very sin they, as art-socialists, attributed to the High Art protagonists – the separation of artefacts into grades of merit. The snobbery of classicism was replaced by the snobbery of mediaevalism. Even the liberal-minded Lethaby, at so late a date as 1922, wrote that 'although a machine-made thing can never be a work of art in the proper sense, there is no reason why it should not be good in a secondary order'. Such snobbery produced a generation of 'hermit-craftsmen', doomed to live precariously on wealthy patrons, for none of the workmen Morris loved could afford their products; in addition it produced an unsuitable art training and a hostile attitude to industrial and commercial art lasting up

to the forties. Herbert Read, writing of the period, described an art school as a place 'where industrial design is not merely segregated, but barely tolerated'.[24]

By 1911 the dangers of divorce from machine industry had become apparent to C. R. Ashbee, due to his contacts with the industrial designers of the Art Nouveau and German Werkbund movements. 'Modern civilization rests on machinery,' he wrote, 'and no system for the teaching of art can be sound that does not recognize this.'[25] A further drawback of the Arts and Crafts Movement was the insistence upon tradition-based styles, and as a result of this, and of the rejection of the machine, by 1914 the initiative had been lost to Germany. Lethaby wrote that in England there had been 'a timid reaction and the re-emergence of the catalogued styles. German advances have been founded on the English Arts and Crafts.'[26]

THE WERKBUNDS

The first real integration of art education with machine production commenced in 1919 at the Weimar Bauhaus under the direction of Walter Gropius, an adherent of the Deutscher Werkbund (see below). The Germans were enthusiastic enough about the Arts and Crafts Movement to set up *kunstgewerbeschulen*, but, like the Americans, they were far too progressive and practical to indulge a mediaeval type of artist-craftsman, isolated from the mass of society; thus, whereas British design education in the early decades of this century was dominated by Morris and Crane, two artist-craftsmen, the initiative in Germany and Belgium came from the architect/teachers, Wagner, Loos, Hoffman, Muthesius, van de Velde, Behrens and Gropius.

An attempt was made for coordination in the professional field in 1907, when the Deutscher Werkbund was founded by Hermann Muthesius (1861–1927), superintendent of the Prussian Board of Trade's Schools of Arts and Crafts. Austrian and Swiss Werkbunds followed in 1910 and 1913 respectively, and in 1915 the Design and Industries Association was established in Britain by Lethaby and Clutton Brock. Membership of these associations was open to designers, architects, craftsmen, manufacturers, and tradesmen, the main intention being cooperation to produce works of high quality. Muthesius and Behrens, the leaders in Germany, were particularly keen on cooperation guided by utility, standardization, appropriate use of materials, and modern techniques; but many of the persons involved, such as van de Velde in Belgium and Germany, and Lethaby and Image in England, were too much admirers of individualism and refined craftsmanship to work towards a unified system of designing based on the machine and functional construction. A new form of art education was needed.

THE BAUHAUS

In 1915, during his war service, Walter Gropius, formerly assistant to Behrens, was summoned to an interview by the Grand Duke of Sachsen-Weimar-Eisenach who was seeking a successor for Henri van de Velde as principal of the Grand Ducal School of Arts and Crafts. The Belgian had recommended Gropius for the position, and during his remaining service in the German army the young architect found time to consider the amalgamation of adult art education in Weimar. After demobilization in 1918 Gropius was given charge of this project and appointed director of the School of Arts and Crafts and the School of Fine Art; in the following year these were combined as the Staatliches Bauhaus Weimar, Gropius being confirmed as director on 1 April 1919 by the Republican Government of Weimar.

Bau is the German noun for building, in the sense of construction, thus *baugruppe* means a construction unit, *baustab* a construction staff, so the closest translation of Bauhaus into English would be construction-house. The course which Gropius established there was the most purposeful ever practised in art education, planned to foster creativity, analysis and appreciation of art, craftsmanship, and technology in order to produce the artist/craftsman/industrial designer. After a six month's preliminary instruction (*Vorlehre*) on theory of form together with experiments with materials, each student, having signed articles of apprenticeship, served three years in a Bauhaus workshop receiving craft instruction (*Werklehre*) and instruction in form (*Formlehre*). At first each workshop was supervised by both a master-craftsman and an artist, but later at Dessau, when the system had produced its own instructors, each workshop was commanded by an artist-craftsman. At the end of this course a student had to pass his journeyman's diploma in the presence of master-craftsmen. Talented pupils could attempt the more difficult Bauhaus apprenticeship examination, and, if particularly promising, were accepted for the third part of the course, structural instruction (*Baulehre*), which consisted of gaining experience of additional crafts in the workshops, working on building sites, and experimenting in the Bauhaus Research Station and Design Studio. Successful graduates were awarded a master builder's diploma.

The translation of *lehre* as instruction is a little misleading; the word also means apprenticeship, and it should be understood in this sense, rather than as formal instruction. Gropius conceived the workshop as a laboratory for industry in which students worked as a team learning from the masters' and each other's experiments. Crafts were undertaken, proceeding from simple tools to machinery, from the viewpoint of integration with industry and architecture, and the academic concepts of painting and sculpture were banished. Painting was classified under

Colour in the Werklehre, sculpture under Stone, and both were intended to be architectonic. The relevant workshop for painting was the Wall-Painting Workshop: 'the wall itself had to be rediscovered'. Formal and decorative murals, posters, abstract painting, and colour experiments were encouraged. Much drawing and painting were done during the preliminary course and in the Formlehre section of the apprentice courses and in the Stage Workshop.

During his directorship Gropius assembled a brilliant staff, including Johannes Itten (Preliminary Course), Josef Albers (glass and furniture), Laszlo Moholy-Nagy (metal), Marcel Breuer (furniture), Herbert Bayer (typography), Oskar Schlemmer (stage and wall-painting), Gerhard Marcks (pottery), Adolf and Hannes Meyer (architecture), and the world-famous painters Wassily Kandinsky, Lyonel Feininger, and Paul Klee of the Blaue Reiter (Blue Rider) group.

With the rise of the Peoples Party in Weimar the Bauhaus became suspect as the centre of 'Art-Bolshevism'. Adequate finance was withheld, so Gropius took advantage in 1925 of an invitation from Fritz Hesse, the mayor of Dessau, to accommodate the school in that town. The new Bauhaus designed by Gropius was opened in 1926, and consisted of a studio wing with a dining hall, theatre, and studio apartments for resident students, a workshop wing, and a technical wing. It was an outstanding building from an aesthetic viewpoint, and more important, it was planned for a community, a community which justified itself by products which revolutionized the Western concept of industrial design. It is not possible in this book to give an account of the tubular steel chairs, the universal type, the tubular and globe light fittings and other articles which made the school's reputation.*

In 1928 Gropius resigned, owing to increasing commitments in his architectural practice, and Hannes Meyer succeeded as director until 1930, when he in turn was followed by Mies van der Rohe until 1933, when the Nazi government closed the school. Most of the leading teachers sought refuge in the United States and introduced Bauhaus concepts into American art and architecture institutions, Gropius and Breuer at Harvard, Moholy-Nagy and van der Rohe at Chicago, and Albers at Black Mountain College, North Carolina, and Yale. Bayer and Feininger also crossed to the United States.

A SOCIOLOGICAL CONCEPT OF ART EDUCATION

The basis of Gropius's concept of art education is sociological. The frequent use in his writings of such words as collaboration, coordination,

* Readers should refer to *Bauhaus*, by Herbert Bayer and Walter and Ise Gropius, published by Charles Brandford, Boston, Mass., 1959.

combination, community, integration, interrelation, and standardization leaves no doubt on this score. Whereas Morris desired a craftsman's culture, Gropius not only wished to tear down the barriers between art, craft, architecture, industry, and society, but also the barriers between the arts in art education. Morris's concept of a career in craftwork was eradicated; Bauhaus students achieved mastery of a craft to prepare for designing for an industrial society, and many of the models made in the school's 'industrial laboratories' or workshops were successfully mass-produced by industrial firms. In each workshop the emphasis was on the material being used, not on the traditional craft, and thus barriers were broken; for example, sheet tin and paper were used plastically, steel used for furniture, and textiles for pictorial compositions. Students, though they were not as fully conscious of the terms as we are today, began to think in terms of two and three dimensions. The modern movement towards integration of the visual arts, advocated today by Victor Pasmore, started at the Bauhaus.

Gilbert Herbert's work, *The Synthetic Vision of Walter Gropius*,[27] stresses the way Gropius wished to combine the arts; above all he desired the collaboration of teams of creative designers under 'co-ordinators' or master builders, complete or 'total building' in fact. He did not intend standardized works to be produced in a certain style for congruity, but regarded standardization and prefabrication as welcome necessities to abolish physical toil. He urged adventurous variation in the use of 'norms'.

The most creative and exciting staff and student body ever assembled in an art institution give the lie to any suggestion that there was anything uniform or dull in Gropius's concept of integration with industry. The only views he would not tolerate were those which separated the artist from contemporary society, lest they produced an 'art proletariat lulled into a dream of genius and enmeshed in artistic conceit – destined to social misery – condemned to a life of fruitless artistic activity – social drones, useless, by virtue of their schooling, in the productive life of the nation'; thus he rejected a fantastic Bauhaus school uniform made by a student under Itten's influence because, he thought, an artist should dress as modern society dressed. Itten's emphasis on 'inward-directed thought', rather than outward-directed research, also disturbed Gropius.[28]

The Bauhaus plan of instruction was never fully realized owing to lack of public money to finance an architecture school for advanced structural instruction; nevertheless, the Bauhaus has been the most influential art institution of this century. Gropius's philosophy of art education is given fully in the book *Bauhaus* (see footnote, page 316), and in *The New Architecture* by Gropius (Faber and Faber, 1956).

Sources

1. VITRUVIUS, MARCUS *Ten Books on Architecture* Translated Morgan, Morris Hicky, and Howard, Andrew, edited Warren, H. L. (1914) Dover Publications, New York, and Constable, London, 1960 (Book I, Chapter 2.2)
2. MASSE, H. J. *Art Workers' Guild* Shakespeare Head Press, Oxford, 1935 (p. 3)
3. Ibid. (p. 7)
4. Ibid. (p. 13)
5. CRANE, W. *An Artist's Reminiscences* Methuen, London, 1907 (p. 300)
6. *Art Journal*, 1884 (p. 310)
7. CRANE, W. *An Artist's Reminiscences* Methuen, London, 1907 (pp. 307–8)
8. *Art Worker's Quarterly*, 1903 (No. 6, Vol. II, p. 91)
9. CRANE, W. *An Artist's Reminiscences* Methuen, London, 1907 (p. 457)
10. PEVSNER, NIKOLAUS *Academies of Art* Cambridge University Press, 1940
11. ARCHER, R. L. *Secondary Education in the Nineteenth Century* Cambridge University Press, 1921 (p. 308)
12. BLISS, DOUGLAS PERCY *Charles Rennie Mackintosh and the Glasgow School of Art* Glasgow School of Art, 1961
13. HOLME, CHARLES (editor) *Arts and Crafts* Studio, London, 1916 (p. 101)
14. Ibid. (p. 105)
15. *Report* of the Society for Bettering the Condition and Increasing the Comfort of the Poor W. Bulmer & Co., London, 1809 (p. 307 note); LOCKE, JOHN 'Some Thoughts concerning Education' In *Educational Writings of John Locke* Edited Adamson, J. W. Cambridge University Press, 1922 (p. 169)
16. TOMLINSON, R. R. *Crafts for Children* Studio, London, 1935 (p. 78)
17. PICKERING, G., and ROBINSON, J. *Handwork and Geography* Pitman, London, c. 1920 (p. 111)
18. MARTIN, J., and MANLEY, C. *Educational Handwork* Blackie, London, 1912 (p. viii)
19. ASHBEE, C. R. *Should we Stop Teaching Art?* Batsford, London, 1911 (pp. 4, 15, 16, 21)
20. BROWN, FRANK P. *South Kensington and its Art Training* Longmans, Green, London, 1912 (p. 21)
21. *Art Workers' Quarterly*, 1903 (No. 5, Vol. II, p. 2)
22. CRANE, W. *The Claims of Decorative Art* Lawrence & Bullen, London, 1892, (pp. 3, 8, 33, 77, 95, 121, 186)
23. CRANE, W. *The Bases of Design* G. Bell, London, 1898; and CRANE, W. *Line and Form* G. Bell, London, 1900
24. READ, SIR HERBERT *Art and Industry* (1934) Faber & Faber, London, fourth edition 1956 (p. 190)

25. ASHBEE, C. R. *Should we Stop Teaching Art?* Batsford, London, 1911 (p. 4)
26. LETHABY, W. R. *Form in Civilization* Oxford University Press, 1922 (pp. 46, 96, 211); also PEVSNER, NIKOLAUS *Pioneers of Modern Design* (1936) Penguin Books, Harmondsworth, 1960 (p. 220, note 33)
27. HERBERT, GILBERT 'The Synthetic Vision of Walter Gropius' *South African Architectural Record*, December 1955
28. GROPIUS, W. *Idee und Aufbau des Staatlichen Bauhauses Weimar* Bauhaus-verlag, Munich, 1923, translated in *Bauhaus 1919–1928*, edited Bayer, Herbert, and Gropius, Walter and Ise C. T. Branford, Boston, 1959 (pp. 20–1); ITTEN, JOHANNES *Design and Form* Thames and Hudson, London, 1964 (p. 11)

18

The Recognition of Child Art

Three factors contributed to the recognition of child art, namely studies in psychology, the growth of interest in primitive art, and the appreciation of the characteristics of modern art. These developments provided advocates of child art education with solid bases for reasoned argument and comparison.

The concept that art education for the child should differ from that for adolescents and adults stemmed from Rousseau's scheme of education in *Emile* (1762), which consisted of four consecutive stages based on the child's original nature or inborn predispositions. In the second or childhood stage he instructed: 'Exercise the limbs, senses, and organs, which are the instruments of intellect.' There should be no formal teaching, only learning by directed activities; for example, visual perception should be developed by exercises in judging distance, drawing, practical geometry, and ball games. Rousseau's dislike of drawing masters has been mentioned earlier in the description of Heath Wilson's concept of art education. He reasoned that a child must learn from nature, not from adult art. 'Childhood has its own way of seeing thinking and feeling,' he wrote.

Rousseau arrived at these conclusions from his belief in the rightness of nature. Nature is rational, he argued, therefore to live according to nature is rational. All the ills of society are due to departure from a state of nature, Rousseau asserted in his *Discours sur les arts et sciences* (1750), and all formal education is a social contrivance contrary to nature, he informed Madame d'Epinay (1756). 'God makes all things good, man meddles with them and they become evil,' are the opening words of *Emile*.

Rousseau's faith in the divine endowment of nature was later to be completely adopted by Cizek and Viola, who were both very concerned with preserving natural Child Art from any adult influence. Many Continental educators, such as Basedow, Pestalozzi and Froebel, adopted Rousseau's view that the child needs a special type of education suited to its nature and development, but it was Herbert Spencer who brought this concept home to the British.

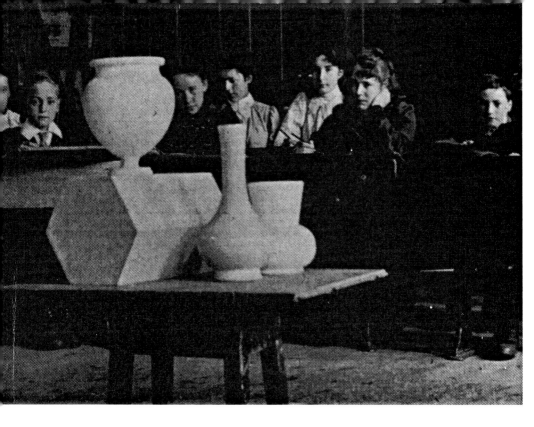

32. Drawing from set models or 'type solids': Birmingham (*c.* 1900)
33. Teacher training—drawing from daffodils: Manchester (*c.* 1910)

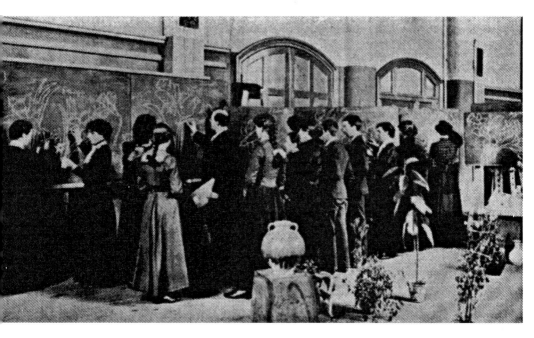

34 and 35. Lino prints by children of Cizek's Juvenile Art
Class
From 'The Child as Artist' by Francesca Wilson

HERBERT SPENCER (1820–1903)

Two contrasting schools of Utilitarian thought influenced education in the nineteenth century. The 'no–nonsense' school, which gave the Utilitarians a bad name, believed that the child was an energetic machine ready to be stuffed with facts, and to be trained in useful drawing, or useful anything else, in mechanical steps; of this school were Lowe, Cole, and Redgrave. Their step-by-step theories were abstract, paying no heed to the nature of the child. The other school of thought followed James Mill's interest in the analysis of the mind and the principle of evolution, conceived by Lamarck and Erasmus Darwin, and rationalized by Charles Darwin (1809–82) in his *Origin of Species* (1859). Outstanding among the latter school was Herbert Spencer, inventor, railway engineer, and sub-editor of *The Economist*, the first educationist to make general use of the principle of evolution.

To a certain extent Spencer assimilated Rousseau's concept of the special nature of the child through studying Edward Bibers's *Account of Pestalozzi's Life and Writings* (1831), but he modified Rousseau's idealist view of Nature from the scientific viewpoint of a nineteenth-century evolutionist. J. W. Adamson commented, 'Spencer gave *Emile* an English nineteenth-century setting.'[1]

Spencer was interested in a child's predispositions and natural preferences, not only because he regarded them as an endowment received from the experience of ancestors, but also because of his Utilitarian belief in that kind of education which would bring happiness to the greatest number. His views on art education first became known through an article in the *North British Review* of May 1854, subsequently reprinted with other articles in the form of the book *Education* (published by Williams and Norgate, 1878). Such a modern approach towards the nature of a child was astonishing in the eighteen-fifties. Spencer wrote:

'Had teachers been guided by Nature's hints, not only in making drawing a part of education but in choosing modes of teaching it, they would have done still better than they have done. What is it that the child first tries to represent? Things that are large, things that are attractive in colour, things round which pleasurable associations most cluster, human beings from whom it has received so many emotions; cows and dogs which interest by the many phenomena they present; houses that are hourly visible and strike by their size and contrast of parts. And which of the processes of representation gives it most delight? Colouring. Paper and pencil are good in default of something better; but a box of paints and a brush – these are the treasures. The drawing of outlines immediately becomes secondary to colouring . . . The priority of colour to form,

which, as already pointed out has a psychological basis, should be recognized from the beginning, and from the beginning also, the things imitated should be real' [not card copies].

The reader may have noticed that Spencer's essay preceded the publication of *The Origin of Species*, and that his views do not coincide with Darwin's scientific approach. It is Spencer's debt to the evolutionary laws of Jean Lamarck (1744–1829), the French naturalist, which is obvious from this article. Spencer tended to regard the mind as an organ which could be developed by constant employment of its faculties, in conformity with Lamarck's third law: 'The development of organs and their force of action are constantly in ratio to the employment of these organs.'[2]

Spencer also believed, in conformity with Lamarck, that a child's early art expressed needs which must be fulfilled in order to engender new habits and modify and develop the mind. He wrote of children that:

'By their endeavours to draw, they solicit from us just that kind of culture which they most need . . . The extreme indefiniteness which, in conformity with the law of evolution, these first attempts exhibit, is anything but a reason for ignoring them. No matter how daubed and glaring the colours. The question is not whether the child is producing good drawings. The question is, whether it is developing its faculties. . . . During early childhood no formal drawing lessons are possible. Shall we therefore regress, or neglect to aid, these efforts at self-culture? or shall we encourage and guide them as normal exercises of the perceptions and the powers of manipulations? . . . it must happen that when the age for lessons in drawing is reached, there will exist a facility that would else have been absent.'[3]

Spencer did not regard fulfilment of the art needs expressed by the child as only necessary for its own evolution, but rather as necessary for the perpetual evolution of *homo sapiens*. In conformity with Lamarck's fourth law, Spencer believed that the needs manifested by the child demonstrate the character acquired from thousands of years of modification in the organization of its ancestors' organisms, and that evolution in art, or any other subject, would carry on perpetually through one's descendants towards perfection. To Spencer anything that repressed the inherited nature of the child was hindering evolution. On account of this he reserved special fury for the geometrical type of outline drawing advocated by the Science and Art Department, and to some extent by the Society of Arts, which he regarded as 'an inversion of the normal order' because the 'abstract is to be preliminary to the concrete'. He wrote:

'. . . we condemn the practice of drawing from copies, and still more
so the formal discipline in making straight lines and curved lines and
compound lines, with which it is the fashion of some teachers to
begin. We regret that the Society of Arts has recently, in its series
of manuals on "Rudimentary Art Instruction", given its counten-
ance to an elementary drawing book, which is the most vicious in
principle that we have seen. We refer to the Outline from Outline,
or from the Flat, by John Bell, sculptor. As explained in the pre-
fatory note, this publication proposes "to place before the student
a simple yet logical mode of instruction" – The work is, in short a
grammar of form, with exercises.'[4]

Spencer compares it to drilling in the parts of speech before learning
the art of talking, or 'prefacing the art of walking by a course of lessons
on the bones, muscles and nerves of the legs'.

Wilhelm Viola quoted Cizek giving the lead to a psychologist by
saying: 'First the child speaks, then he learns the grammar, not the
other way round.' Viola added that Cizek meant to say, 'First they are
creative, and only much later comes the grammar of drawing and
painting. This is the right way.' An educationist who knew his Spencer
would hardly have needed this advice. It is also interesting to note that
Viola quotes from a paper by Ebenezer Cooke, which describes Mr Ablett
referring to outline drawing as 'a dreary discipline of copying lines'. This
is an exact quote from Spencer. R. R. Tomlinson and J. F. Mills also
give this phrase as Ablett's in *The Growth of Child Art* (1966). Ablett
was, of course, quoting Spencer. Spencer's views on art education at first
fell on stony ground as far as art teachers were concerned, since copying
outlines continued unabated for the next fifty years; yet his objective
psychology made a deep impression on future psychologists, and on
educationists such as James Sully and Ebenezer Cooke.

The only drawback in Spencer's viewpoint was that, although he
believed in following the child's predispositions, he still regarded them
as nature's means of developing the faculties towards accuracy. He wrote:

'This effort to depict the striking things they see is a further
instinctive exercise of the perceptions – a means whereby still
greater accuracy and completeness of observation are induced.'[5]

This is only one reason for the child's wish to depict striking things;
sometimes he wishes to be accurate, but often he is expressing an idea
for its own enjoyment. Alexander Bain was the first psychologist to cast
doubt upon the theory that the purpose of art education was to develop
accuracy and completeness of observation. Even Rousseau had believed
this. Bain's research into instincts and emotions led him to think
otherwise.

ALEXANDER BAIN, JAMES SULLY, AND EBENEZER COOKE

Bain and Sully were both adherents of the associationist school of psychology, initiated by Hartley, and formulated clearly in James Mill's *Analysis of the Phenomena of the Human Mind*. The associationists believed that the mind is formed by associations of one thing with another as if chemical formulae were being constantly added – in fact, this has been called 'mental chemistry'. Their theories were more academic, more abstract, than Spencer's, and less evolutionary, biological and sociological. Therefore, as far as child education was concerned, they were less progressive than he was, but their analysis of breaking-down of the phenomena of the mind led them to refute the popular claim of other Utilitarians, such as Cole, that the chief virtue of Drawing as an educational subject was as a mind-trainer, instilling accurate thought in other subjects.

Alexander Bain (1818–1903), professor of logic at Aberdeen and life-long friend of John Stuart Mill, wrote:

> 'The utility of Drawing as a general accomplishment must not be overrated. It is an additional acquirement of the hand, and for special purposes is valuable or even indispensable. But as a foundation of intellectual training, its influence is liable to be mistaken. It is supposed to train the observing powers, thus helping to store the mind with knowledge of visible objects. But this is too vague to be correct. Drawing compels the child to observe just what is necessary to the ends and no more: if to copy another drawing, the lines of that must be carefully noted; if to draw from nature, the form and perspective of the original must be attended to; but this does not imply much; it does not involve an eye for outward things generally in all their important characters. The pupil does not necessarily give any more heed to the things that he does not intend to draw. . . .'[6]

Bain's view was certainly true as far as the Victorian system of slow and slavish copying was concerned. Bain arrived at this criticism of drawing as a mind-trainer because of his interest in emotions and instincts. His analysis of psychological phenomena convinced him that art was an instinctive emotion, 'one of the great sources of pleasure', not a science; that 'When Drawing is pursued so as to become a taste or fascination, it is too engrossing . . . and indisposes for other tasks . . . the mind tends to remain in the concrete', and 'when colour interest takes a deep hold of the mind, it . . . breeds an unfitness for the abstract and analytic procedure of science'.

Bain not only argued that Drawing was not a universal mind-trainer, but also that art appreciation, or the cultivation of 'Art-Emotion' as he

put it, was the important factor in education, not Drawing. He wrote in *Education as a Science* (1878):

'There can be little doubt that one way of attaining to Art-Emotion, is to become an artist . . . But a wide view must be taken of the cultivation of the feeling for Art, only a few are artists . . . It is considered desirable that people generally should not merely have access to performances and treasures of Art, but should be taught, or in some way assisted to reap the full pleasure that these are fitted to afford.'[7]

Bain's idea that art education should be to provide opportunities for the children to express pleasurable emotion was a great step forward in educational thought, but it did not penetrate into the Victorian classrooms.

James Sully (1842–1923) studied for a University of London honours degree in philosophy while resident at the Baptist College at Regent's Park, and was treated to a staple diet of J. S. Mill, Spencer, and Bain. He was appointed lecturer on the theory of education at Maria Grey Training College in 1879, and Grote Professor of Mind and Logic at University College in 1892, in which year his first notable work, *The Human Mind*, was published. In this work Sully analyses perception and indicates the path Lowenfeld followed forty years later, in so much as Sully suggests that visual and haptic perception are not separate developments but interdependent – 'visual perception has thus in a manner grown out of tactual perception', concluded Sully.

In 1887 Corrado Ricci's *L'arte dei bambini* was published at Bologna. This was a milestone in the history of art education, in so far as it was the first book to consider child art as a separate entity. In 1888 *L'art et la poesie chez l'enfant* was published in Paris. The author, Bernard Perez, a child psychologist, stressed the importance of studying early art-activity as a vital stage in a child's development, and drew attention to child art as expression or language showing the workings of the child's mind. Sully was impressed by both these works, and highly amused by a remark of Ricci, which dealt a light-hearted blow at Sully's friend Spencer and fellow evolutionists. Ricci had commented, 'that children in their drawings reverse the order of natural creation by beginning instead of ending with man'.

For Sully an invaluable source of information and material on child art was Ebenezer Cooke, a teacher best known for producing the first complete edition in English of Pestalozzi's *How Gertrude Teaches her Children* (1894). Cooke's paper on 'Our Art Teaching and Child Nature', published in December and January 1885–6 in the *Journal of Education*, outlines the progressive views he had arrived at through

discussing with Sully the psychological implications of child nature as expressed in the writings of Rousseau, Pestalozzi, and Froebel.

Cooke stressed that the study of the nature of the child was just as important as the artistic study of natural objects. 'Go to nature,' he wrote, 'the artist's cry of reform, means usually to nature objective only. It should include the nature that goes also.' Cooke continued:

> 'All intellectual growth results from exercise of faculty or function. Mr Sully is not alone in saying, "Training a faculty means regularly calling it into activity by supplying the conditions of its existence." . . . Rousseau and Froebel held that each age had its own completeness, and that the later stage was only perfected through the perfection of the earlier . . .
>
> 'It is more difficult to evolve expression, to exercise imagination, to stimulate voluntary mental activity, than to teach mechanically. Drawing can easily be used for the lower purpose. Imagination some teachers consider their enemy – Froebel makes it the very centre of his system; for his aim is education, not instruction, still less decoration. The unfolding of all the child's powers, the easiest and best, – the only way, – is to use its own natural activities. He finds the child a creative being, with active imagination. He accepts the fact, adapts his teaching to it, and supplies materials, for "exercise strengthens faculty." For him, imagination has the wide and full scope of Mr. Sully . . .
>
> 'The teacher who includes child-nature in his subject . . . its progressive capacity, its extending interests, as they develop . . . will try and get this and all natural forces on his side. . . . The nature of the child can no more be altered by us. We must study, sympathize and conquer by obeying it.'[8]

THOMAS ABLETT AND THE ROYAL DRAWING SOCIETY

In his paper Cooke referred to the views of T. R. Ablett, Superintendent of Drawing of the London School Board. Cooke wrote:

> 'Mr Ablett offered an easy practical suggestion. We admire Greek and Japanese freedom, precision, and beauty. Yet the brush, their special instrument, is not used generally; its point hardly at all for drawing with colour. The "thoroughly sound training in outline drawing", rare in the schools of this country, of Mr Sparkes [headmaster at South Kensington], was to Mr Ablett "a dreary discipline of copying lines" . . . What freedom does a lead pencil give compared with its facile colleague the brush? . . . Muscular sense is the element for underlying all, even the questions of materials and instruments . . . Mr Sparkes thinks of copying only, not of the child expressing its thought.'[9]

Thomas Robert Ablett (1848–1945) lived long enough to see great changes in the nature of art education. As a young man he taught art at Bradford Grammar School and, choosing to depart from the contemporary practice of hard outline drawing in pencil, encouraged the children to draw freely from memory and imagination, maintaining that the so-called Freehand Drawing of the Department of Science and Art was not freehand at all, but rather attempted geometrical drawing without instruments. His success at Bradford led to his appointment to the London School Board in 1882.

In 1888 Ablett read a paper to the Society of Arts on drawing as a means of education, and he was encouraged in that year to found the Drawing Society. Lord Leighton, Holman Hunt, Lewis Carroll, Sir John Tenniel, Viscount Bryce and Lord Baden-Powell were early supporters; and Princess Louise, the artist daughter of Queen Victoria, was the Society's president from its inception to her death in 1939.

Another milestone on the path to recognition of child art was passed in 1890 when the Society staged the first exhibition of children's art ever shown in Britain. Princess Louise's husband, the Duke of Argyll, dubbed it 'The Children's Royal Academy' and the title has been used ever since. The Victorian public, familiar with the child worlds created by Kate Greenaway, Tenniel, and Carroll, were enthusiastic about the annual exhibitions of the Society, and in 1892 it was honoured by the prefix 'Royal'. In this same year Princess Louise made her own contribution to the recognition of child art by purchasing 'Babyland', a water colour consisting of 112 figures, exhibited by a girl of twelve years.

Ablett also organized graded art examinations and, by this means and by its exhibitions, the Society has since discovered and assisted many budding artists from Britain and abroad with awards and advice. Outstanding artists who received early encouragement from the Society included Sir William Rothenstein, Rex Whistler, Sir Gerald Kelly, P.R.A., Edward Halliday, Claude Rogers, A. R. Thomson, Robert Austin, and Anna Zinkeisen. Drawings by Whistler submitted from the age of five, and 'Babyland', are still in the possession of the Society.

Ablett made two notable contributions to methods of art education. One of these, 'written design', arose from his conviction that a child would get delight from drawing and arranging letters freely, and consisted of using letters of the alphabet as motifs for design. The modern practice of letter patterns for juniors and Marion Richardson's 'writing patterns' stemmed from Ablett's written design.

'Snapshot drawing' was Ablett's other innovation. The child was encouraged to observe an object carefully but quickly, say a plant or figure, and then draw it when removed from view. It was one variation on Boisbaudran's system, others being Catterson Smith's 'shut-eye

drawing' and Marion Richardson's mental imagery. Lord Baden Powell took up this method from an early age and later introduced 'snapshot drawing' for tests for the Scout's artist's badge, appointing Ablett as examiner.

Both Cooke and Ablett arrived at their views on child art primarily from the current new theories of child education and psychology, rather than from a special appreciation of the aesthetic merit of child art. This is evident from the phrases used by Cooke in his paper of 1885: 'exercise of function . . . to evolve expression . . . to stimulate voluntary mental activity'; and from the words of Ablett, such as 'freedom' and 'muscular sense is the element'. Ablett arrived at his methods by grasping a psychological principle. Like Bain, he believed that art must arise from an instinct of which the fulfilment was pleasurable emotion. Ablett called his system 'Drawing from Delight', and his belief that art must be primarily delight led him to seek appropriate media, such as brush and paint, for the child, suitable for easy and natural manipulation.

Both Cooke and Ablett pioneered investigations into children's scribbles and were deeply interested in the theories of Sully, which were made known to a wide public in the nineties.

'STUDIES OF CHILDHOOD'

In 1895 Sully's *Studies of Childhood* was published. It contained the first comprehensive analysis and classification of the stages of development of the drawings of young children. These stages, illustrated with children's drawings supplied by Cooke, were the bases upon which were founded the analyses of later psychologists such as Kerschensteiner, Levinstein, Stern, Luquet, Krotzsch, Burt, and Eng, the most rigidly defined and best known being in Burt's *Mental and Scholastic Tests* (1922).

His studies of the early stages of child art reveal that Sully grasped the fact that a child evolves schemes or schemata to enable it to repeat ideas; for example, Sully refers to a child's 'lunar scheme of the human face', and, when he referred to 'the well-known toasting-fork or rake hand', he noted 'that this scheme seems to be widely diffused among children of different nationalities'. Sully's concept of a 'schema' was to prove an important development in psychology, although it is very doubtful whether he realized its great significance.

The writings of Spencer, Bain, Cooke, and Sully did not effect a swift change of viewpoint in Britain towards child art, but they did demonstrate that existing practices were not suited to the child's natural development, and prepared the way for a new approach. The lack of immediate impact on art education was due to the fact that in the nineties the fine qualities of colourful primitive, Egyptian, and post-

Impressionist art were not widely appreciated, so child art was not comparable to any admired branch of art, as art. Even Sully did not regard children's early work as art but as 'pre-artistic and a kind of play'. He referred to 'crude child art' and 'rude embryonic art'. Although Sully grasped that 'the art of children is a thing by itself', the most that he could grasp was that although it was crude and defective, it was at least in the direction of true art. He wrote:

> 'Crude, defective, self-contradictory even, as these early designs undoubtedly are, they are not wholly destitute of artistic qualities. The abstract treatment itself, in spite of its inadequacy, is after all in the direction of true art, which in its essential nature is selective and suggestive rather than literally reproductive.'[10]

The children had to wait until Cizek, an adherent of a modern movement in art, grasped that child art, far from being defective or inadequate, is a wonderful art in its own right and 'the first and purest source of artistic creation' which, once its blossoming time is over, will never come again.

RECOGNITION OF CHILD ART THROUGH PRIMITIVE ART

It is fitting that child art, as art, should have been first revealed to a wide public by practising artists such as Franz Cizek, Roger Fry, and Marion Richardson – and, make no mistake about it, child art at its best is a very fine form of art, for there are passages in children's paintings that have both a technique and a perception which make many adult artists feel inadequate.

The downfall of academic High Art at the end of the nineteenth century, and the inrush of the colourful post-Impressionist work shortly afterwards, made possible for the first time a comparison between child and adult art. Child art, primitive art, tribal art, and Western Asiatic art were no longer regarded as crude, but rather as sensitive and expressive forms of art. Sir Herbert Read rightly stated that it was 'a growing appreciation of primitive art and revolutionary developments in modern painting' which 'helped to bring children's art within the general range of aesthetic appreciation'.[11]

The methodical approach to archaeology, which developed in the nineteenth century, caused scholars to analyse and attempt to understand primitive and ancient art. Sir Gardner Wilkinson, commenting on Egyptian art in 1841, typified the new approach when he asserted that representation in profile 'is primitive, and characteristic of the commencement of art. From its simplicity it is readily understood; the most inexperienced perceive the object intended to be represented, and no effort is required to comprehend it.'

Spencer, interested in primitive art as a manifestation of man's evolution, brought to notice in 1862 the language element of early art, the Egyptians' rendering of space and colour, and their repeated schemata, all common to child art. In his *First Principles* he wrote:

> 'Strange as it seems then, all forms of written language, of painting, of sculpture, have a common root in those rude drawings of skins and cavern walls.
>
> 'An Egyptian sculpture-fresco represents all its figures as on one plane . . . It uses scarcely any but the primary colours and these in full intensities . . . all the trees are of the same height, have the same number of leaves, and are equidistant. When water is imitated, each wave is a counterpart of the rest; and the fish, almost always of one kind, are evenly distributed.'[12]

As far as I can judge, Corrado Ricci was, in 1887, the first writer to draw attention to the parallel phenomena of child art and primitive art, but in the same year Alfred Lichtwark in his *Die Kunst in der Schule* (*Art in the School*) stated that the child simplifies according to eternal laws, adding that 'we have recognized the relation between the first attempts of the child and those of primitive man'.

In 1905 the return to Berlin of Dr Theodor Koch-Grünberg, who had spent two years with the primitive tribes of North Western Brazil, drew scholars' attention to the parallel between primitive and child art. He returned with a collection of drawings by Brazilian Indians which are astonishingly like the drawings of children of five to eight years of age, both in method of execution and details. The publication of some of these in his *Aufange der Kunst im Urwald* (*Beginnings of Art in the Primeval Forest*) (Berlin, 1905), and in *Zwei Jahre unter den Indianern* (*Two Years among the Indians*) (Berlin, 1909), made a deep impression. In the former work Grünberg noted the childlike qualities of these drawings, their 'X-ray' tendency, for example, and referred to Siegfried Levinstein's *Untersuchengen uber das Zeichnen der Kinder bis zum 14. Lebensjahre* (*Inquiries about the Drawings of Children up to 14 Years of Age*) (Leipzig, 1904).

The evidence that there is such a thing as primitive art, possessing certain common characteristics, was increased by the publication of Helen Tongue's *Bushman Drawings* (Oxford, 1909). Roger Fry was particularly struck by these careful copies executed by Miss Tongue in South Africa, and he drew the public's attention, through the medium of the *Burlington Magazine,* to 'the main principles of drawing among primitive peoples and among our own children'.

Five Years later Max Verworn published his *Ideoplastische Kunst* (*Ideoplastic Art*) (Jena, 1914), the first searching study into the

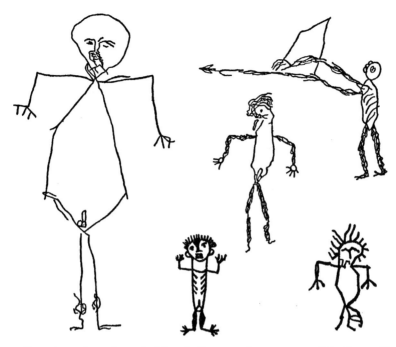

Drawings done by primitive Indians at the request of Professor Koch-Grünberg. The largest figure is the professor. After an illustration in *Zwei Jahre unter den Indianern* (Berlin, 1909).

Example of 'folding over' in Egyptian art, after an illustration in Heinrich Schafer's *Von Ägyptischer Kunst* (Leipzig, 1919), and the same subject by Christopher Bradley, aged seven years.

9 Primitive Art and Child Art

psychological implications of primitive and child art. His concept of physioplastic and ideoplastic art is described in Chapter 20. Herbert Kuhn and Theodor Danzel followed Verworn with their own investigations of the psychology of primitive art. The system of a dual classification for psychological types of art laid down by Verworn, Kuhn, and Danzel was later adopted by Viktor Lowenfeld for his classification of child art.

Art teachers brought up on the idea that art was fine, whereas all that was 'primitive' was crude, naturally resisted the recognition of primitive art as worthwhile art, but by the thirties the new appreciation of the modern movements caused the public to appreciate the virtues of simplicity. Herbert Read wrote:

> 'From a study of the Negro and the Bushman, we are led to an understanding of art in its most elementary form, and the elementary is always the most vital.'[13]

PARALLELS BETWEEN PRIMITIVE AND CHILD ART

'The best way to understand Child Art is to study primitive art,
both of the races that lived tens of thousands of years ago
and the art of living primitives.'
Wilhelm Viola[14]

What is meant by 'primitive art'? The art of primitive man? Leonhard Adam has pointed out the difficulties of defining primitive man as distinct from civilized man. Primitive peoples have been found to possess one or more attributes of civilization, such as moral standards, codes of laws, complicated social structure, knowledge of astronomy, mathematics and technology, and so on.

Adam's definition of primitive peoples is: 'those tribes who are outside the spheres of (a) modern European civilization, and (b) the great Oriental civilizations – in other words, peoples representing comparatively low cultural stages'. It is quite usual for modern writers on child art to include the art of the ancient civilizations of the Near East in the category primitive art for the purposes of making comparisons with child art. This is allowable, because of various unchanging schemata of the art of Egypt, and of Western Asia, from pre-dynastic times.

Before discussing the psychological and physical parallels between primitive and child art, it is interesting to note a philosophical one. Admirers of the natural savage, in the tradition of Rousseau and D. H. Lawrence, are keen to equate the low cultural and mental level of primitive man and the child with purity and sincerity. Both Viola and Adam quote a passage from G. A. Stevens's *Educational Significance of Indigenous African Art* in which he wrote:

'Primitive art is the most pure, most sincere form of art there can be, partly because it is deeply inspired by religious ideas and spiritual experiences, and partly because it is entirely unself-conscious as art; there are no tricks which can be acquired by the unworthy, and no technical exercises which can masquerade as works of inspiration.'[15]

Viola seems impressed with this viewpoint and follows with another idealistic quotation on child art, this time by Sir William Rothenstein: 'Simplicity as well as wisdom comes from the Gods.' Leonhard Adam, unlike Viola, does not share Stevens's viewpoint and comments in a tolerant way that 'the "primitive" artist is not always as naïve as one would like to think'. Certainly the ideal concept of a noble pure savage, unselfconscious and responding in a simple way to a natural environment, is hard to justify. One could call it the 'Golden Age syndrome'. Experiences of the customs of primitive races show them as extremely self-conscious, much involved with bodily habits, full of superstition, taboos, and magical tricks, practising bodily mutilation, afraid of the natural state of darkness, and so complex and confused in outlook as to be unable to be sincere, albeit spasmodically. Stevens's view that primitive races do not intend to impress with technique is also debatable. Adam asserts: 'The aim of the primitive artist is good craftsmanship.'[16]

Equations of the outlook of the primitive artist and the modern child can be dubious. Sully warned that we should not expect a perfect parallelism, yet in point of technique and method both often appear similar. Is there a scientific explanation for these phenomena?

A BIOGENETIC EXPLANATION

All biogenetic theory is based on the evolutionist principle that each living organism arises from a parent living organism. The possibility of a development of this principle was put forward by Karl Ernst von Baer (1792–1876), the discoverer of the human ovum, as a result of his research into the growth stages of the embryo. 'Are not,' he wrote, 'all animals in the beginning of their development essentially alike, and is there not a primary form common to all?'[17]

A further development of biogenetic theory was initiated by Ernst Heinrich Haeckel (1834–1919), arising from his conviction that the present development of an organism is mainly an epitome of the modifications undergone by successive ancestors. He defined the following law: '. . . the history of individual development, or Ontogeny, is a short and quick recapitulation of palaeontological development, or Phylogeny'.[18]

The psychological implications of Baer's 'law of development' and of

his own 'biogenetic law' became clear to Haeckel; in short, that not only the physiological development of an individual from foetus to adult repeats the evolutionary stages of the human race, but also the mental growth of a child repeats the evolution of the human mind. In fact, Haeckel, an extreme evolutionist, believed that no distinction was possible between physiology and psychology, the latter being merely a branch of the physiological development of the organism. The research in morphology stimulated in the nineteenth century by Haeckel's law, to deduce phylogenetic relationships from the ontogenesis, convinced many educationists of its validity.

The educational principle, which the biogenetic law now reinforced, had been stated many years before by Goethe, who affirmed that 'youth must always start again from the beginning and as an individual traverse the epochs of the world's culture'. Hegel added: 'In the progress of the schoolroom we may recognize the course of the education of the world, drawn, as if in shadowy outline.' Herbert Spencer contributed: 'the education of the child must accord in mode and arraangement with the education of mankind considered historically.'

It was only to be expected that, since the only manifestation we have of the mental activity of primitive man is his art and craftwork, research into the similarities between it and child art was stimulated.

Two major discrepancies inhibited those who, against Sully's advice, attempted to draw an exact parallel – the naturalism of the painting of the palaeolithic hunter and the same characteristic of some Bushman painting. One of the main parallels noted, common to child art, the art of most primitive races, and that of the ancient Middle East, was the use of images, symbols, and signs, rather than naturalistic representations; yet the palaeolithic and Bushman art seemed realistic to investigators. Max Verworn, for instance, considered palaeolithic art to be purely physioplastic, and for that reason dismissed the possibility of establishing a parallel to child art.

Viktor Lowenfeld in defence of the biogenetic law has suggested that the normal child would probably recapitulate this primitive naturalistic type of art as the first stage of his artistic development, before the existing stage of making symbols, if his muscular control was developed sufficiently. His justification is that blind and weak-sighted children show evidence of this first stage; but to me the conclusions of Verworn and Lowenfeld are very dubious.[19] Can we regard palaeolithic work as a first stage? If we try to tidy up the biogenetic theory in this way we are still faced with the problem that some of the earliest Aurignacian art consists of small carved humans which are in the symbolic tradition of most primitive sculpture and of the first stages of child art, the figures being assembled schemata representing breasts, bellies, thighs and featureless

heads, completely unlike the graceful naturalism of palaeolithic paintings. It could be claimed therefore that earliest Aurignacian art, and earlier art still, was probably more symbolic than realistic, conforming to the first stage of the normal child. Even in the palaeolithic periods symbols abound such as cup markings, tectiforms, penniforms, groups of dots, rectangles, lattice designs, symbolic vulvas, and so on.[20]

Palaeolithic paintings of animals may not be free visual physioplastic sketches in the sense of Impressionist works or of memory compositions, but rather pictures expertly painted from extended or crouched dead animals, using learned schemata such as the stereotyped hooves, hair, horns, and antlers. It has even been argued that the skill and style of cave art demonstrate that a type of formal art training existed in some areas. For example, at La Madeleine only fine works were executed, whereas at Les Eyzies thousands of bones were discovered, on which are what resemble the attempts of trainees.

Lowenfeld's argument that probably the child misses out the first stages of artistic development, those that correspond to the naturalistic cave art, because the child's muscular control does not allow it, seems illogical from the point of view of manipulation. Surely the logical and natural way for both a child and a primitive man to develop manipulative skill and primary simple concepts of shape is to start off as a child actually does with straight line and curved line scribbles, then rough circles and rectangles, then more complicated symbols. The rhythmic scribbles of our primitive cousin, the ape, seem to endorse this; also many lower creatures such as spiders and insects instinctively create simple geometric patterns (gestalten). Surely the earliest artistic attempts of primitive man occurred when he modelled a ball of clay between his hands or tentatively scratched and scribbled marks, exactly as a young child does. Thus the ontogenesis does recapitulate the phylogenesis.

Only those who expect a smooth gradual progression, contrary to nature and phylogenesis, would be concerned with the blossoming of mature palaeolithic art, because even a child passing through what Lowenfeld describes as the schematic stage displays short brilliant flashes of vivid and true Impressionism in his work which any adult artist would envy.

EXPRESSION AND COMMUNICATION

Viola states: 'Primitive art and Child Art are first expression, not representation.'[21] Since primitive art existed long before satisfactory language or writing, obviously expression was its primary purpose.

An infant, like a primitive man, cannot write, nor does its experience of language (again like primitive man) enable it to express the total

mental activity generated by the multitude of experiences which flood in upon it. The child will therefore mime, dance, make continuous burblings, crow, clap, and scribble to express its reactions to various stimuli. It is obvious to the parents and teachers that most of these are meaningful expressions, not mere motor activities. It is not quite so obvious, however, with the scribbles until the infant suddenly points to one, looks at the adult, and declares, say, 'Dad', or 'Bus'. Unlike the primitive man the civilized child slowly absorbs the enormous resources of modern communication and, if the art instinct is neglected by home and school, having lost the need, many a child will lose the desire to produce art. That this is not a natural state of affairs is evident from the morale and behaviour of children in a good art department.

Some years ago, lying on my back viewing the rock ceiling at Altamira, I was struck by the great power of expression of the paintings, arising, I thought, from the tremendous desire of primitive man to communicate. I had the same telepathic experience in an Egyptian tomb, as if messages from long-dead artists filled the chamber. One receives a similar stimulus from powerful child art; the intense experience of the child is conveyed to the spectator. Marion Richardson, after she had stood alone among the paintings at the closure of her famous exhibition of child art (1938), was moved to write: 'Pictures are strange things to be with when it is getting dark; and six hundred of them had a great power. They shone. I felt that if I could have stayed looking at them all night I might, possibly, have understood just what it is that goes into a drawing when it is made, and lives in it for ever and ever . . .'[22]

Since most of the art of young children is composed of symbols, why is the impact so strong? One answer is that these symbols are all meaningful. A young child represents an event with all the information it feels is essential, and the spectator feels the same delight as when listening to the direct words of a child, as opposed to the dull formulae of adult speech. Is this the only answer, or do young children form extremely vivid eidetic images distinct from memory images? Does the formation of such eidetic images explain the animism common to primitive and child art? These are very difficult questions for psychologists to answer from tests. Fox in his *Educational Psychology* asserted that the introduction of a third type of image, in addition to hallucinatory and normal images, caused monstrous confusion in child psychology, and referred to the eidetic image as 'a psychological abortion'.[23]

Nevertheless our experiences show us that in primitive art, indeed in the art of all the ages of symbolism before the Renaissance, and in child art, many works communicate a super-realistic imagery, which people of the past would have considered magical. It should be stated, however, that, for every one of these highly-charged exciting images created by

primitive races and children, there are thousands of very formal images or symbols through which they both communicate their endeavours to order and stabilize their changing environment.

SYMBOLS AND STABILIZATION

The use of symbols in the art of children and in that of many primitive races provides an obvious parallel. Cyril Burt considered that the stage of 'descriptive symbolism' is usually achieved by five, and that the child then repeats his favourite schema for each object.

The repetition of favourite schemata or symbols is analogous to all primitive art and most oriental art. To the primitive artist symbols are convenient and sufficient for conveying events and ideas, and for making images, so he has no urge towards realism; thus the Australian aborigine draws a circle or spiral to indicate a waterhole or hill. Likewise a child repeats circles for a head or a tree-top. His schemata or symbols have no root in immediate observation, they are repeated like words. Sully remarked that the way a four-year-old child repeats a schema of lines for a cat 'is closely analogous to the symbolism of language'.[24] Viktor Lowenfeld has affirmed that only this type of child art, art not derived from observation of nature, is comparable to primitive art, and that 'in the art of weak-sighted children we find in their purest form all those parallels to primitive art . . .'.[25]

By nine years of age the modern child is working from nature to a limited extent, and by eleven years the realization that his favourite symbols are non-realistic causes him to abandon them. Creativity is usually terminated in the frustrations of attempted realism.

The need felt for realizing symbols by young children and by primitive races stems from their mutual desire to order their environment. Worringer in his *Formprobleme der Gothik* stated: 'For primitive man . . . artistic activity . . . meant the impulse to establish . . . a world of absolute and permanent values.'[26] Stabilization can be discerned in all primitive forms of art. The primitive Egyptian painted simple and complete triangles on his pottery to represent the wild mountains to his east, and later both the Egyptians and Babylonians created geometrical mountains of stone or brick; similarly a child stabilizes a forest of wild trees into orderly rows of geometrical lollipops.

TECHNICAL PARALLELS

Today the technique which most resembles that of primitive artists is that displayed by the young child of four to nine years, those years in which he first evolves schemata in line form and then repeats them.

The technical basis of primitive and child art is outline, either outline which circumscribes the whole or main parts of an object, or line to

suggest the silhouette of thin objects – arms, fingers, flower petals, chairs in profile, for example. That the child is thinking in terms of enclosing a shape with an outline is proven by the fact that usually the fingers, flower petals, and so on, will be outlined as shapes if the drawing or painting is large.

Unlike the symbols used by primitive artists, those used by the modern child vary, each individual developing favourite schemata. The circle is the most invariable schema, nearly always serving for heads, eyes, tree-tops, ponds, and similar objects. Rectangles, triangles, and oblongs are interchangeable. These basic geometrical schemata or primary outlines are used as frames inside which, and on to which, are gathered the symbols representing the details of the object depicted. The outlines of objects drawn by primitive artists serve the same purpose.

It is strange to think that, when Cole and Redgrave decided to commence the National Course of Instruction with geometrical and freehand outline, they were unconsciously, albeit in a rigid way, starting off with a parallel to primitive and child development.

The free outlines produced by the young child of today, if produced by a suitably bold tool such as a brush, can have much aesthetic merit akin to those of primitive artists, though the latter are executed with much more precise craftsmanship.

REPRESENTATIONS OF SPACE

Lowenfeld, referring to the real field of primitive art, wrote: 'We find that in representing space, the basic line is used in exactly the same way as it is in the drawings of the weak-sighted.'[27] But in the prehistoric periods of primitive art attempts to represent space are not apparent. Wild animals or men may be depicted in close proximity or in groups, as in Bushman painting, but the overlapping of figures, as they are actually seen, is very rarely practised. Even the individuals of a herd are placed in separation, sometimes in linear procession. It is necessary to advance to the ancient civilizations of the Middle East before the constant use of symbols to represent space are discernible.

An infant occasionally loves to sit in a box or on a square of paper, or to lie absolutely prone on the floor looking along its surface. These actions are efforts to establish relationships with surrounding space. Practically as soon as the normal child has achieved a recognizable schema for drawing the human figure, the first space schema appears, the primary base line. The primary base line can appear right at the bottom of a child's paper as early as in his fourth year of age, and, if the child is not taught otherwise, it will continue to be its basic means of expressing space until at least ten years of age. The primary base line will tend to rise from the bottom of the paper, once the child has firmly established it

as a schema for supporting figures, buildings, and plants. This usually occurs by six years of age. From about seven years triangular and curved humps appear, secured to the primary base line, to represent hills. It is important to realize that the definition 'base line' is not used because of its low position on the paper, but because it quickly becomes a base from which all the figures spring.

Apart from the primary base line, other base lines are soon organized by the child. By eight years a circular or square enclosure is drawn with a single line for a pond, or a park, or for any enclosed space; and, using this line for a base, the child will draw buildings, trees, or figures 'folded out' or 'folded in' from it. Occasionally one or two base lines are drawn right across the middle of the paper for a river or street, and trees or houses are 'folded out' from it. This 'folding over' of objects reflects the child's concept of any bounded enclosure, even a road surface, as a bird's-eye plan, and his concept of solid objects as profile elevations.

The clearest demonstration of the concern of both the primitive artist and the young child with outlining significant schemata, rather than with imitating reality is provided by their transparent or X-Ray pictures. Clear examples of the internal structure of animals show in the art of primitive races. Bones, intestines, and edible flesh have been sharply outlined in the works of the Eskimo, the Australian aborigine and the Indian. Populated interiors of buildings appear in the paintings of the ancient Egyptian and the modern child.

Too much psychological significance should not be attributed to X-Ray drawings in themselves; they only crop up occasionally, and are just one viewpoint taken by the child-artist to express significant aspects of his subject. For example, a child or a primitive artist will invariably choose to draw an animal with all its legs visible. The worthy Professor Koch-Grünberg was intrigued to find that the Brazilian Indian depicted him with his genitals showing, significant of his manhood.

From a technical point of view it could be claimed that the work of a young child, like that of the Assyrian, Egyptian, and primitive artist, gives a clearer viewpoint than the sophisticated perspectives and projections of today. A young child draws a circle of children holding hands with the children at the top of the group upside-down to show its circular organization. Similar organization of a group is shown on a bark-painting in Melbourne University collection, a group of natives being arranged, with the topmost upside-down, around a group of prostrate bodies of the dead.

The child instinctively expresses an architectural concept of space, rather than a visual one, by the constant use of elevations, plans, and sections. These viewpoints are much superior, for the child's purpose of expressing space, than perspective. For example, if we had to describe

the positions of football players on a field, or the streets around our house, such map-like and architectural views would be ideal and eye-level perspective would be useless.

A child draws the bird's eye view of a pond, because it best shows the shape or schema of a pond. Fish in the pond are depicted in profile elevation to show the most clear schema of a fish. The Egyptian artists drew ponds likewise, and on occasion drew a house or a tomb in a connected group of plans, elevations and sections, each part being given from the clearest viewpoint. The quest for varying appearance of objects in space would have run counter to the Egyptian's desire for orderly and permanent stabilization, as it would today with a child. It is obvious from the above facts about the representation of space by children, that any attempt to teach formal perspective in a junior school would merely frustrate the natural mental growth of the child and create confusion.

With a knowledge of primitive art and biogenetic theory a teacher can certainly better understand the artistic progress of the child, in realizing that fundamental laws of evolution are being manifested as the child advances, and that communication must be in terms relevant to the concepts of the child. Parallels to primitive art help us to understand that child art is not an immature version of adult art, but a distinct stage of mental growth.

FRANZ CIZEK (1865-1946)

It seems appropriate that the art teacher whose influence was to free children from the dreary discipline of copying should be born a Bohemian and a compatriot of the liberal educationist Comenius. Cizek's native town, Leitmeritz, was part of the Austrian empire and in 1885, at the age of twenty, he entered the Akademie der bildenden Künste in the capital, Vienna.

During his time at the Akademie the first stirrings of the modern movement in architecture and design, which eventually led to the establishment of the Bauhaus, were taking place in Vienna. Otto Wagner (himself a teacher at the Akademie), Josef Olbrich, his pupil Josef Hoffman, Karl Moser, and Gustav Klimt were all close acquaintances of Cizek. This group, all architects and designers except the painter Klimt, were already influenced by the Arts and Crafts Movement and were becoming attached to Art Nouveau. Naturally they abhorred academic art and convinced Cizek of the need for creative modern art. The group founded the Sezession movement in 1897, Hoffman founding the Kunstschau in 1907, and Hoffman and Moser later setting up the famous Wiener Werkstätte. These architects were also designers, much influenced by the symbolic and anti-realist tendencies of Klimt, whose

decorative pictures, full of bright pattern and the symbolic shapes of Art Nouveau, made a deep impression on Cizek.

The young artist had the good fortune to have lodgings where there were many children, and he encouraged them to paint in his room. Cizek was surprised by the rhythmic, symbolic, and decorative qualities of the work produced by the younger children. He also observed the graffiti of children in the Vienna streets, particularly some chalk drawings executed by homeward-bound schoolchildren on a large hoarding opposite his window on the Florianigasse in the university quarter.[28] What particularly intrigued him were the similarities in this unsupervised work. It dawned upon him that child art is a particular branch of art, in his own words: 'Child Art is an art which only the child can produce.'

Child art is Art! It is not there to be analysed by the psychologist or educationist, but to be admired as a thing in itself. It is Art! It was this concept, rather than the work of Cizek's class, which proved a milestone in the philosophy of art education. Cizek was so excited with his discovery that he took examples of young children's work to show Klimt and his circle, and they urged him to obtain a permit from the School Board to open a new type of art school, for children only.[29] The Viennese authorities could not see the point of such a class; the Board ran a graduated drawing course in all its schools, so, to clarify matters, they requested a work programme. It proved brief: 'To allow the children to grow, develop, and mature.'

Cizek's application was rejected, but educationists in Germany, notably Georg Kerschensteiner of Munich and Professor Gotze, were approaching a viewpoint similar to his, and in 1897 he was appointed assistant in the Vienna Realschule and granted permission to start private classes for juveniles at the weekend. His art lessons at the Realschule had to follow the official graduated drawing programme, but in addition he encouraged children to draw figures, boats, cars, and landscape. Cizek was given encouragement at this period in his bid to break away from formal drawing by the introduction, against strong opposition, of cut paper work into the Vienna schools in 1900 by Professor Alfred Roller.[30] Franz immediately took a deep interest in this medium, and the children exploited it to the full.

Gotze, president of the Hamburg Union of Art Education, examined the work of Cizek's pupils, highly recommending it to the university authorities and the Austrian Minister of Education, and in 1903 the first official provision for his weekend classes was made. The School Board offered Cizek the use of rooms in the Kunstgewerbeschule on Saturdays and Sundays, and it was here that he put into practice his philosophy of art education for thirty-five years. His Jugendkunstklasse (Juvenile Art Class) consisted of forty to sixty children, mostly of ages ranging from

seven to fourteen years, although there were occasionally a few older or younger, even as young as two. They painted in water colour and poster colour, executed woodcuts, linocuts, and papercuts, modelled in clay, embroidered, and stitched appliqué, working from imagination. Nothing was taken from nature or copies.

Cizek arrived at his methods from intuition and his love of the imaginative qualities of modern art, but a colleague to the west, Kerschensteiner, Superintendent of the Munich School Board, was also discovering, from the examination of hundreds of thousands of drawings, that young children drew best from imagination, not from objects. His findings were published in *Die Entwicklung der zeichnerischen Begabung* (*The Development of the Graphic Gift*) (Munich, 1905).

Though Kerschensteiner discouraged the copying of objects in the Munich schools, and Cizek's children surprised the Germans with their efforts, there was no great change in the German system of art education. The Germans were too committed to systematic and purposeful methods of drawing to countenance Cizek's philosophy that children's pictures should be allowed to grow like flowers, free from adult influence. It was to be in Britain and America that Cizek's philosophy had the greatest impact.

In 1908 the International Art Congress was held in Britain and amongst the most exciting work exhibited were the children's drawings submitted by Professor Wesley Dow of the Teachers' College of Columbia University. Cizek exhibited work from his Juvenile Class, including some striking pictures of Mount Etna exploding and, according to R. R. Tomlinson, was profoundly affected by the American drawings. Cizek's reputation was now growing slowly. The Austrians did not appreciate him greatly, Dr Viola doubts whether they ever did, but in 1920 an ill wind blew some good.

A financial crisis gripped defeated Austria after the first world war, one result of which was the withdrawal of the grant to the Jugendkunstklasse. Fortunately two distinguished war relief workers, Bertram Hawker and Francesca Mary Wilson, arrived in Vienna to organize assistance for displaced and impoverished children. Hawker, an advocate of Montessori methods of education, introduced Cizek to Francesca Wilson, and she, an experienced Birmingham teacher, was deeply impressed by the Jugendkunstklasse.[31] From this meeting in 1920 Cizek's rise to world fame began. Hawker and Francesca Wilson undertook to organize exhibitions of the class's work in Britain and an advisory committee, which included Lethaby, Clutton Brock, and Charlotte Mason, was set up to plan the work and raise subscriptions for the 'Children's Art Exhibition Fund – Professor Cizek's Class'. Francesca Wilson undertook the work to be done in Vienna, writing

catalogues and booklets, and having postcards of child art printed; and from then on the work of the Jugendkunstklasse was exhibited in British galleries with great success, and at regular intervals, until 1935.

Exhibitions were also organized in France and America, and from these early post-war years until the Nazi seizure of Austria, thousands of visitors, particularly from Britain and America, flocked to the Fichtegasse to observe the master Cizek and his assistant Fraulein Staudek at work. Undoubtedly the greatest advocate of Cizek's work has been Wilhelm Viola, whose lectures from 1934 onwards in universities, training colleges, and education societies have made thousands of teachers familiar with the Austrian's philosophy of art education. Viola's classic *Child Art* continues to inspire contemporary teachers, although unfortunately we can no longer visit Franz Cizek at work. His juvenile art class was closed in 1938, but he carried on with some art teaching until 1941, in spite of increasing blindness. He died in 1946.

CIZEK'S CONCEPT OF SELF ACTIVITY

'Nothing here is made, it has grown like flowers . . .
Look inside yourselves, there are the most beautiful picture books . . .
I should like the children to grow up on islands amongst themselves.'
Franz Cizek

It is probably best at the outset to state that the summary given here of Cizek's philosophy is based on what he preached, that philosophy which was passed on by Francesca Wilson and Wilhelm Viola to inspire thousands of teachers. It is not in the main the philosophy which Cizek practised in the Jugendkunstklasse, and which is explained in the following pages.

Short shrift seems to be given to Cizek by art educationists who base their views on psychology. Lowenfeld and Brittain do not mention him in *Creative and Mental Growth*, and in his *Nature of Creative Activity* Lowenfeld only mentions him once, when he likens the 'mere' intuitive approaches of Natalie Cole to Cizek's.[32] The Austrian's belief in inherent art, art which can be derived by the child from its own internal stock of imaginative pictures, is difficult to justify from a psychological viewpoint. Over thirty years ago a perceptive student at Leeds Training College saw this difficulty and asked Dr Viola: 'Is there such a thing as imagination?' An even more difficult question would have been: 'What is imagination?'[33] Certainly psychologists can not be expected to enthuse over Cizek's intuitionism.

Cizek's basic philosophy was near that of Rousseau, 'that the first impulses of nature are always right', indeed he was more extreme, for he did not believe in the degree of adult interference recommended in *Emile*. What children do must be right argued Cizek. 'Children have their own

laws which they must obey.' He did not even consider, as Rousseau did, that art for the child should help development towards adult concepts. 'People make a great mistake,' said Cizek, 'in thinking of Child Art merely as a step to adult art. It is a thing in itself, quite shut off and following its own laws, and not the laws of grown-up people.'[34] His concept of eternal laws agreed with Lichtwark's belief that 'the child in his representations of things simplifies according to laws valid for all times and all peoples'.[35]

During Cizek's youth the Germans were feeling the full impact of the educational philosophy of Friedrich Froebel (1782–1852), who believed that everything, animal, vegetable, and mineral, has an inherent self-active 'drive' to develop itself along certain lines appropriate to its nature. Development of everything, including that of the child, comes from within, using the thought 'which is innate in everything that has come out of God's creative mind'. It is the Froebelian concept that the child is a creative self-active organism which dominated Cizek's philosophy of art education. 'Education is growth and self-fulfilment,' said Cizek; 'Make your schools into . . . gardens where flowers may grow as they grow in the garden of God.'[36] He believed that inspiration was derived from the internal nature of a child, and would have disagreed with Rousseau's idea of drawing Emile's attention to external nature. 'Ah, Nature, Nature,' Cizek exclaimed to Francesca Wilson; 'Is it not enough that der liebe Gott created Nature, that Man must be always trying to ape Him? Nature is right enough in its place, but Man should be after creating something fresh. That is what I am always telling them. Get away from Nature. We want Art, we don't want Nature. . . . Here they draw things out of their heads, everything they feel, everything they imagine, everything they long for . . .'[37] The child's mind must be protected from adult influence. 'What right have grown-ups to interfere?'

Such was the trust Cizek professed in the child as a completely self-active organism.

THE PARADOX OF CIZEK'S METHODS

A modern art teacher after reading Cizek's philosophy would be astonished to see the reproductions of the work of his Jugendkunstklasse, which appear in *The Child as Artist* by Francesca Wilson (1921), *Christmas* edited by Edmund Dulac (1922), and *Children's Coloured Paper Work* by Cizek himself (1927). Far from being free and fluent with the bold, delightfully crude, and imaginative touches found in free child art, the work illustrated is extremely sophisticated, extremely competent, and very much influenced by adult folk art and illustrations done for children's tales by adults. Many of the works, notably the patterns of the complicated woodcuts and papercuts, require very

careful measuring and working out. It was their sheer competence which astonished British and American art teachers, many of whom thought that a well-shaded group of solids was the apogee of child art.

Francesca Wilson had already observed the technical excellence of Cizek's pupils when visiting his class, and had noted that 'the technique of so many of these pictures is so marvellous for such young children'.[38] The saintly Marion Richardson also remarked on 'the highly competent and mannered works' exhibited by the class, but she took a kind view and excused these departures from his philosophy. 'The precocious skill and sophistication of the Viennese children were among his problems, and not things to be praised. His own approval was of all that is simple, sincere, and childlike.' This does not seem to explain why such mannered and complicated works were selected, not only for exhibition, but also for the book Cizek wrote five years later. Many of the works of Cizek's class bring to mind the sophisticated tradition of children's book illustration exemplified in Britain by Caldecott, Kate Greenaway, Beatrix Potter, and Mabel Lucy Atwell. These works of his class were reproduced to decorate the walls of schools and nurseries. It seems today that he had developed a children's style. In his *Children's Coloured Paper Work* Cizek affirmed: 'The combined influence of the child's personality, and the limitations imposed by the materials used, lead to the final object of our aim: pure style.' He also declared: 'We eliminate all amateurish and counterfeit workmanship.'[39]

It is possible that Francesca Wilson and Wilhelm Viola were so carried away by Cizek's philosophy of self-activity and free expression that they blinded themselves to the firm methods he used with his pupils. To give some idea of the confusion caused among art teachers who attempted to correlate the technical excellence displayed with his philosophy, a quotation from J. Littlejohns, the author of *Art in Schools* (1928) and of the art section of Newnes's *Modern Teaching*, is useful. Littlejohns declared that Cizek dealt with his pupils 'upon lines which would have been regarded by most teachers as the depth of absurdity and danger', and that as far as the work exhibited was concerned 'the effect was staggering. It was hard to believe that children of seven to fifteen, however highly endowed, could express with certainty, vividness and power, such individual and truly inspired conceptions. And when the methods of the teacher became known [through Francesca Wilson's handbooks] amazement gave way to incredulity. For the children were not, in the usual sense of the word, taught at all! There was no insistence on technique, no ordered method of study. . . . Method, material, subject, purpose, all these are left to the child's free choice.'[40] The last sentence is completely erroneous, but its content was widely believed, and still is by many idealistic students who imbibe Dr Viola's *Child Art*.

They often receive a shock on teaching practice when they discover that undirected children are not the bubbling creative vessels they had assumed.

Nor are children who 'grow up on islands amongst themselves', as Cizek recommended, full of creative ideas. Margaret Mead, the distinguished anthropologist, persuaded the Manus children of the Admiralty Islands, who were 'cut off from the stimulation of adult life' by tribal custom, to produce thousands of drawings. She found that, just as their play was dull and unimaginative, so in their drawings they did not 'build up imaginative edifices' like civilized children who are stimulated by adult ideas and precedent. She summed up: 'Those who believe that all children are naturally creative, inherently imaginative, that they need only be given freedom to evolve rich and charming ways of life for themselves, will find in the behaviour of Manus children no confirmation of their faith.' However, Margaret Mead also reasoned that, since the wood carving of a neighbouring tribe was very fine, perhaps the Manus children would have produced far better work in this medium.[41] Dr Viola seized this last opinion as an argument for his views and Cizek's, but, if careful thought is given to the opinion, it is rather an argument against the creativity of isolated children, and one for the necessity of precedent and adult influence.

The excellent technique displayed by Cizek's class was to some extent due to the fact that it was a weekend class, akin to the voluntary museum and gallery art classes in Britain and America today, and naturally the majority of the children were those who were most keen and accomplished. Francesca Wilson wrote: 'The age he loved most was from one to seven', and it was unfortunate that very little work of this age range was exhibited or reproduced. Cizek professed to have little time for any artist over fourteen years of age. 'Until then,' he said, 'their ideas grow like flowers in a wood – naïve, untrained, gaily-coloured. But after fourteen they became dull very often. They see too much, they grow sophisticated. I seldom keep them after fifteen.'[42]

Believing that children should live in an environment created by themselves, Cizek praised Morris and Ruskin for bringing art into people's homes, adding, 'I make children do their own decorating – that is my contribution.' The art of his class was essentially decorative, and it is evident from the reproductions in *Christmas*, *The Child as Artist*, and *Children's Coloured Paper Work*, that, from the ages of nine to fifteen, Cizek's pupils were being guided towards a 'pure style' of decorative art, brightly coloured and within very firm outlines. He affirmed that 'a teacher must give his pupils strictly correct ideas, if they are to get a solid basis for their work'.[43] The pupils could thus be induced to produce purely coloured shapes and forms, or gestalten. 'You must learn

Gestalten,' Cizek told the children. A brief outline of his teaching methods follows.

Materials: These were carefully chosen and restricted by Cizek. For example, he issued colours separately, sometimes one colour at a time. The children used them unmixed with other colours, and he objected to the use of brown, mauve, grey and sometimes black. Red and yellow were the colours he considered most suitable for children. 'Red is the most beautiful colour on earth,' he declared. The children were often restricted to using three colours.

Procedure: A subject was set by Cizek and he discussed the details of the objects to be depicted by the children. Previous work in the style Cizek admired would be shown to the class, sometimes of the same subject, and then removed to prevent direct copying. He then gave the children directions on how to start laying out the picture.

After the class had started Cizek debated the work with different pupils, often drawing other children into the discussion. Some points which he insisted upon were: that the paper should be filled, that strong rhythmic outlines should be drawn, that work should start at the top of the paper, that each part of any figure should be outlined separately starting with the head near the top of the paper, that figures should be full of character and movement, that colours should not be painted over other colours, that the outlines should show after the painting was completed, that decorative patterns should be included where appropriate, and finally that the child did 'not get ahead of her age' by using other styles of work.

Edmund Dulac reported: 'At the end of the lesson, he pins up their work on the wall, and discusses each picture separately, while the whole class listens. The Professor is lavish with his praise . . .'[44] Those who seek further information on the Austrian's methods should read Francesca Wilson's description of a visit to his class in her book, *In the Margins of Chaos*, or Viola's reports of Cizek's lessons in *Child Art*.

Cizek did in practice allow his pupils to use sophisticated adult concepts, provided they brought out the decorative qualities he considered most suitable for child art (see Plates 34 and 35).

Cizek's importance is due to the fact that he was the first to recognize the decorative rhythmic art which comes most naturally to children. His insistence on keeping them so strictly away from adult concepts which he did not think suitable for child art is very dubious from an educational viewpoint; for just one example, he sometimes prevented a child from using a realistic colour scheme when the child wished to. The Austrian wished to preserve and extend childhood for as long as possible. 'There is so much of the Summer and Autumn,' he told Francesca Wilson, 'but the Spring never comes again.'

ARTHUR WESLEY DOW AND 'COMPOSITION'

In the United States it was Arthur Wesley Dow, a contemporary of Ablett and Cizek, who urged art for children in place of copying; and from 1904 to 1922, the years that Dow was employed at the Teachers' College of Columbia University, this New York college grew to dominate art teacher training in the United States.

Dow substituted 'composition', an aesthetic concept, for mechanical imitation; 'the expression of Beauty, not Representation,' he claimed.[45] The climate for such a change was opportune at the turn of the century. Art for art's sake and the Aesthetic movement were sweeping Europe and America. Dow derived his concept of composition from the analysis of works of art, especially Japanese, and his most influential book *Composition* (1899) urged that line, spacing, and *notan* – the elements of composition – should be the basis of art instruction. *Notan,* so dominant in Japanese art, is the balance of light and dark areas, a different concept from representation of natural light and shade as understood by nineteenth-century art teachers. A very close parallel to Dow's teachings were those of Walter Crane at Manchester School of Art in the early nineties, published as *Line and Form* in 1900. The Englishman had acquired his appreciation of *notan* in the eighteen-sixties from Japanese prints.[46]

Dow attacked the contemporary emphasis on learning to draw, which he termed 'the academic method', and recommended an emphasis on composition, termed 'the synthetic method'. He believed that the practice of composition would enable pupils to build up their work on sound aesthetic principles, and that analysis of composition would enable them to appreciate all the visual arts. He declared: 'The true purpose of art teaching is the education of the whole people for appreciation.'[47]

Although Dow's method was more stimulating for pupils than academic drawing methods, composition is still primarily a disciplined intellectual exercise, and, as taught by Dow, it produced a strongly defined pictorial style which pervaded American schools in the twenties and thirties. This type of work could not be said to conform to the philosophy of art as experience as expressed by Dewey, Dow's colleague at the Teachers' College, nor to the growing movement for self-expression; indeed, Dow's synthetic method as elaborated in his *Theory and Practice of Teaching Art* (1908), with its analysis of line, dark-and-light, and colour, has more in common with modern basic or foundation courses. One passage of Dewey's *Art as Experience* seems to owe much to Dow's concept of composition. Dewey wrote:

> 'The function we are likely to assign to line, upon first thinking of it, is that of form. A line relates, connects It is an integral means

of determining rhythm. Reflection shows, however, that what gives the just relationship in one direction constitutes individuality of parts in the other direction. Suppose we are looking at an ordinary "natural" landscape consisting of trees, undergrowth, a patch of grassy field, and a few hills in the background. The scene consists of these parts. But they do not compose well as far as the entire scene is concerned. The hills and some of the trees are not placed right, we want to rearrange them.'[48]

The main contribution which Dow made to art education was that he diverted the schools from training in accurate drawing towards the practice and appreciation of art.

MARION RICHARDSON AND THE 'NEW ART TEACHING'

From 1930 to 1939 a revolution took place in art teaching methods in Britain and Canada, initiated mainly by Marion Richardson and R. R. Tomlinson, inspectors of London County Council, the new methods being styled the 'New Art Teaching' by contemporary teachers. Roger Fry, Sir Kenneth Clark, Mrs Eccott, and Evelyn Gibbs all contributed to the movement.

After leaving the Birmingham School of Arts and Crafts at the age of nineteen to take up her first teaching post at Dudley Girls' High School, Marion Richardson found herself faced with several important problems. While at Birmingham in Catterson Smith's class for 'shut-eye' drawing, she had become convinced that representations of vivid mental images were far more artistic than accurate copies, and her first difficulty was the unimaginative work which the girls had to practise for examination purposes. The senior girls had to sit for the School Certificate, which demanded accurate object drawing, plant drawing, and costumed-life drawing. Marion Richardson's solution was to make this set work as interesting as possible by strengthening the imagery of the subjects. Object groups were sometimes placed in semi-darkness, lit by a bicycle lamp. 'This cast long shadows,' she explained, 'which linked the objects and gave the group a most moving and dramatic quality.' In the case of plants the children were encouraged to make pictures out of groups of contrasting and unfamiliar flowers, or seaweeds. For costumed-life Marion Richardson added dress accessories and often used the artificial light method, which, she declared, 'showed the seated figure as a sort of statue carved out in great shadowy shapes'.[49]

Time could be spared from these required subjects to do the creative work Marion Richardson desired, especially with the younger girls, but a lantern was not available to show slides in the way Catterson Smith had done, so she fell back on vivid word pictures. 'I knew that the

children did their best work when painting from mental images,' she wrote: 'I was myself a natural visualizer and found that the children were interested in descriptions of my own imagery . . . and that whatever possessed for me the genuine picture quality had a sort of incandescence which I could communicate.'[50] Many of the 'pictures' were of ordinary contemporary subjects from her pupils' environment in Dudley. Once the children had acquired the habit of these 'mind-pictures', they brought to school many they had done at home. By these methods, carried out in a wide range of media, the imaginative, rhythmic, and colourful qualities of child art were retained up to the teenage years.

Marion Richardson took a selection of her pupils' work with her when visiting a children's exhibition at the Omega Workshops, and Roger Fry asked to see it. The art critic was so impressed that he asked if he could include some of the paintings in the exhibition. This meeting with Fry proved of great importance, for through Roger and Margery Fry, and their friend Margaret Bulley, the art historian, Marion Richardson became acquainted with the leading artists and critics of her day, and recognition of her work was assured. An exhibition of her pupils' art was shown with great success at the Grafton Galleries in 1920; in 1924 she was appointed Lecturer in Art at the London Day Training College, and in 1930, District Art Inspector to the London County Council. R. R. Tomlinson was her senior colleague at County Hall. It was during her time as an inspector that her famous writing patterns were evolved, which were intended to develop rhythmically 'side by side' with painting.*

The immensely popular courses that Marion Richardson gave for teachers, and her exciting methods, such as colour games, rag pictures, and fairy flowers, are fully described in her classic, *Art and the Child* (University of London Press, 1948). Her teachings were not confined to Britain, for in 1934 she toured Canada at the invitation of the Carnegie Trust, giving lectures illustrated by the work of English children. She was delighted with the enthusiasm of the Canadian teachers, but her greatest satisfaction must have been to see the splendid results of all her efforts at the great exhibition of child art in the County Hall, opened by Sir Kenneth Clark on 12 July 1938 and visited by 26,000 people.

MARION RICHARDSON AND THE ROLE OF THE TEACHER

Marion Richardson was primarily a teacher, a teacher of the average child, not the especially artistic pupil. Teachers recognized this, and that her methods worked, hence her popularity. She taught that children needed positive stimulation by the teacher before they could realize how to express their ideas. This is the difference between her teaching

* Her series *Writing and Writing Patterns*, published by University of London Press Ltd.

philosophy and that of Cizek, who claimed to be a mere onlooker who allowed the children's lids to come off. She expressed the following view of the teacher's role:

'It is not too much to say that unless relationship amounting to love exists between teachers and children, children's art, as it is now understood, is impossible.

'How does this love translate itself into action? For work such as is seen here is not "free expression" as generally understood, which may be merely unconscious imitation, but a disciplined activity in which the teacher's own imaginative gifts play a very important part. . . . One essential is established. The good art teacher will always take his children and their drawings completely seriously. Perhaps this counts for more than anything else and is the means of inducing the children to demand the very best of themselves. They need, especially as they approach self-consciousness, the authority of a grown-up to convince them that their own art is worth while and to warn them against accepting the ready-made and secondhand which surrounds them on every side. This seriousness comes easily to the teacher as he realizes that his work with children may in the end provide for him a key to the understanding of art in its widest sense.'[51]

Marion Richardson believed that the natural rhythm of the child's movements should be fostered by writing patterns and bold use of media in art work. She affirmed that poetry, music, and dancing, to which she often referred, all contributed to the development of the rhythmic endowment of the child, and that her methods of art teaching would encourage the creation of 'a music of shapes', her definition of beauty. She was not the first pioneer of writing patterns. Ablett had practised some with children over thirty years before, and had written:

'The tedious methods of teaching writing, at present universally adopted, are terribly wasteful of the precious hours of school life . . . Yet experience shows it is quite possible to greatly reduce this time, by making the practice of the curves of the letters as charming to a child as its own spontaneous efforts to make pictures.

'In such spontaneous efforts in outline-drawing, the very young use the method of making a line which is employed in writing. Each separate idea, or perception of form, is represented by one effort of the hand.'[52]

Marion Richardson arrived at the same conclusion from her own observations, and perfected a rhythmic and practical system.

R. R. TOMLINSON

R. R. Tomlinson merits a special place in the history of art education for disseminating knowledge of the new methods of art teaching. Tomlinson was a pioneer of intelligent and artistically illustrated books on child art. His *Crafts for Children* (Studio, 1935) is a remarkable book for its time, inasmuch as it gives a brief history of craft teaching, and treats the reader as an intelligent educationist, rather than following the old pattern of dishing out methods to copy. His *Picture-Making by Children*, published in the previous year, was described in *Teachers World* as 'the first serious attempt to describe and adequately illustrate the new spirit in art teaching that is pervading the schools, not only in this country, but throughout the world'; a revised edition, *Picture and Pattern Making for Children* was published by Studio in 1950. Tomlinson's latest production written in conjunction with John Fitzmaurice Mills, *The Growth of Child Art*, is another example of constructive writing on art education.[53] Apart from his writings, Tomlinson should also be remembered as a pioneer of art appreciation for children and of fine prints for schools. He is the present (1969) chairman and president of the Royal Drawing Society.

Sources

1. ADAMSON, J. W. *English Education 1789–1902* Cambridge University Press, 1930 (p. 296)
2. LAMARCK, JEAN BAPTISTE *Histoire naturelle des animaux sans vertèbres* (1815): Introduction
3. SPENCER, HERBERT *Education* Williams & Norgate, London, 1878 (pp. 79–81)
4. Ibid.
5. Ibid.
6. BAIN, ALEXANDER *Education as a Science* Kegan Paul, Trench, Trubner, London, 1896 (p. 171)
7. Ibid. (p. 426)
8. *Journal of Education*, 1 December 1885, and 1 January 1886: Paper read to the Education Society on 'Our Art Teaching and Child Nature' (the paper reviewed the discussion at the Art Section of the International Conference on Education's Health Exhibition, 1884)
9. Ibid.
10. SULLY, JAMES *Studies of Childhood* Longmans, Green, London, 1895; also SULLY, JAMES *Children's Ways* Longmans, Green, London, 1897
11. *Catalogue* to the Exhibition of British Children's Drawings for North and South America, 1941–2: Introduction by Sir Herbert Read
12. SPENCER, HERBERT *First Principles* (1862) (Thinkers' Library edition) Watts & Co., London, 1937 (pp. 317–18)

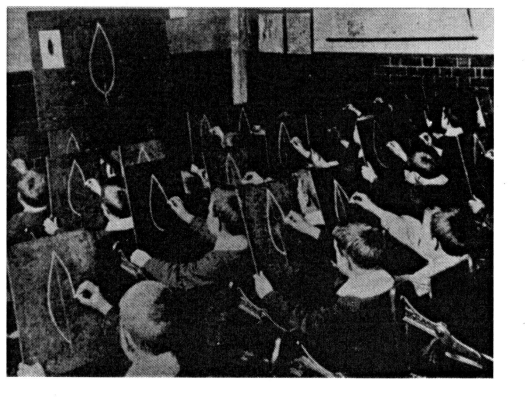

Before and after the 'New Art Teaching':
36. Freearm drawing (1901), introduced on a national scale in 1895
 by the *Alternative Syllabus* of the Department of Science and Art
 By permission of Thomas Nelson and Sons
37. Bringing colour into a dull environment, Manchester (*c.* 1945)

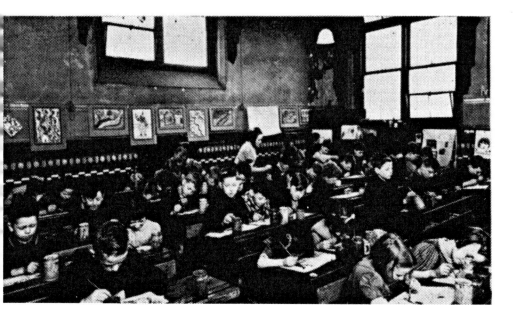

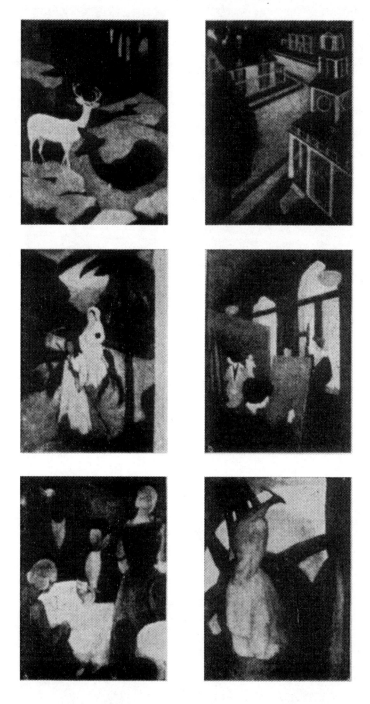

38. Compositions based on 'notan' by students of the
Teachers' College, Columbia University (1925)
By permission of William Heinemann Ltd

13. READ, SIR HERBERT *The Meaning of Art* Faber & Faber, London, 1931 (pp. 39–40)
14. VIOLA, WILHELM *Child Art* University of London Press, second edition 1944 (p. 16)
15. STEVENS, G. A. 'Educational Significance of Indigenous African Art' In *Arts and Crafts of West Africa* Edited Sadler, Sir Michael Oxford University Press, 1935 (p. 13)
16. ADAM, LEONHARD *Primitive Art* Penguin Books, Harmondsworth, 1949 (pp. 27, 33)
17. BAER, KARL ERNST VON *Ueber die Entwickelungs-geschichte der Thiere* (*History of the Development of Animals*) 1828 (Vol. I, p. 223)
18. HAECKEL, ERNST HEINRICH *Natürliche Schöpfungsgeschichte* (1868) G. Reimer, Berling, 1874 (p. 10); and HAECKEL, ERNST HEINRICH *The History of Creation* Translated Lankester, E. Ray Henry King & Co., London, 1876 (Vol. I, pp. 10–11)
19. LOWENFELD, VIKTOR *The Nature of Creative Activity* (Vienna, 1938 first English translation, 1939) Routledge & Kegan Paul, London, second edition 1965 (pp. 136–8)
20. UCKO, P., and ROSENFELD, A. *Palaeolithic Cave Art* (World University Library) Weidenfeld & Nicolson, London, 1967 (p. 38)
21. VIOLA, WILHELM *Child Art* University of London Press, second edition 1944 (p. 20)
22. RICHARDSON, MARION *Art and the Child* University of London Press, 1948 (p. 82)
23. FOX, CHARLES *Educational Psychology* Kegan Paul, Trench, Trubner, London, 1925 (p. 81)
24. SULLY, JAMES *Children's Ways* Longmans, Green, London, 1897 (p. 173)
25. LOWENFELD, VIKTOR *The Nature of Creative Activity* Routledge & Kegan Paul, London, edition of 1965 (p. 133)
26. WORRINGER, W. *Formprobleme der Gothik* Munich, 1912; and translation *Form in Gothic* G. P. Putnam's Sons, London, 1927 (p. 29)
27. LOWENFELD, VIKTOR *The Nature of Creative Activity* Routledge & Kegan Paul, London, second edition 1965 (p. 135)
28. TOMLINSON, R. R. *Picture and Pattern Making for Children* (1934) Studio, London, revised edition 1950
29. Ibid.
30. CIZEK, FRANZ *Children's Coloured Paper Work* Anton Schroll, Vienna, 1927 (p. 3)
31. WILSON, FRANCESCA MARY *In the Margins of Chaos* John Murray, London, 1943 (p. 124)
32. LOWENFELD, VIKTOR *The Nature of Creative Activity* Routledge & Kegan Paul, London, edition of 1965 (p. xviii)
33. VIOLA, WILHELM *Child Art* University of London Press, second edition 1944 (p. 94)
34. WILSON, FRANCESCA MARY *A Lecture by Professor Cizek* (pamphlet) Children's Art Exhibition Fund, London, 1921

35. LICHTWARK, ALFRED *Die Kunst in der Schule (Art in the School)* 1887

36. WILSON, FRANCESCA MARY *A Lecture by Professor Cizek* (pamphlet) Children's Art Exhibition Fund, London, 1921

37. WILSON, FRANCESCA MARY *The Child as Artist: Some conversations with Professor Cizek* Vienna, 1921 (pp. 4, 6)

38. RICHARDSON, MARION *Art and the Child* University of London Press, 1948 (p. 52)

39. CIZEK, FRANZ *Children's Coloured Paper Work* Anton Schroll, Vienna, 1927

40. LITTLEJOHNS, J. *Art in Schools* Introduction by R. R. Tomlinson University London Press, 1928 (p. 38)

41. MEAD, MARGARET *Growing Up in New Guinea* Penguin Books, Harmondsworth, 1942 (pp. 76, 80, 87, 154, 155, 167)

42. WILSON, FRANCESCA MARY *The Child as Artist* Vienna, 1921 (pp. 6, 8)

43. CIZEK, FRANZ *Children's Coloured Paper Work* Anton Schroll, Vienna, 1927

44. DULAC, EDMUND (editor) *Christmas* J. M. Dent, London, 1922 (Introduction)

45. DOW, ARTHUR WESLEY *Composition* (1889) Doubleday, New York, 1913 (pp. 5–6)

46. CRANE, W. *Line and Form* G. Bell, London, 1900; and CRANE, W. *An Artist's Reminiscences* Methuen, London, 1907 (pp. 76, 107)

47. DOW, ARTHUR WESLEY *Theory and Practice of Teaching Art* Teachers' College, Columbia University, New York, 1908; and COX, GEORGE J. *Art for Amateurs and Students* Heinemann, London, 1926 (p. 202)

48. DEWEY, JOHN *Art as Experience* Allen & Unwin, London, 1934 (p. 202)

49. RICHARDSON, MARION *Art and the Child* University of London Press, 1948 (pp. 25, 63)

50. Ibid. (p. 14)

51. RICHARDSON, MARION *Note* to Exhibition of Children's Drawings at County Hall, London, July 1938

52. ABLETT, T. R. *How to Teach Drawing* Blackie, London, no date, third edition *c.* 1895 (pp. 19–20)

53. TOMLINSON, R. R., and MILLS, JOHN FITZMAURICE *The Growth of Child Art* University of London Press, 1966

19

University and Polytechnic

In January 1959 the Minister of Education appointed the National Advisory Council on Art Education, under the chairmanship of Sir William Coldstream, to consider both the suggestions of the Report of the National Advisory Committee on Art Examinations of 1957, and the Minister's subsequent recommendation in Circular 340 that a new diploma of a higher standard should replace the National Diploma in Design (N.D.D.). The first report of the Council in 1961 outlined the requirements for the new award, the Diploma in Art and Design (Dip.A.D.). These were, in brief, a pre-diploma course of one year, followed by a three-year diploma course in one of four areas of specialization: Fine Art, Graphic Design, Three Dimensional Design, and Textiles/Fashion. History of art was to be studied throughout the course and examined for the diploma, and fifteen per cent of the course was to be devoted to the history of art and complementary studies.

To enter the diploma course a student must have reached the age of eighteen and have obtained at least five O-level passes in the General Certificate of Education, but these minimum qualifications could be waived for a student of outstanding artistic promise.

The Advisory Council also recommended that an independent body should be established to administer the new award, to be responsible for approval of the courses 'from the academic point of view', and for examination arrangements; thus in March 1961 the Minister of Education set up the National Council for Diplomas in Art and Design under the chairmanship of Sir John Summerson to ensure that the new courses were of the breadth envisaged in the Coldstream Report, and of a height above the existing N.D.D. Applications for the new diploma courses were invited and battle was joined in February 1962, when the visitations of the five area panels of the Summerson Council commenced. One panel represented each of the four areas given above, and the fifth inspected facilities for history of art and complementary studies.

Traumatic neurosis resulted from the Council's findings, a symptom described by Maurice de Sausmarez as 'diploma daze'. Out of 201

Dip.A.D. courses applied for by 87 colleges, only 61 were approved at 29 colleges. Colleges which had not long before been judged fit to be called 'Regional', after a rigorous Ministry inspection, now found themselves without approval, and the policy, only recently established, of a college serving local needs received a severe setback. In the words of the Art Colleges Working Party of the N.U.S. (1964), 'some large areas of the country had now no provision whatever. East Anglia, Mid and North Wales, still have no Dip.A.D. courses, and the failure of Stoke-on-Trent College to obtain recognition for its pottery course has now become a legend.'* The first Report of the Council in February 1964 stated that it had no concern 'either with the number of courses or of places within a national pattern or with the geographical distribution of colleges conducting approved courses'.

The Summerson Report was at its most damning on the history of art and complementary studies, remarking that 'many of the proposals submitted were for courses of lectures which had not yet been given and for which lecturing staff had not been appointed', but this was hardly surprising considering that the principals had been allowed barely a year since the Coldstream Report to implement the new policies before the visitations commenced. The Council were concerned with standards, not sociological facts and figures, and the main source of the ensuing unrest arose from injured pre-Diploma students. There were only 1480 places available on Dip.A.D. courses and 3030 pre-Diploma students. In London in the same year (1964) there were over 400 applicants for one centre.

By 1969 forty Colleges of Art had achieved recognition for Dip.A.D. courses. A list of these colleges and the courses appears in Appendix B.

ROBBINS: STRATIFICATION AND INTEGRATION

In 1961 the Robbins Committee was appointed by the Prime Minister 'to review the pattern of full-time higher education in Great Britain', and, doubtless because of the current Coldstream and Summerson activities, little attention was given to the position of local art colleges in the various strata of institutions envisaged. At first glance the Report, published in 1963, seems to have little import for the status of art colleges apart from the recommendation that 'the Royal College of Art should be treated administratively in the same way as Colleges of Advanced Technology and brought within the ambit of the Grants Commission'. The policy put forward for art colleges seems bizarre against the background of the current massacre of the Regional College system, namely that 'advanced courses in art should develop on the lines of Regional and Area Colleges'. The Report also stressed, following the

* This situation was later somewhat ameliorated (see Appendix B, 1).

suggested elevation of the Royal College to university status, that 'diplomas, rather than degrees, should in general be the awards open to advanced students in art'. Many art lecturers sensed that area art colleges had been robbed of the promised 'first degree' status. Corin Hughes-Stanton expressed this view in the *S.I.A. Journal*: 'Dip.A.D. was originally supposed to have put recognized schools or colleges on a par with the Colleges of Advanced Technology. But hardly had this happened than the Robbins Report recommended that ten CATS should be given university status. – So that while a degree is necessary for a technical qualification, it is not necessary for an industrial design qualification. Therefore it is not so important; therefore it is at the bottom of the priorities list; therefore it is going to be harder to get the necessary money and support.'[1]

THE ROYAL COLLEGE BECOMES A UNIVERSITY INSTITUTION

Following the recommendation of the Robbins Report that the Royal College of Art should be brought within the ambit of the University Grants Commission, an advisory committee was set up under Lord Redcliffe Maud which recommended that the College should become an independent university institution granting its own degrees. A Royal Charter was granted to the College by Queen Elizabeth II on 11 September 1967, and thus, one hundred and thirty years after the foundation of the first School of Design at Somerset House, the central art institution achieved university status.

The honour was deserved on account of the rapid progress made in the field of industrial design from 1948 when the present rector, Sir Robin Darwin (knighted in 1964), was appointed principal. Up to this date there had been no great change in policy since the reorganization of 1901, described in Chapter 17. 'Design' and classes for 'workshop instruction in the crafts' had thriven under Lethaby and his successor Professor E. W. Tristram, also the fine arts had prospered greatly during the principalship (1920–35) of Sir William Rothenstein, but the accommodation remained a disgrace for a leading national institution. Following the climate of opinion created by the Gorell Report, the Board of Education had in 1936 set up a committee under the chairmanship of Viscount Hambleden to report on advanced art education, with special reference to the Royal College. The Hambleden Report recommended complete new buildings and equipment, but these developments, and progress in industrial design, were arrested by the outbreak of war and evacuation to Ambleside in the Lake District, where the principal, P. H. Jowett, sadly commented: 'we could not bring much of our heavy equipment with us'. The pictorial bias of 'Design' at that time was demonstrated by the staffing, the three assistants in the School of Design

being John Nash, Paul Nash, and Edward Bawden, all famous as painters and illustrators, the 'Craft Teachers' being classified separately.

The change of policy in 1948 is best described by Sir Robin Darwin:

> 'Of the academic changes, much the most important was my decision to pursue a policy of rigid specialization in all fields of design, to discard responsibility towards the teaching profession and to provide courses of a thoroughly professional nature in all primary industrial fields.'[2]

Not until 1962 was the first new building completed at Kensington Gore. Appropriately, priority was given to the School of Industrial Design, for it was in this field that the greatest advance had been made, the College's achievements including the Lion and Unicorn Pavilion in the Festival of Britain (1951), stained glass windows for Coventry Cathedral, the interior design and furnishings for s.s. *Oriana*, and the casings of certain B.R. diesel-electric engines. Sir Henry Cole, the founder of the institution at South Kensington, would have been delighted with the policy of charging full professional fees for these commissions and using the ensuing profits for educational purposes! More recently the College has been engaged on design research for Government departments and other important bodies. The Research Unit of the College is run by Bruce Archer under the superintendence of Misha Black, Professor of Industrial Design (Engineering). It is calculated that over a fifth of the income of the Royal College of Art will derive directly from programmes of research sponsored by industry or the Government during the year 1968–9.

The College now awards the degree of Master of Art, designated M.Art (R.C.A.) in Painting (Professor, Carel Weight, C.B.E., R.A.), in Sculpture (Professor, Bernard Meadows), in Graphic Design (Professor, Richard Guyatt), in Ceramics and in Glass (Professor, Lord Queensberry) and in Film and Television (Professor, Keith Lucas). The degree of Master of Design, designated M.Des. (R.C.A.), is awarded in Industrial Design (Engineering) (Professor, Misha Black), in Furniture Design (Professor, David Pye), in Interior Design (Professor, Sir Hugh Casson), in Textile Design (Professor, Roger Nicholson), in Ceramics and in Glass (Professor, Lord Queensberry), in Silversmithing and in Jewellery (Professor, R. Y. Gooden), in Fashion Design (acting head, Joanne Brogden). Every student, unless specially exempted, has to attend a two-year course of lectures and seminars in General Studies under the direction of the Dean, Christopher Cornford.

Many graduates will have studied for one year as a pre-Diploma student, plus three years for Dip.A.D., plus three years for M.Art or M.Des., and may continue for an eighth (pedagogic) year. These

students should certainly be *'la crème de la crème'* as Cornford has called them. *Ars longa* . . .

BACHELOR OF EDUCATION WITH ART, AND FINE ART DEGREES

The Robbins Committee expressed the hope that Colleges of Education would be federated in university schools of education, and would provide four-year courses leading to the university degree of Bachelor of Education. This offered a unique opportunity for students to take art together with education and other academic subjects, and by September 1966 several of the more progressive universities had approved such courses.

Against a background of four years' sound studies in educational philosophy, psychology, sociology, and history, the B.Ed. courses in art will no doubt promote new approaches to the problems of art teaching, especially as many colleges are running a four-year course in the theory and practice of art education. While the art students at the colleges are encouraged to regard themselves as creative artists, the annual teaching practices, during which they take other subjects, confirm their roles as teachers and liberate them from the bathetic neuroses of those struthious art students who refuse to face reality until the eleventh hour.

The greatest disadvantage is the time element, for in many colleges only the equivalent of one day's practical work per week can be supervised throughout the whole course. Art education and art history may even eat into this time, and the total number of hours spent upon practical work may not reach the sum achieved by an art school student on the completion of his pre-Diploma course. Not only is the college student out on teaching practice at least once a year, but also his tutors may be out on this duty during three separate months in the same period. In these circumstances the quality and quantity of work produced by some students is admirable.

Frequent contact with the successes and failures of artwork in schools enables the staff constantly to re-examine the fundamental problems of art and design teaching. The first B.Ed. courses in art have only just terminated and their final achievement remains to be seen.

During the nineteenth century several universities instituted degrees for which it was possible to carry out practical art. Unlike the Slade's, which has already been discussed, these university courses include much history of art. Edinburgh University awards an M.A. Fine Art; Leeds, Newcastle, and Reading Universities a B.A. Fine Art. These universities have instituted a combined portfolio inspection scheme, whereby candidates for the courses submit portfolios and photographs of work at an inspection centre. Studio work at Edinburgh is carried out in conjunction with local Colleges of Art. The courses planned by Victor

Pasmore and Richard Hamilton at Newcastle are an important step in the history of art education.

Fine art courses leading to a degree have also been instituted at the Universities of Cambridge, East Anglia, Essex, Exeter, and Sussex. Presumably the intention is to produce a graduate who has achieved a high standard of both fine art and scholarship. This is a difficult task unless the studio work is done in cooperation with a major College of Art.

<div align="center">STUDENT UNREST 1968</div>

On 28 May 1968 the students at Hornsey College of Art staged a sit-in, took over the telephone exchange, and forced the principal, H. H. Shelton, to leave the premises. The students' requests varied from moderate suggestions for more dialogue and representation, to extreme demands for abolition of all academic entry and course requirements, student government of the College, and complete reorganization of national art education. The unrest spread to a few other colleges of art, notably Guildford and Birmingham, and some principals awaited the coming session with anxiety. The vast majority of these principals and their governors, who have to bear the brunt of this unrest, as well as criticism by press and television pundits, have had little to do with shaping the policies for the Dip.A.D.; nor has the National Society for Art Education (N.S.A.E.), the professional association for art teachers since 1888, been involved. The present situation is the eventual result of the deliberations of the distinguished gentlemen on the Coldstream and Summerson Councils, upon which there were very few local principals. Hornsey, where the first major signs of unrest occurred, is judged to be following the policies of the Coldstream Report so successfully that the Summerson Council has recognized the College for Dip.A.D. in all four areas of study. Little wonder that some principals, who have had to tolerate the painful imposed policies and the arbitrary assessments of recent years, have become reserved, politic, and uncommunicative.

It is clear from Document No. 11 of the Hornsey students' action committee, and from the resolutions and actions at Birmingham, that some students doubt the need for any serious academic studies either in their schooldays or at a College of Art. They not only demand the abolition of G.C.E. entrance requirements, but the elimination at art college of compulsory examinations based on academic study. At Hornsey their only serious academic discipline, 'the history of art component', was specifically mentioned, and at Birmingham the sit-in was to prevent students from taking their history of art examinations. The Hornsey students say that an art student should not necessarily be 'particularly fluent with the pen'. But what are these fearsome entrance

requirements laid down by the Coldstream Report which they wish to abolish? A mere five O-levels, one of which may be art, and only three of which need be academic subjects. This does not demand 'particular' fluency at anything; the requirement merely ensures a minimum level of intelligence, and even then the Coldstream Report was liberal enough to recommend 'that students of outstanding artistic promise who are capable of taking a diploma course but have not obtained the proposed minimum educational qualifications should be eligible for admission . . .'. There are not many such admissions; 36 were allowed in 1967, for example. But principals may be pardoned for doubting whether many applicants without the minimum academic requirements have the intelligence and industry to render them 'capable of taking a diploma course'.

Some of the objections raised by the students are by no means unreasonable. The most intense opposition to the entrance requirements and to the need for academic studies comes from the students on Vocational Courses, who started hopefully in pre-Diploma courses, are now completing their courses with no diploma in design recognized at a national level, and who complain that in the second Coldstream Report vocational courses were defined as low level semi-apprenticeships. The Report's recommendation for the award of Area certificates was disappointing. The treatment of vocational day and evening students in art education has been a disgrace from 1837 to the present day. Often some pundit, who aspires to be above all such lowly things as diplomas, informs students that diplomas do not matter when they apply for jobs, that it is their work that is judged. This is most misleading: initially diplomas matter very much in this meritocracy of ours. The pundit himself is usually inordinately well-armed with diplomas and degrees, and invariably ensures comfortable security by teaching. It has been suggested that one solution to the problem of a qualification for vocational students is the provision of courses leading to the award of Licentiate of the Society of Industrial Artists (L.S.I.A.).

The Society of Industrial Artists and Designers, incorporated in 1930, has acquired a very high reputation, due largely to its policy that persons are only admitted to full membership (M.S.I.A.) who can provide examples of commissioned industrial art of a high standard. Art college graduates may or may not be competent designers, but a M.S.I.A. is almost certain to be within his specialized field, and the senior officers such as Milner Gray, Hulme Chadwick, Neville Ward, Jack Howe, Peter Lord, and John Reid have international reputations. Recently the Society has taken practical steps, through its education committee, and student affairs sub-committee, to assist student designers. Those who hold the Dip.A.D. can now be granted the L.S.I.A. on

application, and colleges may register courses for direct entry into the Society, providing they invite the Society to appoint external examiners.

The students' complaints about 'arbitrary' examinations are probably valid. There has been some improvement since the mad years from 1952 to 1964, when internal assessments for diplomas were frequently turned completely upside down by the arbitrary artist-examiners, those who were, in the opinion of a whole staff, the best students being failed – indeed, on occasion whole schools being failed in a particular subject: results which the Councils of the N.S.A.E. and the Association of Art Institutions declared 'freak'. But even today consistent assessments and reasonable moderation are often wanting.

Another suggestion made by the students is that Art and Design schools should not be governed by the councillors and educationists upon local education committees, but by bodies of practising artists and expert art educationists. Sir Hugh Casson is of the opinion that in his experience 'councillors can be far more liberal and understanding than artists and experts'.[3] In fact, as Casson implies, practising artists and art educationists have always been more ruthless and domineering than councillors or general educationists: artists tend to be single-minded. It was Redgrave who imposed the awful National System of Instruction with such fanatical zeal, it was Poynter who introduced a two years' course of drawing exclusively from the cast, it was Millais who considered art schools unnecessary, it was Ashbee who suggested their abolition, it was the practising artists of the Summerson Council area panels who ruthlessly pruned the art schools, and it is Reg Butler who advocates 'the ruthless exclusion from art schools of all doubtful candidates', adding: 'Separating the men from the boys at the beginning and during the early stages of any course should be handled much more ruthlessly.'[4] In the past it was local councillors who donated funds to build art schools and art galleries, precious little ever being given by senior wealthy professional artists, who mostly seem to have the attitude that only the very best should pursue art. The frogs may eventually get rid of their councillor governors and acquire a stork king, or a few water serpents.

POLYTECHNICS AND THE FUTURE

In 1966 the White Paper, *A Plan for Polytechnics and Other Colleges*, was published following Anthony Crosland's* speech at Woolwich Polytechnic in which the binary system in higher education was outlined. Polytechnics are to be, in the words of the Paper, 'the main centres for the future development of full-time education within the further education system'. The Paper proposed twenty-eight possible Polytechnics, and local education authorities were asked to submit schemes for amalgam-

* He was then Secretary of State for Education and Science.

ating institutions. Sixteen schemes were provisionally approved in 1968, nine of which include art colleges: Bristol, Manchester, Newcastle, Portsmouth, Sheffield, Stoke, Sunderland, Waltham Forest, and Wolverhampton. Disquiet is felt by some art teachers at the prospect of some first-class art colleges being amalgamated with second-class technical and commercial institutions, but others believe that an art college of a Polytechnic may eventually be more free from varying 'national art education' recommendations.

Local art colleges are now attempting to put into practice the Cold-stream recommendation that students should work within a broad area, say Three Dimensional Design, with possible supporting studies from any other area. The Report clarified this recommendation for each area; for example, for Three Dimensional Design: 'In all courses the aim should be to give students an opportunity both to range over a number of three dimensional subjects and to exploit more thoroughly the possibilities of one particular subject or group of subjects.'[5]

Much debate has been stimulated by this recommendation, regarding the comparative merits of 'linear' or 'network' systems. The intention of a broad approach is to give a 'liberal education in art', but critics of this system argue that, in practice, the result is superficial experimentation together with endless theorizing, tending to produce the type of social drone Gropius detested. Misha Black believes that wider interests and discipline 'develop from intense concentration rather than the reverse'.[6] Some fear that the barriers between art and craft disciplines, and the disciplines themselves, may be smashed so thoroughly that an abstract 'cultural' education results – 'four years delightful holiday', in the words of a modern student. Joyce Storey, a member of the S.I.A.D., writes: 'The breadth of Dip.A.D. courses can so easily be interpreted as meaning freedom for a student to pursue his own ideas completely uninfluenced by considerations of production methods, economics, and market research and so on. Surely a design student must be made to understand that designing is creativity channelled to a given end, and that it is not sufficient to do a splodge of colour over which he then coos with delight and rapture.'[7] Peter Farrell, lately on the staff at Guildford, seems to be on the other side of the fence, and declares that 'what they [the students] do with available equipment and how they do it is for the students to decide'.[8]

Whatever side we take in the present controversies, surely it is high time that the governors, principals, and staffs of recognized major art institutions should be allowed to decide their own policies for the award of their colleges' Dip.A.D., in communication with the ideas and needs of their students? The Department of Education and Science could instruct educational authorities that the awards of these institutions were

degree equivalents. Why does the award of internal 'full-time' art diplomas have to be supervised by a national body in the same way as external and part-time qualifications? Many major art institutions had a high reputation long before some present universities existed. It is a fact that those art institutions which have achieved the highest reputation at various times, namely the Slade, the Central School, the Glasgow School, and the Royal College, have done so at that time when they deviated from national art education policies. In July 1968 the Coldstream Council, prompted by the recent unrest, invited written views 'on any matters relating to the general structure of art and design education in colleges and schools of art', and we now await their deliberations. Perhaps in the future, under the Polytechnic umbrella, major art institutions may eventually achieve the freedom both to develop their own policies and to administer completely the award of a degree of their own institutions.

Sources

1. HUGHES-STANTON, CORIN 'Art Schools, Too Little, Too Late' *S.I.A. Journal*, February 1965 (No. 144, p. 1)
2. DARWIN, SIR ROBIN, in *The Times Educational Supplement*, 10 November 1967
3. CASSON, SIR HUGH, in *Sunday Times*, 14 July 1968
4. BUTLER, REG *Creative Development* Routledge & Kegan Paul, London, 1962 (pp. 13, 19)
5. *First Report* of the National Advisory Council on Art Education H.M.S.O., London, 1960 (para. 22, p. 7)
6. BLACK, MISHA *Cantor Lecture* to the Royal Society of Arts, 17 May 1965
7. STOREY, JOYCE Letter in *The Designer*, July 1967 (No. 173, p. 13) (Society of Industrial Artists and Designers, London)
8. FARRELL, PETER, in *Sunday Times*, 22 September 1968

20
Basic Design and Visual Education

*'The mind of the painter ought to be as continually concerned
with as many orderly analyses as there are forms or notable
objects appearing before him . . . The first principle of the science
of painting is the point, then comes the line, then the surface,
and then the body bounded by a given surface.'*[1]
Leonardo da Vinci

BASIC AND FOUNDATION COURSES IN GERMANY AND AMERICA

Art education is today becoming increasingly analytical, logical, and
thematic. This development originates from the Preliminary or Basic
Course initiated by Johannes Itten in the autumn of 1919 at the Bauhaus,
which was planned to liberate students from second-hand traditional
information, and to make them learn basic principles from direct
analyses and their own direct experience with materials. The course
work included:

Materials and Texture Studies: Exact depictions of nature's materials
from life and memory to give understanding of their structure, texture,
and inherent design; listing and collecting all manner of natural and
man-made materials; montages and assemblages of materials of
contrasting textures; creating textures with tools.

Studies of the Principles of Design: Analysis and representation of
contrasting elements and characters, such as point, line, plane, volume,
large/small, light/dark, transparent/opaque, smooth/rough, contrasting
directions, positive/negative, etc.; compositions of basic geometric
forms such as circles, squares, cones, etc., and compositions based on
their characters; compositions of forms abstracted from nature; precise
paintings of plants with emphasis on contrasting tones and textures.
Exercises in regular and irregular rhythms; formal colour theory
exercises, followed by painting themes suitable to bring out the
expressive character of colours; analyses of the pictorial constructions

and light/dark contrasts used by the old masters; expressionistic lines and compositions.

Itten wrote: 'The foundation of my design teaching was the general theory of contrast. Light and dark, material and texture studies, form and colour theory, rhythm and expressive forms were discussed and presented in their contrasting effects.'[2] His philosophy and his course are best studied in his book *Design and Form* (Thames and Hudson, 1967).

After Itten left the Bauhaus in 1923 the Preliminary Course was directed by Laszlo Moholy-Nagy and Josef Albers, the latter being an ex-student of the school. Under the supervision of these two artists the course turned towards three-dimensional construction. Albers commenced his part of the course with direct work on materials with manual tools, and encouraged the students to use materials in different ways from established processes. Plastic use was made of paper, card, and sheet tin. Simple units, such as matchboxes, sticks, sheets of glass, and razorblades were used as the bases of constructions. He also encouraged the creation of three-dimensional effects upon a flat plane – today's Op Art. The object of his course was to train the students in 'constructive thinking', with special reference to economy of form and the function of materials. Moholy-Nagy, a constructivist, was primarily concerned with aesthetically arranged space, 'space relationships; shapes which represent the fluctuating play of tensions and forces', and encouraged students to make pure space compositions, carefully balanced, and usually light in structure. Nagy's views are clearly stated in his book, *The New Vision* (W. W. Norton, New York, 1938). He left the Bauhaus in 1928, but Albers continued to take the Preliminary Course until the closure of the Bauhaus in 1933.

At Weimar, and later at Dessau, Klee and Kandinsky conducted courses at the Bauhaus, Klee instructing the students to look behind the façade of nature, to dig down, and so to learn to recognize the 'antecedents of the visible', and Kandinsky introducing linear analytical drawing of the constructional elements and forces in objects. Their teachings, and the colour experiments of their colleague, Hirschfeld Mack, contributed greatly to the modern analytical approach.

The ill wind which dispersed the Bauhaus staff brought the Preliminary Course to America. Albers was the first of the staff to arrive, being appointed Professor of Art at Black Mountain College, North Carolina, in 1933. In this experimental college, which provided optional courses and combined 'events' in art, music, and drama, Albers organized a basic Elementary Course. Xanti Schawinsky, who had studied display and stagework at the Bauhaus, also instructed at Black Mountain. Gropius and Moholy-Nagy arrived in 1937, Gropius to take up the senior professorship in architecture at Harvard, and Nagy to establish the New

Bauhaus in Chicago (now the Institute of Design of the Illinois Institute of Technology). A Preliminary Course was established by Nagy at the school and two of his Bauhaus pupils, Hinrick Bredendieck and Gyorgy Kepes, joined him on the staff. Basic courses were also started by ex-Bauhaus students at the New York Laboratory School of Industrial Design and the South California School of Design. Nagy died in 1946, but Albers continued to spread the movement in the late forties through courses at various American universities, before his appointment as chairman of the Department of Design at Yale. More recently the books of Gyorgy Kepes, and the courses in Visual Design at the Massachusetts Institute of Technology, have given great impetus to the swing towards visual education.

THE MOVEMENT IN BRITAIN

Britain did not follow the German lead until the fifties. There was an isolated example of a preliminary course set up in 1940 at Manchester School of Art by its principal, John Holmes, but the movement did not spread. The course at Manchester, supervised by Olive Sullivan, now a distinguished member of the S.I.A.D., was planned for all art and architecture students, and was described as follows: 'Students receive basic training in theory of drawing, form, and colour. Experimental workshop practice is combined with research into basic forms and study of materials.'[3] The course had many features of the Bauhaus course, including experiments in a wide range of media, studies and collections of materials, and basic training in crafts such as woodwork. The course never developed fully in the years following, because of requirements for the Intermediate examinations, and because the senior art staff, engrossed in representational work and possessed of vague ideas of the Bauhaus as a school of functional architecture, were uncertain what it had to do with fine art.

Though British art schools in the forties were indifferent to basic form studies, constructivist art, and other forms of non-figurative work, some British artists were becoming deeply interested. The best known of this group were Ben Nicholson and Barbara Hepworth, influenced by Mondrian and Naum Gabo respectively; others were the painters Victor Pasmore, Alan Davie, William Gear, John Wells, and Wilhelmina Barns-Graham, and the sculptors Robert Adams, Reg Butler, Lynn Chadwick, Bernard Meadows, Eduardo Paolozzi, and William Turnbull. Pasmore, Paolozzi, Adams, Turnbull, and Davie were on the staff of the Central School, together with Richard Hamilton and Victor Halliwell, and, approximately from 1952, abstract work, strongly related to basic forms, was introduced into the School by these artists. Pasmore followed this development by directing courses concerned with the basic

elements of art at the Scarborough summer school of the North Riding Education Committee, together with Harry Thubron, Tom Hudson, and Wendy Pasmore of the Leeds College of Art. Pasmore and Hamilton then set up a basic course at Newcastle; and Thubron, assisted by Hudson, Davie, Hubert Dalwood, and Terry Frost did the same at Leeds.

The movement was accelerated by exhibitions at the Institute of Contemporary Arts, organized by Hamilton, Pasmore, Thubron, Davie, Hudson, Frost, and Dalwood – e.g., 'Growth and Form' (1951), 'Man, Machine and Motion' (1955), and 'The Developing Process' (1959). The setting up of pre-Diploma courses following the Coldstream Report also contributed, for, although the report advised 'Each art school should be free to construct its own pre-diploma courses . . .', many young teachers looked to Pasmore, Hamilton, Thubron, and Hudson for leadership. The exhibition at that time of the coursework of the Department of Foundation Studies at Leicester, entitled 'The Visual Adventure' and organized by Hudson, inspired many art teachers. The principal at Leicester College of Art, E. E. Pullée, described the course as 'an initial programme prior to any form of specialization'. The new approach was keenly supported by Martin Froy and Robyn Denny of Bath Academy of Art.

The course at the Bauhaus provided many growth points which are just being comprehended today. In the recent past how often has one heard the foolish remark, 'We are past the Bauhaus', from an art educator whose class has not reached its point of development, and is practising one limited aspect of the courses of Itten, Albers, or Nagy; as Tom Hudson states, 'Apart from a few isolated and fitful attempts there has been little development in this country of the work of those great pedagogues.' Some educators and practising artists, such as Pasmore and Hudson, do not now conceive the new approach as confined to basic courses, but rather to the whole of art education. Hudson, Director of Studies at Cardiff, urges the need for every student to be given opportunity to shape his own ideas of form by personal discovery, working alongside a large group of students, the desirable situation being anti-art, inasmuch as the purpose is not to produce a preconceived artefact, but to discover forms from the process and material. The work is not without direction, on the contrary the student works on a planned project, say on proportion, or relating like and unlike forms, in order to invite new experiences and widening attitudes to art. The situation is open-ended, and the individual results are critically analysed by the class. Hudson advocates more three-dimensional work and the use of the machine in art education to introduce procedures related to today's industry and technology.

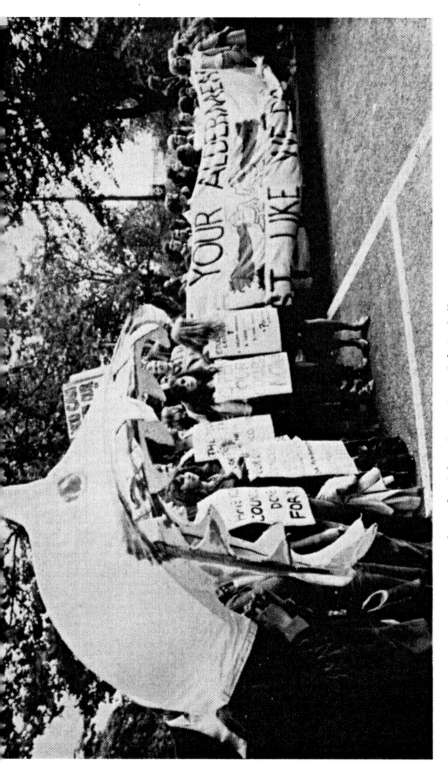

39. Hornsey students protesting about the delayed opening of their College
'*Daily Telegraph*' *24th September 1968, Copyright*

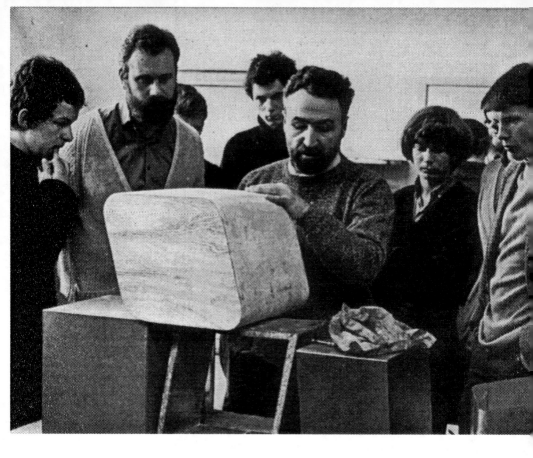

40. Tom Hudson discussing a problem with students at Cardiff
41. Work of the Grundlehre, Staatlichen Werkkunstschule, Saar-
 brücken (1968), illustrating stress upon geometry and measure
 (Director: Oskar Holweck)

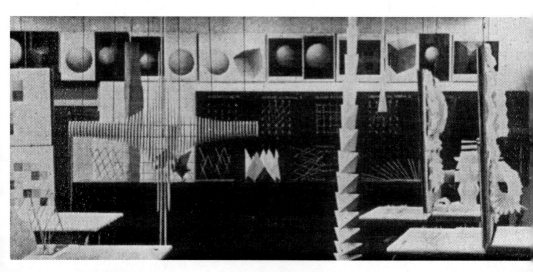

RECENT DEVELOPMENTS IN GERMANY

The most systematic and scientific foundation courses are to be found today, as might be expected, in Germany, for example, the Grundlehre at the Hochschule fur Gestaltung at Ulm, or the foundation course of the Staatlichen Werkkunstschule at Saarbrücken. The private school of industrial design at Ulm,* first directed by Max Bill, and later by Tomas Maldonado, rejects self-expression, and the first year course consists of disciplined exercises carefully graded from the simple to the complex, exercises in which the relationships of shapes are worked out scientifically; only in the second year are practical designs attempted. In the first year at Ulm there is an emphasis on the expert use of materials, and technical drawing is taught, for one of the main purposes of the school is, in the words of Hans Gugelot, 'to give to a student with an art education the technical background he needs to become an industrial designer'.[4]

The course at Saarbrücken directed by Oskar Holweck displays a forthright honesty and a logic unusual in art education; as Ueli Mueller states: 'Due to its clarity of concept, it enables us to gain a deep insight into the essential nature of foundation studies.'[5] The method of working is prescribed as analytical or synthetic, or a combination of both, according to the exercise; and the students work within a rigid framework which ensures the production of variations on a narrow theme. For example, the products might be various combinations of a square, modified through parabolic and straight folds, or, in another experiment, variations of dematerialization of wood by sawing. Many of the exercises, especially those upon dimensions and spatial movement, are based upon mathematics, and all students study algebra and applied geometry. Holweck maintains that only through such strongly directed experiments can students discover the possibilities for expression.

Some of the most exciting work in the Saarbrücken exhibition which toured Britain in 1968 was contained in the section on finding shapes in material. Dematerialization or modifications of shape of various materials were caused by boring, burning, hammering, cracking, rotting, chemicals, heating, chasing, splintering, and sawing. It is typical of the logical approach at Saarbrücken that an axiom results from these experiments: 'The more a material is exposed to destruction, the more similar it becomes in appearance to other materials [also undergoing destruction].'[6] The standards of technique and presentation demanded at Saarbrücken would cause a great exodus of the weaker brethren if applied in British colleges of art, not to mention the mathematical, metalwork, woodwork, and history of art requirements.

* The Hochschule was merged with the University of Stuttgart, winter semester 1969-70.

AIMS OF BASIC AND FOUNDATION COURSES

Divergences of opinion abound on the nature of a desirable basic course, but it is possible to define certain aims held in common by leading protagonists.

Firstly, a course should be designed to free the students from a disorderly conglomeration of previous art knowledge, and make them re-learn from direct experience. Itten includes in the first task of his course the advice that 'students should free themselves gradually from dead conventions'. Hamilton says that at Newcastle, 'The first aim of our course is a clearing of the slate. Removing preconceptions.'[7]

Next, a course should encourage an analytical outlook by imparting a knowledge of the visual elements through creative work. A student may then be able to think in terms of visual grammar, and a standard terminology may eventually be achieved. Itten paved the way with the introduction of art work based upon analytical terminology such as point, line, plane, volume, motion and counter-motion, rhythm, placement, accent points, form characters, line-analysis, balance, transition positive-negative, and so on. Sir Herbert Read referred to 'a new language, a language of forms'. Maurice de Sausmarez alluded to 'the component factors and elements of pictorial and structural expression'.[8]

A course should also acquaint the student with the structure of natural objects through analytical drawing, biological and geological slides, diagrams, and collections, and use of the microscope. For example, at Manchester College of Art and Design there is a special room for this purpose under the supervision of Ruth Hopwell.

Finally, a course should train the student to look critically and analytically at the work of notable masters by isolating and representing diagrammatically the elements of their compositions, whether of structure, tone, texture, or colour.

The aim of each schematic experiment of the Saarbrücken course is 'to realize and visualize, working to a prescribed rule and set schema, the whole range of available possibilities in using a certain number of elements'. Holweck argues that the frames of restriction of the exercises 'are merely a means to prove to the student that within this field can be found undiscovered freedom', and that working to a prescribed rule trains methodical thinking.[10]

Christopher Cornford gives the following general outline of class procedure on a basic course:

'A session of the class typically consists of a short lecture/demonstration by the instructor on the theme under consideration: an exercise carried out by the students: and finally a collective criticism and discussion. Notebooks are essential: students should

formulate and record the material of lectures as well as points which emerge in practice and criticism: otherwise much of value gets forgotten.

'Exercises are normally framed towards more than one of the aims, but they can vary in emphasis, some being directed more towards information and definition, others more towards invention and imaginative liberation.

'A good proportion of the exercises should be highly disciplined and exact – freedom without a basis of precision and clarity is meaningless and devitalizing. A grammar is being taught – but this will be dreary only to the extent that the instructor is himself uninspired.'[11]

Pasmore stresses that the basic course is essentially a 'developing process – All categories therefore overlap and point to other categories.'[12]

A common criticism of basic or foundation courses, as some are practised, is that, far from liberating themselves, the students produce stereotyped art forms, particularly in the constructivist tradition of the Bauhaus, the *De Stijl* group, and Gabo. Some 'basic' shows exhibit a hygienic array of smooth strips, tubes, and curving plastic forms worthy of a sanitary-ware designer, together with box-like and can-like structures and hard-edge graphics pleasing to a package artist. Some argue that such work forms a basis for industrial design, but not for other art; others, that students are doing tediously with their hands, or with simple tools, what is best done by machines.

Foundation courses in art schools are by no means all planned on the 'basic' tradition of progressive analytical experiments, nor was any particular type of course envisaged by the Coldstream committee. Procedures vary from a course of centralized classwork under the supervision of a special foundation course staff, to a course of projects in several departments under departmental staff. The artefacts resulting from some centralized courses are predominantly constructivist, from others surrealistic, and from others Op or Pop. Courses based on the intellectual analytical/personal-creative foundation seem to be more sound than those based upon the so-called widening experiences of making surrealist and Pop Art transmogrifications of everyday objects – transmogrifications in scale and material repeated annually.

Too much concentration upon abstract and intellectual/technical products frustrates the natural expression of students. Our nature is bio-technical, and the biological/instinctive/sensual aspects must be considered; hence a proportion of basic coursework for young people must be derived freely from natural objects, otherwise the natural rhythms in nature and within ourselves, which Itten emphasized, will be stultified by over-emphasis on geometric, formal, and technical elements,

and the course will not be the personal 'dynamic voyage of discovery' advocated by Pasmore, but a series of imposed abstractions.

VISUAL EDUCATION AND VISUAL DEVELOPMENT

'The goal of art is to aid in the
comprehension of the world's ideas.'
Georg Wilhelm Hegel

Visual elements, visual grammar, language, and literacy, visual communication, visual kinetics, visual perception, experience, and awareness, visual phenomena – the proliferation of such phrases in contemporary writings manifests the growing interest of art teachers in a visual education designed to benefit all children, not just the talented.

Together with Rousseau, past opponents of a predominantly aesthetic/ literary education have pointed out that child art education must take a form purposeful for all pupils, not a form primarily aimed at producing artefacts and artists: Cole and Walter Smith advised simple drawing, geometry, and perspective for all; Dow urged simple methods for art appreciation; and more recently Read put forward the view that education itself should be through art. Today, producing certain types of Child Art is not the dominant purpose of art education which it was a decade since; however, it was interest in Child Art and psychology in the thirties which caused progressive teachers to make the art lesson child-centred, and to study the child's visual needs. Evelyn Gibbs, writing in 1934, declared: 'The Teacher . . . must not teach the child how to draw so much as help him to see.'[13] A visual educationist today would go further than this and stress that a child should be led to comprehend the various elements of what he is seeing and making.

In *Education Through Art* (1943),[14] Herbert Read proposes that art education 'should more properly be called visual or plastic education' and should form two aspects of his total scheme for aesthetic education. In the scheme, visual education is for the eye, plastic education for the touch, musical education for the ear, kinetic education for the muscles, verbal education for speech, and constructive education for thought. Read's passion for neat classification and tables of correspondences, although intended to clarify, often makes heavy going and leads to confusion from a modern psychological standpoint, manifested in this case by the separation of 'thought' from most of the activities. In a further table he associates design with sensation, music and dance with intuition, poetry and drama with feeling, and craft with thought – all rather meaningless, as each mental process can be combined equally or unequally when performing each technique.

Read assumes that 'the general purpose of education is to foster the growth of the individual in each human being, at the same time har-

monizing the individuality thus educed with the organic unity of the social group'. He stresses the uniqueness of the individual and his primary concern in his book is with types of personality, expression, and imagery, rather than with the child's understanding of visual phenomena and positive visual education. Read's book brought to the attention of the art teacher for the first time a mass of psychology previously unfamiliar to artists, and the great increase in the study of psychology by art students in recent years is mainly due to him. It is possible here to give only a brief outline of these studies. A separate history is required for the psychology of art education.

<center>STAGES AND TYPES OF PERCEPTION</center>

The study of child psychology for art teachers in training today could be divided into two main categories:

1. stages of visual development;
2. types of expression and perception.

Probably the stages of visual development best known today are those of Sir Cyril Burt, Helga Eng, and Viktor Lowenfeld, Sully being usually remembered only as a pioneer. Burt in *Mental and Scholastic Tests* (1922) gave the stages as: Scribble (2-5 years), Line (4 years), Descriptive Symbolism (5-6 years), Descriptive Realism (7-8 years), Visual Realism (9–10 years), Repression (11–14 years), Artistic Revival (early adolescence). Helga Eng contented herself with defining three stages up to eight years – Scribbling, Transition, and Formalized Drawing – in her *Psychology of Children's Drawings* (1931), but the work contains a complete case study of the visual development of her niece Margaret up to eight years.[15] Lowenfeld and Lambert Brittain in *Creative and Mental Growth* (1947) define the stages as: Scribbling (2–4 years), Preschematic (4–7 years), Schematic (7–9 years), Dawning Realism (9–11 years), Pseudo-Naturalistic (11–13 years), The Period of Decision (adolescence).[16] This last system has the advantage of making use of the concept of *schema*, the fundamental basis of the psychology of Piaget, whose researches into children's perception are rewarding for the art teacher, especially *The Child's Conception of the World* and *The Child's Conception of Space* (with Barbel Inhelder).

The study of types of expression and types of aesthetic appreciation help the art teacher to understand the artistic preferences of individual children. The most significant line of theory for art education seems to be that established by Verworn, Munz, and Lowenfeld. Max Verworn, in his *Ideoplastiche Kunst* (1914), defined physioplastic and ideoplastic art: physioplastic, 'consisting of a direct reproduction of the natural object or of its immediate memory image', and ideoplastic, expressing ideas or abstract knowledge. Ludwig Munz was, through his research

into the art of the blind, the first to discover the relationship between it and the art of the seeing; and his colleague Lowenfeld has clarified and elaborated this relationship in *The Nature of Creative Activity* (1939),[17] in which he defines the two creative types as visual and haptic. A summary of the characteristics of each type might be given as follows:

Visual Type: concerned with depicting outer world by visual imagery – objective – realist and impressionist forms and colours – approximates to Jung's extrovert.

Haptic Type: concerned with projecting inner world by symbolic imagery – subjective – conceptual, symbolic, and expressionist forms and colours – approximates to Jung's introvert – tactual and synthetic concept of form as in the modelling of the blind.

Many attempts have been made to isolate and contrast types of aesthetic appreciation: C. W. Valentine's *Experimental Psychology of Beauty* (1962) describes many of them.[18] The field seems infinite, because one can classify the art to be judged how one wishes – detailed naturalism, say, as opposed to abstract design, or even, as in Edith Newcomb's experiment, 'trivial' as opposed to 'sublime'. The most commonly accepted contrasting types of appreciation, or, I prefer to say, perception, are the objective and the subjective, and the synthetic and the analytic. Results of experiments are often confusing, especially when attempts are made to make traditional personality types correspond to traditional divisions in styles of art. Lowenfeld does not fall into this error, his types are types of perception, but when Burt's experiments relate unstable introverts to the Impressionist style and the stable extroverts to the Realist style, the results are very dubious.[19] If the Impressionist picture had been a snow scene, and the Realist one very colourful, would the results be the same? In Burt's table, Classical pictures are preferred by the stable introverts; yet we know Classical art was produced and admired mainly by the Mediterranean races – hardly the place where such personality types abound! Edward Bullough's four aspects of appreciation, the objective, the intra-subjective, the associative, and the character aspects, provide the art teacher with a useful guide,[20] but probably the more rewarding research today for the teacher concerns visual perception, rather than traditional aesthetics associated with 'Beauty'. The researches of Lowenfeld, Vernon, Arnheim, Piaget, and the Gestalt psychologists deal with the perception of shapes, colours, lines, and space in a scientific manner – most informative for the visual educationist.

APPRECIATION AND HISTORY OF ART AND DESIGN

There has long been resistance to academic studies by art teachers and students, especially to the learning of anything factual for examination.

Appreciation is generally approved: the word 'history' provokes hostility. The opposition seems mainly located in the art schools. Many university students and schoolchildren are particularly keen upon the history of art, design, and architecture, and it is sad that, while children are keen to assimilate facts about their visual environments, many art teachers are disinterested.

Examinations in the history of art were introduced into schools in 1858 by the Oxford Delegacy and by the Cambridge Syndicate. The Oxford 'Drawing and Architecture' examination for seniors contained a section on the 'History and Principles of Design', but the questions set, probably by Dyce and Cockerell, were completely beyond the ken of Victorian drawing masters and less than fifteen per cent of the art candidates attempted this section. In following years several boards abandoned written papers on the history of art and architecture, because the art masters did not apply for them for their pupils. Richard Carline in *Draw They Must* (Arnold, 1968) records of the London Board paper, established in 1915, 'There can have been few candidates, since the papers were seldom sent.'[21] He also mentions that in recent years candidates for the history of art at G.C.E. O-level barely numbered two to three per cent of the total candidates in art. Donald Milner, chairman of the art advisory committee of the Associated Examining Board, states that he 'recently discovered that not one of a group of 24 senior students from a number of art schools had ever heard of the classical orders of architecture, nor could they name them'.[22]

Today some of the art teachers who are still interested in the subject feel that too much weight has been given to Renaissance painting, and Gothic and Renaissance architecture, and that there has been comparative neglect of the great movements in industrial and modern art. Papers would certainly be more stimulating to visual education if half the questions concerned the children's knowledge of art and architecture seen locally, as in the Bristol papers. The present sketch/notebooks presented by some schools for the new C.S.E., devoted to local study projects, are an excellent contribution. Studies of periods and styles of art are an essential aid to social and historical studies in the school, but visual experience of actual art and architecture is more stimulating.

VISUAL EDUCATION IN THE SCHOOL

The frequent use of such terms as 'visual grammar' and 'visual elements' gives us the key to the origin of the modern concept of visual education: both grammar and elements demand precise analyses of visual phenomena as advocated by Itten, Klee, and Kandinsky at the Bauhaus. Some visual education courses in the secondary school are intrinsically involved

with the basic approach. Peter Thursby of Hele's School, Exeter, designates his first year sixth form course a 'Foundation Course', and the notable success of the Exeter course, and the basic design course devised by James Bradley at Sidcot School, Somerset, have clearly demonstrated the possibilities of the new approach. Lewis Heath of Burton Grammar School has a very controlled approach and has compiled a textbook of experiments. Every pupil has a copy of this and an art exercise book in which he writes an outline of the current experiment.[23] Thursby declares that 'we have persistently taught art as a craft or skill which can be mastered by only a talented minority. Art is a human reaction to environment and man's existence. We must therefore cease seeing art teaching as a means of passing on a mystique to those born with talent. Our aim is to provide a visual education, and in the process develop perception and sensitivity.'[24]

The foundation course at Hele's consists of monthly projects, or a series of investigations, by the boys into the structure of natural forms, the properties of growth, spacial relationships, properties of line and colour, optical illusions, texture, constructions, and the history of art. Each project is expressed in two or three dimensions. The following year the boys study three art subjects for A-level requirements, attend Life Classes, and carry out their experimental work for the school's annual exhibition. Thursby claims that the school is perfectly able to provide a foundation course comparable to pre-Diploma courses, and certainly Hele's is one of the few schools to conduct a successful course for direct entry into Dip.A.D. courses.

Edward Jenkins of Cardiff School of Art expresses a very strong view of the value of visual education as opposed to an aesthetically biassed art education for the production of artefacts. 'Art Education,' Jenkins declares, 'can and does suffer from a limited interpretation of ART as being the dominant factor ... We should be establishing a non-art situation not a process of self-conscious art making, not endowing the artefact with the "mystique" of esoteric significance.' He argues that creative visual education requires the teacher 'to be himself open-ended and without preconceived ideas as to "good" form, colour, processes more suitable to art, materials more particular to art, ideas more applicable to visual and plastic form. To be without the safety-net of any artefact, and create and sustain a situation in which the individual can invent. ... The teacher can afford no longer to teach from his own, or anyone else's propositions, formal understanding, systems, and/or personal dominance of style ... we should aim not so much at giving our students ideas but perhaps more towards giving students' ideas a chance.'[25]

Many advocates of visual education would not agree with a course

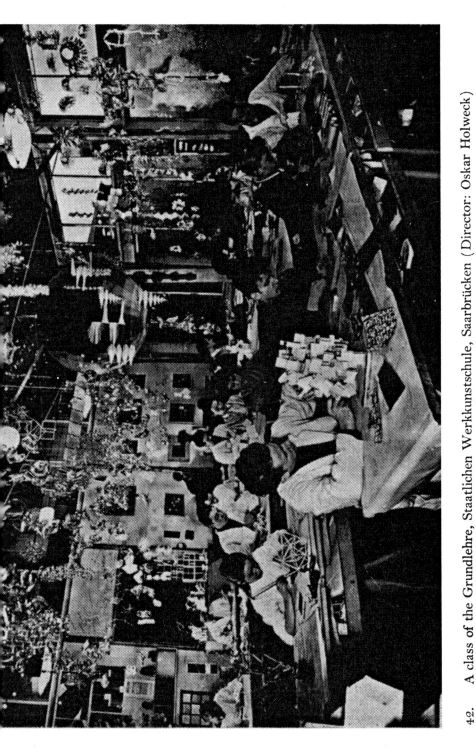

42. A class of the Grundlehre, Staatlichen Werkkunstschule, Saarbrücken (Director: Oskar Holweck)

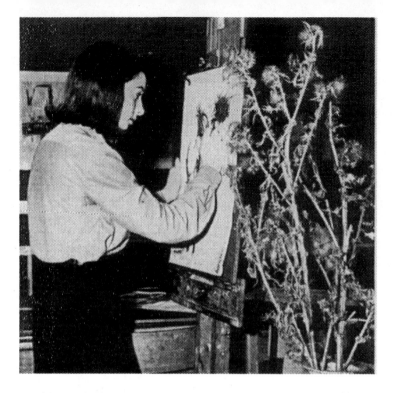

43. Creative drawing from desiccated herbs: St Clare's Secondary School, Manchester, 1969 (Teachers: N. Wakeling, J. Whittaker, J. McConville)
By courtesy of Manchester Education Committee (photo: B. Henderson)

44. 'Black and White': Hele's School Exhibition, 1967 (Teacher: Peter Thursby)

which ignores recognized examples of fine form and colour, and would endeavour to show their pupils as wide a range as practicable of historic and modern artefacts. They maintain that visual education based mainly on experimental studio work places too much faith in the inherent ideas of children. Lionel Burman, lecturer in charge of Manchester Education Committee's museum service, declares: 'Visual education should mean more than studio teaching', and urges the vital part museums should play in education.[26] Some enthusiastic teachers not only make use of the national School Museum Services, which are provided, sometimes by the local education authority, sometimes by the Museum authorities, but also from their own visual education collections in the school, consisting both of artefacts and natural objects.

Kurt Rowland, largely through his series, *Looking and Seeing*, has encouraged teachers to inculcate an analytical outlook upon artefacts and natural objects. He argues that visual language cannot be learned from a series of abstract exercises but that learning must be related to life at every point, otherwise the elements absorbed will not be usable.[27] Peter Green of Hornsey College of Art declares: 'A broad design education course could and should cut right across the whole secondary curriculum, a command of visual language being awarded the same importance as literacy and numeracy.'[28] A bold attempt at such a course, exploring the possibilities in Rowland's books, has been made by William Wilkins at Malvern College. The course, aimed at the needs of all the boys, includes pottery and woodwork. Wilkins suggest an O-level certificate in 'vision and design', and regrets that the present certificate syllabi are fine arts orientated, remote from the non-specialist breadth we require.[29] Will visual education achieve such official approval in the coming years? The most fascinating feature of art education is that a method evolves, then thrives or decays according to the quality of its products, not the artefacts but the living products – the students.

Sources

1. VINCI, LEONARDO DA *Treatise on Painting* (Codex Urbinas Latinus, 1270) Translated McMahon, A. Philip Princeton University Press, 1956 (Vol. I, p. 4)
2. ITTEN, JOHANNES *Design and Form* Thames & Hudson, London, 1964 (p. 12)
3. *School Calendars*, Manchester Municipal School of Art, 1940–3
4. GUGELOT, HANS 'On the Training of Industrial Designers' *The Designer*, December 1962 (p. 6)
5. MEULLER, UELI *Introduction* to the Zurich Exhibition of the Staatlichen Werkkunstschule, Saarbrücken, 1967
6. Outline of Foundation Course, Saarbrücken (provided at exhibitions)

7. HAMILTON, RICHARD 'Interview with Victor Willing' *Studio International,* September 1966 (p. 132)

8. SAUSMAREZ, MAURICE DE *Basic Design: the dyanmics of visual form* Studio Vista, London, 1964 (p. 11)

9. HUDSON, TOM *The Visual Adventure* Leicester College of Art, *c.* 1961

10. Brochure to the Manchester Exhibition of the Saarbrücken Werkkunstschule Manchester Education Committee, September 1968

11. CORNFORD, CHRISTOPHER Lecture notes, Royal College of Art, London, 1966

12. PASMORE, VICTOR 'The Developing Process' *Art News and Review,* 25 April 1959 (Vol. XI, No. 7, p. 2)

13. GIBBS, EVELYN *The Teaching of Art in Schools* (1934) Williams & Norgate, London, fourth edition 1948 (p. 15)

14. READ, SIR HERBERT *Education through Art* (1943) Faber & Faber, London, third edition 1958

15. ENG, HELGA *The Psychology of Children's Drawings* (1931) Routledge & Kegan Paul, London, second edition 1954

16. LOWENFELD, VIKTOR, and BRITTAIN, W. LAMBERT *Creative and Mental Growth* (1947) Collier-Macmillan, London, and Macmillan, New York, fourth edition 1964

17. LOWENFELD, VIKTOR *The Nature of Creative Activity* Routledge & Kegan Paul, London, second edition 1965

18. VALENTINE, C. W. *The Experimental Psychology of Beauty* Methuen, London, 1962

19. BURT, SIR CYRIL 'The factorial analysis of emotional traits' Part 2 *Character and Personality,* VII, June 1939

20. BULLOUGH, EDWARD 'The "Perceptive Problem" in the Aesthetic Appreciation of Single Colours' *British Journal of Psychology,* II (pp. 406–63), 1906–8; and 'Recent Work in Experimental Aesthetics' Ibid. XII (pp. 86–7), 1921–2

21. CARLINE, RICHARD *Draw They Must* Edward Arnold, London, 1968 (p. 253)

22. MILNER, DONALD E. 'The Art Teacher's Responsibility' *The Times Educational Supplement,* 19 June 1964

23. HEATH, LEWIS 'Art Laboratory' *Colour Review,* Spring Term 1968 Winsor & Newton, Narrow (pp. 4–6)

24. THURSBY, PETER 'Art Education for a New Society' *Colour Review,* Spring Term 1968 Winsor & Newton, Harrow (pp. 7–10)

25. JENKINS, EDWARD Lecture to Art Conference of the Colleges of Education of Manchester University, October 1967

26. BURMAN, LIONEL Address to the National Society for Art Education, April 1968

27. ROWLAND, KURT 'A Total Visual Education' *The Designer,* July 1966 (No. 161, p. 4)

28. GREEN, PETER 'Design for Teachers' *The Designer,* July 1966 (No. 161, p. 9)

29. WILKINS, W. 'Organizing a Visual Education Course' *The Designer,* July 1966 (No. 161, p. 9)

Table of Dates

c. 1488	Lorenzo dei Medici sets up a school of art in his garden at the Piazza San Marco, Florence
c. 1530	Baccio Bandinelli running an academy in the Belvedere, Vatican
1563	Accademia del Disegno established by Vasari in Florence
1593	Accademia di San Luca established in Rome under the protection of Pope Sixtus V
1648	Académie Royale founded by Louis XIV
1666	Académie de France established in Rome
1754	Society of Arts founded in London. The Society institutes drawing competitions
1760	Trustees' Academy founded in Edinburgh
1768	Royal Academy of Arts founded in London
1794	An academy founded in Philadelphia, reconstituted as the Pennsylvania Academy of Fine Arts in 1807
1802	Academy of Fine Arts established in New York
1807	Elgin Marbles arranged for private viewing in London
1825	Ingres opens his atelier in the Rue de Marais
1826	National Academy of Design established in New York
1835	Select Committee on Arts and Manufactures (Britain)
1837	Normal School of Design established in Somerset House, London
1841	First normal class for art teachers set up at Somerset House
1843	Art inspectorship commenced in Britain
1849	Select Committee on the School of Design
1851	The Great Exhibition in Hyde Park
1852	Department of Practical Art of the Board of Trade established at Marlborough House under Henry Cole and Richard Redgrave. Museum of Ornamental Manufactures formed (nucleus of later Victoria and Albert Museum)
1853	Department of Science and Art established with Lyon Playfair as Secretary. Elementary drawing examinations (First Grade) introduced into the public day schools by Cole at the request of the Committee of Council on Education
1856	Department of Science and Art, together with Education Department, put under Committee of Council on Education. Museum moved to iron building at South Kensington
1857	Central Art Training School transferred to South Kensington. Playfair resigns, and Cole appointed Secretary of the Department of Science and Art

1863	Complete Payment on Results introduced for art masters from 1 October 1863 by Minute of the Committee of Council of 24 February 1863
	Central Art Training School renamed the National Art Training Schools
1864	Select Committee on the Schools of Art
1869	School of Fine Arts opened at Yale
1871	Slade School of Fine Art opened at University College, London
1873	Henry Cole resigns as Secretary of the Department of Science and Art and Director of the South Kensington Museum
	Massachusetts State Normal Art School founded in Boston by Walter Smith
1875	E. J. Poynter succeeds R. Redgrave as Director of the Department of Science and Art
1876	Alphonse Legros takes charge of the Slade
1878	City and Guilds of London Institute founded
1884	Reports of the Royal Commission on Technical Instruction
	Art Workers' Guild founded
1885	Woodwork class set up at Beethoven Street School, London
1888	First exhibition of the Arts and Crafts Exhibition Society
	Society of Art Masters founded (now National Society for Art Education)
	Royal Drawing Society founded
1890	Government grants for manual training (woodwork and metalwork) following the Cross Commission of 1888
1892–1900	Walter Crane's books on design published
1895	'Freearm drawing' introduced in the elementary schools by the Alternative Syllabus of the Department of Science and Art
	Studies of Childhood by James Sully published
1896	National Art Training Schools reconstituted as Royal College of Art
	London County Council established the Central School of Arts and Crafts
1897	Cizek's Juvenile Art Class opened in Vienna
1898	Walter Crane appointed principal of the Royal College, where he introduced craftwork
1899	Board of Education Act. Department of Science and Art and Education Department merged into Board of Education
1900	Council of Advice on Art appointed by Board of Education
1901	Royal College reorganized into four schools: architecture, painting, sculpture, and design. Schools of Art follow suit
1902	Education Act (Balfour–Morant). Schools of Art put under the newly-created local education authorities. End of Payment on Results: art masters now on full salaries
1907	Deutscher Werkbund founded by Hermann Muthesius
1908–35	Exhibitions of the work of Cizek's class in Germany, France, the U.S.A. and Britain

1913	Board of Education Grouped Drawing Examinations replace the many categories of drawings required for the Art Masters Certificate. Rules 109 published and courses on Principles of Teaching and School Management introduced for art students
1915	National Competition for Schools of Art abolished Design and Industries Association founded
1919	Bauhaus founded by Walter Gropius in Weimar
1924	Marion Richardson appointed to London Day Training College
1925	Bauhaus moves to Dessau
1926	Hadow Report suggests that Practical Instruction (handicrafts) should be linked with art
1930	Marion Richardson appointed District Art Inspector by London County Council
1932	Gorell Report on production and exhibition of articles of good design
1933	Board of Education's Teaching Certificate for Teachers in Schools of Art renamed Art Teachers Diploma (A.T.D.) The Board recommends regional art colleges Bauhaus closed
1934	Council for Art and Industry formed by the Board of Trade
1936	Hambleden Committee
1944	Council of Industrial Design set up by the Board of Trade to organize exhibitions, discussions, and lectures; to provide advice for design development; and to assist the establishment of design centres
1946	National Diploma in Design introduced by Ministry of Education. Board's examinations in drawing replaced by Ministry's Intermediate Examination in Arts and Crafts Ministry's Pamphlet No. 6, *Art Education*, published (H.M.S.O.) dealing with every level of art education from nursery to art teacher training
1957	Report of the National Advisory Committee on Art Examinations
1959	National Advisory (Coldstream) Council on Art Education appointed
1961	First Report of the (Coldstream) Council. Diploma in Art and Design (Dip. A.D.) instituted to replace the National Diploma in Design. National (Summerson) Council for Diplomas in Art and Design appointed
1962	Second Report of the (Coldstream) Council: *Vocational Courses in Colleges and Schools of Art*
1963	Robbins Report: *Higher Education* (recommendation for B.Ed. courses) Certificate of Secondary Education instituted
1964	Third Report of the (Coldstream) Council: *Post-Diploma Studies in Art and Design*
1966	White paper: *A Plan for Polytechnics and Other Colleges*
1967	Plowden Report: *Children and their Primary Schools* (includes report on primary art education)

1967 Royal College of Art granted university status by Royal Charter. Degrees of M.Art and M.Des. instituted

1968 Art students' demonstrations and protests against the national system of art education

Appendix A

Early Government Schools of Art in Great Britain and Ireland with the dates of their foundations

Those founded before 1852 were firstly Schools of Design under the Head School at Somerset House. Some schools mentioned were mere classes.

1837	The Normal, Central, or Head School of Design, Somerset House (London). This became the Central Training School at Marlborough House (1852), then at South Kensington (1857), renamed the National Art Training Schools (1863), reconstituted as the Royal College of Art (1896) which moved into new buildings at Kensington Gore in 1962
1838	Manchester School of Design opened; recognized for grant, 1842
1841	Spitalfields (London)
1842	Female School (London), York (Minster Yard)
1843	Nottingham, Sheffield, Coventry, Birmingham, Newcastle upon Tyne
1844	Glasgow
1845	Norwich
1846	Stoke, Paisley, Leeds
1847	Hanley
1849	Belfast, Cork, Dublin
1850	Macclesfield
1851	Stourbridge, Worcester
1852	Limerick, Waterford
1853	Aberdeen, Bristol, Caernarvon, Cheltenham, Chester, Dudley, Durham, Newcastle under Lyme, Penzance, St Thomas's Charterhouse Branch (London), Swansea, Truro, Warrington
1854	Andover, Bath, Carlisle, Exeter, Lambeth (London), Tavistock, Wolverhampton, St Martin's (London)
1855	Birkenhead Park, Birkenhead (The Holt), Liverpool (South and North Districts), Southampton (Hartley Institute), Shrewsbury
1856	Coalbrookdale, Dundee (High School), Lancaster, Taunton
1857	Darlington, Stirling, Great Yarmouth
1858	Cambridge, Edinburgh (Male and Female Schools), Ipswich, Devonport (Mechanics' Institute)
1859	Brighton, Gloucester, Halifax
1860	Boston, Bromsgrove, Cirencester, Preston (Harris Institute), Reading, Stroud, Bridgewater

1861	Hull, Warminster, Sunderland
1862	Kidderminster, West London
1863	Lincoln, Perth
1864	Devizes, Trowbridge
1865	Bridport, Frome, Inverness, Oxford, Oldham, Salisbury
1867	Dorchester, Kilmarnock
1868	Cardiff, Croydon, Lewes, North London, Wakefield
1869	Burslem, Manchester (Grammar School), Portsmouth
1870	Derby, Dover, Keighley, Kendal, Leamington, Leicester, Winchester
1871	Bradford (Mechanics' Institute), Northampton, Ryde, Shipley, Walsall
1872	Farnham, Huddersfield, Stratford, Redditch, Selby, Southampton (Philharmonic Hall Branch)
1873	Berwick-on-Tweed, Islington (London), Middlesbrough
1874	Barnsley, Barrow-in-Furness, Bradford (Church Institute and Grammar School Branches), Stafford, Watford, Rotherham
1875	Bideford, Dumfries, Hastings and St Leonards, Londonderry, Newport
1876	Birmingham (Hope Street, Moseley Road, Osler Street, and Smith Street Branches), Bolton, Elgin, Mansfield, Plymouth, Westminster (London)
1877	Barnstaple, Doncaster, Glasgow (Buchanan Institute Branch), Weymouth
1878	Bromley, Falkirk, Manchester (Longsight Branch), Newcastle upon Tyne (Corporation Street)
1879	Birmingham (Jenkins Street Branch), Burnley, Chesterfield, Plymouth (Y.M.C.A.), Sleaford
1880	Blackheath (London), Brighton (Reading Room and Hove Branches), Manchester (Mechanics' Institute), Kennington Park Road (London), Newcastle upon Tyne (Mechanics' Institute), Carmarthen, Leicester (Wyggeston's Hospital Branch), Gosport, York (Lower Ousegate Branch)
1881	Bedford, Bournemouth, Burton-on-Trent, Hertford, Chiswick (London), Ilkley, South Shields, Waterford
1882	Canterbury, Helensburgh, Hornsey (London), Chelsea (London), Lowestoft, Stoke Newington (London), Peterborough, Scarborough, Tiverton, Weston-super-Mare
1883	Accrington, Ayr, Blackburn, Bradford (Technical College Branch), Harrogate, Holloway (London), Burnley (Briercliffe Branch), Broseley, Newark-on-Trent, Preston (Cross Street Branch), Welshpool
1884	Banbury, Camborne, Dumbarton, Cork (Kinsale, Kenmare and, Killarney Branches), Gravesend, Hawick, Leek, Maidenhead, Manchester (Deansgate Branch), London (Bayswater, Birkbeck Institute, Putney and Saffron Hill Branches), Teignmouth

Appendix B

1. *Colleges of Art and Polytechnics in England and Wales in which Diploma in Art and Design courses are approved by the National Council for Diplomas in Art and Design (correct at January 1970), classified by subjects*

FINE ART

Painting and Sculpture: Bath, Birmingham, Bristol, Camberwell, Cardiff, Central (London), Chelsea, Cheltenham (Gloucestershire College of Art), Coventry, Exeter, Falmouth, Goldsmiths' (London), Hornsey, Kingston (on Thames), Kingston upon Hull, Leeds, Leicester, Liverpool, Loughborough, Maidstone, Manchester, Newcastle (upon Tyne), Newport, Nottingham, Portsmouth, Ravensbourne (Bromley), Sheffield, St Martin's (London), Sunderland, Winchester, Wolverhampton
Painting only: Brighton, Canterbury, Norwich, Stourbridge, Wimbledon

GRAPHIC DESIGN

Bath, Birmingham, Brighton, Bristol, Camberwell, Canterbury, Central (London), Chelsea, Coventry, Hornsey, Kingston (on Thames), Leeds, Leicester, Liverpool, London College of Printing, Maidstone, Manchester, Newcastle (upon Tyne), Newport, Norwich, Ravensbourne (Bromley), St Martin's (London), Stoke-on-Trent, Wolverhampton

THREE-DIMENSIONAL DESIGN

Silversmithing: Leicester, Loughborough, Sheffield
Silversmithing and Jewellery: Birmingham
Silver-Metal: High Wycombe, Hornsey
Jewellery: Central (London)
Industrial Design (Engineering): Birmingham, Central (London), Leeds, Leicester, Manchester, Newcastle (upon Tyne)
Furniture: Birmingham, Bristol, Central (London), High Wycombe, Hornsey, Kingston (on Thames), Leeds, Leicester, Loughborough, Newcastle (upon Tyne), Ravensbourne (Bromley)
Ceramics: Bath, Bristol, Camberwell, Cardiff, Central (London), Farnham, Hornsey, Leicester, Loughborough, Stoke-on-Trent, Wolverhampton
Interior Design: Brighton, Kingston (on Thames), Leeds, Leicester, Manchester

Wood–Metal–Ceramics: Manchester
Theatre: Central (London), Wimbledon
Glass: Stourbridge

TEXTILES/FASHION

Woven and Printed Textiles: Birmingham, Camberwell, Central (London), Hornsey, Leicester, Liverpool, Loughborough, Manchester, Winchester
Woven Textiles only: Farnham
Fashion: Birmingham, Cheltenham (Gloucestershire College of Art), Hornsey, Leicester, Liverpool, Manchester, Nottingham, Ravensbourne (Bromley), St Martin's (London)
Embroidery: Birmingham, Goldsmiths' (London), Loughborough, Manchester

2. Colleges of Art and Polytechnics in England and Wales approved for post-Diploma courses leading to the Higher Diploma in Art or the Higher Diploma in Design (correct at January 1970), classified by subjects

Painting: Birmingham, Chelsea
Sculpture: Birmingham, Chelsea, Manchester
Graphic Design: Birmingham, Central (London), Leicester, Manchester
Industrial Design (Engineering): Birmingham, Central (London), Leicester, Manchester
Interior Design: Leicester, Manchester
Woven and Printed Textiles: Birmingham, Central (London), Manchester
Fashion: Leicester
Printmaking: Chelsea

3. Central institutions authorized by the Scottish Education Department to grant the Diploma in Art

Aberdeen (Gray's School of Art)
Drawing and Painting
Design and Crafts (two or more of the following: Embroidery; Graphic Design; Jewellery; Silversmithing; Textiles; Weaving)
Sculpture

Dundee (Duncan of Jordanstone College of Art)
Drawing and Painting
Design (specializing in either Graphic Design or Textile Design)
Interior Design
Silversmithing and Jewellery
Modelling and Sculpture

Edinburgh College of Art
Drawing and Painting
Design and Crafts (main subjects: Calligraphy and Lettering; Ceramics; Dress
 Design and Fashion Drawing; Furniture Design; Glass Design; Graphic
 Design (General); Interior Design; Illustration; Jewellery; Lithography,
 Silk Screen and Etching; Murals; Silversmithing and Allied Crafts; Stained
 Glass; Printed Textiles; Woven Textiles; Tapestry)
Sculpture
(The University of Edinburgh in collaboration with the governors of the
Edinburgh College of Art awards the degree of M.A. with Honours in Fine Art)

Glasgow School of Art
Drawing and Painting
Design (Ceramics; Embroidery and Weaving; Industrial Design; Interior
 Design; Printed Textiles; Silversmithing, Jewellery and Allied Crafts;
 Stained Glass, Mural Decoration and Mosaic)
Sculpture
Graphic Design

Appendix C

The National Course of Instruction for Government Schools of Art in Britain

All work in the Schools of Art up to 1889 (Technical Instruction Act) was based on this Course. Most of the students were on Stages 1–10 and on occasion as many as half of them were on Stage 2.

THE DRAWING COURSE

Ornament Stages

Stage 1. Linear drawing with instruments

a) Linear geometry

b) Mechanical drawings of architectural details

c) Linear perspective

Copies: plates mounted on card of Geometry, Architectural detail and Perspective from the Department

Stage 2. Freehand outline of rigid forms from the flat copy

a) From a copy of an object

b) From a copy of an ornament

Copies: for *a*) Brown's eight plates of freehand drawing; for *b*) copy of Tarsia Scroll supplied by the Department, No. 256; or the Trajan Scroll from *Specimens of Ornamental Art* by L. Gruner; or the Trajan Frieze from Albertolli, Department No. 1271

Stage 3. Freehand outline from the round (solids or casts)

a) From models and objects

b) From a cast of ornament

Cast: either lower portion of the pilaster of the gates from La Madeleine, or a portion of the two pilasters from the tomb of Louis XII, Department Nos. 460 and 478

Stage 4. Shading from the flat, examples or copies [usually in chalk]

a) From copies of models and objects

b) From a copy of ornament

Copies: for ornament, either Renaissance Rosette, Department No. 291, or copy of an ancient car or biga from *Specimens of Ornamental Art* by L. Gruner (p. 14)

Stage 5. Shading from the round, solids or casts [usually in chalk]

a) From solid models and objects

b) From cast of ornament

c) Time sketching and sketching from memory

Cast: either the Egg Plant of the architrave of the Gates of Ghiberti, or the lower portion of the Florentine Scroll, Department No. 474

Figure and Flower Drawing Stages

Stage 6. Human or animal figure from the flat
a) In outline
b) Shaded
Copies: outline of 'Laocoon', Department No. 249 or 579; or Farnese 'Hercules', Department No. 501; or outlines of the figure by Mr Herman, 22 plates

Stage 7. Flowers, foliage and objects of natural beauty from the flat
a) In outline
b) Shaded
Copies: Dicksee's *Foliage, Fruit and Flowers*, mounted 25 in. × 21 in. (e.g. The Wallflower, The Passion Flower), or Albertolli's *Foliage*, 8 plates

Stage 8. Human or animal figures from the round or from nature
a) Outline from cast
b) Shaded from cast
c) From the nude model
d) Draped
e) Time sketching from memory
Casts: *a*) the Panathenaic frieze from the Parthenon, Department No. 497, British Museum 29, or the portion of British Museum 30, to be drawn 22 in. x 25½ in.; or *b*) the 'Discobolus' of Myron, Department No. 453, or the 'Discobolus' of Naucydes, or the 'Fighting Gladiator'

Stage 9. Anatomical studies
a) Of the human figure from the flat
b) Of animals from the flat
c) Of either modelled
Examples: bones and muscles filled within the outline of the 'Discobolus' of Myron, Department No. 459, or man and horse from the Panathenaic frieze

Stage 10. Flowers, foliage, landscape details and objects of natural beauty from nature
a) In outline
b) Shaded

THE PAINTING COURSE

Stage 11. Painting ornament from the flat
a) In monochrome
b) In colour (water colour, tempera, or oil for both)
Copies: the Trajan Scroll for *a*), and J. C. Robinson's *Collection of Coloured Ornaments*, Plates 3 or 9, Department Nos. 588 and 594

Stage 12. Painting ornament from the cast
Cast: Roman Rosette from the Capitol (hexafoil with re-curved leaves), Department No. 30; or Pomegranate and Egg Plant portion of the architrave of the Ghiberti Gates; or Trajan Scroll, Department No. 471

Stage 13. Painting flowers, objects of natural beauty or landscapes from the flat

Copies for flowers: Torrenia Asiatica, Department No. 306, or Pelargonium, Department No. 300; for copies in tempera: Brooks's *Studies of Flowers*; for flat tints: Department Nos. 1536 or 1539

Stage 14. Painting the above from nature [a favourite with advanced Ladies' Classes]

Stage 15. Painting sketches of an object or a group as a colour composition

Stage 16. Painting the human figure or animals in monochrome from the cast
Cast: female torso from British Museum, Department No. 455, or dancing girl with wreath (high relief in panel)

Stage 17. Painting the human figure
a) From the flat copy
b) From nature, nude or draped
c) Time sketches and compositions

THE MODELLING COURSE

Stage 18. Modelling ornament
a) From the cast
b) From drawings
c) Time sketches from example and memory
Cast: nest of the scroll of the pilaster from the Villa Medici, Department No. 473

Stage 19. Modelling the human figure or animals
a) From the cast or models of animals
b) From drawings
c) From the nude or draped [a student from Carlisle sent in a finished marble bust under (*c*)]
Cast: 'Hercules', or the 'Discobolus' of Myron or of Naucydes

Stage 20. Modelling flowers, fruit or foliage or objects of natural history from nature

Stage 21. Time sketches in clay of the human figure or animals from nature

THE DESIGN COURSE

[To win the highest award, a National Scholarship to the Central School, South Kensington, a student or teacher must have won a National Medallion at the National Competition in one of the sub-sections below.]

Stage 22. Elementary design
a) Natural objects ornamentally treated usually botanical
b) Ornamental arrangement to fill a given space in monochrome
c) In colour [this was very popular – shape and plant were prescribed by the Department, e.g. fill a hexagon with an arrangement of a mallow]
d) Studies of historic ornament drawn or modelled

Special Technical Stage

[These advanced stages were based on the Special Classes set up in 1852 in Marlborough House and later at South Kensington.]

Stage 23. Applied design. Technical studies
a) Machine and mechanical drawing, plans, mapping and surveys
b) Architectural design
c) Surface design
d) Plastic design
e) Moulding, casting, chasing
f) Lithography
g) Wood engraving
h) Porcelain painting

Index of Names

Ablett, T. R., 267, 323, 326, 327–8, 351
Adam, L., 332, 333
Adams, R., 367
Agatharcus, 52
Albers, J., 316, 366
Albert, H.R.H. Prince, 67, 129–30, 140, 170, 178, 181, 192, 201
Alberti, F., 49
Alberti, L. B., 41, 46, 50, 54
Alcott, A. Bronson, 253
Allan, Sir W., 76
Anaxagorus, 52
Anderson, G. Wedgwood, 166, 214
Anderson, J., 37, 76
Aristotle, 49
Armstrong, Sir T., 288, 294
Arnheim, R., 374
Ashbee, C. R., 311, 314, 362

Bacon, F., 56
Baer, K. E. von, 333
Bain, A., 323, 324–5
Bandinelli, B., 24
Barnard, H., 253
Beaumont, Sir G., 61
Behrens, P., 314
Bell, J. Z., 85–8, 90, 144, 287
Bell, Q., 41, 120
Bentham, J., 226, 228
Berkeley, G., 278
Bertoldo, 24
Birkbeck, G., 37, 68, 76
Black, M., 358, 363
Blake, W., 58
Boethius, 19, 52
Boisbaudran, L. de, 272–3
Bonomi, J., 45
Borenius, T., 279
Bowler, H. E., 205
Bradley, J., 376

Bramante, 46
Brinsley, J., 150
Brittain, L. W., 373
Brock, A. Clutton, 314
Brougham, Lord H., 60
Brown, F., 269, 270, 275, 277
Brunelleschi, F., 52
Bullough, E., 374
Burchett, R., 98, 131, 158, 163, 166, 174, 189, 210, 226, 227, 230
Burke, E., 56–7
Burman, L., 377
Burt, Sir C., 328, 337, 373
Butler, R., 281, 362, 367

Calderon, A. A., 34
Callcott, Sir A. Wall, 69
Carey, F. S., 33
Carline, R., 375
Carracci, L., 25
Casson, Sir H., 358, 362
Castiglione, B., 54, 149
Cecil, Lord D., 61
Cellini, B., 19, 21
Cennini, C., 22
Chadwick, H., 361
Chambers, Sir W., 28, 62
Chantrey, Sir F., 69, 70
Cizek, F., 320, 340–7
Clark, J. B., 274
Clark, Sir K., 349
Clark, T., 106–7
Cockerell, C. R., 63, 69, 93, 101, 127
Coldstream, Sir W., 280, 281–2, 355
Cole, Sir H., 101, 102, 107, 108, 129–31, 133–41, 145, 148, 157–85, 188–92, 196–206, 207–24, 226–33, 248
Collins, P., 229–32
Comenius, J. A., 50
Constable, J., 64

Index

Cooke, E., 267, 323, 326
Cooper, D. Davies, 95, 102, 104
Cornford, C., 358, 370, 371
Crane, W., 239–40, 292–7, 311–14
Crosland, A., 362
Cubitt, Sir W., 201
Cygnaeus, U., 306

Daintrey, A., 275, 276
Danzel, T., 332
Darwin, C., 321
Darwin, Sir R., 357–8
David, J. L., 26, 54, 286
Davidson, E. A., 151, 217
Davie, A., 367
da Vinci, L., 17, 23, 46, 49, 51, 53, 99, 365
Day, L., 241
Delaroche, P., 287
de La Tour, A., 25
della Torre, M., 50
Democritus, 52
Denby, W., 83, 131
Denny, R., 368
de Rachewiltz, B., 17
Deverell, W. H., 131, 135
Deverell, W. R., 89, 134, 178
Dewey, J., 348
Dickens, C., 179, 223, 229–32
Dickinson, T., 280
Dobson, W. C. T., 106, 144
Donatello, 24, 52
Donnelly, Major General Sir J., 203, 293, 296
Dow, A. Wesley, 260, 342, 348–9
Dresser, C., 249
Du Maurier, G., 265, 285, 288
Dunlap, W., 31, 32
Durrant, H., 83, 104
Dury, J., 150
Dyce, W., 75, 77–88, 92–3, 100, 118–26, 131–2, 151, 153, 230, 254

Eakins, T., 32, 33
Eastlake, Sir C., 193, 244
Elyot, Sir T., 149
Eng, H., 373
Ettlinger, L. D., 280
Etty, W., 29, 70, 103, 127
Eudoxus, 48
Ewart, W., 61, 65, 67, 70, 75, 81, 120

Farrell, P., 363
Fechner, C. T., 48
Feilding, K., 229–31
Fellenberg, P. von, 76, 77
Findon, A. E., 83
Finnie, J., 173, 192
Forster, W. E., 223
Fowke, Capt. F., 171, 202, 203, 205, 216, 223
Fowle, W. Bentley, 253
Fox, C., 336
Franklin, B., 253
Frith, W. Powell, 30, 33
Froebel, F., 306, 344
Frost, T., 368
Frost, W. E., 33
Froy, M., 368
Fry, R., 279, 330, 349, 350
Fuseli, H., 30

Galen, L., 44, 49
Gaunt, W., 264
Gear, W., 367
Gérôme, J., 32, 287
Ghirlandajo, D., 24
Ghyka, M., 49
Gibbs, E., 349
Gibson, C. Milner, 138
Gifford, E., 102, 105
Glazier, R., 247, 296
Goethe, J. W. von, 334
Goldscheider, L., 23
Gombrich, E., 280
Gordon, Sir J. W., 76
Graham, J., 76
Granville, Earl G. L. G., 108, 130–1, 139, 140, 146, 197, 212, 217, 218, 223
Gray, M., 361
Greenaway, K., 239
Greenham, P., 31
Gropius, W., 315–17, 363
Gros, Baron., 85
Grünberg, T. Koch-, 330, 331
Gruner, L., 91
Guyatt, R., 358

Haeckel, E. H., 333
Hall, S. Carter, 100, 133
Halliwell, V., 367
Hambidge, J., 48
Hamilton, R., 360, 367, 368, 370

393

Index of Subjects

academic principles, 41–58
Academies:
 in France, 25–7
 in Italy, 23–5
 in the United States of America, 31–3
 Academia di Baccio Brandin (Baccio Bandinelli), 24
 Leonardi Vinci, 23
 Académie de France (Rome), 25, 26
 des Beaux Arts (Brussels), 27
 des Beaux Arts (Lyon), 79
 des Beaux Arts (Paris), 26
 Julian, 289–90
 Academy, Kneller's, 27
 National (New York), 32
 Pennsylvania, 32
 Royal (London), 27–31, 62–7, 175
 St Martin's Lane, 28
 Thornhill's, 28
 Trustees' (Edinburgh), 76
 Accademia degli Incamminati (Bologna), 25
 del Disegno (Florence), 24
 di San Luca (Rome), 24
American art education, see United States
anatomy, 24, 29, 32, 33, 34, 49–51, 116–17, 278–9
antique, drawing from the, 27, 152, 193–8, 263, 274
apprenticeship, 21–3
Art-Socialists, ideas of the, 310–11
Art Teachers' Diploma, 304–5
Art Workers' Guild, 292–3, 297
artisans' classes, 151–2, 176–7
Arts and Crafts Exhibition, 293
ateliers, Paris, 284–90

Bachelor of Education degree, 359
base line in child art, 338–9
basic courses, 365–72, 376

Bauhaus, 315–18, 365–7
beauty, 53–4
biogenetic theory, 333–5
Black Mountain College (North Carolina), 316, 366

Canon of Polykleitos, 44–6
'Chamber of Horrors', 178–9
child art, and evolution, 321–2, 333–5
 compared with primitive art, 329–35
 recognition of, 320–52
 symbols and schemata, 337
City and Guilds of London Institute, 306, 309
colleges of education, 359
common schools (U.S.A.), drawing in, 253–4
'composition' 347–9
copies, 191–2
crafts, 298–309

Department of Practical Art, 141, 157, 189
Department of Science and Art, 161, 162, 166, 172, 179, 181, 183, 198, 205–6
design, as science, 121–4
 definition of, 291
 Morris and Crane on, 312–14
 schools, 301–3
 South Kensington concepts of, 230–50
Dilettanti Society, 36, 64, 65, 66
Diploma in Art and Design, 305, 355–7, 363–4, 385–7
drawing, books, 122–3, 153, 323
 elementary, 155, 160, 223–4, 257–8
 life, see life drawing
 masters, 144–6, 147
 memory, 272–3, 349
 Slade, concept of, 277–9

United States of America, art education in, 31–3, 253–61, 316, 347–9, 366–7

universities, 92, 261, 267, 316, 342, 348, 359–60, 366, 367

university degrees in fine art, 359–60

Victoria and Albert Museum, *see* South Kensington Museum

visual development, *see* stages of visual development

visual education, 372–7

Werkbunds, 314

woodwork, 298, 305–7

X-Ray drawings, 339

Printed in the United Kingdom
by Lightning Source UK Ltd.
117033UKS00001B/36